THE ART NEWSPAPER

provides art market details for all the artists
and essential facts about the leading art cities
of the world

137 Artists at the Rise of the New Millennium

137 Künstler zu Beginn des 21. Jahrhunderts — 137 Artistes au commencement du 21ème siècle

Edited by Uta Grosenick & Burkhard Riemschneider

TASCHEN

Contents — Inhalt — Sommaire

Preface — Vorwort — Préface

Three years after the publication of ART AT THE TURN OF THE MILLENNIUM, we present ART NOW, a new book focusing on young artists at the beginning of the 21st century.

However, ART NOW is in no way intended merely as a follow-up. At the end of the 20th century we looked at artists whose careers began in the 1980s and 90s. Now, at the dawn of the 21st, we turn our attention to a younger generation that has conquered the exhibition scene only in the last few years. It was, of course, logical to reconsider some of the artists featured in ART AT THE TURN OF THE MILLENNIUM. On the one hand, the innovative nature of those who occupied key positions in the 1980s and 1990s provides a firm point of reference for younger artists. On the other, it was important to us to chart the progress of the work of artists whose career was only just beginning at the time ART AT THE TURN OF THE MILLENNIUM was published.

Although, then as now, our main focal point is the Western art world, we have also taken account of the increasing internationalisation of the art scene. ART NOW includes a number of artists from Asia, Africa and Latin America, thus broadening a perspective that so often concentrates only on Europe and North America. We cannot emphasise enough – especially when we consider the many reactions to ART AT THE TURN OF THE MILLENNIUM – that our subjective choice has been made from a far greater number of promising and exciting artists.

Here, we present a total of 137 artists, each of whom has been allotted four pages showing typical examples of their most recent output. Visually, the new layout underlines the unique style of this collection. We include the usual factual information: artists are listed alphabetically, with short texts on their work written by ten international authors from the United States, Germany, Denmark and Poland. This is accompanied by reproductions of their most important works, plus biographical details, most significant exhibitions, publications about them and a personal statement. The up-dated glossary has been extended to include specific expressions that constantly crop up in texts and discussions about contemporary art. The second, completely new, part of the book provides a useful addition: a comprehensive supplement compiled by THE ART NEWSPAPER.

ART NOW is both an up-to-date work of reference and an exciting, lavishly illustrated book, aimed at professionals and art lovers alike.

We hope that this view of the new millennium will attract the same gratifying and widespread attention as ART AT THE TURN OF THE MILLENNIUM received.

Uta Grosenick and Burkhard Riemschneider
Cologne and Berlin, May 2002

We would like to thank everyone who helped bring this book to fruition, first and foremost the artists, the galleries representing their work, and the photographers who have documented their work.
Thanks also to the authors of the texts and glossary: Kirsty Bell, Ariane Beyn, Frank Frangenberg, Barbara Hess, Gregor Jansen, Anke Kempkes, Lars Bang Larsen, Nina Möntmann, Raimar Stange, Rochelle Steiner and Adam Szymczyk.
We are grateful to associate editor Sabine Bleßmann, the designers Andy Disl and Birgit Reber, Ute Wachendorf of the production department, and Kathrin Murr for her support.
Our warmest thanks also go to the publisher Benedikt Taschen for his enormous enthusiasm throughout the whole creative process.

Mit ART NOW legen wir drei Jahre nach dem Erscheinen von ART AT THE TURN OF THE MILLENNIUM wieder ein Buch vor, in dem junge Künstlerinnen und Künstler zu Beginn des 21. Jahrhunderts präsentiert werden.

ART NOW versteht sich jedoch keineswegs nur als Folgeband. Haben wir zum Ausklang des Jahrtausends Künstlerinnen und Künstler vorgestellt, deren Karrieren in den achtziger und neunziger Jahren begannen, rücken wir jetzt, zu Beginn des 21. Jahrhunderts, bewusst eine jüngere Generation ins Blickfeld, die erst in den letzten Jahren die Ausstellungsszene erobert hat. Dazu gehören natürlich auch Künstlerinnen und Künstler, die in ART AT THE TURN OF THE MILLENNIUM präsentiert wurden. Auf der einen Seite nehmen sie Schlüsselpositionen der achtziger und neunziger Jahre ein und bieten durch ihren innovativen Charakter einen festen Bezugspunkt für jüngere Künstler. Auf der anderen Seite war es uns wichtig, das Werk von Künstlerinnen und Künstlern weiterzuverfolgen, deren Karriere bei Veröffentlichung von ART AT THE TURN OF THE MILLENNIUM erst am Anfang stand.

Auch wenn unser Hauptaugenmerk nach wie vor der westlichen (Kunst-)Welt gilt, tragen wir der zunehmenden Internationalisierung der Kunstszene Rechnung: Asiatische, afrikanische und südamerikanische Künstlerinnen und Künstler in ART NOW erweitern den oftmals auf Europa und Nordamerika fixierten Blickwinkel. Dabei können wir nicht aufhören zu betonen – gerade wenn wir an die vielen Reaktionen auf ART AT THE TURN OF THE MILLENNIUM denken –, dass unsere subjektive Auswahl aus einer weit größeren Anzahl von jungen, vielversprechenden und spannenden Künstlerinnen und Künstlern stammt.

Insgesamt stellen wir 137 Künstlerinnen und Künstler auf je vier Seiten mit exemplarischen Beispielen ihrer jüngsten Produktion vor. Das neue Layout betont auch optisch die Eigenständigkeit des vorliegenden Kompendiums. Beibehalten sind die gewohnten informativen Elemente – wie die alphabetische Reihenfolge der Künstlerinnen und Künstler, kurze Texte zum Werk, die von zehn Autorinnen und Autoren aus den Vereinigten Staaten, aus Deutschland, Dänemark und Polen verfasst wurden, Abbildungen der bedeutendsten Arbeiten der Künstlerinnen und Künstler sowie ihrer Porträts, Nennung ihrer wichtigsten Ausstellungen und der über sie erschienenen Publikationen sowie ein eigenes Statement. Das aktualisierte Glossar wurde um viele spezifische Begriffe erweitert, die in den Texten oder in der Diskussion um zeitgenössische Kunst immer wieder auftauchen. Eine sinnvolle Ergänzung bietet der neue Anhang: ein von THE ART NEWSPAPER zusammengestellter umfangreicher Serviceteil.

Damit ist ART NOW aktuelles Nachschlagewerk, anregender Bildband und Kunstguide zugleich; ebenso unterhaltsam und informativ für Einsteiger wie Kenner der jungen Kunstszene.

So hoffen wir, dass auch diesem Ausblick auf das neue Jahrtausend die erfreulich große Aufmerksamkeit zukommt, die ART AT THE TURN OF THE MILLENNIUM auf sich gezogen hat.

Uta Grosenick und Burkhard Riemschneider
Köln und Berlin, im Mai 2002

Bedanken möchten wir uns bei allen, die am Zustandekommen dieses Buches mitgewirkt haben, zuallererst bei den Künstlerinnen und Künstlern, den Galerien, die ihr Werk repräsentieren, sowie den Fotografinnen und Fotografen, die diese Arbeiten dokumentiert haben. Bei den Autorinnen und Autoren der Texte und des Glossars Kirsty Bell, Ariane Beyn, Frank Frangenberg, Barbara Hess, Gregor Jansen, Anke Kempkes, Lars Bang Larsen, Nina Möntmann, Raimar Stange, Rochelle Steiner und Adam Szymczyk. Außerdem sind wir der Ko-Lektorin Sabine Bleßmann, den Designern Andy Disl und Birgit Reber, der Herstellerin Ute Wachendorf sowie Kathrin Murr für ihre freundliche Unterstützung zu großem Dank verpflichtet. Herzlichen Dank sagen möchten wir auch dem Verleger Benedikt Taschen, der das Entstehen der Publikation mit enormem Enthusiasmus begleitet hat.

Preface — Vorwort — Préface

Avec ART NOW, trois ans après la publication d'ART AT THE TURN OF THE MILLENNIUM, nous présentons de nouveau un choix de jeunes artistes à l'orée du 21ème siècle.

Pour autant, ART NOW ne s'entend en aucune façon comme une suite d'ART AT THE TURN OF THE MILLENNIUM. Si la fin du millénaire avait été pour nous l'occasion de présenter des artistes dont la carrière avait débuté dans les années 80 et 90 du 20ème siècle, aujourd'hui, au début du 20ème siècle, nous attirons l'attention sur une génération plus jeune qui n'a conquis les espaces d'exposition qu'au cours de ces dernières années. Il était évidemment logique d'intégrer dans ce livre un certain nombre d'artistes déjà présents dans ART AT THE TURN OF THE MILLENNIUM. D'un côté, ces artistes occupent des positions clés des années 80 et 90, et leur apport fait d'eux une référence obligée pour les artistes de la jeune génération. D'un autre côté, il nous semblait important de suivre le cheminement d'artistes dont les carrières n'étaient qu'à leurs débuts au moment de la publication d'ART AT THE TURN OF THE MILLENNIUM.

S'il est vrai que notre attention porte à nouveau principalement sur la scène (artistique) occidentale, nous rendons néanmoins compte de l'internationalisation croissante du monde de l'art : dans ART NOW, plusieurs artistes asiatiques, africains et sud-américains élargissent un champ de vision trop souvent focalisé seulement sur l'Europe et l'Amérique du Nord. Ceci étant posé, il nous faut répéter ici – notamment au regard des nombreuses réactions qui ont suivi la parution d'ART AT THE TURN OF THE MILLENNIUM – que notre choix, qui reste subjectif, est parti d'un nombre beaucoup plus important de jeunes artistes passionnants et prometteurs.

Nous présentons ici 137 artistes au total, respectivement sur 4 pages, avec des exemples significatifs de leur production récente. Le caractère autonome de la présente compilation est souligné visuellement par une nouvelle mise en page. On retrouvera ici les éléments informatifs déjà connus – de même que l'ordre alphabétique de présentation des artistes et le court texte sur l'œuvre, écrit par dix auteurs internationaux d'origine américaine, allemande, danoise et polonaise –, mais bien sûr aussi la reproduction des œuvres les plus importantes des artistes, leur portrait, le nom de leurs principales expositions et les publications les concernant, ainsi qu'une déclaration personnelle. Le glossaire a été mis à jour et englobe de nombreux termes spécifiques qu'on retrouve sans cesse dans les textes et les débats sur l'art d'aujourd'hui. Un complément judicieux est formé par une seconde partie entièrement inédite, compilée par THE ART NEWSPAPER.

ART NOW est donc un ouvrage de référence en prise directe sur l'actualité artistique aussi bien qu'un passionnant livre illustré. A ce titre, il devrait constituer un enrichissement pour le professionnel comme pour l'amateur d'art.

Il nous reste à souhaiter à cette ouverture sur le nouveau millénaire toute l'heureuse attention suscitée précédemment par la parution d'ART AT THE TURN OF THE MILLENIUM.

Uta Grosenick et Burkhard Riemschneider
Cologne et Berlin, mai 2002

Nous souhaitons adresser ici nos remerciements à tous ceux qui ont contribué à la réalisation de ce livre, en tout premier lieu aux artistes, aux galeries qui défendent leurs œuvres et aux photographes qui les ont documentées.
Ensuite, aux auteurs des textes et du glossaire : Kirsty Bell, Ariane Beyn, Frank Frangenberg, Barbara Hess, Gregor Jansen, Anke Kempkes, Lars Bang Larsen, Nina Möntmann, Raimar Stange, Rochelle Steiner et Adam Szymczyk.
Nous tenons aussi à remercier particulièrement la co-lectrice Sabine Bleßmann, les designers Andy Disl et Birgit Reber, Ute Wachendorf pour la production des illustrations, ainsi que Kathrin Murr pour son aimable soutien.
Enfin, nous remercions chaleureusement l'éditeur Benedikt Taschen, qui a accompagné ce projet de son indéfectible enthousiasme.

We are especially grateful to the following individuals and institutions for generously making visual material and information available to us. — Unser besonderer Dank gilt folgenden Personen und Institutionen, die großzügig Bildmaterial und Informationen zur Verfügung gestellt haben. — Nos remerciements particuliers vont aux personnes et institutions suivantes pour leur généreuse mise à disposition de documents visuels et d'informations :

Air de Paris, Paris — Galerie Paul Andriesse, Amsterdam, Petra Heck — Arndt & Partner, Berlin, Julie Burchardi, Petra Gördüren — ars Futura Galerie, Zurich, Verena Hutzer, Nicola von Senger — Art & Public, Geneva — Kunsthalle Basel, Basle, Christina Vegh — Blum & Poe, Santa Monica (CA), Kirsten Y. Biller, Tim Blum, Jeffrey Poe — Marianne Boesky Gallery, New York (NY), Elisabeth Ivers, Siobhan Lowe — Tanya Bonakdar Gallery, New York (NY), Ethan Sklar, Jennifer Stackpole — Gavin Brown's enterprise, New York (NY), Corinna Durland, Laura Mitterrand — Galerie Daniel Buchholz, Cologne, Michael Kerkmann, Alice Koegel, Christopher Müller — Galerie Luis Campaña, Cologne, Annette Völker — Galerie Gisela Capitain, Cologne, Nina Kretzschmar — carlier l gebauer, Berlin, Almut Benkert, Karin Schyle — Galleria Massimo De Carlo, Milan, Nathalie Brambilla — chouakri brahms, Berlin, Edzard Brahms, Mehdi Chouakri — Sadie Coles HQ, London, Sofia Tournikiotis — Contemporary Fine Arts, Berlin, Anikó Beitschler — Paula Cooper Gallery, New York (NY), Simone Subal — Deitch Projects, New York (NY), Shira Carmi, Julia Chiang — Dia Center for the arts, New York (NY), Alysa Nahmias — Eigen + Art, Berlin/Leipzig, Ulrike Gast, Gerd Harry Lybke — Galerie Kerstin Engholm, Vienna, Eva Kernbauer — Atelier Ayse Erkmen, Berlin, Caroline Käding — Feature Inc., New York (NY) — Galerie Jennifer Flay, Paris — Foksal Gallery Foundation, Warsaw, Joanna Mytkowska, Andrzej Przywara, Adam Szymczyk — Emi Fontana, Milan — Galeria Fortes Vilaça, São Paulo, Luciana A Dacar, Alexandre Gabriel — Stephen Friedman Gallery, London, Patricia Kohl, Kirsten MacDonald Bennett, Katarina Wadstein — Frith Street Gallery, London — Gagosian Gallery, New York (NY), Cynthia Honores, Kay Pallister, Nicole Zaks — Gasser & Grunert Inc., New York (NY), Ashley Ludwig — c/o Atle Gerhardsen, Berlin, Rebekka Ladewig — Barbara Gladstone Gallery, New York (NY), Carter Mull — The Estate of Felix Gonzalez-Torres, New York (NY), Michelle Reyes — Marian Goodman Gallery, New York (NY) and Paris, Catherine Belloy, Katell Jaffrès — Greene Naftali Gallery, New York (NY), Carol Greene — Galerie Hauser & Wirth, Zurich, Claudia Friedli, Tse-Ling Uh — Galerie Hauser & Wirth & Presenhuber, Zurich, Claudia Klausner, Tanja Scartazzini — Galerie Max Hetzler, Berlin, Wolfram Aue, Martina Kratsch — Jablonka Galerie, Cologne, Christian Schmidt — Galerie Martin Janda, Vienna, Liliana Wolff — Johnen + Schöttle, Cologne, Markus Lüttgen — Jay Jopling/White Cube, London, Sophie Greig, Honey Luard — Georg Kargl, Vienna, Gabriele Friedl — Anton Kern, New York (NY) — Galerie Peter Kilchmann, Zurich, René Ammann — The Estate of Martin Kippenberger, Cologne, Regina Schultz-Möller — Klosterfelde, Berlin, Nikola Dietrich, Isabelle Erben, Lena Kiessler — Jeff Koons Studio, New York (NY), Sasha Weinbaum — Tomio Koyama Gallery, Tokyo — Kunstverein für die Rheinlande und Westfalen, Düsseldorf, Anette Freudenberger — Kunstverein in Hamburg, Katrin Sauerländer — Galerie Yvon Lambert, Paris — Zoe Leonard Studio, New York (NY), Jocelyn Davis — Atelier van Lieshout, Rotterdam, Charlotte Martens, Murïelle Polak — Lisson Gallery, London, Rosa Bacile — Luhring Augustine, New York (NY) — Maccarone Inc., New York (NY) — Galerie Philomene Magers, Munich, Tanja Pol — André Magnin, Léa Grunitzky, Paris — Galleria Giò Marconi, Milan, Laura Garbarino — Matthew Marks Gallery, New York (NY), Katie Lane — Matt's Gallery, London, Jessica Wallwork — Patrick Meagher, New York (NY) — Metro Pictures, New York (NY), Alison Card, Haan Chau — Galerie Karlheinz Meyer, Karlsruhe — Meyer Riegger Galerie, Karlsruhe, Jochen Meyer, Thomas Riegger — Victoria Miro Gallery, London, Kathy Stephenson, Kelly Taylor — The Modern Institute, Glasgow, Ben Harman — The Museum of Contemporary Art, Chicago (IL), Renée Jessup — The Museum of Contemporary Art, Los Angeles (CA), Julia Langlotz — Galerie Christian Nagel, Cologne, Anja Dorn, Jens Mentrup, Dorothee Sorge — Galerie Michael Neff, Frankfurt am Main — Galerie Neu, Berlin, Sibilla Calzolari, Alexander Schröder, Thilo Wermke — neugerriemschneider, Berlin, Tim Neuger, Christiane Rekade, Salome Sommer — Galleria Franco Noero, Turin, Luisa Salvi Del Pero — Galerie Jerôme de Noirmont, Paris, Vincent Boucheron — Anthony d'Offay Gallery, London, Laura Ricketts — Bob van Orsouw, Zurich, Kurt Kladler, Tal Trost — P.S.1 Center for Contemporary Art, New York (NY), Carolyn Bane — Patrick Painter, Inc., Santa Monica (CA), Mayo Thompson, Sachi Yoshimoto — Maureen Paley/Interim Art, London — Mark Parrish, New York (NY) — Galerie Emmanuel Perrotin, Paris, Adeline Cacheux — Friedrich Petzel Gallery, New York (NY), Blaire Dessent — Paul Pfeiffer Studio, New York (NY), Cathy Blanchflower — Portikus, Frankfurt am Main, Jochen Volz — Fondazione Prada, Milan — The Project, New York (NY) and Los Angeles (CA) — Galerie Thomas Rehbein, Cologne — Andrea Rosen Gallery, New York (NY), Sarah Cohen, John Connelly — Atelier Thomas Ruff, Düsseldorf, Jens Ullrich — Schipper & Krome, Berlin, Iris Scheffler, Annika von Taube, Christophe Wiesner — Jack Shainman Gallery, New York (NY) — Shugoarts, Tokyo, Akane Ikeda, Shugo Satani — Brent Sikkema, New York (NY), Denis Gardarin, Michael Jenkins — Sommer Contemporary Art, Tel Aviv, Irit Mayer-Sommer — Monika Sprüth Galerie, Cologne, Lilian Haberer — Nils Stærk, Copenhagen, Heidi Frølund — 303 Gallery, New York (NY), Kurt Brondo — Wolfgang Tillmans Studio, London, Valerie Stahl — Galleri Nicolai Wallner, Copenhagen, Nicolai Wallner — Galerie Barbara Weiss, Berlin, Jutta Voorhoeve — Atelier Franz West, Vienna, Gudrun Ankele, Ines Turian — workweb_art, Cologne — Galerie Xippas, Paris, Jane Kim — Zeno X Gallery, Antwerp, Frank Demaegd — Galerie Michael Zink, Regensburg — Kokerei Zollverein, Essen, Florian Waldvogel — David Zwirner, New York (NY), Brennan Grayson, Eugenia Lai

ARTISTS

Franz Ackermann

1963 born in Neumarkt St. Veit, lives and works in Berlin, Germany

Franz Ackermann is more than just a painter. He is a tracker, map-reader, collector, code-breaker and constructor, a real roving observer. Location and connection are emotive words in an age when real spaces are being superseded by virtual ones. Ackermann transplants apparently firmly situated spaces, architectural structures, images and motifs to other, different and disorienting settings. He creates a new kind of cartography, in which the once-universal horizon becomes merely a part, one of the "tiles" – like tourism, colonialism, urbanisation, appropriation, movement and speed – that together form the mosaic of cultural identity. Ackermann is an arranger of heterotopias (as Foucault defined areas of social contact). He explores the surfaces that determine our perceptions of three-dimensionality. The eye of the artist eye moves restlessly, oscillating and looking for a foothold, caught up in the urge to deconstruct. His small sketches or "mental maps", his large-format "Evasions" and his vast panoramas are more than convincing, albeit interwoven now and then with a touch of utopianism. We the viewers are invited to explore these brave new worlds and see them through Ackermann's eyes, to embrace his intimate personal take on reality and understand how we, with our unsuspected ability to look forward and back, fit into the picture. Public space and private perception are brought atmospherically together, breaking down barriers and allowing the artist's intentions to shine through. Using photographs and mirrors – to symbolise the reality and non-reality of place – Ackermann creates a fusion of utopias and heterotopias, a platform for effective and wide-ranging debate on the issues of art and functionality.

Franz Ackermann ist mehr als nur Maler. Er ist Spurensucher, Kartenleser, Sammler, Dechiffrierer und Konstrukteur, eigentlich ein reisender Beobachter. Verortung und Vernetzung sind Reizworte in einer Zeit, in der reale Räume durch virtuelle ersetzt werden. Ackermann verpflanzt das scheinbar Verortete – Räume und Architekturen, Bilder und Motive – und schafft andere Bezugsfelder, in denen die Orientierung schwer fällt. So entstehen neue Kartografien, in denen der vormals universale Horizont in Teile zerlegt wird wie Tourismus, Kolonialismus, Urbanität, Aneignung, Bewegung, Geschwindigkeit, die gemeinsam das Mosaik der kulturellen Identität bilden. Ackermann ist ein Arrangeur von Heterotopien, wie Foucault die Räume sozialer Kontakte nannte. Er erforscht die Oberflächen, die unsere Wahrnehmung von Dreidimensionalität bestimmen. Der bewegte Blick ist unruhig, schwingt, sucht Halt und berauscht sich an dekonstruktiven Elementen. In seinen kleinen Skizzen, den „mental maps", den großflächigen „Evasionen" bis zu raumfüllenden Panoramen ist er mehr als überzeugend, obgleich manchmal ein wenig Utopismus aufscheint. Schöne neue Welt. Wir sollten sie mit den Augen Ackermanns abtasten, mit der innerbildlichen Realität verbinden und den eigenen Standort verstehen, der ungeahnte Rück- und Ausblicke ermöglicht. Der öffentliche Raum und die persönliche Wahrnehmung kommen atmosphärisch zusammen, riegeln sich nicht ab oder bilden eine Barriere, sondern lassen die Absichten des Künstlers durchscheinen. Insofern sind die verwendeten Fotografien und Spiegel, die die Realität und Nichtrealität des Ortes symbolisieren, eine Verschränkung der Utopien und Heterotopien, die eine Grundlage für eine vielfältige und weitreichende Debatte über die Probleme von Kunst und Funktionalität bildet.

Franz Ackermann est davantage que simplement un peintre. Il est fixeur de traces, lecteur de cartes, collectionneur, déchiffreur et constructeur : en fait, c'est un observateur-voyageur. La référence spatiale et la mise en réseau sont des notions tentantes à une époque où les espaces virtuels remplacent les espaces réels. Ackermann cultive les sites apparemment localisés – espaces et architectures, images et motifs – et les transforme en champs référentiels dans lesquels le repérage devient ardu. Il en résulte des cartographies nouvelles où l'horizon jadis horizontal devient enclave dans l'identification de soi : tourisme, colonialisme, urbanité, appropriation, mouvement, vitesse. Les hétérotopies, telles qu'elles ont été pensées par Foucault, sont des espaces de contact dont l'arrangeur Ackermann travaille l'espace iconique à l'instar des surfaces qui déterminent l'idée que nous nous faisons de la tridimensionnalité. Le regard s'inquiète, oscille, cherche un point d'appui et se grise d'éléments déconstructifs. Dans ses petits croquis, les « mental maps », dans les généreuses « évasions » jusqu'aux panoramas spatiaux, Ackermann devient largement crédible, avec une note occasionnelle d'utopie. Beauté d'un monde nouveau que nous devrions toucher avec les yeux d'Ackermann et combiner avec le monde de l'image, afin de comprendre notre propre emplacement comme un modèle iconique permettant des regards rétrospectifs et des ouvertures insoupçonnées. L'image et l'espace ouverts rapprochent leurs atmosphères, ne se ferment pas l'un à l'autre, ne dressent pas des barrières, mais font apparaître cet emplacement. Dans cette mesure, les photographies et les miroirs employés par Ackermann, qui transforment le lieu en non lieu, se situent à mi-chemin entre les utopies et les hétérotopies, en ceci que l'art et l'œuvre entretiennent un débat performatif et immensément diversifié.

G. J.

1

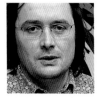

SELECTED EXHIBITIONS →
1999 *German Open*, Kunstmuseum Wolfsburg, Germany **2000** Castello di Rivoli, Turin, Italy; *Close Up*, Kunstverein Freiburg, Germany/ Kunsthaus Basselland, Basle, Switzerland **2001** Gavin Brown's enterprise, New York (NY), USA; Tomio Koyama, Tokyo, Japan; *Form Follows Fiction*, Castello di Rivoli, Turin, Italy; *hybrids*, Tate Gallery, Liverpool, UK; *Painting at the Edge of the World*, Walker Art Center, Minneapolis (MN), USA **2002** Kunsthalle Basel, Switzerland; Stedelijk Museum, Amsterdam, The Netherlands; Kunstmuseum Wolfsburg

SELECTED BIBLIOGRAPHY →
1997 *Atlas Mapping*, Offenes Kulturhaus Linz and Kunsthaus Bregenz; *Mental Maps*, Portikus, Frankfurt am Main **1999** *Mirror's Edge*, Bild Museet, Umeå **2000** *OFF*, Kasseler Kunstverein

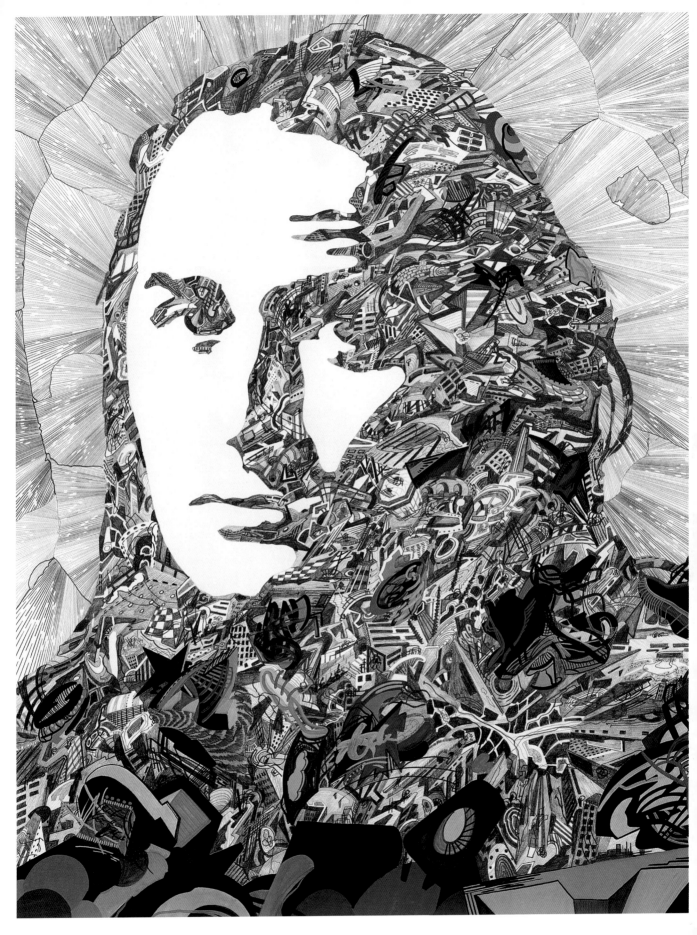

1 **Faceland,** 2001 (detail of white crossing), mixed media on paper, 85 x 65 cm
2 **B2 (Barbecue with the Duke),** 1999, oil on canvas, 240 x 400 cm
3 Installation views, *HausSchau – Das Haus in der Kunst*, Deichtorhallen, Hamburg, 2000
4 **Helicopter XV–...,** 2001, wall paintings, installation view, Walker Art Center, Minneapolis

„Wenn ich Kunst herstelle, überlappen sich gesellschaftliche und politische Fragestellungen mit meinem Interesse, bestimmte Erfahrungen zu vermitteln."

« Quand je fabrique de l'art, les questionnements sociaux et politiques se recouvrent avec l'intérêt que j'éprouve à transmettre certaines expériences. »

"When I make art, social and political questions overlap with my interest in communicating certain experiences."

3

2

4

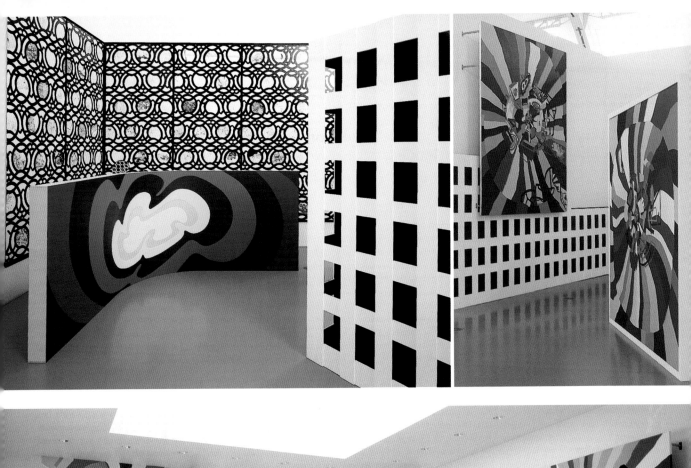
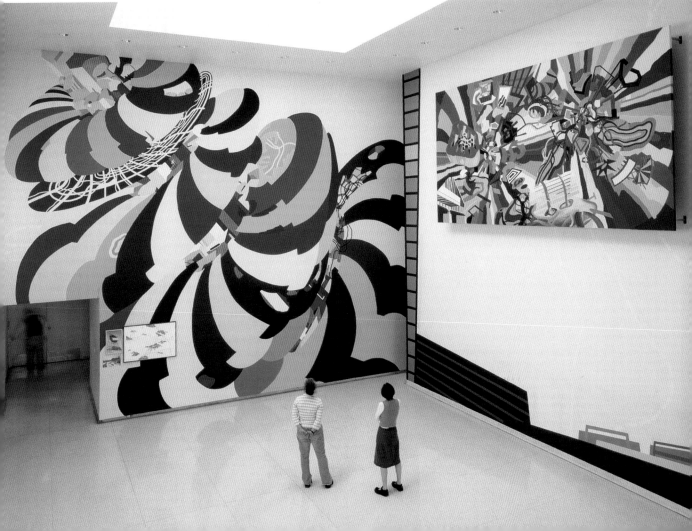

Doug Aitken

1968 born in Redondo Beach (CA), lives and works in Los Angeles (CA), USA

Doug Aitken's multi-screen video installations address the complex inter-relationships between man, media, industry and landscape. The viewer's experience of *Eraser*, 1998, an imposing seven-screen installation, is as much a process of discovery as the making of the piece was for Aitken. He draws us into a wild and hostile landscape with no sign of human life save a scattering of abandoned houses and disused machinery. Gradually it becomes apparent that this is all that remains of the settlements since the island's volcano erupted, destroying almost all traces of civilisation. The films' narratives reveal themselves in intricate spirals in which the viewer is forced to actively engage, both physically by passing through the exhibition space to see the various projections, and mentally as the multiple images prevent a single linear inter-pretation. The nature and perception of time itself become central in *Electric earth*, 1999. A solitary youth, like a pre-millennial everyman, strides across the urban wasteland in this sprawling eight-screen installation. The environment of blinking street lights, surveillance cameras, automatic car windows and neon signs around him begins to accelerate and he speeds up in turn, mimicking its jerky rhythms against a soundtrack of sampled ambient sound. Information overload is expressed through both the features of the man's external surroundings and his twitchy mental state as each affects the other, articulating the interdependency of man and his environment that informs all of Aitken's work.

Doug Aitken beschäftigt sich in seinen Videoinstallationen, in denen er mehrere Monitore einsetzt, mit der komplexen Wechsel-beziehung zwischen Mensch, Medien, Industrie und Landschaft. Die Erfahrung des Betrachters der auf sieben Bildschirmen präsentierten, beeindruckenden Installation *Eraser*, 1998, ist eine ganz ähnliche Entdeckungsreise, wie sie die Arbeit an dem Werk für Aitken war. Er zieht uns gleichsam in eine wilde und abweisende Landschaft hinein, ohne ein Zeichen menschlichen Lebens bis auf eine Ansammlung verlassener Häuser und ausrangierter Maschinen. Allmählich tritt zutage, dass dies alles ist, was nach einem verheerenden Vulkanausbruch auf der Insel, der nahezu alle Spuren menschlicher Zivilisation zerstörte, von der Siedlung blieb. Die Geschichten, die in den Filmen erzählt werden, entfalten sich wie ineinander verschlungene Spiralen. Sie zwingen den Betrachter zu aktiver Teilnahme: physisch durch das Durchschreiten der Installation, um die verschiedenen Projektionen zu sehen; mental, weil die verschiedenen Bilderfolgen sich einer einheitlichen linearen Interpretation entziehen. Zentrale Frage von *Electric earth*, 1999, ist das Wesen und unsere Wahrnehmung der Zeit. Diese Installation mit acht Monitoren zeigt einen einsamen Jugendlichen – gewissermaßen ein Jedermann am Vorabend der Jahrtausendwende –, der durch eine Großstadtwüste wandert. Dabei beschleunigt sich allmählich der Rhythmus der blinkenden Ampeln, der Überwachungskameras, der Autofenster, die sich automatisch heben und senken, und der Neonzeichen um ihn herum. Auch der junge Mensch geht immer schneller und zeichnet die abgehackten visuellen Rhythmen – vor einem Klangteppich aus Hintergrundgeräuschen – gewissermaßen nach. Die Reiz-überflutung findet ihren Ausdruck also zum einen in dem Trommelfeuer an Eindrücken, dem er ausgesetzt ist, zum anderen in seinen nervösen Reaktionen. Beide Aspekte beeinflussen sich wechselseitig, und genau diese reziproke Abhängigkeit von Mensch und Umgebung ist das Thema, mit dem sich Aitken in allen seinen Arbeiten beschäftigt.

Les installations vidéos à écrans multiples de Doug Aitken traitent des interactions complexes entre l'homme, les médias, l'industrie et le paysage. Dans *Eraser*, 1998, une imposante installation à sept écrans, l'expérience du spectateur est autant un processus de découverte que l'a été la réalisation de l'œuvre par Aitken. Il nous entraîne dans un paysage sauvage et hostile où il ne reste plus aucun signe de vie humaine hormis quelques maisons vides ici et là et des machines abandonnées. Il devient peu à peu évident que c'est là tout ce qu'il reste de la colonie de l'île depuis l'éruption d'un volcan qui a détruit pratiquement toute trace de civilisation. Les narrations du film se révèlent en spirales imbriquées dans lesquelles le spectateur est obligé de s'impliquer activement, tant physiquement en déambulant dans l'espace de l'exposition pour voir les différentes projections, que mentalement, car les images multiples empêchent une interprétation unique et linéaire. La nature et la perception du temps sont au cœur de *Electric earth*, 1999. Dans cette installation étendue, comptant huit écrans, un adolescent solitaire, tel un homme générique hors du temps, traverse un désert urbain. Autour de lui, un paysage de feux de croisement clignotants, de caméras de surveillance, de vitres de voitures automatiques et d'enseignes au néon semble s'accélérer à mesure qu'il hâte le pas, imitant leurs rythmes saccadés, sur un fond sonore réalisé avec un échantillonnage de bruits d'ambiance. La surcharge d'information s'exprime à la fois par les caractéristiques extérieures du décor et par l'agitation mentale du personnage, les deux s'affectant mutuellement, articulant l'interdépen-dance entre l'homme et son environnement, thème que l'on retrouve dans toute l'œuvre d'Aitken.

K. B.

SELECTED EXHIBITIONS →
1997 *Whitney Biennial*, The Whitney Museum of American Art, New York (NY), USA **1999** *Concentrations 33: Doug Aitken, Diamond Sea*, Dallas Museum of Art, Dallas (TX), USA; *APERTuttO, 48. Biennale di Venezia*, Venice, Italy **2000** *Glass Horizon*, Wiener Secession, Vienna, Austria; *Let's Entertain*, Walker Art Center, Minneapolis (MN), USA; *Biennale of Sydney*, Australia **2001** Serpentine Gallery, London, UK

SELECTED BIBLIOGRAPHY →
1998 *Metallic Sleep*, Taka Ishii Gallery, Tokyo **1999** *Concentrations 33: Doug Aitken, Diamond Sea*, Dallas Museum of Art, Dallas **2000** *I AM A BULLET*, London; *diamond sea*, Book works, London **2001** *sources for no religions, sources for new religions*, London

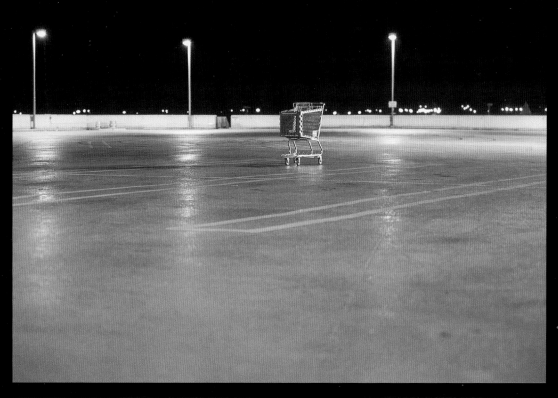
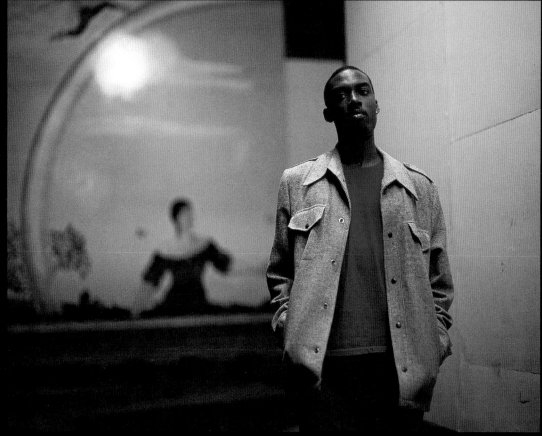

1 **Electric earth,** 1999, production stills

2 **I am in you,** 2000, 3 laser discs, 5 projections, installation views, Galerie Hauser & Wirth & Presenhuber, Zurich

„Für mich lautet die Frage: Wie kann ich die Zeit gewissermaßen zusammenbrechen oder expandieren lassen, das heißt ihre enge Form aufsprengen."

« La question que je me pose est : comment faire en sorte que le temps se replie sur lui-même ou s'élargisse, afin qu'il ne s'écoule plus sous cette forme étroite. »

"The question for me is how can I make time somehow collapse or expand, so it no longer unfolds in this one narrow form."

2

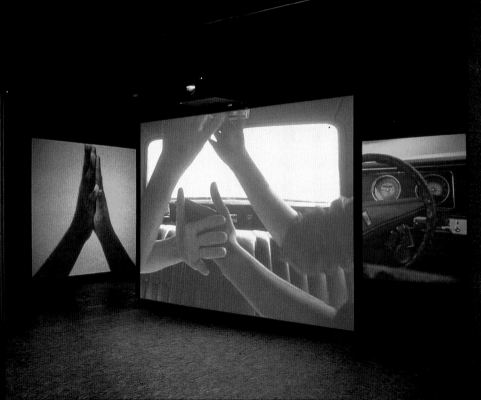

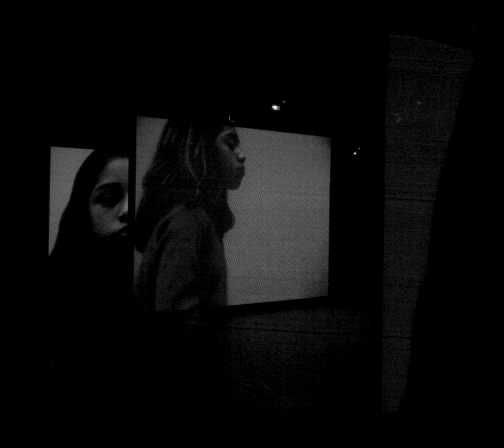

Darren Almond

1971 born in Wigan, lives and works in London, UK

Darren Almond's work focuses on the passage, duration and experience of time. He considers the paradox that a length of time passes slowly or quickly depending on the circumstances in which you find yourself. He is also interested in the differences between analogue and digital representations of time – or those that demonstrate measurable quantities versus those that are symbolic representations. In *A Real Time Piece*, 1996, Almond created a live video-link from his studio in West London to an alternative exhibition space and presented a 24-hour projection of his empty studio. The image portrayed the passage of time through the sound of a clock and changes in light quality in the room. Almond's *Tuesday (1440 Minutes)*, 1997, a grid of photographs documenting 24 hours on a particular Tuesday, developed out of *A Real Time Piece*. Shot in his studio, the photos reveal every minute of the day's duration. Also related is *H. M. P. Pentonville*, 1997, in which Almond set up a live video-link from an empty cell in London's Pentonville Prison to the Institute of Contemporary Arts in London. This piece emphasises the slow passage of time prisoners experience, and in turn it makes prisoners out of its viewers. The relationship between time and space is similarly in the forefront of *Meantime*, 2000, a giant LED clock constructed in a 12-metre shipping container. The artist sailed from London to New York with the container for six days, during which time it was connected to a global tracking satellite displaying Greenwich Mean Time. The piece serves as a representation of the passage of time and movement through space.

Darren Almond befasst sich in seiner Arbeit mit dem Verstreichen, der Dauer und der Erfahrung von Zeit. So interessiert ihn das Paradox, dass ein Zeitabschnitt je nach den Umständen schneller oder langsamer vergeht. Ferner faszinieren ihn die Unterschiede zwischen analogen und digitalen beziehungsweise quantitativen und symbolischen Repräsentationen der Zeit. So hat Almond für *A Real Time Piece*, 1996, zwischen seinem Atelier in West-London und einem alternativen Ausstellungsraum eine direkte Videoleitung geschaltet und 24 Stunden lang die Ansicht seines leeren Ateliers übertragen. Das Verstreichen der Zeit wurde durch das Ticken einer Uhr und die wechselnden Lichtverhältnisse in dem Raum spürbar gemacht. Aus *A Real Time Piece* ging im folgenden Jahr *Tuesday (1440 Minutes)*, 1997, hervor, ein Fotozyklus, der die 24 Stunden eines beliebigen Dienstags „widerspiegelt". Die in Almonds Atelier aufgenommenen Fotos dokumentieren die Dauer des Tages von Minute zu Minute. Ganz ähnlich strukturiert war auch *H. M. P. Pentonville*, 1997, für das Almond eine direkte Videoleitung zwischen einer leeren Zelle im Londoner Pentonville-Gefängnis und dem Institute of Contemporary Arts – ebenfalls in London – schaltete. In dieser Arbeit ist das langsame Verstreichen der Zeit dokumentiert, wie Gefängnisinsassen es empfinden mögen, zugleich fühlten sich die Zuschauer in die Situation von Häftlingen versetzt. Die Beziehung zwischen Zeit und Raum steht auch im Mittelpunkt der Arbeit *Meantime*, 2000. Dabei hat Almond eine riesige LED-Uhr in einen 12 Meter langen Container eingebaut. Danach ist er mit dem Container samt der Uhr, in die über Satellit permanent die Greenwich-Normalzeit eingespeist wurde, auf einem Schiff in sechs Tagen von London nach New York gereist. Die Arbeit dokumentiert somit das Verstreichen der Zeit und die Fortbewegung im Raum.

Darren Almond travaille sur le passage, la durée et l'expérience du temps. Il analyse le paradoxe qui veut qu'un moment passe lentement ou rapidement selon les circonstances dans lesquelles on se trouve. Il s'intéresse également aux différences entre les représentations analogiques et numériques du temps – ou encore, entre celles faisant état de quantités mesurables et celles qui consistent en représentations symboliques. Dans *A Real Time Piece*, 1996, Almond a établi une liaison vidéo en direct entre son atelier dans l'ouest de Londres et un espace d'exposition alternatif, présentant une projection de 24 heures de son atelier vide. L'image dépeignait l'écoulement du temps par le tic-tac d'une pendule et les changements de la qualité de la lumière dans la pièce. *A Real Time Piece* a ensuite débouché sur *Tuesday (1440 Minutes)*, 1997, un montage de photographies documentant 24 heures d'un certain mardi. Prises dans son atelier, les clichés montraient chaque minute du déroulement de la journée. Pour un autre projet apparenté, *H. M. P. Pentonville*, 1997, Almond a établi une liaison vidéo entre une cellule vide de la prison londonienne de Pentonville et l'Institute of Contemporary Arts de Londres. Cette œuvre mettait l'accent sur le lent passage des heures ressenti par les détenus et, en retour, faisait des spectateurs des prisonniers du temps. Cette relation entre temps et espace était au cœur de *Meantime*, 2000, une horloge géante à cristaux liquides construite dans un conteneur d'environ 12 mètres. L'artiste a ensuite fait le trajet en bateau avec le conteneur entre Londres et New York pendant six jours tout en étant relié à un satellite de surveillance mondiale réglé sur l'heure standard de Greenwich. Cette œuvre illustre la représentation du passage du temps et du mouvement à travers l'espace.

Ro. S.

SELECTED EXHIBITIONS →
1997 Institute of Contemporary Arts, London, UK; *Sensation*, Royal Academy of Arts, London, UK **1999** The Renaissance Society, Chicago (IL), USA **2000** *Making Time: Considering Time as a Material in Contemporary Video and Film*, Palm Beach Institute of Contemporary Art, Palm Beach (FL), USA; *Apocalypse: Beauty and Horror in Contemporary Art*, Royal Academy of Arts, London, UK **2001** Tate Gallery, London, UK; Kunsthaus Zürich, Zurich, Switzerland

SELECTED BIBLIOGRAPHY →
2001 *Darren Almond*, Kunsthaus Zürich, Zurich

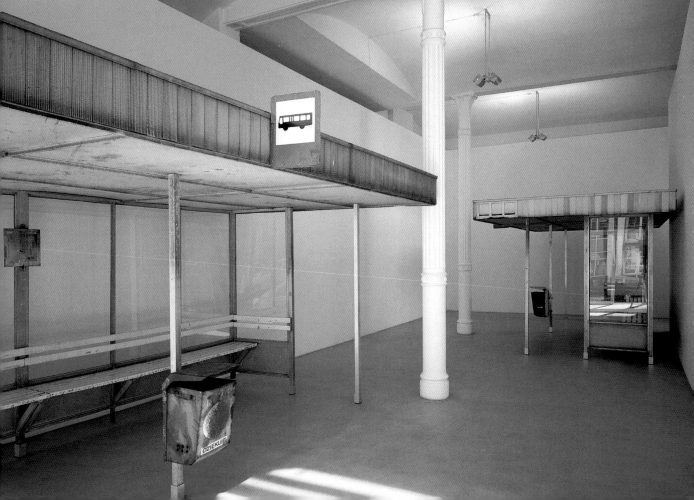

1 **Border,** 1999, aluminium, paint, dimensions variable
2 **Bus Stop,** 1999, aluminium, glass, 2 bus shelters, each 6.03 x 3.03 x 2.70 m, installation view Galerie Max Hetzler, Berlin
3 **Fan,** 1997, aluminium, electro-mechanics, ca. Ø 4.50 m

4 **Mine,** 2001, two part video installation with sound DVD, 50 min, installation view, E-Werk, Abspannwerk Buchhändlerhof, Berlin-Mitte
5 **Meantime,** 2000, steel sea container, aluminium, polycarbonate, computerised electronic control system and components, 2.90 x 12.20 x 2.44 m, installation view, Matthew Marks Gallery, New York (NY)

„Wir bedienen uns immer mehr einer binären Sprache des JA/NEIN, die Abstufungen nicht mehr kennt. Das schließt jedoch biologische oder organische Prozesse, also Gefühle aus."

« Nous avons adopté un langage binaire. Dans le binaire, il n'y a qu'un OUI et un NON, sans état intermédiaire. Cela exclue les processus biologiques et organiques : l'émotion. »

"We have adopted the language of binary terms. With binary there is only a YES and a NO and no inbetween state. This excludes biological and organic processes: emotion."

3

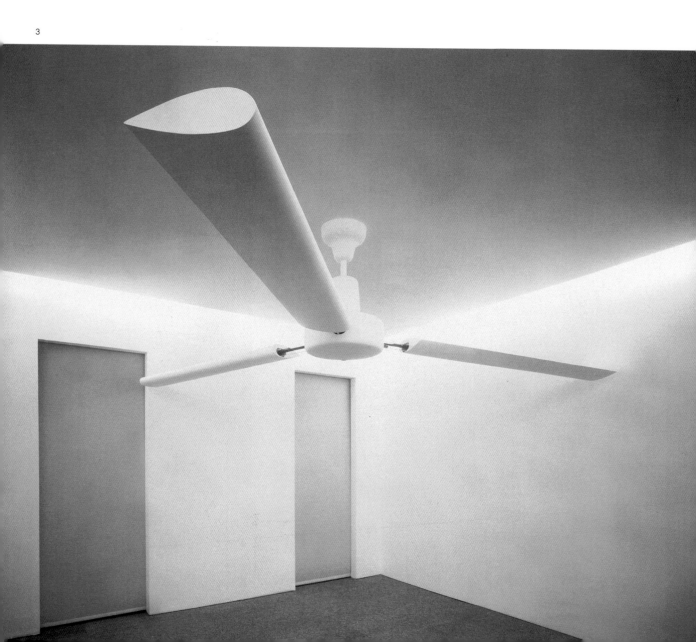

4

5

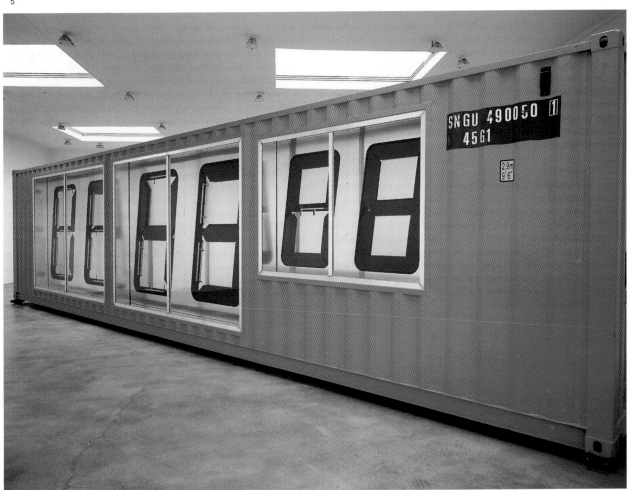

Paweł Althamer

1967 born in Warsaw, lives and works in Warsaw, Poland

At the turn of the 21st century, stubborn realism appeared in art in opposition to the world of total artifice. Just as the reality show is becoming common on television, Paweł Althamer confronts the viewer with reality undiluted by transmission. He is an artist-director whose films are screened without cinema projectors and without cinemas. The action takes places in three dimensions, in the setting of a street or gallery. The actors perform simple roles observed by the artist in the chosen location. Is the man drinking coffee at the table an actor or an "ordinary" man? Is the military parade in a town square a part of Althamer's film or does it belong to the real world? Althamer suggests that the distinction between "arranged" and "raw" reality is an artificial one. Human behaviour is simultaneously artificial and natural. It is a continuous performance, in front of others and for the sake of others. An artist's task is to follow either one step behind or one step in front of reality. Althamer also creates uncanny totemic sculptures, many of which are self-portraits. A realistic sculpture made with wax and rope is a self-portrait, and so is the "guard" – an elderly man in a cheap grey suit, hired to keep watch at his exhibition *The Afterlife*, 1996. He stresses that all his works, including the non-figurative ones, are variations on the theme of "Althamer".

An der Wende zum 21. Jahrhundert hat sich als Reaktion auf die völlige Künstlichkeit der Welt in der Kunst ein hartnäckiger Realismus Bahn gebrochen. Während in den Medien das „Reality-TV" immer mehr um sich greift, konfrontiert Paweł Althamer den Betrachter mit einer durch technische Übertragungstechniken unverstellten Realität. Dieser Künstler-Regisseur verzichtet bei der Aufführung seiner Filme auf die konventionelle Projektionstechnik und auf das klassische Kinoambiente. Die Handlung vollzieht sich im dreidimensionalen Raum, sei es auf der Straße oder in der Galerie. Die Amateur-Schauspieler spielen einfache Rollen und werden dabei vom Künstler an ausgewählten Schauplätzen beobachtet. Ist der Mann, der dort drüben an dem Tisch Kaffee trinkt, nun Schauspieler oder ein „gewöhnlicher" Mensch? Handelt es sich bei der Militärparade auf dem Platz einer Stadt um ein „reales" Geschehen oder um eine Inszenierung? Althamer verweist darauf, dass wir relativ willkürlich zwischen „inszenierter" und „echter" Wirklichkeit unterscheiden. Menschliches Verhalten ist zugleich künstlich und natürlich. Ja, es ist eine permanente Selbstinszenierung vor den anderen und um der anderen willen. Dem Künstler kommt dabei die Aufgabe zu, der Realität um einen Schritt hinterherzuhinken beziehungsweise ihr einen Schritt vorauszueilen. Althamer kreiert aber auch unheimlich wirkende totemistische Skulpturen, bei denen es sich häufig um Selbstbildnisse handelt. So hat er etwa ein aus Wachs und Seilen gearbeitetes Selbstbildnis geschaffen. Aber auch bei dem älteren Mann, der in einem billigen grauen Anzug in Althamers Ausstellung *The Afterlife*, 1996, als Aufsichtsperson fungierte, handelte es sich um ein Selbstporträt. Er betont, dass alle seine Werke, einschließlich seiner ungegenständlichen Arbeiten, Variationen des Themas „Althamer" sind.

Au début du 21ème siècle, l'art a vu poindre un réalisme obstiné s'opposant à un monde de l'artifice total. Tout comme le « reality show » se banalise à la télévision, Paweł Althamer confronte le public à une réalité qui n'a pas été diluée par la retransmission. Les films de cet artiste-réalisateur sont montrés sans projecteur ni salle de cinéma. L'action se déroule en trois dimensions, avec, pour décor, la rue ou une galerie. Les acteurs jouent des rôles simples observés par l'artiste sur un site choisi. L'homme qui boit un café à une table est-il un acteur ou un homme « ordinaire » ? Le défilé militaire sur la place de la ville fait-il partie du film d'Althamer ou appartient-il au monde réel ? Althamer laisse entendre que la distinction entre la réalité « arrangée » et la réalité « brute » est un leurre. Le comportement humain est à la fois artificiel et naturel. Il s'agit d'une performance permanente, devant et pour les autres. L'artiste a pour tache d'avoir un temps de retard ou un temps d'avance sur la réalité. Althamer crée également d'étranges sculptures totémiques dont bon nombre sont des autoportraits. Une sculpture réaliste réalisée en cire et corde est un autoportrait, tout comme le « Gardien », un vieillard en costume gris bon marché, engagé pour monter la garde lors de son exposition *The Afterlife*, 1996. Il souligne que toutes ses œuvres, y compris les non figuratives, sont des variations sur le thème « d'Althamer ».

A. S.

SELECTED EXHIBITIONS →
1997 Kunsthalle Basel, Basle, Switzerland; *documenta X*, Kassel, Germany **1998** Centre for Contemporary Art, Ujazdowski Castle, Warsaw, Poland **2000** *Manifesta 3*, Ljubljana, Slovenia **2001** Museum of Contemporary Art, Chicago (IL), USA; *Neue Welt*, Frankfurter Kunstverein, Frankfurt am Main, Germany

SELECTED BIBLIOGRAPHY →
1997 *Paweł Althamer*, Kunsthalle Basel, Basle **2000** *Manifesta 3*, Ljubljana; *Amateur*, Konstmuseum, Göteborg **2001** *Neue Welt*, Frankfurter Kunstverein, Frankfurt am Main

26

1 **Motion Picture,** 2000, series of events at *Manifesta 3*, Ljubljana
2 **Bródno,** 2000, event in Warsaw

3 **Astronaut 2,** 1997, installation views, *documenta X*, Kassel
4 **Untitled (Tent),** 1999, installation view, Galeria Foksal, Warsaw

„Mich verwundert am meisten, was üblicherweise als banal, als alltäglich gilt."

« Je suis fasciné par ce qui est considéré comme banal, ordinaire. »

"I am amazed by what passes for the banal, the ordinary."

2

3

4

Kai Althoff

1966 born in Cologne, lives and works in Cologne, Germany

Kai Althoff is famous for his idiosyncratic, eccentric pictorial language. He moves, chameleon-like, between different media, from drawings and sculpture through music and photography to video, sometimes fusing them all in a complete installation that creates the illusion of a separate world. Althoff is engaged in a perpetual search for aesthetic variation. In projects with his band "Workshop", he tries to create a kind of pop utopia. His quest for evolved lifestyles harks back to the social change and alternative freedoms of the 1970s, and includes fantasies of breaking away from sexual convention. Althoff's style is often hermetic and not easily accessible. His installations feature characters from stories of the artist's own invention, with baffling titles like *Eulenkippstadt wird gesucht* (In Search of Eulenkippstadt) or *Hakelhug*. The artist himself assumes the role of a medium or "seer" who experiences the social situations and transforms them into art. Through Althoff's eyes, we see the world as a kaleidoscope of insubstantial, fragile meanings. Things we thought we knew, whose significance we took for granted, unexpectedly change and turn out to be the opposite of what we believed them to be. It is precisely from this penetrating view of the world that Althoff draws his hypersensitive creative perception, producing an array of absurd, grotesque figures, melancholy landscapes, sensual and spiritual experiences in garish colours, ominous scenarios and mazes.

Der Kölner Künstler Kai Althoff ist bekannt für seine eigenwillige, exzentrische Bildsprache. Wie ein Chamäleon bewegt er sich zwischen verschiedensten Medien von Zeichnung über Skulptur, Musik und Fotografie bis zu Video, fasst diese manchmal zu einer kompletten Raumerfindung zusammen, die er zur Illusion einer eigenständigen Welt verdichtet. Althoff macht sich immer wieder auf die Suche nach ästhetischer Veränderung, nach Pop-Utopien, wie etwa in den Projekten mit seiner Band „Workshop". Sein Interesse gilt einer Politik selbst erfundener Lebensformen, Lifestyles, die an Ideen von sozialer Veränderung und libertinär-alternative Entwürfe der siebziger Jahre anknüpfen, inklusive dem fantasievollen Bruch auch von sexuellen Konventionen. Dabei entwickelt er oftmals einen hermetischen Stil, der den Zugang zu seinen Arbeiten erschwert. In seinen Inszenierungen treten Fantasiewesen aus selbstersonnenen Geschichten auf, die rätselhafte Titel tragen wie *Eulenkippstadt wird gesucht* oder *Hakelhug*. Der Künstler selbst nimmt dabei die Rolle eines Mediums oder eines „Sehers" ein, der gesellschaftliche Gegebenheiten exemplarisch durchlebt und in Kunst überführt. Wir sehen durch Althoffs Augen die Welt als ein Kaleidoskop aus fragilen, brüchigen Bedeutungen. Dinge, die wir glauben zu kennen, deren Bedeutung wir als gegeben annehmen, verändern sich oft unerwartet und kippen in ihr Gegenteil um. Gerade aus dieser zugespitzten Wahrnehmung gewinnt Althoff sein hypersensibles, kreatives Potenzial: ein Kabinett skurriler und grotesker Figuren, elegische Landschaften, Erotik und Spirituelles in giftigen Farben, bedrohliche Szenarien und Irrgärten.

L'artiste colonais Kai Althoff est connu pour son langage artistique singulier et excentrique. Il évolue comme un caméléon à travers les médiums les plus divers – du dessin à la vidéo en passant par la sculpture, la photographie et la musique – qu'il réunit parfois dans des inventions spatiales totales développées jusqu'à créer l'illusion d'un monde particulier. Le travail d'Althoff est une quête permanente du changement par l'esthétique et les utopies pop, comme le montrent notamment les projets de son groupe musical « Workshop » ; il propose une politique de formes et de styles de vie inventés qui se rattachent aux idées de transformation sociale et aux projets libertaires alternatifs des années 70, de même qu'à la rupture créative des conventions sexuelles. Althoff élabore souvent pour cela un style hermétique qui rend plus ardu l'accès à ses œuvres. Dans ses mises en scène apparaissent des êtres fabuleux issus de contes inventés portant des titres aussi énigmatiques que *Eulenkippstadt wird gesucht*, qu'on peut traduire par *A la recherche de la ville à bascule aux chouettes*, ou *Hakelhug*, un nom propre fantaisiste. L'artiste lui-même adopte le rôle du médium ou du « voyant » qui vit les conditions sociales à titre d'exemple, et qui les transpose dans le domaine de l'art. A travers les yeux d'Althoff, le monde nous apparaît comme un kaléidoscope de significations fragiles et friables. Les choses que nous croyons connaître et dont le sens nous semble acquis, subissent souvent des mutations inopinées qui les inversent en leur contraire. C'est de cette perception exacerbée qu'Althoff tire précisément son potentiel hypersensible et créatif, dans un cabinet de figures bouffonnes et grotesques, de paysages élégiaques, d'érotisme et de spiritualité aux couleurs vénéneuses, aux décors et aux labyrinthes menaçants.

A. K.

1

SELECTED EXHIBITIONS →
1996 *Heetz, Nowak, Rehberger*, Städtisches Museum Abteiberg, Mönchengladbach, Germany; *Home Sweet Home*, Deichtorhallen Hamburg, Germany **1997** *Eulenkippstadt wird gesucht*, Robert Prime, London, UK **1999** *Ein noch zu weiches Gewese der Urian-Bündner*, Galerie Christian Nagel, Cologne, Germany; *oLdNEWtOWn*, Casey Kaplan, New York (NY), USA; *German Open*, Kunstmuseum Wolfsburg, Germany **2001** *Aus dir*, Galerie Daniel Buchholz, Cologne, Germany

SELECTED BIBLIOGRAPHY →
1996 *Heetz, Nowak, Rehberger*, Städtisches Museum Abteiberg, Mönchengladbach **1997** *Home Sweet Home*, Deichtorhallen, Hamburg **1999** *German Open*, Kunstmuseum Wolfsburg; Burkhard Riemschneider/Uta Grosenick (eds.), *Art at the Turn of the Millennium*, Cologne

1 **Stigmata aus Großmannssucht,** 2000, mixed media, installation view
2 **Bernd, Eeric und Oliver proben für „Grenzen am Rande der Neustadt",**
1994, performance, Galerie Lukas & Hoffmann, Cologne

3 **Ohne Titel,** 2001, from the series **Impulse,** epoxy resin, drawing, 70 x 64 cm
4 **Ohne Titel,** 1998, crayon and pencil on paper, 35 x 47 cm

3

4

Francis Alÿs

1959 born in Antwerp, Belgium, lives and works in Mexico City, Mexico, and New York (NY), USA

Francis Alÿs' work embraces figurative painting, performance art, photographic series and web projects. The central reference point of his art is the concept rather than the production of an object. He commissioned poster painters to create enlarged copies of the small-format oils on which he worked until 1997, and in so doing gave them space for their own interpretations. Examples include *The Liar, The Copy of the Liar*, 1994. In his performances Alÿs crosses the urban landscape on foot, behaving in subtle and sometimes absurd ways as he walks. For example, for one walk across Havana he wore magnetic shoes, which attracted an assortment of metal objects (*Magnetic Shoes*, 1994). For a whole week, he strolled through Copenhagen, each day under the influence of a different drug (*Narcoturismo*, 1996). His way of negotiating the city is reminiscent of the Paris Situationists' practice known as the Dérive (literally "wandering"). Certain motifs, such as dogs, crop up repeatedly in Alÿs' paintings and performances and accompanying videos: sleeping dogs in his photo series (*Sleepers*, 1999), or the dog-on-wheels in his performance *The Collector*, 1991/92. Alÿs frequently appears in politically significant places, such as the Zócalo, Mexico City's main square, where rallies and demonstrations are held. In *Cuentos Patrióticos* (Patriotic Stories, 1997), he drove a herd of sheep in a circle around the flagpole in the square – a critical take on the notion of unthinking political allegiance. Alÿs also likes to cast an ironic eye on the art world. At the 2001 Venice *Biennale*, he let loose five peacocks, which proudly strutted their stuff among visitors in the Giardini during the opening ceremony.

Die Arbeit von Francis Alÿs umfasst figurative Malerei, Performances im Stadtraum, Fotoserien und Web-Projekte. Der zentrale Bezugspunkt seiner Kunst ist das Konzept und nicht die Produktion eines Objekts: Seine kleinformatigen Ölbilder, die er bis 1997 malte, ließ er von Plakatmalern in größerem Maßstab kopieren, wobei er ihnen Freiraum für eigene Interpretationen gab (z. B. *The Liar, The Copy of the Liar*, 1994). In seinen Performances durchquert er die Stadt zu Fuß und nimmt dabei subtile, manchmal skurrile Interventionen vor. So trug Alÿs bei einem Gang durch Havanna magnetische Schuhe, die ein Sammelsurium von Gegenständen aus Metall anzogen (*Magnetic Shoes*, 1994), oder er lief, jeden Tag unter einer anderen Droge stehend, eine Woche lang durch Kopenhagen (*Narcoturismo*, 1996). Eine Herangehensweise an den Stadtraum, die an das „Dérive", das Umherschweifen der Situationisten in Paris, erinnert. Häufig tauchen in Alÿs' Bildern, seinen Performances und den dazugehörigen Videodokumentationen ähnliche Motive auf, wie der Hund: schlafende Hunde in seiner Fotoserie *Sleepers*, 1999, oder ein hundeähnliches Gefährt in der Performance *The Collector*, 1991/92. Häufig interveniert Alÿs an politisch bedeutsamen Orten, etwa dem Zócalo, dem zentralen Platz von Mexico, an dem Kundgebungen und Demonstrationen stattfinden. In *Cuentos Patrióticos*, 1997, führte er eine Herde von Schafen in einem Kreis um den dort aufgestellten Fahnenmast herum. So nimmt er kritisch Stellung zum politischen Mitläufertum. Auch der Kunstbetrieb steht bei Alÿs zur Diskussion: Auf der *Biennale* in Venedig 2001 setzte er fünf Pfauen aus. Die eitlen Tiere stolzierten während der Eröffnung zwischen den Besuchern in den Giardini umher.

Le travail de Francis Alÿs englobe de la peinture figurative, des performances dans l'espace public, des séries photographiques et des projets pour le web. Le point de référence central de son œuvre est le concept, et non la production d'un objet : jusqu'en 1997, l'artiste faisait agrandir ses petites huiles par des peintres d'affiches à qui il laissait une certaine marge d'interprétation (par exemple *The Liar, The Copy of the Liar*, 1994). Dans ses performances, Alÿs traverse des villes à pied et procède à des interventions subtiles, parfois bouffonnes. C'est ainsi que pour une traversée de La Havane, l'artiste portait des chaussures magnétiques qui attirèrent tout un fatras d'objets métalliques (*Magnetic Shoes*, 1994) ; ou bien il traversait Copenhague pendant toute une semaine, chaque jour sous l'emprise d'une autre drogue (*Narcoturismo*, 1996) – une approche de l'espace urbain qui rappelle la « dérive » des situationnistes à Paris. Dans les tableaux d'Alÿs, dans ses performances et dans les documentaires vidéo qui les accompagnent, on relève souvent l'existence de motifs récurrents tel que le chien : chiens dormants de sa série photographique *Sleepers*, 1999, ou véhicule évoquant un chien dans la performance *The Collector*, 1991/92. Souvent, Alÿs intervient sur des sites politiquement significatifs comme le Zócalo, la place centrale de Mexico, où se font les annonces publiques et où ont lieu des manifestations. Ainsi, dans *Cuentos Patrióticos*, 1997, l'artiste menait un troupeau de moutons en rond autour du drapeau national hissé au centre de la place, prenant ainsi position sur l'instinct grégaire en politique. Le marché de l'art est lui aussi un thème de son œuvre. Pour la *Biennale* de Venise 2001, Alÿs exposait cinq paons : pendant l'inauguration, les vaniteux volatiles se mêlaient à la foule des visiteurs des Giardini. N. M.

1

SELECTED EXHIBITIONS →
1997 *In Site 97*, Tijuana, Mexico/San Diego (CA), USA
1998 *Web Site Project*, Dia Center for the Arts, New York (NY), USA
1999 *Mirror's Edge*, Bild Museet Umeå, Sweden **2000** *Cinema Without Walls*, Rotterdam 2000, Rotterdam, The Netherlands
2001 *Matrix 145*, Wadsworth Atheneum, Hartford (CT), USA; *7th Istanbul Biennial*, Istanbul, Turkey; *49. Biennale di Venezia*, Venice, Italy

SELECTED BIBLIOGRAPHY →
1999 *Signs of Life*, Melbourne International Biennial, Melbourne
2000 *Francis Alÿs, The Last Clown*, Fundació "la Caixa", Barcelona
2001 *Francis Alÿs*, Musée Picasso, Antibes

1 **The Winner/The Looser (Mexico City 1995 – Stockholm 1998),** 1998, reworked photograph
2 **Re-enactments (Mexico City, November 2000),** 2000, video still

3 **The Collector (Mexico City, October 1991),** 1991, reworked photograph
4 Detail of the performance **The Collector (Mexico City, October 1991),** 1991

„Nicht alle Ideen müssen sich in Produkte verwandeln. Nicht selten verdichten sich die besten Ideen sogar zu Geschichten und unterliegen nicht dem Zwang, in Produkte umgesetzt werden zu müssen."

« Toute idée ne débouche pas forcément sur une production, même si les meilleures tendent à devenir des récits sans pour autant se transformer en productions. »

"Not all ideas need to turn into products though, the best ones tend to become stories, without the need to turn into products."

2

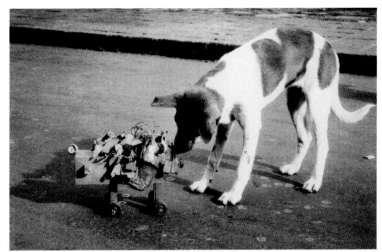

4

3

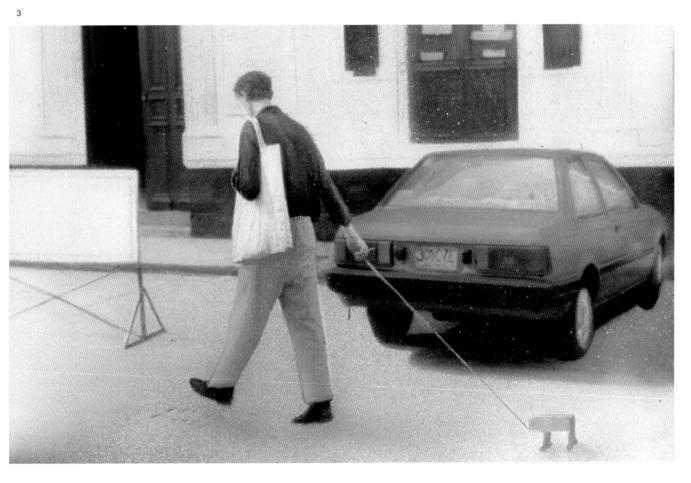

Ghada Amer

1963 born in Cairo, Egypt, lives and works in Paris, France, and New York (NY), USA

Ghada Amer's embroidered canvases pull together conflicting viewpoints regarding female stereotypes, based on her contradictory experience growing up as an Egyptian in France. An early work titled *Cinq Femmes au Travail*, 1991, is a group of four neatly embroidered tableaux, each of which shows a woman performing a domestic chore: cooking, cleaning, shopping and childcare; the fifth woman referred to in the title presumably being the artist herself, stitching. In her 1998 installation, *Private Rooms*, a collection of satin garment bags in pastel shades were embroidered with texts from the Koran detailing prohibitions for women. But for Amer, the dogma of French feminist theory was as stifling as outdated stereotyping or Islamic fanaticism. Looking for a means to express this conflict, she turned to the ongoing discourse of sexual identity and gender, subverting embroidery's domestic associations by using it to reproduce images of women appropriated from pornographic magazines and repeated in grids or lines on the canvas. The multi-coloured stitched outlines of these figures overlap and bleed into each other. The brutalist nature of the imagery becomes subordinate to formal concerns of line and colour, as each canvas' character is determined by the structure of hanging threads overlaying swathes and drips of paint in home-craft reinterpretations of abstract expressionist motifs. These works recuperate the sensuality suppressed by both the aggressive masculine gesture and the oppressive male gaze: luxurious dangling threads replace violent paint-flinging while the pleasure of female auto-eroticism is freed from its ghetto.

Mit ihren bestickten Leinwänden thematisiert Ghada Amer gegensätzliche Auffassungen von der Rolle der Frau, basierend auf ihren widersprüchlichen Erfahrungen, die sie als in Frankreich aufgewachsene Ägypterin gemacht hat. Die frühe Arbeit *Cinq Femmes au Travail*, 1991, ist eine Gruppe von vier sorgfältig gestickten Tableaus. Jedes zeigt eine Frau, die klassischer Hausfrauenarbeit nachgeht: Kochen, Sauber-machen, Einkaufen und Kinderpflege. Mit der fünften im Titel genannten Frau dürfte die stickende Künstlerin gemeint sein. Für die Installation *Private Rooms*, 1998, hat Amer fünf in Pastellfarben gehaltene Satin-Kleiderbeutel mit dem Koran entnommenen Verbotsanweisungen bestickt, die nur für Frauen gelten. Doch sind für Amer die Dogmen des französischen Feminismus genauso beengend wie überkommene Stereotypen oder der islamische Fanatismus. Um diesen Konflikt aufzuzeigen, hat sie sich dem aktuellen Diskurs über sexuelle und Geschlechtsidentität zugewandt. Sie hat die enge mentale Verknüpfung des Stickens mit der heimischen Sphäre aufgebrochen, indem sie mithilfe der „häuslichen" Technik Frauen aus Porno-Magazinen auf der Leinwand reproduzierte. Dabei überschneiden sich die in unterschiedlichen Farben gestickten Umrisslinien der Figuren und fließen ineinander. Allerdings sind die brutalen Darstellungen den formalen Kriterien der Linienführung und des Farbauftrags unterworfen, da der Charakter jeder Leinwand durch die Struktur der herabhängenden Fäden bestimmt wird, hinter denen sich Farbspuren und -kleckse verbergen wie in einer handwerklichen Interpretation des abstrakten Expressionismus. Zugleich ist in diesen Arbeiten die durch den aggressiven maskulinen Gestus samt zugehöriger Unterdrückung beschädigte Sinnlichkeit bewahrt. Dabei wird der geradezu schmerzhafte Farbauftrag durch luxuriöse Fadenformationen ersetzt, während sich die weibliche Autoerotik zugleich aus ihrem Ghetto-Dasein zu befreien vermag.

Les toiles brodées de Ghada Amer rassemblent des points de vue conflictuels sur les stéréotypes féminins, inspirés par son expé-rience contradictoire d'Egyptienne ayant grandi en France. Une des ses premières œuvres, intitulée *Cinq Femmes au Travail*, 1991, est un ensemble de quatre tableaux soigneusement brodés, chacun représentant une femme effectuant une tâche domestique: la cuisine, le ménage, les courses et l'éducation des enfants, la cinquième femme mentionnée dans le titre est sans doute l'artiste elle-même, cousant. Son installation de 1998, *Private Rooms*, est constituée d'une série de housses à vêtements en satin de couleur pastel brodés de textes coraniques détaillant les interdits des femmes. Amer considère toutefois le dogme du féminisme français aussi étouffant que les stéréotypes d'autrefois ou le fanatisme islamique. Pour exprimer ce conflit, elle s'est penchée sur le débat actuel autour de l'identité sexuelle, détournant les connotations domestiques de la broderie en reproduisant des images de femmes prises dans des revues pornographiques sous forme de quadrillages ou de lignes cousues sur la toile. Les silhouettes multicolores se chevauchent et se fondent les unes dans les autres. La nature brutaliste de l'image est ainsi assujettie à des préoccupations formelles de lignes et de couleurs, le caractère de chaque toile étant déterminé par la structure des fils pendants qui recouvrent des échantillons de tissus et des coulures de peinture dans une interprétation façon « ouvrage de dames » des motifs classiques de l'expressionnisme abstrait. Ces œuvres récupèrent la sensualité réprimée à la fois par le geste masculin agressif et le regard masculin oppressif : les fils pendant voluptueusement remplacent les violentes giclées de peinture tandis que le plaisir de l'auto-érotisme féminin n'est plus discriminé.

K. B.

1

SELECTED EXHIBITIONS →
1998 Espace Karim Francis, Cairo, Egypt; *Loose Threads*, Serpentine Gallery, London, UK **1999** *dAPERTuttO, 48. Biennale di Venezia, Venice*, Italy; *Looking for a Place*, SITE Santa Fe 3rd International Biennial, Santa Fe (NM), USA **2000** Institute of Visual Arts, Milwaukee (WI), USA; *Intimate Confessions*, Tel Aviv Museum of Art, Tel Aviv, Israel; *Kwangju Biennale*, Kwangju, South Korea; *Whitney Biennial*, The Whitney Museum of American Art, New York (NY), USA **2001** *Pleasure*, Contemporary Arts Museum, Houston (TX), USA

SELECTED BIBLIOGRAPHY →
1994 *Bifurcations*, Abbaye Saint Andre, Meymac **1995** *Le Duc sur le Noyau de Cerise et la Princess au Petits Pois*, Friedenstein Castle, Kunstverlag Gotha **1998** *Echolot*, Museum Fridericianum, Kassel **2000** *Whitney Biennial*, The Whitney Museum of American Art, New York (NY); *Ghada Amer: Intimate Confessions*, Tel Aviv Museum of Art, Tel Aviv **2001** Uta Grosenick (ed.), *Women Artists*, Cologne

1 **The Tree, the Girl and the Mice,** 2001, acrylic, embroidery on canvas, 107 x 91 cm
2 **Private Rooms,** 1998, embroided sculpture, installation view, Rhona Hoffman Gallery, Chicago (IL)

3 **Johanna's Grid,** 1999, acrylic, embroidery and gel medium on canvas, 153 x 182 cm
4 **Johanna's Grid** (detail)

„Ich habe nach einer Möglichkeit gesucht, mich mit dem Thema Extremismus auseinander zu setzen – sowohl dem Feminismus als auch dem religiösen Fanatismus. Was mich vor allem interessiert, sind die ganz ähnlich gelagerten Probleme beider Richtungen mit dem Körper und seinem Verführungspotenzial."

« Il me fallait un moyen de traiter de l'extrémisme du féminisme et du fanatisme religieux et des problèmes similaires qu'ils entretiennent avec le corps et son rapport à la séduction. »

"I had to find a way to address extremism – both feminism and religious fanaticism and their parallel problems with the body and its relationship with seduction."

2

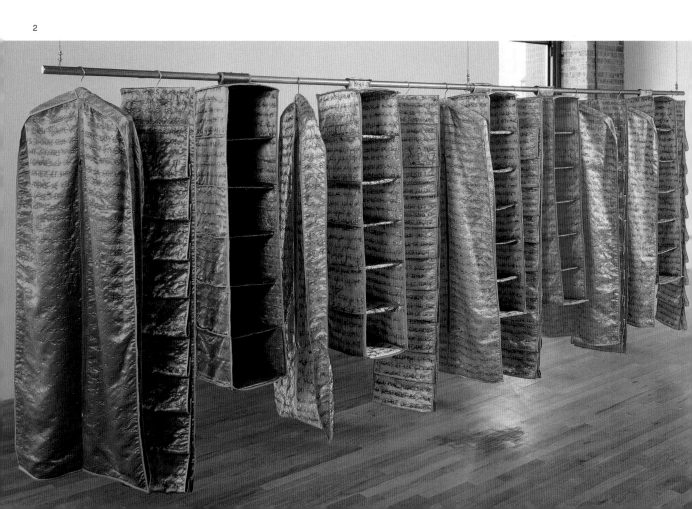

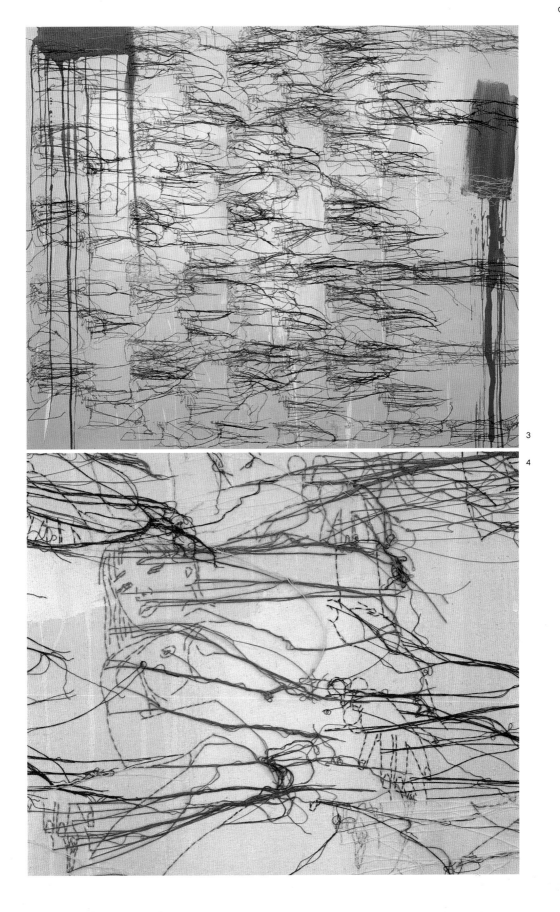

Miriam Bäckström

1967 born in Stockholm, lives and works in Stockholm, Sweden

The photographer Miriam Bäckström concentrates her artistic endeavours on the pictorial archiving and reconstruction of rooms. All her photographed interiors reveal yearnings of both an individual and a collective nature. Bäckström has photographed the living spaces of the recently deceased (*Estate of a Deceased Person*, 1992–96), the recreated interiors of exhibiting institutions (*Museums, Collections and Reconstructions*, 1998/99), and the IKEA museum in the Swedish town of Älmhult. All of these unpopulated places are carefully kept in their "original state"; nothing has been arranged or staged. Bäckström uses purely photographic means to capture the rooms' inhabitants and users' ambitions, yearnings and fears. The artist first came to public attention with her *Set Constructions*, 1995–2001. The subjects for these photographs include obsolete film sets, empty factories, sterile kitchens, a dismal street and the façade of a small theatre. Again, nothing has been changed; only available light is used, and Bäckström also retains the (film) camera markings. However, the format is different, so items that are not noticeable on film become evident: spotlights, false walls and added floors. Consequently, the constructed character of the room and its image reveals itself almost incidentally, film and photography being anything but "authentic". And yet, or perhaps exactly because of this, the emotions they suggest feel genuine.

Die Fotografin Miriam Bäckström konzentriert sich in ihrer künstlerischen Arbeit auf die bildliche Archivierung und Rekonstruktion von Räumen. Stets sind den von ihr abgelichteten Räumen individuelle und kollektive Sehnsüchte zugleich ablesbar. So hat Bäckström sowohl Wohnräume kürzlich Verstorbener fotografiert (*Estate of a Deceased Person,* 1992–96) als auch rekonstruierte Innenräume im Ausstellungswesen (*Museums, Collections and Reconstructions,* 1998/99) oder das IKEA-Museum in der schwedischen Stadt Älmhult. Menschenleer sind alle diese Orte, die die Künstlerin exakt in ihrem „Originalzustand" belässt. Nie wird hier arrangiert oder inszeniert, allein die Mittel der Fotografie nutzt Bäckström, um die in den Räumen sichtbar werdenden Ambitionen, Sehnsüchte und Ängste ihrer Bewohner und Nutzer festzuhalten. Bekannt geworden ist die Künstlerin vor allem mit ihren *Set Constructions,* 1995–2001. In diesen Fotografien sind ausgediente Filmkulissen aufgenommen, leere Fabrikhallen, sterile Küchen, eine trostlose Straße und etwa die Fassade eines kleinen Theaters. Wieder ist nichts verändert, einzig das verfügbare Licht wurde genutzt und auch an die Markierungen für die (Film-)Kamera hat sich Bäckström gehalten. Das Bildformat allerdings ist ein anderes und so fällt ins Auge, was im Film unsichtbar bleibt: Scheinwerfer, doppelte Wände und eingezogene Böden. Die Konstruiertheit des Raumes und des von ihm gemachten Bildes verraten sich so fast nebenbei – Film und Fotografie sind eben alles andere als „authentisch". Und dennoch, oder vielleicht gerade deshalb, sind die von ihnen suggerierten Emotionen so gefühlsecht.

Dans son œuvre, la photographe Miriam Bäckström se concentre sur l'archivage iconique et la reconstitution des espaces. Les espaces qu'elle photographie ressortent toujours de désirs individuels et collectifs. Ainsi, Bäckström a photographié l'habitat de personnes récemment décédées (*Estate of a Deceased Person*, 1992–96) aussi bien que les espaces intérieurs reconstitués de certaines institutions exposantes (*Museums, Collections and Reconstructions*, 1998/99), comme ce fut le cas du musée IKEA d'Älmhult en Suède. Tous ces lieux rigoureusement laissés dans leur « état d'origine » sont exempts de toute présence humaine. L'artiste n'arrange rien, elle ne met jamais rien en scène, mais se sert uniquement des moyens de la photographie pour fixer les ambitions, les désirs, les angoisses de leurs habitants et utilisateurs, telles qu'il se manifestent dans ces espaces. Bäckström s'est surtout fait connaître par ses *Set Constructions*, 1995–2001. Ces photographies montrent des studios de cinéma et des halles d'usines désaffectés, des cuisines aseptisées, ou encore telle rue morose, telle façade d'un petit théâtre. Là encore, tout est laissé en l'état, seule la lumière disponible est utilisée, et Bäckström n'a pas même effacé les marques de la caméra. En revanche, le format a changé, et ce qui reste invisible pour la caméra saute aux yeux : projecteurs, cloisons, sols. Le caractère construit des espaces et de l'image qu'ils dispensent se trahit presque accessoirement. Il est vrai que le cinéma et la photographie sont tout sauf « authentiques ». Et pourtant – ou peut-être justement pour cette raison – les émotions suggérées sont infiniment vraies.

R. S.

SELECTED EXHIBITIONS →
1996 Galleri Larsen, Stockholm, Sweden; *The art of conservation*, London, UK **1999** Ludwig Museum, Budapest, Hungary; Almut Gerber, Cologne, Germany; *Insight-Out*, Kunstraum Innsbruck, Austria; Lombard-Freid Gallery, New York (NY), USA **2000** Institute of Contemporary Arts, London, UK; *Set Constructions*, Sprengel Museum, Hanover, Germany; *What if*, Moderna Museet, Stockholm, Sweden; *Norden*, Kunsthalle Wien, Vienna, Austria

SELECTED BIBLIOGRAPHY →
2000 *Set Constructions*, Sprengel Museum, Hanover; *Norden*, Kunsthalle Wien, Vienna

1

2

42

1 Scenografier/Set Constructions, 1995–2001, Cibachrome on aluminium,
 50 x 64 cm
2 Scenografier/Set Constructions, 1995–2001, Cibachrome on aluminium,
 50 x 64 cm
3 Ten Variations of Light, Tiljan, Stockholms Stadsmuseum (details), 2000,
 Cibachromes mounted on aluminium, each 20 x 25 cm
4 Apartments, 2001, Cibachrome, 48 x 55 cm
5 Apartments, 2001, Cibachrome, 48 x 55 cm

„Ich sehe keine eindeutige Grenze zwischen meiner Wirklichkeit
und der des Bildes."

« Je ne vois pas de limite nette entre ma réalité et celle de l'image. »

"I do not see a clear boundary
between my reality and that of the image."

3

4

5

Matthew Barney

1967 born in San Francisco (CA), lives and works in New York (NY), USA

Every detail of Matthew Barney's lavish sculptures and films – from colour, form and material to costume, character and location – is part of a code that constitutes an intricately imagined parallel world. In his early work, Barney subjected himself to ordeals of physical endurance such as scaling the walls and ceiling of a gallery naked (*Blind Perineum*, 1991), exploring themes of gender identity and athleticism which remain central to his work. Since 1994 Barney has been absorbed in the *CREMASTER* series, a five-part drama of Wagnerian proportions. Each part comprises a film, a group of objects and a book of still images and has a specific symbolic setting which defines its atmosphere, formal appearance and content. Although there is little dialogue, the films have a narrative structure in which Barney plays the central protagonist with a supporting cast of ambiguously gendered fairies, Busby Berkeley-style chorus girls or horse-riding mounties. Each film is packed with obscure symbols and actions which suggest sexual reproduction while shrouding it in mystery. The work is named after the Cremaster muscle, which controls the raising and lowering of the testicles and is also responsible for the descent of the reproductive organs at fetal stage. As such, it can be read as an elaborate allegory about the process of sexual differentiation. But this reading is obscured by the vast accumulation of other references in each work, drawn from local culture, recent popular history or Barney's own personal history to create a multi-levelled mythological narrative with its own unique heroes, symbols and rituals.

Jedes Detail in den opulenten Skulpturen und Filmen von Matthew Barney – von Farbe, Form und Material bis zu den Kostümen, der Figurenzeichnung oder dem Schauplatz – ist Bestandteil eines Codes, der eine komplex angelegte Parallelwelt konstituiert. In seinem Frühwerk unterzog Barney sich der körperlichen Strapaze, die Wände und die Decke einer Galerie nackt zu erklettern (*Blind Perineum*, 1991), dabei die Themen der Geschlechteridentität und des Körperkults auslotend, die bis heute im Mittelpunkt seiner Arbeit stehen. Seit 1994 beschäftigt sich Barney vor allem mit seinem *CREMASTER*-Zyklus, einem fünfteiligen Drama von wagnerischen Dimensionen. Jede dieser Arbeiten besteht aus einem Film, einer Gruppe von Objekten sowie einem Buch mit Standfotos und hat ein bestimmtes symbolisch aufgeladenes Umfeld, das ihre Atmosphäre, ihr formales Erscheinungsbild und ihren Gehalt definiert. Auch wenn seine Filme kaum Dialoge haben, kommt Barney in ihrer narrativen Struktur die Hauptrolle zu; Nebenrollen spielen geschlechtsunspezifische Feen, in Busby-Berkeley-Manier agierende Chormädchen oder auch berittene Polizisten. Jeder der Filme verweist mit einer Vielzahl obskurer Symbole und Handlungen auf die sexuelle Fortpflanzung und umgibt sie zugleich mit einem Geheimnis. Benannt ist der Zyklus nach den Kremaster-Muskeln, die das Anheben und Absenken der Hoden ermöglichen, die aber auch den Austritt der männlichen Geschlechtsorgane beim Fötus bewirken. So gesehen lässt sich der Zyklus auch als subtile Allegorie auf den Prozess der sexuellen Differenzierung deuten. Diese Lesart wird in sämtlichen Filmen durch eine Vielzahl anderer Verweise relativiert, die Barney verschiedenen Kulturen, der neueren Populär-Geschichte und seiner persönlichen Biografie entnimmt. Auf diese Weise erschafft er eine vielschichtige mythologische Erzählung mit ganz eigenen Helden, Symbolen und Ritualen.

Les moindres détails des somptueux films et sculptures de Matthew Barney – de la couleur, des formes et des matériaux aux costumes, aux personnages et aux sites – font partie d'un code qui constitue un monde parallèle imaginaire et complexe. Dans ses premières œuvres, Barney se soumettait à des épreuves d'endurance physique, telle qu'escalader les murs et le plafond d'une galerie entièrement nu (*Blind Perineum*, 1991), explorant les thèmes de l'identité sexuelle et de l'athlétisme qui restent au cœur de son travail. Depuis 1994, Barney a été accaparé par sa série *CREMASTER*, une dramatique en cinq parties aux proportions wagnériennes. Chaque partie comprend un film, un groupe d'objets, un livre de photographies et dispose d'un décor symbolique spécifique qui définit son atmosphère, son aspect formel et son contenu. Bien qu'il y ait peu de dialogue, les films ont une structure narrative où Barney joue le rôle principal entouré d'une distribution de fées sexuellement ambiguës, de girls à la Busby Berkeley ou de membres de la police montée canadienne. Chaque film est rempli de symboles et d'actions obscures qui suggèrent la reproduction sexuelle tout en la nimbant de mystère. L'œuvre tient son nom du muscle cremaster, qui contrôle la levée et la descente des testicules et est également responsable de la descente des organes génitaux au stade fœtal. En tant que tel, on peut y voir une allégorie sophistiquée sur la différentiation sexuelle. Mais cette lecture est obscurcie par l'accumulation d'autres références dans chaque œuvre, puisées dans la culture locale, l'histoire populaire récente ou l'histoire personnelle de Barney lui-même, pour former un récit mythologique à couches multiples avec ses propres héros, symboles et rituels.

K. B.

1

SELECTED EXHIBITIONS →
1996 *CREMASTER 1* and *CREMASTER 4*, San Francisco Museum of Modern Art, San Francisco (CA), USA **1997** *CREMASTER 5*, Portikus, Frankfurt am Main, Germany **1998** *CREMASTER 5*, Fundació "la Caixa", Barcelona, Spain; *Wounds: Between Democracy and Redemption in Contemporary Art*, Moderna Museet, Stockholm, Sweden **1999** *CREMASTER 2*, Walker Art Center, Minneapolis (MN), USA **2001** *Public Offerings*, Los Angeles Museum of Contemporary Art (CA), USA **2002** The Cremaster Cycle, Museum Ludwig, Cologne, Germany

SELECTED BIBLIOGRAPHY →
1995 *MATTHEW BARNEY: CREMASTER 4*, Fondation Cartier pour l'Art Contemporain, Paris **1997** *MATTHEW BARNEY: CREMASTER 5*, Portikus, Frankfurt am Main; *MATTHEW BARNEY: CREMASTER 1*, Kunsthalle Wien, Vienna/Museum für Gegenwartskunst Basel, Basle **1999** *MATTHEW BARNEY: CREMASTER 2*, Walker Art Center, Minneapolis (MN); Burkhard Riemschneider/Uta Grosenick (eds.), *Art at the Turn of the Millennium*, Cologne

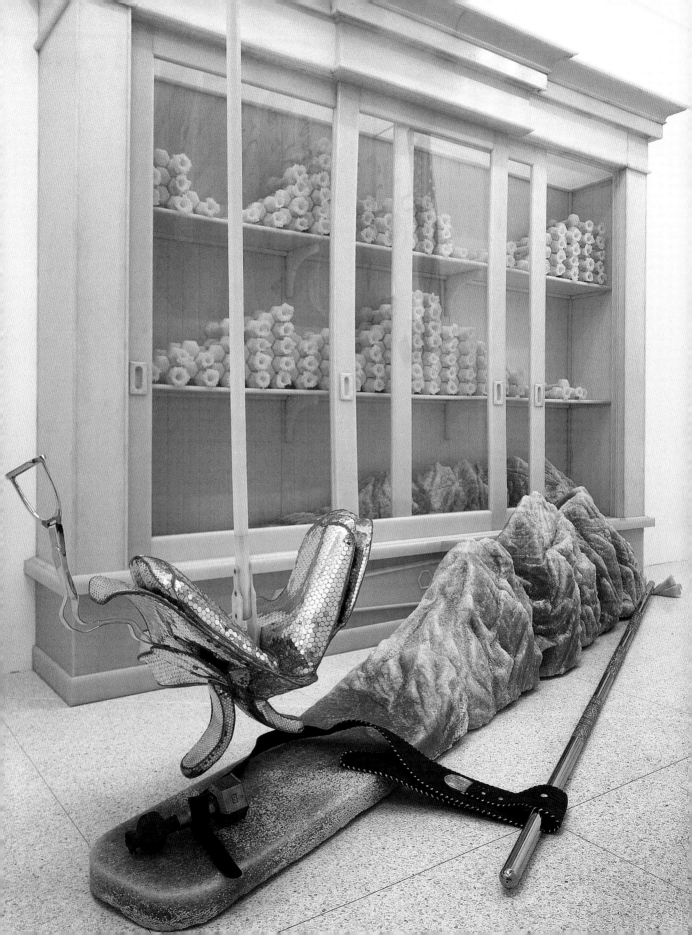

1 CREMASTER 2: The Drone's Exposition, 1999, mixed media sculpture installation including 35 mm film transferred from HDTV, 12 c-prints and 5 drawings in acrylic frames
2 CREMASTER 1: Goodyear Field, 1996, mixed media installation, overall 823 x 681 x 137 cm
3 CREMASTER 4: The Isle of Man, 1994/95, mixed media installation, overall 610 x 914 cm
4 CREMASTER 2: Genealogy, 1999, c-print in acrylic frame, 71 x 60 cm
5 CREMASTER 1: Goodyear Chorus, 1995, c-print in self-lubricating plastic frame, 111 x 137 cm

„Mir erscheint meine Arbeit nicht sonderlich merkwürdig. Entscheidend ist doch nur die Disziplin, eine Idee in all ihren Möglichkeiten auszuloten, ihre äußersten Grenzen zu erkunden."

« Je ne trouve pas que mon travail soit si étrange. L'important est d'avoir la discipline d'aller jusqu'au bout d'une idée, de l'étirer jusqu'au bout de ses limites. »

"I don't think my work is so strange. It's just a matter of having the discipline to go the whole way with an idea, to stretch it as far as it can go."

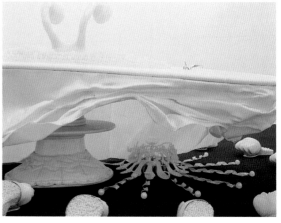

2

3

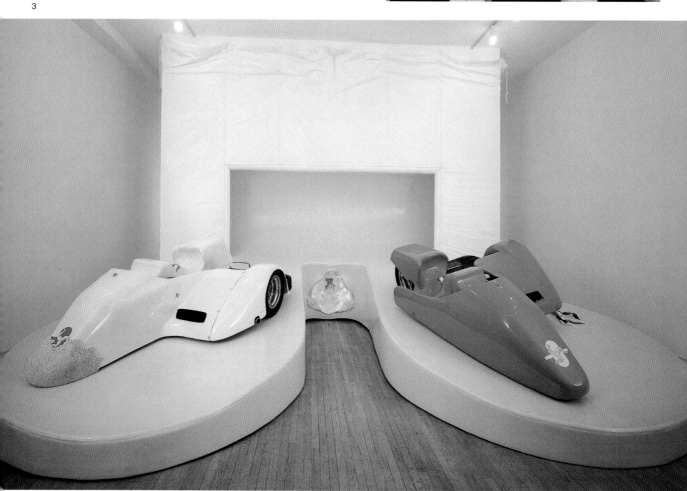

4

5

John Bock

1965 born in Gribbohm, lives and works in Berlin, Germany

John Bock is first and foremost a performance artist. He defines his comic, absurd, enigmatic performances as *Aktionen,* or "happenings". They cover a wide range of genres, from rustic buffoonery through complex didactic plays and multimedia psychodramas. Bock designs rough-and-ready costumes for himself and his troupe. The crude sets with simple props, many of them bits of junk, create the sometimes harmonious, sometimes totally incongruous backdrop to shows which, like a virus, run completely out of control. In these settings occupying large areas of space, the former student of economics reels off impenetrable formulae to explain the relationship between creativity and economics. For example, he soaps himself with unfeasibly generous quantities of shaving foam, or carries out deadly serious scientific experiments, some of them on himself. In the various performances staged throughout the duration of exhibitions of his work, he gives cryptic "lectures", plays schmaltzy records, and shows baffling videos. Crucial to these almost incomprehensible happenings is the fact that, as in the happenings of the 1960s and 1970s, there is no internal logic between the perplexing but seemingly autonomous subjects. Instead, we have a fanciful, sometimes manic analytical process in which the dogmatic Freudian view of the subconscious is placed under an aesthetic microscope. Bock does not perform dismal dramas of identity, but colourful burlesques like *ArtemisiaSogJod→Meechwimper lummering,* 2000, an incredible insight into the motivations that drive us.

John Bock ist vor allem ein Performancekünstler; er selbst bezeichnet seine so komisch-absurden wie hintergründigen Auftritte schlicht als „Aktionen". In diesen „Aktionen", die diverse Genres wie rustikalen Schwank, komplexes Lehrstück oder polymorph-perverses Psychodrama zitieren, treten der Künstler und seine Mitspieler in kruden, von Bock selbst entworfenen Kostümen auf. Aus einfachen, oftmals gefundenen Materialien gestaltete Bühnenbilder sorgen für den passend unpassenden Rahmen für die wie ein Virus wuchernden Schauspiele. In diesen raumgreifenden Settings erklärt der ehemalige Betriebswirtschaftsstudent mit für den Verstand unbegreiflichen Formeln den Zusammenhang von Kreativität und Ökonomie, lässt sich etwa mit einer Unmenge Rasierschaum einseifen oder führt todernst paradoxe wissenschaftliche Experimente und Selbstversuche durch. Kryptische Lesungen finden statt, sentimentale Schallplatten werden aufgelegt, und verwirrende Videos dokumentieren anschließend im Laufe der jeweiligen Ausstellung die ästhetischen Aktionen, die der Künstler während ihrer Eröffnung vorgeführt hat. Entscheidend an diesen kaum wirklich zu interpretierenden Aktionen ist, dass es bei ihnen nicht mehr – wie in vielen Performances vor allem in den sechziger und siebziger Jahren – um die psychische Logik von krisengeschüttelten, aber scheinbar autonomen Subjekten geht. Stattdessen steht hier die lustvolle, bisweilen manische Auflösung einer freudianisch vorgeschriebenen „diktatorischen Konzeption des Unterbewussten" auf dem ästhetischen Prüfstand. Nicht die Dramen trister Identität werden von Bock vorgespielt, sondern bunte Travestien, die wie ein *ArtemisiaSogJod→Meechwimper lummering,* so der Titel einer Aktion Bocks (*2000*), unglaubliche Einblicke in unseren Triebhaushalt erlauben.

John Bock est avant tout performer. Lui-même qualifie simplement d'« actions » ses interventions aussi profondes qu'absurdes et comiques. Dans ces actions, qui abordent des genres aussi différents que la farce paysanne, la pièce didactique complexe ou le psychodrame polymorphe et pervers, l'artiste et ses acolytes se présentent en costumes crus dessinés par Bock lui-même. Des décors réalisés à partir de matériaux simples, souvent trouvés par hasard, assurent un cadre aussi approprié qu'inapproprié pour ces pièces pullulantes comme une infection virale. Dans des compositions investissant tout l'espace, cet ancien étudiant en économie développe alors les liens entre créativité et économie en des formules qui échappent à l'entendement ; il se laisse ainsi enduire d'une énorme quantité de mousse à raser ou réalise avec un flegme imperturbable des expériences scientifiques paradoxales ou portant sur sa propre personne. Dans les expositions corollaires, des lectures sibyllines, des disques vinyles sentimentaux et des vidéos ahurissantes illustrent ensuite les actions esthétiques présentées pendant l'inauguration. Dans ces actions défiant toute interprétation, loin de la logique psychique de tant de performances des années 1960 et 1970, où des individus apparemment autonomes étaient secoués par une crise intérieure ou sociale, le facteur décisif est ici la dissolution ludique, voire obsessionnelle, des dogmes freudiens d'une « conception dictatoriale de l'inconscient » mis à l'épreuve de l'esthétique. Bock ne nous propose pas en effet les drames d'une tristesse identitaire, mais des travestissements hauts en couleurs qui, tel ce *ArtemisiaSogJod→Meechwimper lummering,* – titre d'une action (*2000*) –, ouvrent de stupéfiantes perspectives sur le jardin de nos pulsions. R. S.

SELECTED EXHIBITIONS →
1998 *1.berlin biennale,* Berlin, Germany **1999** Kunsthalle Basel, Basle Switzerland; Anton Kern Gallery, New York (NY), USA; *Home & Away,* Kunstverein, Hanover, Germany; *German Open,* Kunstmuseum Wolfsburg, Germany; *48. Biennale di Venezia,* Venice, Italy **2000** *Floß,* Gesellschaft für Aktuelle Kunst, Bremen, Germany; *Aller Anfang ist Merz,* Sprengel Museum, Hanover, Germany **2001** *Im Dilemma der ExistoEntropie,* Bonner Kunstverein, Bonn, Germany

SELECTED BIBLIOGRAPHY →
1999 *John Bock,* Kunsthalle Basel, Basle; *Home & Away,* Kunstverein, Hanover **2001** *Le Republiche dell'Arte Germania,* Siena; *John Bock. Gribbohm,* Bonner Kunstverein, Bonn/Gesellschaft für Aktuelle Kunst, Bremen

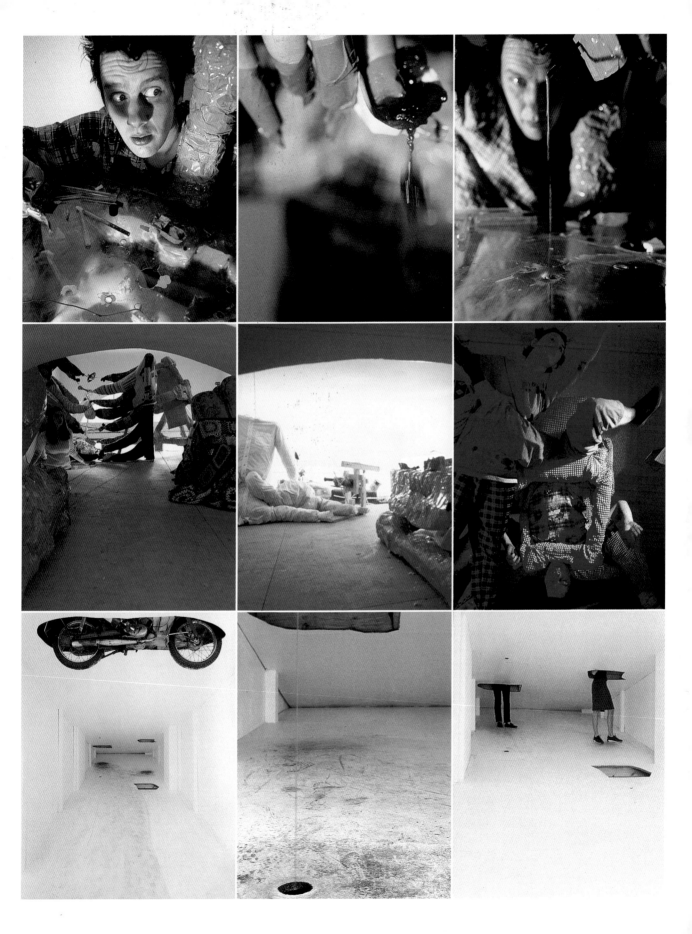

1 **ArtemisiaSogJod→Meechwimper lummering,** 2000, installation and performance, Klosterfelde, Berlin

2 **Lombardi Bängli,** 1999, installation and performance, Kunsthalle Basel

„NachschlageWERK schweige stille."

« ŒUVRE de référence ne dis rien. »

"You won't find it in the dictionary."

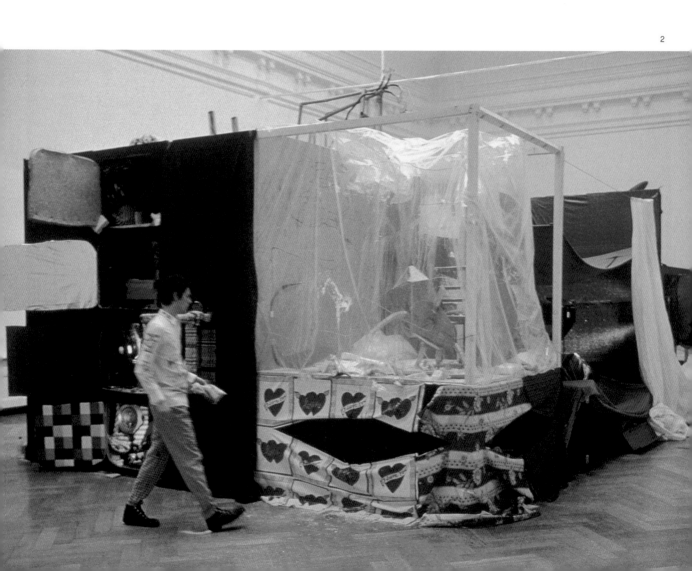

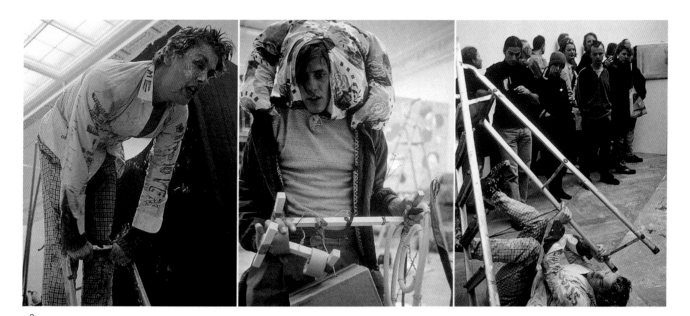

2

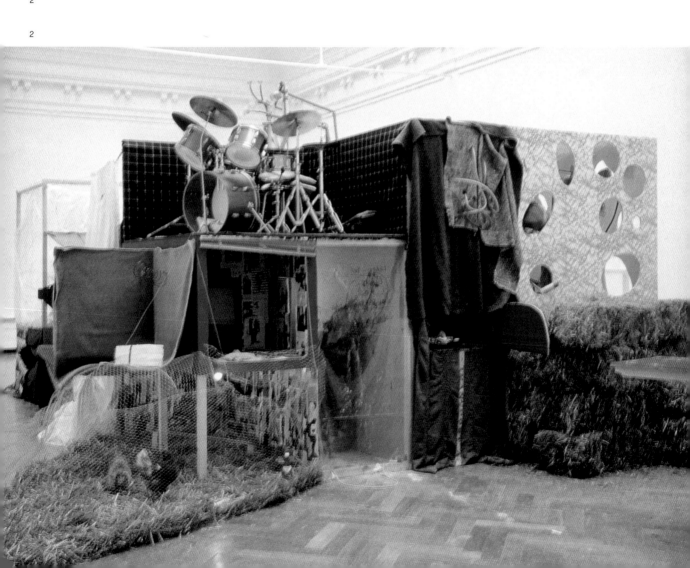

Cosima von Bonin

1962 born in Mombasa, Kenya, lives and works in Cologne, Germany

Cosima von Bonin is one of the most idiosyncratic players on the contemporary art scene. Since her début in the early 1990s, she has developed her own poetic language. Paintings, sculptures, installations, films and performances – her work is not confined to any single medium or material. Using textiles such as wool, cotton, linen, loden, felt, silk and velvet, she sews together or embroiders soft, delicate fabrics. Hers is art that has no need of a paintbrush. Cute, loden-covered mushrooms sprout from gallery floors; *Hermès*, 2000, presents surreally swollen Prada and Hermès handbags fashioned from felt. Her huge wall hangings made from stitched-together handkerchiefs are reminiscent of Sigmar Polke. Bonin puts materials together. She makes things and people work together. Her exhibitions repeatedly refer to artistic models which she integrates into her own work, which defies any stylistic or thematic classification. Bonin always invites other artists and friends to her exhibitions, turning them into family gatherings. Her work is all about communication and she places group interaction above the demands of art. Bonin's work not only fills space, it also extends over time, like a book whose pages are turned one by one. She tells stories and creates narrative stage sets, like her 1997 installation *Löwe im Bonsaiwald* (Lion in the Bonsai Forest). The viewer is led along a series of forking, corridor-like paths, pushing material aside in order to reach an ever more distant point. Those who are prepared to become completely involved gain the greatest pleasure from Bonin's art.

Zu den prägnantesten Protagonisten der Gegenwartskunst zählt Cosima von Bonin. Seit ihrem ersten Auftreten zu Beginn der neunziger Jahre hat sie ihre eigene poetische Sprache entwickelt. Bilder, Skulpturen, Installationen, Filme und Performances – auf kein Medium beschränkt sie ihr Werk, auf kein Material. Wir erleben Textilien wie Wolle, Baumwolle, Leinen, Loden, Filz, Seide oder Samt. Die schwachen, weichen Materialien werden vernäht und bestickt: Kunst, die auf den Pinsel verzichtet. Niedliche, mit Loden bespannte Pilze wuchern aus Galerieböden, Handtaschen von Prada und Hermès werden surreal vergrößert und in Filz ausgeführt (*Hermès*, 2000), große Wandarbeiten aus zusammengenähten Taschentüchern erinnern an Sigmar Polke. Bonin stellt Materialien zusammen. Sie lässt Dinge und Leute miteinander arbeiten; immer wieder finden sich in ihren Ausstellungen Verweise auf künstlerische Vorbilder, die in ihre eigenen Werke integriert werden. Sie selber entzieht sich einer stilistischen oder thematischen Einordnung. Bonin lädt immer wieder Künstler und Freunde zu ihren Ausstellungen ein, die dadurch zu Familienfesten werden. Diese Geste der Künstlerin, die den Gruppenbezug ihrer Arbeit über den Kunstanspruch stellt, macht die Kommunikation untereinander zum Gegenstand ihres Werkes. Bonin füllt mit ihren Arbeiten nicht allein den Raum, sie erstrecken sich in der Zeit, wie ein Buch im Nacheinander von Seite um Seite erschlossen wird. Geschichten, sprechende Kulissen: Ihre Installation *Löwe im Bonsaiwald* von 1997 ist eine Bühne; Wege führen wie Schneisen durch die Präsentation, schieben das Material beiseite, teilen sich vor dem Betrachter, der Bonin bis zu einem immer entfernter liegenden Punkt folgt. Das volle Vergnügen genießt, wer sich ganz auf ihre Objekte einlassen kann.

Cosima von Bonin compte parmi les protagonistes les plus marquants de l'art contemporain. Depuis sa première apparition au début des années 1990, elle n'a cessé de développer son propre langage poétique. Tableaux, sculptures, installations, films et performances – son travail ne se limite à aucun médium ni à aucun matériau particulier. Nous relevons la présence de toutes sortes de textiles : laine, coton, lin, loden, feutre, soie, velours. Ces matériaux souples et doux sont cousus et brodés : l'art de Bonin se passe volontiers du pinceau. De ravissants champignons tendus de loden jaillissent du sol des galeries, des sacs à main de chez Prada ou Hermès prennent des proportions surréalistes et sont exécutés en feutre (*Hermès*, 2000), de grandes œuvres murales faites de mouchoirs cousus ensemble rappellent certaines œuvres de Sigmar Polke. Bonin combine des matériaux. Elle fait collaborer les choses et les gens ; dans ses expositions, on trouve toujours des références à des modèles artistiques qu'elle intègre dans son propre travail. Elle-même échappe en revanche à toute classification stylistique ou thématique. Bonin lance toujours des invitations, à des artistes, à des amis. Cela transforme ses expositions en grandes fêtes familiales. La démarche de l'artiste, qui fait de la référence au groupe une priorité par rapport à sa revendication artistique personnelle, a pour objet la communication. Les œuvres de Bonin n'occupent pas seulement l'espace, elles s'étendent aussi dans le temps, comme on s'approprie un livre au fil des pages. Histoires, décors parlants : son installation *Löwe im Bonsaiwald* (Lion dans la forêt de bonsaïs, 1997) est une scène ; des parcours traversent cette présentation comme des layons et se fraient un chemin à travers le matériau qu'ils écartent, se séparent devant le spectateur, qui suit Bonin vers un point toujours plus éloigné. Tout le plaisir est pour le spectateur capable de s'investir pleinement dans ses objets. F. F.

SELECTED EXHIBITIONS →
1996 *Heetz, Nowak, Rehberger*, Städtisches Museum Abteiberg, Mönchengladbach, Germany; *Glockengeschrei nach Deutz*, Galerie Daniel Buchholz, Cologne, Germany **1998** *mai 98*, Josef-Haubrich-Kunsthalle, Cologne, Germany **1999** *Wyoming*, Kunsthalle St. Gallen, Switzerland; *German Open*, Kunstmuseum Wolfsburg, Germany **2000** *The Cousins*, Kunstverein Braunschweig, Germany **2001** *Bruder Poul sticht in See*, Kunstverein in Hamburg, Germany; Moderna Museet, Stockholm, Sweden; *Vom Eindruck zum Ausdruck – Grässlin Collection*, Deichtorhallen Hamburg, Germany

SELECTED BIBLIOGRAPHY →
2000 *The Cousins*, Kunstverein Braunschweig; Dimitrios Georges Antonitsis (ed.), *Summer Camp – Camp Summer*, Hydra; *Rabbit at Rest*, Ursula-Blickle-Stiftung, Kraichtal

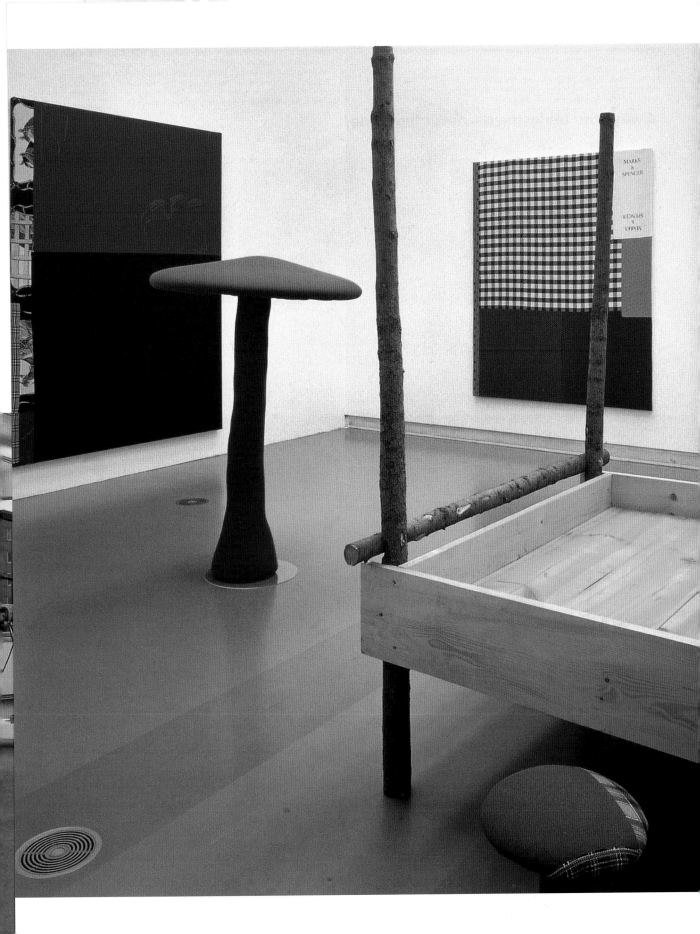

Monica Bonvicini

1965 born in Venice, Italy, lives and works in Berlin, Germany, and Los Angeles (CA), USA

Different ways of using gallery walls became an important theme in art and exhibition planning around 1970. Monica Bonvicini works with the wall – with the architecture and the illusion of absolute presence it creates – in an entirely different manner. She makes critical reference to sophisticated formal experiments that defined the opponent in the 1970s – the white cube of galleries. The most literal example of that approach is the widely discussed *Wallfuckin'* video, 1995. On a monitor positioned on the gallery floor near a white wall, we see the body of a woman embracing a piece of wall and rubbing herself against it. Her uncompromising and aggressive artistic approach brings tangible effects. Walls continue to stand but sometimes they crack, as in the installation that borrows its title from Le Corbusier: *I Believe in the Skin of Things as in that of Women*, 1999. Holes kicked through plaster walls alternate with quotations from the canon of architectural theory, which provokes the artist's ridicule in obscene graffiti and scrawl. The title of the installation *Destroy She Said*, 1998, refers to the Marguerite Duras novel. Fragments of films by renowned 1960s directors are projected on slightly inclined plaster walls. In them, women who are trapped in their homes are seen slumping against walls, clinging to them, as if they have lost control. Scattered around are traces of the presence of the workers who elevated the wall-screens: bits of unused materials, sawdust. Many contemporary artists use the history of cinema as a repertoire of motifs. Bonvicini throws the debris of the spectacle's site in the viewer's face.

Seit 1970 etwa ist die Möglichkeit, die Wände eines Ausstellungsraumes ganz unterschiedlich zu nutzen, für Künstler und Ausstellungs- planer ein stets wiederkehrendes Thema. Monica Bonvicini hingegen nähert sich dem Thema der Wand – also der Architektur und der Illusion einer absoluten Gegenwart, die sie erzeugt – auf eine völlig andere Weise. Dabei bezieht sie sich kritisch auf die formalen Experimente der siebziger Jahre, die gegen den weißen Kubus der typischen Galerie aufbegehrten. Ein charakteristisches Beispiel für diesen Ansatz ist ihr umstrittenes Video *Wallfuckin'*, 1995. Darin sehen wir auf einem Monitor, der neben einer weißen Wand auf dem Boden des Ausstellungsraumes platziert ist, den Körper einer Frau, die ein Stück Wand umschlungen hält und sich daran reibt. Bonvicinis kompromisslose und aggressive künstlerische Haltung zeitigt ganz handfeste Folgen. Zwar stehen auch bei ihr die Wände weiterhin aufrecht, können allerdings bisweilen durchaus mal zusammenkrachen, wie in der Installation *I Believe in the Skin of Things as in that of Women*, 1999, deren Titel sie bei Le Corbusier entlehnt hat. Hier wechseln sich in Gipswände getretene Löcher mit Zitaten aus dem Kanon der Architekturtheorie ab, über die sich die Künstlerin in obszönen Graffitis und Kritzeleien lustig macht. Der Titel der Installation *Destroy She Said*, 1998, verweist auf einen Roman von Marguerite Duras. Hier werden Ausschnitte aus Filmen namhafter Regisseure der sechziger Jahre auf leicht geneigte Gipswände projiziert, auf denen der Betrachter in ihrem Heim gefangene Frauen sieht, die gegen Wände anrennen beziehungsweise sich daran schmiegen, als ob sie die Kontrolle über sich selbst verloren hätten. Ringsum liegen diverse Materialien wie Baustoffe und Sägemehl. Sie verweisen auf die Arbeiter, die die zur Leinwand umfunktionierten Wände errichtet haben. Viele zeitgenössische Künstler durchstöbern die Filmgeschichte nach geeigneten Motiven. Bonvicini hingegen haut dem Betrachter den Müll um die Ohren, der bei der Herrichtung des Schauplatzes ihrer Arbeiten angefallen ist.

Dans les années 70, on a cherché à réinventer la manière d'utiliser les murs dans les musées et les galeries d'art. Monica Bonvicini travaille avec les murs – avec l'architecture et l'illusion de présence absolue qu'elle crée – mais d'une toute autre façon. Elle fait des références critiques aux expériences formelles sophistiquées qui définissent l'adversaire des années 70 – le cube blanc des galeries. L'exemple le plus littéral de cette démarche est sa vidéo largement débattue intitulée *Wallfuckin'* (Baiser les murs), 1996. Sur un écran posé à même le sol de la galerie près d'un mur blanc, on voit le corps d'une femme étreignant un pan de mur et se frottant contre lui. Sa démarche artistique agressive et intransigeante a des effets tangibles. Les murs tiennent toujours debout mais commencent à se lézarder, comme dans l'installation *I Believe in the Skin of Things as in that of Women*, 1999, qui emprunte son titre à une phrase de Le Corbusier. Sur des murs en plâtre, des impacts de coups alternent avec des citations empruntées au canon de la théorie architecturale. Des messages obscènes et des gribouillis tournent en dérision la construction masculine de ce canon. Le titre de l'installation *Destroy She Said* (Détruire, dit-elle), 1998, renvoie à un roman de Marguerite Duras. Des fragments de films de réalisateurs connus des années 60 sont projetés sur des murs en plâtre légèrement inclinés. Des femmes enfermées chez elle, se pressent contre les murs, s'accrochent à eux comme si elles avaient perdu le contrôle d'elles-mêmes. Le sol est jonché des traces des ouvriers qui ont installé les murs écrans : des éclats de matériaux, de la sciure … De nombreux artistes contemporains utilisent l'histoire du cinéma comme un répertoire de thèmes. Bonvicini, elle, nous lance au visage les débris du site où se déroule le spectacle. A. S.

SELECTED EXHIBITIONS →
1998 *1. berlin biennale*, Berlin, Germany **1999** *dAPERTuttO*, *48. Biennale di Venezia*, Venice, Italy; *Bonvicini, Moro, Toderi*, Stichting De Appel, Amsterdam, The Netherlands **2000** *bad bed bud pad bet pub*, Kunsthaus Glarus, Switzerland **2001** *Inside Space: Experiments in Redefining Rooms*, MIT-List Visual Arts Center, Cambridge (MA), USA **2001** *Scream & Shake*, Magasin – Centre National d'Art Contemporain, Grenoble, France

SELECTED BIBLIOGRAPHY →
1999 *Monica Bonvicini, Liliana Moro, Grazia Toderi*, Stichting De Appel, Amsterdam **2000** *Monica Bonvicini. Bau*, GAM – Galleria Civica d'Arte Moderna e Contemporanea, Turin **2001** *Monica Bonvicini. Scream & Shake*, Magasin – Centre National d'Art Contemporain, Grenoble

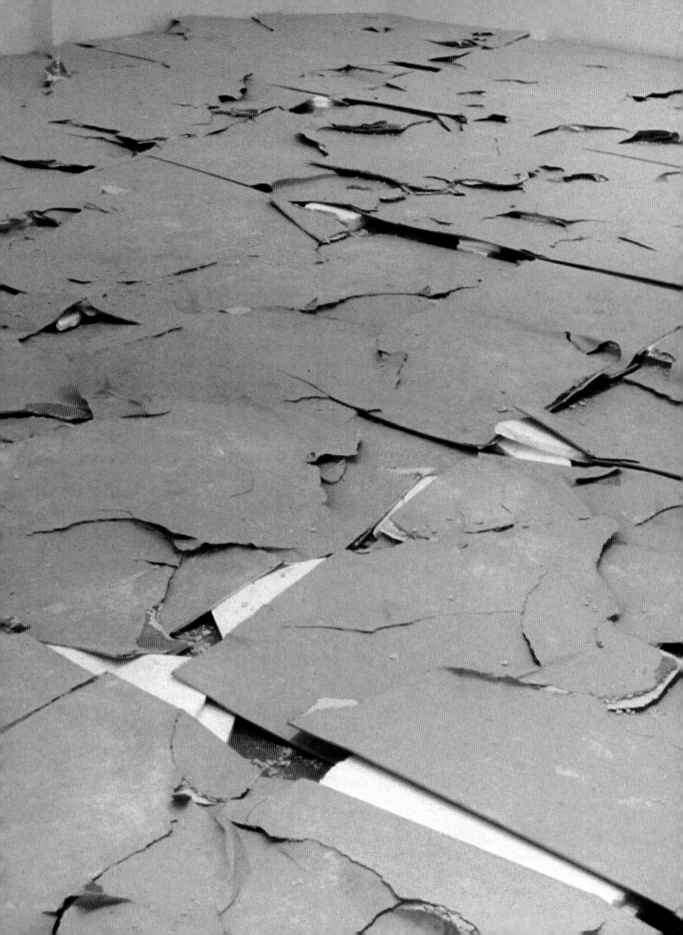

1 **Plastered,** 1998, plasterboard, polystyrene, dimensions variable
2 **Wallfuckin',** 1995, plasterboard, aluminium structure, stone wall, black and
 white video, wood panels, 250 x 310 x 330 cm

3 Drawing to **Hausfrau Swinging,** 1997, mixed media on paper, 70 x 100 cm
4 **Hausfrau Swinging,** 1997, plasterboard, wood structure, video,
 205 x 150 x 45 cm

„Ausruhen kannst du dich zu Hause. Vor der Kunst musst du agieren." « Pour vous reposer, restez chez vous. Devant l'art, il faut agir. »

"You can chill out at home. In front of art you should act."

2

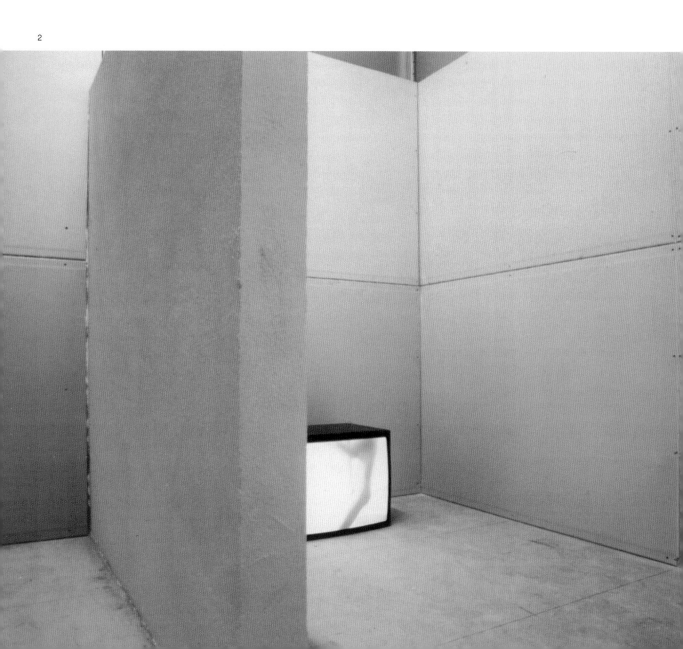

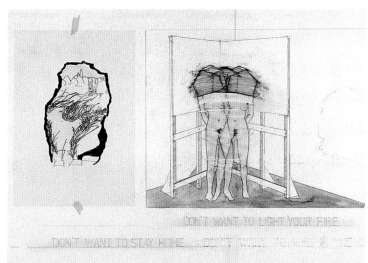

3

4

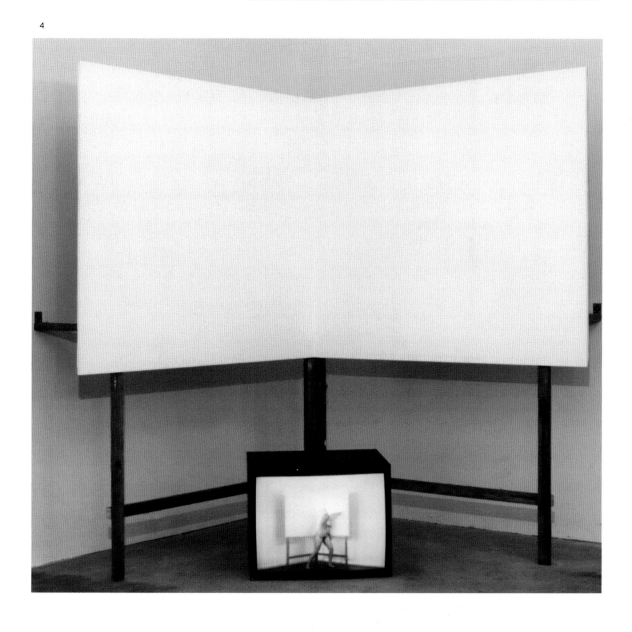

Candice Breitz

1972 born in Johannesburg, South Africa, lives and works in New York (NY), USA

In an age in which globalisation impinges on every aspect of our lives, photographic and video artist Candice Breitz uses her art to deal with themes of personal identity, cultural difference and ethnic variety. In her powerful montages, as politically committed as they are erratic, the white South African artist constantly draws disturbingly on the imagery of international pop culture. Typical of her strategy are photomontages like *Rainbow Series*, 1996. Here, Breitz follows the tradition of Surrealist collages, piecing together pornographic and ethnographic fragments to form images of the human body. For example, she fuses the upper body of a black woman with the pubic hair of a white porno-star to form a bewildering jigsaw, which is both a critique of the power of the exotic to arouse sexual desire and a comment on the impossibility of clearly delineated identity. Instead of showing the usual effect of globalisation, which is to obscure cultural differences, the artist here explicitly juxtaposes these differences to stress both their potential and their problems. In her video *Babel Series*, 1999, Breitz explores the tension between different languages. She recorded short sequences made up of a range of musical clips, in which artists like Madonna, Sting and Grace Jones sing brief sets of sounds like "da da da" or "pa pa pa" which she then spliced together into endless loops. A multilingual cacophony like something out of the Tower of Babel issues from seven monitors. The individual voices meld into a single one, underlining the total meaninglessness of what they are singing.

Die Foto- und Videokünstlerin Candice Breitz behandelt in ihrer Kunst vor allem Themen der subjektiven Identität, kulturellen Differenz und ethnografischen Vielfalt im Zeitalter einer in alle Lebensbereiche eingreifenden Globalisierung. In ihren eindringlichen, so engagierten wie erratischen Bildmontagen verfremdet die weiße Südafrikanerin immer wieder vorgefundenes Material aus der internationalen Welt der Populärkultur. Typisch für ihre künstlerische Strategie sind zum Beispiel die Fotomontagen aus *Rainbow Series*, 1996: Breitz hat hier in der Tradition surrealistischer Collagen pornografische und ethnografische Fragmente zu neuen körperähnlichen Gebilden zusammengesetzt. Schwarze Frauenoberkörper und die Schamhaare einer weißen Pornoakteurin etwa fügen sich zu einem verwirrenden Puzzle zusammen, das von der Erotisierung des Fremden genauso erzählt wie von der Unmöglichkeit einer ungebrochenen und stringenten Identität. Statt die Unterschiede verschiedener Kulturen, wie in der Globalisierung üblich, zu vertuschen, werden sie hier durch ihr direktes Aufeinandertreffen potenziert und zugleich problematisiert. Auch in ihrer Videoarbeit *Babel Series,* 1999, geht es Breitz um die Spannung zwischen unterschiedlichen Sprachen. Aus diversen Musikclips hat sie kurze Sequenzen entnommen, in denen zum Beispiel Madonna, Sting und Grace Jones kurze Lautfolgen wie „da da da" oder „pa pa pa" singen, und sie zu endlosen Loops zusammengeschnitten. Von sieben Monitoren erklingt ein babylonisches Sprachgewirr, dessen einzelne Stimmen nur eines verbindet: die absolute Sinnlosigkeit ihrer Aussage.

Dans son travail, la photographe et vidéaste Candice Breitz traite les thèmes de l'identité subjective, de la différence culturelle et de la diversité ethnographique à l'ère d'une mondialisation intervenant dans tous les domaines de la vie. Dans ses montages photographiques saisissants, aussi engagés qu'erratiques, l'Africaine du Sud de race blanche détourne sans cesse des matériaux trouvés issus de l'univers de la culture populaire à l'échelle planétaire. Un aspect caractéristique de sa stratégie apparaît notamment dans les photomontages des *Rainbow Series*, 1996, qui recomposent, à partir de fragments pornographiques et ethnographiques, des figures plus ou moins corporelles traitées dans la tradition surréaliste. Des torses de femmes noires et les poils pubiens d'une actrice porno noire y composent un puzzle troublant qui parle aussi bien de l'érotisation de l'étranger que de l'impossibilité de créer une identité homogène valide. Ici, plutôt que de gommer les différences entre les cultures, comme le fait constamment la globalisation, celles-ci sont au contraire accentuées et problématisées par leur collision. Dans une vidéo comme *Babel Series*, 1999, Breitz travaille sur la tension entre différentes langues. L'artiste a extrait de plusieurs clips vidéo de brèves séquences dans lesquelles Madonna, Sting ou Grace Jones chantent de courtes suites de sons comme « da da da » ou « pa pa pa », puis les a mises en boucle. Sept moniteurs diffusent dès lors un brouhaha proprement babylonien des langues, dans lequel les voix isolées sont uniquement liées par l'insignifiance absolue de leur message.

R. S.

SELECTED EXHIBITIONS →
1997 *2nd Johannesburg Biennale,* Cape Town, South Africa
1999 Rüdiger Schöttle Galerie, Munich, Germany; *Global Art 2000,* Museum Ludwig, Cologne, Germany **2000** Chicago Project Room, Chicago (IL), USA; Art & Public, Geneva, Switzerland; *Taipeh Biennale 2000,* Taipeh, Taiwan; *Kwangju Biennale,* Kwangju, South Korea
2001 Galleria Francesca Kaufmann, Milan, Italy; Kunstmuseum St. Gallen, Switzerland; *Tele(Visions),* Kunsthalle Wien, Vienna, Austria

SELECTED BIBLIOGRAPHY →
2000 *Die verletzte Diva,* Munich **2001** *Candice Breitz Cuttings,* Offenes Kulturhaus/Centrum für Gegenwartskunst Oberösterreich, Linz; *Monet – Ordnung und Obsession,* Hamburg

1 **Double Annie (Thorn In My Side),** 1985/2000; **Double Whitney (I Will Always Love You),** 1999/2000, DVD installation
2 **Ghost Series #10,** 1994–96, c-print, 69 x 102 cm
3 **Ghost Series #8,** 1994–96, c-print, 69 x 102 cm
4 Installation view, *Surrogate Portraits,* Johnen + Schöttle, Cologne, 1998
5 **Babel Series,** 1999, multi-channel DVD installation, installation view, New Museum of Contemporary Art, New York, 2000

„Der Ausdruck der Unterschiede, die an den Grenzen der Dinge wirksam werden, findet sein ästhetisches Gegenstück in der Fotomontage."

« L'expression de la différence que révèle la limite a son pendant esthétique dans le photomontage. »

"The expression of the differences created on the boundaries between things finds its aesthetic counterpart in photomontage."

2

3

4

5

Olaf Breuning

1970 born in Schaffhausen, Switzerland, lives and works in New York (NY), USA

Olaf Breuning works primarily with the media of photography, video, installations and performance. He uses the language of Hollywood films, the genre of historical paintings, he alludes to displays in department stores or to the visual strategies of advertising. Breuning mixes differing codes in his often opulently produced works, and designs almost surreal worlds of imagery while at the same time denying that there is a difference between kitsch and art, artificiality and authenticity, even between time-honoured historicity and post-modern actuality. A characteristic of Breuning's works is the powerful symbolism that attracts the viewer with its superficial narrative structure, but then the effect quickly dissipates, leaving behind a sense of emptiness. There is a great deal of drama in these shimmering inventions of images. One example is *Knights*, 2001, a photograph of five people of both sexes and various skin colours dressed in war-like suits of armour. Each suit of armour is from a different historical period – but who is the opponent, and why are these living museum pieces presented in such an artificial scene? In the photograph *Lara*, 1997, the artist turns to a contemporary icon of aggressive grace, namely the heroine in the video game Lara Croft. But Breuning offers us a cheap copy of the superwoman: instead of splendour and perfection, what we have here is a cheap T-shirt, an electric drill in her hand and a rucksack on her back, striking something of a ludicrous note. And yet the picture insinuates itself cleverly into the day-to-day current of media images, whose mystery lies in their very banality.

Olaf Breuning arbeitet vor allem mit den Medien Fotografie, Video, Installation und Performance. Dabei greift er die Sprache des Hollywood-Films genauso auf wie das Genre der Historienmalerei, spielt an auf Displays in Kaufhäusern oder auf die visuellen Strategien der Werbung. So mixt Breuning in seinen oftmals opulent ausgestatteten Werken differierende Codes, inszeniert fast schon surreale Bildwelten und leugnet dabei jedweden Unterschied von Kitsch und Kunst, von Künstlichkeit und Authentizität, von altehrwürdiger Geschichtlichkeit und post-moderner Aktualität. Ausschlaggebend ist in den Arbeiten von Breuning eine überschäumende Symbolkraft, die mit ihrer vordergründigen Erzählstruktur den Betrachter sofort fasziniert, dann aber schnell in der Leere eines fehlenden Sinns zurücklässt. Dramatisch also geht es zu in diesen schillernden Bilderfindungen, etwa in *Knights*, 2001, einem Foto, auf dem fünf Menschen beiderlei Geschlechts und unterschiedlicher Hautfarbe in martialischen Ritterrüstungen zu sehen sind. Jede Rüstung stammt aus einer anderen historischen Epoche – doch wer ist hier der Gegner, zu welchem Zweck präsentieren sich die lebendigen Museumsstücke im Kunstraum? In dem Foto *Lara*, 1997, widmet sich der Künstler einer aktuellen Ikone kämpferischer Grazie, der Hauptfigur des Videospiels Lara Croft nämlich. Breuning präsentiert uns gleichsam eine billige Kopie der Superfrau: Statt Glanz und Perfektion geben hier ein billiges T-Shirt, ein elektrischer Bohrer in der Hand von Lara und ein Rucksack auf ihrem Rücken den fast schon lächerlichen Ton an. Und doch schleust sich das Bild geschickt ein in den alltäglichen Strom medialer Bilder, deren Rätselhaftigkeit gerade in ihrer Banalität liegt.

Olaf Breuning travaille essentiellement comme photographe, vidéaste, installateur et performer. Dans ces médias, il fait appel tout aussi bien au langage du film hollywoodien qu'à la peinture d'histoire, et se réfère aux affichages électroniques des grands magasins comme aux stratégies visuelles de la publicité. Dans ses œuvres d'une profusion souvent débordante, Breuning procède à un mixage des codes les plus divers, mettant en scène des univers quasi surréalistes et niant pour cela toute forme de différence entre le kitsch et l'art, entre l'artificiel et l'authentique, mais aussi entre une historicité respectable et une actualité empreinte de postmodernisme. Ce qui est déterminant pour son travail, c'est avant tout le débordement de la puissance symbolique, dont la trame narrative superficielle fascine d'emblée le spectateur avant de l'abandonner bientôt dans l'inanité du manque de sens. Ainsi, ces inventions iconiques hautes en couleurs présentent une action souvent dramatique, comme on le voit dans *Knights*, 2001, un photographie qui montre cinq êtres humains de sexe et de couleur de peau différents, aux allures passablement martiales dans leurs armures de chevaliers. Si chaque armure appartient à une époque historique différente, on s'interroge néanmoins sur l'identité de l'adversaire, et sur les raisons pour lesquelles ces pièces de musée vivantes se présentent dans l'espace artistique ? Dans la photographie *Lara*, 1997, l'artiste se consacre à une icône actuelle de la grâce guerrière, l'héroïne du jeu vidéo Lara Croft. Breuning nous présente en quelque sorte une copie bon marché de la superwoman : au lieu de l'éclat et de la perfection, Lara Croft apparaît en T-shirt bon marché, une perceuse électrique à la main et un sac à dos, cet accoutrement confinant au ridicule. Et malgré tout, cette image s'insère habilement dans le grand courant des images médiatiques dont l'énigme réside précisément dans la banalité. R. S.

SELECTED EXHIBITIONS →
1998 *Woodworld*, Kunsthaus Glarus, Switzerland **1999** *They live!*, ars Futura Galerie, Zurich, Switzerland; *DACH*, Galerie Krinzinger, Vienna, Austria; *Young*, Fotomuseum, Winterthur, Switzerland **2000** *Reality Bites*, Kunsthalle Nürnberg, Nuremberg, Germany; *Vis-à-Vis*, Kunsthaus Zürich, Zurich, Switzerland **2001** Artspace, Auckland, Australia; Metro Pictures, New York (NY), USA; Galerie Air de Paris, Paris, France; *More than one*, Andrea Rosen Gallery, New York (NY), USA

SELECTED BIBLIOGRAPHY →
2000 *Reality Bites*, Nuremberg **2001** Galerie Air de Paris, Paris; *Olaf Breuning, Ugly*, Ostfildern-Ruit

„Hüte dich vor mir, ich bin obdachlos."

« Méfiez-vous de moi, je suis SDF. »

"Don't trust me, I'm homeless."

2

3

4

Glenn Brown

1966 born in Hexham, lives and works in London, UK

Some contemporary artists recognise an attitude in the art of the Surrealist movement that seems completely relevant today, and this is an opinion that Glenn Brown presumably agrees with. Frank Auerbach meets Salvador Dalí in his canvases, since Brown has appropriated their works indiscriminately from photographs. Brown "presents" painting, he gives new life to a historic practice, and at the same time he infiltrates it when he paints what look like photographic replicas of the works of other artists. He takes his references from the élite sphere of high art as well as the user-friendly mainstream and easily blends sources from different centuries in his paintings. His smooth, flat representations of works by famous colleagues raise the issues of authorship, authenticity and originality. His works are not exact replicas of famous paintings by Fragonard, Rembrandt, van Gogh or de Kooning. He carefully manipulates them: colours are heightened, certain details added or subtracted, and crucially, any texture is wiped away in favour of a closed surface that is as unremittingly flat as a photograph. Brown eliminates any trace of his own hand and cites contexts beyond the pictures themselves. His version of a Fragonard, for example, is called *Disco*, 1997/98; a Rembrandt portrait is entitled *I Lost my Heart to a Star Ship Trooper*, 1996. Science fiction livens up many of his paintings. Floating asteroids and futuristic cities are enlarged to an epic scale and found in paintings such as *The Tragic Conversion of Salvador Dalí (after John Martin)*, 1998. Here, Brown re-works the style of 19th-century painter John Martin with elements of Chris Foss, a popular sci-fi illustrator. And the message the viewer takes away is that great visions require great gestures.

In der Kunst des Surrealismus erkennen manche Zeitgenossen eine der Jetztzeit verwandte Geisteshaltung – eine Sichtweise, der der englische Maler Glenn Brown vermutlich zustimmen würde. Auf seinen Leinwänden treffen Frank Auerbach und Salvador Dalí aufeinander, deren Werke sich Brown unterschiedslos nach fotografischen Vorlagen aneignet. Brown präsentiert Malerei: Er belebt die historische Praxis und unterwandert sie zugleich, wenn er fotorealistische Bilder nach den Vorlagen anderer Künstler malt. Er findet seine Referenzen in der elitären Hochkunst wie im publikumsnahen Mainstream und mixt mühelos Jahrhunderte. Seine glatten, flachen Darstellungen von Arbeiten berühmter Kollegen stellen die Frage nach Autorschaft, Authentizität und Originalität. Seine Arbeiten sind keine exakten Kopien der berühmten Arbeiten von Fragonard, Rembrandt, van Gogh oder de Kooning. Er hat sie sorgfältig manipuliert: Farben wurden aufgehellt, bestimmte Details hinzugefügt oder entfernt, und vor allem ist jede Textur weggewischt zugunsten einer geschlossenen Oberfläche, gleichförmig wie eine Fotografie. Brown eliminiert jede Spur einer eigenen Handschrift und verweist auf Zusammenhänge, die den Rahmen des Bildes verlassen. Seine Version eines Fragonard heißt beispielsweise *Disco*, 1997/98, ein Rembrandt-Porträt *I Lost my Heart to a Star Ship Trooper*, 1996. Sciencefiction belebt einen Großteil seiner Gemälde. Flottierende Asteroide und futuristische Städte sind zu einem epischen Maß aufgeblasen in Bildern wie *The Tragic Conversion of Salvador Dalí (after John Martin)* von 1998, in dem Brown den Stil des Malers John Martin aus dem 19. Jahrhundert mit dem des aktuell populären Sciencefiction-Illustrators Chris Foss mischt. Große Visionen brauchen große Gesten, sagen die Bilder von Brown.

Certains contemporains identifient dans l'art surréaliste une attitude apparentée à celle de notre époque – un regard auquel le peintre anglais Glenn Brown ne manquerait sans doute pas de souscrire. Dans ses toiles, on assiste à la rencontre entre Frank Auerbach et Salvador Dalí, dont Brown s'approprie les œuvres inchangées à partir de photographies. Brown présente de la peinture. En peignant des tableaux photoréalistes d'après les modèles proposés par d'autres artistes, il donne vie à la pratique historique tout en la minant. Il puise ses références aussi bien dans un art élitiste que dans le courant populaire dominant et mélange les siècles avec aisance. Ses représentations planes et léchées des œuvres de collègues célèbres reposent la question de l'auteur, de l'authenticité et de l'originalité. Ses œuvres ne sont pas les copies exactes de peintures célèbres de Fragonard, de Rembrandt, de van Gogh ou de de Kooning. Elles sont soigneusement manipulées par l'artiste : les couleurs ont été rehaussées, certains détails ont été ajoutés ou supprimés, et surtout, toute texture a été supprimée au profit d'une surface hermétique, uniforme comme une photographie. Brown fait disparaître toute trace d'écriture personnelle et fait référence à des contextes extra-picturaux. Ainsi, sa version d'un Fragonard s'appelle *Disco*, 1997/98, un portrait de Rembrandt est intitulé *I Lost my Heart to a Star Ship Trooper*, 1996. La science-fiction anime une grande partie de ses peintures. Des astéroïdes flottants et des villes futuristes sont amplifiées jusqu'à l'épique dans des tableaux comme *The Tragic Conversion of Salvador Dalí (after John Martin)*, 1998, dans lequel Brown mélange le style de John Martin, un peintre du 19ème siècle, avec celui de l'illustrateur de science-fiction contemporain Chris Foss. Comme le disent les tableaux de Brown, les grandes visions requièrent de grandes poses.

F. F.

1

SELECTED EXHIBITIONS →
1994 *Here and Now*, Serpentine Gallery, London, UK **1995** *Brilliant!*, Walker Art Center, Minneapolis (MN), USA **1997** *Sensation*, Royal Academy of Arts, London, UK **1998** Patrick Painter Inc., Los Angeles (CA), USA **1999** *Examining Pictures: Exhibiting Paintings*, Whitechapel Art Gallery, London, UK **2000** *The British Art Show 5*, Hayward Gallery, London, UK; *Hypermental*, Hamburger Kunsthalle, Hamburg, Germany **2001** Patrick Painter Inc., Los Angeles; Galerie Max Hetzler, Berlin, Germany **2002** *Biennale of Sydney*, Australia

SELECTED BIBLIOGRAPHY →
1997 *Glenn Brown*, Queens Hall Arts Centre, Hexham **2000** *Glenn Brown*, Centre d'Art Contemporain du Domaine de Kerguéhennec, Bignan

1 **Joseph Beuys,** 2001, oil on panel, 96 x 80 cm
2 Installation view, Domaine de Kerguéhennec, France, 2000;
left to right: **Jesus; The Living Dead (after Adolf Schaller),** 1998, oil on canvas; **The Andromeda Strain,** 2000, oil and acrylic paint on plaster; **Böcklin's Tomb (after Chris Foss),** 1998, oil on canvas

3 **Little Deaths,** 2000, oil on panel, 68 x 54 cm
4 **Life without Comedy,** 2001, oil on panel, 69 x 53 cm
5 **It's a Curse It's a Burden,** 2001, oil on panel, 105 x 75 cm

„Ich wähle Künstler aus, die mir gefallen und meiner Ansicht nach nicht genügend Anerkennung finden."

« Je choisis des artistes que j'aime et ceux que je considère sous-estimés. »

"I pick artists I like and those that I feel aren't given enough credit."

2

3

4

5

Daniele Buetti

1956 born in Fribourg, Switzerland, lives in Berlin, Germany, and Zurich, Switzerland

Beautiful surfaces just ask to be touched. This is precisely what Daniele Buetti does to the faces of stunningly beautiful women in fashion and lifestyle magazines. Applying a ballpoint pen to the back of the page, he literally brings them back to life, aggressively scrawling patterns on the back of the image and making holes like scars, simultaneously wounding and beautifying the gorgeous surface like a tattoo artist. Instead of worshipping the images from afar, Buetti's aesthetic master plan brings him up close and personal. The seductive world of pop glamour, alluring advertising messages and sensual eroticism is also reflected in Buetti's almost endlessly repetitive, multicoloured installations. Monochrome light boxes appear alongside provocative nudes; hand-written slogans like "I dream of you" and "Trust me" hang next to cheekily manipulated cornflakes packets. Music and videos create enchanting media overkill. Private pipe-dreams and common aspirations are subjected to a stylish, postmodern critique in highly attractive artistic form, skilfully linking narcissistic longing with romantic utopianism. Buetti never loses sight of the perils of this seemingly ingenuous imagery, whose obvious artistry also betrays the wholly commercial character of this kind of beauty. Hence the name of General Electric inscribed on the walls of the installation *Could a dream be enough*, 1999, and the self-critical question "Why should I change my attitude?" written on the photo of a model in the same work.

Schöne Oberflächen wollen angefasst werden. Die Gesichter der traumhaften Beauties aus Modezeitungen und Lifestyle-Magazinen hat Daniele Buetti tatsächlich berührt: Mit seinem Kugelschreiber rückt er ihnen auf ihrer Rückseite buchstäblich zu Leibe und fügt ihnen aggressiv kritzelnd Wülste und Löcher zu, Narben gleichsam, die den auratischen Schein verletzen und zugleich ornamental schmücken wie Tätowierungen. Statt distanzierter Vergötterung steht bei Buetti nämlich hautnahe Verehrung auf dem ästhetischen Masterplan. Die verführerischen Welten von poppigem Glamour, lockenden Werbebotschaften und erotischer Sinnlichkeit spiegelt Buetti in seinen kunterbunten Rauminstallationen in beinahe unendlicher Wiederkehr. Monochrome Leuchtkästen stehen da neben aufreizenden Akten, handgeschriebene Slogans wie „I dream of you" oder „trust me" hängen neben frech bearbeiteten Cornflakes-Packungen. Musik und Videos sorgen endgültig für einen charmanten medialen Overkill. Individuelle Wünsche und populäre Begierden bekommen hier im Zeichen postmoderner Zitat- und Stilkultur eine künstlerische, überaus attraktive Form. Dabei verschränken sich geschickt narzisstische Sehnsüchte und romantische Utopien. Die Gefährdungen dieser „gefühlsechten" Stimmungslage geraten Buetti aber nie aus dem Blickwinkel, denn die offensichtliche Künstlichkeit offenbart sogleich den absoluten Warencharakter dieser Art von Schönheit. Darum auch ist der Firmenname „General Electric" an die Wände der Installation *Could a dream be enough*, 1999, geschrieben und ist die selbstkritische Frage „Why should I change my attitude" in der gleichen Arbeit auf dem Foto eines Models zu lesen.

Les belles surfaces veulent être touchées. Daniele Buetti touche très concrètement les visages des beautés de rêve des revues de mode et de style : au stylo-bille, il s'en prend concrètement à leur apparence et leur inflige agressivement toutes sortes de perforations et de boursouflures, cicatrices qui malmènent leur apparence auratique et les affublent en même temps de décors ornementaux évoquant des tatouages. Plutôt qu'une divinisation distancée, ce qui mobilise l'intérêt esthétique de Buetti, c'est une admiration littéralement épidermique de ses modèles. Dans ses installations hautes en couleur, Buetti traduit les mondes séduisants du glamour huppé, les messages publicitaires affriolants et la volupté érotique, sous la forme d'un – presque – éternel retour. Des caissons électroluminescents s'y dressent tout à côté de nus aguichants, des slogans écrits à la main – « I dream of you », « trust me » – s'affichent à côté d'emballages de corn-flakes insolement retravaillés, tandis que la musique et la vidéo distillent une ultime overdose de séduction médiatique. Sous le signe de la culture postmoderne du mélange des styles et des citations, les désirs individuels et les convoitises populaires sont soumis à un traitement artistique formidablement attrayant qui mêle habilement nostalgie narcissique et utopies romantiques. Mais les menaces qui pèsent sur ces ambiances de « sentiment authentique » demeurent toujours présentes à l'esprit de Buetti, car le caractère ostensiblement artificiel manifeste dans un même temps la nature commerciale de ce type de beauté. C'est pour cette raison qu'on trouve sur les murs de l'installation *Could a dream be enough*, 1999, un logo comme « General Electric », et que dans ce même travail, la question autocritique « Why should I change my attitude » apparaît à même la photographie d'un top-model.

R. S.

SELECTED EXHIBITIONS →
1996 Galerie ars Futura, Zurich, Switzerland **1997** ACE Gallery, Los Angeles (CA), USA; *5th Istanbul Biennale*, Istanbul, Turkey; *Places to stay*, Büro Fiedrich, Berlin, Germany **1998** Kunstverein Ulm, Germany; *Freie Sicht aufs Mittelmeer*, Kunsthalle Zürich, Zurich, Switzerland **1999** Museumsakademie Berlin, Germany; Espai Lucas, Valencia, Spain **2000** *Reality Bytes*, Kunsthalle Nürnberg, Nuremberg, Germany; *Unhoused*, Museo de Arte Contemporáneo, Mexico City, Mexico

SELECTED BIBLIOGRAPHY →
1999 *Peace*, Migros Museum für Gegenwartskunst, Zurich
2000 *Close up*, Kunstverein Freiburg

1 **Bulgari,** 1996–98, altered photograph, 180 x 120 cm
2 **Nike,** 1996–98, altered photograph, 120 x 180 cm
3 **Looking for Love,** 1995–98, altered photographs, partly on aluminium, 300 x 420 x 75 cm, installation view, *Life Style,* Kunsthaus Bregenz, 1998
4 **Looking for Love,** 1997, pinboard, altered photographs and drawings, 25 parts, 160 x 190 cm

5 **Just one more,** 1999/2000, wood framework, tables, polystyrene, neon lights, torches, perforated photographs, colour foils, text images, poinsettias, videos, 4.50 x 12 x 10 m, installation view, *Peace,* Migros Museum für Gegenwartskunst, Zurich

„Erhöht das Gefühl, dass das Leben zu kurz ist, die Intensität und Leidenschaft für das Leben in wünschenswerter Weise?"

« Le sentiment que la vie est trop courte accroît-il de manière souhaitable l'intensité et la passion de vivre ? »

"Does feeling that life is too short increase the intensity and passion of it in a desirable way?"

2

3

4

5

Angela Bulloch

1966 born in Fort Frances, Canada, lives and works in London, UK, and Berlin, Germany

Angela Bulloch creates binary systems in space, which operate on the "on-off" principle. For example, with *Video Sound Systems*, 1997, when the viewer sits on the "sound clash bench" to watch the monitor, the pressure on the seat turns the sound on. In *Betaville*, 1994, a "drawing machine" tracing vertical lines switches to horizontal ones, while the viewer is seated in front of it. Bulloch's understanding of participation is based on the perception of the viewer as a social being, who radiates physical impulses, and on the behaviourist concept of stimulus and response. In her *Rules Series* – sets of rules of how to behave in specific situations which are mounted on the wall or on display panels – she is also exploring patterns of social behaviour in the context of institutional power structures. The new complex of pixel works uses digitally controlled light boxes to probe the interactive relations between the production and reception of visual images. In her *Prototypes* series, she stacks specially created pixel monitors in 50 x 50 x 50 cm format, which light up in the 16 million colours of an 8-bit monitor. Some of Bulloch's work reflects her interest in theories of how the electronic media affect ways of seeing. For example, for *BLOW UP T. V.*, 2000, she uses a brief still from Michelangelo Antonioni's film "Blow Up", reducing the resolution to 17 pixels. The scenes that appear on the monitors become completely unrecognisable. Here, she is referring to the possibilities of changing perception through technological means and the way in which the act of enlarging an image can both reveal and conceal its content.

Angela Bulloch schafft binäre Systeme im Raum, die nach dem Prinzip von „on" und „off" funktionieren. So schaltet sich beim Setzen auf die „sound clash benches" der Ton zu dem auf einem Monitor gezeigten Video ein (*Video Sound Systems*, 1997), oder eine „drawing machine" wird in Gang gesetzt, deren sonst senkrechte Linienführung während der Sitzdauer waagerecht verläuft (*Betaville*, 1994). Bullochs Verständnis von Partizipation beruht darauf, dass der Betrachter ein soziales Subjekt ist. Er gibt physische Impulse, die dem aus der Verhaltenspsychologie bekannten behavioristischen Muster von Reiz und Reaktion folgen. In ihren *Rules Series* – ortsbezogenen Verhaltensregeln, die auf der Wand oder auf Displays angebracht sind – untersucht Bulloch soziale Verhaltensmuster auch im Hinblick auf institutionelle Machtstrukturen. Der neue Werkkomplex der Pixel-Arbeiten untersucht die Wechselwirkung von Bildproduktion und Bildrezeption anhand digital gesteuerter Lichtkästen. In der *Prototypes* betitelten Serie stapelt sie eigens entwickelte Pixel-Boxen im Format 50 x 50 x 50 cm, die in 16 Millionen Farben eines 8-Bit-Monitors aufleuchten. Darüber hinaus lassen einige Arbeiten durch ein theoretisches Interesse am Einfluss elektronischer Medien auf das Sehen schließen. So reduziert Bulloch in *BLOW UP T. V.*, 2000, eine kurze Einstellung aus dem Film „Blow Up" von Michelangelo Antonioni auf 17 Pixel. Von der ursprünglichen Szene ist auf den Monitoren nichts mehr zu erkennen. Damit bezieht sie sich auf die technischen Möglichkeiten des Erkennens, die durch Vergrößerung sowohl aufdecken als auch verschleiern können.

Angela Bulloch crée dans l'espace des systèmes binaires qui fonctionnent sur le principe « Marche/Arrêt ». Le fait de s'asseoir sur un de ses bancs appelés « sound clash benches », déclenche le son de la vidéo qu'on voit passer sur un moniteur (*Video Sound Systems*, 1997) ; ou bien une « drawing machine » qui dessinait des lignes horizontales, se met à dessiner des traits verticaux tout le temps que le spectateur reste assis devant elle (*Betaville*, 1994). La manière dont Bulloch conçoit la participation du spectateur repose sur le fait que le spectateur est conçu avant tout comme un sujet social. Celui-ci fournit des impulsions physiques qui suivent le schéma « stimulus/réponse » tel qu'on le connaît de la psychologie behaviouriste. La nouvelle série des travaux à pixels explore l'interaction de la production de l'image et de sa réception à l'aide de caissons lumineux à commande numérique. Dans sa série *Prototypes*, Bulloch empile des moniteurs à pixels conçus par ses soins, de format 50 x 50 x 50 cm, qui s'allument dans les 16 millions de couleurs d'un moniteur de 8-Bit. Dans certaines œuvres, l'intérêt théorique porté sur l'influence des médias électroniques renvoie au regard. Pour *BLOW UP T. V.*, 2000, Bulloch se sert d'un bref passage du film « Blow up » de Michelangelo Antonioni, dont la résolution a été réduite à 17 pixels. La scène initiale n'est plus identifiable à l'écran. Bulloch se réfère ainsi aux possibilités technologiques de la connaissance, où l'agrandissement peut aussi bien révéler que voiler. N. M.

SELECTED EXHIBITIONS →
1993 *Aperto, 45. Biennale di Venezia*, Venice, Italy **1996** *Traffic*, capcMusée d'Art Contemporain, Bordeaux, France **1997** *Vehicles*, Le Consortium, Centre d'Art Contemporain, Dijon, France **1998** *Superstructure*, Museum für Gegenwartskunst Zürich, Zurich, Switzerland **2000** *Sonic Boom – The Art of Sound*, Hayward Gallery, London, UK **2002** *Claude Monet…bis zum digitalen Impressionismus*, Fondation Beyeler, Basle, Switzerland; *Ann Lee*, Kunsthalle Zürich, Zurich, Switzerland

SELECTED BIBLIOGRAPHY →
1994 *Angela Bulloch*, Fonds régional d'art contemporain Languedoc-Roussillon, Montpellier/Kunstverein in Hamburg **1998** *Satellite – Angela Bulloch*, Museum für Gegenwartskunst, Zurich **2000** *Angela Bulloch – Rule Book*, London **2001** Uta Grosenick (ed.), *Women Artists*, Cologne; *Angela Bulloch – Z Point*, Kunsthaus Glarus

EARTH FIRST

1. Learn how to agitate – successful movements like the Civil Rights movement, trade unions etc., spent lots of time out in communities talking to people and offering solutions

2. Remember 'the earth is not dying, it is being murdered and the people murdering it have names and addresses

3. Create a movement that people want to join and stay in We need to create a system that reduces our dependency on capitalism and destabilises it. By working closer with LETS schemes etc., we could create a parallel economy that would make the capitalist one irrelevant

4. Counteract the media backlash by pointing out our successes more.

5. Criminal damage must be talked about! You don't have to say you do it, but always say that it is understandable, given people's frustrations Sometimes it is inappropriate and we have to have the intelligence to know when this is.

6. Learn from current 'successful' organisations like The Land is Ours and Friends of the Earth, who score by being well connected, wealthy and strategic. But let's not allow them to set the agenda – use their networks and work with them on local issues

7. Should EF! develop itself? A difficult one this. We are, by nature and necessity, shy of centralised structures, but could we do with a little more centralisation for fund-raising, resource gathering, concentrated outreach, access to expertise, etc?....

Think About It!

1 **Earth First,** 2000, installation view, Kokerei Zollverein, Essen, 2001
2 **Prototypes,** 2000, installation view, Galerie Hauser & Wirth & Presenhuber, Zurich

3 **Codes,** 1998, installation view, Schipper & Krome, Berlin

„Manche Werke hören auch nach ihrer Realisierung nicht auf, sich weiter-zuentwickeln, weil in ihnen bereits ein Element der Veränderung angelegt ist beziehungsweise ein Potenzial, das solche Prozesse ermöglicht."

« Les travaux continuent souvent à évoluer après avoir été réalisés pour la simple raison qu'ils sont conçus avec un élément de changement ou un potentiel inhérent de modifications qui peuvent survenir. »

"The works often continue to evolve after they have been realised, simply by the fact that they are conceived with an element of change, or an inherent potential for some kind of shift to occur."

2

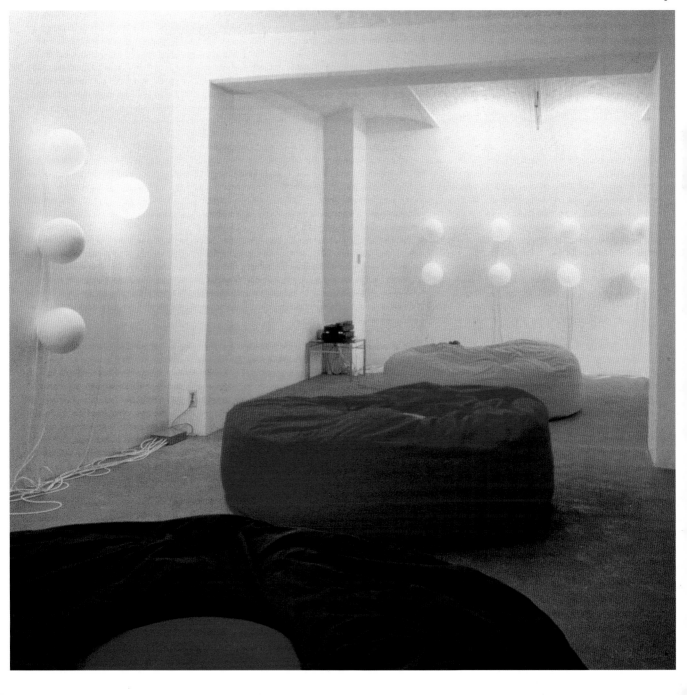

Janet Cardiff

1957 born in Brussels, Canada, lives and works in Berlin, Germany

Janet Cardiff uses sound to heighten and alter individuals' experiences of space and time. She is interested in the ways our surroundings are perceived and memories are represented. In her site-specific *Walks* she layers recordings of her voice and audio effects, simultaneously delivering a narrative and guiding visitors on a predetermined path. Using binaural recording, Cardiff creates lifelike representations of sounds that can be perceived three-dimensionally. These pieces, which play on personal CD players, benefit from the portable technology of Discmans, which allows listeners to be enveloped by sound and block out their surroundings while walking around, thus existing in a self-contained realm. Cardiff integrated images into the sound work in her *Walk* for the 1999/2000 *Carnegie International*. She used handheld digital video recorders to enable individuals to view the piece's route and take part in the story on miniature screens. In *The Paradise Institute*, 2001, a collaboration with George Bures Miller for the *Venice Biennale*, she constructed a small-scale theatre fitted with seats and a screen on which their film played. The soundtrack, which was recorded using the binaural technique and played through individual headphones, mixed multiple story lines: the realms of the filmic space, constructed theatre space, and actual real-time experiences converge. The power of Cardiff's work lies in the intersection of various realities as well as her ability to build and deliver multi-layered and provocative narratives.

Janet Cardiff verwendet Klangmaterial, um unsere Raum- und Zeiterfahrung zu verändern und zu vertiefen. Sie interessiert sich dafür, wie wir unsere Umgebung wahrnehmen und unsere Erinnerungen wiedergeben. In ihren standortspezifischen *Walks* schneidet sie Aufnahmen ihrer Stimme und andere Audioeffekte übereinander. So erzählt sie zugleich eine Geschichte und leitet den Besucher auf einen festgelegten Pfad. Dank zweikanaliger Aufnahmeverfahren gelingt es Cardiff, lebensnahe Tonaufzeichnungen zu machen, die sich dreidimensional wahrnehmen lassen. Die Arbeiten sind auf CD festgehalten und werden über tragbare Discmans abgespielt, so dass der „Zuhörer" sich – durch Umgebungsgeräusche ungestört – in einer Klangwolke fortbewegen kann und sich in eine selbstgenügsame kleine Welt versetzt fühlt. Cardiff hat in ihre Klangwerke auch Bilder integriert, so in der Arbeit *Walk*, die sie für die Ausstellung *Carnegie International* 1999/2000 geschaffen hat. Dabei hat sie digitale Videorekorder verwendet, damit der Betrachter sich einen Eindruck von der Route verschaffen und die Geschichte auf Minibildschirmen verfolgen konnte. Für die Arbeit *The Paradise Institute*, 2001, entstanden in Zusammenarbeit mit George Bures Miller für die *Biennale* in Venedig, hat sie ein mit Sitzen und einer Leinwand ausgestattetes kleinformatiges (Film-)Theater entworfen. Der Zweikanalton des hier aufgeführten Films wurde den Zuschauern per Kopfhörer individuell zugespielt. Auf der Tonspur waren verschiedene Vorgänge zugleich gespeichert: So verschmolzen der filmische Raum, der künstlich konstruierte Theaterraum und konkrete Echtzeiterfahrungen zu einer unauflöslichen Einheit. Die Kraft von Cardiffs Arbeiten liegt zum einen in der Überschneidung ganz unterschiedlicher Realitäten, zum anderen in ihrer Fähigkeit, vielschichtige und provozierende Erzählungen zu entwickeln und vorzuführen.

Janet Cardiff se sert des sons pour renforcer et altérer les expériences individuelles d'espace et de temps. Elle s'intéresse aux manières dont nous percevons notre environnement et dont les souvenirs sont représentés. Sur ses *Walks* (Promenades) créées en fonction de chaque site, elle associe des enregistrements de sa voix et des effets sonores, racontant une histoire tout en guidant les visiteurs sur un chemin prédéterminé. Utilisant un enregistrement binaural, Cardiff crée des représentations réalistes qui peuvent être perçues de manière tridimensionnelle. Ces pièces, qui s'écoutent sur des lecteurs de CD personnels, bénéficient de la technologie portable Discmans, qui permet à chacun d'être enveloppé par le son tout en se déplaçant, oubliant son environnement en étant plongé dans une sphère autonome. Dans son *Walk* pour 1999/2000 *Carnegie International*, Cardiff a intégré des images dans son travail sonore : elle a utilisé de petits caméscopes numériques qui permettent aux visiteurs de voir l'itinéraire de l'œuvre et de participer à l'histoire par l'intermédiaire d'écrans miniatures. Dans *The Paradise Institute*, 2001, une collaboration avec George Bures Miller pour la *Biennale* de Venise, elle a construit un petit théâtre équipé de sièges et d'un écran sur lequel était projeté leur film. La bande son, enregistrée avec la technique binaurale et diffusée dans des casques individuels, mélangeait plusieurs trames narratives : les domaines de l'espace filmique, l'espace théâtral construit et les expériences vécues en temps réel convergeaient. La puissance du travail de Cardiff se situe à l'intersection des différentes réalités ainsi que dans sa capacité à construire et présenter des narrations multicouches et provocantes.

Ro. S.

1

SELECTED EXHIBITIONS →
1997 *Skulptur. Projekte*, Münster, Germany **1998** *XXIV Bienal de São Paulo*, Brazil **1999** *London Walk*, Artangel, London, UK; *The Museum as Muse: Artists Reflect*, The Museum of Modern Art, New York (NY), USA; *Carnegie International*, Carnegie Museum of Art, Pittsburgh (PA), USA **2000** *Sleep Talking*, Kunstraum München, Munich, Germany; *Wonderland*, Saint Louis Art Museum, St. Louis (MS), USA **2001** Canadian Pavilion, *49. Biennale di Venezia*, Venice, Italy **2001** *010101*, San Francisco Museum of Modern Art (CA), USA

SELECTED BIBLIOGRAPHY →
1996 *NowHere*, Louisiana Museum of Modern Art, Humlebaek **1997** *Present Tense: Nine Artists in the Nineties*, San Francisco Museum of Modern Art (CA); Klaus Bußmann/Kasper König/Florian Matzner (eds.), *Skulptur. Projekte*, Münster **1999** *Carnegie International*, Carnegie Museum of Art, Pittsburgh (PA) **2000** Janet Cardiff/Kitty Scott, *Janet Cardiff: The Missing Voice (Case Study B)*, Artangel, London

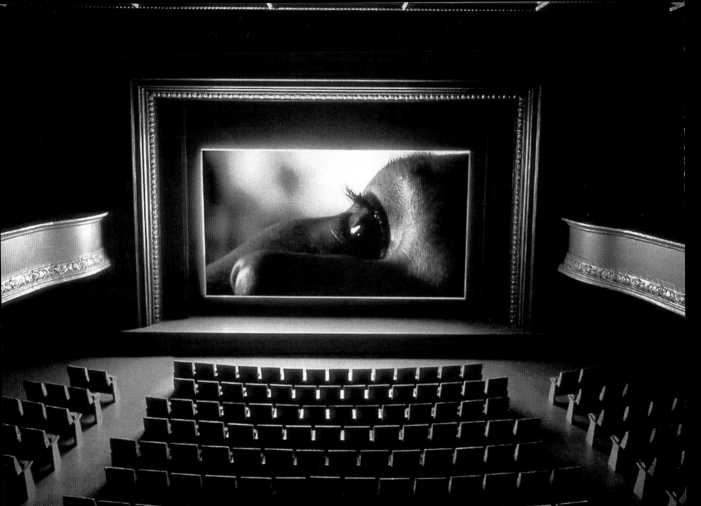

1 In collaboration with George Bures Miller:
 The Paradise Institute, 2001, audio, video, mixed media
2 **Forest Walk,** 1991, site-specific audio
3 **Louisiana Walk #14,** 1996, mixed media

4 In collaboration with George Bures Miller:
 The Dark Pool, 1996, wooden tables, chairs, loudspeakers, electronic
 equipment, various components and objects

„Ständig erreichen Klänge und Geräusche unser Ohr,
und wir lassen uns davon viel stärker beeinflussen, als uns bewusst ist."

« Le son nous affecte constamment et nous dépendons de lui
beaucoup plus qu'on ne le pense. »

"Sound affects us constantly and we rely on it much more than we realise."

2

3

Merlin Carpenter

1967 born in Pembury, lives in London, UK, and Berlin, Germany

Merlin Carpenter's approach to the medium of painting is deeply ambivalent. On the one hand, he produces meaningless paintings, alluding to the style of artists like Jackson Pollock and Julian Schnabel. On the other, he promotes what he calls the "de-subjectivisation of the brush stroke", with his hand-painted imitations of the aesthetics of computer graphics. In his exploration of what he has called "overdetermined imagery" and his quotations from everyday visual culture, such as fashion photography, Carpenter also reveals his own fascination with concepts like "beauty" and "perfection". In his exhibition *As a Painter I Call Myself the Estate Of*, 2000, he marked out the parallels and differences between art and non-artistic luxury items, by displaying a motor boat next to his pictures. Alongside his work as an artist, Carpenter is engaged in a range of other activities, all reflecting the social context in which art is created and his own position as an artist. These include writing texts, such as articles on painting for the periodical "Texte zur Kunst" and contributing to a catalogue for Michael Krebber – as well as taking part in joint ventures. In the 1990s Carpenter, Dan Mitchell, Nils Norman and others set up the experimental "Poster Studio" in London. From the outset it was only intended as a short-term initiative, in order to avoid monopolisation by any single medium. Its aims were to produce a critical analysis of the contemporary London art world and to encourage informal networking among artists.

Die Herangehensweise von Merlin Carpenter an das Medium Malerei zeugt von einer grundlegenden Ambivalenz: So verweisen seine Bilder in entleerender Absicht auf die Malstile von Künstlern wie Jackson Pollock oder Julian Schnabel. Dabei propagiert Carpenter eine „Entsubjektivierung des Pinselstrichs" (M. C.), etwa indem er manuell die Ästhetik von Computermalprogrammen imitiert. In seiner Auseinandersetzung mit überdeterminierten Positionen der Malerei, aber auch in seinen Zitaten der visuellen Alltagskultur wie Modefotografie, manifestiert Carpenter allerdings zugleich seine eigene Fasziniertheit von Wertbegriffen wie „Schönheit" und „Gelungenheit". Auf Differenzen und Parallelen zwischen Kunst und anderen, nicht-künstlerischen Luxusgütern spielte er in seiner Ausstellung *As a Painter I Call Myself the Estate Of*, 2000, an, indem er neben seinen Bildern auch ein Motorboot präsentierte. Seine künstlerische Produktion flankiert Carpenter mit einer Reihe paralleler Aktivitäten, die die gesellschaftlichen Voraussetzungen und Rahmenbedingungen von Kunst sowie seine eigene Position als Künstler reflektieren: Dazu gehört das Schreiben von Texten – zum Beispiel über Malerei in der Zeitschrift „Texte zur Kunst" oder ein Katalogbeitrag für Michael Krebber – ebenso wie seine Beteiligung an kollektiven Projekten. So gründete Carpenter Mitte der neunziger Jahre zusammen mit Dan Mitchell, Nils Norman und anderen den experimentellen Londoner Projektraum „Poster Studio": eine Initiative, die von vornherein als zeitlich befristet konzipiert war, um sie einer medialen Vereinnahmung möglichst zu entziehen. Ihre Ziele waren die kritische Analyse der damaligen Londoner Kunstwelt und die Förderung informeller Netzwerke.

La manière dont Merlin Carpenter approche le médium « peinture » ressort d'une ambiguïté fondamentale. Sous le signe de l'évidement sémantique, ses tableaux renvoient aux styles picturaux d'artistes comme Jackson Pollock ou Julian Schnabel. En même temps, Carpenter pratique une « désubjectivation du trait de pinceau » (M. C.), comme lorsqu'il imite l'esthétique « fait main » de certains programmes informatiques de peinture. Cela dit, dans son travail sur les positions surdéterminées de la peinture comme dans ses citations de la culture visuelle quotidienne – notamment de la photographie de mode –, Carpenter montre aussi sa propre fascination à l'égard de jugements de valeur comme « beau » et « réussi ». Dans l'exposition *As a Painter I Call Myself the Estate Of*, 2000, l'artiste mettait ainsi en évidence les différences et les similitudes entre l'art et les articles de luxe, présentant entre autres un canot à moteur à côté de ses peintures. La production artistique de Carpenter s'accompagne d'une série d'activités parallèles qui veulent donner un reflet des conditions sociales et du contexte de l'art, mais aussi de la propre position de l'artiste, activités parmi lesquelles on compte l'écriture de textes – comme celui sur la peinture paru dans la revue « Texte zur Kunst » ou la contribution à un catalogue de Michael Krebber –, mais aussi la participation à des projets collectifs. Au milieu des années 90, avec Dan Mitchell, Nils Norman et quelques autres, Carpenter créait ainsi à Londres l'espace expérimental « Poster Studio » – une initiative conçue dès le départ comme limitée dans le temps afin de la soustraire autant que possible à toute récupération médiatique. Les buts de ce collectif étaient l'analyse critique de la scène londonienne de l'époque et la revendication de réseaux informels. B. H.

SELECTED EXHIBITIONS →
1994 Friedrich Petzel/Nina Borgmann, New York (NY), USA; *Untitled Group Show*, Metro Pictures, New York (NY), USA **1998** *Chant No 1,* Galerie Max Hetzler, Berlin, Germany **1999** *Malerei*, INIT Kunsthalle, Berlin **2000** *As a Painter I Call Myself the Estate Of*, Wiener Secession, Vienna, Austria; *Girlfriend* (curated by Sarah Morris), Galerie für Zeitgenössische Kunst, Leipzig, Germany **2001** *My Father, the Castaway*, WhiteCube, Kunstakademi Bergen, Norway; *Jewels-in-Art*, Galerie Bleich-Rossi, Graz, Austria

SELECTED BIBLIOGRAPHY →
1993 Merlin Carpenter/Nils Norman, *Meet You by the Strange Twisted Old Oak Tree on the Secluded Knoll at Dawn in Your Swimming Trunks and I'll Tell You Something Secret (Don't Be Late)*, Galerie Z, Göttingen **1995** *Voluntary Effort*, Tom Solomon's Garage, Los Angeles (CA) **2000** *Merlin Carpenter. As a Painter I Call Myself the Estate Of*, Wiener Secession, Vienna

1 **When There's Nothing Inside But You,** 1999, oil on canvas, 183 x 140 cm 3 **The 14th Floor,** 1999, oil on canvas, 130 x 183 cm
2 Installation view, Galerie Max Hetzler, Berlin, 2000

„Für mich ist es so: Wenn eine Information handelbar ist, « Pour moi, si une information est commerciable,
ist sie es nicht wert, gehandelt zu werden." elle ne vaut pas la peine d'être commercialisée. »

"For me, if a piece of information can be traded then it's not worth trading."

2

Maurizio Cattelan

1960 born in Padova, Italy, lives and works in New York (NY), USA

Art is separate from reality, and it's possible to get away with more within its boundaries. This common opinion is challenged by artists who raise questions about the limits of artistic freedom and try to shake the rules that keep reality safe. One of Pier Paolo Pasolini's short films shows The Passion being shot by a mad film crew. An extra playing one of the criminals actually dies on the cross by accident; he starves to death when the rest of the crew forget to get him down from the cross because they are busy stuffing themselves. Maurizio Cattelan, the jester of the art world, makes a radical attempt to ridicule the principles on which the artist's smooth functioning in society is based. He selects the privileged – but also ambiguous – position of a notorious provocateur, in order to show the hypocritical customs that facilitate the soporific, steady flow of ideas and cash in the contemporary art world. A gallery owner fastened to a wall with adhesive tape (*A Perfect Day*, 1999); the Pope struck down by a meteorite (*La Nona Ora*, 1999); a praying little Hitler (*Him*, 2001); a squirrel that shoots itself with a gun (*Bidibidobidiboo*, 1996): the characters created by Cattelan are at the same time caricatured and tragic. Playing with the great icons of history and the heroes of everyday life, Cattelan follows a path once trodden by villains, conjurors and charlatans. Artists have too often sought refuge in the nimbus of their own art, lecturing and proclaiming like prophets.

Die Kunst ist von der Wirklichkeit verschieden und lässt innerhalb ihrer Grenzen größere Freiheiten zu. Dieser gängigen Meinung treten jene Künstler entgegen, die Fragen über die Grenzen der künstlerischen Freiheit aufwerfen und gegen die Abschottung zwischen Kunst und Realität rebellieren. In einem von Pier Paolo Pasolinis Kurzfilmen ist ein verrücktes Filmteam zu sehen, das die Passion Christi verfilmt. Dabei kommt versehentlich ein Statist zu Tode, der einen der beiden Schächer darstellt. Der Mann verhungert, weil die übrigen Mitarbeiter des Teams ihn versehentlich am Kreuz hängen lassen, während sie sich den Bauch vollschlagen. Ganz ähnlich unternimmt auch Maurizio Cattelan, der Spaßvogel der Kunstszene, den radikalen Versuch, die Prinzipien, von denen das reibungslose Funktionieren des Künstlers in der Gesellschaft abhängt, der Lächerlichkeit preiszugeben. Er stellt sich auf den ebenso privilegierten – wie ambivalenten – Standpunkt des notorischen Provokateurs und versucht die heuchlerischen Mechanismen sichtbar zu machen, die in der heutigen Kunstszene einen ebenso gleichmäßigen wie einschläfernden Fluss der Ideen gewährleisten. Ein Galerist, der mit Klebeband an einer Wand fixiert ist (*A Perfect Day*, 1999); der von einem Meteoriten getroffene Papst (*La Nona Ora*, 1999), ein betender kleiner Hitler (*Him*, 2001), ein Eichhörnchen (*Bidibidobidiboo*, 1996), das sich selbst erschießt: Die Figuren, die Cattelan kreiert, sind zugleich karikaturistisch überzeichnet und tragisch. Er spielt mit den großen Ikonen der Geschichte und den Heroen des Alltagslebens und verfolgt dabei einen Weg, auf dem früher nur Schurken, Verschwörer und Scharlatane anzutreffen waren. Nach seiner Auffassung haben sich die Künstler bisher zu häufig hinter dem Nimbus ihrer Kunst verborgen und sich in der Pose des Propheten und des Predigers gefallen.

L'art est séparé de la réalité. A l'intérieur de ses frontières, on peut aller plus loin. Cette opinion très répandue est contestée par des artistes qui remettent en question les limites de la liberté artistique et tentent de dépoussiérer les règles qui préservent la réalité du danger. Dans un court métrage, Pier Paolo Pasolini montre La Passion filmée par une équipe de fous. Un figurant jouant un des larrons meurt sur la croix pendant le tournage: l'équipe l'a oublié et l'a laissé littéralement mourir d'inanition pendant qu'elle s'empiffrait. Maurizio Cattelan, le bouffon du monde de l'art, fait une tentative radicale pour ridiculiser les principes sur lesquels l'artiste opère sans heurts dans la société. Il a choisi la position privilégiée – mais également ambiguë – de provocateur notoire afin de dénoncer les mœurs hypocrites qui facilitent le flux soporifique et régulier d'idées et de liquidités dans le monde de l'art contemporain. Un propriétaire de galerie scotché à un mur (*A Perfect Day*, 1999) ; le Pape écrasé par un météorite (*La Nona Ora*, 1999); un petit Hitler en prière (*Him*, 2001) ; un écureuil qui se suicide d'une balle dans la tête (*Bidibidobidiboo*, 1996) : les personnages créés par Cattelan sont à la fois caricaturaux et tragiques. En jouant avec des personnalités historiques et nos héros de tous les jours, Cattelan suit un chemin déjà tracé autrefois par les mécréants, les conjurateurs et les charlatans. Les artistes ont souvent cherché refuge dans les nimbes de leur propre art, se prenant pour des prophètes en sermonnant et proclamant.

A. S.

SELECTED EXHIBITIONS →
1993 *Aperto, 45. Biennale di Venezia*, Venice, Italy **1997** *Italian Pavilion* (with Enzo Cucchi, Ettore Spalletti), *45. Biennale di Venezia*, Venice, Italy; *Skulptur. Projekte*, Münster, Germany **1998** *Manifesta 2*, Luxembourg **2000** Museum für Gegenwartskunst, Zurich, Switzerland; *Let's Entertain*, Walker Art Center, Minneapolis (MN), USA; In Between, EXPO 2000, Hanover, Germany **2001** *Hollywood*, special project in the *49. Biennale di Venezia*, Venice, Italy; *Dévoler*, Institut d'Art Contemporain, Villeurbanne, France

SELECTED BIBLIOGRAPHY →
1997 Klaus Bußmann/Kasper König/Florian Matzner (eds.), *Skulptur. Projekte*, Münster; *Maurizio Cattelan*, Castello di Rivoli, Turin; *Dynamo Secession*, Wiener Secession, Vienna **1998** *Projects 65: Maurizio Cattelan*, The Museum of Modern Art, New York **1999** *Maurizio Cattelan*, Kunsthalle Basel, Basle **2000** Francesco Bonami/Barbara Vanderlinden/Nancy Spector, *Maurizio Cattelan*, London

1 **Him,** 2001, wax, human hair, suit, polyester resin, 101 x 41 x 53 cm, installation view, Fargfabriken, Stockholm
2 **Hollywood,** 2001, nine giant letters, 23 x 170 m, special project for the

49. Biennale di Venezia, Venice, 2001, with the Patronage of the City of Palermo, Sicily
3 **La Nona Ora,** 1999, mixed media, installation view, Kunsthalle Basel, Basle

„Wer die Macht besiegen will, muss sich ihr stellen, sie sich zu Eigen machen und sie unablässig wiederholen."

« Pour être vaincu, le pouvoir doit être abordé, récupéré et reproduit à l'infini. »

"To be defeated, power must be approached, reappropriated and endlessly replicated."

3

2

Jake & Dinos Chapman

Jake Chapman, 1966 born in Cheltenham, and Dinos Chapman, 1962 born in London; live and work in London, UK

Jake and Dinos Chapman are fascinated with horror, from grisly physical violence to grotesque deformity and visions of hell. In *The Disasters of War*, 1993, based on Goya's famous series of etchings, they recreated each scene of death and mutilation in three dimensions using remodelled plastic figurines. In *Tragic Anatomies,* 1996, groups of variously cojoined and mutated child mannequins with obscene genitalia sprouting from their bodies revel in an ironic pastoral setting of plastic plants and Astroturf, suggesting the nightmarish results of a malevolent genetic experiment. The Chapmans' sculptures, drawings and prints recall the physical and sexual aggression typical of adolescent schoolboys' doodles, while exposing the voyeuristic attraction to disaster that remains in adulthood. Their most elaborate sculpture to date, *Hell,* 2000, is a huge swastika-shaped diorama in which 5,000 figurines, each hand-painted to represent either Nazi soldiers or mutants, engage in minute acts of torture and punishment. This orgy of self-consuming violence appears to be a plastic illustration of Dante's Inferno with added elements of Hieronymous Bosch, all transported to the 20th-century Western world where the Holocaust is our most painfully immediate conception of hell. While the Chapmans clearly delight in shock tactics and obscenity, they also examine ways in which questions of morality can be squeezed from acts of sin. This is attested by the fundamental moral questions which have arisen in the controversial debates over their work.

Jake und Dinos Chapman sind fasziniert vom Horror, ob in Gestalt grässlicher physischer Gewalt, grotesker Deformationen oder von Höllenvisionen. In der Arbeit *The Disasters of War*, 1993, inspiriert durch Goyas berühmte Radierfolge, haben sie jede einzelne Todes- und Verstümmelungsszene dreidimensional mit Hilfe von umgestalteten Plastikfigurinen dargestellt. *Tragic Anatomies*, 1996, besteht aus Gruppen ganz unterschiedlich miteinander verschmolzener und mutierter Kinder-Puppen, aus deren Leibern obszöne Genitalien hervorsprießen – in einem pseudo-pastoralen Ambiente aus Plastikpflanzen und Kunstrasen, als seien sie die albtraumhaften Ergebnisse eines böswilligen gentechnischen Experiments. Die Skulpturen, Zeichnungen und grafischen Arbeiten der Chapman-Brüder erinnern an die physische und sexuelle Aggressivität, wie man sie in den Kritzeleien pubertierender Schuljungen antrifft, während sie zugleich die voyeuristische Faszination spürbar machen, die das Grauen auch für den Erwachsenen bereithält. Die bislang komplexeste plastische Arbeit *Hell*, 2000, ist ein riesiges swastikaförmiges Diorama, in dem 5000 handbemalte Figurinen, die entweder Nazisoldaten oder Mutanten darstellen, an detailliert wiedergegebenen Folter- und Bestrafungshandlungen teilnehmen. Dieser alles verzehrende Gewaltexzess erscheint wie eine plastische Illustration zu Dantes Inferno mitsamt Anklängen an Hieronymus Bosch. Dies alles übertragen in die abendländische Welt des 20. Jahrhunderts, in der bislang der Holocaust als unsere schmerzlichste unmittelbare Höllenerfahrung gilt. Mögen die Chapman-Brüder auch Freude an Schocktaktiken und Obszönitäten haben, suchen sie gleichwohl nach Wegen, in immer neuen Akten des Sündenfalls die Frage nach der Moral aufzuwerfen. Bezeugt wird dies auch durch die fundamentalen moralischen Fragen, die in den kontroversen Debatten um ihre Arbeit aufgeworfen werden.

Jake et Dinos Chapman sont fascinés par l'horreur, de la violence physique macabre aux déformations et aux visions grotesques de l'enfer. Dans *The Disasters of War*, 1993, basé sur la célèbre série de gravures de Goya, ils ont récréé chaque scène de mort et de mutilation en trois dimensions avec des poupées en plastique remodelé. Dans *Tragic Anatomies*, 1996, des groupes de mannequins enfants diversement accouplés et mutilés, avec des organes génitaux obscènes jaillissant de leur corps, jouent dans un décor pastoral ironique fait de plantes en plastique et de pelouse synthétique, suggérant les résultats cauchemardesques d'une expérience génétique malveillante. Les sculptures, dessins et gravures des Chapman rappellent les agressions physiques et sexuelles typiques des gribouillis de collégiens, tout en révélant une attirance voyeuriste pour la catastrophe qui perdure à l'âge adulte. Leur sculpture la plus élaborée à ce jour, *Hell*, 2000, est un immense diorama en forme de croix gammée où 5,000 personnages, chacun peint à la main pour représenter soit un soldat nazi soit un mutant, effectuent des actes infimes de torture et de châtiment. Cette orgie de violence autodestructrice évoque une illustration en plastique de l'Enfer de Dante à laquelle viendraient s'ajouter des éléments empruntés à Jérôme Bosch, le tout transposé dans le monde occidental du 20ème siècle, où l'Holocauste représente notre conception la plus douloureusement immédiate de l'enfer. Si les Chapman prennent un plaisir évident à choquer par leur violence et leur obscénité, ils examinent également les façons dont le péché peut être détourné en questions de moralité. En témoignent aussi les questions morales fondamentales soulevées dans les controverses autour de son travail.

K. B.

SELECTED EXHIBITIONS →
1993 *The Disasters of War*, Victoria Miro Gallery, London, UK **1995** *Brilliant!*, Walker Art Center, Minneapolis (MN), USA **1996** *Chapmanworld*, Institute of Contemporary Arts, London, UK **1997** *Six Feet Under*, Gagosian Gallery, New York (NY), USA; *Sensation*, Royal Academy of Arts, London, UK **1999** *The Disasters of War*, Jay Jopling/ White Cube, London, UK; *Heaven*, Kunsthalle Düsseldorf, Germany **2000** Kunst-Werke, Berlin, Germany; *Apocalypse: Beauty and Horror in Contemporary Art*, Royal Academy of Arts, London, UK

SELECTED BIBLIOGRAPHY →
1996 *Chapmanworld*, Institute of Contemporary Arts, London **1997** *Unholy Libel*, Gagosian Gallery, New York (NY) **1999** Burkhard Riemschneider/Uta Grosenick (eds.), *Art at the Turn of the Millennium*, Cologne

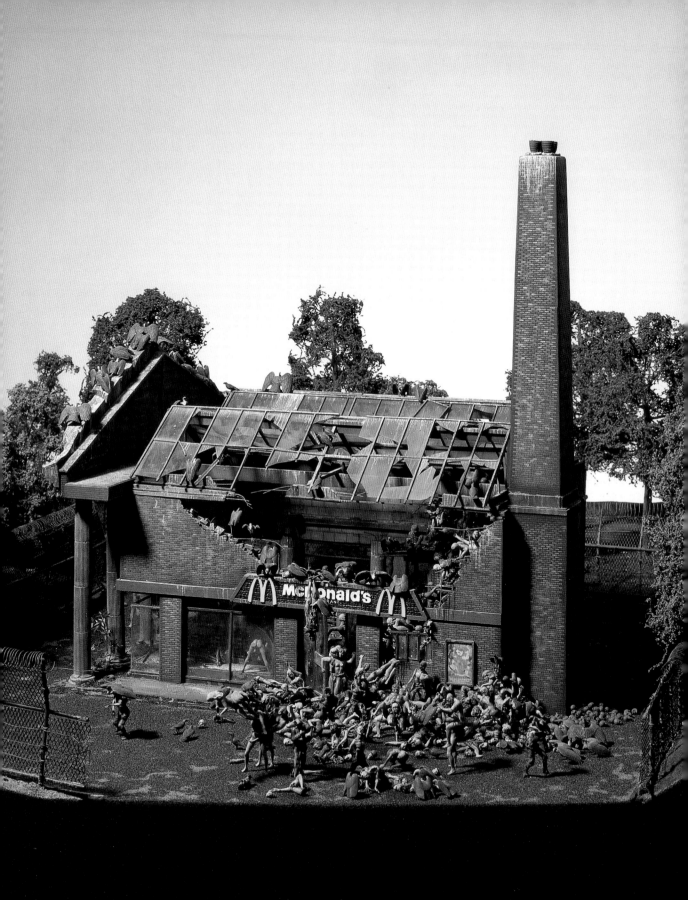

1 **Arbeit McFries,** 2001, mixed media, 122 x 122 x 122 cm
2 **Hell,** 1999/2000, glass-fibre, plastic and mixed media, 9 parts,
 8 parts: 244 x 122 x 122 cm, 1 part: 122 x 122 x 122 cm
3 **Hell** (detail)

4,5 **Exquisite Corpse I,** 2000, set of 20 etchings, handcoloured,
 watercolour, each 47 x 38 cm
6 **The tragik konsequekes of Driving Karele//ly,** 2000, mixed media,
 36 x 99 x 99 cm

„Unser Ziel ist es, die Erinnerung an sämtliche Formen des Terrorismus wach zu halten und dem Betrachter das Vergnügen bestimmter Horrorempfindungen zu verschaffen, ihn in den Zustand einer gewissen bourgeoisen Erschütterung zu versetzen."

« Nous cherchons à récupérer toutes les formes de terrorisme afin d'offrir au spectateur le plaisir d'un certain type d'horreur, d'un certain type de convulsion bourgeoise. »

"We are interested in recuperating every form of terrorism in order to offer the viewer the pleasure of a certain kind of horror, a certain kind of bourgeois convulsion."

2

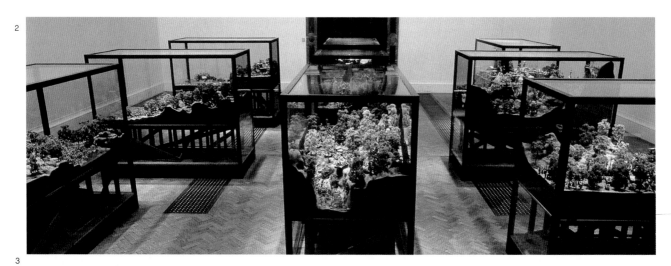

3

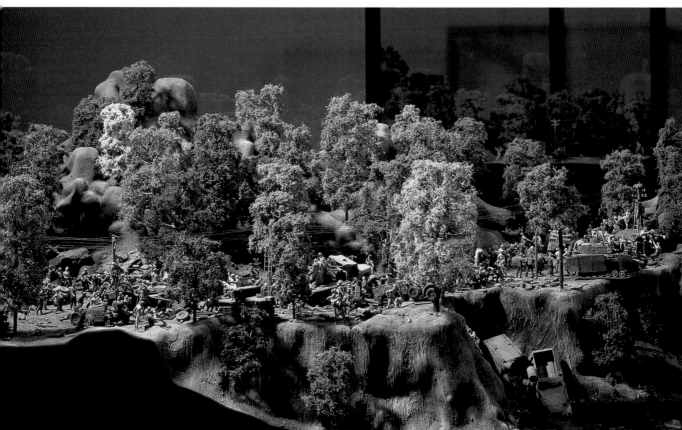

4

5

6

Martin Creed

1968 born in Wakefield, UK, lives and works in Alicudi, Italy

Martin Creed's exhibitions are often closely attuned to the architectural nature of gallery space. His best-known works are balloon-filled rooms realised in several versions, utilising the exhibition space as container and unit of measurement. A prime example is *Work No. 201: Half the air in a given space*, 1998, with multicoloured balloons. Since 1987, Creed has numbered his works, thereby acknowledging the principle of series as a leitmotif for his artistic activity. For *Work No. 228: All of the sculpture in a collection*, 2000, he gathered together all Southampton City Art Gallery's sculptures, from Rodin to Whiteread, in one room. In contrast to the overcrowded feel of this project, *Work No. 227: The lights in a room going on and off*, 2000, is an empty room in which the usual gallery lighting is replaced by lights operated by a time switch, turning on and off at five-second intervals. It is precisely through these minimalist interventions that Creed focuses the viewer's attention on the physical environment. For his outdoor projects, Creed often uses neon signs, like the vague but optimistic declaration that "Everything is going to be alright", which works both as an ironic message above New York's Times Square, and on the abandoned portico of a former orphanage in the London Borough of Hackney. Singing and playing guitar and keyboards with the three-piece band "Owada", Creed clearly demonstrates the association between minimalist reductionism and self-expression. His emotionally charged singing style is accompanied by the repetitive rhythms of the instruments: "from none take one, add one, make none".

Die Ausstellungen von Martin Creed beschäftigen sich häufig mit der architektonischen Situation des Galerieraums. In seinen bekanntesten Arbeiten, den mit Luftballons gefüllten Räumen, die er in unterschiedlichen Variationen realisierte, benutzte er den Ausstellungsraum als Container und Maßeinheit (zum Beispiel *Work No. 201: Half the air in a given space*, 1998, mit farbigen Ballons). Seit 1987 nummeriert er seine Arbeiten durch, wobei sich das sukzessive Prinzip der Serie als Leitmotiv seiner Vorgehensweise bereits in den Titeln vermittelt. Für *Work No. 228: All of the sculpture in a collection*, 2000, stellte er alle verfügbaren Skulpturen der Southampton City Art Gallery, von Rodin bis Whiteread, in einem Raum zusammen. Im Kontrast zur Fülle dieser Arbeiten steht der leere Raum in *Work No. 227: The lights in a room going on and off*, 2000, wobei lediglich die übliche Galeriebeleuchtung mit einer Zeitschaltuhr im 5-Sekunden-Takt ein- und ausgeschaltet wird. Gerade diese minimalen Eingriffe lenken die Wahrnehmung auf die physische Umgebung. Für Arbeiten im Außenraum verwendet Creed häufig Neonschriftzüge, wie den unspezifischen Hoffnungsmacher „Everything is going to be alright", der sowohl die Situation am Times Square in New York ironisch beleuchten kann wie auch den verlassenen Portikus eines ehemaligen Waisenhauses im Londoner Stadtteil Hackney. Bei seiner dreiköpfigen Band „Owada", in der Creed als Sänger und Bassist agiert, wird besonders deutlich, wie er minimalistische Reduktion mit einem Selbstausdruck verbindet. Sein emotional aufgeladener Gesang begleitet den repetitiven Rhythmus der Instrumente: „from none take one, add one, make none".

Les expositions de Martin Creed sont souvent liées à la configuration architecturale de l'espace d'exposition. Dans ses œuvres les plus célèbres, des salles remplies de ballons, dont il a réalisé différentes versions, Creed se sert de l'espace d'exposition comme container et comme unité de mesure (par exemple *Work No. 201: Half the air in a given space*, 1998, avec des ballons de couleur). Depuis 1987, Creed assigne à ses œuvres un numéro d'ordre. Le principe de succession de la série, leitmotiv de sa démarche, est donc déjà présent dans les titres. Pour *Work No. 228: All of the sculpture in a collection*, 2000, il rassemblait toutes les sculptures disponibles de la Southampton City Art Gallery, de Rodin à Whiteread, dans une seule salle. Contrastant avec la profusion de ce travail, on trouve l'espace vide de *Work No. 227: The lights in a room going on and off*, 2000, une œuvre pour laquelle un minuteur allume et éteint toutes les 5 secondes l'éclairage ordinaire de la galerie. Ce sont ces interventions minimalistes qui concentrent la perception de l'environnement physique. Pour ses œuvres dans l'espace public, Creed se sert souvent d'écritures au néon, figurant par exemple l'espoir artificiel et anonyme d'une phrase comme « Everything is goin to be alright », qui éclaire de son ironie la situation de Times Square, à New York, ou le portail d'un orphelinat désaffecté situé au bout d'une petite voie à sens unique de Hackney, à Londres. Dans son groupe « Owada » composé de trois membres, et dont il est chanteur et bassiste, on voit clairement comment Creed associe la réduction minimaliste et l'expression de soi. La forte charge émotionnelle de son chant accompagne le rythme répétitif des instruments : « from none take one, add one, make none ».

N. M.

SELECTED EXHIBITIONS →
1995 Camden Arts Centre, London, UK **1997** *Lovecraft,* Centre for Contemporary Arts, Glasgow, UK **1998** *Biennale of Sydney,* Australia; *Crossings,* Kunsthalle Wien, Vienna, Austria **1999** *Nerve,* Institute of Contemporary Arts, London, UK; *Work No. 203,* The Portico, London, UK **2000** *The British Art Show 5,* Hayward Gallery, London, UK **2001** *Work No. 265,* Micromuseum for Contemporary Art, Palermo, Italy; *The Turner Prize Exhibition,* Tate Britain, London (UK)

SELECTED BIBLIOGRAPHY →
1996 *Life/Live,* Musée d'Art Moderne de la Ville de Paris **2000** *Martin Creed works,* Southampton City Art Gallery, Southampton

1 **Work No. 227: The lights in a room going on and off,** 2000, frequency 5 seconds on, 5 seconds off, materials variable, dimensions variable

2 **Work No. 201: Half the air in a given space,** 3rd March, 1998, balloons in assorted colours, dimensions variable, installation view, Gavin Brown's enterprise, New York (NY)

3 **Work No. 247: Sorge Dich Nicht,** 2000, neon, installation, St. Peter's tower, Cologne

4 **Work No. 203: Everything is going to be alright,** 1999, neon, installation, Clapton, London, 60 x 1220 cm

„In vielen meiner Werke versuche ich, zugleich etwas zu schaffen und ungeschehen zu machen ..., also ein Nichts zu kreieren, das zugleich etwas ist."

«Dans un long processus, je tente de faire et de défaire à la fois ... ce qui produit en quelque sorte du rien tout en étant quelque chose.»

"In a lot of work I try to make it and unmake it at the same time, ... which sort of adds up to nothing but at the same time is something too."

2

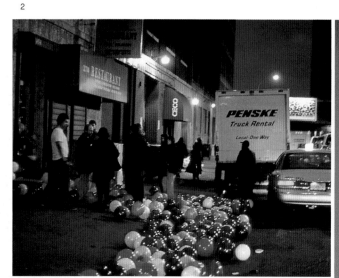

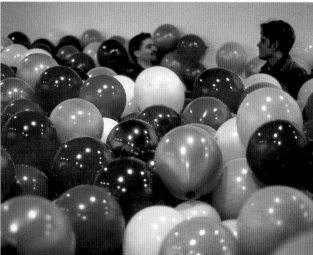

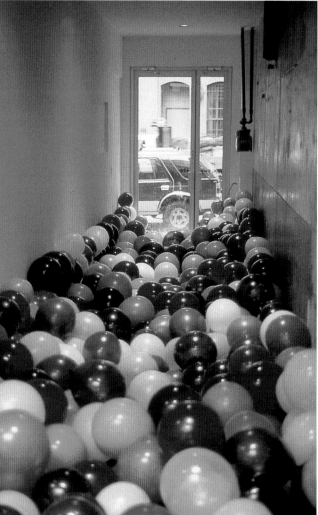

John Currin

1962 born in Boulder (CO), lives and works in New York (NY), USA

John Currin is a painter whose work requires a second look. At first view, his pictures, or at least his portraits, recall Renaissance painting and early Mannerism. In the style of the Old Masters, Currin's engaging creations question the traditions of painting and how they influence contemporary ways of seeing. On second look, the viewer realises that the American artist has loaded his appealing images with modern-day notions of beauty and morality. The standards set by fashion and gossip magazines, with their kitsch clichés, are clearly exposed and gloriously caricatured in the manner of "great art". Outsized busts, super-slim and super-fit beauties and the joys of family life, even in old age, are constantly recurring motifs. He paints nudes, sometimes classical, sometimes pornographic, and banal scenes of daily life straight out of the TV soaps. But beneath the seemingly smooth surface of upper middle class aesthetics, we soon discover extreme ugliness. Hysterical laughter, grotesquely overblown physical proportions, tasteless humour and bodily decay, which elegant attire can barely hide, subtly spoil the sensual pleasure of Currin's paintings. Glamorous and cynical at the same time, the paintings create a tension, which viewers are invited to break by laughing at what they see. A typical example is *Park City Grill,* 2000, in which a couple are seen flirting with each other. But their tensely casual attitude and clichéd beauty betray the artificiality and hollowness of the world in which they live.

John Currin ist ein Maler für den zweiten Blick. Auf den ersten Blick erinnern seine Bilder, zumeist handelt es sich um Porträts, an die Malerei der Renaissance und des frühen Manierismus. Im „altmeisterlichen" Stil befragen Currins sinnenfreudige Werke die Tradition der Kunst und ihre Rolle in der zeitgenössischen Bildrezeption. Auf den zweiten Blick erkennt der Betrachter nämlich, dass der amerikanische Künstler seine ansprechenden Motive mit aktuellen Vorstellungen von Schönheit und Moral aufgeladen hat. Kitschige Klischees und normative Regeln, wie wir sie aus Modemagazinen oder aus der Regenbogenpresse kennen, finden sich hier entlarvend deutlich im Glanz „großer Malerei" karikiert: Übergroße Busen, sportlich-schlanke Beauties und alte Menschen in einer Familienidylle zählen zu den immer wieder-kehrenden Sujets des Künstlers – genau wie mal eher klassisch, mal eher pornografisch anmutende Akte oder banale Alltagsszenen, die direkt einer TV-Seifenoper entnommen sein könnten. Aber auch übertriebene Hässlichkeiten entdeckt man schnell unter der glatten Oberfläche dieser scheinbar durch und durch großbürgerlichen Ästhetik. Hysterisches Lachen, grotesk überdehnte Körperproportionen, peinliche Possenspiele und körperlicher Verfall, der kaum von edler Kleidung verdeckt wird, verderben klammheimlich das sinnliche Vergnügen an den Bildern von Currin. Glamourös und zynisch zugleich bauen die Gemälde einen Spannungsbogen auf, der sich in einem befreienden Lachen über das Dargestellte entlädt. Typisch dafür ist zum Beispiel das Bild *Park City Grill,* 2000, das ein flirtendes Paar zeigt – beide Protagonisten verraten mit ihrer angespannten Lässigkeit und klischeehaften Schönheit die Künstlichkeit und Hohlheit ihrer Welt.

John Currin est un peintre dont le travail s'adresse au deuxième regard. Au premier regard en effet, ses tableaux – le plus souvent des portraits – rappellent les peintures de la Renaissance et des débuts du Maniérisme. Dans le style des « anciens », ses œuvres hautes en couleurs interrogent la tradition de la peinture et son rôle dans la perception contemporaine de l'image. Au deuxième regard, le spectateur s'aperçoit que l'artiste américain investit ses motifs séduisants des conceptions de beauté et de morale qui sont aujourd'hui monnaie courante. Les clichés kitsch et les règles normatives connues des magazines de mode ou de la presse à sensations sont clairement démasqués et caricaturés sous le signe de la « grande peinture » : poitrines opulentes, beautés sportives hyper-sveltes, bonheur familial authentique même au troisième âge, comptent parmi les sujets de prédilection de l'artiste. Aussi bien que les nus de tendance tantôt classique, tantôt porno-graphique, ou les scènes de la vie quotidienne qui pourraient être tirées directement d'un feuilleton télévisé. Mais sous la surface de cette esthétique en apparence entièrement bourgeoise, on découvre aussi des laideurs exagérées. Rires hystériques, étirement grotesque des proportions corporelles, blagues de mauvais goût, déchéance physique transparaissant sous le vêtement distingué gâchent secrètement le plaisir sensuel des images proposées par l'artiste. De manière mi glamoureuse, mi cynique, ces peintures créent un champ de tension dont l'énergie se décharge dans une dérision libératrice de la représentation. Un exemple caractéristique en est le tableau *Park City Grill,* 2000, qui montre un couple en train de flirter : la décontraction contrainte et la beauté convenue des deux protagonistes trahissent l'artifice et l'inanité de leur univers.

R. S.

SELECTED EXHIBITIONS →
1995 *Aperto, 45. Biennale di Venezia,* Venice, Italy **1995** Institute of Contemporary Arts, London, UK **1998** *Young Americans 2,* Saatchi Gallery, London, UK **1999** Regen Projects, Los Angeles (CA), USA; *Malerei,* INIT Kunsthalle, Berlin, Germany **2000** Monika Sprüth Galerie, Cologne, Germany; Sadie Coles HQ, London, UK; *Whitney Biennial,* The Whitney Museum of American Art, New York (NY), USA **2001** Andrea Rosen Gallery, New York (NY), USA; *Works on Paper,* Victoria Miro Gallery, London, UK; *About Faces,* C & M Arts, New York (NY), USA

SELECTED BIBLIOGRAPHY →
1998 *Young Americans 2,* London; *Pop Surrealism,* The Aldrich Museum of Contemporary Art, Ridgefield (CT) **1999** *Carnegie International,* Carnegie Museum of Art, Pittsburgh (PA); Burkhard Riemschneider/Uta Grosenick (eds.), *Art at the Turn of the Millennium,* Cologne

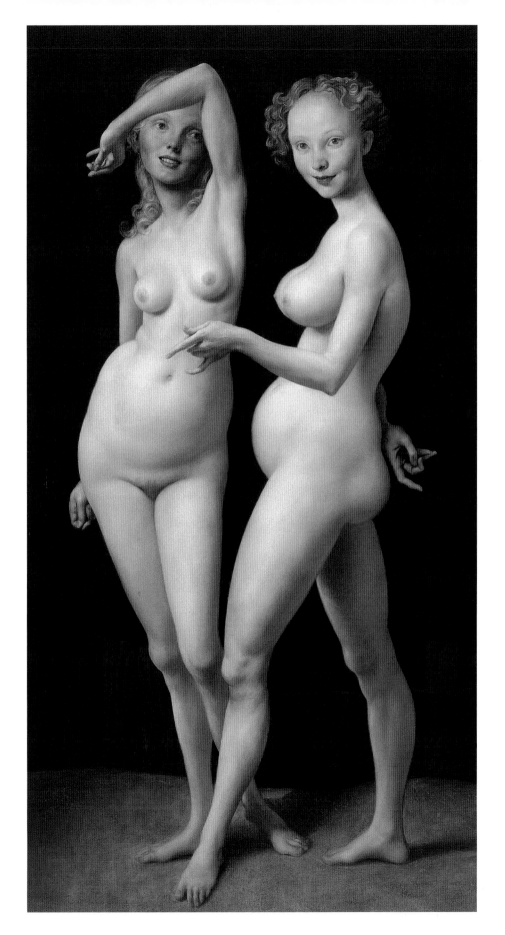

„Es ist am besten, sich Gesichter als Spiegel vorzustellen."

« Le mieux est de recevoir ces visages comme des miroirs. »

"It is best to think of the faces as mirrors."

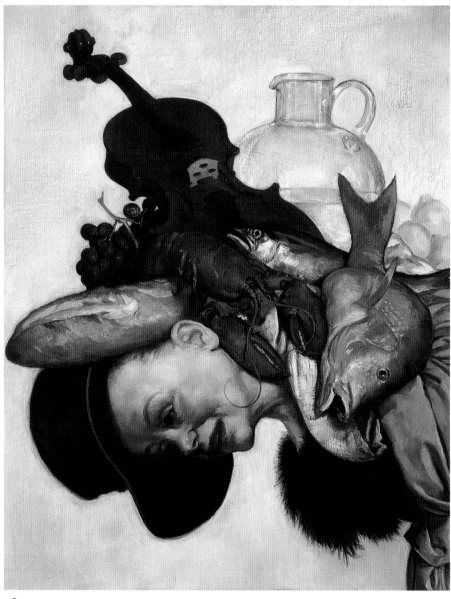

2

3

4

5

6

Björn Dahlem

1974 born in Munich, lives and works in Berlin, Germany

Björn Dahlem could be described as a sculptor, but also as a set designer. His sculptural creations usually stand inside a spatial context within which he presents diverse references to film, to science and to literature using fragile constructions. At first glance these unwieldy bar-like sculptures are reminiscent of Arte Povera. The artist works with sensitivity and at the same time with austerity, using simple materials such as roof tiles, wooden frameworks and sticky tape. However, Dahlem also uses factory-made neon tubes, trashy furniture and modern video monitors for his artistic creations. Amateurish models and mathematical constructions appear side by side, and folklore and futurism appear as though reconciled, whether they are seen in a cold techno light or in soft, romantic coloured lights. There are references to science-fiction films in *Shiva Matrix*, the installation created by Dahlem in 1999. Binary number combinations – a reference to the Hollywood film "Matrix" – appear in a room bathed in a pink light. A roughly constructed wooden structure turns it into a cell reminiscent of a spaceship. A video monitor over on one of the walls shows the artist in scenes which parody movies such as "Terminator 2". In *club horror vacui*, 1999, he brings the far-off distance of outer space into play; an office chair is placed by a table piled high with wooden sticks while behind it there is nothing but a large black area. You sit and stare into the all-consuming "black hole" – in other words, the horror vacui. The scene is set for an ordinary, mundane moment, but also for a thoroughly "galactic" myth.

Als Bildhauer könnte man Björn Dahlem bezeichnen, aber auch als Bühnenbildner. Meist nämlich stehen seine skulpturalen Arbeiten in einem räumlichen Zusammenhang, in dem er mit fragilen Konstruktionen mannigfaltige Bezüge zu Film, Wissenschaft und Literatur vorführt. Auf den ersten Blick erinnern diese sperrigen Gitterskulpturen an die Arte Povera, denn der Künstler arbeitet sensibel und spröde zugleich mit einfachen Materialien wie Dachlatten, Holzgerüsten und Klebeband. Aber auch industriell gefertigte Neonröhren, trashige Möbel und moderne Videomonitore nutzt Dahlem für seine künstlerischen Arbeiten. Dilettantische Bastelei und mathematische Konstruktion gehen Hand in Hand, Folklore und Futurismus scheinen sich im mal technoid kalten, mal romantisch farbigen Licht miteinander zu versöhnen. Bezüge zum Sciencefictionfilm führt Dahlem beispielsweise in seiner Rauminstallation *Shiva Matrix*, 1999, vor. Binäre Zahlenkombinationen – eine Anspielung auf den Hollywoodfilm „Matrix", der schon im Titel präsent ist – erscheinen in einem rosa beleuchteten Raum. Ein roh gezimmertes Holzgerüst verwandelt diesen in eine raumschiffähnliche Zelle. An einer Wand steht zudem ein Videomonitor, der Sequenzen zeigt, in denen der Künstler Motive aus Filmen wie „Terminator 2" parodiert. Auch in dem Ensemble *club horror vacui*, 1999, kommt die Ferne des Weltraumes ins Spiel: Ein Bürostuhl steht vor einem mit Holzstäben vollgestellten Tisch. Dahinter wartet nichts als eine große dunkle Fläche. So sitzt man, starrt in ein alles verschluckendes „schwarzes Loch" und wird vom Horror vacui erfasst. Ein alltäglicher, irdischer Moment also ist in Szene gesetzt, aber auch ein überaus „galaktischer" Mythos.

On pourrait décrire Björn Dahlem aussi bien comme un sculpteur que comme un scénographe. Le plus souvent, ses œuvres sculptées sont placées dans une cohérence spatiale dans laquelle leurs fragiles constructions présentent en outre des liens multiples avec le cinéma, la science et la littérature. Au premier regard, ces sculptures austères faites de grillages rappellent l'Arte Povera. L'artiste travaille en effet de manière à la fois sensible et brute avec des matériaux simples : planchettes et structures de bois ou ruban adhésif. Mais dans son travail, Dahlem se sert aussi de tubes de néon industriels, de meubles trash et de moniteurs vidéo modernes. Le bricolage d'amateur et la construction mathématique y occupent une même place, le folklore et le futurisme semblent se réconcilier dans un éclairage tantôt technoïde et froid, tantôt romantique et multicolore. Dahlem entretient des rapports avec la science-fiction, notamment dans une installation comme *Shiva Matrix*, 1999. Des combinaisons de chiffres binaires, qui font référence au film « Matrix », comme l'indique déjà le titre, apparaissent dans une salle plongée dans une lumière rose. Une structure de bois grossière transforme cet espace en une sorte de module d'un vaisseau spatial. Au mur, on aperçoit en outre un écran vidéo présentant des séquences avec lesquelles l'artiste parodie des motifs tirés de films comme « Terminator 2 ». Dans l'installation *club horror vacui*, 1999, Dahlem fait intervenir l'espace intersidéral : une chaise de bureau est placée devant une table pleine de baguettes de bois. Derrière, on ne voit qu'une grande surface sombre. On est donc assis devant cette table, les yeux rivés sur un « trou noir » qui engloutit tout, l'« horror vacui » vous saisit. Mise en scène d'un moment quotidien, terrestre, mais aussi d'un mythe hautement « galactique ».

R. S.

SELECTED EXHIBITIONS →
1998 Kunstverein Offenburg, Germany **1999** Schnitt Ausstellungsraum, Cologne, Germany; *club horror vacui*, Luis Campaña, Cologne, Germany **2000** *Modell, Modell ...*, Neuer Aachener Kunstverein, Germany; *handikraft*, Artspace, Auckland, New Zealand **2001** Kunsthalle St. Gallen, Switzerland; Galleria Giò Marconi, Milan, Italy; *Futureland*, Städtisches Museum Abteiberg, Mönchengladbach, Germany; *Zero Gravity*, Kunstverein für die Rheinlande und Westfalen, Düsseldorf, Germany **2002** *Superspace*, Kunsthalle St. Gallen, Switzerland

SELECTED BIBLIOGRAPHY →
2000 *Modell, Modell ...*, Neuer Aachener Kunstverein, Aachen **2001** *Zero Gravity*, Kunstverein für die Rheinlande und Westfalen, Düsseldorf **2002** *Superspace*, Cologne

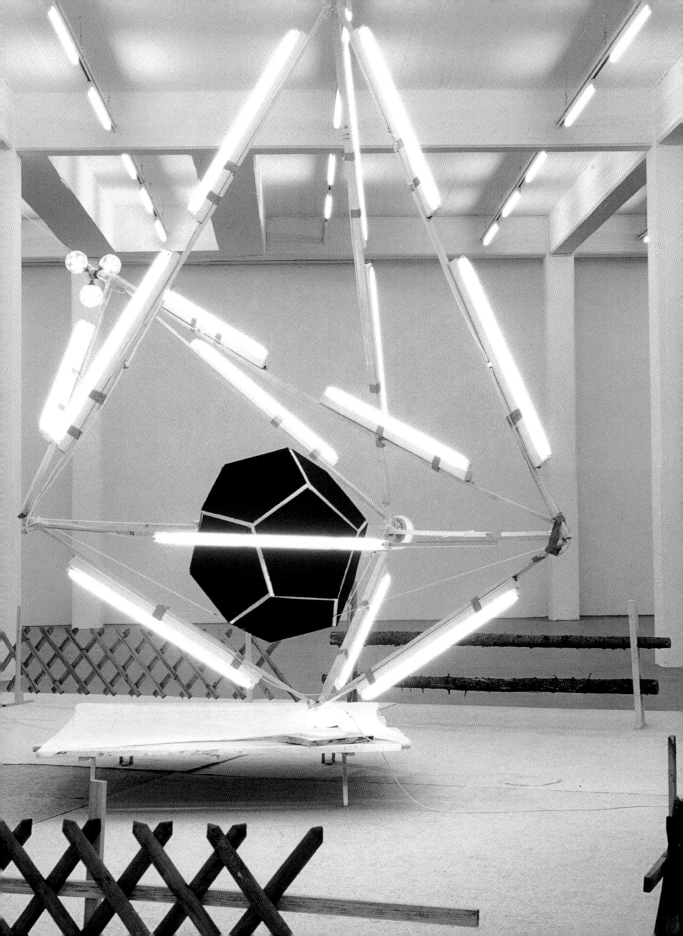

106

1 **Club Superspace 3 – Charm-Sphären (Deuterium Attenzione)**, 2001, installation view, Kunstverein in Hamburg
2 **club horror vacui**, 1999, roof slats, neon, armchair, mixed media
3 **Andromeda**, 1999, roof slats, neon, mixed media

4 **Groundcontrolbüro**, 2001, roof slats, styrofoam, carpet, video, installation view, *Zero Gravity*, Kunstverein für die Rheinlande und Westfalen, Düsseldorf

„Ich will die Arbeiten schnell aufbauen und sobald sie da sind, interessieren sie mich schon nicht mehr."

« Je veux installer mes œuvres rapidement ; dès qu'elles existent, elles ne m'intéressent déjà plus. »

"I want to construct the works quickly and as soon as they're done, I lose interest in them."

2

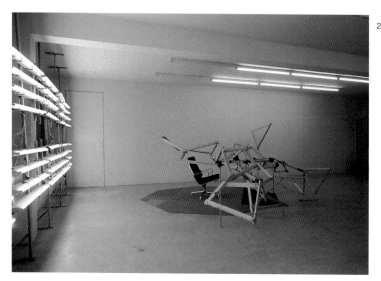

3

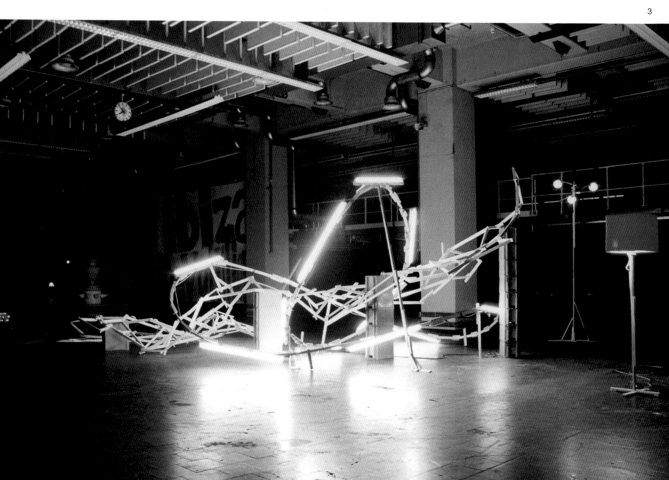

4

4

Tacita Dean

1965 born in Canterbury, UK, lives and works in Berlin, Germany

If cartographers represent space by drawing it in two dimensions, and archaeologists draw the axis of historical time by studying human artefacts, it must be possible to find a more complete method of referring to the totality of the human experience of space and time. *Totality,* 2000, is the title of one of Tacita Dean's works. In her art, films, photographs and chalk drawings, the artist wanders through regions that have traditionally been divided by science. She is interested in strange and unique phenomena, private utopias and interrupted narratives, in which culture is reflected and human longings find their place. In her *Disappearance at Sea* cycle, 1996/97, the protagonist slowly loses himself in the sea, convinced that has succeeded in going beyond the boundaries of ordinary time and cognizable space. The ocean is the last residuum of not-knowing in a world that is perfectly transparent and measured. With the common theme of entropy and disintegration in almost all contemporary human creations, Dean makes reference to Robert Smithson's work in her sound piece entitled *Trying to Find the Spiral Jetty,* 1997. Dean combines in her work a thirst for emotion and the sensitivity of a romantic wanderer with the analytical passion of an enlightened vivisectionist. She blends diagrams, strange objects and visual substitutes for sensations experienced by the other senses, along with film images. These are constructed with the precision of a classical sonnet, as calm and beautiful as the moon before Man first set foot on it.

Auch wenn die Kartografen und die Archäologen sich darauf beschränken mögen, den Raum als zweidimensionale Fläche darzustellen beziehungsweise die Achse der historischen Entwicklung durch das Studium menschlicher Artefakte sichtbar zu machen, muss es dennoch möglich sein, die Totalität der menschlichen Raum- und Zeiterfahrung in umfassenderer Weise erlebbar zu machen. Wohl deshalb hat Tacita Dean einem ihrer Werke den programmatischen Titel *Totality,* 2000, gegeben. In ihren Arbeiten, Filmen, Fotografien und Kreidezeichnungen durchwandert die Künstlerin Regionen, die üblicherweise als Gegenstandsbereiche verschiedener Wissenschaften gelten. Sie interessiert sich vor allem für sonderbare oder einzigartige Phänomene, private Utopien und unterbrochene Erzählungen, in denen sich die Kultur spiegelt und menschliche Sehnsüchte ihren Ausdruck finden. In ihrem Zyklus *Disappearance at Sea,* 1996/97, versinkt der Protagonist allmählich in der See und scheint davon überzeugt, die Grenzen der gewöhnlichen Zeit und des wahrnehmbaren Raumes überschritten zu haben. Der Ozean ist in unserer Welt die letzte Sphäre des Nicht-Wissens, zugleich vollkommen transparent und begrenzt. In ihrem Sound-Stück *Trying to Find the Spiral Jetty,* 1997, das auf Robert Smithsons Arbeit Bezug nimmt, befasst sie sich mit dem Thema der Entropie und der Auflösung, das heute in zahllosen künstlerischen Äußerungen eine so zentrale Rolle spielt. In Deans Arbeiten fließen die Sehnsucht nach Gefühlen, die Sensibilität der romantischen Wanderin und die analytische Passion der aufgeklärten Vivisektionistin zusammen. Sie kombiniert Diagramme, merkwürdige Objekte und visuelle Zeichen, die für die Empfindungen der übrigen Sinnesorgane stehen, mit Filmbildern. Diese Arbeiten sind mit der Präzision eines klassischen Sonetts komponiert und präsentieren sich in solcher Ruhe und Schönheit wie der noch von keines Menschen Fuß betretene Mond.

Si les cartographes représentent l'espace en deux dimensions et que les archéologues reconstituent l'axe du temps historique en étudiant les objets fabriqués par l'homme, il doit être possible de trouver une méthode plus complète de se référer à la totalité de l'expérience humaine de l'espace et du temps. L'une des œuvres de Tacita Dean s'intitule *Totality,* 2000. Dans son art, ses films, ses photographies et ses dessins à la craie, elle se promène dans des régions qui, traditionnellement, ont été divisées par la science. Elle s'intéresse aux phénomènes étranges et uniques, aux utopies privées et aux récits interrompus, où la culture se reflète et les aspirations humaines trouvent leur place. Dans son cycle *Disappearance at Sea,* 1996/97, le protagoniste se perd lentement en mer en étant convaincu d'être parvenu à dépasser les limites du temps ordinaire et de l'espace connu. L'océan est le dernier bastion du non-connu dans un monde parfaitement transparent et mesuré. Les thèmes de l'entropie et de la désintégration étant communs à presque toutes les créations humaines contemporaines, Dean fait référence au travail de Robert Smithson dans sa pièce sonore intitulée *Trying to Find the Spiral Jetty,* 1997. Dans son travail, Dean associe un désir d'émotion et la sensibilité d'une promeneuse romantique à la passion analytique d'une vivisectionniste éclairée. Elle mêle diagrammes, objets étranges, substituts visuels de sensations perçues par les autres sens à des images filmées. Le tout est construit avec la précision d'un sonnet classique, aussi calme et beau que la lune avant que le premier homme ne marche dessus.

A. S.

SELECTED EXHIBITIONS →
1997 Frith Street Gallery, London, UK **1998** Institute of Contemporary Art, University of Pennsylvania, Philadelphia (PA), USA **1999** *Tacita Dean, Lee Ranaldo, Robert Smithson,* Dia Center for the Arts, New York (NY), USA **2000** Museum für Gegenwartskunst, Basle, Switzerland; *Intelligence,* Tate Britain, London, UK; *Mixing Memory and Desire,* Neues Kunstmuseum, Lucerne, Switzerland **2001** *Arcadia,* National Gallery of Canada, Ottawa, Canada; Tate Britain, London, UK

SELECTED BIBLIOGRAPHY →
1997 *Missing Narratives,* Witte de With Centre for Contemporary Art, Rotterdam **1998** *Tacita Dean,* Institute of Contemporary Art, University of Pennsylvania, Philadelphia (PA) **2000** *Tacita Dean,* Museum für Gegenwartskunst, Basle **2001** *Tacita Dean,* Tate Britain, London

1 **Teignmouth Electron,** Cayman Brac, 1999, black and white photograph, 103 x 69 cm

2 **Bubble House (Exterior),** 1999, colour photograph, 148 x 173 cm

3 **Bubble House (Seaview),** 1999, colour photograph, 110 x 143 cm

4 **Fernsehturm,** 2001, 16 mm colour anamorphic film, optical sound, 44 min

„Ich möchte, dass die Menschen sich mit Zeit geradezu überflutet fühlen."

« Je désire que les gens se sentent inondés de temps. »

"I want people to feel drenched in time."

2

3

4

Thomas Demand

1964 born in Munich, lives and works in Berlin, Germany, and London, UK

The artist Thomas Demand is a photographer and he is also a sculptor, for everything he photographs has been painstakingly and precisely created by him. His subjects range from single interiors to whole buildings, even entire streets. On second glance these locations, most of which remain deserted, are revealed to be models, and the questions arise: what is the original, which is the fabrication and at what point are the boundaries of simulation reached? The pictures have a symbolic effect, designed to jog memories of "fundamentality": the convincing solemnity of a study in *Büro* (Office), 1995; the vertiginous height of *Sprungturm* (Diving Board), 1994, at the swimming baths; or the technical smoothness of *Rolltreppe* (Escalator), 2000. Demand does not shy away from politically explosive and emotionally charged locations in his works. The bathtub in which a German politician was found dead in mysterious circumstances in a hotel room in Geneva is recreated and photographed by the artist in *Badezimmer* (Bathroom), 1997, as is the prototype of the exhibition hall designed by the Nazi architect Albert Speer for the 1937 Paris World Fair, in *Modell* (Model), 2000. For these two works, Demand used pre-existing photographs to construct his models, which were in turn translated back into photographs. Via the detour of his reconstructed models, Demand succeeds in claiming that social reality can be interpreted as fiction.

Der Künstler Thomas Demand ist Fotograf und im selben Moment ein Bildhauer, denn alles was er fotografiert, hat er zuvor in penibler und präsizer Arbeit selber hergestellt. Das Spektrum seiner konstruierten Sujets reicht von einzelnen Innenräumen über komplette Gebäude bis hin zu ganzen Straßen. Orte, meist bleiben sie menschenleer, werden zum Modell ihrer selbst, entlarven sich auf den zweiten Blick als Täuschung und stellen so die Frage nach Original und Fälschung sowie die nach den Grenzen der Simulation. Zudem behaupten die Bilder auch eine zeichenhafte Wirkung, die Erinnerungen an „Wesentliches" in Gang setzen soll: Die akkurate Tristesse eines Arbeitsraums in *Büro*, 1995, die Schwindel erregende Höhe vom *Sprungturm*, 1994, im Schwimmbad, oder die technische Glätte der *Rolltreppe*, 2000, erzählen beredt genau davon. Aber auch politisch brisante und emotional aufgeladene Orte finden sich in Demands Werk. Die Badewanne, in der ein deutscher Politiker unter mysteriösen Umständen in einem Genfer Hotelzimmer tot aufgefunden worden war, stellt der Künstler ebenso nach und fotografiert sie in *Badezimmer*, 1997, wie den Prototyp der Ausstellungshalle in *Modell*, 2000, die der nationalsozialistische Architekt Albert Speer für die Weltausstellung 1937 in Paris entworfen hatte. Bei diesen beiden Arbeiten basieren die Vorlagen für das von ihm gebaute Modell auf Fotografien, die also gleichsam zurückübersetzt werden in neue Fotografien. Durch den Umweg, den Demand dabei über seine nachgebauten Modelle geht, gelingt es ihm, gesellschaftliche Realität als interpretierbare Fiktion zu behaupten.

L'artiste Thomas Demand est à la fois photographe et sculpteur. Tout ce qu'il photographie a été réalisé par ses soins dans un travail pénible et précis. L'étendue de ses sujets construits de toutes pièces va d'espaces intérieurs spécifiques à des rues entières en passant par des immeubles. Le plus souvent exempts de toute présence humaine, des lieux deviennent le modèle d'eux-mêmes et n'apparaissent comme un leurre qu'au second regard, posant ainsi le problème de l'original et de la copie, mais aussi des limites de la simulation. De plus, les photographies font l'effet d'un signe qui évoque le souvenir de quelque chose d'« essentiel » : comme l'évoquent avec une éloquente précision la tristesse poignante d'un espace de travail dans *Büro* (Bureau), 1995, le vertige des hauteurs dans *Sprungturm* (Plongeoir), 1994, dans une piscine ou la perfection technique d'un *Rolltreppe* (Escalator), 2000. La baignoire d'une chambre d'hôtel de Genève, dans laquelle un politicien allemand fut retrouvé mort dans des conditions mystérieuses, a été reconstituée par l'artiste et photographiée dans *Badezimmer* (Salle de bains), 1997, aussi bien que le prototype de la halle d'exposition que l'architecte nazi Albert Speer conçut pour l'Exposition universelle de Paris en 1937 (*Modell*/Maquette, 2000). Dans ces deux œuvres, les modèles des maquettes construites par Demand s'appuient sur des photographies, qui sont donc en quelque sorte reconverties en de nouvelles photographies. Par le détour qu'il emprunte à travers ses reconstitutions, Demand parvient à affirmer la réalité sociale comme une fiction interprétable.

R. S.

1

SELECTED EXHIBITIONS →
1999 *Tunnel, Art Now 16*, Tate Gallery, London, UK; *Große Illusionen*, Museum of Contemporary Art, North Miami (FL), USA **2000** Fondation Cartier pour l'Art Contemporain, Paris, France **2001** *Report*, Sprengel Museum, Hanover, Germany; *Discovery*, pitti immagine, Palazzo Pitti, Florence, Italy; Stichting De Appel, Amsterdam, The Netherlands **2000** *Age of Influence*, Museum of Contemporary Art, Chicago (IL), USA; *Dinge in der Kunst des XX. Jahrhunderts*, Haus der Kunst, Munich, Germany **2001** *6ème Biennale de Lyon*, France

SELECTED BIBLIOGRAPHY →
1999 Burkhard Riemschneider/Uta Grosenick (ed.), *Art at the Turn of the Millennium*, Cologne **2000** *Thomas Demand*, Fondation Cartier pour l'Art Contemporain, Paris; *Small World*, Museum of Contemporary Art, San Diego (CA) **2001** *Big Nothing. Die jenseitigen Ebenbilder des Menschen*, Staatliche Kunsthalle Baden-Baden; *Thomas Demand. Report*, Sprengel Museum, Hanover; Thomas Demand, Aspen Art Museum, Aspen (CO)/Stichting De Appel, Amsterdam

1 **Podium,** 2000, c-print/Diasec, 296 x 178 cm
2 **Poll,** 2001, c-print/Diasec, 180 x 260 cm
3 **Stapel/Pile,** 2001, c-print/Diasec, 5 parts, 53 x 84 cm

4 **Stapel/Pile,** 2001, c-print/Diasec, 5 parts, 42 x 54 cm
5 **Copyshop,** 1999, c-print/Diasec, 184 x 300 cm

„Ich habe den Eindruck, dass sich Fotografie nicht mehr sehr auf symbolische Strategien verlassen kann und sie stattdessen psychologische Erzählstränge innerhalb des Mediums erkundet."

« J'ai l'impression que la photographie ne peut plus compter beaucoup sur des stratégies symboliques et qu'au lieu de cela elle explore des fils narratifs psychologiques à l'intérieur du médium. »

"I have the impression that photography can no longer rely much on symbolic strategies and has to probe psychological narrative elements within the medium instead."

2

3

4

5

Rineke Dijkstra

1959 born in Sittard, lives and works in Amsterdam, The Netherlands

Portraits are central to the work of Dutch photographer Rineke Dijkstra. The artist generally creates her documentary projects by approaching children and young people in public spaces such as beaches, parks and nightclubs. This results in intense collaborations and, although her models are lifted out of their everyday contexts, they are given leeway to choose the manner in which they express themselves. This endows the photographs with a poignancy and humour that belies their sociological coolness. In the late 1990s the artist turned to the medium of video. In *The Buzzclub, Liverpool, UK/Mysteryworld, Zaandam, NL,* 1996/97, young clubbers were positioned facing a static video camera in a bare, dimly lit studio. Dressed for clubbing, the adolescents dance to "their" music, but now they must do so without the protection of a crowd. Using a variety of settings, Dijkstra repeatedly reveals the discrepancy between norm, uniformity and individual identity. This is evident once more in her latest cycle of photographs, *Israel Portraits,* 2001. Prompted by an invitation from the Herzliya Museum of Art she was inspired to take portraits of Israelis on military service, an important period in the lives of young Israelis, who are expected to serve irrespective of their gender. Dijkstra photographed the recruits dressed in both uniform and civilian clothes on their first day, and in full gear after a military exercise in the Golan Heights. The faces of the young soldiers speak of pride and insecurity, adventurousness and vulnerability. These photographs document individual transitions that are marked by the rites of social initiation and political and personal ambivalence.

In den Arbeiten der niederländischen Fotografin Rineke Dijkstra spielt das menschliche Porträt die zentrale Rolle. Für ihre dokumentarischen Projekte spricht die Künstlerin zumeist Kinder und Jugendliche im öffentlichen Raum an – etwa am Strand, im Park oder in einer Diskothek. Es entsteht eine intensive Zusammenarbeit, bei der die Modelle zwar aus ihrem alltäglichen Kontext herausgelöst werden, aber gleichzeitig Raum für einen selbst gewählten Ausdruck erhalten. Dadurch haben die Fotografien, bei aller soziologischen Kühle, rührende und humorvolle Momente. Ende der neunziger Jahre wandte sich die Künstlerin dem Medium Video zu. In *The Buzzclub, Liverpool, UK/Mysteryworld, Zaandam, NL,* 1996/97, filmte sie junge Diskobesucher, die sie in einem leeren Studio bei fahler Beleuchtung frontal vor eine statische Kamera stellte. Die Jugendlichen in ihrem nächtlichen Outfit beginnen zu „ihrer" Musik zu tanzen, allerdings ohne den Schutz der Masse. Es ist immer wieder diese Diskrepanz zwischen Norm, Uniformiertheit und individueller Identität, die Dijkstra in verschiedenen Milieus zum Vorschein bringt – so auch in ihrem neuesten Fotozyklus, den *Israel Portraits,* 2001. Angeregt durch eine Einladung des Herzliya Museum of Art, wuchs die Idee, Porträts von Israelis während ihres Militärdienstes zu machen, der eine wichtige Rolle im Leben israelischer Jugendlicher spielt, zumal Männer und Frauen gleichermaßen eingezogen werden. Dijkstra fotografierte die Rekruten in ihren Uniformen und in ihrer Zivilkleidung, am ersten Tag ihres Dienstes und in voller militärischer Montur nach einer Waffenübung auf den Golan-Höhen. In den Gesichtern der jungen Soldaten steht der Ausdruck von Stolz neben Verunsicherung, Abenteuergeist neben Verletzlichkeit. Es sind Dokumente eines Übergangs, gezeichnet von den Riten gesellschaftlicher Initiation und von politischer und persönlicher Ambivalenz.

Dans les œuvres de la photographe néerlandaise Rineke Dijkstra, le portrait occupe une place centrale. Pour ses projets documentaires, l'artiste fait le plus souvent appel à des enfants et à des jeunes dans l'espace public – à la plage, dans les parcs ou dans les discothèques. Il en résulte une intense collaboration qui fait certes sortir les modèles de leur environnement quotidien tout en leur donnant du champ pour un mode d'expression librement choisi. De ce fait, malgré une froideur toute sociologique, ces photographies contiennent des moments émouvants et pleins d'humour. A la fin des années 90, l'artiste se tourne vers la vidéo. Dans *The Buzzclub, Liverpool, UK/Mysteryworld, Zaandam, NL,* 1996/97, elle s'attache à filmer de jeunes danseurs de discothèque – frontalement, devant une caméra fixe, dans un studio vide baignant dans un éclairage glauque. Vêtus de leur accoutrement nocturne, les jeunes commencent à danser sur « leur » musique, sans bénéficier il est vrai de la protection de la foule. C'est toujours ce décalage entre norme, uniformité et identité individuelle que Dijkstra met en évidence dans différents milieux. Ceci vaut également pour son dernier cycle de photographies, les *Israel Portraits,* 2001. Sur une invitation du Herzliya Museum of Art, Dijkstra conçut l'idée de photographier des Israéliens pendant leur service militaire, qui joue un rôle important dans la vie des jeunes Israéliens, notamment au regard du fait qu'hommes et femmes sont également appelés sous les drapeaux. Dijkstra a photographié les jeunes recrues dans leurs uniformes et dans leurs habits civils, le premier jour de leur service, en équipement militaire complet, après un exercice de tir sur les hauteurs du Golan. Dans leurs visages, l'expression de fierté côtoie celle de l'insécurisation, l'esprit d'aventure la vulnérabilité. Ces documents sont ceux d'une transition signée par les rites de l'initiation sociale et de l'ambivalence politique et individuelle. A. K.

SELECTED EXHIBITIONS →
1997 *47. Biennale di Venezia,* Venice, Italy **1998** Museum Boijmans Van Beuningen, Rotterdam, The Netherlands; *XXIV Bienal Internacional de São Paulo,* Brazil **1999** *The Buzzclub, Liverpool, UK/Mysteryworld, Zaandam, NL,* Museu d'Art Contemporàni de Barcelona, Spain **2001** *Israel portraits,* The Herzliya Museum of Art, Herzliya, Israel; *Focus: Rineke Dijkstra,* The Art Institute of Chicago (IL), USA

SELECTED BIBLIOGRAPHY →
1996 *Prospekt 96. Photographie in der Gegenwart,* Schirn Kunsthalle, Frankfurt am Main **1998** *Rineke Dijkstra, Über die Welt,* Sprengel Museum, Hanover; *Menschenbilder,* Museum Folkwang, Essen **2001** *Israel portraits,* The Herzliya Museum of Art, Herzliya; *Rineke Dijkstra and Bart Domburg: Die Berliner Zeit,* DAAD Galerie, Berlin

1

2

3

4

1, 2, 4 **Induction Center,** Tel Hashomer, Israel, April 12, 1999, c-prints, each 126 x 107 cm
3 **Abigael,** Herzliya, Israel, April 10, 1999, c-print, 126 x 107 cm

5 **The Buzzclub, Liverpool, UK/Mysteryworld, Zaandam, NL,** 1996/97, two screen video installation, duration 26:40 min
6 **Golani Brigade,** Eyakim, Israel 26, 1999, c-prints, each 180 x 150 cm

„Mich interessiert vor allem die paradoxe Beziehung zwischen der Identität und der Uniformität, der Macht und der Verletzlichkeit jedes Individuums und jeder Gruppe. Dieses Paradox versuche ich sichtbar zu machen, indem ich das Augenmerk auf Posen, Einstellungen, Gesten und Blicke richte."

« Je m'intéresse au paradoxe entre l'identité et l'uniformité, au pouvoir et à la vulnérabilité de chaque individu et de chaque groupe. C'est ce paradoxe que je tente de visualiser en me concentrant sur des poses, des attitudes, des gestes et des regards. »

"I am interested in the paradox between identity and uniformity, in the power and vulnerabiltiy of each individual and each group. It is this paradox that I try to visualise by concentrating on poses, attitudes, gestures and gazes."

5

Mark Dion

1961 born in New Bedford (MA), lives in Beach Lake (PA), USA, and works worldwide

Since the late 1980s, Mark Dion has been involved with the history of collection, classification and display as practised by scientific institutions such as natural history museums. A main focus of his work of recent years has been a range of archaeological digs, one of which is *Raiding Neptune's Vault*, 1997/98, in the Lagoon of Venice or the *Tate Thames Dig*, 1999, carried out with the assistance of a number of people on the banks of the River Thames at Millbank and Bankside, at the same time forming the topographic environment of the Tate Britain and Tate Modern galleries. In his attempt to analyse the institutions within which he works – their ideological foundations and their myths of objectivity and neutrality – Dion frequently uses a strategy of imitation. He assumes the changing roles of entomologist, marine biologist or scientific researcher and explorer and uses pre-museum principles of archiving and presentation such as those used in the Wunderkammer and Cabinets of Curiosity. Although his projects are characterised by an obviously fictional and at the same time deconstructionist moment, they always include "realistic" facts based on research, for example when Dion uses the theme of the overexploitation of the eco-systems in his *Alexander von Humboldt (Amazon Memorial)*, 2000, or in his documentation of two hundred different types of insects in *Roundup: An Entomological Endeavour for the Smart Museum of Art*, 2000. In these theatrically exaggerated, performative assumptions of different roles and practices, there is always – in addition to a self-reflective, often parodying or even ironic resonance – the expression of his own fascination with these institutions.

Seit den späten achtziger Jahren beschäftigt sich Mark Dion mit der Geschichte des Sammelns, Klassifizierens und Präsentierens, wie sie von wissenschaftlichen Einrichtungen wie den naturhistorischen Museen ausgeübt werden. Einen Schwerpunkt seiner Arbeiten der letzten Jahre bildet eine Reihe von „archäologischen Grabungen", wie etwa *Raiding Neptune's Vault*, 1997/98, in der Lagune von Venedig oder der mithilfe zahlreicher Mitarbeiter durchgeführte *Tate Thames Dig*, 1999, an den Themseufern Millbank und Bankside, die zugleich das topografische Umfeld der Tate Britain und der Tate Modern bilden. Um die Institutionen zu analysieren, innerhalb derer er agiert, ihre ideologischen Grundlagen und ihre Mythen von Objektivität und Neutralität zu erforschen, bedient sich Dion häufig einer scheinbar identifikatorischen Strategie der Imitation. So nimmt er wechselnde Rollen als Insektenforscher, Meeresbiologe oder naturkundlicher Forschungsreisender an und adaptiert (vor-)museale Prinzipien der Archivierung und Präsentation wie die der Wunderkammer und des Kuriositätenkabinetts. Obwohl seine Projekte durch ein offenkundig fiktionales und zugleich dekonstruierendes Moment geprägt sind, bringen sie immer auch auf Recherchen basierende, „reale" Tatsachen zum Vorschein, etwa wenn Dion in *Alexander von Humboldt (Amazon Memorial)*, 2000, den Raubbau an Ökosystemen thematisiert oder in *Roundup: An Entomological Endeavor for the Smart Museum of Art*, 2000, in einem Kunstmuseum zweihundert verschiedene Insektenarten dokumentiert. In diesen theatralisch überspitzten, performativen Aneignungen verschiedener Rollen und Praktiken kommt – neben einer selbstreflexiven, oft parodistischen oder ironischen Brechung – zugleich immer auch die eigene Faszination für diese Institutionen zum Ausdruck.

Depuis la fin des années 1980, Mark Dion s'intéresse à l'histoire de collection, classement, présentation, telles qu'elles sont observées par des institutions scientifiques comme les musées d'histoire naturelle. Un accent fort a été donné dans ses œuvres récentes avec une série de « fouilles archéologiques » comme *Raiding Neptune's Vault*, 1997/98, dans la lagune de Venise, ou encore *Tate Thames Dig*, une fouille réalisée en 1999 avec une nombreuse équipe de collaborateurs sur les quais de la Tamise Millbank et Bankside, qui constituent aussi l'environnement topographique de la Tate Britain et de la Tate Modern. Pour analyser en leurs fondements idéologiques et en leurs mythes d'objectivité et de neutralité les institutions au sein desquelles il travaille, Dion se sert souvent d'une stratégie de l'imitation qui semble tenir de l'identification, adoptant tour à tour les rôles de l'entomologiste, du biologiste-océanographe ou de l'explorateur scientifique, adaptant à son travail les principes (pré)muséaux de l'archivage et de la présentation : chambre au trésor, cabinets de curiosités, etc. Bien que ses projets soient marqués par un trait manifestement fictionnel et déconstructif, ils n'en mettent pas moins toujours en évidence des faits « réels » fondés sur des recherches. Ainsi, avec *Alexander von Humboldt (Amazon Memorial)*, 2000, Dion illustrait l'exploitation éhontée des écosystèmes, tandis qu'avec *Roundup : An Entomological Endeavor for the Smart Museum of Art*, 2000, il présentait quelque deux cents espèces d'insectes dans un musée d'art. Parallèlement à une note autoréflexive, souvent parodique ou ironique, ces appropriations théâtrales, exacerbées, de différents rôles et pratiques, manifestent aussi la fascination de l'artiste dans ce type d'institutions. B. H.

SELECTED EXHIBITIONS →
1999 *Tate Thames Dig – Beachcombing on London's Foreshore*, Tate Modern, London, UK; *Weird Science*, Cranbrook Art Museum, Bloomfield Hills (MI), USA; *The Museum as Muse: Artists Reflect*, The Museum of Modern Art, New York (NY), USA **2000** *Ecologies*, The Smart Museum of Art, University of Chicago (IL), USA; *Herausforderung Tier. Von Beuys bis Kabakov*, Städtische Galerie Karlsruhe, Germany **2001** *Cabinet of Curiosities*, Frederick R. Weisman Art Museum, Minneapolis (MN), USA

SELECTED BIBLIOGRAPHY →
1997 Lisa Graziose Corrin/Miwon Kwon/Norman Bryson (eds.), *Mark Dion*, London **1999** Alex Coles/Mark Dion (eds.), *Mark Dion. Archaeology*, London; Burkhard Riemschneider/Uta Grosenick (eds.), *Art at the Turn of the Millennium*, Cologne **2001** *Mark Dion. New England Digs*, Fuller Museum of Art, Brockton (MA)

1 **Roundup: An Entomological Endeavor for the Smart Museum of Art,** 2000, 136 black and white photographs, each 23 x 26 cm, museum mannequin, height 1.80 m, mixed media, installation view, Galerie Christian Nagel, Cologne
2 **Alexander von Humboldt (Amazon Memorial),** 2000, tiled aquarium, c. 1400 litres of water, 10 piranhas, mixed media, 214 x 360 x 105 cm, installation view, Galerie Christian Nagel, Cologne

3 **New England Digs,** 2001, Providence collector cupboard
4 **Theatrum Mundi,** 2000, crayon on paper, 36 x 42 cm

„Kritisch zu sein ist vielleicht nur eine andere Art, diese Museen zu lieben. Diesen Widerspruch versuche ich durch die Produktion von Kunst aus-zuloten. Allerdings verbringe ich keine schlaflosen Nächte, weil dieser Widerspruch womöglich unauflöslich ist. Arbeit sollte Spaß machen."

« Critiquer ces musées peut aussi être une façon de les aimer. J'essaie d'explorer cette contradiction en réalisant mes œuvres. Peu m'importe que cette contradiction soit peut-être impossible à résoudre. Le travail devrait être un plaisir. »

"Being critical may also be just another way to love these museums. That contradiction is what I try to explore through my production of artwork. I don't lose sleep over the fact that the contradiction may be irresolvable. Work should be pleasure."

2

3

The spirit world empty shelf

The Antiquarian Intellect
Artefacts, Medals, coins,
souvenirs, weapons,
architectural fragments,
reliquaries, ecclesiastical
regalia, curiosities

WISDOM tracts, scrolls,
books, pamphlets, Manuscripts

REASON/BALANCE
Plumbs, instruments for
weighing, levels, rulers,
clocks, drawing instruments,
vessels, keys and locks

IMAGINATION/INVENTION
Architectural Models, drawing
and painting equipment,
engineering demonstration
models, ceramics,
sculpture, musical
instruments

The Senses, wax
fruit, optical equipment,
musical instruments,
human anatomy models,
Perfumes

WARM-BLOODED
ANIMALS Mammals and
birds (skulls, stuffed
skins, skeletons, models,
liquid preparations)

COLD-BLOODED
ANIMALS reptiles,
amphibians, fishes (models
liquid preparations, mounted
skins, skeletons)

INVERTEBRATES Corals,
sponges, starfish, Arthropods,
Mollusks, sea urchins, etc

PLANTS ferns, conifers,
flowering plants, mosses,
cycads, horsetails, etc.
(botanical mounts, real plants,
dried specimens, wax fruit)
Also Fungi

MINERALS various
crystals and ores, etc.

Rocks various sedimentary
volcanic and conglomerate
stones, etc.

Theatrum Mundi M. Dion 2000

4

Peter Doig

1959 born Edinburgh, lives and works in London, UK

Peter Doig paints picturesque landscapes inspired by images in photographs, films, books and other popular media. In *Night Fishing*, 1993, he started with an image found in an advertisement for a fishing holiday in Canada, from which he created a scene set on a lake at dusk. *Daytime Astronomy*, 1997/98, was inspired by a photograph of Jackson Pollock taken by Hans Namuth, in which Pollock lies on his back gazing upwards. Doig does not paint nature scenes from within the landscape itself, and his use of reproductions is also indirect: he works from photocopies and sketches that are generations removed from the originals by his repeated reworking of the images. Doig has created multiple versions of similar scenes as paintings and as intimate drawings and studies. Inspired by a scene in the horror movie "Friday the 13th", he painted several images of a lake with a figure slumped over a canoe. A related group of works entitled *Echo-Lake*, in which a figure cups his hands to shout out across the lake, is inspired by the same movie. In addition to sources in popular culture, Doig is interested in the use of intense colour by Impressionist and Post-impressionist painters, as well as the effect of the camera on the way artists have visualised the natural world for more than a century. While his work has been compared to that of Gerhard Richter because of the strong relationship between painting and photography, Doig looks more towards the tradition of painting and the ways artists such as Friedrich, Constable and Monet interpreted and abstracted the landscape.

Peter Doig malt pittoreske Landschaften und lässt sich dabei von Fotos, Filmen, Büchern und sonstigen populären Medien inspirieren. So liegt etwa der Arbeit *Night Fishing*, 1993, ein Bild zugrunde, das er in einer Werbung für einen Angelurlaub in Kanada entdeckt hat. Ausgehend von diesem Bild hat Doig eine Szene in der Abenddämmerung auf einem See gestaltet. Auch zu dem Werk *Daytime Astronomy*, 1997/98, hat Doig sich von einem Foto anregen lassen, das Hans Namuth von dem auf dem Rücken liegenden Jackson Pollock gemacht hat. Aber Doig verzichtet bei seiner Landschaftsmalerei nicht nur auf die unmittelbare Anschauung der Natur, er ist sogar auf möglichst große Distanz zu seinen Motiven bedacht: So arbeitet er zum Beispiel nach Fotokopien und Skizzen, die durch wiederholte Überarbeitungen gleich um mehrere „Generationen" von den Originalen entfernt sind. Doig hat zahllose Versionen ganz ähnlicher Motive mal als Gemälde, dann wieder als intime Zeichnungen oder als Studien gestaltet. So ist etwa eine Szene aus dem Horrorfilm „Freitag der 13." Ausgangspunkt etlicher verschiedener Versionen eines Sees mit einer Figur, die über einem Kanu zusammengebrochen ist. In einer weiteren – *Echo-Lake* betitelten – Werkgruppe ist eine Figur mit erhobenen Händen zu sehen, die etwas über einen See brüllt. Auch hier hat wieder derselbe Film als Inspirationsquelle gedient. Doig entnimmt seine Motive aber nicht nur aus Vorlagen der Pop-Kultur, er beschäftigt sich auch mit den intensiven Farben der impressionistischen und postimpressionistischen Malerei. Außerdem befasst er sich mit der Frage, wie die Erfindung der Kamera den Blick der Künstler auf die Natur in den letzten 150 Jahren verändert hat. Wegen der engen Beziehung zwischen Malerei und Fotografie hat man Doig immer wieder mit Gerhard Richter verglichen. Doch gilt sein Interesse vor allem jener malerischen Tradition und jenen Interpretations- und Abstraktionsverfahren, von denen sich Landschaftsmaler wie Friedrich, Constable und Monet haben leiten lassen.

Peter Doig peint des paysages pittoresques inspirés par des images trouvées dans des photographies, des films, des livres et d'autres médias populaires. Dans *Night Fishing*, 1993, il est parti d'une image trouvée dans une publicité pour un séjour de pêche au Canada, avec laquelle il a créé une scène située sur un lac au crépuscule. De même, *Daytime Astronomy* 1997/98, s'inspire d'une photographie de Jackson Pollock prise par Hans Namuth, où Pollock est allongé sur le dos, fixant le ciel. Doig ne peint pas les paysages d'après nature. Son recours aux reproductions est tout aussi indirect : il travaille à partir de photocopies et de croquis qui, à force d'être retravaillés, finissent par être à des générations de l'original. Doig a créé des versions multiples de scènes similaires sous forme de peintures, de dessins et d'études. Inspiré par une scène du film d'horreur « Vendredi 13 », il a peint plusieurs images d'un lac avec un silhouette affalée dans un canoë. Une série d'œuvres apparentées, *Echo-Lake,* où une silhouette met ses mains en porte-voix pour appeler quelqu'un de l'autre côté du lac, renvoie au même film. Outre la culture populaire, Doig s'inspire des couleurs intenses des impressionnistes et postimpressionnistes. Il s'intéresse également à l'influence de l'appareil photo sur la manière dont les artistes visualisent la nature depuis plus d'un siècle. Son travail a souvent été comparé à celui de Gerhard Richter du fait de ses liens étroits entre la peinture et la photographie, mais Doig s'oriente davantage vers la tradition picturale et la façon dont des artistes tels que Friedrich, Constable et Monet ont interprété et traduit le paysage de manière abstraite. Ro. S.

SELECTED EXHIBITIONS →
1994 *The Turner Prize Exhibition*, Tate Gallery, London, UK **1996** *Homely*, Gesellschaft für Aktuelle Kunst, Bremen, Germany **1998** *Blizzard seventy-seven*, Kunsthalle Nürnberg, Nuremberg, Germany **1999** *Version*, Kunsthaus Glarus, Switzerland; *Examining Pictures*, Museum of Contemporary Art, Chicago (IL), USA **2000** *Currents 83: Peter Doig*, Saint Louis Art Museum, St.Louis (MS), USA; *Twisted*, Stedelijk Van Abbe Museum, Eindhoven, The Netherlands **2002** Santa Monica Museum of Art, Santa Monica (CA), USA

SELECTED BIBLIOGRAPHY →
1996 *Homely*, Gesellschaft für Aktuelle Kunst, Bremen **1998** *Peter Doig: Blizzard seventy-seven*, Kunsthalle Nürnberg, Nuremberg/Kunsthalle zu Kiel/Whitechapel Art Gallery, London **1999** *Peter Doig. Version*, Kunsthaus Glarus **2000** *MATRIX 183: Peter Doig, Echo-Lake*, University Art Museum, Berkeley (CA); *Currents 83: Peter Doig*, St. Louis Art Museum (MS)

1 **The heart of Old San Juan,** 1999, oil on canvas, 250 x 196 cm
2 **Untitled (Pond Painting),** 2000, oil on canvas, 200 x 250 cm

3 **Echo-Lake,** 1998, oil on linen, 229 x 359 cm
4 **100 Years Ago,** 2000, oil on canvas, 200 x 296 cm

„Ich betrachte meine Bilder durchaus nicht als realistisch. Ich glaube vielmehr, dass sie vornehmlich im Kopf entstehen und nicht allzu viel mit dem zu tun haben, was wir da draußen vor uns sehen."

« Je ne considère pas du tout mes peintures comme réalistes. Je les conçois comme découlant de ce qu'on a dans la tête plutôt que de ce qu'on a sous les yeux. »

"I don't think of my paintings as being at all realistic. I think of them as being derived more from within the head than from what's out there in front of you."

2

3

4

128

Keith Edmier

1967 born in Chicago (IL), lives and works in New York (NY), USA

Keith Edmier's highly detailed representational sculptures refer to memories of his childhood in 1970s Midwestern America and have been described as "Sentimental Realism". Conflating personal history with collective memory, he relieves the autobiographical content of his work by adding details which refer to icons of recent history. *Beverley Edmier, 1967*, 1998, is a life-size rendering of his heavily pregnant mother wearing the same Chanel suit as Jackie Kennedy wore on the day of the president's assassination while *Jill Peters*, 1997/98, is a waxy portrait of his first love, sporting the infamous feather-flick hairstyle of Farah Fawcett, who was the first love of countless American teenagers of Edmier's generation. A sense of vulnerability is implied by cartoonish exaggerations of scale, lurid primary colours or suggestively phallic structures that recall the ungainly awkwardness and sexual discomfort of adolescence. Edmier's fascination with childhood heroes led to a collaboration with Evel Knievel and a small-scale bronze monument (*Evel Knievel, American Daredevil*, 1996) and inspired a recent project which returns to his teenage fascination with Farah Fawcett. When he discovered that Fawcett is a practising artist as well as a famous actress, Edmier contacted her and suggested they collaborate on a work. Their first collaborative sculpture, *Untitled (Hands)*, 2000, is a marble carving of his and her hands. With a touching sincerity, Edmier conveys the gap between the intensity of childhood and its recollection in maturity and the transformation of a boy's unqualified hero-worship into a mutual adult affiliation.

Die ungemein detailliert herausgearbeiteten Skulpturen von Keith Edmier, bisweilen als „sentimentaler Realismus" beschrieben, beziehen sich auf seine Kindheit im Mittleren Westen der siebziger Jahre. Durch Verschmelzung persönlicher Erfahrungen und kollektiver Erinnerung relativiert Edmier den autobiografischen Bezug seiner Arbeiten: Er fügt ihnen Details hinzu, die auf die Ikonen der jüngeren Vergangenheit verweisen. *Beverley Edmier, 1967*, 1998, ist eine lebensgroße Skulptur, die Edmiers hochschwangere Mutter in demselben Chanel-Kostüm zeigt, das Jackie Kennedy am Tag der Ermordung des Präsidenten trug. *Jill Peters*, 1997/98, wiederum ist ein Wachsbildnis seiner ersten Liebe, dargestellt mit der berüchtigten Frisur jener Farah Fawcett, die die erste Liebe zahlloser männlicher Teenager aus Edmiers Generation war. Einen Eindruck von Verletzlichkeit vermitteln karikaturistisch überzeichnete Größenverhältnisse, gespenstisch wirkende Primärfarben sowie suggestive phallische Elemente, die an die ersten linkischen Annäherungsversuche und das sexuelle Unbehagen der Pubertät erinnern. Edmiers Faszination für die Heroen seiner Kindheit führte zur Zusammenarbeit mit Evel Knievel, die eine kleinformatige Bronzeskulptur (*Evel Knievel, American Daredevil*, 1996) ergab, sowie ein neueres Werk, das einmal mehr auf seine jugendliche Begeisterung für Farah Fawcett zurückgeht. Als Edmier herausfand, dass Fawcett nicht allein eine berühmte Schauspielerin, sondern zudem praktizierende Künstlerin ist, nahm er Kontakt zu ihr auf und regte eine Zusammenarbeit an. Die erste gemeinsam geschaffene Skulptur *Untitled (Hands)*, 2000, ist eine in Marmor gemeißelte Nachbildung seiner und ihrer Hände. Mit anrührender Aufrichtigkeit verweist Edmier auf die Kluft zwischen intensiver Kindheitserfahrung und der Erinnerung des Herangewachsenen, zwischen der unqualifizierten Heldenverehrung des Jungen und der gegenseitigen Verbundenheit Erwachsener.

Qualifiées de « Réalisme sentimental », les sculptures figuratives très détaillées de Keith Edmier renvoient à des souvenirs de son enfance dans le Midwest américain des années 1970. Associant son histoire personnelle à la mémoire collective, il dilue le contenu auto-biographique de ses œuvres en y ajoutant des détails liés à des personnalités symboliques de l'histoire récente. *Beverley Edmier, 1967*, 1998, est une reconstitution grandeur nature de sa mère enceinte portant le même tailleur Chanel que Jackie Kennedy le jour de l'assassinat de son mari. *Jill Peters*, 1997/98, est un portrait en cire de son premier amour coiffée à la lionne avec la fameuse crinière à la Farah Fawcett, elle-même premier amour d'innombrables adolescents américains de la génération d'Edmier. Il se dégage une impression de vulnérabilité de ses distorsions d'échelles, très bande dessinée, de ses couleurs primaires criardes ou de ses structures phalliques suggestives qui évoquent la gaucherie et la gêne sexuelle de l'adolescence. La fascination d'Edmier pour les héros de son enfance a débouché sur sa collaboration avec Evel Knievel et un petit monument en bronze (*Evel Knievel, American Daredevil*, 1996). Elle lui a également inspiré un autre projet lié à sa passion adolescente pour Farah Fawcett. Lorsqu'il a découvert que la célèbre actrice était également une artiste plasticienne, il l'a contactée et lui a proposé une collaboration. Leur première œuvre commune, *Untitled (Hands)*, 2000, est une sculpture en marbre de leurs mains. Avec une sincérité touchante, Edmier traduit l'écart entre l'intensité de l'enfance et son souvenir à l'âge adulte, ainsi que la transformation de la vénération inconditionnelle d'un héros par un garçon en une affiliation réciproque entre adultes.

K. B.

SELECTED EXHIBITIONS →
1995 *Human/Nature*, The New Museum of Contemporary Art, New York (NY), USA **1997** University of South Florida Art Museum, Tampa (FL), USA; *Gothic*, Institute of Contemporary Art, Boston (MA), USA **1998** Sadie Coles HQ, London, UK **1999** *Abracadabra*, Tate Gallery, London, UK **2000** *Greater New York*, P.S.1, Long Island City (NY), USA; *Age of Influence: Reflections in the Mirror of American Culture*, Museum of Contemporary Art, Chicago (IL), USA **2002** *Whitney Biennial*, The Whitney Museum of American Art, New York (NY), USA

SELECTED BIBLIOGRAPHY →
1997 *Gothic*, Institute of Contemporary Art, Boston (MA); *Keith Edmier*, University of South Florida Art Museum, Tampa (FL) **1998** *Keith Edmier*, Douglas Hyde Gallery, Dublin **1999** *Abracadabra*, Tate Gallery, London; Burkhard Riemschneider/Uta Grosenick (eds.), *Art at the Turn of the Millennium*, Cologne **2000** *Greater New York*, P.S.1, Long Island City (NY)

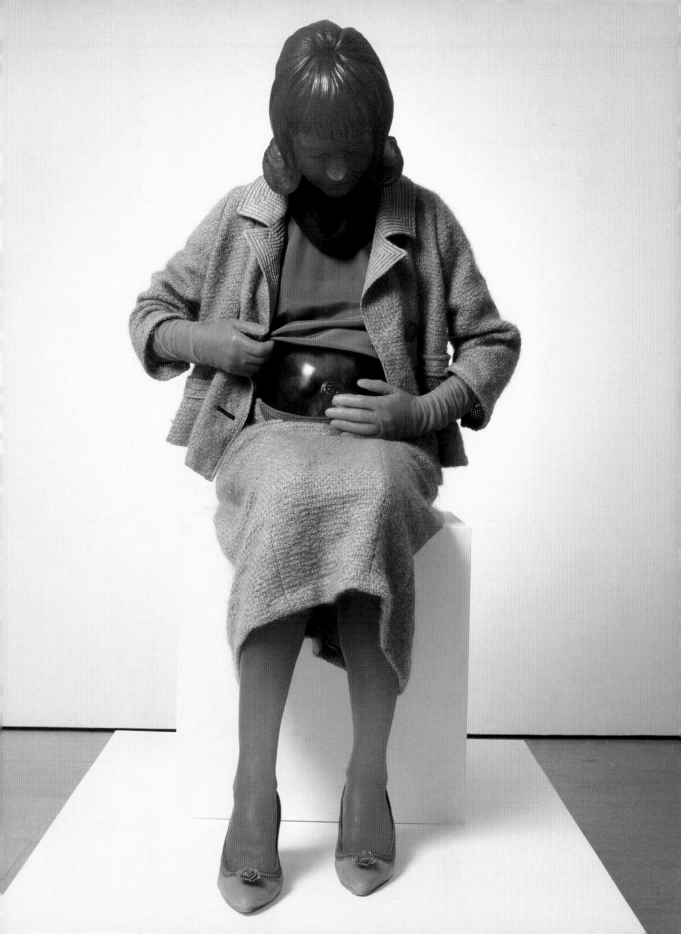

1 **Beverley Edmier, 1967,** 1998, cast resin, silicone, acrylic paint, fabric, 129 x 80 x 57 cm
2 **KE:EK,** 1997, installation view, University of South Florida Art Museum, Tampa (FL)

3 In collaboration with Farah Fawcett:
 Untitled (Hands), 2000, alabaster, wood pedestal, 36 x 18 x 17 cm
4 **Emil Dobbelstein and Henry J. Drope, 1944 – Presidential Wreath,** 2000, installation view, neugerriemschneider, Berlin

„An der Vorstellung festhalten, dass in der Kunst alles möglich ist, aber auch die Konsequenzen dieser Freiheit zu akzeptieren."

« S'en tenir à l'idée que tout est possible en art mais accepter les conséquences de cette liberté. »

"To hold on to the idea that anything is possible in art, but to accept the consequences of that freedom."

2

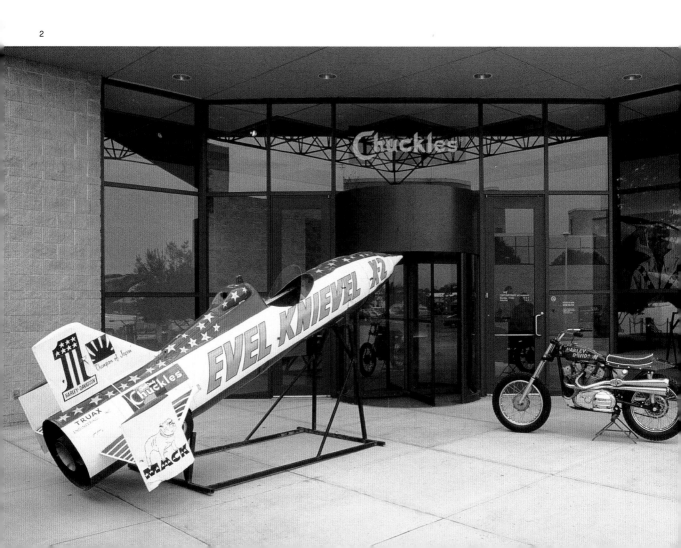

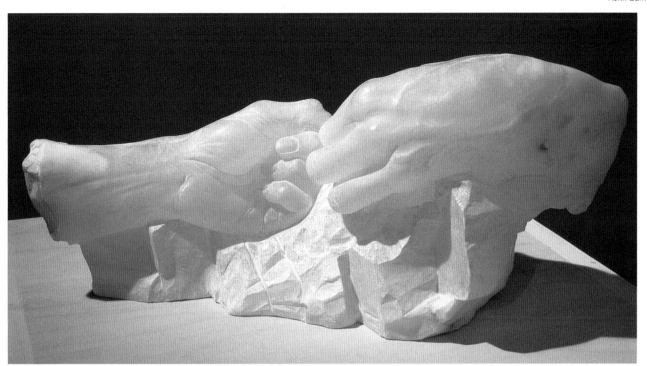

Olafur Eliasson

1967 born in Copenhagen, Denmark, lives and works in Berlin, Germany

Olafur Eliasson's work is focused on natural elements and the conditions under which they are experienced. Water, light, moss, ice, steam and rainbows are among the phenomena that have been central to his sculptural installations. In *Your strange certainty still kept*, 1996, he created an indoor waterfall and used strobe lights to make the flowing liquid appear to be suspended in mid-air. He created a similar effect in *The drop factory. A short story on your self-ref and rep*, 2000, at the Saint Louis Art Museum, in which he enclosed his water-and-strobe effects inside a dome resembling the utopian architecture of R. Buckminster Fuller as well as the igloo-shaped structures prevalent in Iceland. Mirrored panels covered the interior and exterior of Eliasson's dome, and viewers became part of its kaleidoscopic reflections. While his work is often compared to the seamless installations by Light and Space artists James Turrell and Robert Irwin, Eliasson lets viewers see the ordinary lamps, hoses, pumps and valves used to create extraordinary effects. In *Your repetitive view*, 2000, and *Your now is my surroundings*, 2000, both at a gallery in New York, Eliasson also employed mirrors to create kaleidoscopic effects. For these pieces he opened up the gallery's walls and ceiling and brought the outdoors into the space in the form of reflections of the sky and urban elements. The use of mirrors is just one of the ways Eliasson underscores the human subjectivity and individual perception at the basis of his work. Viewers are integral participants in Eliasson's sensory environments, with their roles often signaled by the word "your" in his titles.

Das Werk von Olafur Eliasson kreist um die Natur und die Bedingungen, unter denen wir sie erfahren. Wasser, Licht, Moos, Eis, Dampf und Regenbögen sind nur einige der zentralen Phänomene in seinen skulpturalen Installationen. Für *Your strange certainty still kept*, 1996, hat er einen Innenraum-Wasserfall geschaffen und Stroboskoplampen installiert, deren Licht die herabstürzende Flüssigkeit in der Luft optisch gefrieren ließ. Mit ganz ähnlichen Effekten hat er auch bei *The drop factory. A short story on your self-ref and rep*, 2000, für das Saint Louis Art Museum gearbeitet. Diesmal hat er den Wasserfall in eine Kuppel verlegt, die zugleich an die utopische Architektur eines R. Buckminster Fuller und die traditionelle isländische Iglubauweise erinnert. Eliassons Kuppel war innen und außen mit Spiegeln verkleidet, so dass der Betrachter selbst zum Bestandteil dieser kaleidoskopartigen Reflexionen wurde. Eliassons Arbeiten werden immer wieder mit den makellosen Installationen der Licht-und-Raum-Künstler James Turrell und Robert Irwin verglichen. Doch zeigt Eliasson ganz offen die profanen Lampen, Schläuche, Pumpen und Ventile, die die ungewöhnlichen Effekte erzeugen. In *Your repetitive view*, 2000, und *Your now is my surroundings*, 2000, beide ausgestellt in einer New Yorker Galerie, hat Eliasson Spiegel verwendet, um eine kaleidoskopartige Wirkung zu erzielen. Er hat für diese Werke sogar die Wände und die Decke der Galerie geöffnet und das Außen als Spiegelung der Sonne und des städtischen Umraums in den Raum hineingelenkt. Die Spiegelelemente, mit denen Eliasson arbeitet, unterstreichen die subjektive und individuelle Rezeption seiner Werke. In Eliassons sinnlichen Installationen ist der Betrachter ein unverzichtbarer Mitspieler, der in den Werktiteln durch Verwendung des Wortes „your" direkt angesprochen wird.

Le travail d'Olafur Eliasson se concentre sur les éléments naturels et les conditions sous lesquelles ils sont vécus. L'eau, la lumière, la mousse, la vapeur et les arcs-en-ciel comptent parmi les phénomènes ayant fait l'objet de ses installations sculpturales. Dans *Your strange certainty still kept*, 1996, il a créé une cascade en salle et a utilisé des lumières stroboscopiques pour donner l'illusion que le liquide était suspendu dans l'air. Il a créé un effet similaire dans *The drop factory. A short story on your self-ref and rep*, 2000, au Saint Louis Art Museum. Il a enfermé ses effets d'eau et de lumière stroboscopique sous un dôme rappelant l'architecture utopique de R. Buckminster Fuller ainsi que les structures en forme d'igloo d'Islande. Des panneaux en miroirs tapissaient l'intérieur et l'extérieur du dôme, si bien que les spectateurs devenaient partie intégrante de ses reflets kaléidoscopiques. On compare souvent son travail aux installations des artistes de la lumière et de l'espace, James Turrell et Robert Irwin, si ce n'est qu'Eliasson montre les outils ordinaires – lampes, tuyaux, pompes et valves – qu'il utilise pour créer des effets extraordinaires. Dans *Your repetitive view*, 2000, et *Your now is my surroundings*, 2000, tous deux à une galerie new-yorkaise, Eliasson emploie à nouveau des miroirs pour créer des effets kaléidoscopiques. Pour ces œuvres, il a ouvert les murs et le plafond de la galerie et amené l'extérieur à l'intérieur par l'intermédiaire des reflets du ciel et des éléments urbains. Le recours aux miroirs n'est qu'un des moyens dont il se sert pour souligner la subjectivité et la perception individuelle à la base de son travail. Les spectateurs participent intégralement à ses environnements sensoriels, leur rôle étant souvent indiqué par l'emploi du possessif « your » (le votre) dans ses titres.

Ro. S.

SELECTED EXHIBITIONS →
1998 *XXIV Bienal Internacional de São Paulo*, Brazil; *1. berlin biennale*, Berlin, Germany **1999** Dundee Contemporary Arts, Dundee, UK; Stichting De Appel, Amsterdam, The Netherlands; Kunstverein Wolfsburg, Germany; *Carnegie International*, Carnegie Museum of Art, Pittsburgh (PA), USA; *dAPERTuttO, 48. Biennale di Venezia*, Venice, Italy **2000** *Your surrounded intuition versus your intuitive surroundings*, The Art Institute of Chicago, Chicago (IL), USA; *Wonderland*, Saint Louis Art Museum, St. Louis (MS), USA

SELECTED BIBLIOGRAPHY →
1997 *Olafur Eliasson, The Curious Garden*, Kunsthalle Basel **1998** Olafur Eliasson, *USERS*, Copenhagen/Berlin **1999** *Carnegie International*, Carnegie Museum of Art, Pittsburgh (PA) **2000** *Wonderland*, Saint Louis Art Museum, St. Louis (MS)

134

1 **The mediated motion,** 2001, installation view, Kunsthaus Bregenz
2 **Orientation lights,** 1999, stainless steel, glass, striplights, colour filters, 200 x 70 x 70 cm, installation view, Zentrum für Kunst und Medien-

technologie, Karlsruhe
3 **The double sunset,** 1999, Utrecht
4 **Waterfall,** 1998, installation view, *Biennale of Sydney*, Botanical Garden

„Ich glaube, mein Begriff von Raum und Bewusstsein lässt sich nur vor dem Hintergrund meiner skandinavischen Herkunft verstehen, und ganz sicher würde die Natur für mich eine andere Rolle spielen, wenn ich zum Beispiel in New York aufgewachsen wäre."

« Je tiens sans doute ma notion de l'espace et de la conscience de mes origines scandinaves. Elle est différente du rôle que la nature jouerait dans ma vie si je venais de New York, par exemple. »

"I believe my notion of space and consciousness is derived from my Scandinavian background, and it is different from the role nature would play in my life if I were from New York, for example."

2

3

Michael Elmgreen & Ingar Dragset

Michael Elmgreen, 1961 born in Copenhagen, Denmark, and
Ingar Dragset, 1969 born in Trondheim, Norway; live and work in Berlin, Germany

Michael Elmgreen and Ingar Dragset work with space in its multiple meanings: architectural space, mental space, private space, sexual space, art space and public space. Their installations and environments are analogous with different types of behaviour. Often, their work launches a critique on the way dominant ideologies assert themselves in space. These critiques are performed in what could be called interactive works, where everyday, concrete activity is solicited or commented upon, as well as in a deconstruction of recent art history and the white cube of the gallery space viewed from different perspectives, for example gay. Gay culture has traditionally been forced to adapt settings reserved for other purposes – public toilets, bathhouses, parks – into intimate spaces. Elmgreen and Dragset go with and against this grain of gay culture. While some of their works directly solicit "illegitimate" types of behaviour, others perform crackdown on the functionality of queer coding – and queer space itself is being queered. Finding yourself in Elmgreen and Dragset's displaced ambiences is to feel the pull of your identity, irrespective of whether you are "in" or "out". Space is messed up because function is messed up. "What do you desire most?" their works seem to ask. Elmgreen and Dragset's work acknowledges that something is fundamentally wrong with the social body into which we are born, and that our ability to interpret this misfit has no fixed locus because of its global character. However, within this global dimension they also show the possibility of opening up new places for the subject, with no fixed insides or outsides.

Michael Elmgreen und Ingar Dragset arbeiten mit den vielfachen Bedeutungen räumlicher Sphären: dem architektonischen, dem Ausstellungs- und dem öffentlichen Raum, der geistigen, der sexuellen und der Privatsphäre. Ihre Installationen und Environments entsprechen bestimmten Verhaltenstypen. Vielfach üben sie in ihren Werken Kritik an dem Stellenwert, den dominante Ideologien für sich beanspruchen. Ausdruck findet diese Kritik in – wie man sagen könnte – interaktiven Arbeiten, die konkrete alltägliche Aktivitäten auslösen beziehungsweise kommentieren sollen; ferner in einer Dekonstruktion der neueren Kunstgeschichte und des weißen Kubus der Galerie aus verschiedenen Perspektiven, zum Beispiel der homosexuellen. Die Schwulen-Kultur sah sich herkömmlicherweise vor den Zwang gestellt, Örtlichkeiten, die eigentlich für andere Zwecke vorgesehen waren – öffentliche Toiletten, Badehäuser, Parks –, in intime Räume zu verwandeln. Elmgreen und Dragset akzeptieren und verwerfen zugleich diesen Zug der schwulen Kultur. Während sie in einigen ihrer Arbeiten „illegitime" Formen des Verhaltens geradezu herausfordern, lassen sie in anderen die Funktionalität der schwulen Kodierungen zusammenbrechen und untergraben gewissermaßen den „schwulen" Raum. Elmgreens und Dragsets – im buchstäblichen Sinn – deplatzierte Rauminstallationen berühren unmittelbar unsere Identität – ganz gleich, ob wir sie von „innen" oder von „außen" erleben. Der Raum erscheint chaotisch, weil auch die Funktionalität dem Chaos weichen muss. „Was wünschst du dir am meisten?" scheinen die Werke den Betrachter zu fragen. Elmgreens und Dragsets Arbeiten zeigen, dass der Gesellschaftskörper, in den wir hineingeboren werden, zutiefst gestört ist, und dass es keinen Standpunkt gibt, von dem aus sich diese Schieflage interpretieren ließe, weil es sich dabei um die allgemein gültigen Verhältnisse handelt. In dieser globalen Perspektive verweisen sie den Einzelnen zugleich auf die Möglichkeit, für sich selbst neue Orte ohne eindeutig definiertes Innen und Außen zu schaffen.

Michael Elmgreen et Ingar Dragset travaillent avec les significations multiples de l'espace : l'espace architectural, mental, privé, sexuel, artistique et public. Leurs installations et leurs environnements sont analogues à différents types de comportement. Souvent, leur travail lance une critique sur la manière dont les idéologies dominantes s'affirment dans l'espace. Ces critiques s'expriment dans ce qu'on pourrait appeler des œuvres interactives où, chaque jour, une activité concrète est sollicitée ou commentée, ainsi que dans la destruction de l'histoire de l'art récent et du cube blanc de l'espace de la galerie vue depuis différentes perspectives, par exemple, d'un point du vue gay. Traditionnellement, la culture homosexuelle a été contrainte d'adapter des décors conçus pour d'autres fonctions – toilettes publiques, saunas, parcs – en des espaces intimes. Elmgreen et Dragset vont avec et contre cette veine de la culture gay. Si certaines de leurs œuvres sollicitent directement des types « illégitimes » de comportement, d'autres démontent la fonctionnalité du codage gay. L'espace homosexuel est lui même « homosexualisé ». En vous retrouvant dans les ambiances déplacées d'Elmgreen et Dragset, vous sentez la pression sur votre identité, que vous soyez « in » ou « out ». L'espace est perturbé parce que la fonction l'est aussi. Leurs œuvres semblent demander : « Et vous? Que désirez-vous le plus? » Le travail d'Elmgreen et Dragset reconnaît que quelque chose va fondamentalement de travers dans le corps social dans lequel nous sommes nés, et que notre capacité à interpréter cette mauvaise donne n'a pas de lieu précis en raison de sa nature globale. Toutefois, au sein de cette dimension globale, il montre également qu'il est possible d'ouvrir de nouveaux espaces pour le sujet, sans intérieurs ni extérieurs déterminés.

L. B. L.

SELECTED EXHIBITIONS →
1999 *Powerless Structures, fig. 57–60*, The Project, New York (NY), USA
2000 *Zwischen anderen Ereignissen*, Galerie für Zeitgenössische Kunst, Leipzig, Germany; *What if*, Moderna Museet, Stockholm, Sweden **2001** *Taking Place*, Kunsthalle Zürich, Zurich, Switzerland; *A Room Defined by its Accessibility*, Statens Museum for Kunst, Copenhagen, Denmark; *Powerless Structures, fig. 111*, Portikus, Frankfurt am Main, Germany; *7th Istanbul Biennial*, Istanbul, Turkey **2002** Sala Montcada/Fundació "la Caixa", Barcelona, Spain; *XXV Bienal Internacional de São Paulo*, Brazil; Palais de Tokyo, Paris, France

SELECTED BIBLIOGRAPHY →
2000 *Zwischen anderen Ereignissen*, Galerie für Zeitgenössische Kunst, Leipzig **2001** *A little bit of history repeated*, Kunst-Werke Berlin; *Taking Place*, Kunsthalle Zürich, Zurich; Witte de With, Center for Contemporary Art, Rotterdam

1 **Powerless Structures, fig. 111,** 2001, 4.80 x 7.50 x 15 m, Portikus, Frankfurt am Main
2 **Powerless Structures, fig. 21 (Queer Bar),** 1998, MDF, spray paint, beer taps, bar stools, 1.20 x 3 x 3 m
3 **Powerless Structures, fig. 146 (Elevated Gallery),** 2001, installation view, Statens Museum for Kunst, Copenhagen

4 **Traces of a Never Existing History/Powerless Structures, fig. 222,** 2001, wood, steel, profile letters, plexi glass, aluminium, paint, 3.10 x 4.30 x 7.80 m, installation view, *7th Istanbul Biennial*, Istanbul
5 **Powerless Structures, fig. 11,** 1997, MDF, spray paint, blue vinyl, aluminium ladder, 65 x 85 x 220 cm

„Jede Struktur lässt sich verändern oder austauschen."

« Toute structure est modifiable, échangeable ou interchangeable. »

"Any structure can be altered, exchanged or interchanged."

2

3

4

5

Tracey Emin

1963 born in London, lives and works in London, UK

Provocation and scandal seem predetermined wherever she turns up. Yet in recent years Tracey Emin's appearances, frequently dressed in her friend Vivienne Westwood's designs, have been so diverse that her range can only be described as wide and impressive. For the Turner Prize nomination in 1999 she exhibited *My Bed,* malodorous and rumpled after a week's illness, with all the paraphernalia she had used in it – books, bottles, cigarette butts, condoms and handkerchiefs – making a direct emotional communication with the observer. Feelings are important to her, and a desire that nobody is left unmoved by her art. Her life as a ready-made object, her private universe, her excesses, her failures and her loves are relentlessly spread out, exhibited and examined. Emin takes as her theme statements about herself and her relationships, her life, body and feelings in such an open and shocking manner that the public, faced with this excess of exhibitionism, generally reacts with unease, shame, anger or grief. Nevertheless, the honesty and authenticity with which Emin confronts her everyday traumas can hardly be described as exaggerated; rather, they issue from a remarkable sensitivity and sense of the aesthetic – rare virtues in our era of endemic superficiality. *Helter fucking skelter,* 2001, is a stage for her emotions, adrift on a never-ending ride in the funfair of life: her joys and heartbreaks, her fate both as a celebrity in the art world and in her private relationships. Emin's skill at illustrating the undepictable with her installations, stories, drawings, sculptures, embroideries and films is continually accompanied by sentimentality and passion. However, she truly believes that there is a powerful dimension to art, which pukes at all that is profane and uncertain.

Wo immer sie auftaucht, scheinen Provokation und Skandal vorprogrammiert. Dabei ist Tracey Emin in den letzten Jahren derart unterschiedlich aufgetreten, bisweilen ausstaffiert von ihrer Freundin Vivienne Westwood, dass ihr enormes Spektrum als schillernd bezeichnet werden muss. Bei der Turner-Prize-Nominierung 1999 stellte sie *My Bed,* ihr nach einer Woche Krankheit übel riechendes und zerwühltes Bett samt aller darin benutzten Utensilien wie Bücher, Flaschen, Zigarettenkippen, Kondome, Taschentücher aus – eine unmittelbare Übertragung ihrer Gefühle auf den Betrachter. Emotionen sind ihr wichtig, denn kalt lässt diese Kunst niemanden. Es sind ihr Leben als Ready-Made, ihre Privatsphäre, ihre Exzesse, ihr Scheitern und ihre Liebe, die ständig ausgebreitet, vorgeführt und überprüft werden. Emin thematisiert Stellungnahmen zu ihrer Person und ihren Beziehungen, ihrem Leben, Körper und ihren Gefühlen derart offen und schockierend, dass das Publikum vor soviel Exhibitionismus zumeist nur Beklemmung, Scham oder Wut und Trauer befällt. Gleichwohl sind ihre Ehrlichkeit und Authentizität gegenüber den Traumata ihres Alltags kaum überzogen zu nennen, sondern vielmehr ästhetisch und erstaunlich sensibel – seltene Qualitäten in einer von Oberflächlichkeiten geprägten Zeit. Mit *Helter fucking skelter,* 2001, inszeniert sie ihre Affekte als endlose Rutsche auf dem Rummelplatz des Lebens: ihre Freude und Tragik, ihr Schicksal als öffentliche Berühmtheit der Kunstwelt und ihre privaten Beziehungen. Emins Fähigkeit, das Nichtabbildbare in Installationen, Erzählungen, Zeichnungen, Skulpturen, Stickereien oder Filmen zu zeigen, wird permanent von ihrer eigenen Sentimentalität und Leidenschaft unterlaufen. Aber sie glaubt an eine kraftvolle Dimension in der Kunst, die jede profane Beliebigkeit absolut zum Kotzen findet.

Partout où elle passe, la provocation et le scandale semblent programmés d'avance. Il reste que les apparitions de Tracey Emin – parfois habillée par son amie Vivienne Westwood – ont été ces dernières années si diverses que l'immense éventail de ses possibilités doit être qualifié de stupéfiant. Lors de la remise du Prix Turner en 1999, elle expose *My Bed,* son lit défait, malodorant suite à une semaine d'alitement, y compris tous les objets utilisés pendant la maladie – livres, bouteilles, mégots, préservatifs, mouchoirs –, transmission directe de ses sentiments au spectateur. Les émotions jouent un rôle capital pour elle. L'artiste ne laisse personne indifférent : ce sont sa vie comme ready-made, sa sphère privée, ses excès, ses échecs et ses amours, qui sont sans cesse exhibés, présentés, vérifiés. Emin dépeint des prises de positions sur sa propre personne ; ses relations, sa vie, son corps et ses sentiments sont mis à nu de manière si ouverte et choquante que le public n'en ressent souvent que gêne, honte, rage ou tristesse. Cependant, sa sincérité et l'authenticité dont elle fait preuve face aux traumas de sa vie quotidienne ne peuvent guère être qualifiés d'inflationnistes, ils sont plutôt esthétiques et d'une sensibilité frappante – qualités rares à une époque empreinte de superficialité. Avec *Helter fucking skelter,* 2001, elle met en scène ses affects perdus comme un interminable toboggan sur la foire d'empoigne de la vie : ses joies, sa tragédie, son destin comme célébrité du monde de l'art et dans ses relations privées. La capacité d'Emin à montrer l'irreprésentable dans ses installations, ses récits, dessins, sculpture, broderies ou ses films, est sans cesse sapée par sa sentimentalité et sa passion. Elle croit cependant à une dimension puissante dans l'art, qui vomit tout arbitraire profane. G. J.

SELECTED EXHIBITIONS →
1998 *Sobasex (My Cunt is Wet with Fear),* Sagacho Exhibition Space, Tokyo, Japan **1999** *Every Part of Me's Bleeding,* Lehmann Maupin, New York (NY), USA; *Hundstage,* Gesellschaft für Aktuelle Kunst, Bremen, Germany; *The Turner Prize Exhibition,* Tate Gallery, London, UK **2000** *Nurture and Desire,* Hayward Gallery, London, UK; *Diary,* Cornerhouse, Manchester, UK; *The British Art Show 5,* Hayward Gallery, London, UK **2001** *You forgot to kiss my soul,* White Cube, London, UK; *Century City,* Tate Modern, London, UK

SELECTED BIBLIOGRAPHY →
1994 *Exploration of the Soul,* London **1997** *Always Glad to See You,* London **1998** *Tracey Emin. Holiday Inn,* Gesellschaft für Aktuelle Kunst, Bremen **2000** *Diary,* Cornerhouse Manchester **2001** *Century City,* Tate Modern, London; Uta Grosenick (ed.), *Women Artists,* Cologne

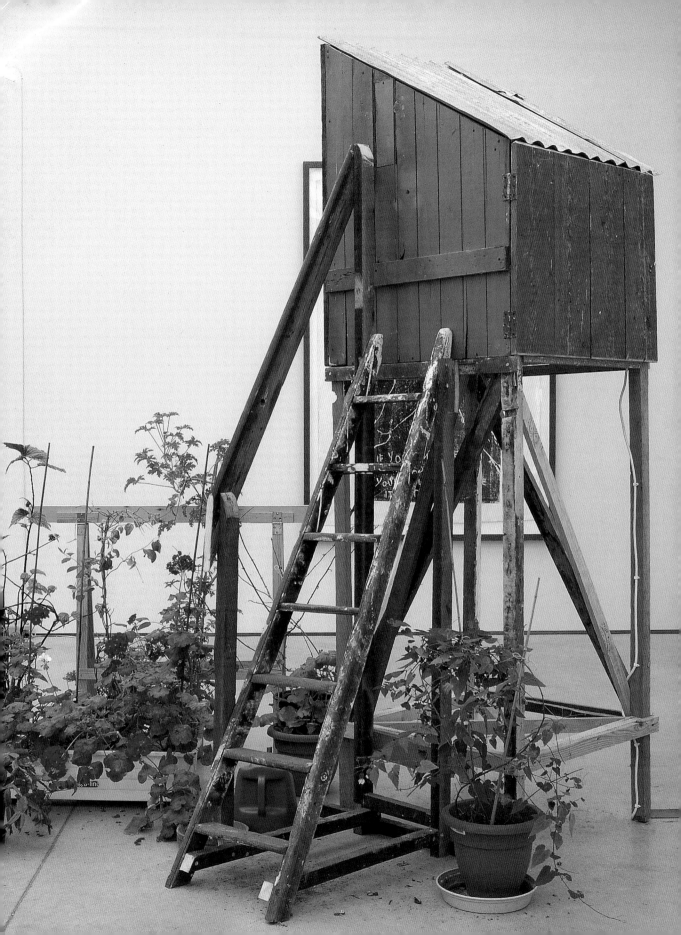

1 **The Perfect Place to Grow,** 2001, wooden birdhouse, DVD, monitor, trestle, plants, wooden ladder, 261 x 83 x 162 cm
2 Installation view, *The Turner Prize Exhibition,* Tate Gallery, London, 1999

3 **Sometimes ...,** 2001, c-type print mounted on foam board, 101 x 168 cm
4 Installation view, *You forgot to kiss my soul,* White Cube[2], London, 2001; foreground: **Upgrade,** 2001, papier-maché concorde, wood and metal stand, 160 x 110 x 75 cm

„Zeitlebens habe ich eine schwere Last mit mir herumgetragen. Auch wenn sie heute immer noch da ist, bedrückt sie mich nicht mehr so sehr."

« J'ai eu toute ma vie une grosse puce électronique sur les épaules. Je l'ai encore aujourd'hui, mais elle ne m'écrase plus. »

"I've had a big chip on my shoulder all my life. I've still got it but now it's not weighing me down."

2

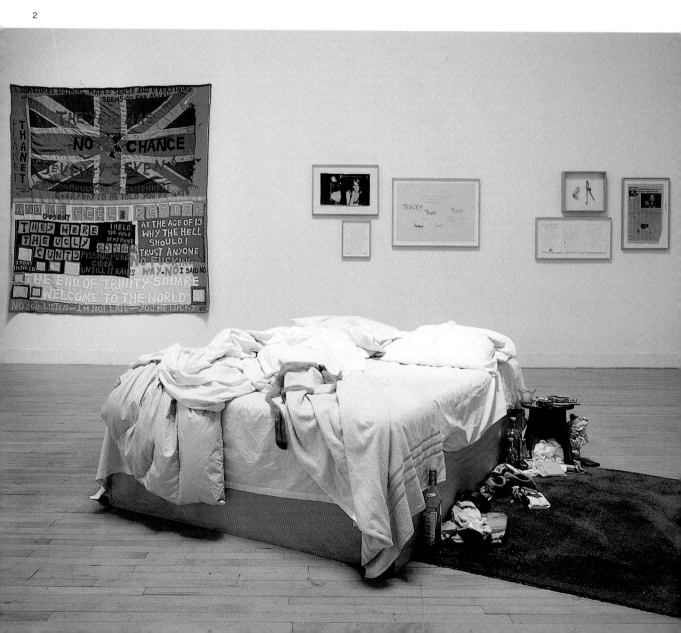

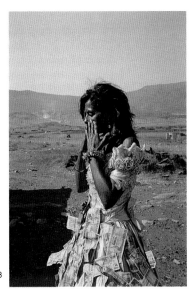

3

4

Ayşe Erkmen

1949 born in Istanbul, lives and works in Istanbul, Turkey, and Berlin, Germany

For a month in 2001 three ferry boats from Istanbul, Venice and the Japanese city of Shingu shuttled back and forth across the River Main in Frankfurt. *Shipped Ships* was a "choreography of interconnecting cultures in the heart of a multinational metropolis", through which Ayşe Erkmen breathed new life into what was once a vital line of communication for the city. Born in Istanbul, the video video artist and sculptor lives in the great Turkish city and in Berlin. Her first solo exhibition in the West was in Berlin in 1993. Erkmen confronts the viewer with unexpected situations, allusively and playfully linking art to its environment. Her works only last as long as the exhibition. They cannot be collected because they are specific to time and place. Hence, each one is different from the rest. "The approach to the object creates the image," says Erkmen. She believes that problems are overcome by thinking about them, and ultimately rising above them. When the Catholic Church disapproved of her contribution to *Skulptur. Projekte, in* Münster/*Sculpture, the Münster Projects,* 1997, Erkmen took evasive action by displaying it up in the air, dangling from a helicopter. A series of stone sculptures from the collections of the regional museum swooped over the city centre, recalling the opening scene of Federico Fellini's film "La Dolce Vita", in which a figure of Christ attached to a helicopter flies above Rome. But, as Erkmen points out, art is not just about ideas. "Everyone has good ideas now and then," she says. "They have to be given time to develop them."

In Frankfurt pendelten im Jahr 2001 einen Monat lang drei Fähren aus dem türkischen Istanbul, dem italienischen Venedig und dem japanischen Shingu über den Main. *Shipped Ships* war eine „Choreografie sich kreuzender Kulturen im Herzen einer multinationalen Metropole", deren ehemalige Lebensader, der Main, von Ayşe Erkmen wieder zu neuem Leben erweckt wurde. Geboren in Istanbul, lebt die türkische Videokünstlerin und Bildhauerin in Berlin und in der türkischen Metropole; ihre erste Einzelausstellung im Westen hatte sie 1993 in der deutschen Hauptstadt. Erkmen konfrontiert den Betrachter ihrer Werke mit unerwarteten Situationen. Dafür bezieht sie die jeweilige Umgebung mit in ihre Arbeit ein, assoziativ und spielerisch. Das Werk besteht, solange die Ausstellung dauert. Sammeln kann man ihre Arbeiten nicht, weil sie orts- und zeitgebunden sind. Auch deswegen sieht auch jede Arbeit von ihr anders aus. „Der approach zum Objekt macht das Bild", sagt Erkmen. Probleme werden überwunden, indem man sie überdenkt und, schlussendlich, überfliegt. Da die katholische Kirche ihrem Beitrag für *Skulptur. Projekte,* in Münster 1997 nicht zustimmte, wich Erkmen mit ihrer Präsentation in den Luftraum aus. Von einem Hubschrauber in die Höhe gezogen, schwebte eine Reihe von steinernen Skulpturen aus dem Depot des Landesmuseums über die Innenstadt. Eine Szene wie in Federico Fellinis Film „La Dolce Vita", in dessen Anfangssequenz eine an einem Hubschrauber befestigte Christus-Figur über Rom schwebt. Doch es geht in der Kunst nicht um Einfälle, wie Erkmen weiß: „Alle haben hin und wieder gute Einfälle", meint sie. „Man muss ihnen Zeit geben, sich zu entwickeln."

En 2001, pendant un mois, trois bateaux reliaient les deux rives du Main à Francfort : l'un venait d'Istanbul en Turquie, les deux autres respectivement de Venise et de Shingu, au Japon. *Shipped Ships* se voulait une « chorégraphie de cultures se croisant au cœur d'une métropole internationale » dont le fleuve, ancienne artère vitale, se voyait rendu à une nouvelle vie par Ayşe Erkmen. Née à Istanbul, la vidéaste et sculptrice turque vit à Berlin et dans la métropole turque ; sa première exposition en Europe de l'Ouest avait été organisée en 1993 dans la capitale de l'Allemagne réunifiée. Erkmen met les spectateurs de ses œuvres face à des situations inattendues qui intègrent l'environnement de manière associative et ludique. Ses œuvres ne durent que le temps de leur exposition et ne peuvent donc être collectionnées, car elles sont liées au lieu et au moment. C'est d'ailleurs pour cette raison que ses projets ne se ressemblent jamais. « C'est l'approche de l'objet qui produit l'image », dit Erkmen. On ne surmonte les problèmes qu'en les pensant dans leur globalité, et en définitive, en les survolant. Face au refus de l'Eglise catholique d'exposer sa contribution à *Skulptur. Projekte,* in Münster 1997, Erkmen déplaçait sa présentation vers l'espace aérien. Elevées dans les airs par hélicoptère, une série de sculptures sorties du dépôt du Landesmuseum restèrent suspendues dans le ciel au-dessus du centre-ville : une scène comme dans la « Dolce vita » de Federico Fellini, dont les premiers plans montrent un Christ suspendu à un hélicoptère au-dessus de Rome. Mais l'art n'est pas une question d'idées, comme le sait Erkmen : « Tout le monde peut avoir une bonne idée de temps à autre », déclare-t-elle, « il faut lui donner le temps de se développer. »

F. F.

SELECTED EXHIBITIONS →
1989 *2nd Istanbul Biennial,* Istanbul, Turkey **1993** *Das Haus,* DAAD galerie, Berlin/*Zum Haus,* Galerie von der Tann, Berlin, Germany **1996** *Portiport* (with Andreas Slominski), Portikus, Frankfurt am Main, Germany **1997** *Skulptur. Projekte,* Münster, Germany **2000** *man muss ganz schön viel lernen, um hier zu funktionieren,* Frankfurter Kunstverein, Frankfurt am Main, Germany; *Biennale Montreal,* Canada; *Kwangju Biennale,* South Korea **2001** *Shipped Ships,* Deutsche Bank, Frankfurt am Main, Germany

SELECTED BIBLIOGRAPHY →
1996 *ZuSpiel,* Portikus, Frankfurt am Main **1996** *Manifesta I,* Museum Boijmans Van Beuningen, Rotterdam **1997** Klaus Bußmann/Kasper König/Florian Matzner (eds.), *Skulptur. Projekte,* Münster **2001** Ayşe Erkmen – *Shipped Ships,* Deutsche Bank, Frankfurt am Main

1 **Sculptures on Air,** 1997, helicopter carries various sculptures from storage outside the city via the dome area over the roof of the Westfälisches Landesmuseum, installation view, *Skulptur. Projekte,* Münster

2 **Shipped Ships, Die Defterdar auf dem Weg nach Frankfurt/M.,** 2001, Moment Deutsche Bank, Frankfurt am Main

3 **Shipped Ships,** 2001, Moment Deutsche Bank, Frankfurt am Main

4 **Wertheim ACUU,** goods lift, continously moving up and down, installation view, *4th Istanbul Biennial,* 1995

„Ein Werk sollte ebenso wirklich wie seriös sein.
Das schließt einen ästhetischen Aspekt ein."

« L'œuvre devrait être aussi authentique que sérieuse
ce qui inclut une dimension ésthetique. »

"A work should be as authentic as it is serious, and that includes the aesthetic side."

2

3

4

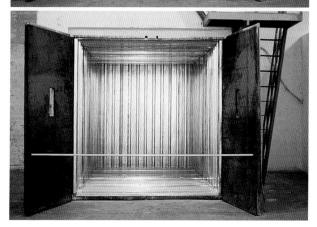

Malachi Farrell

1970 born in Dublin, Ireland, lives and works in Paris, France

Malachi Farrell's oversized installations are distinguished by their technoidal character as well as their criticisms of civilisation. His creations, sometimes difficult to make sense of, at other times clearly structured, are always full of narrative, telling their simple and oppressive tales at various levels. It takes no more than a glance at his works to see Farrell's head-on clashes with historic, political, social and ecological problems. His work *Fish Flag Mourant – Black Kettle*, 1998, for example, consists of countless metal fish lying on the floor. Their shimmering bodies are oddly covered in national flags and the fins flap mechanically in their death throes. Electronic music resounds while the "dying fish" keep moving, computer-driven in what seems like chaotic unevenness. The floor of the room is covered in an acidic solution with a black bed in the middle from which the grotesque head of a robot peeks out. Thus, he highlights the destruction of the marine habitat as the result of the recklessness of global trade. *The Shops are Closed*, 1994–2000, raises the question of surveillance by the media and the discipline of subjugation. Eight white plastic tubes attached to aluminium bars swing to the merciless beat of a military march. Once again this mechanical ballet is controlled by a computer but this time the tubes move, like symbolic governors for modern man, at such repetitive and regular intervals that a dull feeling of control and absolute subordination sets in.

Die raumfüllenden Installationen von Malachi Farrell zeichnen sich durch ihren technoiden, gleichzeitig zivilisationskritischen Charakter aus. Seine mal eher unübersichtlichen, mal klar strukturierten Arrangements sind stets überaus narrativ angelegt und erzählen auf unterschiedlichen Ebenen ihre simplen, immer auch beklemmenden Geschichten. So zeigen sie spätestens auf den zweiten Blick die irritierende Auseinandersetzung von Farrell mit historischen, politischen, sozialen und ökologischen Problemen. Die Arbeit *Fish Flag Murant – Black Kettle*, 1998, etwa besteht aus unzähligen auf dem Boden liegenden Fischen aus Metall. Ihre schillernden Körper sind mit Nationalflaggen verfremdet, die Flossen klappern mechanisch im Todeskampf. Elektronische Musik erklingt, dazu bewegen sich die „Sterbenden" computergesteuert in scheinbar chaotischer Unregelmäßigkeit. Der Boden des Raumes ist zudem mit einer säurehaltigen Lauge bedeckt, in deren Mitte ein schwarzes Bett steht, aus dem ein grotesker Roboterkopf lugt. Die Zerstörung des Lebensraumes Meer durch rücksichtslosen globalen Handelsverkehr steht hier zur Diskussion. In *The Shops are Closed*, 1994–2000, beschäftigte sich der Künstler mit medialer Überwachung und strikter Gleichschaltung. Hier schwingen acht weiße Plastikröhren, aufgehängt an Aluminiumstangen, im gnadenlosen Takt eines Militärmarsches. Auch dieses mechanische Ballett wird computergesteuert, diesmal aber bewegen sich die Rohre als symbolische Statthalter für den modernen Menschen so repetitiv und regelmäßig, dass sich das dumpfe Gefühl von Kontrolle und absoluter Unterordnung einstellt.

Les installations globales de Malachi Farrell se distinguent à la fois par leur caractère technoïde et leur critique de la civilisation. Ses arrangements tantôt foisonnants, tantôt clairement structurés, dénotent une tendance largement narrative et racontent à différents niveaux leurs histoires simplettes, mais toujours oppressantes. Ainsi, au plus tard au deuxième regard, on y perçoit le travail irritant de Farrell sur les questions historiques, politiques, sociales et écologiques. *Fish Flag Murant – Black Kettle*, 1998, consiste par exemple en d'innombrables poissons de métal étalés au sol. Leurs corps chatoyants sont affublés de drapeaux nationaux, les nageoires s'agitent mécaniquement dans la lutte contre la mort. On entend une musique électronique, tandis que les « mourants » asservis par ordinateur s'agitent dans un chaos apparent. Le sol de la salle est en outre couvert d'un liquide saumâtre au centre duquel se dresse un lit noir d'où sort une tête de robot grotesque. La destruction de l'espace vital maritime par un transit commercial mondial sans scrupules est ici mis au débat. *The Shops are Closed*, 1994–2000, traite de la surveillance médiatique et du strict nivellement. Huit tubes en plastique suspendus à des baguettes d'aluminium se balancent au rythme implacable d'une marche militaire. Ce ballet mécanique est lui aussi asservi par ordinateur. Ici, les tubes, représentants symboliques de l'homme moderne, se meuvent cependant de manière si répétitive et régulière que l'on en retire le sentiment confus d'une prise de contrôle et d'une soumission absolues.

R. S.

SELECTED EXHIBITIONS →
1997 *Hooliganism*, Galerie Anne de Villepoix, Paris, France
1999 *Pow*, Emanuel Walter Gallery, The San Francisco Art Institute, San Francisco (CA), USA; capcMusée d'Art Contemporain, Bordeaux, France; *SansSouci*, Badischer Kunstverein, Karlsruhe, Germany
2002 Galerie Xippas, Paris, France; *Expo 02*, Exposition Nationale Suisse, Biel-Bienne, Switzerland; Simulis, Forum Culturel de Blanc-Mesnil, France

SELECTED BIBLIOGRAPHY →
1996 *Fin de Siècle*, Casco, Utrecht **1998** *Do all oceans have walls?*, Gesellschaft für Aktuelle Kunst/Galerie im Künstlerhaus, Bremen **2000** *Epiphanie*, S.M.A.K. – Stedelijk Museum voor Actuele Kunst, Ghent **2001** *Neue Welt*, Frankfurter Kunstverein; *Le Ludique*, Musée de Québec; *Give them an inch and they take a mile*, Contemporary Art Center, Delme

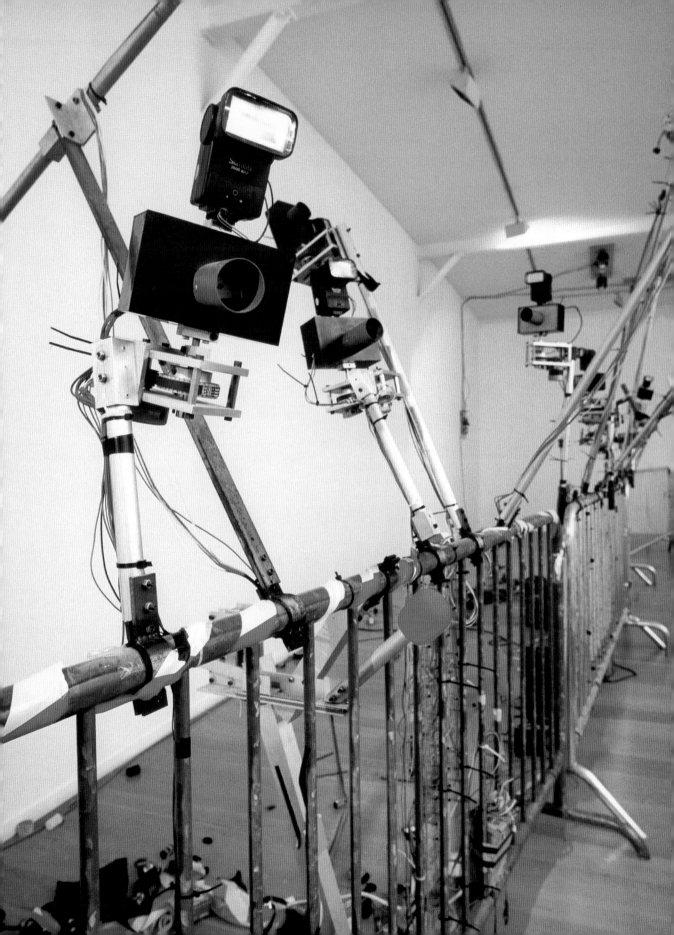

1 **Interview (Paparazzi),** 2000, camera flashes, microphones, aluminium, plastic, sound, motors, computers, steel barriers, electronics, bakelyte, CD player, dimensions variable, installation view, *Qu'est-ce qui se passe chez Xippas*, Galerie Xippas, Paris

2 **Fish Flag Mourant,** 1998–2000, motors, plastic, aluminium, cables, garbage, sound, computer, stereo, gear, boxes, CD player, electronics, dimensions variable, installation view, *Qu'est-ce qui se passe chez Xippas*, Galerie Xippas, Paris

3 **Hooliganism,** 1997, motors, plastic, aluminium, cans, cables, wood, metal blades, clothes, fake money, plastic bottles, monster, soccer ball, sound machine, computers, gear boxes, electronics, CD player, dimensions variable, installation view, MAC – Musée d'Art Contemporain, Marseille

„Trotz offensichtlicher Organisation lässt sich nicht alles kontrollieren." « Malgré une évidente organisation, il est impossible de tout contrôler. »

"Despite obvious organisation, not everything can be controlled."

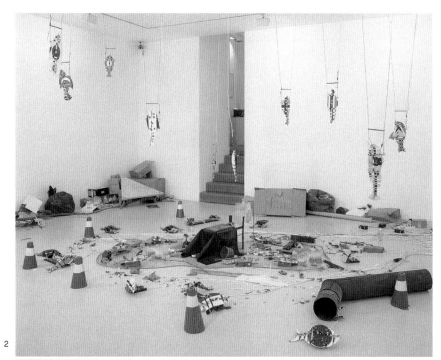

2

2

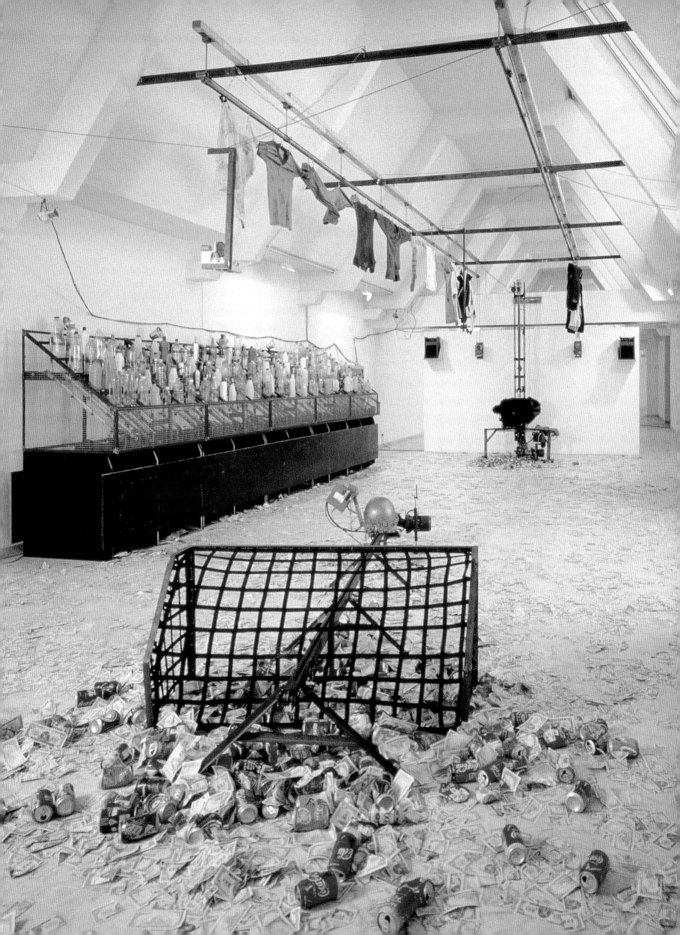

Sylvie Fleury

1961 born in Geneva, lives and works in Geneva, Switzerland

The overture to Sylvie Fleury's work in the early 1990s consisted of careful arrangements of designer label shopping bags or expensive cosmetics packaging. Some early critics interpreted this as a commentary on our consumer society's merchandising fetish. The presentation of these early works already seemed to suggest a profound sympathy with the aesthetics of Pop Art and Minimalism. Fleury moved on rapidly, appropriating the well-known works of male artists by producing obvious copies on which she applied fake fur, which endowed her imitations with a dash of visual and tactile seductiveness. By the late 1990s Fleury had extended the scope of her multi-layered imagery to encompass disparate, sometimes typically "masculine" domains, like motor sports and customised limousines. The increasing complexity of her work, in which various aesthetic sensibilities and fields of reference overlap, makes it difficult to predict Fleury's future artistic development. With her latest works and exhibition projects Fleury gives the impression that she no longer desires to be identified with the cliché of the photogenic "Material Girl". The letters *S. F.* – which could either be read as the artist's initials or the abbreviation for Science Fiction – form the title of her first major exhibition this century, in which she articulates her fascination with Zen, New Age and other spiritual systems. In interviews, Fleury has often emphasised the term "vehicle" to describe her works. Beginning with the body, which serves as a vehicle for the soul, Fleury today also considers shoes, cars and space rockets as instruments of propulsion, both spiritual and physical.

Arrangements aus glamourösen Designer-Einkaufstüten oder Verpackungen von Luxus-Kosmetika bildeten Anfang der neunziger Jahre den Auftakt zum Werk von Sylvie Fleury, das einigen Kritikern zunächst als Kommentar zum Warenfetischismus einer Konsumgesellschaft erschien. Schon in den Präsentationen dieser frühen Arbeiten schwang immer auch ein genaues Wissen um die künstlerischen Ästhetiken von Pop- und Minimal-Art mit. Wenig später ging Fleury dazu über, sich bekannte Werke männlicher Künstlerkollegen durch offenkundige Imitationen anzueignen, und verlieh diesen durch die Verwendung von Kunstfell einen nicht nur visuell, sondern auch haptisch verführerischen „Touch". Ende der neunziger Jahre griff Fleury mit ihren vielschichtigen Bildwelten in unterschiedliche, teils klassisch „männliche" Domänen, wie etwa die des Motorsports und des „Customising" von Straßenkreuzern, über. Die zunehmende Komplexität ihres Werkes, in dem sich verschiedene Ästhetiken und Bezugsfelder überlagern, macht Fleurys künstlerische Entwicklung schwer vorhersehbar. Ihre jüngsten Arbeiten und Ausstellungsprojekte erwecken den Eindruck, dass Fleury nicht (mehr) auf das Klischee eines fotogenen „Material Girl" festgelegt werden möchte. *S. F.* – lesbar als Initialen der Künstlerin, aber auch als Abkürzung für Sciencefiction – lautet der Titel ihrer ersten großen Ausstellung im neuen Jahrhundert, in der sich ihr Interesse für Zen, Newage und andere spirituelle Techniken artikuliert. In Interviews hob Fleury mehrfach die Bedeutung des Begriffs „Vehikel" für ihre Arbeiten hervor: Angefangen beim Körper, der als Vehikel für den Geist dient, sieht Fleury heute auch Schuhe, Autos und Raketen als Instrumente einer nicht allein physischen, sondern auch spirituellen Fortbewegung.

Les arrangements de sacs glamoureux ou d'emballages de cosmétiques de luxe ont marqué le coup d'envoi de l'œuvre de Sylvie Fleury au début des années 90, un coup d'envoi que certains critiques ont d'abord lu comme un commentaire sur le caractère fétichiste de la société de consommation. La présentation de ces premières œuvres procédait toujours d'une connaissance approfondie des esthétiques du Pop Art et du Minimal Art. Un peu plus tard, par des imitations évidentes, Fleury s'attache à s'approprier les œuvres célèbres de collègues masculins et leur confère un « touch » de séduction visuelle, mais aussi tactile, avec l'utilisation de fourrure synthétique. A la fin des années 90, Fleury étend ses mondes iconiques polysémiques à différents domaines considérés comme classiquement « masculins », notamment ceux du sport automobile et de la « personnalisation » des voitures de luxe. La complexité croissante d'un travail où se superposent différentes esthétiques et champs référentiels, rend aujourd'hui l'évolution artistique de Fleury moins prévisible. Ses œuvres et projets d'expositions les plus récents éveillent le sentiment que l'artiste ne veut pas (ou plus) être identifiée au cliché de la photogénique « material girl ». *S. F.*, qu'on peut lire comme les initiales de l'artiste, mais aussi comme l'abréviation de « science fiction », est le titre de la première grande exposition de l'artiste en ce nouveau siècle. Fleury y articule sa fascination pour le zen, le New Age et d'autres techniques spirituelles. Dans ses interviews, Fleury a souligné à plusieurs reprises l'importance de la notion de « véhicule » pour ses œuvres : à commencer par le corps, véhicule de l'esprit. Fleury considère aussi les chaussures, les voitures et les fusées comme les instruments d'un mouvement de nature non seulement physique, mais aussi spirituelle.

B. H.

SELECTED EXHIBITIONS →
1998 *XXIV Bienal Internacional de São Paulo*, Brazil **1999** Galerie Art & Public, Geneva, Switzerland; Ace Gallery, New York (NY), USA; *oh cet écho! (duchampiana)*, Musée d'Art Moderne et Contemporain, Geneva, Switzerland; *Heaven*, Kunsthalle Düsseldorf, Germany **2000** *John Armleder & Sylvie Fleury*, Kunstmuseum St. Gallen, Switzerland; *What if*, Moderna Museet, Stockholm, Sweden **2001** Museum für neue Kunst, Zentrum für Kunst und Medientechnologie, Karlsruhe, Germany

SELECTED BIBLIOGRAPHY →
1998 *Sylvie Fleury. First Spaceship On Venus And Other Vehicles*, XXIV Bienal Internacional de São Paulo; *Close Encounters/Contacts Intimes*, The Ottawa Art Gallery, Ottawa **1999** *Sylvie Fleury*, Ostfildern-Ruit **2001** *S. F.*, Museum für neue Kunst, Zentrum für Kunst und Medientechnologie, Karlsruhe

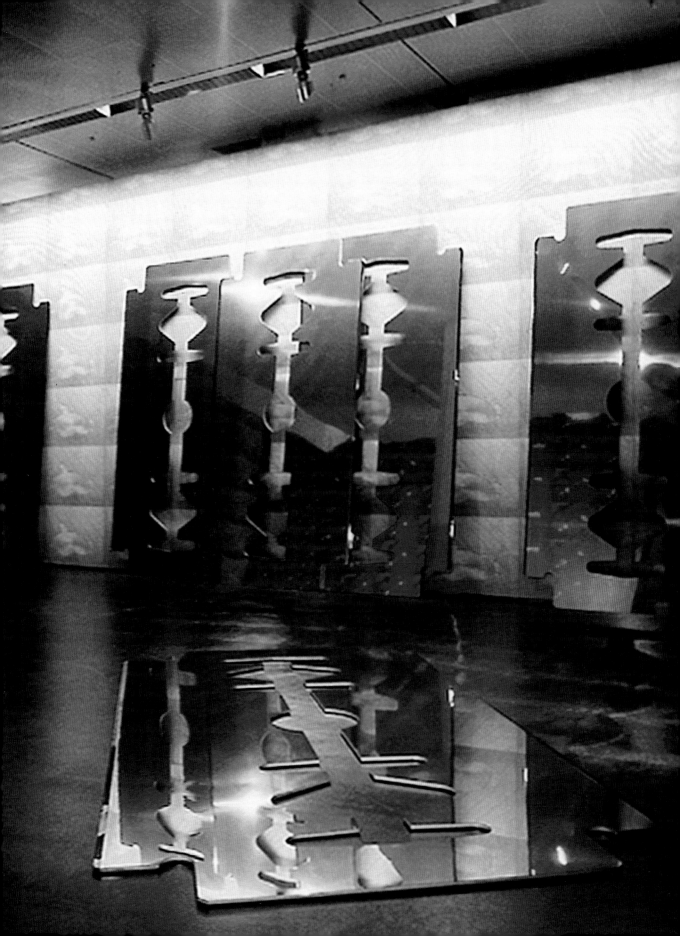

154

1 **Razor Blade,** 2001, aluminium, stainless steel, 8 parts, each
 290 x 145 x 1 cm, installation view, Museum für neue Kunst, Zentrum
 für Kunst und Medientechnologie, Karlsruhe
2 *Sylvie Fleury/John Armleder,* installation view, Kunstmuseum St. Gallen,
 2000

3 **Dog Toy 4 (Gnome),** 2000, styrofoam, paint, 190 x 170 x 150 cm
4 **Ford Cosworth DFV,** 2000, verchromte Bronze, 60 x 65 x 50 cm
5 Installation view, *Sylvie Fleury/John Armleder,* Kunstmuseum St. Gallen,
 2000; foreground: **Spring Summer 2000 (blue),** 2000; **Spring Summer
 2000 (orange),** 2000; background, **Skin Crime 2 (Givenchy 601),** 1997

„Ich zwinge die Betrachter zu genießen!
Was auch immer sie tun müssen, um ihre Kicks zu kriegen."

« J'oblige le spectateur à prendre du plaisir !
Quoi qu'il doive faire pour prendre son pied. »

"I urge the audience to enjoy!
Whatever they must do to get their kicks."

2

3

4

5

Tom Friedman

1965 born St. Louis (MO), lives and works in Northampton (MA), USA

Seen in profile, the face has a strangely classical expression. But this is not a Roman coin engraved with Caesar's countenance; it's Tom Friedman's self-portrait carved in an aspirin (*Untitled*, 1993/94). The material is fragile and the labour-intensive technique has more in common with an amateur modelmaker's skill than with the mythologised effort of grand sculpture. But Friedman's works raise the fundamental questions that a maker of artistic objects faces today. How should you determine the artefact's scale in relation to "real" objects? How durable should an artistic creation be in the midst of so many non-durable items? How significant is the effort put into creating a unique work of art in the face of the principle of mass production of consumer goods? Shifting the context of questions raised by conceptual art, Friedman toys with the realistic tradition by building a lifesize artificial fly, and then ridicules his own skill by showing a genuine dead ladybug whose dots have been slightly highlighted with paint (*Untitled*, 1999). Friedman's obsession with detail and his devilish meticulousness indicate that he has undertaken the difficult task of describing chaos at every possible level of perception – from molecular structures to planetary systems. After all, there are many similarities between a supernova explosion and tea being stirred in a cup.

Das im Profil dargestellte Gesicht besticht durch seinen merkwürdig klassischen Ausdruck. Doch handelt es sich nicht etwa um eine römische Münze, die mit Cäsars Konterfei geschmückt wäre, sondern um ein in Aspirin geschnittenes Selbstbildnis von Tom Friedman (*Untitled*, 1993/94). Ein überaus zerbrechlicher Werkstoff. Und so fühlt man sich durch die arbeitsintensive Technik des Künstlers tatsächlich eher an die Aktivitäten eines dilettierenden Modellbauers als an die geradezu mythischen Anstrengungen großer plastischer Kunst erinnert. Gleichwohl dringt Friedman mit seinen Arbeiten zu den grundlegenden Fragen vor, mit denen sich der „Hersteller" künstlerischer Objekte heute konfrontiert sieht. Nach welchen Kriterien soll man über das Größenverhältnis zwischen Kunstwerk und „realen" Objekten entscheiden? Welche Lebensdauer sollte man einer künstlerischen Schöpfung inmitten einer Welt kurzlebiger Gegenstände zumessen? Welcher Stellenwert kommt den Bemühungen zu, angesichts des vorherrschenden Prinzips der Massenproduktion von Konsumgütern ein einzigartiges Kunstwerk zu schaffen? Friedman rückt die Fragestellungen der Konzept-Kunst in einen neuen Zusammenhang und spielt mit der realistischen Tradition, indem er etwa eine lebensgroße künstliche Fliege kreiert, und amüsiert sich über seine eigene Kunstfertigkeit, wenn er einen echten toten Marienkäfer zeigt, dessen Punkte mit Farbe ein wenig hervorgehoben sind (*Untitled*, 1999). Friedmans Detailbesessenheit und seine teuflische Präzision belegen, dass er das auf sämtlichen Ebenen unserer Wahrnehmung herrschende Chaos sichtbar machen möchte – von den molekularen Strukturen bis zu den planetarischen Systemen. Immerhin gibt es zwischen der Explosion einer Supernova und den Vorgängen, die zu beobachten sind, wenn wir Tee in einer Tasse umrühren, eine Vielzahl von Übereinstimmungen.

Vu de profil, son visage a une expression étrangement classique. Cependant, il ne s'agit pas d'une médaille romaine gravée à l'effigie de César mais de l'autoportrait de Tom Friedman sculpté sur une aspirine (*Untitled*, 1993/94). Le support fragile et la technique laborieuse tiennent davantage du talent du maquettiste que des efforts mythifiés de la grande sculpture. Le travail de Friedman soulève en fait des questions fondamentales auxquelles un créateur d'objets artistiques est confronté aujourd'hui. Comment déterminer l'échelle d'un objet d'art par rapport aux objets « réels » ? Quelle doit être la longévité d'une création artistique au milieu de tant d'articles périssables ? Quel est le sens de l'effort consacré à créer une œuvre d'art unique face au principe de la production de masse des biens de consommation ? Friedman place les questions soulevées par l'art conceptuel dans un nouveau contexte et joue avec la tradition réaliste en construisant une mouche artificielle grandeur nature, puis tourne ses propres compétences en dérision en montrant une vraie coccinelle morte dont les points ont été légèrement soulignés par des touches de peinture (*Untitled*, 1999). L'obsession du détail de Friedman et sa méticulosité diabolique indiquent qu'il a entrepris la tâche ardue de décrire le chaos à tous les niveaux possibles de perception – des structures moléculaires aux systèmes planétaires. Après tout, il y a de nombreuses similitudes entre l'explosion d'une supernova et une tasse de thé que l'on touille.

A. S.

SELECTED EXHIBITIONS →
1995 *Projects 50: Tom Friedman*, Museum of Modern Art, New York (NY), USA **1996** *Affinities: Chuck Close and Tom Friedman*, The Art Institute of Chicago (IL), USA **1999** *Almost Warm and Fuzzy: Childhood and Contemporary Art*, Des Moines Art Center, Des Moines (IA), USA **2000** *The Epic in the Everyday*, Museum of Contemporary Art, Chicago (IL), USA; *The Greenhouse Effect*, Serpentine Gallery, London, UK **2001** *1. Quadriennial of Contemporary Art*, S.M.A.K. – Stedelijk Museum voor Actuele Kunst, Ghent, Belgium

SELECTED BIBLIOGRAPHY →
1998 *cream*, London **2000** *Tom Friedman*, London

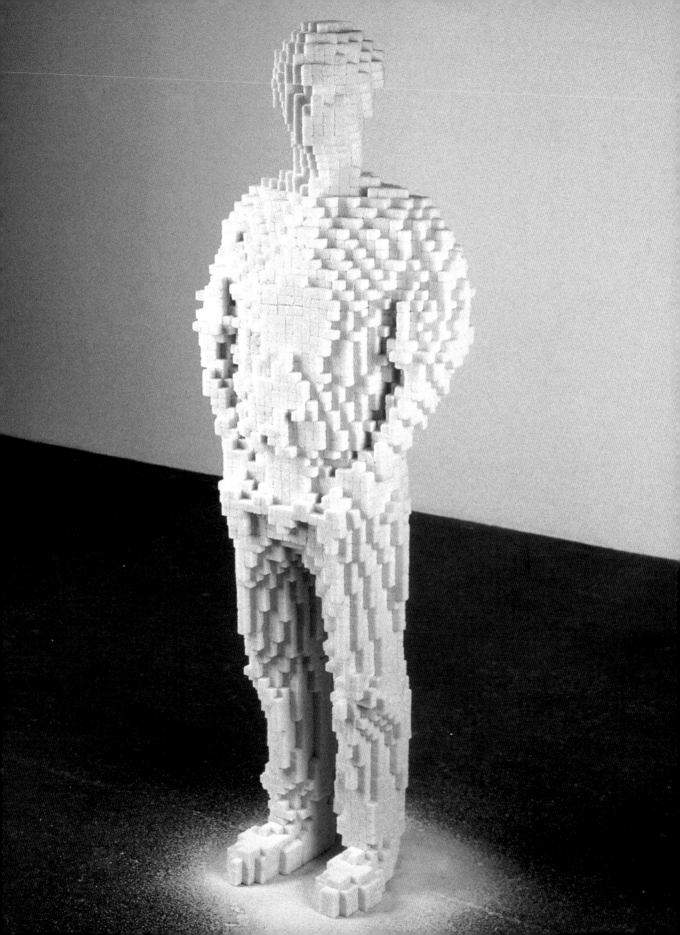

162

„Wenn ich etwas mache, möchte ich es gewissermaßen
vom Atom ausgehend aufbauen, bis ich weiß, was es ist."

« Quand je fais quelque chose, en un sens, je veux le construire depuis
l'atome jusqu'à ce que je sache ce que c'est. »

"When I make something, in a sense,
I want to build it from the atom up to when I know what it is."

2

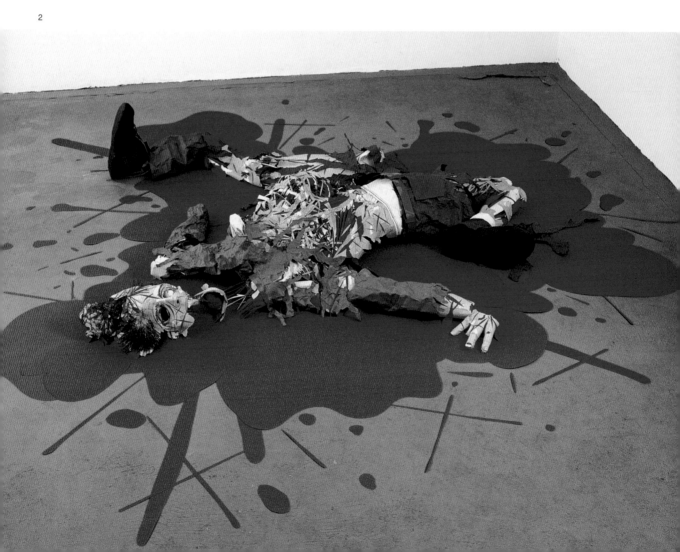

3

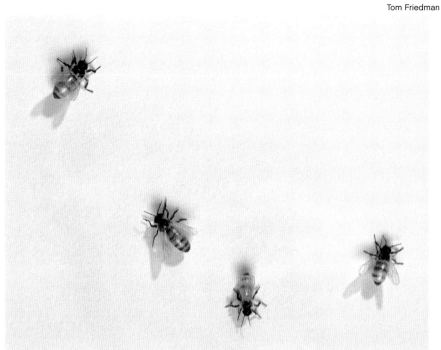

4

5

Ellen Gallagher

1965 born in Providence (RI), lives and works in Provincetown (MA) and New York (NY), USA

"If people want to understand my art they must be ready to step into my world," Ellen Gallagher said enticingly in an interview. She seduces the viewer with the beauty of her images and even more with their hidden meanings. The daughter of a Black African father and a white Irish mother, the artist sensuously balances the abstract and the figurative. Against the carefully crafted backdrop of her canvases, she stages an on-going minstrel show, echoing the 19th-century caricature of African-American creativity in which "blacked-up" white artists performed and sang. Since her début at the 1995 *Whitney Biennial*, Gallagher has created a parallel world in which no complete black bodies appear. All that the viewer sees are the rolling eyes and big lips, as in *Host*, 1996, which draws on the grotesque imagery of American minstrels. Gallagher is heir to a world that treats the African-American culture with disdain. She expresses in painting what rap artists do in music when they call themselves "niggers" and draw strength from emulating those who mock them. Gallagher perpetuates the gross stereotypes in the same way, without attempting any critique. The central motif of her work is the absence of bodies. The artist recalls how, since childhood, she has felt that, while there were possibilities for black individuals, there was no redemption for blacks as a family. Through her work she has seductively made that loss our gain.

„Wenn sie meine Kunst verstehen wollen, sollten sie bereit sein, meine Welt zu betreten", lockte Ellen Gallagher in einem Interview. Sie verführt den Betrachter mit der Schönheit ihrer Bilder und der Andeutung, dass noch mehr dahinter stecken könnte. Als Tochter eines schwarzafrikanischen Vaters und einer weißen, irischen Mutter, balanciert die Amerikanerin in ihrer Kunst abstrakte und figurative Momente auf sinnliche Weise aus. In den minimalistisch gesteppten Hintergründen ihrer Leinwände hat sich eine permanente Minstrelshow eingenistet, die Karikatur afro-amerikanischer Kreativität im 19. Jahrhundert, in der schwarz geschminkte Weiße Schwarze spielten und sangen. Seit ihrem ersten Auftreten auf der *Whitney Biennial* 1995 kreiert Gallagher eine parallele Welt, in der der vollständige schwarze Körper fehlt. Was übrig bleibt – die rollenden Augen und bleckenden Münder, wie in ihrer 1996 entstandenen Arbeit *Host* –, entnimmt Gallagher der grotesken Bildwelt der amerikanischen Minstrelsänger. Wenn Gallagher diese Welt mit ihrer Afro-Amerikaner herabsetzenden Perspektive aufnimmt, vollzieht sie in der Malerei, was Rapper im Sprechgesang zelebrieren, wenn sie sich Nigger nennen und Stärke aus der Besetzung der anderen Position ziehen. Ebenso wiederholt Gallagher groteske Stereotypen der Afro-Amerikaner, ohne an einer Kritik interessiert zu sein. Die Abwesenheit des Körpers in Gallaghers Arbeit ist das zentrale Motiv. Sie hätte es gefühlt, führt die Künstlerin aus, schon als Kind, dass es keine Erlösung für die Familie der Schwarzen gibt, nur Chancen für das schwarze Individuum. Der Verlust wirkt bei ihr verführerisch.

« Si vous voulez comprendre mon travail, vous devez être prêt à entrer dans mon univers ». Tel était l'accroche qu'Ellen Gallagher proposait dans une interview. Gallagher séduit le spectateur en laissant entendre que quelque chose de plus se cache derrière la beauté de ses images. Fille d'un père noir africain et d'une mère blanche irlandaise, l'artiste américaine équilibre de manière sensuelle éléments abstraits et figuratifs. Dans les fonds de ses toiles aux piqûres minimalistes s'est installé un minstrel show permanent, référence aux spectacles du 19ème siècle dans lesquels des blancs fardés de noir jouaient les noirs et chantaient en caricaturant la créativité afro-américaine. Depuis sa première apparition à la *Whitney Biennial* en 1995, Gallagher continue de créer un monde parallèle d'où le corps noir entier est toujours absent. Ce qui en reste, ce sont des yeux qui roulent et des bouches montrant les dents, éléments que Gallagher emprunte au monde d'images grotesque des minstrel singers américains, tels qu'on a pu les voir dans *Host*, 1996. En investissant ce monde de sa perspective humiliante pour les noirs américains, Gallagher réalise en peinture ce que les rappeurs célèbrent dans leurs textes scandés, lorsqu'ils se qualifient eux-mêmes de nègres et qu'ils puisent leur force dans la projection négative de l'autre. Gallagher reproduit les stéréotypes grotesques des Afro-américains sans être intéressée par une critique. L'absence du corps est le motif central de son œuvre. L'artiste explique qu'enfant déjà, elle avait perçu que la situation des noirs était sans issue collectivement, et que leurs chances étaient purement individuelles. Chez elle, l'absence est d'un effet séduisant.

F. F.

SELECTED EXHIBITIONS →
1995 *Whitney Biennial*, The Whitney Museum of American Art, New York (NY), USA **1996** Mary Boone Gallery, New York (NY), USA **1998** Gagosian Gallery, New York (NY), USA; *Piecing together the puzzle*, Museum of Modern Art, New York (NY), USA **1999** Galerie Max Hetzler, Berlin, Germany **2000** Anthony d'Offay Gallery, London, UK; *Greater New York: New Art in New York Now*, P.S.1, Long Island City (NY), USA **2001** Des Moines Art Center, Des Moines (IA), USA; *The Americans*, Barbican Art Gallery, London, UK

SELECTED BIBLIOGRAPHY →
1996 *The Astonishing Nose*, Anthony d'Offay Gallery, London **1998** *Ellen Gallagher*, Gagosian Gallery, New York (NY) **2000** *Ellen Gallagher: Pickling*, Galerie Max Hetzler, Berlin **2001** *Ellen Gallagher: Blubber*, Gagosian Gallery, New York (NY)

1 **Host,** 1996, oil, pencil and paper on canvas, 175 x 27 cm
2 **Falls and Flips,** 2001, painting, 305 x 488 cm

„Ich werde deine Membran nicht durch ein erregendes Bild zum Platzen bringen."

« Je ne vais pas vous faire éclater la membrane avec une image affriolante. »

"I'm not going to pop your membrane with a titillating image."

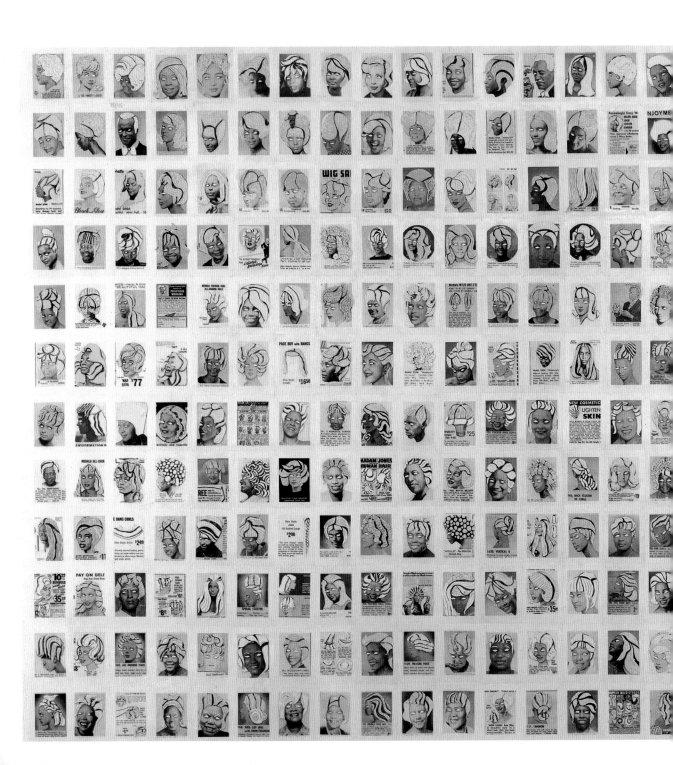

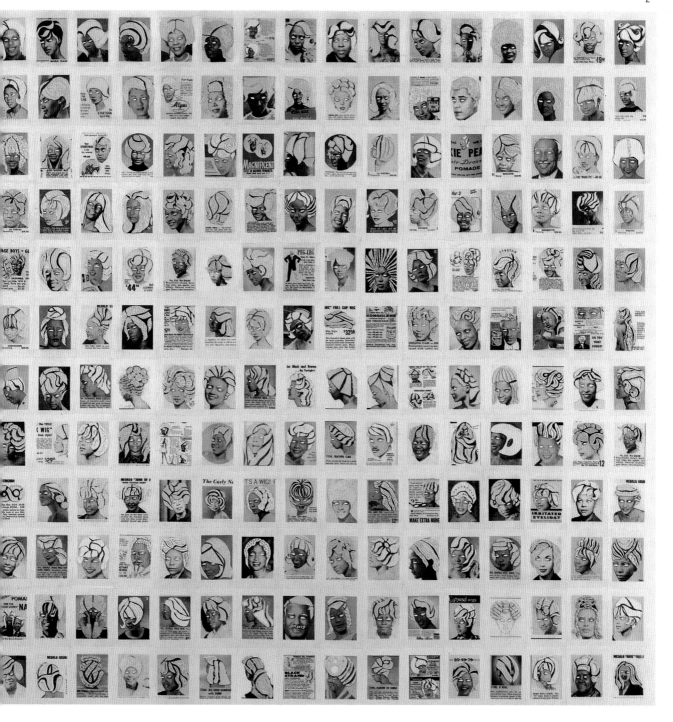

Kendell Geers

1968 born in Johannesburg, South Africa, lives and works in London, UK

Kendell Geers thinks of himself as a subversive, provocative and above all political artist, but not – as he is often described – as the enfant terrible of South Africa. Brought up in a strictly Christian tradition, his dream, as a child, was to become a missionary, but he was unable to find any answers to those questions which seemed important to him. Any form of regimentation and command struck him as suspect, and as a white South African he began to ask analytical questions about social systems (not just those of his native country). Urinating in Duchamp's *Fountain* in the Palazzo Grassi, masturbating on pornographic pin-ups or hiring a private detective to tail Rudi Fuchs, the director of the Stedelijk Museum, are strategies of a principle of participation which play on passive violence. The artist's attitude of denial is a balancing of cold and warm metaphors vis-à-vis the institution of art and the public. Geers' video installations are direct and full of disturbed and destructive energy – the laconic comment "irritating to children and sensitive persons" is intentional – yet they remain at a distance which has an aesthetic function. His art is always conceptual and contextual despite all the superficial effects, drawing on the experience of state power and the suppression of human freedom. He shows the most brutal scenes from the films "The Exorcist", "The Deer Hunter" or "Alien" at full volume on a number of monitors interconnected by a tangle of cables standing on palettes or scaffolding. The horror of the images achieves such a level of fascination that viewers can hardly tear themselves away from it. Geers creates a connection with the public that is about more than just the individual within the the mass media system standing speechless during a commentary, or helplessly being forced to react.

Kendell Geers versteht sich als subversiv wirkender, provozierender und vor allem politischer Künstler, nicht als – häufig so tituliertes – Enfant terrible Südafrikas. Streng christlich erzogen, wollte er als Kind Missionar werden, fand jedoch keine Antworten auf die ihm wesentlichen Fragen. Jede Form von Reglementierung und Befehlsgewalt war ihm suspekt, und als weißer Südafrikaner begann er, analytisch Gesellschaftssysteme (nicht nur das seiner Heimat) in Frage zu stellen. Das Urinieren in Duchamps *Fountain* im Palazzo Grassi, das Onanieren auf Porno-Pin-Ups oder die Beschattung des Direktors des Stedelijk Museums, Rudi Fuchs, durch einen Privatdetektiv sind Strategien eines Partizipationsprinzips, das auf passive Gewalt setzt. Die Verweigerungshaltung des Künstlers ist ein Austarieren von Kälte- und Wärmemetaphern gegenüber der Institution Kunst und dem Publikum. Geers' Videoinstallationen sind direkt und voller verstörender und zerstörender Energie – der lakonische Hinweis „für Kinder und sensible Personen irritierend" ist Programm – bleiben aber auf einer Distanz, die ästhetisch funktioniert. Seine Kunst ist trotz aller vordergründigen Effekte immer konzeptuell und kontextuell, rückbezogen auf die Erfahrung staatlicher Macht und die Unterdrückung menschlicher Freiheit. Er zeigt brutalste Filmszenen aus „Der Exorzist", „The Deer Hunter" oder „Alien" bei voll aufgedrehter Lautstärke auf mehreren, durch ein Kabelgewirr verbundenen Monitoren, die auf Paletten oder Gerüsten stehen. Der Horror des Bildes erreicht so eine Ebene, der man sich kaum entziehen kann. Geers stellt eine Verbindung zum Publikum als einem nicht nur in das System der Massenmedien eingebundenen Individuum her, das sprachlos zu einem Kommentar, hilflos zu einer Reaktion gezwungen wird.

Kendell Geers se comprend comme un artiste provocateur, subversif, activiste, politique surtout, et non pas, comme on a souvent voulu le décrire, comme l'enfant terrible d'Afrique du Sud. Elevé de manière strictement chrétienne, l'enfant voulut être missionnaire, mais ne trouva pas les réponses aux questions pour lui essentielles. Toute forme de réglementation et d'autorité lui était suspecte, et en tant que blanc d'Afrique du Sud, il commença à remettre en question, analytiquement, toutes formes de systèmes sociaux – pas seulement ceux de sa patrie. Uriner dans la *Fountain* de Duchamp au Palazzo Grassi, se masturber sur des pin-up porno ou faire surveiller Rudi Fuchs, le directeur du Stedelijk Museum, par un détective privé sont les stratégies d'un principe de participation qui mise sur une forme de violence passive. L'objection de conscience de l'artiste consiste à savoir pondérer les métaphores du froid et du chaud par rapport à l'institution artistique et au public. Les installations vidéo de Geers sont très directes et débordent d'une énergie troublante, destructrice – la mention laconique « perturbant pour les enfants et les personnes sensibles » fait partie du programme –, mais savent maintenir une distance qui fonctionne esthétiquement. Malgré des effets épidermiques, son art est toujours conceptuel et contextuel, il se réfère à l'expérience du pouvoir politique et à la répression de la liberté humaine. Geers passe les séquences les plus violentes de films comme « L'exorciste », « The Deer Hunter » ou « Alien », le son à plein volume, sur plusieurs moniteurs reliés par un imbroglio de câbles et posés sur des palettes ou d'autres structures. L'horreur de l'image atteint ainsi un niveau de séduction auquel on a du mal à se soustraire. Geers établit un lien avec le public pris individuellement, hors de son assujettissement et de son enfermement dans le système médiatique, un lien qui oblige au commentaire muet et à la réaction impuissante. G. J.

SELECTED EXHIBITIONS →
1995 Villa Arson, Nice, France **1996** *Inklusion : Exklusion*, Künstlerhaus Graz, Austria **1997** *Memento Mori*, De Vleeshal, Middelburg, The Netherlands; *2nd Johannesburg Biennale*, South Africa **1998** ArtPace, San Antonio (TX), USA **1999** *Carnegie International*, Carnegie Museum of Art, Pittsburgh (PA), USA **2000** *Ya Basta*, Le Consortium, Dijon, France; Echigo-Tsumari Art Triennial, Tokaichi, Japan **2001** *Televisionaries*, Württembergischer Kunstverein, Stuttgart, Germany; *The Short Century*, Museum Villa Stuck, Munich, Germany

SELECTED BIBLIOGRAPHY →
1996 *Inklusion : Exklusion*, Künstlerhaus Graz **1998** *The Horror, the Horror*, Nordic Institute for Contemporary Art, Helsinki **2000** *Zeitwenden*, Kunstmuseum Bonn **2001** Christoph Tannert (ed.), *Skulptur-Biennale Münsterland*

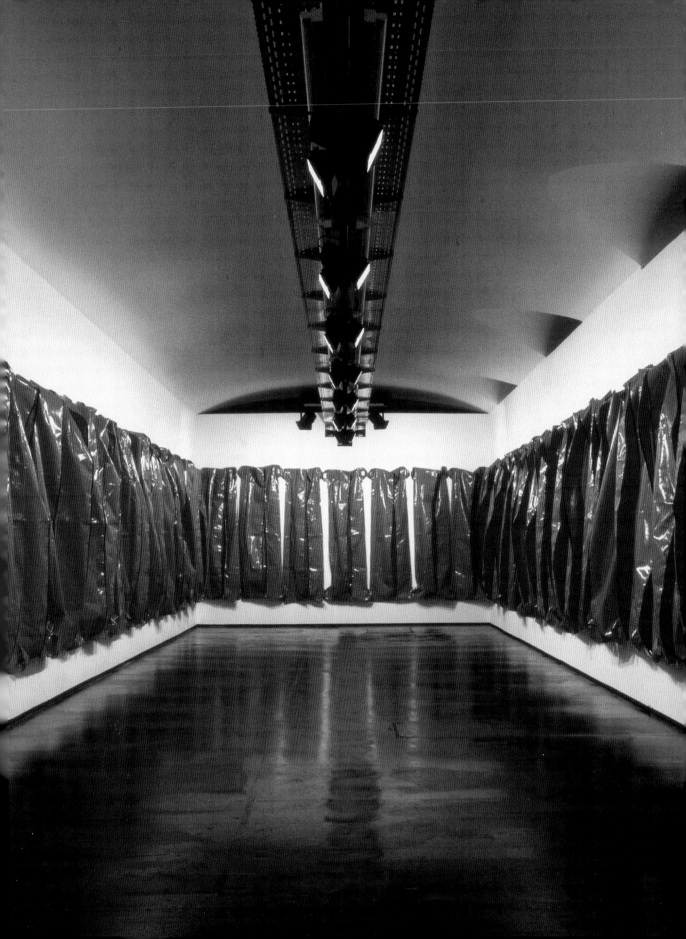

„Ich liebe die Kunst, aber ich hasse die Kunstwelt."

« J'adore l'art, mais je déteste le monde de l'art. »

"I love art, but I hate the art world."

3

2

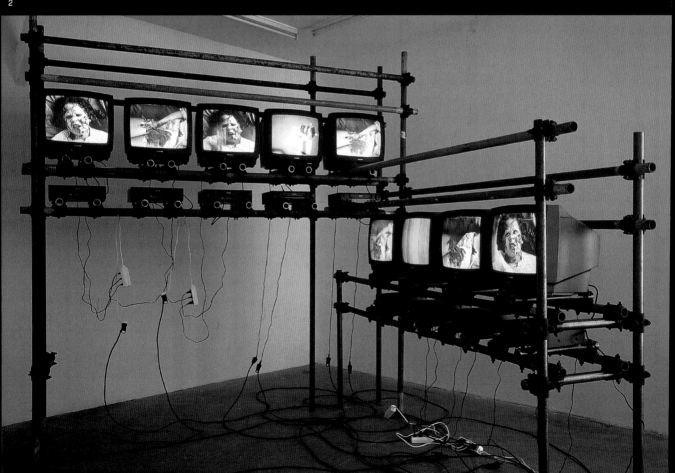

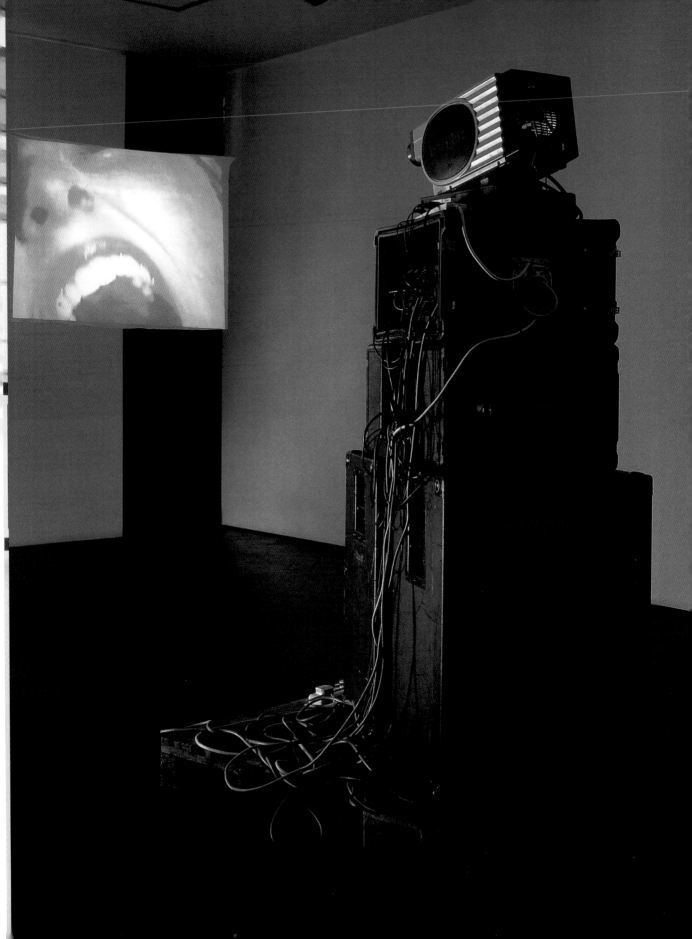

Dominique Gonzalez-Foerster

1965 born in Strasbourg, lives and works in Paris, France

Dominique Gonzalez-Foerster's treatment of objects, spaces, sound and film as time depots has, like her exploration of "biographies", the effect of revealing a narrative. She creates rooms and stages scenes that closely resemble film sets except that something – be it plot, characters or action – is missing. Only the attendance of exhibition visitors, who by their presence become part of the production, can close the gap. In works like *Time Machine*, 1997, she uses visitors as time travellers and recreates everyday experiences and moods to suggest they are both really and virtually in attendance. Her installations, arrangements and videos are all characterised by these elements of empathy and physicality, which combine to create the impression that the viewer is only potentially in existence, and temporarily or permanently absent. Some of her films – such as *Riyo*, 1999, or *Central*, 2001 – contain re-created entertainment, which is combined with the forces of technology and culture to describe a new experience located somewhere between sensationalism, narrative and boredom. Memory and space act as triggers for the transitory impulses that forge links between a tropical ambience and individuality. The relationship between various intimate and public, primarily urban, cultural concepts is highlighted by her exceptionally aesthetic works, which simultaneously arouse a sense of longing in the viewer. Her use of the Japanese Manga character Ann Lee, whose copyright was acquired in 1999 by her co-artist Philippe Parreno, is a rendering of individual moods onto the artificiality of individuality itself. An aficionado of the Japanese cultural scene, Gonzalez-Foerster recognises that constructions of the self have their origin in the superficial myths of the media.

Dominique Gonzalez-Foerster behandelt Dinge und Räume, Ton und Film als Zeitspeicher, die wie ihre Auseinandersetzung mit „Biografien" eine Geschichte offenbaren. Sie inszeniert Räume, schafft Szenerien, die Filmsets gleichen, denen allerdings etwas fehlt: Handlung, Charaktere, Bewegung – erst der Ausstellungsbesucher schließt diese Lücke und wird so Teil der Inszenierung. Es ist die an alltägliche Erfahrung und Stimmungen gekoppelte, kalkulierte Indienstnahme des Besuchers, der wie in der Arbeit *Time Machine*, 1997, als Zeitreisender meist ebenso real wie virtuell zugegen ist. Ein empathisch-physisches Moment prägt ihre Installationen, Arrangements und Videos, so als wäre der Betrachter nur potenziell existent, vorübergehend oder für immer abwesend. In ihren Filmen *Riyo*, 1999, oder *Central*, 2001, spielt sich die Neuschöpfung von Unterhaltung ab, die verbunden mit der Kombination von Technik und Kultur das neue Erleben zwischen Sensation, Erzählung und Langeweile beschreibt. Erinnerung und Raum sind auslösende Momente, transitorische Impulse zwischen tropischer Atmosphäre und Individualität ihre Quelle, und die Beziehung zwischen intimen und öffentlichen, vorrangig urbanen Kulturbegriffen das ungemein ästhetische, Sehnsüchte weckende Ergebnis ihrer Werke. Die Verwendung der japanischen Manga-Kunstfigur Ann Lee, deren Copyright ihr Kollege Philippe Parreno 1999 erworben hat, ist eine Übertragung der individuellen Stimmungen auf die Künstlichkeit der Individualität selbst. Als Kennerin der japanischen Kulturszene weiß sie, wo die Konstruktionen des Selbst ihren Ursprung haben: in den oberflächlichen Mythen der Medien.

Dominique Gonzalez-Foerster travaille sur des choses et des espaces, sur le son et le film conçus comme des réceptacles de temps qui révèlent une histoire – tout comme leur confrontation avec des « biographies ». Elle met en scène des espaces, crée des décors qui ressemblent à des décors de cinéma auxquels manque quelque chose : l'action, les personnages, le mouvement. Cette lacune est seulement comblée par le visiteur de l'exposition, qui devient ainsi un élément de la mise en scène. Dans le cadre de l'expérience et des atmosphères quotidiennes, il s'agit donc d'une mise en service calculée du spectateur, voyageur du temps présent de manière à la fois virtuelle et réelle, comme le montre *Time Machine*, 1997. Un aspect empathique, physique, caractérise les installations, les arrangements et les vidéos de l'artiste, comme si le spectateur n'avait d'existence que potentielle, comme s'il était absent, passagèrement ou pour toujours. Dans les films *Riyo*, 1999, ou *Central*, 2001, on assiste à la recréation du divertissement qui, associé à un mélange de technique et de culture, cerne une nouvelle expérience située entre ennui, récit et sensation. La mémoire et l'espace sont les déclencheurs, les impulsions transitoires – entre atmosphère tropicale et individualité – sont la source, le rapport entre culture intime et publique, essentiellement urbaine, est le résultat singulièrement esthétique, désirable, de ces œuvres. L'utilisation du personnage de manga japonais Ann Lee, dont Philippe Parreno a acquis le copyright en 1999, est une transposition des ambiances personnelles vers l'artifice même de l'individualité. En connaisseuse de la scène culturelle japonaise, Gonzalez-Foerster n'ignore nullement que les constructions du moi puisent leur origine dans les mythes superficiels répandus par les médias.

G. J.

SELECTED EXHIBITIONS →
1996 *Traffic*, capcMusée d'art contemporain, Bordeaux, France
1997 *Cities on the move*, Wiener Secession, Vienna, Austria
1998 *88:88*, Kaiser-Wilhelm-Museum, Krefeld, Germany **1999** *Tropical Modernité*, Fondation Mies van der Rohe, Barcelona, Spain; *48. Biennale di Venezia*, Venice, Italy **2000** *What if*, Moderna Museet, Stockholm, Sweden **2001** *cosmodrome*, Le Consortium, Dijon, France; Portikus, Frankfurt am Main, Germany; *Megawave*, Yokohama Triennale, Yokohama, Japan; *7th Istanbul Biennial*, Istanbul, Turkey

2002 *documenta 11*, Kassel, Germany; *Ann Lee*, Kunsthalle Zürich, Zurich, Switzerland

SELECTED BIBLIOGRAPHY →
1993 *Numéro bleu*, ARC – Musée d'Art Moderne de la Ville de Paris **1998** *88:88*, Kaiser-Wilhelm-Museum, Krefeld **1998** *Dominique Gonzalez-Foerster, Pierre Huyghe, Philippe Parreno*, ARC Musée d'Art Moderne de la Ville de Paris; *Manifesta 2*, Luxembourg

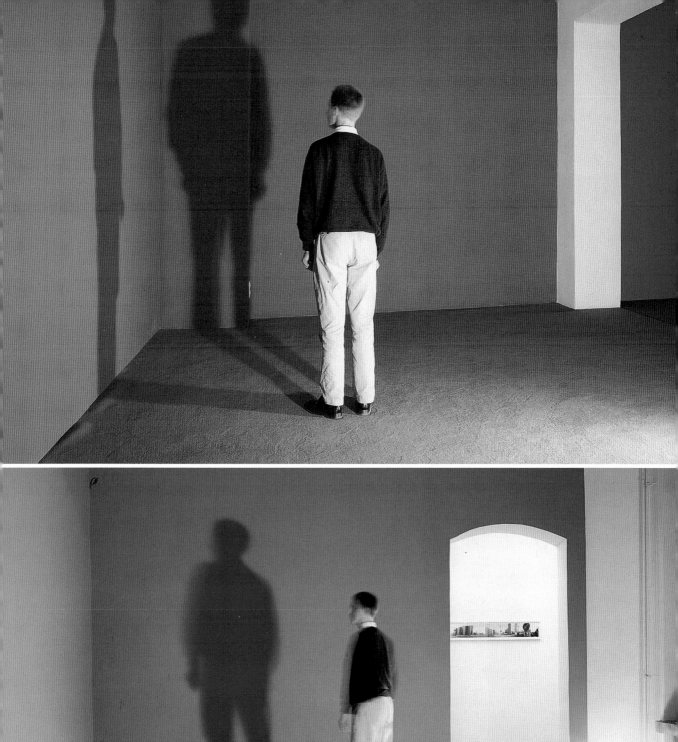

178

1 **Séance de Shadow III,** 1999, installation views, Schipper & Krome, Berlin
2 **Central,** 2001, DVD, 35 mm, installation view, *Riyo Central,* Portikus, Frankfurt am Main
3 **R. W. F.,** 1993, installation view, *1. berlin biennale,* Berlin 1998

4 **Et la Chambre Orange,** 1992, installation view, *Fast Forward/Bodycheck,* Kunstverein in Hamburg, 1999
5 **Ann Lee in Anzen Zone,** 2000, installation view, Galerie Jennifer Flay, Paris

„Ich bin total besessen von der Frage: ‚Wo bist Du jetzt!?'" « Je suis obsédée par cette question : ‹ Où es-tu maintenant !? › »

"I am deeply obsessed by this question: 'Where are you now!?'"

2

3

4

5

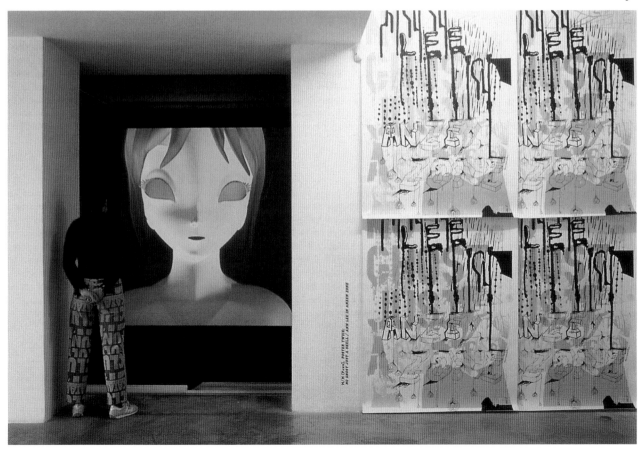

Felix Gonzalez-Torres

1957 born in Güaimaro, Cuba, 1996 died in Miami (FL), USA

Felix Gonzalez-Torres' works invest the most mundane materials (candy, clocks, lightbulbs) and common-place processes (off-set printing, photography) with a preciousness and poetry to convey both the rational value of life and its inevitable transience. His large stacks of sheets of paper printed with a text or image, or lines and carpets of glittering gold-wrapped candies, resemble the stable structures of minimalism, but are in a state of constant transformation as the audience is invited to take a piece of paper or candy away and the piles gradually shrink. There are discrete references to his personal history in titles, or in details such as the weight of the golden candy in *Untitled (Placebo)*, 1991, which equals the combined weight of the artist and his lover; or more overt political references in works such as *Untitled*, 1989, a billboard with text highlighting key moments in the struggle for gay rights, but no didactic explanation is given and the audience is free to bring its own personal associations into play in the construction of meaning. In *Untitled*, 1991, a tender and intimate image of a recently slept in bed is displayed in the most public manner on huge billboards across New York City. This personal elegy to the death of his lover from AIDS becomes an eloquent and universal expression of love, beauty, tragedy and loss. The elusive quality of images such as this, or of a bird flying alone through a cloudy sky in a "stack" piece, is all the more poignant in the light of the artist's own premature death from AIDS in 1996.

Die Arbeiten von Felix Gonzalez-Torres entstehen aus den banalsten Materialien (Bonbons, Uhren, Glühbirnen) und Verfahren (Offset-Druck, Fotografie) und wirken so kostbar und poetisch, dass sie zugleich ein Gefühl für den rationalen Wert des Lebens und dessen unvermeidliche Vergänglichkeit wecken. Seine hohen Stapel mit Texten oder Bildern bedruckter Papierblätter oder seine in Goldpapier gewickelten – in Reihen oder zu ganzen Teppichen angeordneten – glitzernden Bonbons erinnern zwar an die unverrückbaren Strukturen des Minimalismus, befinden sich jedoch in einem Zustand der permanenten Veränderung, da das Publikum eingeladen ist, ein Blatt Papier oder ein Bonbon mitzunehmen, so dass die Materialhaufen allmählich schmelzen. Versteckte Hinweise auf den persönlichen Werdegang des Künstlers finden sich etwa in den Werktiteln, oder aber sie sind in Arbeiten wie dem goldenen Riesenbonbon *Untitled* (Placebo), 1991, enthalten, das genauso viele Kilo auf die Waage bringt wie der Künstler selbst und sein Geliebter zusammen. Explizit politische Verweise finden sich in Werken wie *Untitled*, 1989, einem Plakat mit Texten, die auf die entscheidenden Etappen des schwulen Kampfes um Gleichberechtigung verweisen. Dabei verzichtet der Künstler vollständig auf didaktische Erklärungen, so dass es dem Betrachter freigestellt ist, seine eigenen Assoziationen ins Spiel zu bringen. In der Arbeit *Untitled*, 1991, wurde das zärtliche und intime Bild eines Bettes, in dem noch kurz zuvor jemand geschlafen hatte, in der denkbar öffentlichsten Manier auf riesigen Plakatwänden überall in New York gezeigt. Dabei erweist sich diese persönliche Bekundung der Trauer über den Tod seines an den Folgen von AIDS gestorbenen Geliebten als ebenso beredter wie universell gültiger Ausdruck der Liebe, der Schönheit, der Tragik und des Verlusts. Der fast unwirkliche Charakter solcher Bildmotive, etwa auch des Vogels, der auf den Blättern einer Papierstapel-Arbeit durch einen wolkenverhangenen Himmel fliegt, gewinnt noch eine zusätzliche Prägnanz durch den vorzeitigen Tod des Künstlers, der 1996 ebenfalls an den Folgen von AIDS gestorben ist.

Le travail de Gonzalez-Torres investit avec délicatesse et poésie les matériaux les plus quotidiens (bonbons, pendules, ampoules électriques) et les techniques les plus communes (impression offset, photographie) pour traduire à la fois la valeur rationnelle de la vie et son inévitable nature éphémère. Ses installations – de hautes piles de papiers imprimés avec un texte ou une image, des lignes ou des tapis de bonbons enveloppés dans de la Cellophane dorée – rappellent les structures stables du Minimalisme mais sont dans un état de transformation permanente car le public est invité à prendre une feuille ou une friandise, faisant ainsi progressivement diminuer les tas. On retrouve de discrètes allusions autobiographiques dans ses titres ou des détails, tels que le poids des bonbons dorés dans *Untitled (Placebo)*, 1991, qui correspond à la somme exacte des poids de l'artiste et de son compagnon, ou des références politiques plus directes dans des œuvres telles que *Untitled*, 1989 : un panneau publicitaire avec un texte énonçant les moments importants dans la lutte pour les droits des homosexuels. Néanmoins, ses œuvres ne s'accompagnent d'aucune explication didactique, chacun étant libre de faire participer ses associations personnelles à la construction du sens. Pour *Untitled*, 1991, l'image tendre et intime d'un lit défait était placardée sur d'immenses panneaux publicitaires un peu partout dans New York. Cette élégie à la mort de son compagnon, décédé du Sida, constitue une expression éloquente et universelle d'amour, de beauté, de tragédie et de deuil. La qualité fugace d'images telles que celle d'un oiseau isolé volant dans un ciel nuageux, dans une de ses « piles »', est d'autant plus émouvante à la lumière de la mort prématurée de l'artiste, emporté lui aussi par le Sida en 1996. K. B.

SELECTED EXHIBITIONS →
1994 *Travelling*, Museum of Contemporary Art, Los Angeles CA), USA **1995** Solomon R. Guggenheim Museum, New York (NY), USA **1997** Sprengel Museum, Hanover, Germany **1999** Banco de la Republica Biblioteca Luis Angel, Bogota, Colombia **2000** Serpentine Gallery, London, UK; *Protest and Survive*, Whitechapel Art Gallery, London, UK; *Let's Entertain: Life's Guilty Pleasures*, Walker Art Center, Minneapolis (MN), USA **2002** *Passenger: The Viewer as Participant*, Astrup Fearnley Museet fur Moderne Kunst, Oslo, Norway

SELECTED BIBLIOGRAPHY →
1993 *Felix Gonzalez-Torres*, Los Angeles (CA) **1994** *Felix Gonzalez-Torres*, Museum of Contemporary Art, Los Angeles (CA) **1997** *Felix Gonzalez-Torres, Catalogue Raisonné*, Ostfildern-Ruit **2000** *Felix Gonzalez-Torres*, Serpentine Gallery, London

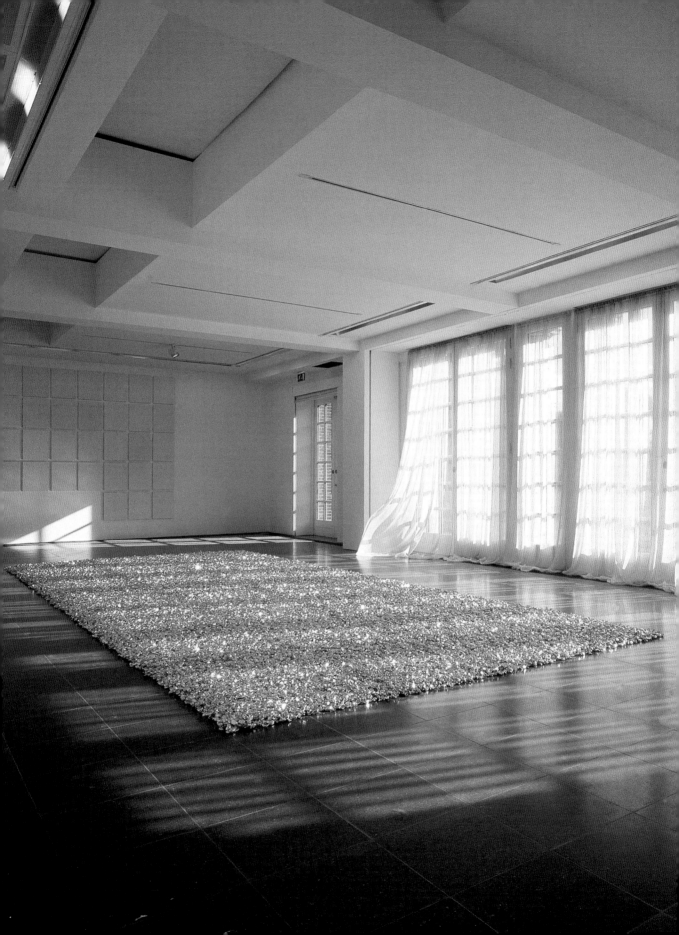

1 Installation view, *Felix Gonzalez-Torres*, Serpentine Gallery, London, 2000; foreground: **Untitled (Placebo)**, 1991, candies, individually wrapped in silver cellophane, endless supply, ideal weight: 500 – 600 kg, background left: **Untitled (Loverboy)**, 1989, blue fabric, metal rod; background right: **Untitled (31 Days of Bloodworks)**, 1991, acrylic, gesso, graphite, photographs, paper on canvas, 31 parts, each 51 x 41 cm

2 **Untitled (Beginning)**, 1994, plastic beads, metal rod, installation view, Andrea Rosen Gallery, New York, 1997
3 **Untitled**, 1995, billboard, as installed for *Felix Gonzalez-Torres*, Andrea Rosen Gallery, New York, 2000, in 24 outdoor locations throughout New York City, location: Atlantic and Washington Avenues, Brooklyn

„Mir geht es vor allem darum, ein Zeichen zu hinterlassen, dass es mich gegeben hat: Ich war hier. Ich war hungrig. Ich habe Niederlagen erlitten. Ich war glücklich. Ich war traurig. Ich war verliebt. Ich habe Angst gehabt. Ich war voll Hoffnung. Ich habe eine Idee gehabt und einen guten Zweck verfolgt, und deswegen mache ich Kunst."

« Il s'agit par-dessus tout de laisser une trace de mon existence. J'ai été ici. J'ai eu faim. J'ai été vaincu. J'ai été heureux. J'ai été triste. J'ai aimé. J'ai eu peur. J'ai espéré. J'ai eu une idée qui m'a paru utile, c'est pourquoi j'ai créé des œuvres d'art. »

"Above all else, it is about leaving a mark that I existed: I was here. I was hungry. I was defeated. I was happy. I was sad. I was in love. I was afraid. I was hopeful. I had an idea and I had a good purpose and that's why I made works of art."

2

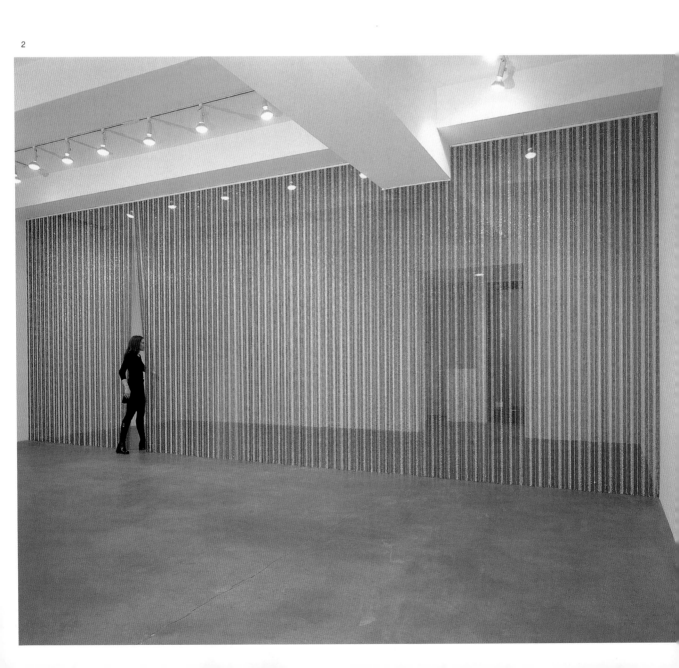

Douglas Gordon

1966 born in Glasgow, lives and works in Glasgow, UK, and New York (NY), USA

The work of Douglas Gordon, one of the most successful international artists of recent years, confronts existential themes such as guilt and fear, love and death, and the problems of memory and vision. Mainly using film, video and photography, he pinpoints these issues and explores them through repetition, enlargement and slow motion. These "ultimate questions" are transformed into succinct statements, which can be read in new ways and re-examined. For his installation *Feature Film*, 1999, Gordon filmed the maestro James Conlon conducting a performance of Bernard Herrmann's music for Alfred Hitchcock's 1957 film, "Vertigo". On the screen the conductor's movements and gestures synchronise with the soundtrack. Feelings such as fear, tenderness or aggression are made visible and engage in constant interplay with the music. At the same time, memories of the film classic sweep the spectator into a turmoil of sensations akin to the dizziness portrayed in "Vertigo". *Hand with Spot,* 2000, is a series of photographs in which Gordon plays with a theme from Robert Louis Stevenson's adventure story "Treasure Island", in which a black spot on the hand was the mark of death. The artist painted a black spot on his own left hand and photographed it with his right. He then enlarged 13 Polaroids and hung them on the wall as an ominous self-portrait. Once again, Gordon stresses the dark, bizarre aspects of life and tries to explore them through visual imagery.

Douglas Gordon, einer der international erfolgreichsten Künstler der letzten Jahre, beschäftigt sich in seiner künstlerischen Arbeit mit existenziellen Themen wie Schuld und Angst, Liebe und Tod sowie mit den Problemen von Erinnerung und Vision. Vor allem in den Medien Film, Video und Fotografie rückt er diese Fragestellungen in den Blickpunkt und überhöht sie eindrucksvoll mit den Mitteln der Wiederholung, Vergrößerung und Verlangsamung. So gerinnen vermeintlich „letzte Fragen" zu prägnanten Gesten, die neu gelesen und in Frage gestellt werden können. Für seine Installation *Feature Film*, 1999, hat Gordon den Dirigenten James Conlon bei der Einspielung der von Bernard Herrmann komponierten Musik zu Alfred Hitchcocks Film „Vertigo" von 1957 gefilmt. Auf der Leinwand ist zu sehen, wie sich die im selben Moment zu hörende Musik in den Bewegungen und der Mimik des Dirigenten spiegelt. Gefühle wie Angst, Zärtlichkeit oder Aggression werden sichtbar und verschränken sich gleichsam mit der Filmmusik. Zudem versetzt die Erinnerung an den Filmklassiker den Rezipienten in einen Strudel von Empfindungen, der dem in „Vertigo" thematisierten Schwindel vergleichbar ist. Gordons Fotoserie *Hand with Spot,* 2000, spielt an auf ein Motiv des Abenteuerromans „Die Schatzinsel" von Robert Louis Stevenson: ein schwarzer Fleck auf der Hand als Todesahnung. Gordon hat sich einen solchen Fleck auf die eigene linke Hand gemalt und dann mit der rechten Hand diesen Fleck fotografiert. Anschließend wurden 13 dieser Polaroids vergrößert und quasi als Unheil verkündendes Selbstporträt an die Wand gehängt. Einmal mehr also betont Gordon hier die dunklen, abgründigen Seiten des Lebens und versucht ihnen mit einer visuellen Inszenierung auf die Spur zu kommen.

Dans son œuvre, Douglas Gordon, l'un des artistes les plus en vue sur le plan international ces dernières années, se penche sur des thèmes existentiels tels que l'angoisse, la culpabilité, l'amour et la mort, ainsi que sur les problèmes de la mémoire et de la vision. Ces problématiques sont surtout traitées et présentées dans des médias comme le cinéma, la vidéo et la photo, dans lesquels Gordon les met en exergue de manière frappante par la répétition, l'agrandissement et le ralenti. Ainsi, des questions touchant aux choses prétendument « dernières » sont figées dans des gestes frappants qui peuvent ainsi être soumis à une nouvelle lecture et à de nouveaux questionnements. Pour son installation *Feature Film,* 1999, Gordon a filmé le chef d'orchestre James Conlon lors de son enregistrement de la musique de Bernard Herrmann composée pour le film d'Alfred Hitchcock « Vertigo », 1957. A l'écran, on peut voir la musique se refléter dans les gestes et les mimiques du chef d'orchestre. Des sentiments tels que la peur, la tendresse ou l'agression deviennent visibles tout en se fondant à la musique du film. En même temps, le souvenir de ce classique du cinéma replace le spectateur dans un tourbillon de sentiments comparable au vertige illustré par le film « Vertigo ». La série photographique *Hand with Spot,* réalisée en 2000, fait allusion à un motif du roman d'aventures de Robert Louis Stevenson, « L'île au trésor », dans lequel une tache noire sur la main figure un présage de mort. Gordon a peint une telle tache sur sa main gauche et l'a ensuite photographiée de la main droite. 13 de ces polaroïds étaient ensuite agrandis et accrochés au mur en guise d'autoportrait funeste. Soulignant une fois de plus les aspects obscurs et abyssaux de la vie, Gordon tente de les appréhender par l'intermédiaire de leur mise en scène visuelle.

R. S.

SELECTED EXHIBITIONS →
1998 *Emotion,* Deichtorhallen Hamburg, Germany **1999** Neue Nationalgalerie, Berlin, Germany; Galeria Foksal, Warsaw, Poland; *Feature Film,* Kölnischer Kunstverein, Cologne, Germany; *peace,* Migros Museum für Gegenwartskunst, Zurich, Switzerland; *Notorious,* Museum of Modern Art, Oxford, UK **2000** Musee d'Art Moderne de la Ville de Paris, France **2001** Museum of Contemporary Art, Los Angeles (CA), USA; Galleri Nicolai Wallner, Copenhagen, Denmark **2002** Kunsthaus Bregenz, Austria

SELECTED BIBLIOGRAPHY →
1998 *Kidnapping,* Rotterdam; *Douglas Gordon,* Kunstverein Hannover, Hanover **1999** *Feature Film,* Cologne **2000** *Douglas Gordon, Black Spot,* Tate Gallery, London **2002** *Douglas Gordon,* Kunsthaus Bregenz

1 **Feature Film,** 1999, 35 mm film, film still
2 **Hand with spot A–M,** 2001, digital c-type prints, each 147 x 122 cm, installation view, Lisson Gallery, London

3 **Monument for X,** 1998, video installation on monitor or projection on wall with semi tuned radio broadcast
4 In collaboration with Jonathan Monk:
 The end uncovered, 2001, slide projection, slide number one of 80

„Ich möchte meine Arbeit nicht unnötig festlegen, indem ich sie als persönlich, autobiografisch oder bekenntnishaft charakterisiere."

« Je ne veux pas définir l'œuvre en disant qu'elle est personnelle, autobiographique ou tenue à la manière d'un journal intime. »

"I don't want to pin the work down by saying it's personal, autobiographical, or diaristic."

2

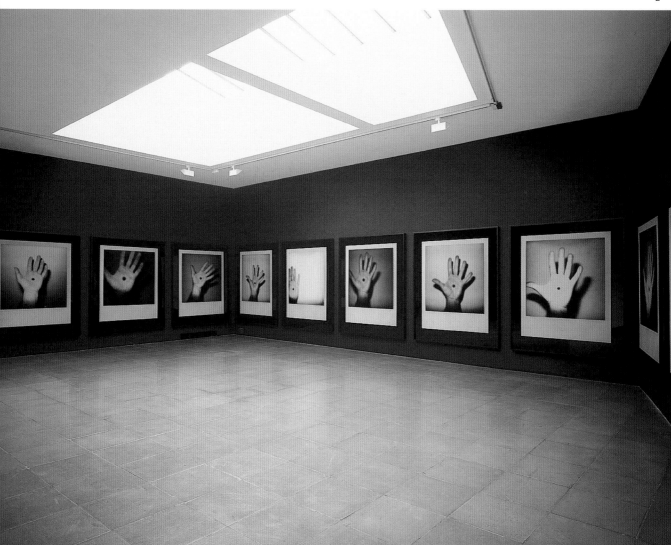

3

4

Andreas Gursky

1955 born in Leipzig, lives and works in Düsseldorf, Germany

Andreas Gursky is a photographer in an age of globalisation: since the mid 1980s his subjects have included ports and airports, the interiors of stock markets and the factory floors of "global players", as well as showcases of fetish items produced by international fashion labels. The extent of his production is limited to some ten pictures a year. Gursky concentrates on individual pictures which can be combined into groups of works related by subject matter. His photographs seem to raise the question of the role allocated to the individual in a worldwide economic and cultural integration. He frequently illustrates human beings as a mass in the form of ornamental abstractions: at raves, rock concerts or boxing matches. Gursky's photographs also seem to want to draw attention to the camera itself, which is still able to capture the individual while the bare eye has long failed to do so. In 1984 when Gursky took a picture of the Klausen Pass he was unaware of the presence of a group of hikers, who only appeared in the final print. In the catalogue of his retrospective at the New York Museum of Modern Art, the great variety of extreme close-ups of faces and gestures blend together into what looks like a homogenous mass from a distance. Since the 1990s, Gursky has been creating extremely large-format works using digital processing and taking full advantage of all the technical means available to this medium. As a result, his pictures appear to be in deliberate competition with the large-format pictures of everyday culture as well as the monumental formats of high art. At the same time they extend the spectrum of how things are viewed – from close-up, highly detailed readings to structural analysis.

Andreas Gursky ist Fotograf im Zeitalter der Globalisierung: Seit Mitte der achtziger Jahre gehören Häfen und Flughäfen, Interieurs von Börsen und von Fabrikationshallen der „global player" sowie in Schaukästen inszenierte Warenfetische internationaler Modemarken zu seinen Sujets. Der Umfang seiner Produktion ist auf etwa zehn Bilder pro Jahr begrenzt; Gursky konzentriert sich auf Einzelbilder, die sich zu motivisch verwandten Werkgruppen zusammenschließen lassen. Dabei scheinen seine Fotografien auch die Frage aufzuwerfen, welche Rolle dem Individuum innerhalb von weltweiten ökonomischen und kulturellen Verflechtungen zufällt. Häufig werden Menschen im Aggregatzustand der Masse, als ornamentale Abstraktionen sichtbar: bei Ravepartys, Rockkonzerten oder Boxkämpfen. Doch Gurskys Fotografien scheinen zugleich darauf aufmerksam machen zu wollen, dass die Kamera das Individuum auch dort noch registriert, wo das bloße Auge längst versagt. Als Gursky 1984 eine Aufnahme des Klausenpasses machte, entging seinem Blick die Präsenz einiger Wanderer, die erst auf dem Abzug zum Vorschein kamen. Auch die Detailvergrößerungen im Katalog seiner Retrospektive im New Yorker Museum of Modern Art betonen die Vielfalt von Gesichtern und Gesten, die sich nur aus der Distanz zur scheinbar homogenen Masse zusammenfügen. Seit den neunziger Jahren verwendet Gursky – unter Einsatz der digitalen Bildbearbeitung – extreme Großformate, die die technischen Möglichkeiten des Mediums restlos ausschöpfen. Damit treten seine Fotografien in bewusste Konkurrenz zu Großbildern der Alltagskultur wie auch zu Monumentalformaten der Hochkunst. Sie erweitern zugleich das Spektrum der Betrachtungsweisen – von einer nahsichtigen, detailverliebten Lektüre bis zur strukturellen Analyse.

Andreas Gursky est photographe à l'ère de la mondialisation : depuis le milieu des années 80, les ports et les aéroports, les salles des bourses et les halles de fabrication des « global players », mais aussi les fétiches commerciaux mis en scène dans les vitrines des grandes marques de la mode, font partie de ses sujets. Sa production est limitée à une dizaine de photographies par an. Gursky se concentre sur des images uniques que leur parenté thématique permet de regrouper en séries. En même temps, ses photographies semblent poser la question du rôle de l'individu au sein des réseaux économiques et culturels mondiaux. Souvent, les êtres sont montrés à l'état grégaire de la masse ou comme des abstractions ornementales : rave-parties, concerts de rock ou combats de boxe. Mais les photographies de Gursky semblent aussi vouloir faire remarquer que l'appareil photo consigne l'existence de l'individu même lorsque l'œil en est devenu depuis longtemps incapable. En 1984, alors qu'il prend une photographie dans les Alpes autrichiennes, quelques randonneurs dont il ne relèvera la présence qu'au tirage, échappent à son regard. Dans le catalogue de la rétrospective organisée par le Museum of Modern Art de New York, les agrandissements de certains détails soulignent la diversité des visages et des gestes que seul l'éloignement fondait en une masse homogène. Depuis les années 90, Gursky s'appuie sur le traitement informatique de l'image pour générer des formats extrêmes qui épuisent toutes les possibilités techniques du médium. Ses œuvres entrent ainsi délibérément en concurrence avec les images de la culture quotidienne comme avec les formats de l'art monumental. Elles élargissent en même temps le spectre des modes de contemplation – de la lecture indulgente, amoureuse du détail, à l'analyse purement structurelle.

B. H.

SELECTED EXHIBITIONS →
1998 *Currents 27*, Milwaukee Art Museum, Milwaukee (WI), USA; *Fotografien 1984–1998*, Kunstmuseum Wolfsburg, Germany; *Fotografien 1984 bis heute*, Kunsthalle Düsseldorf, Germany; *Das Versprechen der Fotografie: Die Sammlung der DG Bank*, Hara Museum of Contemporary Art, Tokyo, Japan **1999** Van Abbemuseum, Eindhoven, The Netherlands **2000** *Architecture Hot and Cold*, The Museum of Modern Art, New York **2001** Museum of Modern Art, New York (NY), USA; *Let's Entertain*, Walker Art Center, Minneapolis (MN), USA

SELECTED BIBLIOGRAPHY →
1998 *Andreas Gursky: Fotografien 1984–1998*, Kunstmuseum Wolfsburg; *Andreas Gursky: Fotografien 1984 bis heute*, Kunsthalle Düsseldorf **2001** *Andreas Gursky*, Museum of Modern Art, New York (NY)

1 **EM Arena, Amsterdam I,** 2000, c-print, 275 x 205 cm 3 **Chicago Board of Trade II,** 1999, c-print, 207 x 337 cm
2 **99 cent,** 1999, c-print, 207 x 337 cm

„Im Rückblick sehe ich, dass mein Wunsch zur Abstraktion immer radikaler wird. Kunst sollte nicht einen Rapport von Wirklichkeit liefern, sondern sollte hinter die Dinge blicken."

« Rétrospectivement, je vois que mon désir d'abstraction devient de plus en plus radical. Plutôt que de proposer un rapport au réel, l'art devrait regarder derrière les choses. »

"In retrospect I can see that my desire to create abstractions has become more and more radical. Art should not be delivering a report on reality, but should be looking at what's behind something."

2

Fabrice Gygi

1965 born in Geneva, lives and works in Geneva and Zürich, Switzerland

Since the late 1980s, Fabrice Gygi has been constructing environments that explore the relationship between social reality and authority. Gygi provides us with the sort of functional shapes and structures – like shelters, podiums and crowd barriers – usually associated with large public events, and invites us to inhabit the space inside their prescribed boundaries. Since his début at the Geneva School of Fine Arts, his tents and performances have focused on activities within the confined spaces created by such frameworks as architecture and clothing. He also applies metaphors of movement to his art, highlighting the nomadic status of the artist promoting the notion of mobility and the temporary appropriation of space. In 1997, he transposed the tattoos on his arms into drawings and used them in an installation entitled *Viens dans ma peau* (Get under my skin), as well as in a publication. These were radical representations of his former life on the margins and a personal expression of the alternative position of the individual in the confrontation between the powers that be and the rest of society. His installations centre around late-capitalist society and its fondness for spectacle, and on established rituals, modes of behaviour and the pressure to behave in a specific way. Although they were installed in connection with specific events, the facilities put in place by the authorities reveal a lot about the intentions behind them. When reduced to bare essentials in Gygi's installations, they say a lot about prestige and expectations, and underline their role in reinforcing hierarchical structures. Gygi goes beyond the principle that "form follows function". In his *Airbags* multiples, he defines and at the same time questions the concepts of social and intergenerational relationships. All it takes is a loud, explosive bang and the whole thing loses its shape and self-destructs.

Das Verhältnis von sozialer Realität zur Autorität ist in den Environments von Fabrice Gygi seit den späten achtziger Jahren thematisiert. Gygi fordert uns auf, Unterstände, Bühnen, Absperrungen, normale funktionelle Gerätschaften, wie sie bei temporären öffentlichen Veranstaltungen eingesetzt werden, zu benutzen und in den festgelegten Handlungsfeldern zu agieren. Mit Zelten und Performances, die er zuerst im Umfeld der Genfer Kunsthochschule realisierte, verdeutlichte er Aktivitäten im Zwischenraum von räumlichen Hüllen wie Architektur und Bekleidung. Und er setzte Bewegungsmetaphern als nomadische Attitüde ein, um eine ebenfalls bewegliche, rein temporäre Besitznahme zu provozieren. Die Zeichnungen, die als Tätowierungen seine Arme zieren, wurden 1997 unter dem Titel *Viens dans ma peau* in einer Installation und Edition verwendet, radikale Zeichen seiner ehemals zu Markte getragenen Haut und eine persönliche, alternative Stellungnahme des Individuums im konfliktreichen Machtsystem von Staat und Gesellschaft. Im Sinne einer Theorie über die spätkapitalistische Gesellschaft des Spektakels stehen festgefügte Rituale, Handlungsangebote und auch -zwänge im Mittelpunkt seiner Installationen. Repräsentation und Erwartung werden mit Einrichtungen offengelegt, die zwar in einem Aktionszusammenhang stehen, aber auf die wesentlichen Strukturen reduziert, viel über ihre hierarchischen Strukturen schildern. Gygi geht über das Diktum „Form folgt Funktion" hinaus. In seiner Serie der *Airbags* gibt er gar einen Gesellschafts- oder Generationenbegriff vor und hinterfragt ihn zugleich: ein explosiv lauter Knall, und die Form gibt ihren Sinn in der Selbstzerstörung auf.

Depuis la fin des années 80, les environnements de Fabrice Gygi thématisent le rapport entre la réalité sociale et l'autorité. Gygi nous incite à nous servir des abris, des tribunes, des barrières, des fonctionnalités urbaines ordinaires, telles qu'elles sont mises en place lors des événements publics temporaires, et d'agir dans des champs d'action clairement définis. Avec des tentes et des performances réalisées d'abord dans l'entourage de l'Ecole des Beaux-Arts de Genève, il développe des actions dans des espaces situés à mi-chemin entre enveloppe architecturale et habillement. Gygi y met en œuvre les métaphores d'un mouvement conçu comme une attitude fondamentalement nomade, visant à provoquer une prise de possession purement temporaire, également mobile. Les dessins qui décorent ses bras sous forme de tatouages ont été utilisés en 1997 sous le titre *Viens dans ma peau,* dans une installation et une publication, signes radicaux d'une peau mise autrefois sur le marché, position alternative personnelle et très directe de l'individu au sein du système oppressant, riche en conflits, de l'Etat et de la société. Au sens d'une théorie de la société post-capitaliste du spectacle, l'accent principal de ses installations est mis sur des rituels fixes et des propositions d'action – mais aussi sur des contraintes d'action. La représentation et les attentes sont mises à nu à l'aide de dispositifs qui s'insèrent dans le contexte d'une action, mais qui n'en sont pas moins réduits à leur structures essentielles et en disent plus long sur les intentions et une manipulation créatrice de structures hiérarchiques. Gygi va au-delà de la devise de « la forme résultant de la fonction ». Dans sa séries des *Airbags*, Gygi présente un concept social ou générationnel qu'en même temps il interroge : un bruit d'explosion , et la forme perd son sens dans l'autodestruction.

G. J.

SELECTED EXHIBITIONS →
1999 *Power,* Galerie für Zeitgenössische Kunst, Leipzig, Germany **2000** Magasin – Centre National d'Art Contemporain, Grenoble, France; Galerie Bob van Orsouw, Zürich, Switzerland; *LKW,* Kunsthaus Bregenz/Bregenzer Kunstverein, Austria; *Over the Edges,* S.M.A.K., Stedelijk Museum voor Actuele Kunst, Ghent, Belgium **2001** MAMCO, Musée d'art moderne et contemporain, Geneva, Switzerland; Swiss Institute of Contemporary Art, New York (NY), USA; *The gift, generous offerings, threatening hospitality,* Palazzo Delle Papesse, Centro d'arte contemporanea, Siena, Italy; *L'Esprit de Famille,* Villa du Parc, Geneva, Switzerland; *The over excited body,* Place du Dôme, Milan, Italy; *Self-Tattoos,* Cabinet des estampes du Musée d'art et histoire, Geneva **2002** XXV Bienal Internacional de São Paulo, Brazil

SELECTED BIBLIOGRAPHY →
2000 *Fabrice Gygi,* Le Magasin, Grenoble

1 **Sans nul titre,** 1998, mixed media, installation view
2 Foreground: **Untitled (sound system),** 1997, mixed media, 100 x 100 x 80 cm; background: **Podium,** 1997, metal, awning, straps, 2.70 x 3.20 x 3.20 m
3 **Tribunal,** 1999, awning, PVC, wood, metal, straps, 4 x 4 x 6 m

4 **Tribune,** 1996, metal, wood, awning, straps, 2 x 6 x 1.40 m
5 **Vidéothèque and Drink,** 1998, awning, PVC, wood, wire netting, metal, straps, corrugated sheet iron, installation view, Centre Culturel Suisse, Paris

„Jede(r) Bürger(in) ist eine potenziell autoritäre Figur,
da er/sie stets den Verlockungen der Macht ausgesetzt ist."

« Chaque citoyen(ne) est une figure autoritaire potentielle,
puisque sa position est toujours contiguë et perméable au pouvoir. »

"Every citizen is a potential authoritarian figure, since his/her position is always contiguous and permeable to power."

2

3

5

Thomas Hirschhorn

1957 born in Berne, Switzerland, lives and works in Paris, France

Thomas Hirschhorn's works are epic and detailed displays. He favours disposable materials such as cardboard, tape and tin foil, with which he mimics and parodies subjects and creates umbilical chords between them. His works could be called small cosmologies, where everything is shown to be connected to everything else. The crude, home-grown character of Hirschhorn's work is underlined by a caricatured resonance with authoritative forms of display; the historical monument or the didactics of the museum display where text and image are mixed. Hirschhorn's environments are archival – meant to be read as well as experienced – and they intervene in the public arena. *Deleuze Monument*, 2000, was a tribute to the philosopher Gilles Deleuze in the form of a public sculpture, which Hirschhorn realised in a Paris suburb in collaboration with local youth. The monument created a sculptural space that wasn't purely plastic. It also consisted of a seminar on Deleuze's thinking, a conversation involving the local public. Hirschhorn's projects embody an interface between realism and utopia. They are interzones that lie in an extension of sensory perceptions offered by everyday life, and in the realm of macro-political movements. If by their scale alone Hirschhorn's large works demonstrate an ambition to recreate the world, their inferior and impermanent forms and materials metaphorically show the fragility of the position from which he is critically challenging power formations. In his art, Hirschhorn uses what he himself calls cheap tricks and stupid things in order to humorously undermine power.

Die Arbeiten von Thomas Hirschhorn sind episch angelegte und detailreiche Werke. Er bevorzugt Wegwerfmaterialien wie Karton, Klebeband und Alufolie, mit deren Hilfe er Motive nachempfindet und parodiert und zwischen ihnen nabelschnurartige Verbindungen herstellt. Man könnte seine Arbeiten als kleine Kosmologien bezeichnen, in denen alles mit allem zusammenhängt. Der für Hirschhorns Arbeiten typische ungeschönte Bastelcharakter wird durch die karikaturistische Einbettung in seriöse Präsentationskontexte hervorgehoben – sei es ein historisches Monument oder die Didaktik der Museumsdarbietung, in der Bild und Text miteinander vermischt sind. Hirschhorns Environments präsentieren sich gewissermaßen als Archive – sie wollen gelesen und erfahren werden – und intervenieren zugleich in die Öffentlichkeit. Mit *Deleuze Monument*, 2000, zollt Hirschhorn dem Philosophen Gilles Deleuze Tribut, in Gestalt einer öffentlichen Skulptur, die er in einem Pariser Vorort mit dort heimischen Jugendlichen realisiert hat. Das Monument bedingt einen skulpturalen – allerdings nicht ausschließlich plastischen – Raum. So war darin ein Seminar über Deleuze' Denken inbegriffen – ein Gespräch, an dem sich auch die Bewohner des Viertels beteiligen konnten. Hirschhorns Projekte bilden eine Schnittstelle zwischen Realismus und Utopie. Sie sind Fortschreibungen der Sinneswahrnehmungen, die wir aus unserem Alltagsleben kennen, und verknüpfen diese mit makro-politischen Vorgängen. Mag allein schon das große Format seiner Arbeiten Hirschhorns Ehrgeiz bekunden, die Welt neu zu erschaffen, so bezeugen ihre ebenso unspektakulären wie kurzlebigen Formen und Materialien zugleich auch die Fragilität der Position, von der aus er die vorgegebenen Machtstrukturen kritisch in Frage stellt. Im Übrigen arbeitet Hirschhorn in seiner Kunst mit – wie er selbst es nennt – billigen Tricks und dummen Sachen, um mit humoristischen Mitteln die Fundamente der Macht zu untergraben.

Les œuvres de Thomas Hirschhorn sont épiques et détaillées. Il privilégie les matériaux jetables tels que le carton, le ruban adhésif et la feuille d'aluminium, avec lesquels il imite et parodie des sujets, puis les relie par des cordons ombilicaux qu'il crée. Ses œuvres pourraient être qualifiées de « petites cosmologies », où tout est montré comme étant lié à tout le reste. La nature brute, improvisée, du travail d'Hirschhorn est soulignée par la résonance caricaturale des formes autoritaires de présentation : le monument historique ou le didactisme de l'exposition du musée où les textes et les images se mêlent. Ses environnements sont comme des archives – censés être lus aussi bien que vécus – et interviennent dans la sphère publique. *Deleuze Monument*, 2000, est un hommage au philosophe Gilles Deleuze sous la forme d'une sculpture publique réalisée dans une banlieue parisienne avec la collaboration de la jeunesse locale. Ce monument créait un espace sculptural qui n'était pas purement plastique. Il consistait également en un séminaire sur la pensée de Deleuze, une conversation impliquant le public local. Les projets de Hirschhorn incarnent une interface entre réalisme et utopie. Ce sont des interzones qui résident dans une extension des perceptions sensorielles offertes par la vie quotidienne ainsi que dans le domaine des mouvements macropolitiques. Si, par leur simple échelle, ses grandes œuvres trahissent une ambition de recréer le monde, leur formes et leurs matériaux inférieurs et éphémères démontrent métaphoriquement la fragilité de la position depuis laquelle il défie par sa critique les formations de la puissance. Dans son art, Hirschhorn utilise ce qu'il appelle lui-même des trucs faciles et des idioties pour saper le pouvoir avec humour.

L. B. L.

SELECTED EXHIBITIONS →
1998 *Premises*, Guggenheim Museum, New York (NY), USA
1999 *World Corners*, Musée d'Art Moderne de Saint-Etienne, France;
Unfinished History, Museum of Contemporary Art, Chicago (IL), USA;
Mirror's Edge, Bild Museet, Umeå, Sweden **2000** *World Airport*,
The Renaissance Society, Chicago (IL), USA; *Protest & Survive*, Whitechapel Art Gallery, London, UK **2001** *Archaeology of Engagement*,
Museu d'Art Contemporani, Barcelona, Spain; *Vivre sa vie*, The
Tramway, Glasgow, UK

SELECTED BIBLIOGRAPHY →
1995 Künstlerhaus Bethanien, Berlin **1996** Kunstmuseum Luzern,
Lucerne **1998** *Ein Kunstwerk, ein Problem*, Portikus, Frankfurt am
Main **2000** *Jumbo Spoons and Big Cake*, The Art Institute of
Chicago

1 **Flugplatz Welt,** 1999, installation view, Arsenale,
 48. Biennale di Venezia, Venice
2 **Jumbo Spoons,** 2000, installation view, The Art Institute, Chicago (IL)

3 **Skulptur-Sortier-Station,** 1997, installation view, *Skulptur. Projekte,* Münster

„Ich mache keine politische Kunst, sondern mache Kunst politisch."

« Je ne fais pas de l'art politique, je fais de l'art politiquement. »

"I don't make political art, I make art politically."

2

Damien Hirst

1965 born in Bristol, lives and works in Devon, UK

Damien Hirst's profile is as much that of showman, entrepreneur and self-promoter as artist. His exhibitions are elaborate large-scale spectacles more familiar to a science museum or theme park than a gallery. A 2000 show entitled *Theories, Models, Methods, Approaches, Assumptions, Results, and Findings* presented an ensemble of 31 sculptures, installations and wall pieces. Alternately grandiose and tongue-in-cheek, they deal with the unwieldy themes of life and death, sickness and science, chaos and order as first seen in 1991 with his infamous preservation of a dead shark in a tank of formaldehyde. Industrially constructed steel and glass cases, hybrids of the minimalist cube and the forensic vitrine, are a signature style of Hirst's. The enormity of scale and ambition of production characteristic of Hirst's work is here in works such as *Hymn*, 2000, a twenty foot high painted bronze human torso, its skin partially removed to reveal its internal organs, an exaggerated version of an educational anatomy model. Huge shiny medicine cabinets containing rows of evenly spaced, multicoloured pills express the world's infinite variety of sickness as well as man's attempts to regulate it (through medicine). A sculpture with the same long title as the show itself, in which dozens of ping pong balls jiggle in two vitrines, held aloft by gusts of air from two ventilators, is a light hearted meditation on the chaos and repetition of life. Hirst's is an existentialism for everyman, expressed with a schoolboy's sense of humour and a surrealist's sense of the absurd.

Damien Hirst gilt ebenso als Showmaster, Unternehmer und Selbstvermarkter wie als Künstler. Seine Ausstellungen sind ausge-klügelte großformatige Spektakel, die man eher in einem Wissenschaftsmuseum oder Themenpark erwarten würde als in einer Galerie. Hirsts im Jahr 2000 gezeigte Schau *Theories, Models, Methods, Approaches, Assumptions, Results, and Findings,* präsentierte ein Ensemble von 31 Skulpturen, Installationen und Wandarbeiten. Mal in grandioser, dann in ironischer Manier befasst er sich hier mit so sperrigen Themen wie Leben und Tod, Krankheit und Wissenschaft, Chaos und Ordnung. Ein erstes Beispiel für diese Vorgehensweise ist der berüchtigte Hai, den er 1991 in einem mit Formaldehyd gefüllten Aquarium konserviert hat. Hirsts Stil ist vor allem duch industriell gefertigte Stahl- und Glasbehälter – Mischformen aus minimalistischen Würfelkonstrukten und gerichtsmedizinischen Vitrinen – charakterisiert. Für die Dimension und die Ambition des Hirstschen Kunstschaffens typisch sind auch Werke wie *Hymn*, 2000, ein knapp sieben Meter hoher bemalter menschlicher Bronzetorso, dessen äußere Hülle stellenweise abgelöst ist und – als gigantisch vergrößertes Anatomiemodell – einen Blick auf die inneren Organe gestattet. Riesige spiegelblanke Medizinschränke, in denen in genau bemessenen Abständen Batterien bunter Pillen arrangiert sind stehen beispielhaft für die unendliche Vielfalt der Krankheiten und für das Streben des Menschen, ihrer mit Hilfe der Medizin Herr zu werden. Eine Skulptur, deren langer Titel gleichlautend mit dem der Ausstellung ist, besteht aus zwei Vitrinen, in denen Ventilatoren Dutzende von Pingpong-bällen in Bewegung halten und ist damit eine beschwingte Überlegung über das Chaos und das ewige Einerlei des Daseins. Hirst praktiziert einen Existentialismus für jedermann, ausgedrückt mit zugleich jungenhaftem Humor und einem surrealistischen Sinn für das Absurde.

Le C. V. de Damien Hirst pourrait tout autant être celui d'une bête de scène, d'un homme d'affaires et d'un spécialiste de l'auto-promotion que celui d'un artiste. Ses expositions sont de grands spectacles sophistiqués qui tiennent davantage du musée des sciences ou du parc d'attraction que de la galerie d'art. En 2000, une exposition intitulée *Theories, Models, Methods, Approaches, Assumptions, Results, and Findings,* présentait un ensemble de 31 sculptures, installations et œuvres murales. Tantôt grandioses, tantôt ironiques, elles traitaient des thèmes plutôt encombrants de la vie et de la mort, de la maladie et de la science, du chaos et de l'ordre, comme cela avait déjà été le cas en 1991 lorsqu'il fit scandale avec sa présentation d'un requin mort conservé dans un aquarium rempli de formol. Ses boîtes industrielles en verre et acier, croisement du cube minimaliste et de la vitrine de criminalistique, sont devenues son signe de reconnaissance. L'énormité de l'échelle et de l'ambition des réalisations de Hirst s'illustre dans des œuvres telles que *Hymn*, 2000 : un torse humain en bronze peint de six mètres de haut, dont la peau en partie ôtée révèle ses organes internes – version exagérée d'un écorché de salle de classe. D'immenses armoires à pharmacie étincelantes, contenant des rangées de pilules multicolores minutieusement espacées, expriment l'infinie variété de la maladie comme dans les espèces) ainsi que les tentatives de l'homme pour la contrôler (par la médecine). Une sculpture portant le même long titre que l'exposition, où des dizaines de balles de ping-pong maintenues en l'air par deux ventilateurs se trémoussent dans deux vitrines, constitue une méditation amusée sur le chaos et la répétition de la vie. L'existentialisme de Hirst s'adresse à tout le monde, s'exprimant avec un humour d'écolier et un sens de l'absurde surréaliste.

K. B.

SELECTED EXHIBITIONS →
1997 *The Beautiful Afterlife*, Bruno Bischofberger, Zurich, Switzerland
1998 *Damien Hirst*, Southampton City Art Gallery, Southampton, UK
1999 *Pharmacy*, Tate Gallery, London, UK **2000** *Sadler's Wells*, London, UK; *Theories, Models, Methods, Approaches, Assumptions, Results, and Findings*, Gagosian Gallery, New York (NY), USA; *Hyper Mental*, Kunsthaus Zürich, Zurich, Switzerland; Hamburger Kunsthalle, Hamburg, Germany; *Ant Noises*, Saatchi Gallery, London, UK **2001** *Double Vision*, Galerie für Zeitgenössische Kunst, Leipzig, Germany; *Public*

Offerings, Museum of Contemporary Art, Los Angeles (CA), USA; Century City, Tate Modern, London, UK

SELECTED BIBLIOGRAPHY →
1995 *Some Went Mad, Some Ran Away*, Serpentine Gallery, London
1997 *Want to Spend the Rest of My Life Everywhere with Everyone, One to One, Always, Forever, Now*, London **2000** *Theories, Models, Methods, Approaches, Assumptions, Results, and Findings*, Gagosian Gallery, New York (NY)

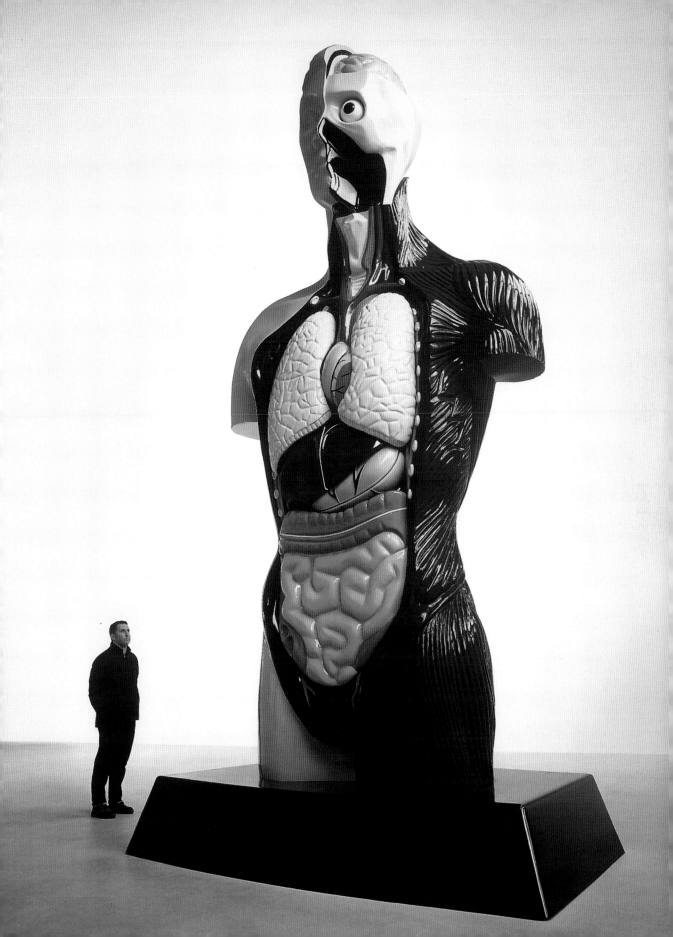

1 **Hymn,** 2000, painted bronze, 610 x 274 x 122 cm
2 **Lost Love,** 2000, vitrine with African river fish, 366 x 213 x 213 cm
3 **Concentrating on a Self-Portrait as a Pharmacist,** 2000, vitrine, portrait,

objects, 244 x 274 x 305 cm
4 **Adam & Eve (Banished from the Garden),** 2000, steel and glass vitrine, 221 x 427 x 122 cm

„Letztendlich handelt es sich um den Wunsch, ewig zu leben. Darum geht es ja schließlich in der Kunst."

« Tout se résume au désir de vivre à jamais. C'est de cela qu'il s'agit en art. »

"It all boils down to the desire to live forever. This is what art's all about."

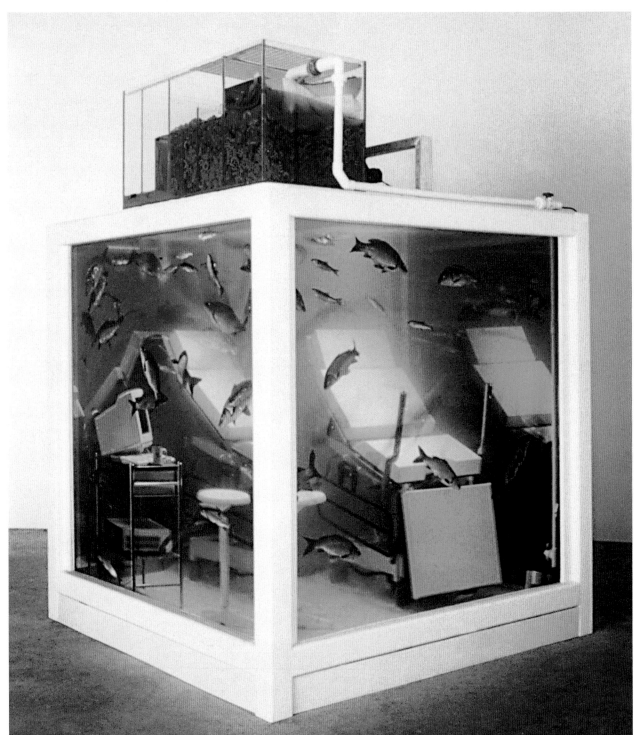

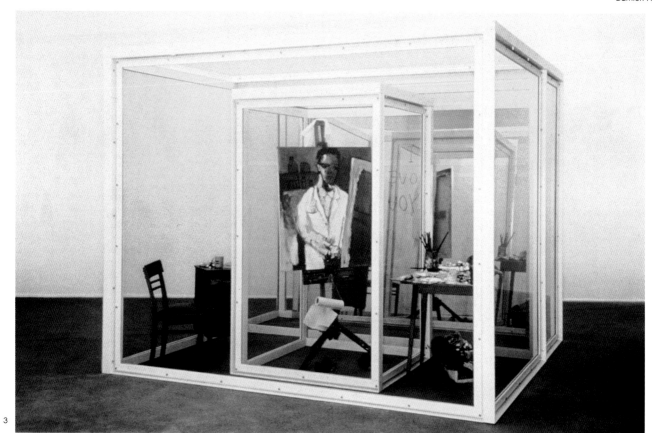

3

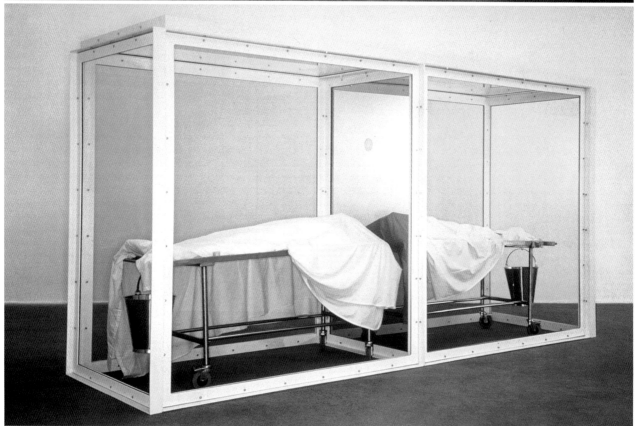

4

Carsten Höller

1961 born in Brussels, Belgium, lives and works in Stockholm, Sweden

Carsten Höller creates a happy combination of art and science. His aim is to extend the boundaries of human perception or, to be more precise, to manipulate it and release it from its most primitive parameters in its search for physiological sensations. If we want to broaden our perceptual horizons, we must abandon our habits and certainties. Since 1999 Höller's white Daimler has been hurtling around the art market and along ordinary streets, covered with stickers in various languages advertising *The Laboratory of Doubt*. Contradicting Adorno's dictum that art acquires meaning in proportion to its lack of function, Höller provides a service. He produces positive effects. His art objects function in the same way as the human body. They give us answers to our questions, like "Who am I? Where am I going? What can I think?" By focussing on physiological sensation and providing physical experiences, he breaks down the barriers between art and behaviour which tend to trivialise art and rob it of meaning and relevance. In 2001 in *Instrumente aus dem Kiruna Psycholabor* (Instruments from the Kiruna Psycholaboratory) Höller used flickering lights to show the synchronisation of brain activity and the visual phenomena experienced by the closed eye, behind the retina and under the eyelids. In his *Light Wall*, 2000, 1,920 light bulbs emit light and heat, rhythmically flashing at a Hertz frequency of 7.8. Even with eyes closed, the viewer cannot escape the light, which creates a multicoloured negative. The brain is compared to an electrical system, synchronising external impulses. The exhibition space is a machine whose task is to synchronise itself with visitors and provide them with a shared experience.

Carsten Höller ist als Künstler ein glücklicher Wissenschaftler. Er arbeitet an der Ausdehnung der menschlichen Wahrnehmung, oder genauer gesagt, daran, dass diese manipulierbar ist, abhängig von primitivsten Parametern, süchtig nach physiologischen Sensationen. Will man seine Wahrnehmung erweitern, muss man Gewissheit und Gewöhnung fahren lassen. Seit 1999 rauscht Höllers weißer Daimler durch den Kunstmarkt und über gewöhnliche Straßen und kündigt mit Aufklebern in diversen Sprachen *The Laboratory of Doubt* an. Ein paar Meilen entfernt von Adornos Diktum, Kunst gewinne in der Funktionslosigkeit ihren Sinn, ist Höller ein Dienstleister, er produziert positive Effekte. Seine Objekte funktionieren ähnlich wie unser Körper, sie antworten auf unsere Fragen: „Wer bin ich, wohin gehe ich, was kann ich denken?" Da er die Aufmerksamkeit auf physiologische Sensationen lenkt und Erfahrungen vermittelt, durchbricht er die Barriere zwischen Kunst und Handeln, die die Kunst trivialisiert und sie der Wirkung einer tatsächlichen Praxis beraubt. Im Jahre 2001 erzählt Höller in *Instrumente aus dem Kiruna Psycholabor* von der Synchronisation der Gehirnaktivitäten durch flackernde Lichter, die bei geschlossenen Augen visuelle Phänomene zaubern, hinter der Retina, unter den Augenlidern. In seiner Arbeit *Light Wall*, 2000, verströmen 1920 Glühbirnen ihr Licht und ihre Wärme, blitzen im Rhythmus des Taktes einer 7,8 Hertz Frequenz. Selbst hinter den Augenlidern hat man keine Ruhe und sieht ein vielfarbiges Negativ. Das Gehirn gleicht einem elektrischen System, dass Impulse von außen synchronisiert. Der Ausstellungsraum ist eine Maschine, deren Aufgabe es ist, sich mit den Besuchern zu synchronisieren, um mit ihnen zusammen etwas zu erleben.

Comme artiste, Carsten Höller est un scientifique comblé. Il travaille sur le développement de la perception humaine, plus précisément sur le fait qu'elle est manipulable, dépendante de paramètres infiniment primitifs, avide de sensations physiologiques. Lorsqu'on se propose d'étendre le champ de sa perception, on doit laisser de côté les certitudes et les habitudes. Depuis 1999, la Daimler blanche de Höller sillonne le marché de l'art et les sentiers battus, répandant la bonne parole du *Laboratory of doubt* à coup d'autocollants en plusieurs langues. A bien des lieues de l'affirmation d'Adorno, selon laquelle l'art prend son sens dans l'absence de fonction, Höller est un prestataire de service. Il produit des effets positifs. Ses objets fonctionnent un peu comme notre propre corps, ils répondent à nos questions : « qui suis-je ? où vais-je ? que puis-je penser ? » En dirigeant l'attention vers les sensations physiologiques et en faisant part de ses expériences, Höller abat la barrière entre l'art et l'action, qui trivialise l'art et le soustrait aux effets d'une pratique concrète. En 2001, dans *Instrumente aus dem Kiruna Psycholabor* (Outils du psycholaboratoire Kiruna), Höller évoque la synchronisation des activités cérébrales à l'aide de lumières clignotantes qui, derrière les paupières baissées, font apparaître des phénomènes visuels sur la rétine. Dans son *Light Wall* (Mur de lumière, 2000), 1,920 ampoules électriques dispensent leur lumière et leur chaleur, flashent au rythme de 7,8 hertz. Même derrière les paupières baissées, l'œil est bombardé de stimuli, et l'on voit un négatif multicolore. Le cerveau est comme un système électrique qui synchronise des impulsions extérieures. La salle d'exposition est une machine dont la fonction est de se caler sur le rythme du spectateur, et de vivre quelque chose avec lui. F. F.

SELECTED EXHIBITIONS →
1997 documenta X (with Rosemarie Trockel), Kassel, Germany
2000 *Liukuratoja – Slides, Tuotanto – Production*, Kiasma, Studio K, Helsinki, Finland; *Synchro System*, Fondazione Prada, Milan, Italy; *Over the Edges*, S.M.A.K., Stedelijk Museum voor Actuele Kunst, Ghent, Belgium; *An Active Life*, The Contemporary Arts Center, Cincinnati (OH), USA; *In Between* (with Rosemarie Trockel), EXPO 2000, Hanover, Germany **2001** *Instrumente aus dem Kiruna Psycholabor*, Schipper & Krome, Berlin, Germany; *Yokohama Triennale*, Yokohama, Japan

2002 *Light Corner*, Museum Boijmans Van Beuningen, Rotterdam, The Netherlands

SELECTED BIBLIOGRAPHY →
1999 *Neue Welt*, Museum für Gegenwartskunst Basel, Basle
2000 *Registro*, Fondazione Prada, Milan; Daniel Birnbaum/Patrik Nyberg (eds.), *Tuotanto/Production*, Helsinki **2001** Hans Ulrich Obrist/Barbara Vanderlinden (eds.), *Laboratorium*, Cologne

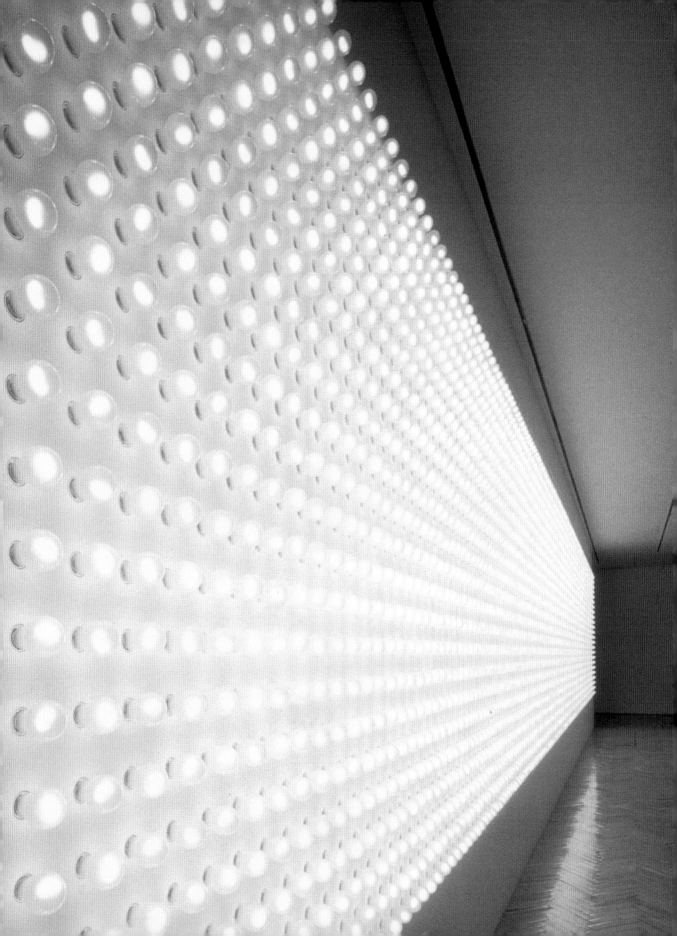

1 **Light Wall,** 2000, installation view, Fondazione Prada, Milan
2 **Valerio I,** 1998, installation view, Kunst-Werke, Berlin
3 **Frisbeehaus,** 2000, installation view, *HausSchau – Das Haus in der Kunst,* Deichtorhallen, Hamburg

4 **Ballhaus** (detail), 1999, installation view, *Sanatorium,* Kunst-Werke, Berlin
5 **Upside Down Mushroom Room,** 2000, installation view, Fondazione Prada, Milan

„Zweifel ist schön."

« Le doute est beau. »

"Doubt is beautiful."

2

3

4

5

Jonathan Horowitz

1966 born in New York (NY), lives and works in upstate New York, USA

Jonathan Horowitz's video works tease apart two aspects of time intertwined in the televisual image: the constructed time scheme of the screen image and the real time in which it is viewed. *MAXELL*, 1990, demonstrates the material deficiencies of video as a medium and the physical time embodied by the tape itself. The Maxell brand name appears against a black background, creating a state of suspended animation as it refuses to vacate the screen. Instead, the image quality steadily degrades, each 10-second fragment of tape having been duplicated from the previous strip. In works such as *Reap the Wild Wind*, 1993, *Countdown*, 1995, and *Movies that Made Me Cry*, 1996, Horowitz appropriates movies or television programmes but disrupts their narrative function by partially obscuring the image, superimposing his own text or dislocating sound and picture. In *Reap the Wild Wind*, he re-edits three classic sit-coms from the 1970s so that the image is visible only when canned laughter is heard on the soundtrack. *The Jonathan Horowitz Show*, 2000, is an autobiographical installation with seven monitors each representing one period of the artist's life. On each monitor, excerpts from TV staples like the "Mary Tyler Moore Show" are interspersed with elliptical fragments of text such as "unable to look up from the floor, 1980–1981" or "I think I have AIDS, 1988–1993" to build a partial portrait of the artist. Horowitz's restructurings of television and its counterpart, home video, reveal their influence in the formation of memory and the overlapping of individual and collective identity.

Die Video-Arbeiten von Jonathan Horowitz machen zwei in der Bildsprache des Fernsehens miteinander verwobene Aspekte sichtbar: zum einen das konstruierte Zeitschema des auf der Mattscheibe Dargebotenen und zum anderen die wirkliche Zeit, die der Zuschauer diesem Geschehen widmet. In der Arbeit *MAXELL*, 1990, beschäftigt er sich mit den materiellen Defiziten des Mediums Video und mit der Realzeit, die ein solches Band speichert: Der Markenname Maxell erscheint vor schwarzem Hintergrund und blockiert den erwarteten Fortgang des Geschehens. Dabei verschlechtert sich zusehends die Bildqualität, da jedes der hintereinander geschnittenen 10-Sekunden-Fragmente eine Kopie des vorhergehenden ist. In Werken wie *Reap the Wild Wind*, 1993, *Countdown*, 1995, und *Movies that Made Me Cry*, 1996, arbeitet Horowitz mit Ausschnitten aus Filmen oder Fernsehsendungen, unterbricht aber den narrativen Ablauf immer wieder, etwa durch Bildstörungen, Einbau eigener Texte oder die Aufhebung der Synchronizität von Ton und Bild. In *Reap the Wild Wind* hat er drei klassische Sitcoms aus den siebziger Jahren so umgeschnitten, dass das Bild nur dann erscheint, wenn auf der Tonspur vorfabriziertes Gelächter eingespielt wird. *The Jonathan Horowitz Show*, 2000, ist eine Installation mit sieben Monitoren, die für eine Phase im Leben des Künstlers stehen. Die einzelnen Bildschirme geben Ausschnitte aus dem Repertoire des Fernsehens wieder, etwa der „Mary Tyler Moore Show". Dazwischen hat Horowitz unvollständige Textfragmente geschnitten, zum Beispiel „unable to look up from the floor, 1980–1981" oder „I think I have AIDS, 1988–1993". Indem er die für die Welt des Fernsehens und des Heim-Videos konstitutiven Elemente neu arrangiert, zeigt Horowitz die grundlegende Bedeutung dieser Medien für die Formierung des Gedächtnisses und für die Überschneidung von individueller und kollektiver Identität.

Les vidéos de Jonathan Horowitz jouent à séparer deux aspects du temps enchevêtrés dans l'image télévisuelle : le temps construit de l'image qui apparaît à l'écran et le temps réel pendant lequel elle est regardée. *MAXELL*, 1990, démontre les déficiences matérielles de la vidéo en tant que médium et le temps physique incarné par la cassette elle-même. Le logo de la marque Maxell apparaît sur un fond noir, créant un état d'animation suspendue en refusant de quitter l'écran. Au contraire, c'est l'image elle-même qui se dégrade progressivement, chaque segment de 10 secondes ayant été copié sur le segment précédent. Dans des œuvres telles que *Reap the Wild Wind*, 1993, *Countdown*, 1995, et *Movies that Made Me Cry*, 1996, Horowitz s'approprie des films ou des émissions de télévision mais perturbe leur fonction narrative en obscurcissant partiellement l'image, en superposant son propre texte ou en disloquant le son et l'image. Dans *Reap the Wild Wind*, il remonte trois sitcoms classiques des années 70 en faisant de sorte que l'image ne devienne visible que lorsque retentissent les « rires en boîte ». *The Jonathan Horowitz Show*, 2000, est une installation autobiographique avec 7 écrans représentant chacun une période de la vie de l'artiste. Sur chaque écran, des extraits de séries TV cultes comme le « Mary Tyler Moore Show » sont intercalés avec des fragments de textes elliptiques tels que « unable to look up from the floor, 1980–1981 » (incapable de relever les yeux du sol) ou « I think I have AIDS, 1988–1993 » (je crois que j'ai le Sida), construisant un portrait partiel de l'artiste. En restructurant la télévision et son complice, le magnétoscope, Horowitz révèle leur influence sur la formation de la mémoire et le chevauchement des identités individuelles et collectives. K. B.

SELECTED EXHIBITIONS →
2000 *Greater New York*, P.S.1, Long Island City, New York (NY), USA; *Making Time: Considering Time as a Material in Contemporary Video & Film*, Palm Beach Institute for Contemporary Art, Palm Beach (FL), USA **2001** Kunsthalle St. Gallen, Switzerland; The *Americans: New Art from the United States*, Barbican Gallery, London, UK; *Tele(visions)*, Kunsthalle Wien, Vienna, Austria; *Casino 2001*, S.M.A.K., Stedelijk Museum voor Actuele Kunst, Ghent, Belgium

SELECTED BIBLIOGRAPHY →
1999 Jan Hoet, *The Collection*, S.M.A.K., Stedelijk Museum voor Actuele Kunst, Ghent **2000** *Zeitwenden*, Kunstmuseum Bonn; Amy Cappellazzo, *Making Time: Considering Time as a Material in Contemporary Video & Film*, Palm Beach Institute of Contemporary Art, Palm Beach (FL); Jan Hoet/Giacinto Di Pietrantonio, *Over the Edges*, S.M.A.K., Stedelijk Museum voor Actuele Kunst, Ghent

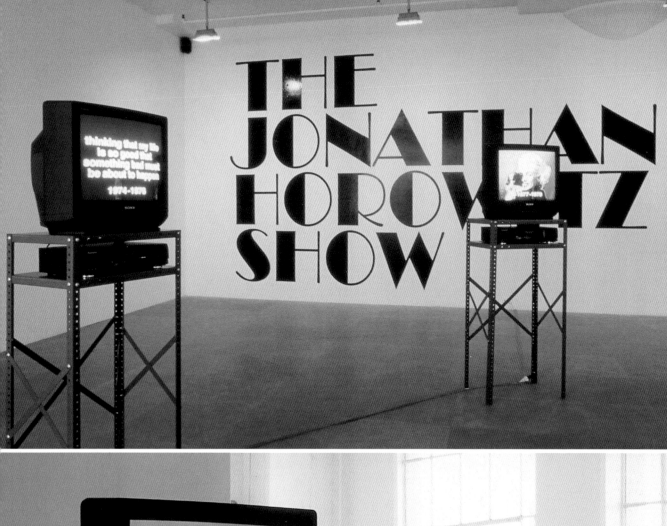

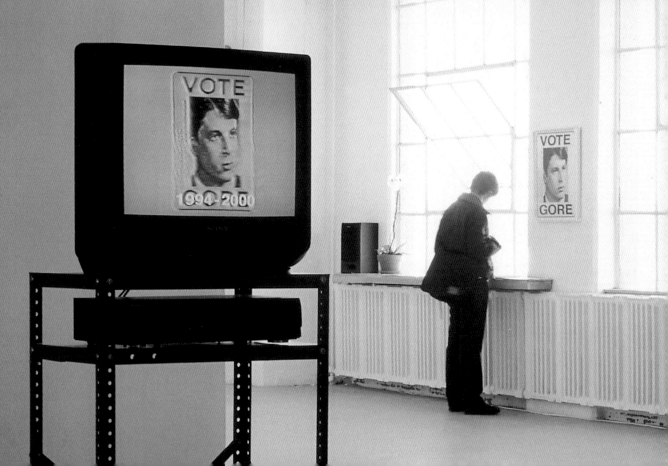

1 **The Jonathan Horowitz Show,** 2000, video and sound installation with equipment, 7 monitors, VHS tapes, wall text, installation view, Greene Naftali Gallery, New York (NY)

„Hinter der destrukturierten Fernseh-Zeit tritt die Erfahrung der wirklichen Zeit zutage."

« Un temps télévisuel déstructuré devient une expérience de temps réel. »

"A destructured televisual time becomes an experience of real time."

1

1974-1976

realizing that people like me more when I am not myself

1977-1979

1982-1987

my mother
holding my hand

1988-1993

I think
I have AIDS

1988-1993

Rob

1994-2000

Gary Hume

1962 born in Kent, lives and works in London, UK

Gary Hume came to public attention in the late 1990s with his *Doors* series of full-scale paintings depicting hospital swing doors. Although they tend to be interpreted as allegorical descriptions of the despair he felt at the time, associated with loss, ending, death or fearful loneliness, he himself regards them as perfect works of art, which counteract the vileness of reality. In the years since then he has remained faithful to this principle. The covers of gossip and pornographic magazines, popular icons of fashion and music, hands, flowers and old master-pieces from the world's museums provide him with templates whose forms and colours he radically abstracts, thereby seeming to negate any real engagement with the original subject. Thus Pop Art meets Rorschach, Art Deco encounters Jan Vermeer, Kate Moss runs into the Renaissance painter Petrus Christus. Nevertheless, the paintings resist all arbitrariness and are a testimony to his interest in exploring the difference between archetype and copy, sign and signified; these are probed by Hume in defiance of the onslaught of decoration, kitsch and bad design. The optical trickery of his pictures is based on the aesthetic use of spaces in which his images move back and forth between gaze and memory ("Being seen"). Different sections are subjected to a variety of treatments, ranging from high gloss to matt hatching, thereby supporting perception and effect, as his signature and brush strokes disappear in favour of the smoothly devised, empty surface. The gaps reflect painting's qualitative advantage in showing empty spaces – regardless of whether the motivation is to be found within or outside the image. One thing is certain, however: Hume enjoys the viewer's irritation to the full and does not shrink from pathos.

Bekannt wurde Gary Hume Ende der neunziger Jahre durch die Serie *Doors*, lebensgroße Gemälde von Schwing-Flügeltüren in Krankenhäusern. Häufig als allegorische Beschreibung seines damaligen, trostlosen Zustands interpretiert, assoziiert mit Verlust, Ende, Tod oder angstvoller Einsamkeit, sind sie seiner Meinung nach perfekte Kunstwerke, die der scheußlichen Realität ein Gegenbild eröffnen. Diesem Prinzip ist er in den Folgejahren treu geblieben. Die Cover von Boulevard- oder Porno-Magazinen, die Pop-Ikonen aus Mode und Musik, Hände, Blumen oder die alten Meisterwerke aus den Museen der Welt liefern ihm die Umrisse, die formal und farblich stark abstrahiert eine Auseinandersetzung mit dem Vorbild scheinbar negieren. So trifft Pop-Art auf Rorschach, Art déco auf Jan Vermeer, Kate Moss auf den Renaissancemaler Petrus Christus. Die Gemälde wehren sich jedoch gegen jede Beliebigkeit und bezeugen das Interesse an der Differenz von Urbild und Abbild, von Zeichen und Bezeichnetem, welches Hume gegen die Phalanx von Dekoration, Kitsch und schlechtem Design auslotet. Der optische Trick seiner Bilder beruht auf der ästhetischen Nutzung der Zwischenräume, in denen das Bild zwischen Sehen und Erinnern ("Gesehen werden") oszilliert. Hierbei unterstützt die unterschiedliche Behandlung der von hoch glänzend bis matt schraffiert reichenden Partien die Wahrnehmung und Wirkung, da seine Signatur und Pinselspur zugunsten der glatt designten, leeren Oberflächen verschwindet. In den Leerstellen liegt der Qualitätsvorsprung der Malerei, Freiräume zur Erscheinung zu bringen – seien sie inner- oder außerbildlich motiviert. Eines aber ist sicher: Unsere wohlige Irritation kostet Hume weidlich aus und scheut sich nicht, pathetisch zu werden.

Gary Hume s'est fait connaître à la fin des années 90 avec sa série *Doors*, des peintures grandeur nature de portes d'hôpitaux à double battant. Souvent interprétées comme une description allégorique de son sentiment de désespérance à cette époque, associées aux idées de perte, de fin, de mort ou d'angoisse devant la solitude, elles sont selon lui des œuvres d'art parfaites qui proposent une image à contre-courant de l'horreur de la réalité. Dans les années qui ont suivi, Hume est resté fidèle à ce principe. Les couvertures de revues pornographiques ou de la presse du cœur, les icônes populaires de la mode et de la musique, les mains, les fleurs ou les anciens chefs-d'œuvre des grands musées fournissent des silhouettes dont la forte abstraction semble nier formellement toute confrontation avec le modèle. Le Pop Art rejoint le test de Rorschach, l'Art nouveau Vermeer, Kate Moss le peintre de la Renaissance Petrus Christus. Mais ces peintures se défendent de tout arbitraire et attestent un intérêt certain pour l'écart entre le modèle et sa représentation, entre le signe et le signifié, intérêt que Hume sonde en le comparant aux légions de décorations, d'images kitsch et de mauvais designs. La virtuosité visuelle de ses tableaux repose sur l'utilisation esthétique des espaces interstitiels dans lesquels le tableau oscille entre contemplation et réminiscence (« être vu »). Les différences de traitement des parties superbrillantes, mates ou hachurées, mettent alors l'accent sur la perception, sur l'effet, d'autant que toute facture personnelle et toute trace de pinceau disparaissent au profit d'une surface vide et lissée comme un design. C'est dans ces intervalles que réside l'avance qualitative de la peinture, qui sait visualiser les espaces vides – que ceux-ci soient motivés par des considérations extérieures ou inhérentes au fait pictural. Une certitude demeure : notre douce irritation fait la délectation de Hume, une délectation qui ne recule pas devant le pathos. G. J.

SELECTED EXHIBITIONS →
1996 Bonnefanten Museum, Maastricht, The Netherlands; *The Turner Prize Exhibition*, Tate Gallery, London **1999** Whitechapel Art Gallery, London, UK; British Pavilion, *48. Biennale di Venezia*, Venice, Italy **2000** Fundació "la Caixa", Barcelona, Spain; *Painting the Century*, National Portrait Gallery, London, UK; *Ant Noises*, Saatchi Gallery, London, UK; *Sincerely Yours*, Astrup Fearnley Museum, Oslo, Norway **2001** *Century City*, Tate Modern, London, UK; *Heads and Hands*, Decatur House Museum, Washington D.C., USA

SELECTED BIBLIOGRAPHY →
1995 *Gary Hume*, Institute of Contemporary Arts, London; *Gary Hume*, Kunsthalle Bern, Berne **1996** Bonnefanten Museum, Maastricht **1998** *Real/Life: New British Art*, Tochigi Prefectural Museum of Fine Arts, Tochigi **1999** *Gary Hume*, British Council, London; Matthew Collings, *This is Modern Art*, London; Richard Cork et al., *Young British Art: The Saatchi Decade*, London; *Gary Hume*, Fundació "la Caixa", Barcelona

1 **Daffodils,** 2000, enamel paint on aluminium panel, 250 x 200 cm
2 **Snowman,** 2000, c-print, 158 x 122 cm

3 Installation views, *New Paintings*, Matthew Marks Gallery, New York (NY), 2001
4 **Spring Angels,** 2000, series of 8 screenprints, each 127 x 102 cm

„Ich möchte etwas Großartiges malen, etwas Vollkommenes –
etwas voller Traurigkeit."

« Je veux peindre quelque chose de splendide, de parfait,
qui soit donc plein de tristesse. »

"I want to paint something that's gorgeous, something that's perfect, so that it's full of sadness."

2

3

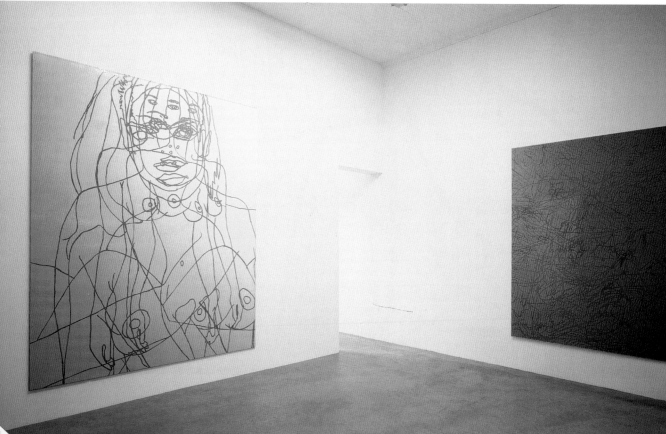

4

3

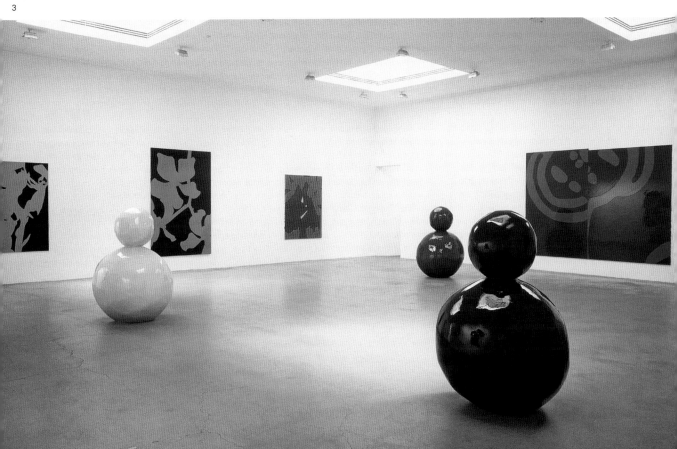

Pierre Huyghe

1962 born in Paris, lives and works in Paris, France

Pierre Huyghe's photographs and films superimpose multiple realities. In his billboard projects of the mid 1990s, he photographed various locations then installed the images in the locations they depicted. The resulting photographs created a temporal displacement while maintaining spatial continuity. Huyghe's films also explore the terrain between overlapping realities: in *L'ellipse*, 1998, a triple video projection, the artist focuses on "l'ellipse" – or jump cut – in Wim Wenders' 1977 film "The American Friend". He hired the film's original actor, Bruno Ganz, and recreated what was implied by the jump cut from a scene shot on one side of the Seine to a scene shot on the other side. Huyghe fills the gap with the "missing" space and time. Although this produces continuity within the span of the film's narrative, Huyghe's footage was shot 21 years later so there is a discrepancy in time, seen through the ageing of Ganz. In his nine-minute film *The Third Memory*, 2000, Huyghe asked John Wojtowicz, who committed a highly publicised bank robbery in 1972, to reenact the crime in a reconstructed set. Not only had the footage of the robbery been seen live on numerous news programmes, Wojtowicz's story had also served as the basis of the 1975 Sidney Lumet film "Dog Day Afternoon", with Al Pacino playing Wojtowicz. Huyghe's footage is intermixed with clips of the real event and Lumet's movie. Just as our knowledge of the robbery is mediated through the Hollywood film, so too is Wojtowicz's memory of it. Fact and fiction mingle as both reality and memory are mediated by spectacle.

In den Foto- und Filmarbeiten von Pierre Huyghe überlagern sich zahlreiche Realitätsebenen. Für seine Plakatwand-Projekte Mitte der neunziger Jahre hat er diverse Schauplätze fotografiert und dann die Bilder genau an den Orten installiert, die auf ihnen abgebildet sind. So erzeugte er ein Gefühl der zeitlichen Dissoziierung, während die räumliche Kontinuität gewahrt schien. Auch in seinen Filmen erkundet Huyghe die Zone zwischen sich überschneidenden Realitäten: In *L'ellipse*, 1998, einer dreifachen Videoprojektion, beschäftigt er sich mit der „Ellipse" – dem harten Schnitt – in Wim Wenders Film „Der Amerikanische Freund", 1977. Mit Bruno Ganz engagierte er eine der Hauptfiguren dieses Films. Dann zeigte er, was „zwischen" den beiden Szenen auf der linken und rechten Seite der Seine passierte, die Wenders durch einen harten Schnitt aufeinander folgen ließ. So gelingt es ihm, den Zeit- und Raumsprung des Filmes zu überbrücken. Selbst wenn dabei im Hinblick auf die narrative Struktur des Films ein Gefühl der Kontinuität entsteht, eröffnet sich zugleich eine zeitliche Diskrepanz, weil Ganz auf dem 21 Jahre später gedrehten Material gealtert ist. Für den Neunminutenfilm *The Third Memory*, 2000, engagierte Huyghe John Wojtowicz, der 1972 einen von den Medien im großen Stil begleiteten Banküberfall begangen hatte. Wojtowicz sollte das Verbrechen vor einer Kulisse abermals aufführen. Der Überfall war nicht nur von verschiedenen Fernsehsendern live übertragen worden, auch Sidney Lumet hat die Geschichte 1975 mit Al Pacino in der Hauptrolle in „Dog Day Afternoon" verfilmt. Huyghe verschränkte Ausschnitte aus der ursprünglichen Berichterstattung und aus Lumets Film mit seinem Material. Nicht nur unser Wissen um den Überfall ist durch den Hollywood-Film eingefärbt, sondern sogar Wojtowicz' eigene Erinnerung. Fakten und Fiktion vermischen sich, und Wirklichkeit und Erinnerung erweisen sich als maßgeblich durch das Medienspektakel konstituiert.

Les photographies et les films de Pierre Huyghe superposent des réalités multiples. Dans ses projets d'affiches géantes du milieu des années 90, il photographiait divers sites puis installait ses images sur les sites qu'elles représentent. Les photos qui en résultaient créaient un déplacement temporel tout en conservant une continuité spatiale. Les films de Huyghe explorent le terrain entre deux réalités qui se chevauchent : dans *L'ellipse*, 1998, un triple projection vidéo, l'artiste se concentre sur une ellipse – ou un raccord entre deux séquences non consécutives – dans le film « L'ami américain » de Wim Wenders, datant de 1977. Recrutant l'acteur du film, Bruno Ganz, et recréant ce qui était rendu implicite par une coupe sèche entre une scène tournée d'un côté de la Seine et la scène suivante tournée sur l'autre rive, Huyghe comble le vide avec l'espace et le temps « manquant ». Bien que cela produise une continuité dans le déroulement du récit, il y a une divergence dans le temps qui apparaît par le vieillissement de Ganz, les plans de Huyghe ayant été tournés 21 ans plus tard. Dans *The Third Memory*, 2000, un film de 9 minutes, Huyghe a demandé à John Wojtowicz, auteur d'un braquage de banque très médiatisé en 1972, de revivre l'épisode dans un décor reconstitué. Non seulement le braquage avait été filmé en direct par plusieurs chaînes de télévision mais l'histoire de Wojtowicz avait également servi de base au film de 1975 de Sidney Lumet « Un Après-midi de chien », avec Al Pacino dans le rôle de Wojtowicz. Huyghe fait alterner ses prises de vue avec des images des vrais événements et des extraits du film de Lumet. Si notre connaissance du braquage est influencée par ce que nous avons retenu du film, les souvenirs de Wojtowicz le sont tout autant. Les faits et la fiction se mêlent tandis que la réalité et la mémoire sont remodelées par le spectacle.

Ro. S.

SELECTED EXHIBITIONS →
1998 *Manifesta 2*, Luxembourg **1999** *Carnegie International*, Carnegie Museum of Art, Pittsburgh (PA), USA; *Notorious*, Museum of Modern Art, Oxford, UK **2000** *The Third Memory*, Centre Georges Pompidou, Paris, France; *Let's Entertain*, Walker Art Center, Minneapolis (MN), USA **2001** French Pavilion, *49. Biennale di Venezia*, Venice, Italy; *Two Minutes out of Time*, Musée d'art moderne et contemporain, Geneva, Switzerland; Institute of Contemporary Arts (with Philippe Parreno), London, UK; *7th Istanbul Biennial*, Istanbul, Turkey **2002** *Ann Lee*, Kunsthalle Zürich, Zurich, Switzerland

SELECTED BIBLIOGRAPHY →
1998 *Dominique Gonzalez-Foerster, Pierre Huyghe, Philippe Parreno*, ARC Musée d'Art Moderne de la Ville de Paris **1999** *Carnegie International*, Carnegie Museum of Art, Pittsburgh (PA) **2000** *The Third Memory*, Centre Georges Pompidou, Paris; *The Trial*, Kunstverein München, Munich/Kunsthalle Zürich, Zurich

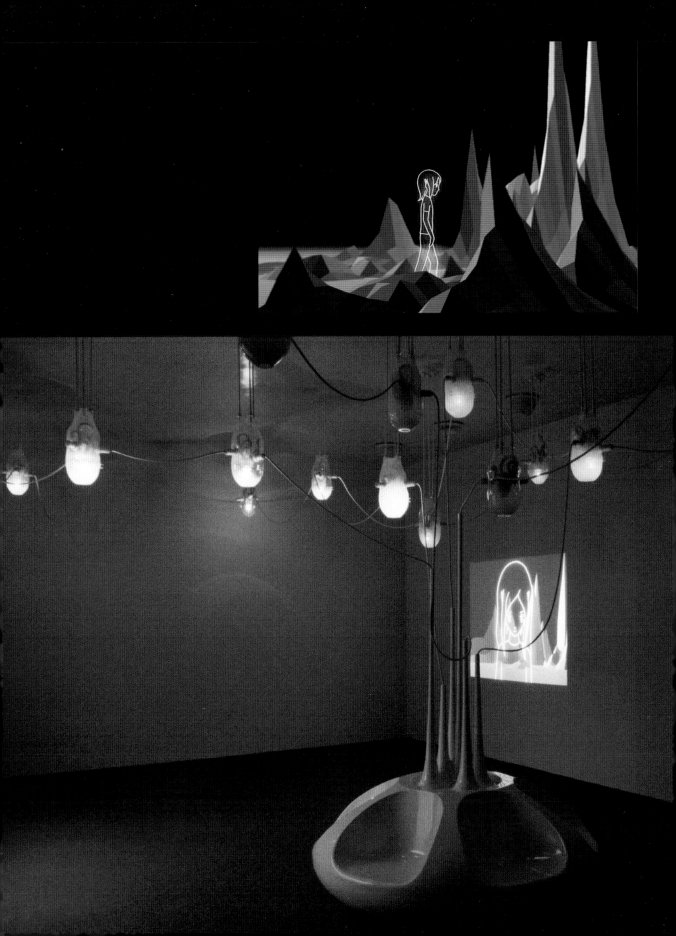

1 In collaboration with Philippe Parreno and M/M Paris:
 Prototype Lights, 2001, installation view, French Pavilion, *49. Biennale di Venezia*, Venice

2 **L'Ellipse,** 1998, video, triple projection, 13 min
3 **The Third Memory,** 1999, video, double projection, 9:46 min
4 **Nine Perfect Minutes,** 2000, video

„Mich interessiert mehr der Transfer des Ereignisses als das Ereignis selbst."

« Je suis plus intrigué par la manière dont on traduit un événement que par l'événement lui-même. »

"I am more curious about the way you translate the event than the event itself."

2

3

Christian Jankowski

1968 born in Göttingen, lives and works in Berlin, Germany

Christian Jankowski's videos present comic, mundane, often absurd situations that are structured by an internal, almost circular logic. His works are infused with his sense of humour, which ironically mocks, critiques and deconstructs the situations he stages. Many of his scenarios focus on the practice and conditions of making and exhibiting contemporary art. In 1997, Jankowski consulted a therapist to explore his own creative block, which had rendered him unable to produce new work for an exhibition at *Steirischer Herbst* in Graz. He video-taped the therapist's conclusions, and the therapy sessions themselves became the contents of the artist's piece entitled *Desperately Seeking Artwork*. Faced with a problematic situation, Jankowski not only found a solution but also analysed his relationship to his work. In *Telemistica*, 1999, which was created on the occasion of the Venice *Biennale*, the artist called Italian fortunetellers during their live television shows and asked them questions about his art work. The questions – which included "Will I complete my new art piece?" "What will the public think about my work?" and "Will I be successful?" – and their responses were video-taped from the television set in his hotel room, and the prophecies served as the content of Jankowski's work. The absurdity of this scenario, in which the fortunetellers weren't familiar with his work and didn't know that their words would become the contents of his video, made for a hilarious, self-generating piece. By creating situations that examine the artist's ability to produce a work of art or consider the way art work is received, Jankowski's work ends up being about its own making.

Die Videos von Christian Jankowski präsentieren komische, nüchterne, häufig absurde Situationen, die von einer fast zirkulären inneren Logik gesteuert werden. In seinen Werken tritt ein Humor zutage, der sich über seine eigenen Inszenierungen belustigt, diese kritisiert und dekonstruiert. Viele seiner Szenarien haben mit den Bedingungen zu tun, unter denen heute Kunst entsteht und präsentiert wird. 1997 konsultierte Jankowski einen Therapeuten, von dem er sich Aufschluss über jene Schaffenskrise erhoffte, die es ihm unmöglich gemacht hatte, seinen Beitrag für den *Steirischen Herbst* in Graz auszuführen. Indem er die Schlussfolgerungen des Psychiaters in der Arbeit *Desperately Seeking Artwork – Kunstwerk verzweifelt gesucht* auf Video festhielt, erwiesen sich die therapeutischen Sitzungen selbst als Gegenstand der künstlerischen Arbeit. Auf diese Weise löste Jankowski nicht nur die schwierige Situation, sondern durchdrang zugleich die Beziehung zu seiner Arbeit analytisch. In *Telemistica*, 1999 konzipiert für die *Biennale* in Venedig, rief er italienische Wahrsager an, die mit ihrer TV-Show gerade auf Sendung waren, und stellte ihnen Fragen über seine Kunst. Zum Beispiel: „Werde ich mein neuestes Kunstwerk tatsächlich vollenden? Was wird das Publikum über meine Arbeit denken? Werden die Leute sie mögen? Ob ich damit Erfolg habe?" Die Antworten der Wahrsager wurden in seinem Hotelzimmer direkt per Videorekorder aufgezeichnet und bildeten gewissermaßen den „Inhalt" von Jankowskis Arbeit. Die Absurdität dieser Inszenierung, das heißt die Tatsache, dass die Wahrsager weder mit Jankowskis Werk vertraut noch sich darüber im Klaren waren, dass ihre Prophezeiungen den Inhalt seines Videos ausmachen würden, gewährleistete den Heiterkeitserfolg dieser Arbeit. Indem er Situationen vorgibt, in denen er die Fähigkeit des Künstlers, ein Kunstwerk zu schaffen, thematisiert oder sich mit der Rezeption eines Kunstwerks auseinandersetzt, zeigt sich, dass sich Jankowski in seiner Kunst letzten Endes vor allem mit dem Prozess ihrer Entstehung auseinandersetzt.

Les vidéos de Christian Jankowski présentent des situations comiques, banales, souvent absurdes, structurées par une logique interne presque circulaire. Ses œuvres sont imprégnées de son sens de l'humour qui ironise sur, se moque de, critique et déconstruit les situations qu'il met en scène. La plupart de ses scénarios traitent de la pratique et des conditions de la réalisation et de l'exposition de l'art contemporain. Dans *Desperately Seeking Artwork*, 1997, il consulte un psychothérapeute pour explorer le blocage créatif qui l'empêche de créer de nouvelles œuvres pour une exposition au *Steirischer Herbst* de Graz. En filmant les conclusions du thérapeute, les séances deviennent elle-même le contenu de l'œuvre de l'artiste. Confronté à une situation problématique, Jankowski trouve non seulement une solution mais il analyse sa relation avec son travail. Dans *Telemistica*, 1999, créé à l'occasion de la *Biennale* de Venise, il a appelé voyantes italiennes lors de leurs émissions télévisées et leur a posé des questions sur ses propres œuvres. Les questions – qui incluaient « Vais-je achever ma nouvelle pièce ? », « Que pensera le public de mon travail ? » et « Aurai-je du succès ? » – et leurs réponses ont été enregistrées par un magnétoscope directement à partir de la télévision de sa chambre d'hôtel, les prophéties devenant le contenu de l'œuvre de Jankowski. L'absurdité de ce scénario, où les voyantes ne connaissaient rien à son travail et ignoraient que leurs réponses feraient partie de cette vidéo, en fait une pièce hilarante qui se suffit à elle-même. En créant des situations qui examinent la capacité de l'artiste à créer une œuvre d'art ou qui considèrent comment une œuvre d'art est perçue, le travail de Jankowski finit par traiter de sa propre réalisation. Ro. S.

SELECTED EXHIBITIONS →
1998 Portikus, Frankfurt am Main, Germany **1999** dAPERTuttO, 48. Biennale di Venezia, Venice, Italy; *German Open*, Kunstmuseum Wolfsburg, Germany **2000** Stichting De Appel, Amsterdam, The Netherlands; *Let's Entertain*, Walker Art Center, Minneapolis (MN), USA; Nationalgalerie im Hamburger Bahnhof, Museum für Gegenwart, Berlin, Germany **2001** Art Pace, San Antonio (TX), USA *2. berlin biennale*, Berlin, Germany **2002** *Whitney Biennial*, The Whitney Museum of American Art, New York (NY), USA

SELECTED BIBLIOGRAPHY →
2001 *Christian Jankowski: Play*, Stichting De Appel, Amsterdam; *Futureland*, Städtisches Museum Abteiberg, Mönchengladbach **2002** *Lehrauftrag*, Klosterfelde, Berlin

" I hope today you're changed. You walk away from this painting not one-dimensionally, but multi-dimensionally."

Peter Spencer
Pastor - Harvest Fellowship Church

" Father, we want this Holy Artwork to make people in the church understand the value of contemporary art and we pray, that this artwork, this Holy Artwork, will be a bridge between art, religion and television."

1 **The Holy Artwork,** 2001, video stills, DVD 19 min, originally commissioned by ArtPace, Foundation for Contemporary Art, San Antonio (TX)
2 **Die Jagd,** 1992, c-print, 20 x 31 cm

3 **Create Problems,** 1999, production still, DVD 36 min, **Szene 4: Traumfrau extrem**
4 **Create Problems,** 1999, production still, DVD 36 min, **Szene 2: Die heiße Autorin**
5 **Telemistica,** 1999, video still, DVD 22 min

„Dieses Statement ist eine gemeinschaftliche Unternehmung." « Cette déclaration est le fruit d'une collaboration. »

"This statement is a collaborative effort."

2

3

4

5

Mike Kelley

1954 born in Detroit (MI), lives and works in Los Angeles (CA), USA

Mike Kelley, who has been around for some thirty years as an artist, performer and musician, is one of the best-known representatives of Californian Post-Conceptualism. He was deeply influenced by the radical political upheavals of the early 1970s and the artistic changes brought about simultaneously by a new generation of artists in the USA and Europe. Los Angeles' emerging performance scene proved to be an important field for experimentation. Kelley is interested in the unconscious, in the darker side of American society and the parts of human nature repressed by the modern world. His work is a synthesis of punk themes, bits of trash, cartoons, folk art and teenage culture. In his numerous happenings, theatre pieces, videos and installations, Kelley presents a surreal world full of strange creatures and taboo-breaking motifs. His opulent space installations are rich in cultural references, while he also sets up absurd experiments using the arsenal of the subculture and the everyday horror vacui – the fear of empty space – to create an art of "cultural exorcism". Kelley has been involved in many collaborations, the most important of which include his enduring partnership with Paul McCarthy. Their performances together are full of recurring allusions to the radical rituals of Viennese Actionism, an aesthetic which they interweave with home-grown American iconography. Kelley's complex, labyrinthine works have made him one of the leading exponents of "crossover art", a genre that knows no boundaries between high and low culture, nor between visual art, music and theatrical forms.

Mike Kelley, seit rund dreißig Jahren als Künstler, Performer und Musiker aktiv, ist einer der bekanntesten Vertreter des kalifornischen Postkonzeptualismus. Er war maßgeblich von den politischen und künstlerischen Umbrüchen geprägt, die Anfang der siebziger Jahre von einer jungen Generation in den USA und in Europa durchgesetzt wurden. Besonders die sich damals formierende Performance-Szene in Los Angeles war ein entscheidendes Experimentierfeld für Kelley. Sein Interesse gilt dem Unbewussten, der dunklen Kehrseite der amerikanischen Gesellschaft ebenso wie dem Verdrängten der Moderne. In seine Kunst integriert er Motive des Punk, Trash-Elemente, Cartoons, Folk-Art und Produkte der Teenage-Culture. In zahlreichen Aktionen, Bühnenstücken, Videos und Installationen zeigt Kelley surreale Welten mit tabubrechenden Motiven, voller bizarrer Kreaturen. Seine opulenten Räume stattet er mit einer Fülle von kulturellen Referenzen aus. Dabei durchkreuzt er immer wieder seine absurden Versuchsanordnungen zur Kunstgeschichte mit den Arsenalen der Subkultur und dem Horror vacui des Alltags. Es entsteht eine Kunst des „kulturellen Exorzismus". Kelley ist viele Kooperationen eingegangen, unter denen besonders die langjährige Zusammmenarbeit mit Paul McCarthy hervorzuheben ist. In ihren gemeinsamen Performances haben die Künstler sich immer wieder auf die radikalen Riten des Wiener Aktionismus bezogen und diese Ästhetik mit Motiven ihrer eigenen amerikanischen Ikonografie durchwoben. Kelley ist mit seinem komplexen labyrinthischen Werk längst zu einem der wichtigsten Vertreter eines Crossover geworden, das weder Grenzen von High und Low noch zwischen Kunst, Musik und theatralischen Formen anerkennt.

Mike Kelley, qui travaille comme plasticien, performer et musicien depuis quelque trente ans, est un des représentants majeurs du postconceptualisme californien. Marqué par les transformations politiques et artistiques que la jeune génération imposait au début des années 70 en Europe et aux Etats-Unis, il voit s'ouvrir devant lui un champ d'expériences avec l'émergence de la scène de la performance à Los Angeles. Son intérêt porte en premier lieu sur l'inconscient, sur la face cachée et sombre de la société américaine et sur les refoulements de la modernité. Dans son art, il intègre des motifs de la scène punk, des éléments trash, des dessins animés, des aspects du Folk Art et les produits de la culture des teen-agers. Ses nombreuses actions, pièces théâtrales, vidéos et installations présentent des mondes surréels emplis de créatures bizarres et de motifs qui brisent les tabous. Dans la perspective d'un art de « l'exorcisme culturel », leurs espaces opulents débordent de références culturelles au sein desquelles l'artiste cherche constamment à faire cohabiter les tentatives de classement absurdes de l'histoire de l'art et l'arsenal de la subculture et de l'horreur du vide quotidiens. Kelley a souvent travaillé en coopération. Dans ce contexte, il convient de souligner les nombreuses années de sa collaboration avec Paul McCarthy. Dans leurs performances communes, les deux artistes se sont inspirés des rituels radicaux de l'actionnisme viennois tout en faisant entrer dans cette esthétique les motifs de leur propre iconographie américaine. Avec son œuvre complexe et labyrinthique, Kelley est depuis longtemps devenu le grand adepte d'un crossover qui fait fi des frontières entre haute et basse culture, entre les arts plastiques, la musique et les formes d'art scéniques. A. K.

SELECTED EXHIBITIONS →
1997 *documenta X* (with Tony Oursler), Kassel, Germany **1999** *On the Sublime*, Rooseum, Center for Contemporary Art, Malmö, *Sweden; The American Century: Art and Culture 1950-2000*, The Whitney Museum of American Art, New York (NY), USA **2000** *The Poetics Project: 1977–1997 (Documenta Version)*, Centre Georges Pompidou, Paris, France (with Tony Oursler); *Sublevel, Framed and Frame, Test Room*, Migros Museum für Gegenwartskunst, Zurich, Switzerland; *Apocalypse: Beauty and Horror in Contemporary Art*, Royal Academy of Arts, London, UK; *Art in the 80's*, P.S.1, Long Island City (NY), USA **2001** *Painting at the Edge of the World*, Walker Art Center, Minneapolis (MN), USA **2002** *Sonic Process*, Centre Georges Pompidou, Paris, France

SELECTED BIBLIOGRAPHY →
1992 Thomas Kellein (ed.), *Mike Kelley*, Basel/Frankfurt/London **1999** *Mike Kelley: Two Projects*, Kunstverein Braunschweig; *Mike Kelley*, London

226

„Mir scheint, dass Kunst rituell vom Leben getrennt werden muss, um Kunst zu sein. Sieht man in ihr mehr als einen Spiegel, erscheint das problematisch."

« Il me semble que l'art doit être rituellement séparé de la vie pour être de l'art, ainsi voir en lui plus qu'un miroir semble problématiques. »

"It seems to me that art has to be ritually separated from life in order to be art, so to talk about it as anything more than a mirror seems problematic."

2

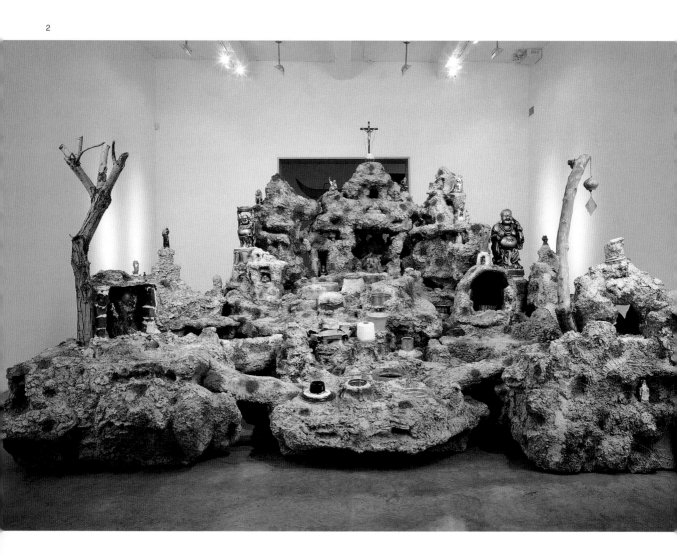

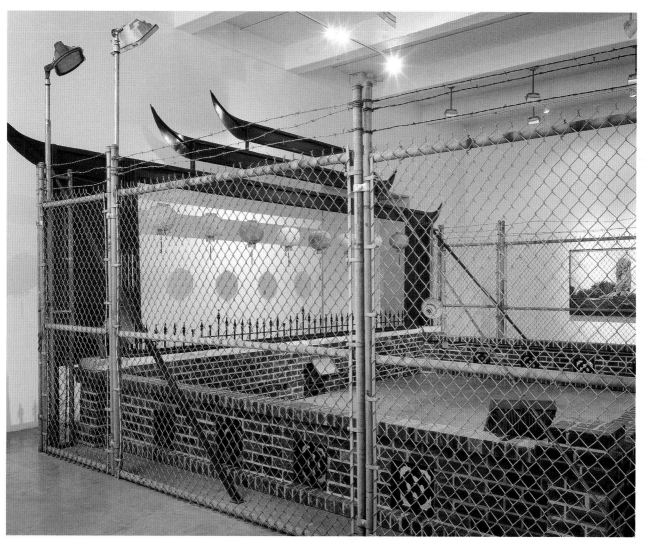

Rachel Khedoori

1964 born in Sydney, Australia, lives and works in Los Angeles (CA), USA

Rachel Khedoori is a sculptress: it would be hard to find anyone else who creates images in such a complex, spatially expansive form as she does in her film installations. Sculpture and film are combined for viewers in such a dynamic way that it is as if they are in motion, and their perception is in motion. Khedoori breaks open the kineastic arrangement engaging the static and passive observer. We see not only the devices of image creation – the projectors and spools – but also the observer as he or she tries to find their way within the complicated, spatially interlocking and fragmented settings, like excerpts of claustrophobic situations from the realm of dreams. Khedoori reaches into the medium of film and its illusionist character using artistic techniques, and she thus makes film a physical experience. The installation *Untitled (Blue Room)*, 1999, is a 35mm film showing a reconstructed room in a house in Pasadena, that takes up an entire room in the gallery. The projection hits two adjoining mirrored surfaces arranged on the gallery wall and gallery floor, and from there it is thrown back, distorted, returned. Unsure where their attention should be focussing, viewers are constantly forced to change their perception. They see a film: an endless loop. They see the technique: the spools, the projector. They see the projected room, while the gallery room itself is in darkness. The observer is obliged to take part in this highly complicated game, assimilating the reflected illusion of the film, the reality of its apparatus, and the sculptural quality of the room which is the scene of the projection. This multi-layered iridescent moment transmitted to the viewer is representative of the complexity of Khedoori's installations.

Rachel Khedoori ist eine Bildhauerin: Kaum jemand bearbeitet Bilder auf so komplexe raumgreifende Weise wie sie in ihren Film-installationen, in denen sie Skulptur und Film in dynamischer Weise für den Betrachter verbindet. Wir sind in Bewegung, unsere Wahrnehmung ist in Bewegung. Khedoori bricht die cineastische Anordnung auf, die den statischen und passiven Betrachter vorsieht. Nicht nur die Apparate der Bilderzeugung, die Projektoren und Spulen werden vorgeführt, der Betrachter ebenso, wenn er sich in komplizierten, räumlich ineinander verschachtelten und verspiegelten Settings zurechtfinden muss, die sich ausnehmen wie klaustrophobische Situationen aus dem Reich der Träume. Khedoori greift mit künstlerischen Techniken in das Medium Film und seinen illusionistischen Charakter ein, damit Film wieder zur gelebten Körpererfahrung wird. Die raumfüllende Installation *Untitled (Blue Room)* von 1999 besteht aus einem 35-mm-Film, der ihr rekonstruiertes Zimmer in einem Haus in Pasadena zeigt. Die Projektion trifft auf zwei an Galeriewand und -boden zusammengefügte Spiegelflächen und wird von diesen verzerrt zurückgeworfen. Unsicher, worauf sich die Aufmerksamkeit richten soll, sind wir zu einem permanenten Wechsel der Einstellungen gezwungen. Wir sehen einen Film: einen bruchlosen Loop; wir sehen die Technik: die Spulen, den Projektor; wir sehen den Raum der Projektion, der Galerieraum selbst ist verdunkelt. Der Betrachter muss teilnehmen an dem höchst komplizierten Spiel, der in sich selbst gespiegelten Illusion des Filmes, der Realität seiner Apparaturen, der skulpturalen Qualität des Raumes, in den gleichzeitig projiziert wird. Das ihm dabei vermittelte, vielschichtig irisierende Moment steht in einem offenbaren Zusammenhang zur Komplexität von Khedooris Installationen.

Rachel Kheedori est une sculptrice : presque personne ne travaille les images de manière aussi spatiale qu'elle le fait dans ses installations cinématographiques, qui procèdent à l'intégration dynamique du spectateur dans la sculpture et le film. Le spectateur est en mouvement, et sa perception est ce mouvement. Kheedori reformule une répartition des rôles qui assigne au spectateur une place statique et passive. Les éléments concrets générateurs de l'image – projecteurs et bobines – ne sont pas seuls à être montrés, le spectateur est lui aussi représenté dans son effort pour se repérer au sein de ces arrangements compliqués dont les imbrications spatiales et les jeux de miroir complexes s'apparentent à des situations claustrophobiques issues de l'univers des rêves. Par des moyens artistiques, Kheedori travaille sur le médium « film » et sur son caractère illusionniste afin que le cinéma devienne une expérience corporelle vécue. L'installation spatiale intégrale *Untitled (Blue Room)*, 1999, consiste en un film en 35 mm montrant la reconstitution de la chambre de l'artiste dans une maison de Pasadena. La projection est dirigée vers deux pans de miroir fixés au mur et au plafond, d'où elle est reflétée, déformée. Hésitant sur l'endroit où il doit diriger son attention, le spectateur se voit obligé à un constant changement de mise au point. Il voit un film : une séquence passée en boucle sans rupture ; il en voit les aspects techniques : les bobines, le projecteur ; il voit l'espace de la projection, l'espace d'exposition étant plongé dans l'obscurité. Le spectateur doit prendre part à ce jeu hautement complexe, à l'illusion cinématographique reflétée en elle-même, à la réalité des appareillages, à la qualité sculpturale de l'espace dans lequel se déroule en même temps la projection. Les différents niveaux de cette déstructuration qui lui sont communiqués sont en rapport direct avec la complexité des installations de Khedoori. F. F.

SELECTED EXHIBITIONS →
1995 Association of the Museum van Hedendaagse Kunst, Ghent, Belgium **1996** *Inklusion: Exklusion*, Steirischer Herbst, Graz, Austria **1998** Suermondt-Ludwig-Museum, Aachen, Germany **1999** David Zwirner, New York (NY), USA; *Vergiss den Ball und spiel weiter*, Kunsthalle Nürnberg, Nuremberg, Germany **2000** Galerie Gisela Capitain, Cologne, Germany; Museum of Contemporary Art, Los Angeles (CA), USA; Sammlung Hauser und Wirth, St. Gallen, Switzerland **2001** Kunsthalle Basel, Basle, Switzerland

SELECTED BIBLIOGRAPHY →
1999 *Vergiss den Ball und spiel weiter – Das Bild des Kindes in zeitgenössischer Kunst und Wissenschaft*, Kunsthalle Nürnberg, Nuremberg **2000** Kunsthalle Basel, Basle; *Flight Patterns*, Museum of Contemporary Art Los Angeles, (CA) **2001** Kunstverein Braunschweig

230

1 **Untitled (Pink Room #5),** 2001, Ilfochrome print, 71 x 53 cm
2 **Untitled (Model),** 2000, multiplex, wood, polycarbonate, 51 x 274 x 152 cm
3 **Untitled (Wanas),** 1997, 16 mm colour film (endless loop, 7 min), looping device, projector, installation view, Kunsthalle Basel, Basle, 2001

4 **Untitled (Blue Room),** 1999, 35 mm colour film (endless loop, 8:15 min), film projector, looper, wooden room, two way mirror, installation view, Kunsthalle Basel, Basle, 2001
5 **Untitled,** 2001, 6 fake tree stumps, photographs, DVD, 2 monitors, wooden room, installation view, Kunsthalle Basel, Basle

2

3

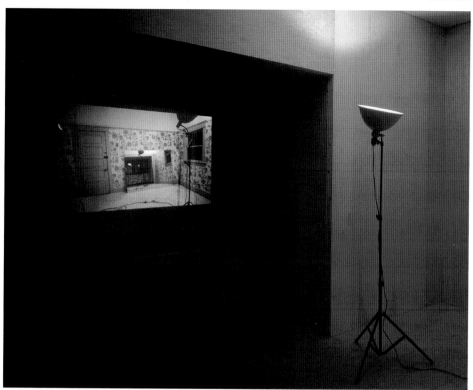

4

5

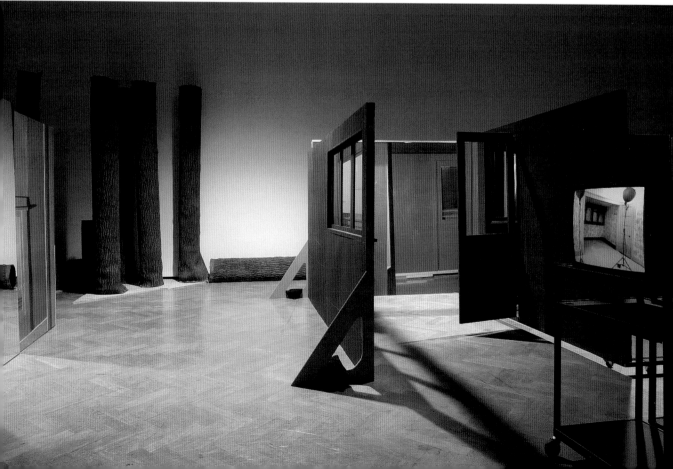

Karen Kilimnik

1962 born in Philadelphia (PN), lives and works in New York (NY), USA

Karen Kilimnik's work transports us to a fantasy world of stage coaches, stately mansions and Gothic forests where 18th-century Russian princesses rub shoulders with 1990s supermodels and TV soap stars. Kilimnik was initially known for "scatter art" installations such as *Hellfire Club Episode of the Avengers*, 1989, which recreated an episode of the cult British TV series as a chaotic assemblage of piles of drugs, guns, fake blood, paper targets and xeroxes of the show's heroine, Emma Peel. These low-tech theatrical stage sets eventually gave way to painting, as she realised the medium's unique potential to fashion a new version of reality without the need for props. Her small, tentative paintings treat events from European history, contemporary tabloid stories or glossy magazine-style glamour with equal fervour. Leonardo DiCaprio appears as Prince Siegfried in *Swan Lake Arriving at a Close Friend's Birthday at His Friend's Castle After Drinks at Maxim's*, 1998, and Kilimnik casts herself as a Kate Moss look-alike in *Me in Russia, 1916, Outside the Village*, 1999. The paintings are installed in allusive contexts, on flock wallpaper or bright red walls sometimes lit by chandeliers or fairy lights. Yet the atmosphere of girlish frippery is undercut by a fascination with the occult, suicide and disaster. The scenarios she depicts are imbued with latent violence and a malignant jealousy underlies her hero-worship. Kilimnik wholeheartedly consumes the reality offered by the media but uses her work like a form of witchcraft to reconstruct it according to her own rules.

Die Arbeiten von Karen Kilimnik entrücken uns in eine Welt der Postkutschen, der prachtvollen Herrenhäuser und der Märchenwälder, in der russische Prinzessinnen des 18. Jahrhunderts, Supermodels und TV-Serienstars der neunziger Jahre sich die Hand reichen. Bekannt geworden ist Kilimnik durch ihre Scatter-Art-Installationen, etwa *Hellfire Club Episode of the Avengers*, 1989: die Nachempfindung einer Folge der britischen Kultserie als chaotische Assemblage aus Drogen, Waffen, künstlichem Blut, Papierzielscheiben und Fotokopien des Serienstars Emma Peel. Von diesen eher simplen theatralischen Inszenierungen ist Kilimnik zur Malerei übergegangen, als ihr bewusst wurde, welche einzigartigen Möglichkeiten der Wirklichkeitsdarstellung ihr dieses Medium auch ohne Rückgriff auf Requisiten bot. Auf ihren kleinformatigen, fast provisorischen Gemälden haben Motive aus der europäischen Geschichte, die Lieblingsthemen der Boulevardpresse und die Sujets der Hochglanzmagazine denselben Stellenwert. Leonardo DiCaprio gibt den Siegfried in *Swan Lake Arriving at a Close Friend's Birthday at His Friend's Castle After Drinks at Maxim's*, 1998. In *Me in Russia, 1916, Outside the Village*, 1999, besetzt Kilimnik sich als Doppelgängerin von Kate Moss. Die Bilder werden in vieldeutigen Kontexten präsentiert, etwa auf Raufasertapete oder vor leuchtend roten Wänden, manchmal auch im Licht eines Lüsters oder in märchenhafter Festbeleuchtung. Die Atmosphäre mädchenhaften Tands wird gebrochen durch Verweise auf Okkultes, auf Katastrophen und Selbstmord. Ihre Bild-Erfindungen sind mit latenter Gewalt aufgeladen, ihr Heldenkult erscheint durch bösartige Seitenhiebe konterkariert. Kilimnik lässt die Wirklichkeit, wie die Medien sie zeichnen, vorbehaltlos auf sich wirken, um sie anschließend in einem magischen Prozess nach ihren eigenen Regeln umzugestalten.

Le travail de Karen Kilimnik nous transporte dans un monde imaginaire de diligences, d'hôtels particuliers et de forêts gothiques où des princesses russes du 18ème siècle côtoient des top models et des vedettes de feuilletons télévisés des années 1990. Kilimnik était autrefois connue pour ses installations du « scatter art » (art dispersé) telles que *Hellfire Club Episode of the Avengers*, 1989, où elle recréait un épisode de la série télévisée britannique culte, Chapeau melon et bottes de cuir, sous la forme d'un assemblage chaotique de piles de médicaments, de revolvers, de faux sang, de cibles en papier et de photocopies de l'héroïne de la série, Emma Peel. Ces décors de théâtre traditionnels ont ensuite cédé la place à la peinture, l'artiste se rendant compte du potentiel unique qu'offrait ce médium, permettant de refaçonner la réalité sans avoir besoin de recourir à des accessoires. Ses petits tableaux expérimentaux traitent des événements de l'histoire européenne, des faits divers parus dans la presse à sensation ou le glamour de papier glacé des revues de luxe avec la même ferveur. Leonardo DiCaprio apparaît en prince Siegfried dans *Swan Lake Arriving at a Close Friend's Birthday at His Friend's Castle After Drinks at Maxim's* (Le lac des cygnes arrivant à l'anniversaire d'un ami proche au château de son ami après un verre chez Maxim's), 1998. Kilimnik se projette elle-même en sosie de Kate Moss dans *Me in Russia, 1916, Outside the Village* (Moi en Russie, en 1916, hors du village), 1999. Ses peintures sont accrochées dans des contextes évocateurs, sur du papier peint floqué ou des murs rouge vif parfois illuminés par des lustres ou des guirlandes électriques. Toutefois, cette atmosphère de frivolité fleur bleue est sapée par une fascination pour l'occulte, le suicide et la catastrophe. Les scénarios qu'elle dépeint sont imprégnés d'une violence latente et son culte des héros se teinte d'une jalousie malfaisante. Kilimnik consomme allègrement la réalité distillée par les médias mais utilise son travail comme une sorte de sorcellerie pour la reconstruire selon ses propres règles. K. B.

SELECTED EXHIBITIONS →
1992 *Post Human*, Musée d'Art Contemporain, Fondation Asher Edelman, Pully/Lausanne, Switzerland **1993** *Whitney Biennial*, The Whitney Museum of American Art, New York (NY), USA **1997** Kunsthalle Zürich, Zurich, Switzerland; *Belladonna*, Institute of Contemporary Arts, London, UK **1999** *Heaven*, Kunsthalle Düsseldorf, Germany; *Fame after Photography*, Museum of Modern Art, New York (NY), USA **2000** South London Gallery, London, UK; Kunstverein Wolfsburg, Germany

SELECTED BIBLIOGRAPHY →
1992 *Escape in Time*, Institute of Contemporary Art, Philadelphia (PA)
1995 *Auf den Leib geschrieben*, Kunsthalle Wien, Vienna
1997 *Drawings by Karen Kilimnik*, Kunsthalle Zürich, Zurich
2001 *Paintings by Karen Kilimnik*, Zurich/New York (NY)

1 **Alexie's Great Grandfather, Emperor Alexander II., 1888,** 1998, water-soluble oil on canvas, 61 x 51 cm
2 **Riding School,** 1999, water-soluble oil on canvas, 20 x 15 cm
3 **John & Paul,** 1990, chalk on paper, 89 x 60 cm

4 **Me – I forgot getting the wire cutters from the car to break into Stonehenge 1982,** 1998, water-soluble oil on canvas, 41 x 51 cm
5 **Battles or the Art of War,** 1991, mural painting, fog machine, theatre cannon, mica, and numerous other materials and objects, installation view, Kunsthalle Zürich, Zurich, 1997

„Für mich ist Malerei wie Magie."

« Pour moi, la peinture est comme la magie. »

"To me, painting is like magic."

2

3

photo
Dick Matthews
Rory Storm,
pictured here
with John + Paul

4

5

Bodys Isek Kingelez

1948 born in Kimbembele Ihunga, lives and works in Kinshasa, Congo

Modernists regard the notion that art can invent anything new as no more than a myth. Nevertheless, Bodys Isek Kingelez's architectural creations are living proof that it is still possible to come up with real innovation. In his model world everything is in bright, even flamboyant colour. He combines fantastic purity of line with oriental kitsch, modern utopianism with postmodernism, cities of the mind, urban landscapes of the imagination. His work can be divided into buildings – like *Kinshasa La Belle*, 1991 – and cities – like *Bodystate*, 1996. They are not sculptures, but what Okwui Enwezor has called "architectonic simulations". Kingelez grew up under the Mobutu dictatorship, first becoming a teacher before working as a restorer at a museum. In 1984 he realised that he was meant to be an artist. His works subvert General Mobutu's efforts to promote an authentic African culture and to ban everything that smacks of colonialism. Kingelez turns his critical and searching eye to his own past and to Africa's role in the worldwide economy. A continent whose history had been systematically denied and suppressed by colonial power struggles is faced with enormous problems as it tries to find or to invent its identity and to acknowledge the authenticity of its native art. Kingelez creates a parallel world somewhere between the "First" and "Third" Worlds, a space removed from political and social assumptions. Most importantly of all, he presents a critique of the naïve and patronising attitude of Western visionaries and planners towards the so-called "primitive". His finest achievement, the various sculptures titled *Ville Fantôme* (Ghost Town), 1995/96, is a master plan for the impossible dream of an urban paradise equipped with all the emblems of prosperity, luxury and power.

Dass Kunst etwas Neues erfindet, ist der Mythos der Moderne, dass sie jedoch mit Neuem aufwarten kann, bezeugen die Architekturen von Bodys Isek Kingelez. In seiner Modellwelt ist es bunt, ja geradezu üppig farbig, fantastisch rein und zugleich asiatisch kitschig, modern utopisch und postmodernistisch verzweigt – Geisterstädte der globalen Simulation im Irgendwo des urbanen Lebensraums. Die in Gebäude (*Kinshasa La Belle*, 1991) und Städte (*Bodystate*, 1996) zu unterscheidenden Arbeiten sind eher „architektonische Simulationen" (Okwui Enwezor) als Skulpturen. Aufgewachsen unter der Diktatur Mobutus, arbeitete Kingelez erst als Lehrer und spater als Restaurator im Museum, bis er 1984 merkte, dass der Beruf des Künstlers seine Bestimmung ist. In seinen Werken wird General Mobutus Forderung nach einer authentisch afrikanischen Kultur, die alles „Koloniale" verbannt, zu einem kritisch suchenden Blick auf die eigene Vergangenheit und die weltwirtschaftliche Sonderrolle Afrikas. Ein Kontinent, dessen Geschichte im kolonialen Machtverhältnis systematisch negiert und unterdrückt wurde, hat enorme Probleme, seine Identität zu (er-)finden und seine Kunst als authentisch zu begreifen. Kingelez schafft eine Nebenwelt zwischen „erster" und „dritter" Welt, einen Umraum neben sozialer und politischer Prägung und letztlich, was als wesentlichstes Moment bezeichnet werden sollte, eine Verortung der naiv-mildtätigen Wertevorurteile westlicher Planer und Visionäre gegenüber den „Primitiven". Seine größte Schöpfung, mehrere Skulpturen mit dem Titel *Ville Fantôme* von 1995/96, ist ein Masterplan für den Traum von einer besseren Welt im städtebaulichen Gefüge, ausgestattet mit allen Insignien des Reichtums, des Luxus und der Macht.

Si l'idée que l'art invente quelque chose de nouveau est un mythe de la modernité, le fait que l'art peut en revanche proposer quelque chose de nouveau ressort clairement des architectures de Bodys Isek Kingelez. Dans son monde de maquettes, tout est coloré, voire bigarré, avec des ramifications aussi bien vers un kitsch japonisant que vers l'utopie moderniste ou postmoderne – villes fantômes de la simulation globale dans un « quelque part » de l'espace vital urbain. Les œuvres de Kingelez, qui peuvent se décliner en immeubles – comme *Kinshasa La Belle*, 1991 – ou en villes – comme *Bodystate*, 1996 – sont donc des « simulations architectoniques » (Okwui Enwezor) plutôt que des sculptures. Ayant grandi sous la dictature du général Mobutu, Kingelez à travaillé comme professeur, puis comme restaurateur de musée, avant de réaliser en 1984 que le métier d'artiste était sa vocation. Dans ses œuvres, l'appel lancé par général Mobutu, qui demandait une culture authentiquement africaine bannissant toute référence « coloniale », devient scrutation critique du passé national et du rôle économique de l'Afrique au niveau mondial. Ce continent dont l'histoire a été systématiquement niée et opprimée par le rapport de force colonial, connaît aujourd'hui d'immenses difficultés à retrouver et à inventer son identité comme à comprendre l'authenticité de son art. Kingelez crée un monde parallèle entre « premier » et « tiers » monde, un environnement loin des empreintes sociales et politiques, et pour finir, quelque chose qui doit être considéré comme essentiel : une approche des préjugés naïfs et douceâtres sous le signe desquels les planificateurs et les visionnaires occidentaux regardent le « primitif ». Sa plus grande réalisation, plusieurs sculptures intitulées *Ville Fantôme* de 1995/96, se lit comme un plan directeur du rêve d'un monde meilleur d'obédience urbanistique doté de tous les insignes de la richesse, du luxe et du pouvoir. G. J.

SELECTED EXHIBITIONS →
1992 Haus der Kulturen der Welt, Berlin, Germany **1995** Fondation Cartier pour l'Art Contemporain, Paris, France **1996** Musée d'Art Moderne et Contemporain, Geneva, Switzerland **1999** *Kunstwelten im Dialog*, Museum Ludwig, Cologne, Germany; *Zeitwenden*, Kunstmuseum Bonn, Germany; *Carnegie International*, Carnegie Museum of Art, Pittsburgh (PA), USA **2000** *Le monde est ma maison*, Le Parvis, Ibos, France; *Vision du Futur*, Grand Palais, Paris, France; *Biennale of Sydney*, Australia **2001** Kunstverein in Hamburg, Germany

SELECTED BIBLIOGRAPHY →
1995 *Bodys Isek Kingelez*, Fondation Cartier pour l'Art Contemporain, Paris; *Big City: Artists from Africa*, Serpentine Gallery, London **1998** *Unfinished History*, Walker Art Center, Minneapolis (MN) **2001** Yilmaz Dziewior (ed.), *Bodys Isek Kingelez*, Ostfildern-Ruit

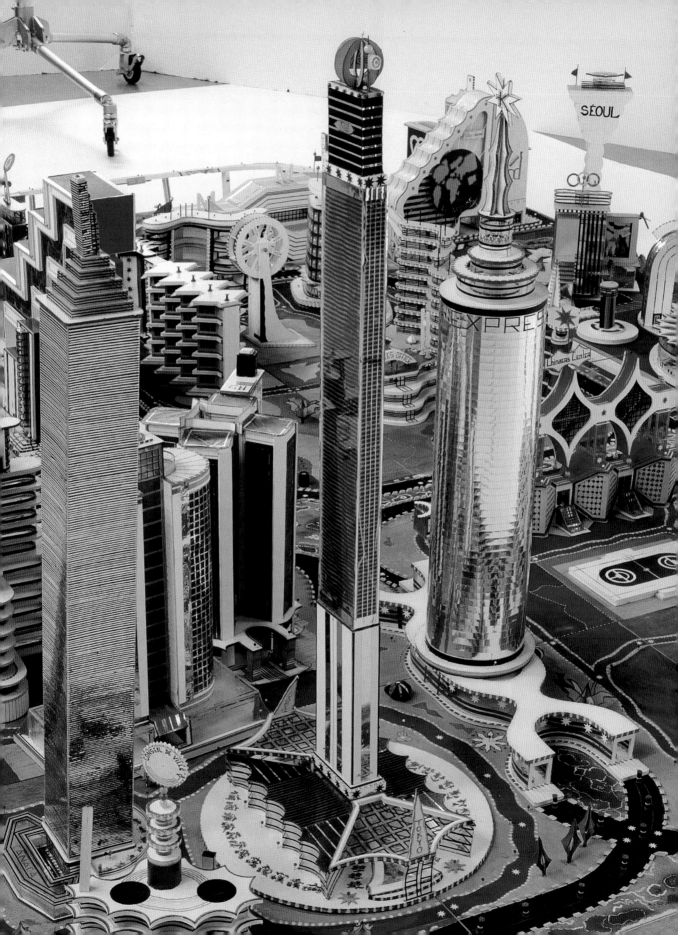

1 **Kimbembele Ihunga** (details), 1993/94, mixed media, 130 x 183 x 300 cm, installation view, Kunstverein in Hamburg, 2001
2 **Ville Fantôme,** 1996, paper, plastic, cardboard, 120 x 570 x 240 cm, installation view, Kunstverein in Hamburg, 2001

3 **Aeromode,** 1991, mixed media, 54 x 80 x 55 cm
4 **Papitheca,** 1992, mixed media, 42 x 67 x 43 cm
5 **Ville Fantôme,** 1996, paper, plastic, cardboard, 120 x 570 x 240 cm, installation view, *Unfinished History*, Walker Art Center, Minneapolis (MN), 1998/99

„Ich finde meine Ideen in Afrika."

"I create my ideas in Africa."

« Je puise mes idées en Afrique. »

2

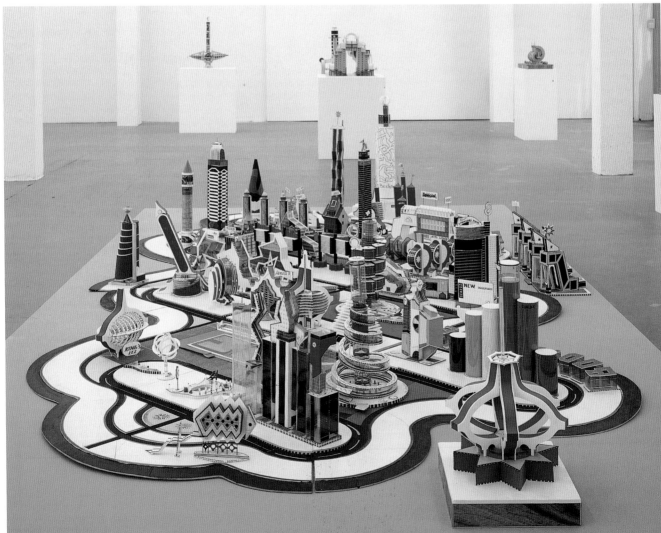

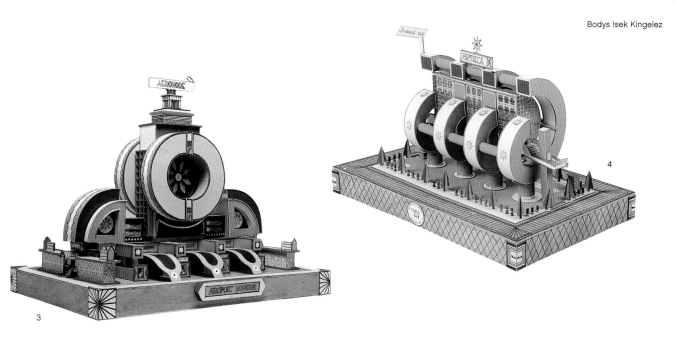

3

4

5

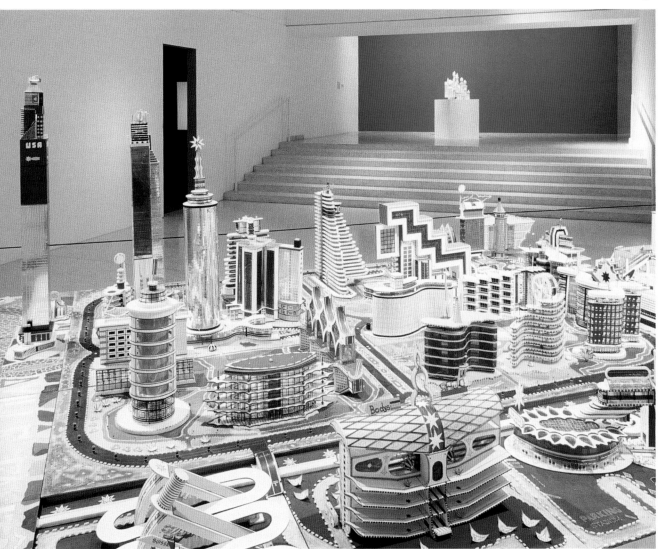

Martin Kippenberger

1953 born in Dortmund, Germany, 1997 died in Vienna, Austria

Hardly anyone else has injected the contemporary image of the artist with so much life as Martin Kippenberger. His early death once again leads us to question the apparent link between creative genius and premature demise. Shrewdly contriving to be born in 1953, he always had a slight advantage over those who would later become his rivals: Werner Büttner and Albert Oehlen, both born in 1954. Always one step ahead, Kippenberger managed to create the impression that he had access to some kind of code, more important than art, artists or art critics. He kept the upper hand in a game that he made his own. Over the course of two decades, starting with "Kippenberger's Büro" in Berlin in the 1970s and ending with his posthumous contributions to *documenta X* in 1997, he achieved an artistic output, one of whose main aims was to spread good humour. Kippenberger's world revolved with fantastic lightness and speed. He loved to tell stories and maintained an ongoing dialogue with art, its history and the aura surrounding it. Thus he was able to bring surprising new perspectives to panel painting, introduce timeless innovations to sculpture, and influence the thinking and behaviour of the present generation of artists. Kippenberger's unique sense of humour, which took the art market as a model of reality, made many people doubt the seriousness of his work. Even so, they were still eager to hear what he had to say. The title of a 1990 installation – *Jetzt geh ich in den Birkenwald, denn meine Pillen wirken bald* (Now I'm going into the birch forest as my pills will take effect soon) – showed the oracular insight we had come to expect of a man like Kippenberger.

Kaum jemand hat das zeitgenössische Bild des Künstlers mit mehr Leben gefüllt als Martin Kippenberger, 1997 in Wien gestorben, 1953 in Dortmund geboren. Sein früher Tod lässt uns einmal mehr den sinnvollen Zusammenhang suchen zwischen genialischer Kreativität und vorzeitigem Ableben. Geschickt ausgesucht sein Geburtsdatum 1953, gab es ihm den kleinen Vorsprung gegenüber seinen späteren Kombattanten aus dem 54er Jahrgang Werner Büttner und Albert Oehlen. Immer einen Schritt vorneweg, konnte Martin Kippenberger den Eindruck erwecken, über eine Vorgabe zu verfügen: vor der Kunst, den Künstlern, der Kritik. Vorteil Kippenberger: ein Spiel, dass der Künstler persönlich nahm. Von den Anfängen im Berliner Büro Kippenberger der siebziger Jahre bis zu den posthum realisierten Beiträgen für die *documenta* 1997 in Kassel – zwei Jahrzehnte künstlerischer Produktion voller Zeichen guter Laune. Kippenbergers Welt drehte sich mit fabelhafter Leichtigkeit und Geschwindigkeit im permanenten, erzählfreudigen Dialog des Künstlers mit der Kunst und ihrer Geschichte, ihrer Aura. Auf diese Weise hat er dem Tafelbild überraschende Perspektiven abringen, dem Skulpturalen zeitlose Neuerungen hinzufügen können und das Denken und Handeln der heutigen Künstlergeneration beeinflusst. Kippenbergers spezifischer Humor, der den Kunstmarkt als Modell der Wirklichkeit akzeptierte, ließ manchen am Ernst seines Werks zweifeln und ihm trotzdem gerne zuhören. *Jetzt geh ich in den Birkenwald, denn meine Pillen wirken bald* – der Titel der Arbeit von 1990 hatte die orakelhafte Weisheit, die man von einem Kippenberger erwarten konnte.

Aucun autre artiste ou presque n'a autant donné vie à l'image de l'artiste contemporain que Martin Kippenberger, mort en 1997 à Vienne, né en 1953 à Dortmund. Son départ dans la force de l'âge nous incite une fois de plus à chercher un lien recevable entre la créativité du génie et une mort prématurée. Une année de naissance habilement choisie lui confère une légère avance sur ses futurs compagnons d'armes du millésime 54, Werner Büttner et Albert Oehlen. Toujours un pas en avant, Kippenberger pouvait donner le sentiment de disposer d'un avantage : sur l'art, sur les artistes, sur la critique. Avantage Kippenberger : un jeu que l'artiste prenait très personnellement. Des débuts au « Büro Kippenberger » à Berlin dans les années 70 jusqu'aux contributions posthumes réalisées pour la *documenta* de 1997 à Cassel – deux décennies de production artistique pleines de signes de bonne humeur. Le monde de Kippenberger virevoltait avec une légèreté et une vitesse fabuleuses dans le dialogue constant, affable de l'artiste avec l'art, son histoire et son aura. C'est ainsi qu'il a su tirer du tableau des perspectives inattendues et enrichi la sculpture d'innovations intemporelles, influençant la pensée et l'action de la génération d'artistes actuelle. L'humour très particulier de Kippenberger, qui acceptait le marché de l'art comme modèle de la réalité, a fait douter du sérieux de son œuvre plus d'un artiste qui néanmoins a eu plaisir à l'écouter. Maintenant, *Jetzt geh ich in den Birkenwald, denn meine Pillen wirken bald* (Je m'en vais dans la forêt de bouleaux, car mes cachets ne tarderont pas à faire effet) – ce titre d'une œuvre de 1990 avait la sagesse prophétique qu'on pouvait attendre d'un Kippenberger.

F. F.

SELECTED EXHIBITIONS →
1997 *Skulptur. Projekte*, Münster, Germany; *documenta X*, Kassel, Germany **1998** Kunsthalle Basel, Basle, Switzerland; Kunsthaus Zürich, Zurich **1999** Deichtorhallen, Hamburg, Germany **2000** Renaissance Society, Chicago (IL), USA **2001** *Let's Entertain*, Kunstmuseum Wolfsburg, Germany; *Vom Eindruck zum Ausdruck - Grässlin Collection*, Deichtorhallen Hamburg, Germany **2002** Zwirner & Wirth, New York (NY), USA; *Lieber Maler, male mir*, Centre Georges Pompidou, Paris, France

SELECTED BIBLIOGRAPHY →
1997 Burkhard Riemschneider, *KIPPENBERGER*, Cologne **1998** *Martin Kippenberger*, Kunsthalle Basel, Basle; *Martin Kippenberger, Die gesamten Plakate 1977–1997*, Kunsthaus Zürich, Zurich **1999** *The Happy End of Franz Kafka's Amerika*, Deichtorhallen, Hamburg **2002** *Kommentiertes Werkverzeichnis der Bücher*, Cologne

1 **Ohne Titel (Jacqueline The Paintings Pablo Picasso Couldn't Paint Anymore)**, 1996, oil on canvas, 180 x 150 cm
2 Installation view, *Zero Gravity*, Kunstverein für die Rheinlande und Westfalen, 2001; left: **Tankstelle Martin Bormann**, 1986, right: **Brasilien aktuell**, 1986

3 **Ohne Titel (Durchgenudelt)**, 1996, mixed media on paper, 28 x 22 cm
4 **Ohne Titel**, 1996, mixed media on paper, 28 x 22 cm
5 **Ohne Titel**, 1994, mixed media on paper, 30 x 21 cm
6 **Ohne Titel**, 1995, mixed media on paper, 30 x 21 cm

„Dieses Leben kann nicht die Ausrede für das nächste sein."

« Cette vie-ci ne peut servir d'excuse pour la prochaine. »

"This life cannot be the excuse for the next."

2

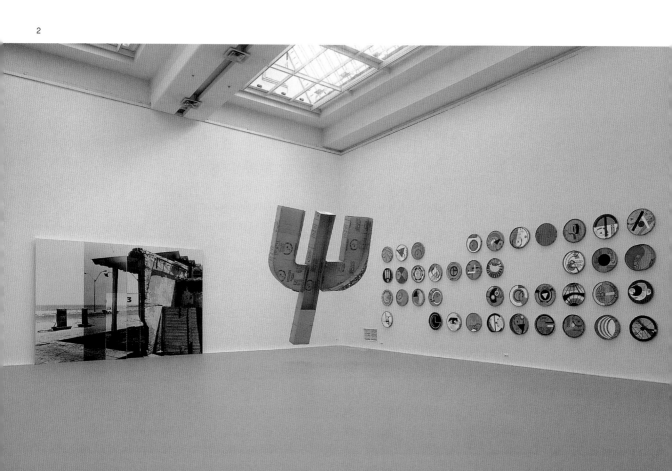

3

DURGHGENUDELT

4

5

6

Jeff Koons

1955 born in York (PA), lives and works in New York (NY), USA

Jeff Koons can rightly be called the one of the most spectacular art-world icons of recent decades. As a self-made man, who used to finance his complex projects in New York by playing the stock market, he has become the promoter par excellence of his own provocative work. From an early age, Koons was attracted by American folk art and Surrealism. Later, he combined these influences with the strategies of pop art. His glamorous sculptures were inspired by the world of advertising, cheap kitsch and everyday objects. Nor did he flinch, in his 1991 *Made in Heaven* series, at appearing in flagrante with his then wife, the Italian porn star Ilona Staller, also known as "Cicciolina". What some saw as sabotage of the art business, others regarded as an expression of the optimism that prevailed during the economic boom of the 1980s. Despite all the scandals, Koons continued to be a great moralist, whose declared aim was to exploit the accessibility and popularity of his work to bring art to the masses. During the 1990s not a great deal was heard of Koons. But in autumn 1999 he returned to the scene with *Easyfun*, a series of large-format paintings and coloured mirrors shaped like the heads of cartoon animals. The *Easyfun* paintings are impressive and exuberant collages of advertising images and references to popular culture, like the bits of breakfast cereal swirling around in a waterfall of milk in *Cut Out,* 1999. He cuts pieces out of certain motifs and underlays them with outlandish images to create an eerie, surreal, psychedelic effect. Koons himself has defined *Easyfun's* ecstatic but calculated imagery as "barococo".

Jeff Koons kann wohl als eine der spektakulärsten Künstler-Ikonen der letzten zwanzig Jahre bezeichnet werden. Als Selfmademan, der seine aufwendigen Projekte in New York mit Börsenspekulationen finanzierte, ist er im großen Stil zum Manager seines eigenen provokanten Werks geworden. Koons' Interesse galt schon früh der amerikanischen Volkskunst und dem Surrealismus. Später verband er diese Einflüsse mit den Strategien der Pop-Art. Er benutzte Anzeigen aus der Werbung und nahm billige Kitschfiguren und Alltagsgegenstände zum Vorbild für seine glamourösen Skulpturen. Auch vor pornografischen Selbstinszenierungen mit seiner damaligen Lebensgefährtin, dem italienischen Pornostar Ilona Staller, genannt „Cicciolina", macht er nicht Halt (*Made in Heaven,* 1991). Was die einen als Sabotage des Kunstbetriebs ansahen, wurde von anderen als Ausdruck eines zeitgemäßen Optimismus der konjunkturverwöhnten achtziger Jahre betrachtet. Allen Skandalen zum Trotz blieb Koons immer ein großer Moralist, dessen erklärtes Ziel es war, durch die allgemeine Verständlichkeit und Popularität seiner Objekte die Kunst zu demokratisieren. Im Verlauf der neunziger Jahre war es ruhig um Koons geworden. Im Herbst 1999 jedoch kehrte er mit der Werkgruppe *Easyfun* in die Kunstszene zurück, einer Reihe von großformatigen Bildern und farbigen Spiegeln in den Umrissen cartoonartiger Tierköpfe. Die *Easyfun*-Gemälde sind eindrucksvolle, farbenfrohe Collagen aus Reklamebildern und Elementen der Alltagskultur, wie im Fall der in einem Sturzbach von Milch wirbelnden Frühstücksflocken in *Cut Out,* 1999. Bestimmte Motive höhlt er gespenstisch aus und unterlegt sie mit artfremdem Bildmaterial, wodurch ein surrealer, psychedelischer Eindruck entsteht. Diese kalkulierte malerische Ekstase von *Easyfun* hat Koons selbst als „Barokoko" bezeichnet.

Jeff Koons peut sans doute être décrit comme l'une des icônes artistiques les plus spectaculaires des vingt dernières années. Self-made-man, il a d'abord financé ses projets onéreux au moyen de spéculations boursières réalisées à New York, avant de devenir le grand manager de son œuvre provocant. Dès le début, Koons s'est intéressé à l'art populaire américain et au surréalisme. Plus tard, il associe ces influences aux stratégies du Pop Art, se servant d'annonces publicitaires et prenant pour modèle de ses sculptures glamoureuses des figures kitsch et des objets quotidiens. Koons n'a pas reculé devant les mises en scène pornographiques de sa propre personne avec sa compagne de l'époque, la star du porno Ilona Staller, dite « Cicciolina » (*Made in Heaven,* 1991). Ce que certains ont décrié comme une opération de sabotage du marché de l'art, a été considéré par d'autres comme l'expression de l'optimisme conjoncturel des années 80 « dorées ». Défiant tous les scandales, Koons est toujours resté un grand moraliste dont le but déclaré a été de démocratiser l'art par l'intelligibilité universelle et la popularité de ses objets. Dans le courant des années 90, un certain silence s'est fait autour de l'artiste. Mais à l'automne 1999, Koons est revenu sur la scène artistique avec *Easyfun*, une série de tableaux grand format et de miroirs de couleur inscrits dans la silhouette de têtes d'animaux qui rappellent des dessins animés. Les peintures de la série *Easyfun* sont d'impressionnants collages bigarrés associant des images publicitaires et des éléments de la culture quotidienne. Dans *Cut Out*, 1999, c'est un déversement de flocons de petit déjeuner virevoltant dans une cascade de lait. Certains motifs sont évidés de manière fantomatique et sous-tendus de matériaux étrangers au genre, ce qui produit une impression surréelle et psychédélique. Koons a décrit l'extase picturale calculée d'*Easyfun* comme du « Barococo ». A. K.

1 **Stream,** 2001, oil on canvas, 274 x 213 cm
2 **Candle,** 2001, oil on canvas, 305 x 427 cm
3 **Sheep (Yellow),** 1999, crystal glass, coloured plastic interlayer, mirrored glass, stainless steel, 180 x 150 x 5 cm

4 **Donkey,** 1999, mirror-polished stainless steel, 198 x 152 x 3 cm
5 Installation view, Royal Academy of Arts, London;
 left: **Balloon Dog (Red),** 1994–2000, high chromium stainless steel (with transparent colour coating), 307 x 363 x 114 cm;
 right: **Moon,** 1994–2000, high chromium stainless steel, 311 x 311 x 99 cm

„Ich wollte immer Kunst machen, die sich mit dem kulturellen Umfeld des Betrachters ändert. Denn dann habe ich manchmal für einen Moment das Gefühl, dass sich das Ego in der Flut der Zusammenhänge verliert."

« J'ai toujours voulu créer de l'art qui se différencie du propre environnement du public. Quelquefois, j'ai l'impression que l'ego se perd dans le flot des connexions. »

"I always wanted to create art that was different from the public's own cultural environment. There are moments when I sometimes feel that ego is swept away in the flood of connections."

2

3

4

5

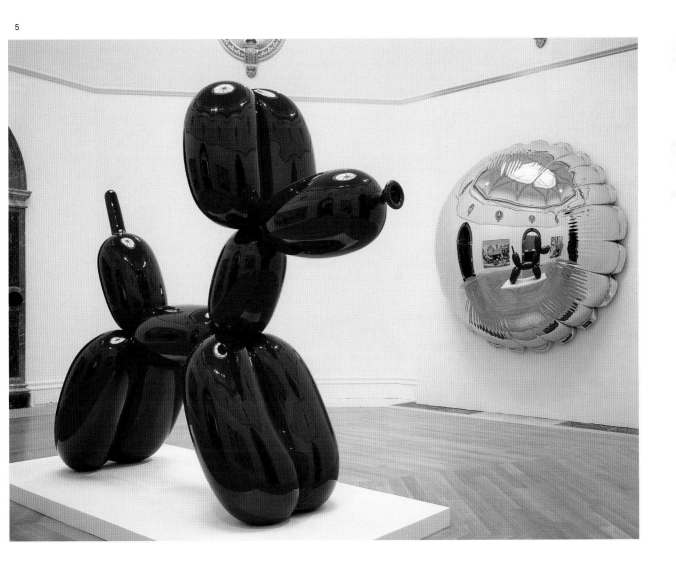

Udomsak Krisanamis

1966 born in Bangkok, Thailand, lives and works in New York (NY), USA

When Udomsak Krisanamis left Thailand for Chicago in 1991, his response to the new culture and efforts to learn its language word by word from daily newspapers provided the starting point for his collage-based paintings. Treating language as an abstract medium, he cut strips of text from newspapers and xeroxed and pasted them onto canvas; then he traced around the text with fine black ink. In the resulting smooth, monochromatic works such as *Smoke on the Water*, 1995, only the circles that form the centres of letters and numbers remain visible in a field of black ink. Krisanamis' paintings have since developed into densely layered abstract structures built up of materials selected by virtue of being close at hand. In *Sweet Tears*, 1998, strands of clear glass noodles are pasted in rivulets onto a rainbow-patterned bedsheet used instead of a canvas support. Titles are also casually come by, lifted from CDs, movies or magazines, and covering a range of clichés from the bittersweet melancholy of *Tears on my Pillow*, 1995, to the glib realism of *Chivas Regal*, 1998, copied straight from the bottle. The deliberately repetitive and mundane process with which Krisanamis meticulously paints around the collaged text and noodles owes more to craft than to the tradition of high art. However, the paintings overcome the banality of their production and are richly evocative, while acknowledging a myriad of influences from Jackson Pollock to Chris Ofili. By reducing language to an abstract binary code and weaving together a random assortment of Eastern and Western cultural detritus, Krisanamis gives craft and art an equal footing.

Nach seinem Umzug 1991 von Thailand nach Chicago wurde Udomsak Krisanamis durch seine Reaktion auf die neue Kultur und seine Bemühungen, die englische Sprache Wort für Wort aus der Tageszeitung zu erlernen, zu seinen ersten Collagen-Gemälden angeregt. Er behandelt Sprache wie ein abstraktes Medium, schneidet Textstreifen aus Zeitungen aus, fotokopiert beziehungsweise klebt sie auf die Leinwand und „ummalt" den Text mit feiner schwarzer Tinte. Das Ergebnis sind monochrome Arbeiten, etwa *Smoke on the Water*, 1995, in denen er lediglich die leeren Innenräume von Buchstaben und Zahlen inmitten einer Fläche aus schwarzer Tinte stehen lässt. Mittlerweile entwickelten sich Krisanamis' Werke zu dicht geschichteten abstrakten Strukturen, deren Materialien er nach ihrer zufälligen Verfügbarkeit auswählt. In *Sweet Tears*, 1998, etwa sind Stränge durchscheinender Glasnudeln auf ein in Regenbogenfarben gemustertes Betttuch aufgeklebt, das als Leinwand fungiert. Auch die Bildtitel sind beiläufig ausgewählt, stammen von CDs, Filmen oder Magazinen und decken ein breites Spektrum von Klischees ab: mal bittersüß melancholisch wie *Tears on my Pillow*, 1995, dann wieder mit zungenfertigem Realismus wie *Chivas Regal*, 1998, unmittelbar von der Flasche kopiert. Das bewusst auf Wiederholung und Nüchternheit angelegte Verfahren, das er bei der sorgfältigen Ummalung seiner Text- und Nudel-Collagen anwendet, ist mehr Handwerk als „hohe Kunst". Gleichwohl transzendieren die Gemälde die Banalität ihres Entstehungsprozesses und bestechen durch ihre assoziative Fülle. Zugleich erkennen sie stets die zahlreichen Einflüsse an, von Jackson Pollock bis Chris Ofili. Da Krisanamis die Sprache auf einen abstrakten binären Code reduziert und beliebige Bruchstücke der östlichen und der westlichen Kultur miteinander verbindet, erscheinen die handwerkliche und die künstlerische Arbeit als gleichwertige Verfahren.

Lorsque Udomsak Krisanamis a quitté la Thaïlande pour Chicago en 1991, ses réactions à cette nouvelle culture et ses efforts pour apprendre sa langue mot après mot dans les quotidiens ont servi de base à ses tableaux-collages. Traitant le langage comme un médium abstrait, il découpe des bandelettes de textes dans les journaux, les photocopie, puis les colle sur des toiles, délimitant ensuite les mots avec des traits fins à l'encre noire. Dans les œuvres lisses et monochromes qui en résultent, comme *Smoke on the Water*, 1995, seuls les cercles formés par le centre des lettres et des chiffres restent visibles sur un fond d'encre noire. Depuis, les tableaux de Krisanamis se sont développés en structures abstraites comptant de nombreuses couches de matériaux sélectionnés au hasard parmi ceux qu'il a sous la main. Dans *Sweet Tears*, 1998, des filaments de nouilles en verre transparent sont collés en rigoles sur un drap arc-en-ciel faisant office de toile. Les titres des œuvres sont également trouvés au hasard, à partir de CD, de films, ou de revues et recouvrent un large éventail de clichés, de la mélancolie douce amère de *Tears on my Pillow* (des larmes sur mon oreiller), 1995, au réalisme désinvolte de *Chivas Regal*, 1998, copié directement de la bouteille. Le procédé délibérément répétitif et prosaïque avec lequel Krisanamis peint méticuleusement autour des textes et des nouilles collés tient davantage de l'artisanat que de la tradition du grand art. Pourtant, ses tableaux dépassent la banalité de leur exécution et sont très évocateurs, tout en trahissant une myriade d'influences allant de Jackson Pollock à Chris Ofili. En réduisant le langage à un code binaire abstrait et en tissant ensemble un assortiment aléatoire de détritus culturels orientaux et occidentaux, Krisanamis place l'artisanat et l'art sur un pied d'égalité.

K. B.

SELECTED EXHIBITIONS →
1990 Goethe-Institut, Bangkok, Thailand **1997** SITE Santa Fe, Santa Fe (NM), USA **1998** *Projects 63: Udomsak Krisanamis*, Museum of Modern Art, New York (NY), USA **1999** *Peter Doig and Udomsak Krisanamis*, Arnolfini Gallery, Bristol, UK; The Fruitmarket Gallery, Edinburgh, UK; *Examining Pictures*, Whitechapel Art Gallery, London, UK **2000** Wexner Center for the Arts, Columbus (OH), USA **2001** *Painting at the Edge of the World*, Walker Art Center, Minneapolis (MN), USA

SELECTED BIBLIOGRAPHY →
1998 *Biennale of Sydney*, Australia **1999** *Dusk, Rirkrit Tiravanija in Nach-Bild*, Kunsthalle Basel; *Cream: Contemporary art in culture*, London; *Peter Doig/Udomsak Krisanamis*, Arnolfini Gallery, Bristol **2001** *The Intimate Portrait: Udomsak Krisanamis*, Wexner Center for the Arts, Columbus (OH)

1 **Hot Spot,** 2000, collage, acrylic, marker on canvas, 180 x 150 cm
2 **Midnight in my Perfect World,** 1997, collage, acrylic on canvas,
 183 x 122 cm

3 **The Wind Cries Mary,** 2001, acrylic, collage, noodles on canvas, 183 x 91 cm

„Alles findet sich im Bild selbst."

« Tout est dans la peinture. »

"Everything is in the painting."

2

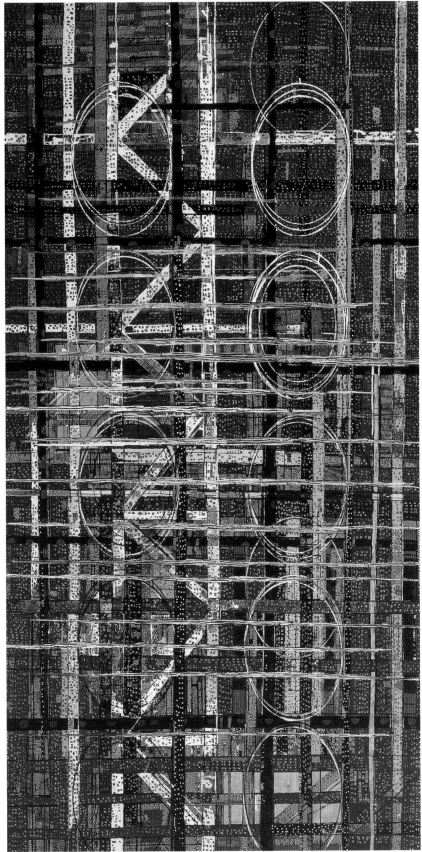

Elke Krystufek

1970 born in Vienna, lives and works in Vienna, Austria, and Rotterdam, The Netherlands

Often (but incorrectly) labelled as a feminist, Elke Krystufek uses her installations, paintings, drawings, videos, photo-collages and performances to pose more honest and more radical questions than women have so far asked. She aggressively deconstructs symbolic values. By displaying and using her own naked body and masturbating, as she does in her performances, she is breaking taboos and denouncing desire. The historical and mythical view of the city of Vienna, home of Otto Weininger, Sigmund Freud and Viennese Actionism, is subverted by Krystufek's exploration of the way women are treated within the context of art. Photography, pop music and pop culture, and the fantasies which assume the media she uses to be extensions of her own body, are far stronger influences on her artistic language and choice of medium. In her many self-portraits, she comes across as an anxious child, demanding to be loved, a demand that cannot be met because of her own destructive relationship with herself. Her body, eyes and language are all means of expression; clothes and wigs are active transmitters of her inner state. Together they provide the possibility of real communication. Behind the masquerade and theatricality lies the core of her art – her questioning of her identity through her body. It is all about the reality in and behind things, about saying the unsayable. It is ultimately about the failure of culture to address our subjective sensibilities. Krystufek manages to take us beyond the outer limits of the visual media. *I am your mirror* is art as collective psychotherapy. It is also not insignificant that she is an art collector – ultimately she conspires with the system.

Oft, aber falsch als Feministin tituliert, stellt Elke Krystufek mit ihren Installationen, Bildern, Zeichnungen, Videos, Fotocollagen und Performances Fragen, die offener und radikaler als vieles bislang von Frauen Dargestellte sind. Symbolische Werte werden von ihr aggressiv dekonstruiert: Mit der Zurschaustellung ihres nackten Körpers, den sie in ihren Performances benutzt und befriedigt, will sie Tabus brechen und Begierde und Begehren denunzieren. Die historische Sicht auf ihre Stadt Wien mit Otto Weininger, Sigmund Freud oder dem Wiener Aktionismus beschwört einen Mythos herauf, der sich auf ihre Erkundung weiblichen Handelns im Kunstkontext übertragen lässt. Ihre künstlerische Sprache ist stark beeinflusst von aktueller Fotografie, Popmusik und Popkultur – von Fantasien, die Medien als Erweiterung des Körpers verstehen. Aus ihren unzähligen Selbstporträts sieht sie uns wie ein ängstliches Kind an; sie fordert ein Geliebtwerden ein, das durch die gebrochene Beziehung zu sich selbst nicht erlangt werden kann. Der Körper ist so Medium zum Außen, der Blick, die Sprache, Mode und Perücken sind aktive Botschafter des Innen. Die Möglichkeit der echten Mitteilung, der wahren Aussage hinter Maskerade und Theatralik ist ihr zentrales Moment, bei dem die Frage nach der Identität über den Körper gestellt wird. Es dreht sich um die Wirklichkeit in und hinter den Dingen, um das Unsagbare. Es ist letztlich das Versagen der Kultur, unser subjektives Empfinden nicht zu pflegen, und es ist Krystufeks Qualität, uns in die Grenzbereiche des medial Visuellen zu verstoßen: *I am your mirror*. Kunst als kollektive Psychotherapie, wobei nicht unwesentlich ist, dass sie selber Kunstwerke sammelt – das System ist letztlich ihr Verbündeter.

Avec ses installations, ses tableaux, dessins, vidéos, collages photographiques et dans ses performances, Elke Krystufek, qu'on qualifie souvent – à tort – de féministe, pose des questions plus ouvertes et plus radicales que beaucoup d'œuvres présentées aujourd'hui par des femmes. Des valeurs symboliques y sont déconstruites agressivement : par l'exhibition de son propre corps, qu'elle utilise et satisfait pendant ses performances, Krystufek entend briser les tabous et dénoncer la convoitise et la cupidité. Si la vision historique de Vienne, sa ville natale, avec Otto Weininger, Sigmund Freud, ou l'actionnisme viennois évoquent un mythe susceptible de s'appliquer à l'exposition publique de l'action féminine dans le contexte de l'art, le langage artistique de Krystufek est en fait marqué surtout par la spécificité du médium, la photographie contemporaine, la musique et la culture pop – par les fantasmes qui tendent à comprendre les médias comme un prolongement du corps. Dans ses innombrables autoportraits, elle nous regarde comme une enfant apeurée, revendiquant d'être aimée d'un amour que les dommages de sa relation à elle-même ne peuvent lui permettre d'atteindre. Le corps devient ainsi le médium du rapport vers l'extérieur, dans lequel le regard, le langage, la mode et les perruques sont les interfaces actives de l'intériorité. La possibilité du message authentique, de l'expression vraie derrière la mascarade et la mise en scène devient l'élément central qui permet d'articuler le problème de l'identité par le biais du corps. Il s'agit de la réalité cachée sous les choses, de l'indicible. En définitive, c'est l'échec de notre culture que de ne pas cultiver le sentiment subjectif, et la qualité particulière de Krystufek consiste à nous pousser dans les retranchements du visuel et du médium : *I am your mirror*. L'art comme une psychothérapie collective dans laquelle on relève que l'artiste collectionne elle-même des œuvres d'art. En définitive, elle a fait du système son acolyte.

G. J.

SELECTED EXHIBITIONS →
1998 *XXIV Bienal Internacional de São Paulo*, Brazil **1998** *Manifesta 2*, Luxembourg **1999** *Sleepingbetterland*, Bahnwärterhaus, Galerie der Stadt Esslingen, Germany **2000** Portikus, Frankfurt am Main, Germany; Gallery Side 2, Tokyo, Japan; *Presumed Innocent, childhood and contemporary art*, capcMusée d'Art Contemporain de Bordeaux, France **2001** *ars Futura*, Zurich, Switzerland; *Double life*, Generali Foundation, Vienna, Austria; *Zero Gravity*, Kunstverein für die Rheinlande und Westfalen, Düsseldorf, Germany

SELECTED BIBLIOGRAPHY →
1992 *Arbeitsbuch Religion*, Galerie Metropol, Vienna **1997** *I am your mirror*, Wiener Secession, Vienna **1998** *Economical Love*, Biennale São Paulo **1999** *Sleepingbetterland*, Georg Kargl, Vienna/Galerie der Stadt Esslingen **2000** *Nobody has to know*, Portikus, Frankfurt am Main

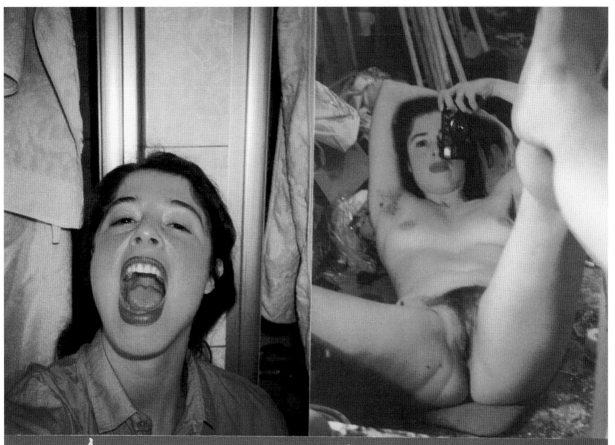

A word is worth a thousand images.

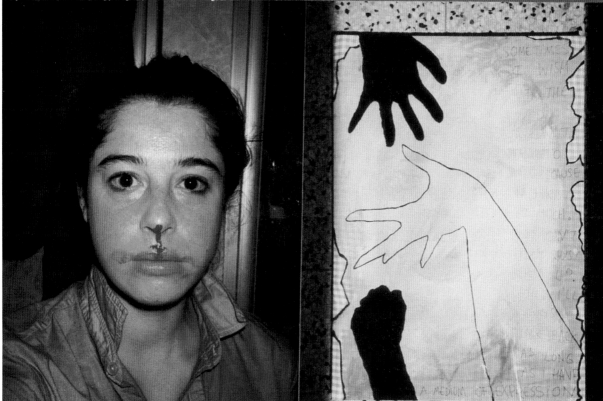

254

1 Top and bottom left: **This is hardcore,** 1998, c-prints, each 70 x 50 cm
 Bottom right: **Time out of mind,** 1998, acrylic, dispersion paint on fabric, 70 x 50 cm
2 **As You Make Your Bed, So You Must Lie Upon It,** 2001, installation view, Generali Foundation, Vienna
3 **Pussy Control,** 1997, acrylic, dispersion paint on canvas, 140 x 130 cm
4 **Woman of Colour,** 1997, acrylic, dispersion paint on canvas, 140 x 130 cm
5 **Nobody has to know,** 2001, installation view, *Zero Gravity*, Kunstverein für die Rheinlande und Westfalen, Düsseldorf

„Ich habe beschlossen, mein Leben zum Kunstwerk zu machen. Ich habe kein Privatleben: Alles ist öffentlich."

« J'ai choisi de faire de ma vie une œuvre d'art. Je n'ai pas de vie privée : tout est public. »

"I decided to make my life a work of art. I have no private life. Everything is public."

2

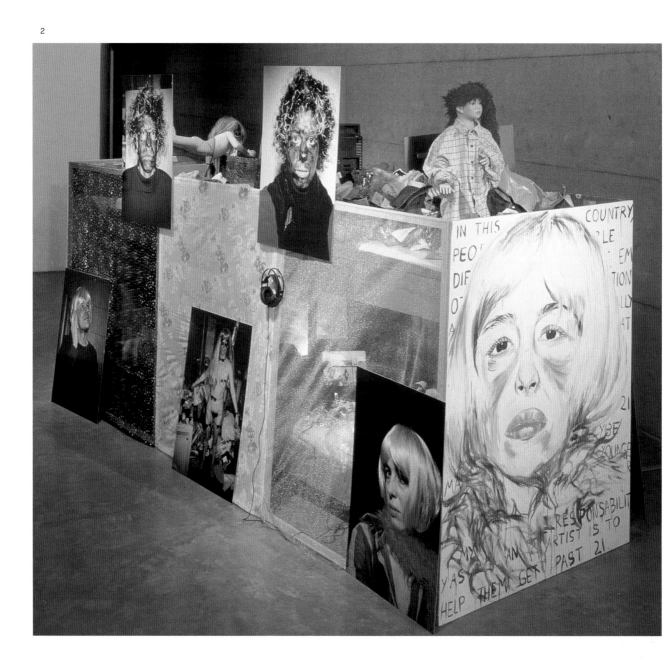

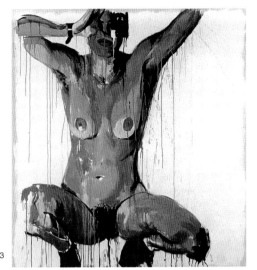
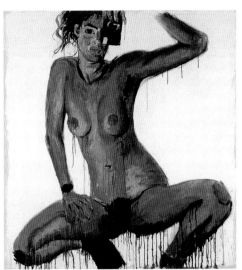

3

4

5

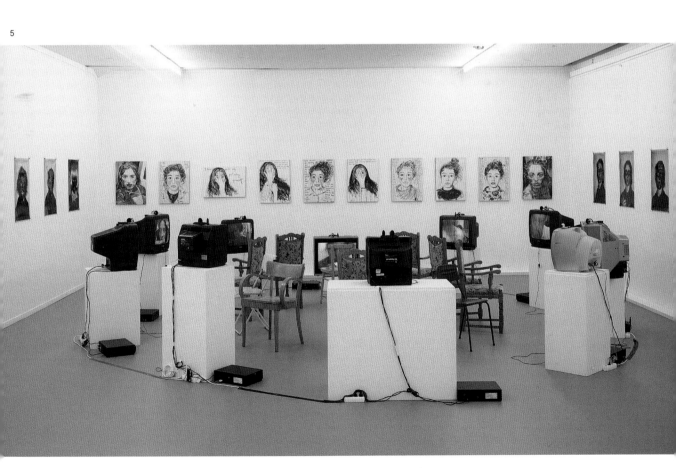

Oleg Kulik

1961 born in Kiev, lives and works in Moscow, Russia

At the beginning of the 1990s, Russia saw the disintegration of a system whose intrinsic feature was the opposition of anonymous government and governed society. Artists tried to act in the cultural abyss that opened in the wake of these changes and the brutalisation of everyday life. Against this background, Oleg Kulik's statement represented the most radical proposal. In his performances, he has brought to the West the figure of a "man-dog" – a Russian dog who barks at the audiences in galleries and bites art critics. In the *I Love Europe, It Does Not Love Me Back* performance (1996), the man-dog is tortured, arrested, always on all fours. As a dog, Kulik freed himself from the art discourse but lost his human rights, which is always risky. In a series of works called *Zoophrenia*, 1998–2001, which used installation, photography and video, Kulik proposed a new vision of the "family of the future" in which the dog, and other animals, would be partners to man. He submitted a proposal that the present social contract must be terminated, in the wake of the complete bankruptcy of Enlightenment-derived ethical and aesthetic ideas. It should be replaced by man's relationship with animals, a zoophiliac transgression for which there is no place in the West. While Western society may be desperately trying to recuperate all possible forms of otherness, it remains anthropocentric and thus, according to Kulik, undemocratic. The future of man is the animal.

Anfang der neunziger Jahre ist in Russland ein System auseinander gebrochen, das vor allem durch den Gegensatz zwischen einer anonymen Regierung und einer autoritär geführten Gesellschaft gekennzeichnet war. Trotz des künstlerischen Abgrunds, der sich im Gefolge dieser grundstürzenden Veränderungen und der Brutalisierung des Alltags aufgetan hat, sind die Künstler des Landes darum bemüht, ihre Handlungsfähigkeit zu verteidigen. Die wohl radikalste Reaktion auf diese Situation ist das Kunstschaffen von Oleg Kulik. Durch seine Performances hat er auch im Westen die Figur des „Menschen-Hundes" bekannt gemacht – eines russischen Hundes, der in Galerien das Publikum anbellt oder schon einmal einen Kunstkritiker beißt. In der Performance *I Love Europe, It Does Not Love Me Back*, 1996, wird der Menschen-Hund, der sich stets auf allen vieren bewegt, gequält und in Arrest genommen. Durch seinen Status als Hund hat Kulik sich einerseits aus dem Kunstdiskurs verabschiedet, andererseits jedoch seine Menschenrechte eingebüßt. Dafür muss er nun immer wieder die Konsequenzen tragen. In einem weiteren, *Zoophrenia*, 1998–2001, betitelten Werkzyklus hat Kulik sich die Mittel der Installation, der Fotografie und der Videokunst zunutze gemacht. Der Zyklus kreist um eine Vision der „Zukunftsfamilie", in der Mensch, Hund und andere Tiere partnerschaftlich zusammenleben. Der Künstler setzt sich dafür ein, den derzeit geltenden Gesellschaftsvertrag aufzukündigen, weil wir nach seiner Auffassung mit den aus der Aufklärung abgeleiteten ethischen und ästhetischen Vorstellungen vollständig Schiffbruch erlitten haben. Stattdessen soll die Beziehung des Menschen zu den übrigen Lebewesen in den Vordergrund treten – eine zoophile Grenzüberschreitung, der im Westen freilich wenig Aussicht auf Erfolg beschieden ist. Mag sich die westliche Gesellschaft auch noch so verzweifelt darum bemühen, alle denkbaren Formen des Andersseins zu integrieren, so bleibt sie dennoch auf ihren – laut Kulik undemokratischen – Anthropozentrismus fixiert. Die Zukunft des Menschen ist das Tier.

Au début des années 90, la Russie a vu la désintégration d'un système dont la caractéristique intrinsèque était l'opposition entre un gouvernement anonyme et une société gouvernée. Les artistes ont essayé d'œuvrer dans l'abîme culturel ouvert à la suite de ces changements et de la brutalité croissante de la vie quotidienne. Sur cette toile de fond, la déclaration d'Oleg Kulik représente la proposition la plus radicale. Par ses performances, il a fait entrer en Occident le personnage de « l'homme chien » – un chien russe qui aboie après le public des galeries et qui mord les critiques d'art. Dans sa performance *I Love Europe, It Does Not Love Me Back*, 1996, l'homme chien est arrêté et torturé, toujours à quatre pattes. En tant que chien, Kulik s'est libéré du discours artistique mais a perdu ses droits humains, ce qui est toujours risqué. Dans une série d'œuvres intitulées *Zoophrenia*, 1998–2001, qui conjuguent l'installation, la photographie et la vidéo, Kulik a proposé une nouvelle vision de la « famille du futur », où le chien et d'autres animaux seraient des partenaires de l'homme. Compte tenu de la déroute totale des idées éthiques et esthétiques issues de l'âge des Lumières, il propose de mettre un terme au contrat social actuel. Il faudrait le remplacer par la relation de l'homme avec les animaux, une transgression zoophile qui n'a pas de place en Occident. La société occidentale tente désespérément de récupérer toutes les formes possibles d'altérité mais demeure obstinément anthropocentrique et donc, selon Kulik, antidémocratique. L'animal est l'avenir de l'homme.

A. S.

SELECTED EXHIBITIONS →
1997 *I bite America & America bites me* (with Mila Bredikhina), Deitch Projects, New York (NY), USA; *5th Istanbul Biennial*, Istanbul, Turkey
1998 Galerie Rabouan-Moussion, Paris, France; *XXIV Bienal Internacional de São Paulo*, Brazil; *Body and the East*, Moderna Galerija, Ljubljana, Slovenia **1999** *Red Room*, XL Gallery, Moscow, Russia; *Fauna*, State CCA, Moscow, Russia **2001** *Deep Into Russia*, S.M.A.K., Stedelijk Museum voor Actuele Kunst, Ghent, Belgium

SELECTED BIBLIOGRAPHY →
2000 *Fresh Cream*, London

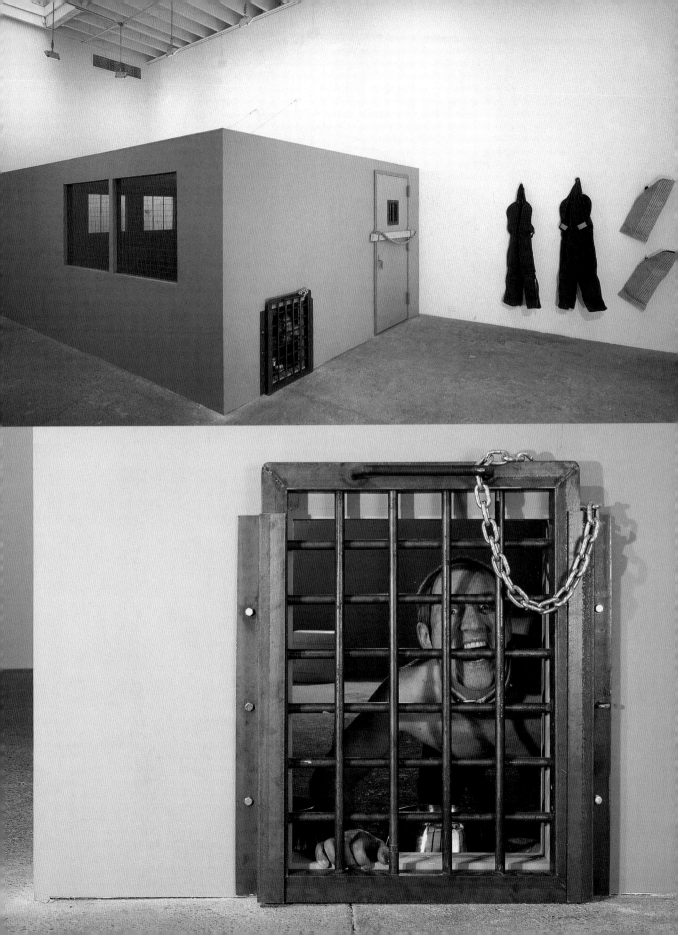

258

1 In collaboration with Mila Bredikhina:
 I Bite America and America Bites Me, April 12 – 26, 1997, installation and
 performance at Deitch Projects, New York (NY)

2 **Reservoir Dog,** March 30, 1995, performance at Kunsthaus Zürich, Zurich
3 **Windows: Walrus,** 2001, c-print, 210 x 250 cm
4 **Alice vs. Lolita,** 1999, colour photograph, 100 x 100 cm

„Das Tier denkt, also ist es."

« L'animal pense, donc il existe. »

"The animal thinks, therefore it exists."

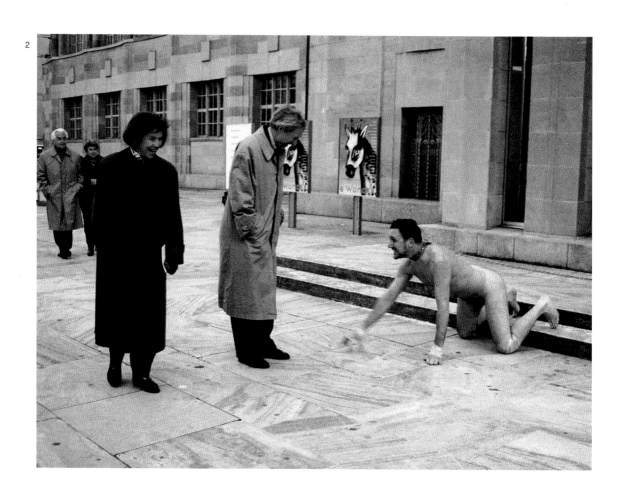

3

4

Jim Lambie

1964 born in Glasgow, lives and works in Glasgow, UK

Glasgow was one of the most influential and productive places on the international arts landscape in the 1990s. Miles away from the arts capital London, previously little-known Glaswegian artists broke out of their isolation and got together as a community to make their mark on the international scene. Glasgow-born Jim Lambie played xylophone with the band "Teenage Fanclub", and music, the branch of culture that reacts fastest and loudest to the mood of the moment, has had a lasting influence on the Scottish artist. His first solo exhibition was entitled *Voidoid*, named after the band of the New York punk icon Richard Hell. The power of punk came from keeping things simple and, like a reborn Malcolm McLaren of the art world, Lambie skilfully elicits virtuosity and beauty from the cheapest materials. His *Psychedelic Soul Sticks*, 1998, were no more than sock-clad sticks leaning casually against the wall, bound with lots of brightly coloured threads, obligingly offering themselves as something to fiddle with in times of stress. There are no decisive tactics, no fixed strategy in his work. Lambie allows himself to be influenced by odd things he comes across. In this sense *Zobop*, 1999, is a symptomatic work: an installation of multicoloured vinyl tape stuck to the floor. The cheap strips zigzag into corners and around projections in the exhibition space, enlarging every detail to create a visual rhythm that makes the whole space pulsate. Lambie is not really so far removed from traditional sculpture. After all, he is faced with the same artistic issues, the same processes of adding and subtracting materials. There is nothing grand about his work. Even so, it has a magical, mysterious effect on the viewer.

Einer der einflussreichsten und produktivsten Schauplätze der internationalen Kunstlandschaft in den neunziger Jahren war Glasgow. Fern der Kunstmetropole London durchbrachen zuvor wenig beachtete Glasgower Künstler ihre Isolation und setzten sich, kooperativ und freundschaftlich verbunden, international wirkungsvoll in Szene. Jim Lambie, gebürtiger Glasgower, spielte Xylophon bei der Band „Teenage Fanclub", und Musik, die Kultur, die am schnellsten und lautesten auf die Gegenwart reagiert, hat auf den schottischen Künstler nachhaltigen Einfluss ausgeübt. Seine erste Einzelausstellung trug den Titel *Voidoid* und zitierte damit den Bandnamen der New Yorker Punk-Ikone Richard Hell. Punk zog seine Kraft aus der Vereinfachung, und mit sicherer Hand entlockt Lambie billigstem Material Virtuosität und Schönheit, als sei er ein wiedergeborener Malcolm McLaren der Kunstwelt. Seine *Psychedelic Soul Sticks*, 1998, waren lediglich Zweige in Socken, lässig lehnten sie an der Wand, umwickelt von vielen bunten Fäden. Zuvorkommend boten sie ihre Dienste an und sollten geschüttelt werden in stressvollen Zeiten. Es gibt keine feste Taktik, keine durchzuhaltende Strategie in seinem Œuvre. Lambie lässt sich beeinflussen von den Dingen, die ihm begegnen. *Zobop*, 1999, ist in dieser Hinsicht eine symptomatische Arbeit: eine Installation vielfarbiger Klebestreifen auf dem Boden. Das billige Klebeband folgt im Zickzack um Ecken und Vorsprünge herum dem Raum und vergrößert jedes Detail zu einem visuellen Rhythmus, der den ganzen Raum pulsieren lässt. Lambie ist gar nicht so weit entfernt von traditioneller Bildhauerei, schlussendlich sind es dieselben künstlerischen Probleme, Material hinzuzufügen, zu entfernen. Sein Werk entfaltet keine Grandezza. Und trotzdem macht es etwas mit dem Betrachter. Magisch. Unerklärlich.

Glasgow a été l'une des scènes les plus influentes et les plus productives de l'art international des années 90. Loin de la métropole londonienne, des artistes peu connus, liés d'amitié, rompaient leur isolement et se mettaient en scène sur le plan international de manière spectaculaire, collective, coopérative. Jim Lambie, lui-même originaire de Glasgow, jouait du xylophone dans le groupe « Teenage Fanclub ». La musique, qui réagit à l'époque présente plus rapidement et plus bruyamment que les autres formes culturelles, a exercé une influence durable sur l'artiste écossais. Avec le titre *Voidoid*, sa première exposition personnelle citait le nom du groupe de Richard Hell, l'icône new-yorkaise du punk. Le punk tirait sa vitalité de la simplification. D'une main très sûre, Lambie sait soutirer aux matériaux les plus triviaux une grande part de virtuosité et de beauté, comme s'il était la réincarnation d'un Malcolm McLaren du monde de l'art. Ses *Psychedelic Soul Sticks*, 1998, étaient tout bonnement des branchages en chaussettes, appuyés au mur avec nonchalance, entourés de nombreux fils multicolores. Très avenants, ils offraient leurs services : on devait les agiter en période de stress. Dans l'œuvre de Lambie, on ne trouve aucune tactique arrêtée, aucune stratégie durable. L'artiste se laisse influencer par tout ce qu'il rencontre. A cet égard, *Zobop*, 1999, est une œuvre symptomatique : il s'agit d'une installation de rubans adhésifs multicolores. Les bandes adhésives suivent le dessin de la salle, zigzaguant autour des angles et des avancées, développant chaque détail en lui imprimant un rythme visuel qui finit par faire pulser toute la salle. Lambie n'est pas si éloigné de la sculpture traditionnelle, avec laquelle il partage finalement les mêmes problématiques : ajouter de la matière, en retrancher. Son œuvre déploie une réelle grandeur. Pourtant, elle agit sur le spectateur, magiquement, inexplicablement.

F. F.

SELECTED EXHIBITIONS →
1999 Transmission Gallery, Glasgow, UK; Sadie Coles HQ, London, UK **2000** Konrad Fischer Galerie, Düsseldorf, Germany; Anton Kern Gallery, New York (NY), USA; *The British Art Show 5*, Hayward Gallery, London, UK; *What If*, Moderna Museet, Stockholm, Sweden; *Raumkörper*, Kunsthalle Basel, Basle, Switzerland **2001** The Modern Institute, Glasgow, UK; *Painting at the Edge of the World*, Walker Arts Center, Minneapolis (MN), USA; *Patterns: Between Object and Arabesque*, Kunsthallen Brandts Klædefabrik, Odense, Denmark

2002 Inverleith House, Edinburgh, UK; Sadie Coles HQ, London, UK; *My Head Is On Fire But My Heart Is Full Of Love*, Charlottenbourg Museum, Copenhagen, Denmark

SELECTED BIBLIOGRAPHY →
1998 *Lovecraft*, Spacex Gallery, Exeter **1999** *ZOBOP*, Transmission/ Showroom Gallery, Glasgow

1 **Diamond,** 2001, record sleeves, tape, mixed media, ø 35 cm, installation view, Galerie Konrad Fischer, Düsseldorf
2 **Handbag,** 1999, record deck, pink glitter, leather, handbag straps, 68 x 45 x 37 cm

3 **Ska's not Dead,** 2001, turntable, glitter, glove, mixed media, 36 x 36 x 72 cm
4 **Psychedelic Soul Stick,** 2001, bamboo, mixed media, thread, 117 x 7 x 7 cm
5 **Zobop,** 1999, multi-coloured vinyl tape, installation view, Transmission Gallery, Glasgow

I say we will have a real cool time tonight
I say we will have a real cool time tonight
I say we will have a real cool time tonight
I say we will have a real cool time tonight
I said we will have a real cool time tonight
I said we will have a real cool time
we will have a real cool time a real cool time tonight.
("real cool time", The Stooges, 1969)

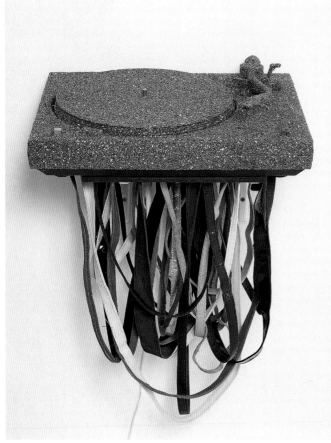

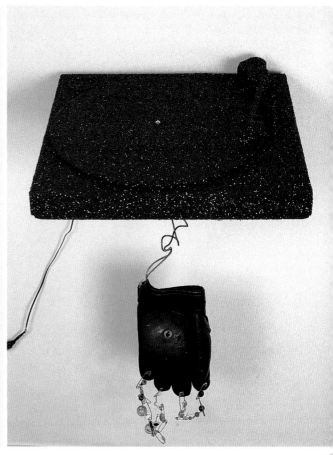

2

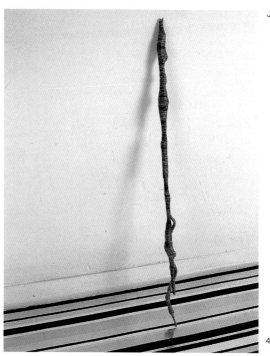

4

5

Zoe Leonard

1961 born in New York (NY), lives and works in New York (NY), USA

In the New York of the late 1980s, Zoe Leonard became involved in the wide-ranging cultural activist scene as a "gay artist", a member of Act-Up and an opponent of censorship. In her art, she abstracted material from her experience of political activities and those of the AIDS campaign. Her photographs of trees, clouds and waves at sea are full of references to the history of photography, avant-garde film and the landscape paintings of former centuries. They can, however, also be viewed as allegories of the passing of time, of memory and contemplation. The triviality of her subjects – improvised shop windows and the cheap displays found in the small shops of New York's Lower East Side, the empty back yards of old brick buildings, plastic bags stuck in trees after being blown there by the wind, crumbling walls and fences – all that is ordinary and desolate has been taken by Leonard and turned into high art. Everything that is empty, banal and trivial is transformed in her photographs into the extraordinary poetry of the representational world. In her work *Mouth open, teeth showing*, 2000, she took 162 children's dolls and arranged them on the gallery floor in a threatening parade. She acquired the dolls in second-hand shops. There are aspects of collector's mania, memory, recurrence and social anthropology all overlapping with each other. The unmistakable human characteristics of the dolls' army, with their batting eyelashes and half-open mouths, are emphasised by what looks like a swinging gait. In *Mouth open, teeth showing* Leonard has designed a sort of "artistic thriller", a suggestive, spatial arrangement in which we see the unfolding of a contradictory mood of passivity and aggression.

Im New York der späten achtziger Jahre hatte Zoe Leonard sich als „gay artist", Act-Up-Mitglied und Zensurgegnerin innerhalb der damals breit gefächerten Kulturaktivismus-Szene engagiert. In ihrer Kunst abstrahierte Leonard von den Bedingungen der politischen Arbeit und den Erfahrungen der AIDS-Kampagne. Ihre Aufnahmen von Bäumen, Wolken und Meereswellen sind voller Bezüge auf die Geschichte der Fotografie, des Avantgardefilms und der Landschaftsmalerei vergangener Jahrhunderte. Sie können aber auch als Allegorien auf Vergänglichkeit, Erinnerung und Kontemplation betrachtet werden. Die Beiläufigkeit ihrer vorgefundenen Motive – improvisierte Schaufenster und billige Auslagen der kleinen Geschäfte in der New Yorker Lower East Side, leere Hinterhöfe alter Backsteinbauten, Bäume, in denen sich herumfliegende Plastiktüten verfangen, marode Mauern und Zäune –, all das gewöhnlich Desolate wird von Leonard zur hohen Kunst erhoben. Die Leere, das Banale und Nebensächliche verwandeln sich in Leonards Fotografien in eine außergewöhnliche Poetik der gegenständlichen Welt. In *Mouth open, teeth showing*, 2000, hat sie 162 Kinderpuppen auf dem Galerieboden zu einer bedrohlichen Parade aufgestellt. Die Puppen hatte Leonard in Secondhandläden erstanden. Aspekte von Sammlermanie, Erinnerung, Wiederkehr und sozialer Anthropologie überschneiden sich. Das unmittelbar Menschliche der Puppenarmee mit den klappernden Wimpern und halboffenen Mündern wurde unterstrichen durch einen scheinbar schwingenden Gang. Leonard inszenierte mit *Mouth open, teeth showing* eine Art Kunstthriller, ein suggestives räumliches Arrangement, in dem sich eine widersprüchliche Stimmung von Passivität und Aggression entfaltet.

Dans le New York de la fin des années 80, Zoe Leonard s'était engagée comme « gay artist », comme membre d'Act-Up et opposante à la censure au sein du large éventail de l'activisme culturel. Dans son art, Leonard s'abstrayait en revanche des termes du travail politique et des expériences de la campagne contre le SIDA. Ses vues d'arbres, de nuages et de vagues sont pleines de références à l'histoire de la photographie, du cinéma d'avant-garde et de la peinture de paysages des siècles passés. Mais elles peuvent aussi se lire comme des allégories de la fugacité, de la mémoire et de la contemplation. L'insignifiance de ses motifs trouvés – vitrines improvisées et présentoirs bon marché des petites boutiques de Lower East Side à New York, arrière-cours vides de vieilles bâtisses en briques, arbres où se sont accrochés des sacs en plastique soulevés par le vent, murs et grillages délabrés – bref, tout ce qui parle de la désolation ordinaire, Leonard l'élève au rang de grand art. Dans ses photographies, l'inanité, le banal et l'accessoire se transforment en une poétique inhabituelle du monde des objets. Dans une de ses dernières œuvres, *Mouth open, teeth showing*, 2000, l'artiste a organisé une parade menaçante à l'aide de 162 poupées installées au sol de la galerie, poupées achetées aux enchères chez un brocanteur. Différentes approches comme la collectionnite, la mémoire, le retour et une anthropologie sociale se superposent ici. L'aspect humain très immédiat de cette armée de poupées aux cils battants et aux lèvres entrouvertes était encore renforcé par une démarche apparemment chaloupée. Avec *Mouth open, teeth showing*, Leonard met en scène une sorte de « thriller artistique », arrangement spatial suggestif dans lequel se déploie une atmosphère contradictoire faite de passivité et d'agression.

A. K.

SELECTED EXHIBITIONS →
1997 Kunsthalle Basel, Basle, Switzerland **1998** Centre National de la Photographie, Paris, France; Philadelphia Museum of Art, Philadelphia (PA), USA; *Fast Forward (Body Check)*, Kunstverein in Hamburg, Germany **1999** Centre for Contemporary Art, Ujazdowski Castle, Warsaw, Poland; *The Museum as Muse: Artists Reflect*, Museum of Modern Art, New York (NY), USA **2000** *Die verletzte Diva*, Kunstverein München, Munich, Germany; *Voilà: Le Monde dans la tête*, Musée d'Art Moderne de la Ville de Paris, France

SELECTED BIBLIOGRAPHY →
1997 *Zoe Leonard*, Wiener Secession, Vienna **1999** *Dramatis Personae*, The Photographic Resource Center, Boston (MA); *Skin-deep: Surface and Appearance in Contemporary Art*, Israel Museum, Jerusalem; *Two by Two for AIDS and Art*, American Foundation for AIDS Research and The Dallas Museum of Art, Dallas (TX); *The Museum as Muse: Artists Reflect*, The Museum of Modern Art, New York (NY) **2001** *Double Life, Identity and Transformation in Contemporary Art*, Generali Foundation, Vienna

1 **Red & white restaurant,** 1999/2001, dye transfer print, 22 x 22 cm
2 **Mouth open, teeth showing,** 2000, 162 dolls, overall dimensions
 12.84 x 11.89 m, installation view, Paula Cooper Gallery, New York (NY)

3 **Mouth open, teeth showing** (details)

„Ich interessiere mich für die Dinge, die wir hinter uns lassen, die Spuren und Zeichen unserer Benutzung; wie archäologische Fundstücke verraten sie so viel über uns."

« Je m'intéresse aux objets que nous laissons derrière nous, les marques et signes de notre utilisation ; à l'instar des trouvailles archéologiques, ils révèlent tant de choses sur nous. »

"I'm interested in the objects we leave behind, the marks and signs of our use; like archeological findings, they reveal so much about us."

2

Atelier van Lieshout

Established in 1995; Joep van Lieshout 1963 born in Ravenstein, lives and works in Rotterdam, The Netherlands

Atelier van Lieshout (AVL), under the direction of Joep van Lieshout, is an artistic corporation that produces art for application in society. Apart from producing different kinds of functional items, such as living units or furniture, AVL's cross-disciplinary production also insists on an anti-authoritarian agency against state monopoly. Notions of collectivism and self-institutionalisation in AVL's production led to the construction of a self-sufficient territory for AVL's employees and production facilities in Rotterdam: the AVL Ville, which opened in 2001. Here, AVL built living units with materials they manufactured themselves. They produce their own food and have the liberty to do otherwise illegal things, such as manufacturing weapons and alcohol. As the critic Dave Hickey has emphasised about AVL, "It's the noise and fun that matter, the sex and democracy." However, the partisan ethos of AVL Ville doesn't come across as cosy hippie idealism, but rather as an implemented alternative to bureaucratic society with one foot in the art world. Instead of letting Utopia remain unrealised, AVL tests artistic autonomy against real world economies. In AVL Ville, this becomes legislation; sculpture becomes a scene for the anarchistic enactment of conviviality and the work of the individual artist assumes collective form and diffuses into the sphere of production. AVL's analysis of the expanded possibilities of the artistic profession is a direct and elementary exploration of space. The social potency and corporate professionalism of AVL propose metaphorical and concrete means for smaller power concentrations than the ones according to which we usually organise our lives.

Das Atelier van Lieshout (AVL) unter Leitung von Joep van Lieshout ist eine Künstlerkooperative, die praktisch nutzbare Kunst produziert. Das AVL entwickelt nicht nur funktionale Dinge, etwa Wohneinheiten oder Möbel, die interdisziplinären Aktivitäten der Kooperative zielen zudem darauf ab, das Herrschaftsmonopol des Staates zu brechen. Der Wunsch nach Gemeineigentum und völliger Autonomie hat zur Gründung eines autonomen Gebiets für Mitarbeiter und die Produktionsstätte in Rotterdam geführt: AVL Ville, eröffnet 2001. Hier hat das AVL aus selbsthergestellten Materialien eine Reihe von Wohneinheiten geschaffen. Die Gruppe erzeugt ihre eigenen Lebensmittel und genießt das Vorrecht, ansonsten ungesetzliche Dinge zu tun: nämlich Waffen und alkoholische Getränke herzustellen. Der Kritiker Dave Hickey betont, dass für AVL „vor allem lautstarke Fröhlichkeit, Sex und Demokratie" zählen. Die AVL-Ville-typische Freischärlermentalität kommt nicht als anheimelndes Hippietum daher, sondern präsentiert sich als künstlerisch inspirierte konkrete Alternative zur bürokratisierten Gesellschaft. Statt auf die Verwirklichung der Utopie zu verzichten, erprobt AVL die künstlerische Autonomie im Wettstreit mit der realen Ökonomie. In AVL Ville hat man dieses Denken nachgerade zum Prinzip erhoben: So erweist sich die Skulptur als Inszenierung einer anarchischen Geselligkeit, und die Arbeit des einzelnen Künstlers nimmt eine kollektive Gestalt an und diffundiert in die Sphäre der Produktion. Die erweiterten Möglichkeiten des künstlerischen Schaffens, wie AVL sie durch seine Aktivitäten stets aufs Neue veranschaulicht, gehen auch mit einer ebenso direkten wie elementaren Erkundung des Raumes einher. Dank seiner sozialen Potenz und Gruppenprofessionalität liefert uns AVL symbolisch, aber auch ganz konkret Beispiele dafür, wie wir unser Dasein in wesentlich überschaubareren als den heute üblichen Machtstrukturen organisieren können.

L'Atelier van Lieshout (AVL), dirigé par Joep van Lieshout, est une corporation artistique qui produit de l'art à appliquer dans la société. Outre la fabrication de différents types d'articles fonctionnels, tels que des espaces habitables ou des meubles, la production interdisciplinaire d'AVL a également mis sur pied une agence anti-autoritaire contre le monopole d'Etat. Ses notions de collectivisme et d'auto-institutionnalisation ont entraîné l'établissement d'un territoire autosuffisant pour les employés d'AVL et des locaux de production à Rotterdam : L'AVL Ville, inaugurée en 2001. Ils y produisent leur propre nourriture et ont la liberté de faire ce qui est illégal ailleurs, comme de fabriquer des armes et de l'alcool. Comme l'a souligné le critique Dave Hickey à propos d'AVL : « C'est le bruit et le plaisir qui comptent, le sexe et la démocratie. » Toutefois, l'esprit partisan d'AVL Ville n'a rien à voir avec un idéalisme hippie douillet. Il s'agit plutôt d'une alternative à la société bureaucratique avec un pied dans le monde de l'art. Au lieu de laisser l'Utopie à l'état d'idéal, AVL met l'autonomie artistique à l'épreuve de l'économie du monde réel. Dans AVL Ville, cela fait force de loi : la sculpture devient une scène pour la promulgation anarchique de la convivialité ; le travail individuel de l'artiste revêt une forme collective et se diffuse dans la sphère de production. L'analyse d'AVL des possibilités accrues de la profession artistique est une exploration directe et élémentaire de l'espace. La puissance sociale et le professionnalisme collectif d'AVL proposent des moyens métaphoriques et concrets pour des concentrations de pouvoir plus petites que celles selon lesquelles nous organisons généralement nos vies.

L. B. L.

SELECTED EXHIBITIONS →
1997 Museum Boijmans Van Beuningen, Rotterdam, The Netherlands; *Skulptur. Projekte*, Münster, Germany **1998** *The Good, the Bad and the Ugly*, Rabastens, France; *artranspennine98*, The Henry Moore Institute, Leeds, UK **1999** *AVL Equipment*, Transmission Gallery, Glasgow, UK; *In the Midst of Things*, Bournville, Birmingham, UK **2000** *Hangover 2000*, *EXPO 2000*, Hanover, Germany **2001** P.S.1, Long Island City (NY), USA; *49. Biennale di Venezia*, Venice, Italy; Walker Art Center, Minneapolis **2002** Biennale of Sydney, Australia

SELECTED BIBLIOGRAPHY →
1997 Joep van Lieshout/Bart Loosma/P. Jonge, *Atelier van Lieshout – A Manual/Ein Handbuch*, Stuttgart; *Skulptur. Projekte*, Münster **1998** Atelier van Lieshout, *The Good, the Bad and the Ugly*, Rotterdam **1999** Miller/Hickey/Dellinger, *A Supplement*, Contemporary Arts Museum, Tampa (FL) **2000** Bart Loosma, *Superdutch: New Architecture in the Netherlands*, London

1 Installation views, *Schwarzes und graues Wasser*, Bawag Foundation, Vienna, 2001
2 Installation view, *Darkroom*, P.S.1, Long Island City (NY), 2001

3 Installation views, *Wonderland*, St. Louis (MS), 2001
4 Installation views, *Women on Waves – A Portable*, Amsterdam, 2001

„Meine Probleme mit der Regierung betreffen ihr Ausmaß: Es gibt eine Unzahl an Vorschriften und Einschränkungen. In einer kleineren Gemeinschaft kann man nach dem gesunden Menschenverstand regieren und entscheiden: Haltet euer Werkzeug in Ordnung und tötet einander nicht. Das sind die Grundlagen." (Joep van Lieshout)

« Ce qui me gêne dans un gouvernement, c'est sa taille : cela génère toutes sortes de règles et de limites. Dans une petite communauté, on peut gouverner et prendre des décisions en usant de bon sens : nettoyez vos outils, ne vous entre-tuez pas. Voilà les principes de base. » (Joep van Lieshout)

"My problem with government concerns its scale: there are all kinds of rules and limitations. If you have a smaller community, you can govern and decide things using common sense: clean your tools, don't kill each other. Those are the basics." (Joep van Lieshout)

2

3

4

Won Ju Lim

1968 born in Kwangju, South Korea, lives and works in Los Angeles (CA), USA

Won Ju Lim is a sculptor and installation artist. Her multimedia work, consisting largely of models, focuses on the tensions between perception, space and subjectivity in the post-modern age. In order to reflect on and represent the shifting relationship between these three elements, she usually takes architectural reconstructions whose "realism" she questions, critically and poetically, through the judicious use of lighting, slide projections and video installations. Literary references crop up constantly in her concentrated, seemingly minimalist but always richly allusive work, and are abundantly clear in installations like *Proustian Bedroom*, 1996, or *Guestroom*, 1997. The latter refers to Edgar Allan Poe's story "The Fall of the House of Usher". Lim arranges furniture in a reconstruction of a mysterious room in the tale. Thus, personal experience, cultural tradition and means of communication create a disturbing connection, which confusingly melds the personal and the social. Her more recent *Horizons*, 2000, stressed the way in which perception depends on cultural perspectives. Lim blocked the four windows of an observation tower with video projection screens and also mounted four video monitors on the tower itself. The videos showed views of both the surrounding landscape and other regions of the world. Mixed into this visual cosmos were clips from famous film classics. *Horizons* provided convincing proof that our response to the world is conditioned by a wealth of media imagery that has long since become part of our own "authentic" experience.

Won Ju Lim ist Bildhauerin und Installationskünstlerin. Ihre multimedialen und meist modellhaften Arbeiten thematisieren die spannungsvolle Beziehung von Wahrnehmung, Raum und Subjektivität in der Postmoderne. Um die Wechselbeziehungen zwischen diesen drei Momenten reflektieren und präsentieren zu können, setzt Lim vor allem auf architektonische Rekonstruktionen, deren „Realistik" sie allerdings durch den sensiblen Einsatz von Beleuchtung, Dia-Projektionen und Videoinstallationen so kritisch wie poetisch hinterfragt. Immer wieder finden sich auch literarische Bezüge in ihrem konzentrierten, zunächst minimalistisch anmutenden, stets assoziationsreichen Werk. Referenzen zur Literatur sind etwa in den Installationen *Proustian Bedroom*, 1996, oder in *Guestroom*, 1997, ablesbar. Letztere bezieht sich auf die Erzählung „Der Untergang des Hauses Usher" von Edgar Allan Poe. Lim arrangierte hier eigene Möbel in der Rekonstruktion eines unheimlichen Zimmers aus besagter Erzählung. Persönliche Erfahrungen, kulturelle Tradition und mediale Vermittlung gehen so eine traumatische Verbindung ein, die Individuelles und Gesellschaftliches widerspruchsvoll miteinander verschmilzt. Die neuere Arbeit *Horizons*, 2000, betont den Aspekt der Wahrnehmung und ihrer Abhängigkeit von kultureller Perspektive. Dazu hat Lim vier Fenster eines Aussichtsturmes mit Videoprojektionsflächen verstellt und auf dem Turm zudem vier Videomonitore verteilt. Zu sehen sind auf den Videos sowohl Ansichten der umliegenden Landschaft wie Ausblicke auf andere Gebiete der Erde. Aber auch Landschaftsmalerei oder Ausschnitte aus berühmten Filmklassikern mischen sich unter diesen visuellen Kosmos. *Horizons* beweist eindrucksvoll: Unsere Rezeption von Welt ist geprägt durch einen medial vermittelten Bilderschatz, der längst unserer eigenen, „authentischen" Erfahrung vorgeschaltet ist.

Won Ju Lim est sculptrice et installatrice. Son travail multimédia se présente le plus souvent sous forme de maquette et thématise les tensions relationnelles entre perception, espace et subjectivité à l'ère post-moderne. Pour élaborer une réflexion sur ces trois aspects, Lim mise avant tout sur des reconstitutions architecturales, dont elle interroge le « réalisme » de manière aussi critique que poétique par de subtils éclairages, des projections de diapos et des installations vidéo. Dans cet œuvre dense, au premier abord minimaliste, mais toujours chargé d'associations, la référence littéraire est omniprésente, comme on peut le voir dans l'installation *Proustian Bedroom*, 1996, ou encore dans *Guestroom*, 1997, qui s'appuie sur la nouvelle d'Edgar Allan Poe « La chute de la maison Usher », et pour laquelle Lim avait installé quelques meubles dans une reconstitution de l'étrange chambre de l'histoire. Expériences personnelles, tradition culturelle et traduction dans le média entretiennent ainsi un rapport traumatique qui opère une fusion contradictoire d'aspects individuels et collectifs. Plus récemment, *Horizons*, 2000, se penche sur l'impact du fait culturel sur la perception. Les quatre fenêtres d'une tour offrant un point de vue panoramique étaient pourvues d'écrans de projection vidéo, quatre moniteurs vidéo étant par ailleurs installés sur le toit. Les vidéos montraient des vues du paysage alentour, mais aussi des images d'autres zones géographiques. Des peintures de paysages ou des extraits de classiques du cinéma venaient en outre s'insérer dans cet univers visuel. *Horizons* apporte la preuve éclatante que notre perception du monde est marquée par un fonds d'images relayées par les médias, et qui est depuis longtemps venu se superposer à notre expérience « authentique ». R. S.

SELECTED EXHIBITIONS →
1999 *Spaced Out/California Vernacular*, Russel Gallery, University of California, San Diego (CA), USA **2000** *Longing for Wilmington*, Künstlerhaus Bethanien, Berlin, Germany; *Cultural Sidewalk*, Gumpendorfer Straße, Kunst im öffentlichen Raum, Vienna, Austria **2001** Patrick Painter Inc., Santa Monica (CA), USA; *Skulptur-Biennale Münsterland*, Germany, *Snapshot: New Art From Los Angeles*, Museum of Contemporary Art, North Miami (FL), USA **2002** Galerie Max Hetzler, Berlin, Germany; *Kwangju Biennale*, Kwangju, South Korea

SELECTED BIBLIOGRAPHY →
2001 *Skulptur-Biennale Münsterland*, Münster; *Snapshot: New Art From Los Angeles*, Museum of Contemporary Art, North Miami (FL) **2002** *Kwangju Biennale 2002: Sites of Korean Diaspora*, Kwangju

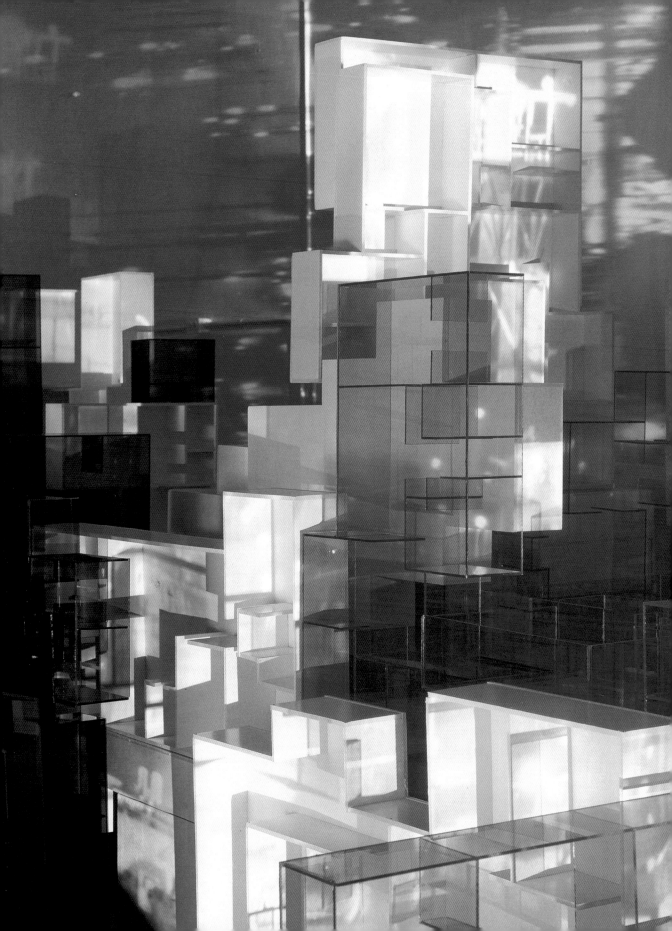

274

1 **Schliemann's Troy,** 2001, foam core, plexiglas, still projection, lamps,
 145 x 488 x 305 cm, installation view, *Snapshot,* UCLA Hammer Museum,
 Los Angeles (CA)
2 **Floating Suburbia,** 2001, acrylic paint on foam, 80 models, size variable,
 performance, *Under the Bridges,* Casino Luxembourg
3 **Displaysed – Carson,** 1998, compressed particle board, foamcore board,
 circuit board, mylar, still image projection, 274 x 206 x 213 cm
4 **Longing for Wilmington,** 2000, plexiglas, foamcore board, still image
 projection, 142 x 533 x 342 cm, installation views, Künstlerhaus Bethanien,
 Berlin

„Mich interessieren die von mir so genannten ‚futuristischen Ruinen',
die Art und Weise, wie Hollywood in seinen Sciencefictionfilmen
die futuristischen Stadtlandschaften dargestellt hat."

« Je m'intéresse à ce que j'appelle des ‹ Ruines Futuristes ›, à la manière
dont Hollywood a représenté des paysages urbains futuristes dans des films
de science-fiction. »

"I have been interested in what I refer to as 'Futuristic Ruins',
how Hollywood has rendered futuristic cityscapes in science fiction films."

2

3

4

1 Untitled, 2000, c-print, 88 x 66 cm
2 Photo from the Collection of Antônio Noberto Bezerra 1999, Interview
 Location Survey of the Aripuanã River Region Regatão Boat, Comandante
 Bezerra, at Pastinho Community, Aripuanã River, Brazil; Interview Subject:
 Antônio Noberto Bezerra, Anthropologist: Ligia Simonian 1999 Interview
 Location Survey of the Aripuanã River Region Pastinho Community,

Aripuanã River, Brazil, Interview Subjects: Ana Lúcia das Neves Pereira;
José Guerra Açaí Cardoso Anthropologist: Ligia Simonian 1999, 1999,
3 framed chrome and gelatin silver prints, overall dimensions 82 x 201 cm
3 Untitled, 2001, Chromogenic print, 62 x 86 cm
4 Untitled, 2000, c-print, 173 x 230 cm

„In letzter Zeit interessieren mich diese Situationen, in denen ein bühnen-
ähnliches Setting schon von sich aus vorhanden ist."

« Dernièrement, je m'intéresse aux situations où un arrangement scénique
est déjà préfiguré. »

"Recently I have become interested in situations where there is already a kind of theatrical setting in place."

2

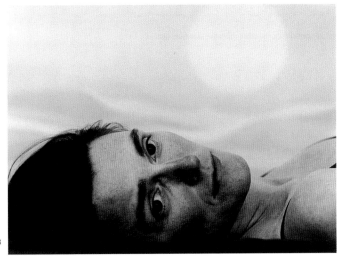

3

4

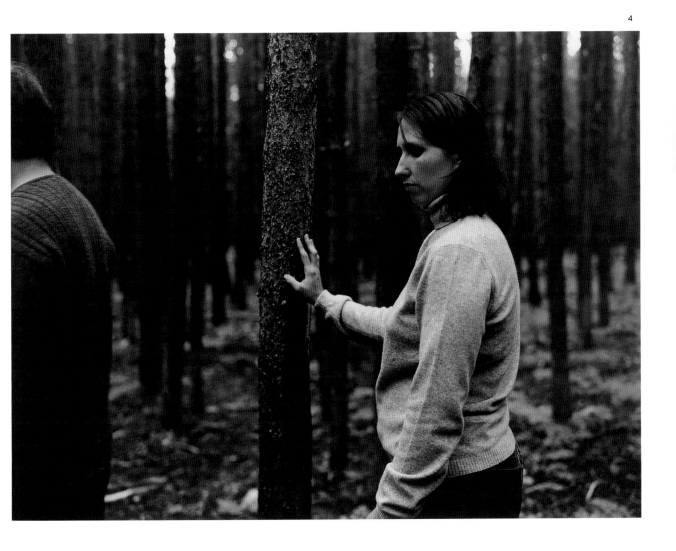

Sarah Lucas

1962 born in London, lives and works in London, UK

Sarah Lucas is one of the key figures on the new London art scene, which acquired a legendary reputation in the 1990s. In 1993, she and Tracey Emin ran a little second-hand shop that became famous as a meeting point for young artists, who swiftly made their names in the international art world while still pursuing their own independent agendas. Emin and Lucas were regarded as the strong women on the scene, unruly females who were not afraid to include obvious sexual content in their work and to portray themselves as "sluts". Lucas takes frequently autobiographical themes and transforms them into grotesque and highly artificial sculptures. Her work is filled to bursting point with provocative allusions to male and female genitalia, self-destruction, depression and death. She took her inspiration for *The Fag Show*, 2000, from her recently conquered tobacco addiction. London's Freud Museum was a particularly apt setting for Lucas' 2000 exhibition *Beyond the Pleasure Principle*, in which she used chairs to represent female bodies. A series of socially and culturally coded chairs were dressed in feminine attire. Garments with clear sexual connotations, like bras, nylons and knickers, were stretched over the furniture, while skinny, limp female legs sprouted grotesquely from the chair backs. These anthropomorphic chair sculptures were integrated into the rooms of Freud's house, the epicentre of psychoanalysis where he described illnesses such as hysteria to which, he claimed, women were especially prone. In a blend of sensitivity and aggression, Lucas' art constantly challenges the stereotypical male view of women.

Sarah Lucas ist eine der zentralen Figuren der neuen Londoner Kunstszene, die sich in den neunziger Jahren als „Young British Art" einen legendären Ruf verschafft hat. Zusammen mit Tracey Emin hatte sie 1993 einen kleinen Secondhandladen betrieben, der als Treffpunkt junger Künstler bekannt war, die neben ihrem raschen Erfolg im internationalen Kunstbetrieb weiter unabhängige Strategien verfolgten. Emin und Lucas galten als die widerspenstigen, starken Frauen der Szene, die sich nicht scheuten, sexuelle Inhalte offen in ihren Arbeiten zu demonstrieren und sich selbst als „Schlampen" zu inszenieren. Biografisches wird oft zum Thema erhoben und in grotesken Arrangements zu hochartifiziellen Skulpturen verformt. Lucas' Arbeiten sind voller provokanter Anspielungen auf männliche und weibliche Genitalien, Selbstzerstörung, Depression und Tod. In ihrem Werkkomplex *The Fag Show*, 2000, hat Lucas ihre gerade überwundene Nikotinsucht zu einem ornamentalen Prinzip erhoben. Als besonders geeigneter Ort für Lucas' Arbeiten erwies sich das Freud Museum in London. Für die Ausstellung *Beyond the Pleasure Principle*, 2000, benutzte Lucas Stühle, die für den weiblichen Körper stehen. Die unterschiedlich sozial und kulturell kodierten Stuhlmodelle versieht sie mit Bekleidungsstücken mit sexueller Konnotation. Büstenhalter, Nylonstrümpfe und Unterhosen werden um das Möbel gespannt, dünne, schlaffe Frauenbeine wachsen grotesk aus den Lehnen. Diese anthropomorphen Stuhlskulpturen integrierte sie in das Freud'sche Interieur, das Epizentrum der Psychoanalyse und der Beschreibung von Krankheitsbildern wie der Hysterie, die besonders Frauen attestiert wurde. In ihrem Werk tritt sie diesen männlichen Sichtweisen immer wieder so aggressiv wie sensibel entgegen.

Sarah Lucas est une des grandes figures de la nouvelle scène artistique londonienne qui a su se forger une réputation légendaire dans les années 90 sous le nom de « Young British Art ». Avec Tracey Emin, Lucas tenait en 1993 une petite boutique de nippes, point de rencontre de jeunes artistes qui continuaient de suivre des stratégies indépendantes parallèlement à leur succès fulgurant sur la scène artistique internationale. Emin et Lucas étaient considérées comme les fortes têtes féminines qui n'hésitaient pas à étaler des contenus sexuels dans leurs œuvres et à se mettre elles-mêmes en scène comme des « délurées ». Dans son travail, Lucas présente souvent des éléments biographiques transformés en sculptures hautement artificielles arrangées de manière grotesque. Ses œuvres débordent d'allusions provocatrices aux organes génitaux masculins et féminins, à l'autodestruction, à la dépression et à la mort. Dans le cycle *The Fag Show*, 2000, elle a élevé au rang de principe ornemental l'addiction à la nicotine dont elle vient de se défaire. Le Freud Museum de Londres est apparu comme un cadre de présentation particulièrement approprié. Pour l'exposition *Beyond the Pleasure Principle*, 2000, l'artiste s'est servie de chaises ayant fonction de corps féminin. Investis de leurs codages socio-culturels respectifs, différents modèles de sièges sont affublés de vêtements présentant des connotations sexuelles. Ces éléments de mobilier sont tendus de slips, de soutiens-gorge et de bas nylon, tandis que des jambes de femmes fines et inertes sortent des dossiers de manière grotesque. Ces sculptures-chaises anthropomorphes s'insèrent dans l'appartement de Freud, épicentre de la psychanalyse et de la description des troubles de l'hystérie, considérée comme une maladie spécifiquement féminine. Dans son œuvre, Lucas s'élève de manière aussi agressive que sensible contre ce type de regard masculins.

A. K.

SELECTED EXHIBITIONS →
1996 Museum Boijmans Van Beuningen, Rotterdam, The Netherlands **1997** *Car Park*, Museum Ludwig, Cologne, Germany; *Sensation*, Royal Academy of Arts, London, UK **2000** *The Fag Show*, Sadie Coles HQ, London, UK; *Beyond the Pleasure Principle*, The Freud Museum, London, UK; *Self Portraits and More Sex*, Tecla Sala, Barcelona, Spain; *The British Art Show 5*, Hayward Gallery, London **2001** *Public Offerings*, Museum of Contemporary Art, Los Angeles (CA), USA; *Century City*, Tate Modern, London, UK

SELECTED BIBLIOGRAPHY →
1996 *Sarah Lucas*, Museum Boijmans Van Beuningen, Rotterdam **1997** *Car Park*, Museum Ludwig, Cologne **1998** *Real/Life: New British Art*, Tochigi Prefectural Museum of Fine Arts, Utsunomiya **2000** *Sarah Lucas: Self Portraits and More Sex*, Tecla Sala, Barcelona **2001** Uta Grosenick (ed.), *Women Artists*, Cologne

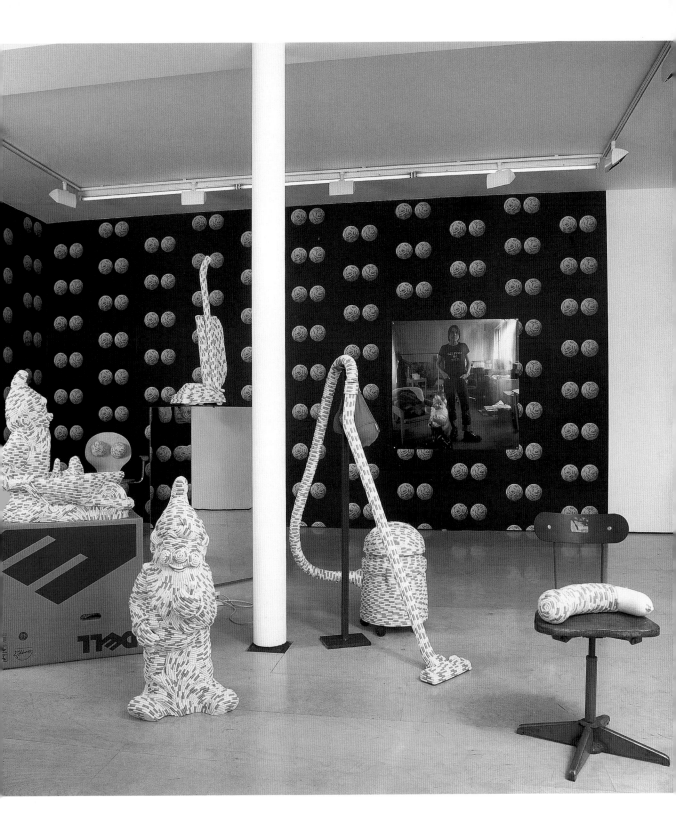

1 **The Fag Show,** 2000, installation view, Sadie Coles HQ, London
2 Installation view, *Beyond The Pleasure Principle,* Freud Museum, London, 2000; front: **Hysterical Attack,** 1999, chair and papier maché; background: **Prière de Toucher,** 2000, colour photograph

3 **Happy Families,** 1999, mixed media, 160 x 183 x 56 cm
4 **Beyond the Pleasure Principle,** 2000, futon mattress, cardboard coffin, garment rail, neon tube, light bulbs, bucket wire, 145 x 193 x 216 cm

„Ich möchte, dass meine Sachen verständlich und zugleich ein wenig respektlos sind. Die Frage ‚Ist das Kunst?' ist der Sargnagel für den Humor in meinen Arbeiten."

« J'aime que mes choses soient accessibles et en même temps légèrement irrévérencieuses. La question ‹Est-ce de l'art ?› est au cœur de l'humour dans mon travail en général. »

"I like my things to be accessible and slightly irreverent at the same time. The 'Is it art?' question is a lynchpin of the humour in my work generally."

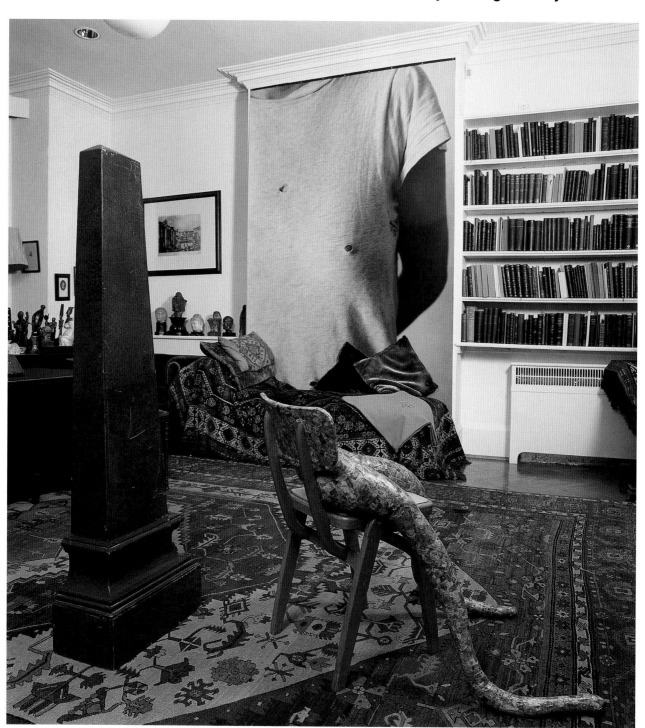

3

4

Michel Majerus

1967 born in Esch, Luxembourg, lives and works in Berlin, Germany

In 2000, the exhibition space at Cologne's Kunstverein was spectacularly taken over by a gigantic skateboarding half-pipe ramp. Forty-two metres long and nearly ten wide, it extended through the entire museum. On either side of the solid structure was a gallery through which visitors could wander in a hunched-forward posture. The huge ramp provided the setting for the fragments with which Michel Majerus works: logos, designer clichés, slogans and colourful bits and pieces all brought together in a vast accumulation of visual imagery. Majerus has made his name with large-scale pieces covering huge areas of space. The viewer becomes part of the picture in a world created by Majerus' painting. By carrying visitors over a distance of forty-two metres, the half-pipe ramp appears to pose the question: "How far does Majerus' art go?" Accusations of cynicism thrown at the artist's dazzlingly colourful installations miss the point. He is interested in everything that surrounds us. He only picks on things that get in his – and our – way. So he is no populist proponent of present-day values. Majerus works in accordance with economic principles. He neither pays lip service to the usual ways of seeing, nor does he indulge in wild "channel-surfing" through different styles and content. He only repeats what design has to say in other areas of art, but keeps his distance from designer forms and painterly attitudes, thus putting both phenomena under the microscope. He dissects well-known and conventional contexts by making them extend over his ever-expanding installations. The unadorned spaces in between the written elements become increasingly visible and tangible. Majerus is asking himself the very simple and determined question: how closely can painting reflect its time?

Eindrucksvoll eroberte im Kölnischen Kunstverein im Jahr 2000 eine gigantische Skateboard-Halfpipe den Raum und füllte ihn souverän. 42 Meter lang und fast 10 Meter breit erstreckte sie sich durch den gesamten Kunstverein. Eine solide Konstruktion, die an beiden Seiten eine Galerie zum gebückten Entlanggehen bot. Die gewaltige Rampenskulptur war der Bildträger für die visuellen Fragmente, mit denen Michel Majerus arbeitet – Warenzeichen, Designerklischees, Slogans, bunte Elemente in enormen visuellen Ballungen. Majerus hat sich einen Namen gemacht mit seinen großzügigen, großräumigen Bildlösungen. Der Betrachter ist im Bild, die Welten von Majerus sind aus Malerei gebaut. Die Skaterrampe trug Betrachter wie Skater 42 Meter weit und stellte die Frage, wie weit die Kunst von Majerus reicht. Der Vorwurf des Zynismus, der an Majerus' grellbunt eklektische Installationen gerichtet wird, zielt fehl. Sein Interesse gilt all dem, was uns umgibt. Majerus greift nur das auf, was sich uns und ihm entgegenstellt. Damit ist er kein Populist seiner Gegenwart. Er arbeitet nach ökonomischen Prinzipien, biedert sich nicht den Sehgewohnheiten an, betreibt also kein wildes Zapping der Stile und Inhalte. Majerus wiederholt nicht einfach, was das Design an anderer Stelle der Kunst vormacht. Er wahrt in seiner Arbeit gleichermaßen Distanz zu den Formen des Designs wie den Attitüden der Malerei und bringt dadurch beides auf den Prüfstand. Sein Werk löst uns bekannte und damit konventionelle Sinnzusammenhänge auf, indem er ihre Körperlichkeit in seinen immer größer werdenden Installationen zerdehnt. Zwischen den Sinn buchstabierenden Elementen werden die unbezeichneten Zwischenräume zunehmend fassbarer. Majerus stellt sich die sehr einfache und zielgerichtete Frage, wie nahe Malerei der Zeit sein kann.

En 2000, une gigantesque « half-pipe » de skate occupait de manière impressionnante le Kunstverein de Cologne, dont elle investissait souverainement l'espace. Sur quelque 42 mètres de long et presque 10 mètres de large, elle s'étirait à travers tout le Kunstverein, construction solide offrant de chaque côté une galerie qui permettait au spectateur de flâner, légèrement courbé. La puissante sculpture en forme de rampe servait de support aux fragments visuels sur lesquels travaille Michel Majerus – logos, clichés de designers, slogans, éléments multicolores aux développements visuels énormes. Majerus s'est fait un nom grâce à des solutions picturales amples et généreuses. Le spectateur est dans le tableau : les univers de Majerus sont construits de peinture. La rampe de skate faisait franchir 42 mètres au spectateur comme au « skater » et posait la question de savoir où s'arrête l'art de Majerus. Le reproche de cynisme dont on accable ses installations éclectiques et stridentes manque de pertinence. L'intérêt de l'artiste porte sur tout ce qui nous entoure. Majerus se contente de saisir au vol ce qui s'oppose à lui comme à nous. On ne peut voir en lui pour autant un populiste contemporain. Il travaille selon des principes économiques, refuse les habitudes visuelles, ne pratique pas le zapping sauvage des styles et des contenus et ne se borne pas à répéter les modèles que le design propose dans d'autres contextes. Dans son travail, il conserve une même distance à l'égard des formes du design et des attitudes picturales, mettant ainsi ces deux domaines à l'épreuve. Son œuvre dissout des associations de sens connues et donc conventionnelles, en étirant leur matérialité dans des installations de plus en plus grandes. Entre les éléments qui déclinent le sens, les intervalles non désignés deviennent de plus en plus palpables. Majerus pose une question très simple et ciblée, celle du rapprochement maximum entre la peinture et l'époque. F. F.

SELECTED EXHIBITIONS →
1994 neugerriemschneider, Berlin, Germany **1996** Kunsthalle Basel, Basle, Switzerland **1997** *qualified*, Galeria Giò Marconi, Milan, Italy **1998** *Manifesta 2*, Luxembourg; *Tell Me a Story*, Magasin, Centre National d'Art Contemporain, Grenoble, France **1999** *dAPERTuttO*, *48. Biennale di Venezia*, Venice, Italy **2000** *if we are dead, so it is*, Kölnischer Kunstverein, Cologne, Germany; *The space is where you'll find it*, Delfina, London, UK; *Taipeh Biennale*, Taipeh, Korea **2001** *Poetry in motion*, MindBar, Lund, Sweden

SELECTED BIBLIOGRAPHY →
1999 *Nach-Bild*, Kunsthalle Basel, Basle; Burkhard Riemschneider/ Uta Grosenick (eds.), *Art at the Turn of the Millennium*, Cologne **2001** *Casino 2001*, S.M.A.K., Stedelijk Museum voor actuele Kunst, Ghent

pure pragmatism deducing it ner than its o

pure pragmatism ng it

at

1 Installation view, *Sein Lieblingsthema war Sicherheit, seine These – es gibt sie nicht,* neugerriemschneider, Berlin, 1999
2 Installation view, *The space is where you'll find it,* Delfina, London, 2000
3 Installation view, *If we are dead, so it is,* Kölnischer Kunstverein, Cologne, 2000
4 **Gold,** 2000, acrylic on canvas, 303 x 348 cm

„Über einen Arbeitsprozess zu reden, der durch die Werkzeuge und die Farben, die man benutzt, benannt wird – das interessiert mich nicht. Genau das zu malen, was man sich vorgenommen hat, das ist das Aufregendste, was es gibt. Denn das Ergebnis ist immer so, wie es niemand anders für einen hätte machen könne."

« Parler d'un processus de travail déjà nommé par les outils et les couleurs employés ne m'intéresse pas. Peindre exactement ce qu'on a prévu de faire, c'est la chose la plus excitante qui soit. Le résultat est toujours tel que personne n'aurait jamais pu le faire à notre place. »

"I am not interested in talking about a working method and what tools and paints to use. Painting exactly what you set out to paint, that's the most exciting thing there is. Because the result is always something that no one else could have done for you."

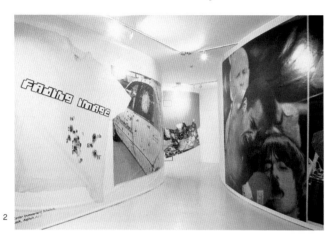

2

3

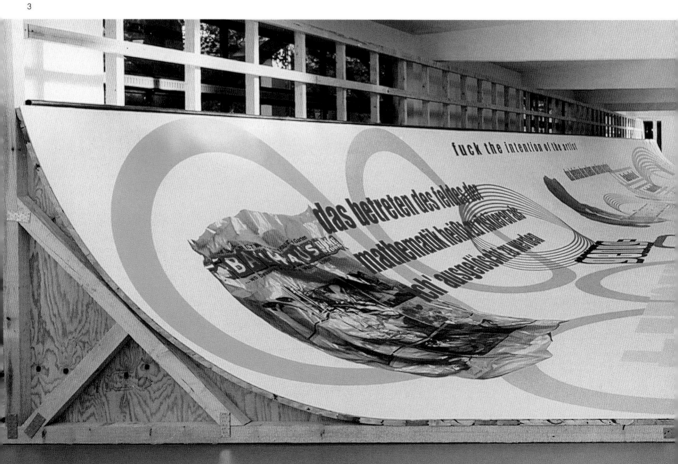

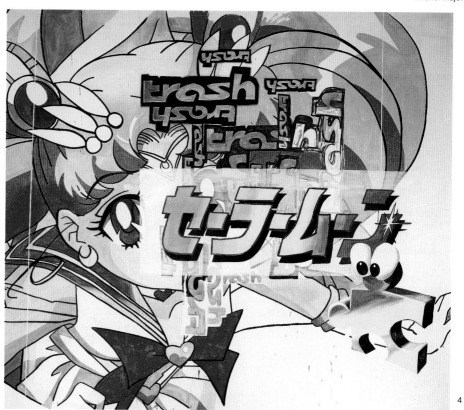

4

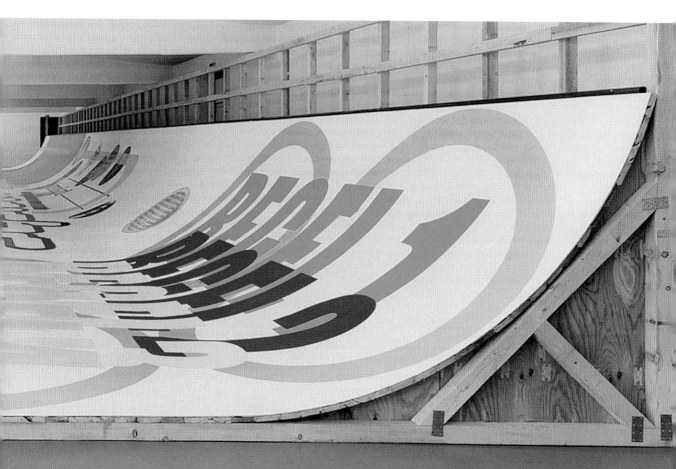

Paul McCarthy

1945 born in Salt Lake City (UT), lives and works in Altadena (CA), USA

The influence Paul McCarthy has exerted on a younger generation of artists is significant, and has occasionally resulted in collaborations with other artists, for example Mike Kelley and Jason Rhoades. Since the late 1960s his performances, environments, films, installations, sculptures and drawings have taken American myths as their theme while simultaneously undermining them. Hence his sculpture *Michael Jackson white* (also *black* and *gold*), 1997–99, can be seen both as a caricature of the pop star and as an appropriation of the work of Jeff Koons. For his performances, McCarthy stages apocalypses of American daily life in which icons of the entertainment industry's illusory world are blended with images from pornography and the hidden horrors of societal ills like violence, rape and paedophilia. Children's television heroes like Heidi and Pinocchio become psychopathic players in his nursery of horrors. As in gore and porn movies, McCarthy has an obsessive preoccupation with bodily orifices and fluids. He wallows in an orgiastic deployment of such viscous foods as ketchup, mayonnaise, mustard and chocolate sauce, which he substitutes for blood, sperm, sweat and excrement. Society is understood as a social body, which finds its concentrated reproduction in each individual human body. The sets for his performances are the rooms where the videos of his performances are subsequently screened for exhibitions. McCarthy's latest works are characterised by greater sparseness and an emphasis on their architectural features – such as *Mechanized Chalet*, 1993–99, or *The Box*, 1999, a detailed reconstruction of his studio tilted by 90 degrees.

Der Einfluss von Paul McCarthy auf eine jüngere Künstlergeneration ist groß; gelegentlich kommt es auch zur Zusammenarbeit, so mit Mike Kelley oder Jason Rhoades. Seine seit den späten sechziger Jahren entstehenden Performances, Environments, Filme, Installationen, Skulpturen und Zeichnungen thematisieren und untergraben amerikanische Mythen. So karikiert er in seiner Skulptur *Michael Jackson white* (auch *black* und *gold*), 1997–99, den Popstar und appropriiert gleichzeitig die Arbeit von Jeff Koons. In seinen Performances inszeniert McCarthy Apokalypsen des amerikanischen Alltags, in denen sich Ikonen aus den Scheinwelten der Unterhaltungsindustrie mit pornografischen Posen und dem unterschwelligen Horror sozialer Dramen wie Gewaltverbrechen, Vergewaltigung und Kindesmissbrauch überlagern. Helden des Kinderfernsehens, wie Heidi und Pinocchio, werden zu psychopathischen Akteuren eines Horrorszenarios im Kinderzimmer. Wie im Splatter- oder Pornofilm thematisiert McCarthy ein obsessives Verhältnis zu Körperöffnungen und -flüssigkeiten. Er zelebriert einen orgiastischen Umgang mit dickflüssigen Nahrungsmitteln wie Ketchup, Mayonnaise, Senf oder flüssiger Schokolade, die als Ersatz für Blut, Sperma, Schweiß oder Exkremente eingesetzt werden. Gesellschaft ist als sozialer Körper aufgefasst, der sich im einzelnen menschlichen Körper konzentriert abbildet. Die Performances finden in inszenierten Räumen statt, in denen später in der Ausstellung die Videos der Performances laufen. McCarthys neuere Arbeiten fallen reduzierter aus, wobei der architektonische Aspekt weiter in den Vordergrund tritt, zum Beispiel *Mechanized Chalet*, 1993–99, oder sein detailliert nachgebautes, um 90° gekipptes Atelier in *The Box*, 1999.

Paul McCarthy a exercé une forte influence sur une jeune génération d'artistes, ce qui se traduit par des collaborations occasionnelles, notamment avec Mike Kelley ou Jason Rhoades. Ses performances, environnements, films, installations, sculptures et dessins thématisent et sapent les mythes américains. Dans la sculpture *Michael Jackson white* (et aussi *black* et *gold*), 1997–99, McCarthy caricature la star en même temps qu'il s'approprie le travail de Jeff Koons. Dans ses performances, McCarthy met en scène des apocalypses de la vie quotidienne américaine où les icônes des mondes fictifs de l'industrie du divertissement côtoient l'horreur sous-jacente de tragédies sociales comme la criminalité, le viol et la pédophilie, où les héros d'émissions de télévision infantiles comme Heidi ou Pinocchio deviennent les acteurs psychopathes de scénarios de l'horreur qui se déroulent dans la chambre d'enfant. Comme dans le film d'horreur ou le film porno, McCarthy thématise un rapport obsessionnel avec les sécrétions et les orifices corporels, célébrant le maniement orgiastique, d'aliments visqueux comme le ketchup, la mayonnaise, la moutarde ou le chocolat liquide employés comme substituts du sang, du sperme, de la sueur ou des excréments. La société est conçue comme un corps social représenté en condensé dans le corps humain. Les performances se déroulent dans des espaces soigneusement mis en scène, dans lesquels les vidéos des performances seront ensuite présentées dans l'exposition. Les œuvres récentes de McCarthy sont plus sobres, même si l'aspect architectural demeure prédominant, comme le montre *Mechanized Chalet*, 1993–99, ou *The Box*, 1999, une reproduction détaillée de l'atelier de l'artiste renversée à 90°.

N. M.

SELECTED EXHIBITIONS →
1999 *Dimensions of the Mind,* Sammlung Hauser und Wirth in der Lokremise St. Gallen, Switzerland **2000** *Au-delà du spectacle, Mike Kelley and Paul McCarthy,* Centre Georges Pompidou, Paris, France; *In Between,* EXPO 2000, Hanover, Germany **2001** *Film- und Videoretrospektive Paul McCarthy,* Kunstverein in Hamburg, Germany **2002** *Retrospective,* Moderna Museet, Stockholm, Sweden

SELECTED BIBLIOGRAPHY →
1996 Ralph Rugoff/Kristine Stiles/Giacinto Di Pietrantonio (eds.), *Paul McCarthy,* London **1999** Burkhard Riemschneider/Uta Grosenick (eds.), *Art at the Turn of the Millennium,* Cologne **2000** *Paul McCarthy,* New Museum of Contemporary Art, New York (NY)

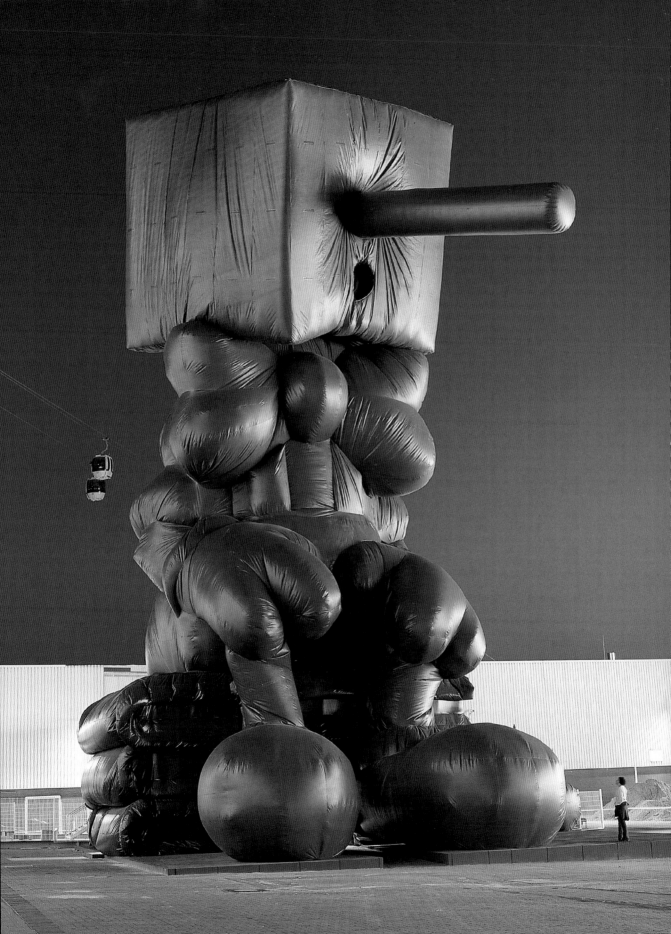

1 **Chocolate Blockhead (Nose Bar Outlet),** 2000, installation view,
 In Between, EXPO 2000, Hanover

2, 3 **The Box,** 1999, mixed media, 5.94 x 16.60 x 4.04 m, installation views,
 'Dimensions of the Mind' The Denial and the Desire in the Spectacle,
 Sammlung Hauser und Wirth, St. Gallen

„Die Definition von Performance als Realität – als konkretes Geschehen –
beschäftigt mich immer weniger. Mein Interesse gilt vielmehr der Imitation,
der Aneignung, der Fiktionalität, der Frage nach der Darstellbarkeit
nach der Bedeutung."

« Pour moi, cette définition de la performance comme d'une réalité –
comme de quelque chose de concret – a peu à peu perdu de son intérêt.
De plus en plus, je me suis intéressé à l'imitation, à l'appropriation,
à la fiction, à la représentation, et à l'interrogation du sens. »

"That definition of performance as reality – as concrete – became less interesting to me. I became more interested in mimicking, appropriation, fiction, representation and questioning meaning."

2

Jonathan Meese

1971 born in Tokyo, Japan, lives and works in Berlin, Germany

In recent years Jonathan Meese has come to public attention as a painter as well as an installation and performance artist. The artist's "miracle chambers" confront the viewer head-on, with every space filled and overflowing with chaos. However, Meese's chief objectives are not immediately apparent: despairing, occasionally aggressive attempts to develop a new German mythology in order to simultaneously destroy it with the assistance of his own internal pathos. Meese's mythological vocabulary finds nourishment in a variety of sources. His broad, frenzied spectrum ranges from Richard Wagner and Adolf Hitler to German pop groups like "Deutsch-Amerikanische-Freundschaft" (German-American Friendship) and other artists such as Anselm Kiefer. His early installation, *Die Räuber* (The Robbers), 1998, already displayed the artist's central working principles: the space is like a typical teenager's room, and its walls are wholly covered by posters, pin-ups, countless photocopies, cuttings from magazines, record sleeves and the like. Meese draws on this junk arsenal of everyday images to create a centre of cult worship. A year later the themes of Meese's room *Erzreligion Blutlazarett/Erzsöldner Richard Wagner/Privatarmee Ernte und Saat/Waffe: Erzblut der Isis/Nahrung: Bluterz* (Arch Religion Bloody Military Hospital/Arch Mercenary Richard Wagner/Private Army of Harvest and Sowing/Weapon: Arch Blood of Isis/Nourishment: Blood Ore) focus entirely on the "German delusion". The word "Erzbayreuthon" (Arch Bayreuthon) is written in black on a wall next to where gravestones have been painted. Militaria lies around, cardboard boxes, heaps of clothing, a dark table with candles: in short, a stylisation of horror – or perhaps a terrible mythogenesis taken to the realms of the absurd?

Als Maler, Installations- und Performancekünstler ist Jonathan Meese in den letzten Jahren bekannt geworden. Raumfüllend, mit überbordendem Chaos, erscheinen dem Betrachter die Angst einflößenden „Wunderkammern" des Künstlers. Erst auf den zweiten Blick erkennt man die wesentliche Intention von Meese: der verzweifelte, zuweilen aggressive Versuch, einen neuen deutschen Mythos aufzubauen, um diesen im selben Moment gerade mithilfe des ihm innewohnenden Pathos zu zerstören. Meeses mythologisches Vokabular speist sich aus unterschiedlichen Quellen. Das weite, ja wüste Spektrum reicht von Richard Wagner über Adolf Hitler bis hin zu deutschen Pop-Gruppen wie „Deutsch-Amerikanische-Freundschaft" oder anderen Künstlern wie beispielsweise Anselm Kiefer. In der frühen Installation *Die Räuber*, 1998, finden sich schon die für den Künstler zentralen Arbeitsprinzipien: Über und über ist der Raum, vergleichbar einem Jugendzimmer voller Poster und Devotionalien, mit unzähligen Fotokopien, Zeitschriftenausschnitten, Schallplattencovern und dergleichen mehr bedeckt. Meese schöpft aus den Arsenalen des alltäglichen Bildermülls, um eine wahre Kultstätte zu inszenieren. Ein Jahr später konzentriert sich Meese dann in seinem Raum *Erzreligion Blutlazarett/Erzsöldner Richard Wagner/Privatarmee Ernte und Saat/Waffe: Erzblut der Isis/Nahrung: Bluterz* thematisch ganz auf das Problem „deutscher Wahn". „Erzbayreuthon" steht da in schwarzer Schrift an der Wand, Grabsteine sind gleich daneben gemalt, Militaria liegen herum, Pappkartons, Kleiderberge, ein dunkler Tisch mit Kerzen … Eine Stilisierung des Grauens also – oder eine unheimliche Mythenbildung, die sich selbst ad absurdum führt?

Jonathan Meese s'est fait connaître ces dernières années comme peintre, performer et créateur d'installations. Ses angoissantes « chambres au trésor » occupent la totalité de l'espace et abordent le spectateur avec un déferlement chaotique. Seul un second regard révèle le propos principal de l'artiste : la tentative désespérée, parfois agressive, de reconstruire un mythe allemand, et en même temps de le détruire – précisément à l'aide du pathos qui lui est inhérent. Le vocabulaire mythologique de Meese puise à différentes sources, dont le vaste éventail va de Richard Wagner à Adolf Hitler en passant par des groupes allemands comme « Deutsch-Amerikanische Freundschaft » (Amitié germano-américaine) ou des collègues artistes comme Anselm Kiefer. Dans une installation ancienne comme *Die Räuber* (Les Voleurs), 1998, on relevait déjà les principes de travail déterminants de l'artiste : un peu comme une chambre d'adolescent pleine de posters et d'objets de dévotion, la pièce est entièrement tapissée de photocopies, de coupures de presse, de pochettes de disques etc. Meese puise dans les arsenaux de la décharge d'images quotidiennes pour mettre en scène un véritable lieu de culte. Un an plus tard, *Erzreligion Blutlazarett/Erzsöldner Richard Wagner/Privatarmee Ernte und Saat/Waffe: Erzblut der Isis/Nahrung: Bluterz* (Religion de base : Hôpital du sang/Soldat de base Richard Wagner/Armée privée Récolte et Semaille/Arme : sang de base d'Isis/Nourriture : airain de sang), est entièrement consacré au problème du « délire allemand ». En lettres noires écrites à même le mur, on y lit le mot « Erzbayreuthon » (Bayreuthon de base). Tout à côté, des pierres tombales peintes, des effets militaires disséminés, des cartons, des monceaux de vêtements, une table foncée avec des bougies … Une stylisation de l'horreur donc – ou l'effrayante construction d'un mythe qui vire par lui-même à l'absurde ?

R. S.

SELECTED EXHIBITIONS →
1998 Contemporary Fine Arts, Berlin, Germany; *1. berlin biennale*, Berlin, Germany **1999** Kunsthalle Bielefeld, Germany; Neuer Aachener Kunstverein, Aachen, Germany; *German Open*, Kunstmuseum Wolfsburg, Germany **2000** P.S.1, Long Island City (NY), USA; Museo Michetti, Francavilla al Mare, Italy **2001** Leo Koenig, New York (NY), USA; Kestner Gesellschaft, Hanover, Germany

SELECTED BIBLIOGRAPHY →
1998 *El Niño*, Städtisches Museum Abteiberg, Mönchengladbach **1999** *Gesinnung '99 – Der letzte Lichtstrahl des Jahrtausends* (with Erwin Kneihsl), Contemporary Fine Arts, Berlin **2000** *German Open*, Kunstmuseum Wolfsburg; *Wounded Time*, Städtisches Museum Abteiberg, Mönchengladbach

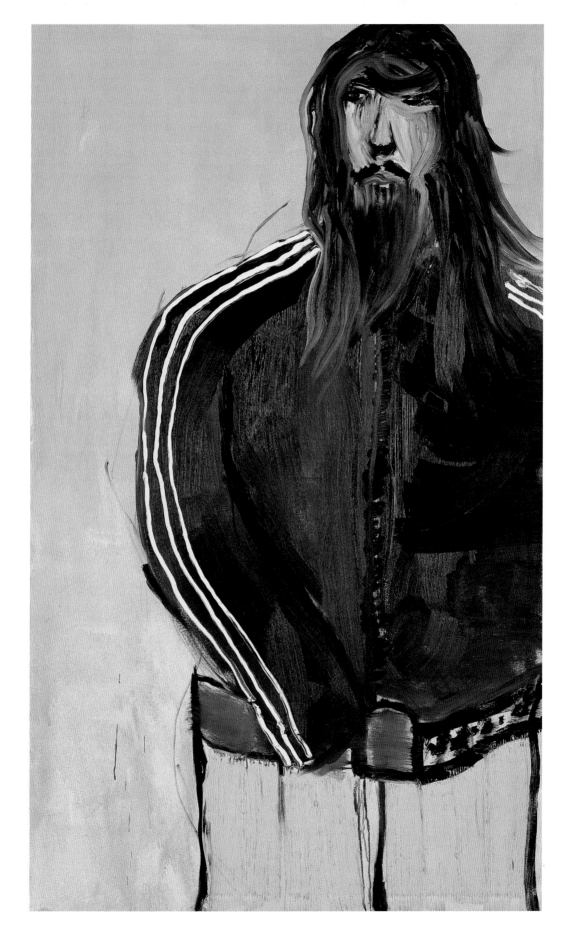

1 **Selbstgetreide – I am the walruß,** 2000, oil on canvas, 185 x 110 cm
2 **Erzreligion Blutlazarett ..,** 1999, installation view, Kunstverein Frankfurt

„Alles muss übel aufstoßen." « Tout doit méchamment défoncer. »

"Everything must be noticeable for its foulness."

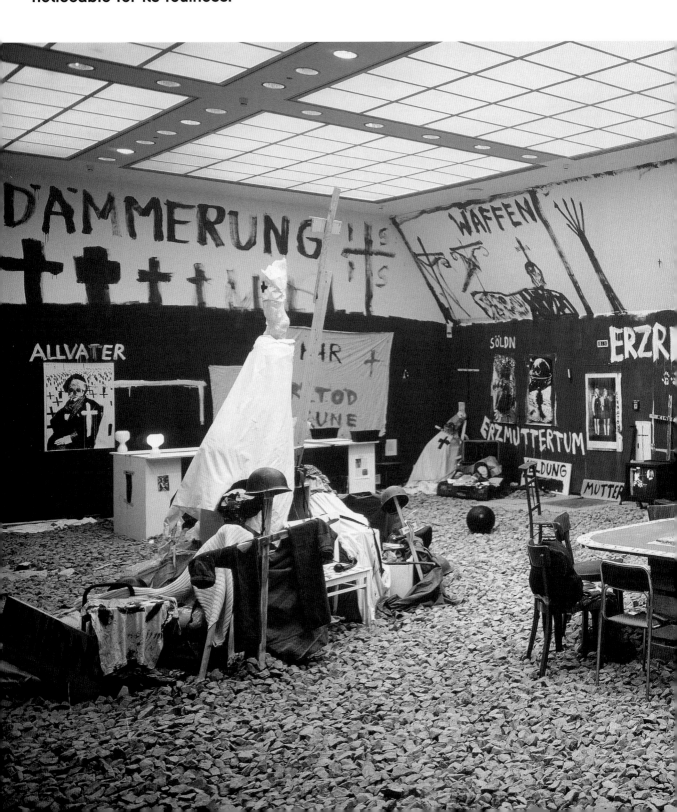

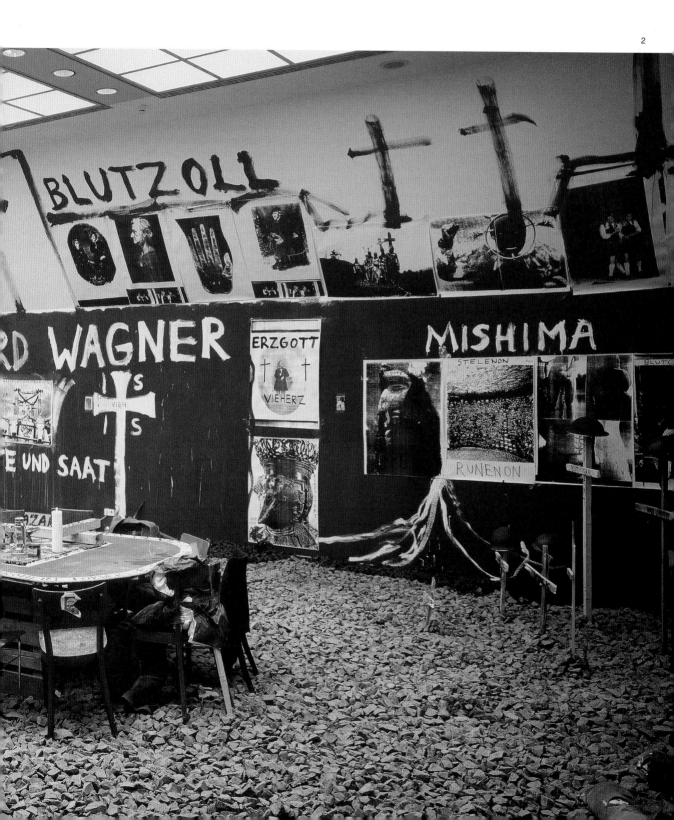

Aernout Mik

1962 born in Groningen, lives and works in Amsterdam, The Netherlands

The work of Dutch video and installation artist Aernout Mik demonstrates the weird ways in which human beings inhabit space. The artist carefully places people in all manner of situations and then documents their sometimes powerful, sometimes irritating presence in a video film. Through the use of disturbing architectural interventions and the absence of sound, Mik skilfully intensifies the evocative nature of his work. The video installation *Glutinosity*, 2001, shows what appear to be typical scenes from a political demonstration. Demonstrators, some of them masked, lie on the street while uniformed security personnel carefully try to move them away. There is hardly any resistance, however, and everything appears to happen more or less peacefully, while the slowly roving camera adds to the air of mystery. The longer we look at this strange scene, the more surreal it seems. Our expectations are pleasantly and surprisingly disappointed. The video *Middlemen*, 2001, shows a busy day's trading on one of the world's stock exchanges. It is set in an unreal space that is more a stage than an actual dealing room. Countless slips of paper are scattered over the floor. Red telephones and computers stand idle while the traders themselves stand or sit around apathetically, their troubled gazes fixed on an invisible electronic board. The camerawork carefully explores details, interrupting its steady movement every now and again with lightning zooms. The stock exchange, the hub of economic power, has clearly been turned upside down; perhaps it has even become superfluous. On the faces of the traders we can read deep unease – that same feeling of disbelief that characterises Mik's artistic output.

Der niederländische Video- und Installationskünstler Aernout Mik führt in seiner Kunst unheimliche Besetzungen von Räumen vor. Die zuweilen machtvolle, dann wieder irritierende Präsenz von Menschen wird von dem Künstler an unterschiedlichsten Orten sorgfältig insze-niert und anschließend als Videofilm dokumentiert. Mit verstörenden architektonischen Eingriffen und der Abwesenheit von Ton verstärkt Mik dabei geschickt den suggestiven Eindruck seiner Arbeiten. Die Videoinstallation *Glutinosity,* 2001, zeigt scheinbar typische Szenen einer politischen Demonstration. Teilweise vermummte Demonstranten liegen auf der Straße, Sicherheitskräfte in fiktiven Uniformen versuchen, sie vorsichtig wegzutragen. Gegenwehr allerdings gibt es kaum; absurderweise mutet das Geschehen fast friedlich an. Die langsam umher-schweifende, beiläufige Kamerafahrt vermittelt zudem eine geheimnisvolle Atmosphäre. Je länger man diesem seltsamen Treiben zuschaut, desto surrealer erscheint die Szenerie. Unser Realitätssinn wird so angenehm wie überraschend enttäuscht. Das Video *Middlemen,* 2001, zeigt einen geschäftigen Handelstag an irgendeiner Börse unserer Welt. Die artifiziell nachgestellte Räumlichkeit ist mehr Bühne als tatsächlich Börse. Unzählige Papierblätter liegen chaotisch verteilt auf dem Boden. Rote Telefone und weiße Computer stehen ungenutzt bereit, die Börsianer schließlich sitzen und stehen apathisch herum, den verstörten Blick auf eine unsichtbar bleibende Anzeigetafel gerichtet. Gefilmt ist all dies mit einer präzise abtastenden Kameraführung, die des Öfteren durch blitzartige Zooms unterbrochen wird. Das ökonomische Macht-zentrum Börse ist offensichtlich aus den Fugen geraten, vielleicht gar überflüssig geworden. Abgrundtiefe Beklemmung ist von den Gesichtern der Börsianer abzulesen – genau dieses Gefühl des Bodenlosen ist prägend für die künstlerische Arbeit von Mik.

L'installationniste et vidéaste néerlandais Aernout Mik présente dans son art des œuvres dont l'emprise sur l'espace est caractéri-sée par l'étrangeté. La présence puissante et parfois irritante des personnes est d'abord soigneusement mise en scène dans les lieux les plus divers, avant d'être documentée sous forme de film vidéo. L'effet suggestif est habilement renforcé par des interventions architectoniques et par l'absence de son. L'installation vidéo *Glutinosity,* 2001, montre les scènes soi-disant typiques de manifestations politiques. Des manifestants partiellement emmitouflés sont allongés dans la rue ; revêtues d'uniformes fictifs, les forces de l'ordre tentent de les emmener avec beaucoup de ménagement. D'ailleurs, la résistance est presque inexistante, et fait absurde, l'événement laisse presque une impression pacifique. Les mouvements errants et comme accessoires de la caméra créent en même temps une ambiance de mystère. Plus on regarde toute cette acti-vité, plus l'événement semble surréaliste. Notre sens des réalités est berné de façon aussi agréable que surprenante. La vidéo *Middlemen,* 2001, montre l'effervescence d'une journée de travail dans une bourse internationale. La recréation artificielle de l'espace tient plus du jeu de scène que de la réalité boursière. D'innombrables papiers jonchent le sol dans une répartition des plus chaotiques. Des téléphones rouges et des ordinateurs blancs n'attendent que d'être utilisés ; enfin, les opérateurs boursiers sont assis ou debout, apathiques, le regard vide fixé sur un invisible panneau d'affichage. Tout ceci est filmé avec un jeu de caméra sensible, précis, souvent interrompu par des zooms fulgurants. Visiblement, rien ne va plus dans le centre névralgique de la puissance économique, peut-être devenu superflu. Dans les visages des cour-tiers, on lit une gêne sans fond – et c'est précisément ce sentiment de mise en abîme qui est caractéristique du travail de Mik. R. S.

SELECTED EXHIBITIONS →
1995 *Wie die Räume gefüllt werden müssen/How spaces must be filled,* Kunstverein Hannover, Hanover, Germany **1997** *Dutch Pavilion, 47. Biennale di Venezia,* Venice, Italy **1998** *Do all oceans have walls?* Gesellschaft für Aktuelle Kunst/Galerie im Künstlerhaus, Bremen, Germany **2000** *3 Crowds,* Institute of Contemporary Arts, London, UK; *Triennale of Yokohama,* Japan **2001** *2. berlin biennale,* Berlin, Germany; Dutch Pavilion, *49. Biennale di Venezia,* Venice, Italy **2002** Stedelijk Museum Bureau, Amsterdam, The Netherlands

SELECTED BIBLIOGRAPHY →
1995 *Wie die Räume gefüllt werden müssen/How spaces must be filled,* Kunstverein Hannover, Hanover **1999** Van AbbeMuseum, Eindhoven **2001** *2. berlin biennale,* Berlin; *49. Biennale di Venezia,* Venice

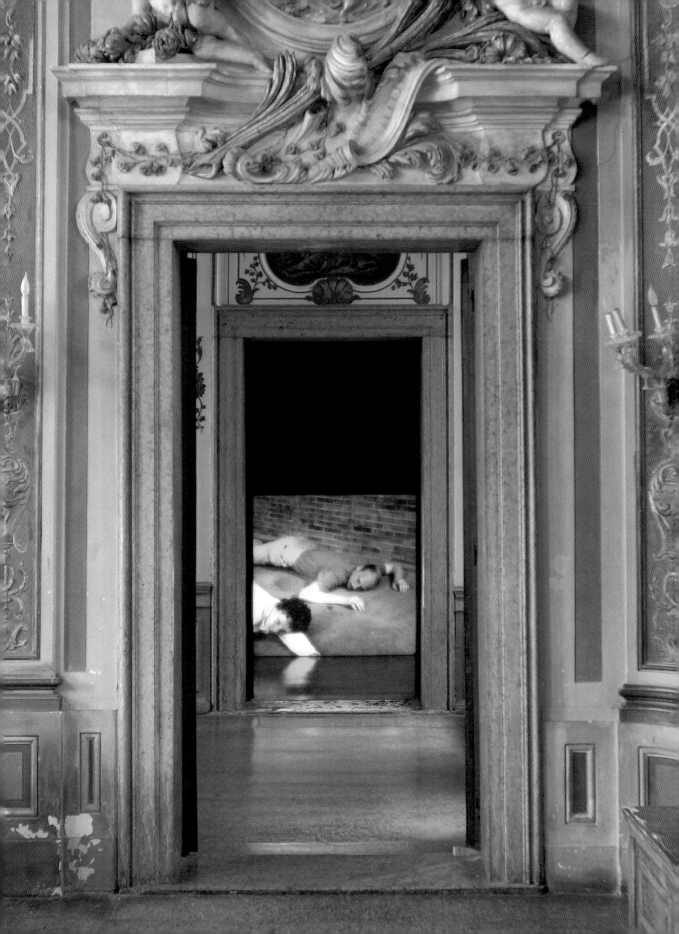

298

1 **Glutinosity,** 2001, video installation, digital video on DVD, installation view, *Post Nature*, Dutch Pavilion, Annexe, Calle Zenobio, *49. Biennale di Venezia,* Venice

2 **Swab,** 1999, video installation, digital video on DVD, installation view, *Primal Gestures, Minor Roles*, 2000, Van Abbe Museum, Eindhoven

3 **Middlemen,** 2001, video installation, digital video on DVD

4 **Middlemen,** 2001, installation view, carlier | gebauer, Berlin

„Ich möchte dem Betrachter das Gefühl geben, an dem Kunstwerk mitzu-wirken, ein unverzichtbarer Bestandteil von dessen Organismus zu sein, und nicht nur distanzierter und ausgegrenzter Zuschauer."

« Je voudrais que le public se sente comme une partie intégrante de mes œuvres, une nécessaire composante de leur organisme, plutôt que d'être seulement un spectateur et un auditoire, avec la distance et l'exclusion que cela implique. »

"I want the viewing audience to feel like a participant in the artwork, a necessary component of its organism, instead of just being the viewer and audience, which implies distance and exclusion."

2

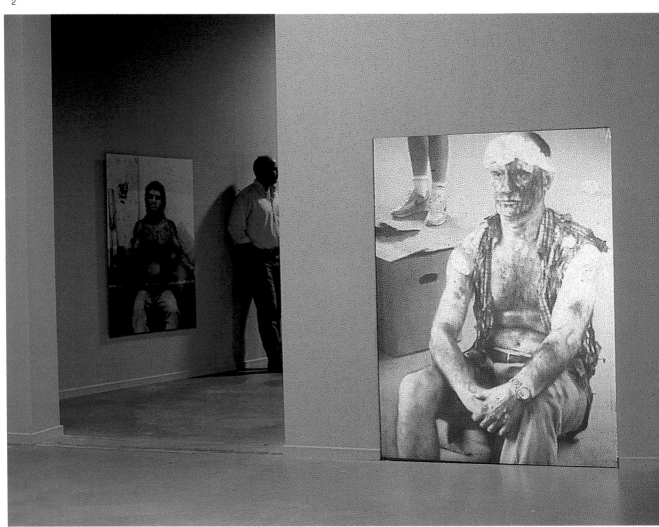

3

4

Jonathan Monk

1969 born in Leicester, UK, lives and works in Berlin, Germany

Jonathan Monk might be called a post-modern grandson of the conceptual artists of the 1960s and 1970s. Among his acknowledged "ancestors" he naturally includes Marcel Duchamp, but his work is also inspired by famous footballers, showbiz stars and family members. Monk has always ignored the boundaries between high and low, public and private, and the conflict between art and life. He also rejects the traditional premise that art is first and foremost a visual experience. Instead, with his often witty sculptures and paintings, photos processed in various ways, videos and installations, Monk appeals to the "intellectual eye", making demands on the intelligence of the viewer, way beyond the rich sensuality of the artefact. Monk first attracted attention with his *Holiday Paintings*, the first of which appeared in 1992. They show adverts for bargain holidays, giving the destination, duration and cost of the trip. The paintings cost exactly the same as the package deal they are promoting, so drawing a parallel between art and leisure. Both offer "disinterested pleasure", relaxation and beauty. Monk's series *The Little Things Make all the Difference*, started in 1999 draws on the world of football. Here, the artist's own creativity goes hand in hand with the performance on the sports field. He has taken newspaper photos of thrilling moments on the pitch, and unobtrusively cut out the ball and shifted it to another part of the picture. Suddenly, a player leaps to save the ball but it shoots into the net. It's the same in life as in art. Even the most minor modification by the artist can extend the boundaries of reality, opening up a whole new field of exciting possibilities.

Jonathan Monk ist gleichsam ein postmoderner Enkel der Konzeptkünstler der sechziger und siebziger Jahre. Zu seinen erklärten „Ahnherren" zählt selbstverständlich Marcel Duchamp, aber auch berühmte Fußballer, Showstars oder Familienmitglieder inspirieren Monk zu seiner Arbeit. Die Grenzen von High and Low, von Öffentlichkeit und Privatheit sowie der Gegensatz von Kunst und Leben werden von ihm ständig ignoriert – genau so, wie die traditionelle Haltung, dass Kunst in erster Linie ein visuelles Erlebnis sei. Statt dessen spricht Monk mit seinen oftmals witzigen Skulpturen und Gemälden, bearbeiteten Fotos, Videos oder Installationen immer das „geistige Auge" an; die Intelligenz des Betrachters ist hier mehr gefragt als die pralle Sinnlichkeit des Artefaktes. Bekannt wurde Monk mit seinen seit 1992 entstehenden *Holiday Paintings*. Auf ihnen sind Werbetafeln für besonders günstige Urlaubsreisen abgemalt: aufgeführt werden Zielort, Dauer und Preis der Reise. Die Bilder kosten exakt dasselbe wie die angepriesene Reise – Kunst und Urlaub werden so miteinander verglichen. Beide sind geprägt durch ein „interesseloses Wohlgefallen", durch Freizeit und Schönheit. Die Welt des Fußballs findet sich in Monks Werkreihe *The Little Things Make all the Difference*, seit 1999. Hier gehen Fremd- und Eigenproduktion Hand in Hand: Aus Zeitungsfotos mit packenden Fußballszenen hat der Künstler kaum merklich den Ball herausgeschnitten und an einer anderen Stelle des Bildes wieder eingesetzt. Plötzlich greift der Torwart ins Leere und der Ball geht doch noch ins Tor. So ist es halt im Leben wie in der Kunst: Jenseits des Realitätsprinzips eröffnet sich durch minimale Eingriffe ein weites Feld lustvoller Versprechungen.

Jonathan Monk est une sorte de descendant post-moderne des artistes conceptuels des années 60 et 70. Parmi ses « ancêtres » déclarés, on compte évidemment Marcel Duchamp ; mais de célèbres footballeurs, des stars du spectacle ou des membres de la famille de l'artiste l'ont également inspiré. Les limites entre high et low, haute et basse culture, entre vie publique et privée, mais aussi l'opposition entre l'art et la vie sont constamment ignorées – tout comme la conception traditionnelle selon laquelle l'art se résumerait avant tout à l'expérience visuelle. Avec ses sculptures et ses peintures souvent humoristiques, ses photos retouchées, ses vidéos et ses installations, Monk s'adresse toujours à « l'œil spirituel ». L'intelligence du spectateur y est plus fortement sollicitée que la sensualité brute de l'artefact. Monk s'est fait connaître avec ses *Holiday Paintings* réalisées depuis 1992. Il y montre des panneaux publicitaires vantant des vacances particulièrement bon marché : les informations contenues dans ces affichages font état du lieu, de la durée et du prix du voyage. Le prix de chaque tableau est toujours le même que le voyage vanté – art et vacances sont ainsi mis sur un même pied. Les deux se caractérisent par un « plaisir désintéressé », par le loisir et la beauté. Le monde du football est apparu dans la série *The Little Things Make all the Difference* depuis 1999. La production personnelle et celle des autres s'y rejoignent : dans des photos de journaux montrant de passionnantes scènes de football, l'artiste a découpé le ballon de manière presque imperceptible pour le faire figurer à un autre endroit de l'image. Soudain, le gardien de but ne saisit que du vide, et le ballon entre quand même dans la cage. Il en va de la vie comme de l'art : au-delà du principe de réalité, d'infimes interventions ouvrent un large champ de plaisantes promesses.

R. S.

SELECTED EXHIBITIONS →
1997 Casey Caplan, New York (NY), USA **1998** Lisson Gallery, London, UK; *Landscape Memories*, Rosamund Felsen, Los Angeles (CA), USA
1999 *Meine Onkel*, Meyer Riegger Galerie, Karlsruhe, Germany
2000 Yvon Lambert, Paris, France; *Transfert*, Biel/Bienne, Switzerland; *For those about to rock*, Galerie der Stadt Schwaz, Austria
2001 *2. berlin biennale*, Berlin, Germany; *Sport als Motiv in der zeitgenössischen Kunst*, Kunsthalle Nürnberg, Nuremberg, Germany

SELECTED BIBLIOGRAPHY →
1996 *Jonathan Monk*, Tramway Visual Arts, Glasgow
1999 *Jonathan Monk, 2*, Stuttgart **2000** *For those about to rock*, Schwaz **2001** *2. berlin biennale*, Berlin

1 **Untitled,** 2001, c-print, 24 x 18 cm
2 Installation view, *Gyrostasis* (in collaboration with Dave Allen), workweb_art, Cologne, 2000
3 **Replica I (version II),** 2000/01, slide number one of 80 slides, double slide projection, 160 slides in total

4 **Replica I (version II),** 2000/01, slide number eighty of 80 slides, double slide projection, 160 slides in total
5 In collaboration with Douglas Gordon: **The end uncovered,** 2001, slide number twenty of 80

„Man nimmt ein Objekt, macht etwas damit, macht dann etwas anderes damit und schließlich noch etwas anderes – und fängt an sich zu langweilen."

« Prendre un objet, en faire quelque chose, en faire quelque chose d'autre, et encore quelque chose d'autre – s'ennuyer. »

"You take an object, do something with it, do something else with it; then something else – you get bored."

2

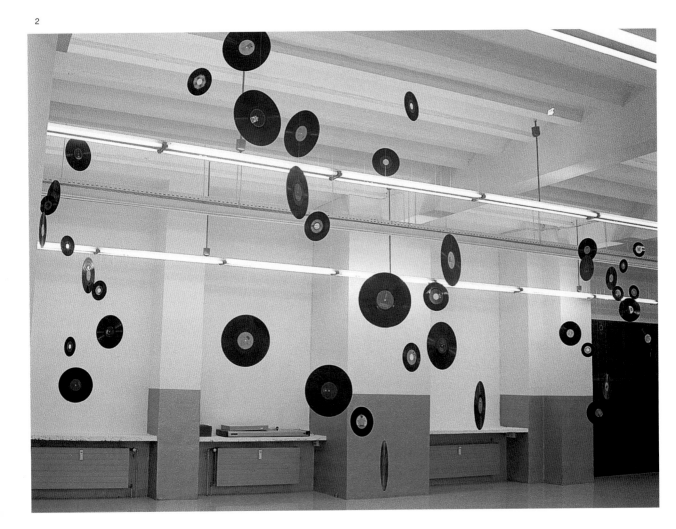

3

4

5

Mariko Mori

1967 born in Tokyo, Japan, lives and works in New York (NY), USA

Mariko Mori is an artist, a being with a strong hint of the extra-terrestrial, and a priestess of her own temple of dreams. Following her meteoric success in the 1990s, this most famous representative of "Tokyo Pop" can now take a step back and translate her virtual realities into three-dimensional works. Nobody else has matched the stridency with which she visualises contemporary Japan's symbiosis of tradition and innovation, nature and high technology, individual and collective dreams. Over and over again she connects the supernatural and meta-physical with the traditional and formal elements of perceptible reality. This creates a tension in her art, which is not a thousand miles away from kitsch, and has prompted its description as an *Esoteric Cosmos*. Her cocoon-like *Body Capsules,* 1995, contain the assembled energy with which she dives into the realm of mysticism. Time appears to stand still, and all is preserved in weightlessness, clarity and spiritual devotion. When Mori's *Dream Temple* construction, 1999, first made an appearance in the video and photographic work *Kumano*, 1998, it was a virtual temple for tea ceremonies, in which humanity and the cosmos were linked by ritual and spirituality. It is now physically accessible and, after passing through the traditional "stone garden of purification", visitors find themselves surrounded by traditional architectural elements based on the Yumedono Temple (AD 739) in Nara, and by transcendental images and celestial sounds. Mori relates to the idea that all the senses are connected, and makes use of high-tech to sensitise the senses and the soul. Her spirituality is a wondrous world of illusion born of the realisation that human existence is finite.

Mariko Mori – die einem Wesen vom anderen Stern gleichende Künstlerin – ist mittlerweile eine Priesterin ihres Traumtempels geworden. Nach ihrem rasanten Erfolg in den neunziger Jahren darf sich die berühmteste Vertreterin des „Tokyo Pop" zurücklehnen und ihre virtuellen Realitäten in die Dreidimensionalität umsetzen. Niemand anders visualisiert so schrill wie sie die Verbindungen von Tradition und Innovation, von Natur und Hoch-Technologie, von individuellen und kollektiven Träumen im heutigen Japan. Immer werden von ihr Beziehungen zwischen Übernatürlichkeit und Vergeistigung zur realen Ebene der traditionell-formalen Elemente geknüpft. Hieraus erhält ihre Kunst eine Spannung, die dem Kitsch nicht fern steht, sodass ihre Welt bereits als *Esoteric Cosmos* bezeichnet wurde. In ihren kokonartigen *Body Capsules*, 1995, sammelt sie Energie, mit der sie in die Welt der Mystik eintaucht. Die Zeit scheint stehen zu bleiben, und alles ist aufgehoben in einer Leichtigkeit, Klarheit und Spiritualität. Moris gebauter *Dream Temple*, 1999, war in der Video- und Fotoarbeit *Kumano*, 1998, noch ein virtueller Teezeremonie-Tempel, in dem die Welt mit dem Kosmos durch die rituelle Handlung und den Geist verbunden war. Jetzt ist er begehbar und umhüllt den Besucher – nach dem Durchschreiten des traditionellen Stein-Gartens der Reinigung – mit althergebrachten Architektur-elementen, basierend auf dem Yumedono-Tempel (von 739) in Nara, und mit transzendenten Bildern und Sphärenklängen. Mori nimmt Bezug auf die Vorstellung, dass alle Sinne zusammenhängen und nutzt die High-Tech zur Sensibilisierung der menschlichen Sinne und des Geistes. Ihre Spiritualität ist eine wunderbare Welt der Täuschung, geboren aus der Erkenntnis, dass das Menschsein endlich ist.

Mariko Mori, l'artiste qui a tout d'un être venu d'une autre planète, est devenue aujourd'hui la prêtresse de son temple du rêve. Après son succès éclatant au cours des années 90, la plus célèbre représentante du « Tokyo Pop » peut aujourd'hui se reposer et transposer ses réalités virtuelles dans les trois dimensions de l'espace. Personne d'autre ne visualise de manière aussi stridente qu'elle les rapports entre tradition et innovation, entre nature et technologie de pointe, entre rêves individuels et collectifs dans le Japon d'aujourd'hui. Elle établit sans cesse des liens entre le surnaturel et la spiritualisation, et le plan réel des éléments formels traditionnels. Son art en tire une tension qui n'est pas éloignée du kitsch, ce qui a valu à son univers le qualificatif de *Esoteric Cosmos*. Dans ses *Body Capsules*, 1995, rappelant un cocon, elle rassemble de l'énergie grâce à laquelle elle plonge dans le monde de la mystique. Le temps semble arrêté, tout s'abolit dans la légèreté, la clarté et la spiritualité. Dans *Kumano* de 1998, le *Dream Temple* de Mori, qui fut construit l'année suivante, n'était encore qu'un temple virtuel de la cérémonie du thé, dans lequel le monde était relié au cosmos par l'acte rituel et l'esprit. Ce temple est désormais visitable et enveloppe le spectateur – une fois franchi le rituel Jardin de la purification – de ses éléments d'architecture traditionnels empruntés au temple Yumedono (de 739) à Nara, et avec des images transcendantes et des sons éthérés. Mori se réfère à l'idée que tous les sens sont liés, et se sert de la technologie de pointe aux fins de sensibilisation des sens humains et de l'esprit. Sa spiritualité est un merveilleux monde d'illusion, né de l'idée que l'existence humaine est limitée.

G. J.

SELECTED EXHIBITIONS →
1999 *Empty Dream*, Brooklyn Museum of Art, New York (NY), USA; *Dream Temple*, Fondazione Prada, Milan, Italy; *Esoteric Cosmos*, Kunstmuseum Wolfsburg, Germany; *Regarding the Beauty*, Hirshhorn Museum and Sculpture Garden, Washington D.C., USA; *Seeing Time*, San Francisco Museum of Art, San Francisco (CA), USA **2000** *Link*, Centre Georges Pompidou, Paris, France; *Sonic Boom: The Art of Sound*, Hayward Gallery, London, UK; *Apocalypse*, Royal Academy of Arts, London, UK **2001** *Miracle*, Gallery Koyanagi, Tokyo, Japan

SELECTED BIBLIOGRAPHY →
1999 *Dream Temple*, Fondazione Prada, Milan; *Esoteric Cosmos*, Kunstmuseum Wolfsburg; Burkhard Riemschneider/Uta Grosenick (eds.), *Art at the Turn of the Millennium*, Cologne **2001** Uta Grosenick (ed.), *Women Artists*, Cologne

306

1 **Dream Temple,** 1999, audio, metal, glass, synthetics, fibre optics, VisionDome, 3D semi-circular display, ø 10 m, height 5 m, installation view, *Apocalypse*, Royal Academy of Arts, London, 2000
2 **Kumano,** 1998, glass with photo interlayer, 5 panels, overall 305 x 610 x 2 cm

3 **Beginning of the End: Paris, La Defense,** 1996, crystal print, wood, pewter frame, 99 x 500 x 8 cm
4 **Burning Desire,** 1997/98, glass with photo interlayer, 5 panels, overall 305 x 610 x 2 cm

„Spirituelle Energie ist ewig; weder Tod noch Geburt können sie tangieren."

« L'énergie spirituelle est éternelle, la mort ni la naissance ne peuvent l'atteindre. »

"Spiritual energy is eternal; no death or birth can touch it."

2

3

4

1 **Federal Reserve (Capital)**, 2001, gloss household paint on canvas, 214 x 214 cm
2 **Midtown**, 1998, 16 mm DVD, 9:36 min

3 Installation view, *Rumjungle*, White Cube², London, 2000
4 **SRHMRRS3**, 2001, gloss household paint on canvas, 257 x 198 cm

„Die Leere und die Eindimensionalität reflektierten die Dinge wie sie sind. Es ist pervers, eine verführerische Leere zu kreieren.
Das Kunstwerk vermittelt ein verzerrtes Bild der Realität, indem es Erfahrungen auf den Status von Kodierungen und Abbildern reduziert. Ich vergrößere, verzerre und übertreibe. Ich trete auf's Gaspedal."

« Le vide et la planéité reflètent la manière d'être des choses. Il est pervers de créer un vide séduisant. L'œuvre distord la réalité en simplifiant les expériences en codes et en icônes. J'amplifie, je distords et exagère. J'enfonce l'accélérateur. »

"The emptiness and flatness reflects the way things are. It's perverse to create a seductive emptiness. The work distorts reality by simplifying experiences into codes and icons. I amplify, distort and exaggerate. I am putting a foot on the accelerator."

2

3

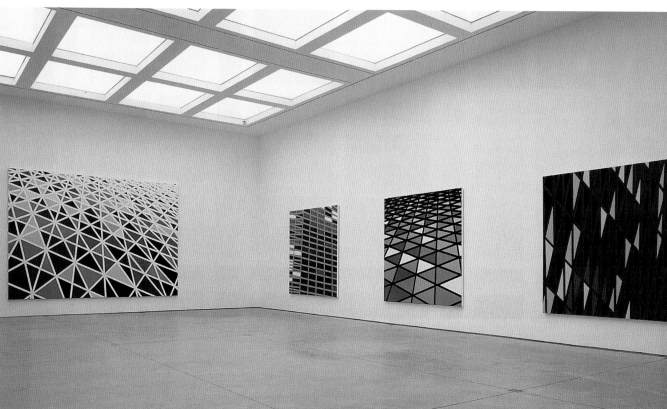

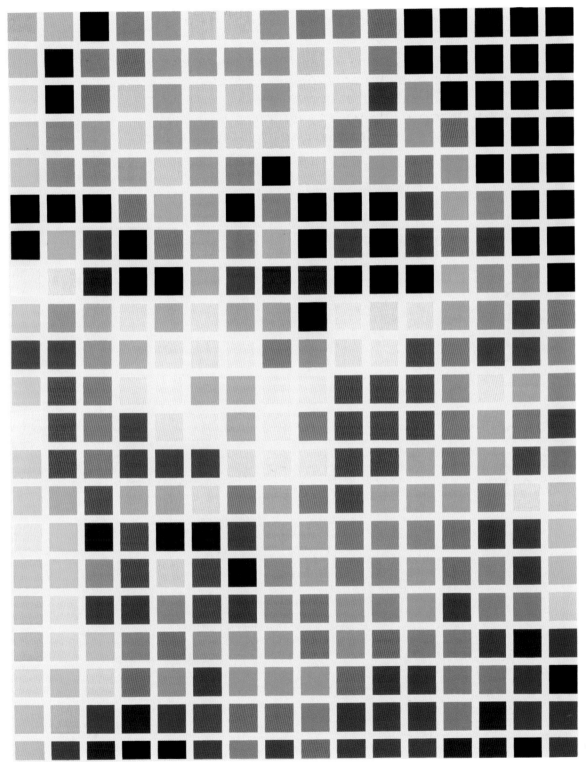

Vik Muniz

1961 born in São Paulo, Brazil, lives and works in New York (NY), USA

Vik Muniz produces witty, seductive photographic images. Their subjects are often comfortingly familiar: a well-known portrait of Sigmund Freud; a Pollock drip painting; Courbet's famous masterpiece "Origin of the World". But the satisfaction of recognition is unsettled when, on closer inspection, the Freud portrait and Pollock painting reveal themselves to be rendered in chocolate syrup, while the Courbet is crafted entirely out of dirt. The dexterity with which Muniz reconstructs these high art images contrasts with the low-brow associations of the materials he employs, creating a juncture through which their illusionism is clearly apparent. His photographs strip bare the mechanisms of representation to question the hierarchy between "original" and "reproduction" while delighting in the discrepancies that proliferate through displacement, interpretation and what he terms "the dynamic theater of visual forms". That the final photographic image is all that remains of his laboriously constructed set-ups hints at the ephemeral nature of human production. For a series entitled *Pictures of Dust*, 2001, he recreated archival images of key minimalist works entirely in dust gathered from the floor of the Whitney Museum of American Art in a succinct summation of the passing of time that can transform even the weightiest of art movements and the most reputable of institutions into dust, history and photographic souvenirs.

Vik Muniz produziert ebenso witzige wie verführerische fotografische Bilder. Die Motive seiner Arbeiten erscheinen häufig beruhigend vertraut: etwa ein bekanntes Sigmund-Freud-Porträt, ein Drip Painting von Pollock, Courbets berühmtes Meisterwerk „Der Ursprung der Welt". Bei näherem Hinsehen zeigt sich allerdings, dass das Freud-Porträt und das Pollock-Bild aus Schokoladensirup gestaltet sind und das Courbet-Werk ausschließlich aus Schmutz. Auf diese Weise wird die Freude über das Wiedererkennen aufseiten der Betrachters stets aufs Neue irritiert. Die Geschicklichkeit, mit der Muniz diese Produkte hoher Kunst rekonstruiert, kontrastiert merkwürdig mit dem eher „primitiven" Charakter der von ihm verwendeten Werkstoffe. Hinter der Überschneidung dieser beiden Ebenen tritt freilich der Illusionscharakter der Arbeiten umso deutlicher zutage. Muniz' Fotografien machen den Mechanimus bildlicher Darstellung sichtbar und hinterfragen die hierarchische Beziehung zwischen „Original" und „Reproduktion". Sie verweisen aber auch auf die Diskrepanzen, die im Gefolge einer Delozierung oder Neuinterpretation und des von ihm so genannten „dynamischen Theaters der visuellen Formen" zu verzeichnen sind. Dass von seinen mit großem Fleiß geschaffenen „Vorlagen" nichts weiter bleibt als ein fotografisches Bild lässt sich aber auch als Verweis auf die Vergänglichkeit jeder menschlichen Produktion deuten. Für die *Pictures of Dust*, 2001, betitelte Serie hat er Archivbilder der wichtigsten Arbeiten des Minimalismus nachgeschaffen, und zwar ausschließlich aus Staub, den er auf dem Boden des Whitney Museum of American Art eingesammelt hat. Mit Hilfe dieser ungemein prägnanten Kondensation der vergehenden Zeit vermag er sogar die gewichtigsten Kunstrichtungen und die angesehensten Institutionen in nichts als Staub, Geschichte und fotografische Erinnerungen zu verwandeln.

Vik Muniz réalise des images photographiques séduisantes et spirituelles. Ses sujets nous sont souvent familiers : un célèbre portrait de Sigmund Freud, un drip painting de Pollock ou le fameux chef-d'œuvre de Courbet, « L'origine du monde ». Toutefois, la satisfaction d'avoir reconnu la source cède rapidement le pas au trouble quand, en regardant de plus près, le portrait de Freud et le tableau de Pollock s'avèrent réalisés avec du chocolat et le Courbet entièrement sculpté avec de la poussière. La dextérité avec laquelle Muniz reconstruit ces images d'art contraste avec les matériaux communs qu'il utilise, créant une jonction à travers laquelle l'illusionnisme apparaît clairement. Ses photographies mettent à nu les mécanismes de la représentation afin de contester la hiérarchie entre « l'original » et la « reproduction », tout en se délectant des divergences qui prolifèrent à travers le transfert, l'interprétation et ce qu'il qualifie de « théâtre dynamique des formes visuelles ». Le fait que l'image photographique finale soit tout ce qu'il reste de ses œuvres laborieusement construites souligne la nature éphémère de la production humaine. Pour une série intitulée *Pictures of Dust*, 2001, il a recréé des images d'archives d'œuvres phares du Minimalisme entièrement avec de la poussière recueillie sur le sol du Whitney Museum of American Art, sorte de résumé succinct du passage du temps, capable de transformer les mouvements artistiques les plus imposants et les institutions les plus respectables en poussière, en histoire et en souvenirs photographiques.

K. B.

SELECTED EXHIBITIONS →
1998 *Seeing is Believing*, International Center of Photography, New York (NY), USA; *XXIV Bienal Internacional de São Paulo*, Brazil **1999** Centre National de la Photographie, Paris, France; *Abracadabra*, Tate Gallery, London, UK **2000** *Whitney Biennial*, The Whitney Museum of American Art, New York (NY), USA **2001** Brazilian Pavilion (with Ernesto Neto), *49. Biennale di Venezia*, Venice, Italy; *Brazil: Body and Soul*, The Solomon R. Guggenheim Museum, New York (NY), USA; *Pictures of Dust*, The Whitney Museum of American Art, New York (NY), USA

SELECTED BIBLIOGRAPHY →
1993 *Vik Muniz, The Wrong Logician*, Grand Salon, New York (NY)/Ponte Pietra, Verona **1995** *Panorama da Arte Contemporanea Brazileira*, Museu de Arte Moderna, São Paulo **1998** *Vik Muniz: Seeing is Believing*, Santa Fe (NM) **1999** *Vik Muniz*, Centre National de la Photographie and Caisse des Depots et Consignations, Paris **2001** *Vik Muniz/Ernesto Neto: Brasilconnects*, 49. Biennale di Venezia, Venice

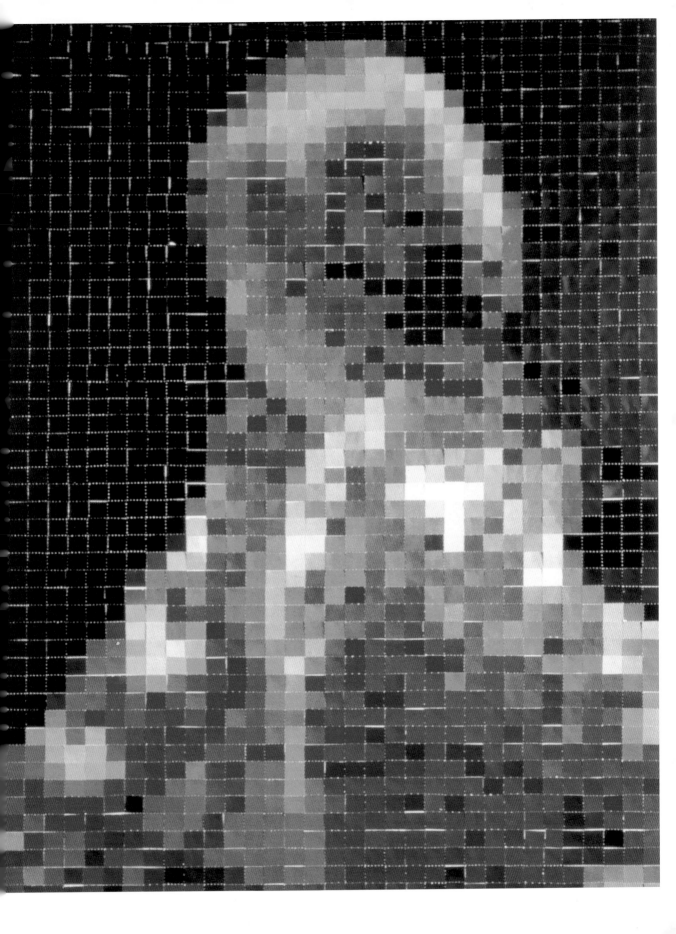

314

1 **After Gerhard Richter (from pictures of Color),** 2001, c-print, 276 x 191 cm
2 **Key,** 2002, toned gelatin silver print, 102 x 127 cm

3 **Disaster (from Pictures of Ink),** 2000, Cibachrome, 102 x 127 cm
4 **Scissors,** 2002, toned gelatin silver print, 102 x 127 cm

„Illusionen, die so kräftig aufgetragen sind wie die von mir erzeugten, wecken im Betrachter ein Bewusstsein für den Täuschungscharakter visueller Informationen und für das Vergnügen, das solche Täuschungen gewähren."

« Les illusions aussi grossières que les miennes font prendre conscience des faux raisonnements de l'information visuelle et du plaisir que de telles erreurs peuvent procurer. »

"Illusions as bad as mine make people aware of the fallacies of visual information and the pleasure to be derived from such fallacies."

2

3

4

Muntean/Rosenblum

Markus Muntean, born 1962 in Graz, Austria, and
Adi Rosenblum, born 1962 in Haifa, Israel; live and work in London, UK, and Vienna, Austria

Working in tandem since 1995, Muntean/Rosenblum extol the objects and people that have failed to signify. Their installations are interiors taking their appearance from standardised and impersonal temples of modernity: a fast-food outlet, a parking lot, a lobby. A motorcycle made from polyurethane foam is covered with a polyurethane tarpaulin. In sculpture as we know it, the material usually pretends to be something it is not, simulating the heterogeneity of the sculpted object and building up suspense. In Muntean/Rosenblum sculptures, packaging and content are one: this motorcycle is not going anywhere. Muntean/Rosenblum paintings include portraits and group scenes rendered in whitened colours. Pieces of furniture and the far-off horizons of metropolitan cityscapes are all encompassed by a rectangular outline with rounded corners. Their heroes, mostly in their teens or early twenties, are slaves to leisure and to the compulsion to be young and creative. Their T-shirts are declarations of independence and war encoded on designer gear. Reflections of the images are found in brief handwritten texts at the base of the white margin surrounding the painting. These are samples taken from philosophical texts and overheard opinions, like cut-outs from the blandness of experience. The texts speak of a longing for the unusual, a need for the mysterious, of the loss of vital experience and of a planned rebellion that the generation Muntean/Rosenblum portray will never have the guts to carry through.

Muntean/Rosenblum arbeiten seit 1995 als Tandem und betonen die Bedeutung von Objekten und Menschen, die ansonsten in der Alltagswelt untergehen. In ihren Installationen gestalten sie Interieurs, die sich in ihrem Erscheinungsbild an den standardisierten, völlig unpersönlichen Tempeln des modernen Lebens orientieren: Fastfood-Lokale, Parkplätze, Foyers. Ein aus Polyurethan geformtes Motorrad etwa ist mit einer ebenfalls aus Schaumstoff hergestellten Plane abgedeckt. Im Bereich der klassischen Skulptur gibt sich der Werkstoff für gewöhnlich als etwas aus, was er gerade nicht ist. Dabei soll das Material die Heterogenität des dargestellten Objektes simulieren und ein Spannungsverhältnis aufbauen. Bei den von Muntean/Rosenblum geschaffenen Skulpturen hingegen sind die Verpackung und der Inhalt eins: Dies Motorrad wird jedenfalls ganz sicher nirgends hinfahren. Im Medium der Malerei haben Muntean/Rosenblum Bildnisse und Gruppenszenen in blassen Farben geschaffen. Ob Möbelstücke oder von ferne gesehene Großstadtlandschaften, stets werden die Motive von einer an den Ecken abgerundeten Umrisslinie eingefasst. Die meist jungen Hauptfiguren sind Sklaven der Freizeitgesellschaft und eines zwanghaften Kults der Jugendlichkeit und der Originalität. Die Designer-T-Shirts, mit denen die Figuren sich schmücken, kommen als Deklaration der Unabhängigkeit und einer martialischen Geisteshaltung daher. Auf dem schmalen weißen Rand, der die Bilder umgibt, sind unten kurze von Hand geschriebene Texte aufgebracht, in denen das Bildthema reflektiert wird. Dabei kann es sich um philosophische Zitate oder zufällig aufgeschnappte Meinungen handeln – willkürlich aus der Ödnis des Alltags aufgeklaubte Schnipsel der Erfahrung. Die Texte artikulieren eine Sehnsucht nach dem Außergewöhnlichen, dem Mysteriösen, sie thematisieren den Verlust vitaler Erfahrungen und sprechen von einer geplanten Rebellion, zu der der von Muntean/Rosenblum porträtierten Generation allerdings der Mut fehlt.

Travaillant en tandem depuis 1995, Muntean/Rosenblum vantent les objets et les personnes qui ont échoué à signifier. Leurs installations sont des intérieurs empruntés aux temples standardisés et impersonnels de la modernité : un fast-food, un parking, un hall d'entrée. Une motocyclette en mousse de polyuréthanne est recouverte d'une bâche en polyuréthanne. Dans la sculpture telle que nous la connaissons, la matériau prétend généralement être ce qu'il n'est pas, simulant l'hétérogénéité de l'objet sculpté et créant un suspense. Dans les sculptures de Muntean/Rosenblum, l'emballage et le contenu ne font qu'un : cette motocyclette n'ira nulle part. Les peintures de Muntean/Rosenblum incluent des portraits et des scènes de groupes aux couleurs blanchies. Les meubles et les silhouettes lointaines de ville sont englobés dans un périmètre rectangulaire aux angles arrondis. Leurs héros, la plupart adolescents ou âgés d'une vingtaine d'années à peine, sont esclaves des loisirs et de la compulsion à être jeune et créatif. Leurs T-shirts sont des déclarations d'indépendance et de guerre encodées sur des vêtements griffés. On retrouve des reflets des images sous la forme de brefs messages rédigés à la main dans la marge blanche qui entoure la peinture. Il s'agit d'extraits de textes philosophiques ou d'opinions entendues à la sauvette, comme des découpages de la platitude de l'existence. Ces textes parlent d'une envie d'inhabituel, d'un besoin de mystère, de la perte de l'expérience vitale et d'une rébellion planifiée que la génération dépeinte par Muntean/Rosenblum n'aura jamais le cran de faire.

A. S.

SELECTED EXHIBITIONS →
1997 *Slaymobil*, City Racing, London, UK; *Zonen der Ver-Störung*, Steirischer Herbst, Graz, Austria **1998** *Lonely Facts*, Kunsthalle Luckenwalde, Germany; *The Campaign Against Living Miserably*, Royal College of Art, London, UK **1999** *International Biennial of Contemporary Art*, Jerusalem, Israel **2000** Jack Tilton Gallery, New York (NY), USA; *Where else?*, Wiener Secession, Vienna, Austria **2001** Interim Art/Maureen Paley, London, UK; *Sport als Motiv in der zeitgenössischen Kunst*, Kunsthalle Nürnberg, Nuremberg, Germany

SELECTED BIBLIOGRAPHY →
1998 *The Campaign Against Living Miserably*, Royal College of Art, London **1999** *Zonen der Ver-Störung*, Graz; *La Casa Il Corpo, Il Cuore*, Museum Moderner Kunst – 20er Haus, Vienna **2000** *Where Else?*, Wiener Secession, Vienna

DREAMINESS IS, AMONG OTHER THINGS, A STATE OF SUSPENDED RECOGNITION AND A RESPONSE TO TOO MUCH USELESS AND COMPLICATED FACTUALITY.

1 **Untitled (Dreaminess is ...),** 2001, acrylic on canvas, 120 x 110 cm
2 **Where else,** 2000, performance at Wiener Secession, Vienna
3 **Where else,** 2000, installation view, Wiener Secession, Vienna

4 **Untitled (Sometimes you get ...),** 2001, acrylic on canvas, 200 x 250 cm
5 Installation view, Interim Art/Maureen Paley, London, 2001

„Wir möchten die ‚Überpräsenz' des von den Medien perfekt konstruierten Körpers brechen, da sie den wirklichen Körper zum Verschwinden bringt."

« Nous essayons de briser la ‹ Superprésence › du corps parfaitement construit des médias, qui provoque la disparition du vrai corps. »

"We are trying to break the 'Superpresence' of the media's perfectly constructed body, which is causing the actual body to disappear."

2

3

4

SOMETIMES YOU GET OVERLY ABSORBED WITH HOW EXACT SEGMENTS OF TIME ARE CONSUMED, AND YOU BEGIN TO FEEL A PLEASURE WITH LIFE THAT IS HOPELESSLY TINGED WITH LONGING.

5

Takashi Murakami

1962 born in Tokyo, lives and works in Tokyo, Japan, and New York (NY), USA

Takashi Murakami plays on the originality and power of images in Japanese culture in an area between the traditional and the innovative. His version of a specifically Japanese contemporary art fuses Japanese painting, with its emphasis on surface, American Pop Art from Warhol to Koons, and the garish fantasy world of the Manga and Anime cartoons. The principle of interpenetrating the fine and applied arts is visible in the development and adaptation of stereotypical Pop paintings of popular figures, such as Mickey Mouse or Sailor Moon, and in the merchandising of ancillary objects from his production site "Hiropon Factory", created in 1995. Under his strict direction, perfectly crafted and arranged pictures and figures are created in the collective. He formulated his image of "Superflatness" with a manifesto and an exhibition, simultaneously maintaining a kind of style and avant garde thinking which up to that point had been encountered in Japanese art mostly as a Western import. Although the effect of Murakami's colourful art cosmos may seem on the surface like a Pop world of symbols and merchandise, his perceptions of the culture and identity of Japanese society are important for the national art world. They embody traumas, hopes and visions developed out of the Westernisation of Japanese culture, and aim to change the status and perception of contemporary art in Japan. On the one hand, these desires might seem childlike, but on the other they ponder the post-modern status quo of American culture in a very adult way. They are decorative and schizophrenic, while at the same time using their content to underline the originality of Japanese art.

Takashi Murakami setzt auf die Macht der Bilder und die Eigenständigkeit der japanischen Kultur zwischen Tradition und Innovation. In der Verschmelzung der japanischen flächenbetonten Malerei, der amerikanischen Pop-Art von Warhol bis Koons und den schrillen Fantasie-welten der Manga- und Anime-Kultur liegt seine Vorstellung einer spezifisch japanischen zeitgenössischen Kunst. Das Prinzip der Durchdringung von bildender und angewandter Kunst ist in der Entwicklung und Abwandlung stereotyper Pop-Malerei, von Populärfiguren wie Micky Maus oder Sailor Moon und im perfekten Merchandising von Auflagenobjekten aus seiner 1995 gegründeten Produktionsstätte „Hiropon Factory" ersichtlich. Im Kollektiv entstehen dort nach seiner Konzeption und unter seiner strengen Regie handwerklich perfekt arrangierte Bilder und Figuren. Mit einem Manifest und einer Ausstellung formulierte er seine Vorstellung der „Superflatness", gleichermaßen einem Stil- und Avantgardegedanken folgend, der der japanischen Kunst bislang zumeist als westliches Importgut begegnete. Wenngleich Murakamis bunter Kunstkosmos oberflächlich wie eine poppige Zeichen- und Warenwelt wirkt, sind seine Überlegungen zur Kultur und Identität der japanischen Gesellschaft wichtig für das nationale Betriebssystem Kunst. Sie verkörpern Traumata, Hoffnungen und Visionen, entwickelt aus der Verwestlichung der eigenen Kultur, und zielen auf die grundlegende Veränderung des Stellenwerts und der Wahrnehmung zeitgenössischer Kunst in Japan. Die kindlich anmutenden Wünsche reflektieren über ihre erwachsenen Attribute den postmodernen Status quo amerikanischer Kultur, sind dekorativ und schizophren, weisen jedoch zugleich inhaltlich weit darüber hinaus auf die Eigenständigkeit japanischer Kunst-produktion.

Takashi Murakami mise sur le pouvoir des images et l'autonomie de la culture japonaise entre tradition et innovation. Sa conception d'un art contemporain spécifiquement japonais réside dans la fusion entre la peinture nationale, qui privilégie la planéité, le Pop Art améri-cain – de Warhol à Koons – et les mondes imaginaires hauts en couleurs de la culture des mangas et des dessins animés. Le principe de l'interpénétration entre les arts plastiques et les arts appliqués apparaît clairement dans la mise au point et la déclinaison d'une peinture stéréotypée habitée de figures populaires comme Mickey ou Sailor Moon, et dans le parfait merchandising des multiples issus de sa « Hiropon Factory », site de production créé en 1995. Selon la conception et sous la direction rigoureuse de Murakami, ce collectif réalise des images et des figures d'une parfaite finition. Avec la publication d'un manifeste et une exposition, Murakami a formulé son idée de « superflatness », suivant en quelque sorte une idée stylistique d'avant-garde que l'art japonais n'a le plus souvent connu jusqu'à ce jour que comme une impor-tation occidentale. Même si l'univers artistique bigarré de Murakami est d'un effet aussi superficiel qu'un monde de signes et de produits de consommation affriolants, ses réflexions sur la culture et sur l'identité de la société japonaise jouent un rôle important dans le système de production artistique national. Elles incarnent les traumas, les espoirs et les visions développés à partir de l'occidentalisation de sa propre culture et visent à une profonde mutation dans l'appréciation et la perception de l'art contemporain au Japon. Par le biais de leurs attributs adultes, les désirs teintés d'infantilisme reflètent le statu quo postmoderne de la culture américaine. S'ils sont décoratifs et schizophrènes, leur contenu n'en va pas moins bien au-delà en tant qu'indicateur de l'autonomie de la production artistique japonaise. G. J.

SELECTED EXHIBITIONS →
1998 *The Manga Age*, Museum of Contemporary Art, Tokyo, Japan **1999** *The Meaning of the Nonsense of the Meaning*, Center for Curatorial Studies, Bard College, Annandale-on-Hudson (NY), USA; *DOB in the Strange Forest*, Nagoya Parco Gallery, Nagoya, Japan; *Back Beat*, Blum & Poe, Santa Monica (CA), USA; *Carnegie International*, Carnegie Museum of Art, Pittsburgh (PA), USA **2000** Marianne Boesky Gallery, New York (NY), USA **2001** Museum of Contemporary Art, Tokyo, Japan; Museum of Contemporary Art, New York (NY), USA

SELECTED BIBLIOGRAPHY →
1996 *Tokyo Pop*, Hiratsuka Museum of Art, Kanagawa **1999** *The Meaning of the Nonsense of Meaning*, Center for Curatorial Studies, Bard College, Annandale-on-Hudson (NY); *DOB in the Strange Forest*, Tokyo **2000** *Superflat*, Nagoya Parco Gallery, Tokyo **2001** Museum of Contemporary Art, Tokyo

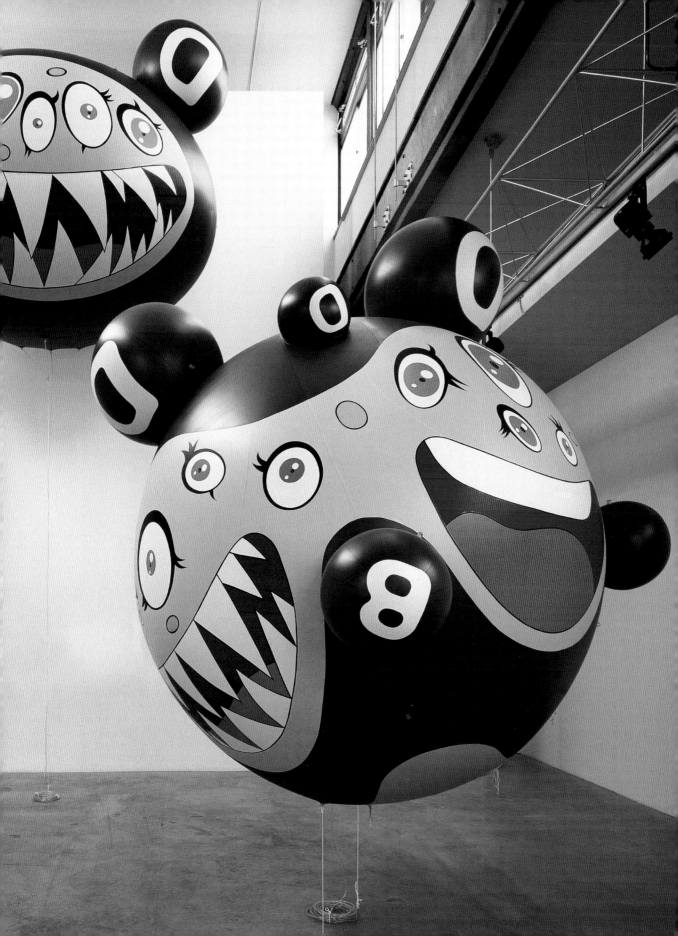

322

1 **Forest of DOB,** 1994, vinyl and helium, dimensions variable, installation
 view, Blum & Poe, Santa Monica (CA)
2 **My Lonesome Cowboy,** 1998, fibreglass, acrylic, oil paint, iron,
 254 x 117 x 91 cm

3 **Hiropon,** 1997, fibreglass, acrylic, oil paint, iron, 178 x 112 x 99 cm
4 **The Castle of Tin Tin,** 1998, acrylic on canvas, 300 x 300 cm

„Für meine Generation besteht das Problem darin, ohne Rückgriff auf
intellektuelle Gewissheiten originelle Produkte herzustellen, da wir uns der
Unterschiede zwischen der Vorgehensweise der zeitgenössischen Kunst in
den westlichen Ländern und den entsprechenden Verhältnissen in Japan
bewusst sind."

« Le problème qui se pose à ma génération est de créer des produits
originaux sans dépendre d'un système intellectuel, dans la mesure où nous
sommes conscients des différences entre les démarches de l'art
contemporain dans le monde occidental et la manière dont les choses
fonctionnent au Japon. »

"The problem for my generation is to create original products without depending on an intellectual system for support, since we are aware of differences between the workings of contemporary art in the West and the way things operate in Japan."

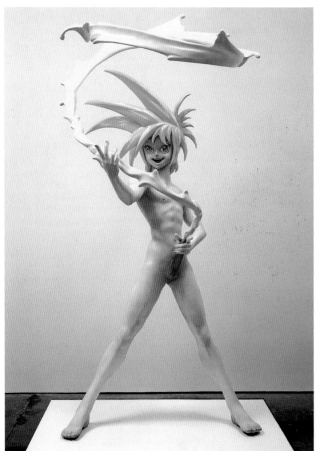

2

3

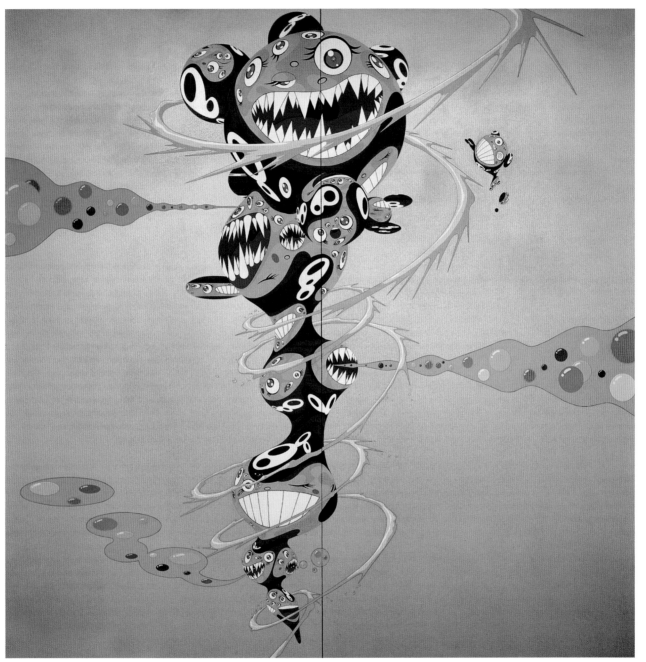

Yoshitomo Nara

1959 born in Hirosaki, lives and works in Tokyo, Japan

Rebellion is the basic principle of Yoshitomo Nara's art. As the artist himself was shaped by a carefree rural childhood and his big-city bases, Tokyo, Cologne and Los Angeles, so his work also swings between two opposite poles. His paintings, drawings and sculptures display an odd, dreamlike tension between aggressiveness and melancholy. His trademarks are children and dogs. Behind his subjects' apparent innocence is a clear potential for violence. They look shy, well brought-up and cute, their relationship to us, the viewers, defined by their great big eyes. Like sleepwalkers, they penetrate our unconscious, where the horror of daily life appears less virtual than real. Sometimes they appear sweet and loveable figures, sometimes malicious and threatening. Nara describes himself as a pop artist. Strongly influenced by rock and punk, by Japanese Manga comics and the well-ordered structure of Japanese society, his recollections of childhood happiness are traumatic portrayals of time lost for ever. His gentle paintings are shot through with the illusion of childhood and innocence, of an easy, sheltered existence. Ultimately, though, the feeling of hopefulness is one engendered by the adult world and hence emotionally loaded, so much so that we are forced to confront Nara's surreal world. But the artist, too, is growing older and his more recent work is less rebellious. Growing up also means acquiring experience and greater awareness. His highly idiosyncratic style, a cross between high and low culture, along with his enthusiasm for other areas of pop culture, have given Nara and his work cult status.

Rebellion ist das Grundprinzip der Kunst von Yoshitomo Nara. Geprägt von dem Gegensatz einer glücklichen Kindheit auf dem Land und den Großstädten Tokio, Köln und Los Angeles, wo er die meiste Zeit seines Lebens verbracht hat, pendelt sein Werk ebenfalls zwischen zwei Polen. Seine Gemälde, Zeichnungen und Skulpturen stehen unter einer seltsam entrückten Spannung von Aggressivität und Melancholie. Markenzeichen sind Kinder und Hunde, die hinter ihrer scheinbaren Unschuld ein metaphorisches Konfliktpotenzial offenlegen. Sie erscheinen isoliert und einsam, manchmal schüchtern, gut erzogen, irgendwie drollig; unser Verhältnis zur eigenen Geschichte zeigt sich in ihren großen Augen. Manchmal dringen sie schlafwandlerisch in unser Unterbewusstsein vor, in dem der alltägliche Horror weniger virtuell denn real erscheint. Mitunter sind Naras knuffige, liebenswerte Figuren aber auch böse und bedrohlich. Nara versteht sich und seine Kunst als Pop. Stark beeinflusst von Rock und Punk, von Manga-Comics und von der geordneten Struktur in der japanischen Gesellschaft, wirken die Werke wie Rückblicke auf die unbeschwerte Jugend, mitunter traumatische Schilderungen der verlorenen Zeit. Die Wirklichkeit und Illusion von Kindheit und Unschuld, von Unbeschwertheit und behütetem Glück durchweben seine zarten Gemälde, letztlich stammen diese Erwartungshaltungen, denen wir in Naras Kosmos surreal gegenübertreten, jedoch aus einer Welt der Erwachsenen. Wenn Nara auch älter geworden ist und seine jüngeren Werke weniger rebellisch scheinen, so ist er doch seinem Reaktion fordernden Stil treu geblieben. Sein sehr eigenständiges Werk, die Vermittlung zwischen High und Low, wie seine Vorliebe zu anderen popkulturellen Bereichen – wie das Schreiben von Musikkritiken – haben die Person Nara und seinem Werk vor allem in seiner Heimat, in der er seit 2000 wieder lebt, Kultstatus erlangen lassen.

La révolte est le moteur fondamental de l'art de Yoshitomo Nara. Marqué par l'antinomie entre la campagne, où il passé une enfance heureuse et les villes de Tokyo, Cologne et de Los Angeles, où il a vécu la majeure partie de sa vie, son œuvre oscille aussientre des pôles binaires. Ses peintures, dessins et sculptures sont placés sous une tension passablement singulière entre agressivité et mélancolie. Un signe distinctif de ses œuvres apparaît avec des enfants et des chiens qui recèlent un potentiel conflictuel significatif sous une apparente innocence. Les enfants semblent bien éduqués, timides, d'une certaine manière amusants, et leurs grands yeux reflètent notre propre rapport à notre propre histoire. Ou alors ils entrent dans notre inconscient comme des somnambules, cet inconscient dans lequel l'horreur quotidienne se manifeste de manière moins virtuelle que réelle. Ils apparaissent parfois comme des êtres mignons, adorables, mais aussi méchants et menaçants. Nara comprend sa propre personne et son art comme du pop. Fortement influencé par le rock et le punk, les mangas et la structure ordonnée de la société japonaise, ses aperçus rétrospectifs sur le bonheur de son enfance sont les descriptions traumatiques d'un temps perdu. L'illusion de l'enfance et de l'innocence, de l'insouciance et d'un bonheur protégé, tissent la trame de ses peintures délicates. Cependant, les attentes qu'elles révèlent appartiennent en définitive au monde des adultes ; et elles sont tellement chargées d'émotion que dans l'univers de Nara, elles apparaissent comme surréelles. Mais Nara a lui aussi fini par grandir, et ses œuvres récentes sont moins rebelles. Toute maturation ressort aussi de prises de conscience et d'expériences accumulées. Son style très indépendant, le lien entre haute et basse culture, ainsi que son amour pour d'autres domaines culturels populaires, ont conféré à l'œuvre et à la personne de Nara un statut culte.　　　　　　　　　　　　　G. J.

SELECTED EXHIBITIONS →
1995 SCAI The Bathhouse, Tokyo, Japan; *The Future of Paintings*, Osaka Contemporary Art Center, Osaka, Japan **1996** Tomio Koyama Gallery, Tokyo, Japan; *Tokyo Pop*, Hiratsuka Museum, Hiratsuka City, Japan **1997** Galerie Michael Zink, Regensburg, Germany **1999** Ginza Art Space, Tokyo, Japan **2000** Museum of Contemporary Art, Chicago (IL), USA; Marianne Boesky Gallery, New York (NY), USA **2001** Yokohama Museum of Art, Yokohama, Japan; *Painting at the Edge of the World*, Walker Art Center, Minneapolis (MN), USA

SELECTED BIBLIOGRAPHY →
1995 *In the deepest Puddle*, SCAI The Bathhouse, Tokyo **1998** *Slash with a Knife*, Tokyo **1999** *Ukiyo*, Tokyo **2001** *Yoshitomo Nara, Lullaby Supermarket*, Nuremberg

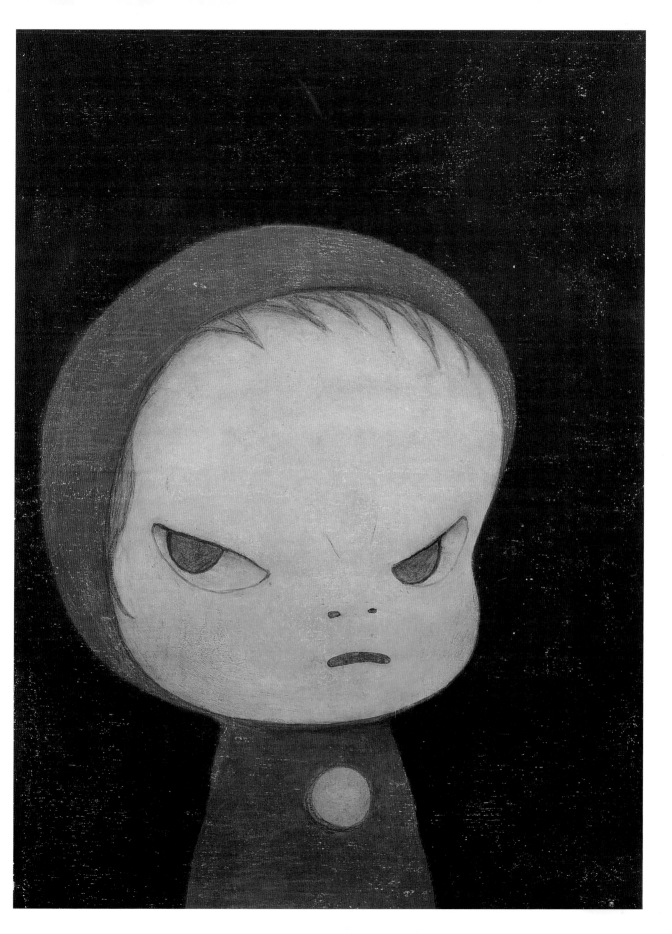

1 **Pyromaniac,** 1999, acrylic and coloured pencil on paper, 51 x 41 cm
2 **Sleepless Night-Sitting,** 1997, acrylic on cotton, 120 x 110 cm
3 **Strait Jacket,** 2000, acrylic on canvas, 234 x 208 cm
4 **Sprout the Ambassador,** 2001, acrylic on canvas, 213 x 183 cm
5 **Dogs From Your Childhood,** 1999, fibreglass, wood, fabric, acrylic paint, each dog 183 x 152 x 102 cm

„Ich mag Punk, aber nicht nur als Musik, sondern auch als Zeichen der Unabhängigkeit."

« J'aime le Punk Rock, pas seulement comme musique, mais comme manifestation d'indépendance. »

"I like punk rock, but not only as music, but as a sign of independence."

2

3

4

5

Mike Nelson

1967 born in Loughborough, lives and works in London and Edinburgh, UK

Mike Nelson's labyrinthine installations weave together literary, cinematic, historical and socio-political references to fabricate realistically convincing but disorientating parallel realities. His 1999 exhibition *To the Memory of H. P. Lovecraft* borrows its title from a story by Jorge Luis Borges, itself an homage to the horror stories of Lovecraft, and constructs a third fiction that breeds what Lovecraft described as "a certain atmosphere of breathless and unexplainable dread of outer, unknown forces." The gallery is empty but the walls have been ripped to shreds by the rabid scratchings of some unknown creature in a prior scene of violent destruction. Offering no simple answers, Nelson leads us into a circular, inconclusive narrative whose meaning resides in the self-consciousness and uncertainty it provokes in our imagination. *The Deliverance and the Patience*, held in Venice in 2001, exploited the vulnerability of an audience already disoriented by the city's confusing geography. On entering the space, the visitor is faced with a choice of doorways, each of which leads to a bewildering maze of rooms and corridors: a dingy sweatshop littered with shards of fabric; a second-rate travel agency; a Captain's bar decorated with tacky seaside souvenirs. The visitor is thrust into the midst of a fictional world. A staircase behind one door leads to a mezzanine level from which the entire enclosed structure containing the maze of rooms can be seen, thereby revealing the mechanics of the spectacle. However, even when armed with this knowledge, the mystery of the deeply imagined fictional inhabitants remains, unsettling our belief in the fixed logic and order of the rational universe.

In den labyrinthartigen Installationen von Mike Nelson verbinden sich literarische, filmgeschichtliche, historische und sozio-politische Verweise zu einer Einheit und schaffen realistisch anmutende, zugleich desorientierende Parallelwirklichkeiten. Den Titel seiner Ausstellung *To the Memory of H. P. Lovecraft*, 1999, hat er einer Erzählung von Jorge Luis Borges entlehnt, die ihrerseits eine Huldigung an Lovecrafts Horrorgeschichten ist. So installiert Nelson eine dritte fiktionale Ebene, die genau jenen Eindruck evoziert, den Lovecraft als „Atmosphäre eines atemlosen, unerklärlichen Grauens vor unbekannten außerweltlichen Mächten" beschrieben hat. Der Ausstellungsraum ist leer, doch seine Wände sind durch die wütenden Kratzspuren einer unbekannten Kreatur gezeichnet. Unter Verzicht auf einfache Antworten befördert Nelson uns in eine narrative Endlosschleife. Ihre Bedeutung erschließt sich einzig aus der Befremdung und der Unsicherheit, die die Situation in unserer Vorstellung auslöst. In *The Deliverance and the Patience*, gezeigt 2001 in Venedig, macht er sich die Verletzlichkeit eines Publikums zunutze, dessen Orientierungsvermögen durch die verwirrende Geografie der Stadt ohnehin bereits auf eine harte Probe gestellt ist. Beim Betreten der Installation musste der Besucher sich zwischen mehreren Türen entscheiden, die jeweils Zutritt zu einem unüberschaubaren Gewirr von Räumlichkeiten und Korridoren gewähren: einer schäbigen Hinterhoffabrik mit zahllosen Stofffetzen, einem zweitklassigen Reisebüro, einer Matrosenkneipe mit geschmacklosem Seemannsdekor. Der Besucher wird in eine fiktionale Welt hineingeworfen. Hinter einer der Türen führt eine Treppe in ein Zwischengeschoss, von dem aus sich die gesamte Struktur dieses verworrenen Labyrinths überblicken lässt, so dass der Mechanismus des ganzen Spektakels verständlich wird. Doch ungeachtet dieses Wissens bleibt der mysteriöse Charakter der lediglich vorgestellten Bewohner erhalten und erschüttert den Glauben an die eindeutige Logik und Ordnung des rationalen Universums.

Les installations labyrinthiques de Mike Nelson tissent des références littéraires, cinématographiques, historiques et socio-politiques pour fabriquer des réalités parallèles réalistes et convaincantes mais néanmoins désorientantes. Son exposition de 1999, *To the Memory of H. P. Lovecraft,* emprunte son titre à une nouvelle de Jorge Luis Borges, elle-même un hommage aux histoires d'épouvante de Lovecraft, et construit une troisième fiction qui dégage « une certaine atmosphère d'angoisse suffocante et inexpliquée suscitée par des forces extérieures inconnues ». La galerie est vide mais ses murs ont été précédemment lacérés par quelque créature inconnue lors d'une scène de destruction violente. N'offrant pas de réponse simple, Nelson nous entraîne dans une narration circulaire sans conclusion claire dont la signification réside dans la conscience de soi et l'incertitude qu'elle provoque dans notre imagination. *The Deliverance and the Patience,* montée à Venise en 2001, exploite la vulnérabilité du public déjà désorienté par la géographie déconcertante de la ville. En entrant dans l'espace, le visiteur doit choisir entre plusieurs portes, chacune ouvrant sur un dédale étourdissant de pièces et de couloirs : un atelier de confection miteux jonché de déchets de tissus, une agence de voyage de seconde zone, un bar de capitaine décoré de souvenir ringards de stations balnéaires. Le visiteur est propulsé dans un monde fictif. Un escalier derrière l'une des portes mène à une mezzanine d'où l'on peut voir l'ensemble de la structure contenant le dédale de pièces, dévoilant ainsi les mécaniques du spectacle. Toutefois, même quand on est armé de cette connaissance, les habitants fictifs conservent tout leur mystère, faisant vaciller notre foi en la logique fixe et l'ordre de l'univers rationnel. K. B.

SELECTED EXHIBITIONS →
1999 *To the Memory of H. P. Lovecraft,* Collective Gallery, Edinburgh, UK **2000** *The Coral Reef,* Matt's Gallery, London, UK; *The British Art Show 5,* Hayward Gallery, London, UK **2001** *The Deliverance and the Patience,* Peer Commission for the 2001 Venice Biennale, Italy; *Nothing is True, Everything is Permitted,* Institute of Contemporary Arts, London, UK; *International Communities,* Rooseum, Center for Contemporary Art, Malmö, Sweden; *The Turner Prize Exhibition,* Tate Gallery, London, UK **2002** *Biennale of Sydney,* Australia

SELECTED BIBLIOGRAPHY →
1997 *Projects 1997,* Galerie im KünstlerHaus, Bremen **1999** *TOURIST HOTEL,* Douglas Hyde Gallery, Dublin **2000** *Extinction Beckons,* Matt's Gallery, London; *British Art Show 5,* Hayward Gallery, London **2001** *A Forgotten Kingdom,* Institute of Contemporary Arts, London

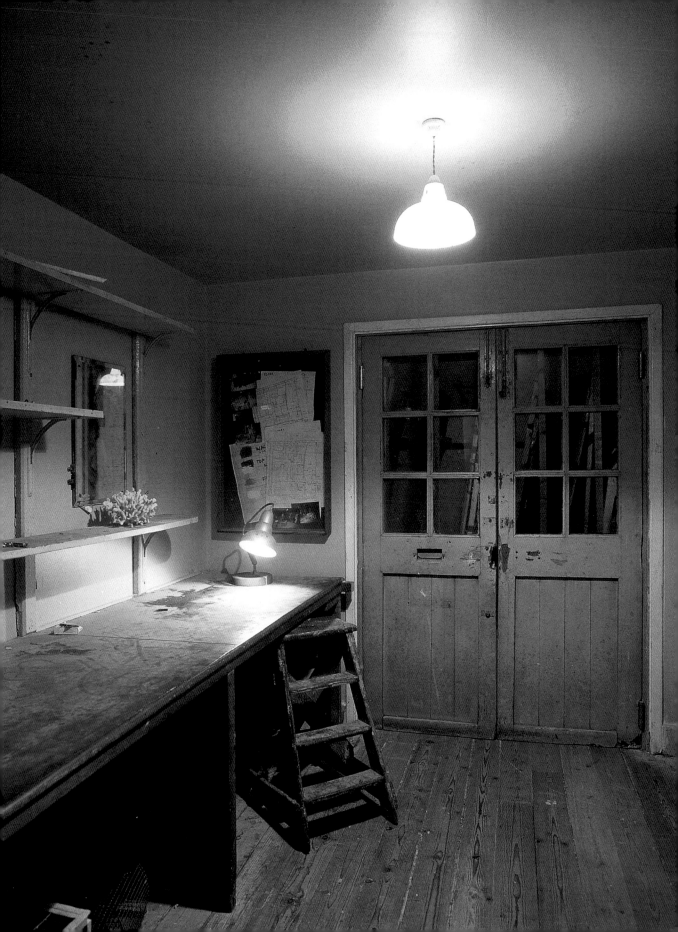

330

1 **The Cosmic Legend of the Uroboros serpent,** 2001, installation view, *The Turner Prize Exhibition,* Tate Britain, London

2 **Nothing Is True, Everything Is Permitted,** 2001, installation view, Institute of Contemporary Arts, London

3 **The Coral Reef,** 2000, installation view, Matt's Gallery, London

„Ich versuche auszudrücken, was vermutlich eine Menge Leute empfinden: Die Unmöglichkeit, an etwas zu glauben, obwohl man unbedingt etwas glauben möchte."

« J'essaie d'exprimer ce que beaucoup de gens ressentent probablement. La volonté de croire en quelque chose et l'impossibilité de croire en quoi que ce soit. »

"I'm trying to articulate what probably a lot of people feel: the impossibility of believing in anything but wanting to believe in something."

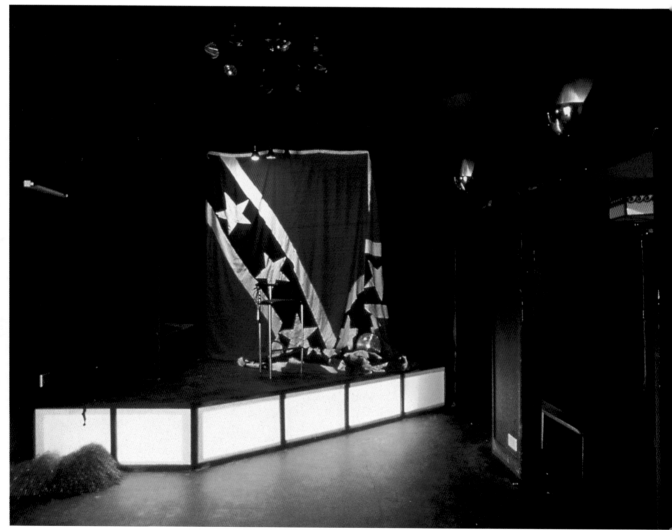

2

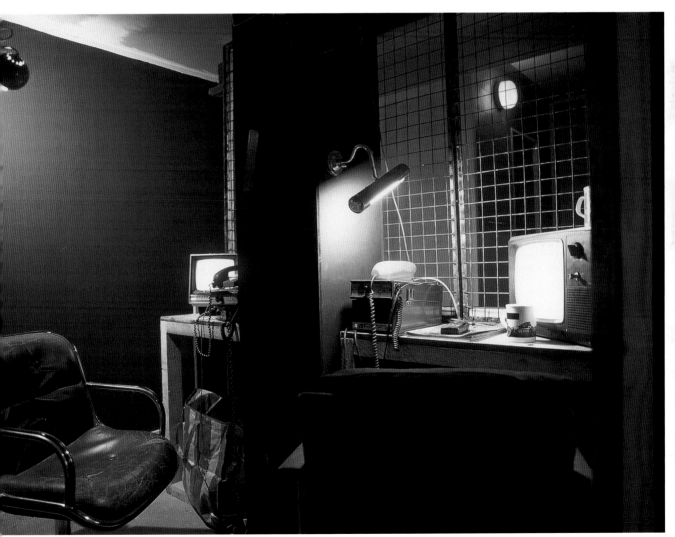

Shirin Neshat

1957 born in Qazvin, Iran, lives and works in New York (NY), USA

Islamic culture used to hold a fascination for the artistic imagination of the West, but now it has become a haunting, unruly Other. In her photographs and videos, Shirin Neshat unveils a political passion that resists the traditional representations of the "orient", especially the stereotypical images of women. What used to be considered seductive and innocent in the classical Western view of Islamic femininity, hits a counterblast in Neshat's images, with the representation of armed and violent women. In her own words, she wishes to pursue a "particular feminism rooted in Islam". *Speechless*, 1996, is a cultural confrontation conveyed by a woman's direct gaze at the viewer. In her work, Neshat uses timeless identification marks of Islamic culture – black chadors, traditional calligraphy – to localise the central conflicts of her work in a space where social law can be artistically examined. In her recent videos, Neshat focuses on emotional complexity within the discussion of identity. Her double-channel video work *Turbulent*, 1998, enacts a visual dialogue between the two screens. In the work's first half a man sings a traditional Sufi mystical poem, surrounded by other men. From the other screen a solitary woman responds, singing wordlessly, with haunting sounds, provoking shocked reactions from the male audience opposite. The duality at stake in the work, between male and female space, organised discourse and disorganised sound, is never redeemed. Isolated from each other, the two protagonists observe separate, almost antagonistic codes of culturally prescribed behaviour, each from their own side of the gallery space.

Früher einmal hat die islamische Kultur auf die künstlerische Vorstellungskraft des Abendlandes eine immense Faszination ausgeübt, während sie heute nur mehr als gespenstisches, aufsässiges Anderes vorkommt. In ihren Fotografien und Videos offenbart Shirin Neshat eine politische Leidenschaft, die sich den traditionellen Darstellungen „des" Orients widersetzt, besonders dem klischeehaften Frauenbild. Was in der klassischen westlichen Wahrnehmung islamischer Weiblichkeit einmal als verführerisch und unschuldig galt, wird durch Neshats Bilder, auf denen bewaffnete, gewaltbereite Frauen zu sehen sind, einfach hinweggefegt. Nach eigener Aussage möchte sie „einen im Islam verwurzelten speziellen Feminismus" erkunden. So handelt es sich etwa bei *Speechless*, 1996, um einen Akt der kulturellen Konfrontation, da die dort abgebildete Frau den Betrachter direkt ansieht. Neshat verwendet zeitlose Symbole der islamischen Kultur, etwa schwarze Tschadors oder traditionelle Kalligrafie, um die zentralen Konflikte ihres Schaffens in einer Dimension zu verorten, die eine künstlerische Auseinandersetzung mit der sozialen Wirklichkeit ermöglicht. In ihren neueren Videos beschäftigt sich Neshat im Kontext des aktuellen Identitätsdiskurses vor allem mit der Frage der emotionalen Komplexität. So hat sie etwa in ihrer Videoarbeit *Turbulent*, 1998, einen Dialog zwischen zwei Projektionsflächen inszeniert. Im ersten Teil der Präsentation singt ein Mann im Kreis anderer Männer ein traditionelles Sufi-Gedicht. Auf dem gegenüberliegenden Bildschirm antwortet eine einzelne Frau, indem sie – wortlos – ergreifende Klänge singt und damit beim männlichen Publikum auf dem Monitor gegenüber schockierte Reaktionen auslöst. Die Dualität zwischen männlich und weiblich besetztem Raum, zwischen organisiertem Diskurs und desorganisiertem Klang, um die es in dem Werk geht, wird nicht zum Verschwinden gebracht. Voneinander abgeschottet, folgen die Protagonisten grundverschiedenen, fast antagonistischen Verhaltensmustern und bleiben, jeder auf seiner Seite des Raums, unaufhebbar getrennt.

Autrefois, la culture islamique fascinait l'imagination artistique de l'Occident mais, aujourd'hui, elle est devenue l'Autre, hantante et indisciplinée. Dans ses photographies et ses vidéos, Shirin Neshat dévoile une passion politique qui résiste aux représentations traditionnelles de « l'Orient », et notamment aux images stéréotypées de la femme. La vision classique occidentale de la féminité islamique, présentée comme séduisante et innocente, trouve une riposte vigoureuse dans les images de Neshat montrant des femmes armées et violentes. Selon ses propres termes, elle souhaite traiter un « féminisme particulier enraciné dans l'islam ». *Speechless*, 1996, est une confrontation culturelle traduite par le regard direct d'une femme qui fixe le spectateur. Neshat utilise des repères atemporels de la culture islamique – les tchadors noirs, la calligraphie traditionnelle – pour localiser les conflits au cœur de son travail dans un espace où la loi sociale peut être examinée sur le plan artistique. Dans ces vidéos récentes, Neshat traite la complexité émotionnelle au sein du débat sur l'identité. *Turbulent*, 1998, recrée un dialogue visuel entre deux écrans vidéo. Pendant la première moitié de l'œuvre, un homme chante un poème mystique soufi traditionnel entouré de collègues masculins. Sur l'autre écran, une femme seule lui répond, chantant sans paroles, émettant des sons troublants qui provoquent des réactions choquées de la part des hommes à côté. La dualité dans son œuvre, entre l'espace féminin et masculin, entre le discours organisé et le son désorganisé, ne connaît aucune rédemption. Les deux protagonistes suivent des codes de comportement séparés, presque antagonistes, dictés par la culture, chacun isolésdans son coin de la galerie.

L. B. L.

SELECTED EXHIBITIONS →
1998 Tate Gallery, London, UK **1999** Malmö Konsthall, Malmö, Sweden; *48. Biennale di Venezia*, Venice, Italy **2000** Serpentine Gallery, London, UK; Kunsthalle Wien, Vienna, Austria; *Biennale of Sydney*, Australia; *Kwangju Biennale*, Kwangju, South Korea; *Whitney Biennial*, Whitney Museum of American Art, New York (NY), USA **2001** Barbara Gladstone Gallery, New York (NY), USA; *Biennial de Valencia*, Spain

SELECTED BIBLIOGRAPHY →
1997 *Shirin Neshat*, Marco Noire Contemporary Art, Turin **1999** *Cream. Contemporary Art in Culture*, London **2000** *Shirin Neshat*, Kunsthalle Wien, Vienna/Serpentine Gallery, London **2001** Uta Grosenick (ed.), *Women Artists*, Cologne; Farzeneh Milani, *Shirin Neshat*, Milan; Octavio Zaya/Yuko Hasegawa/Fumihiko Sumitomo, *Shirin Neshat*, Office for Contemporary Art Museum Construction, Kanazawa

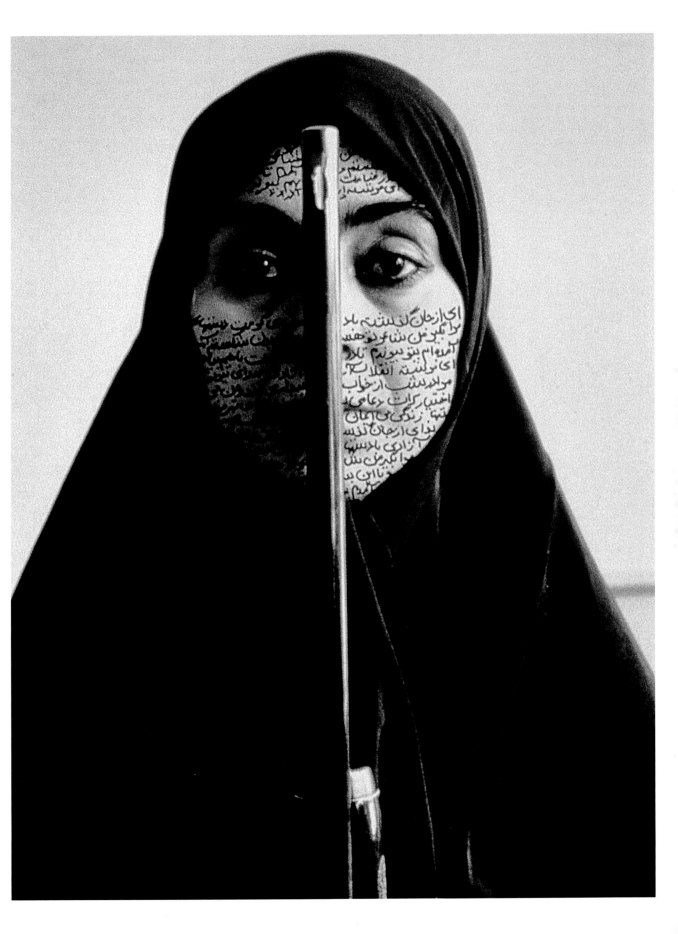

1	**Rebellious Silence,** 1994, gelatin silver print, ink, 36 x 28 cm	3	**The Shadow under the Web,** 1997, video stills
2	**Passage,** 2001, production still	4	**Pulse Series,** 2001, cibachrome print, 45 x 59 cm

„In der gesamten Geschichte haben muslimische Frauen Seite an Seite mit Männern an der Front gekämpft. Hier haben die Frauen an der Verantwortung und den Konsequenzen des Märtyrertums Anteil gehabt. Dabei lässt sich ein merkwürdiges Nebeneinander von Weiblichkeit und Gewalt beobachten."

« Tout au long de l'histoire, les femmes musulmanes ont lutté aux côtés des hommes sur la ligne de front. Elles ont partagé la responsabilité et le coût du martyre. On observe une étrange juxtaposition entre la féminité et la violence. »

"Throughout history, Islamic women have fought alongside men in the line of duty. Here women have shared the responsibility and the cost of being martyred. You can witness a strange juxtaposition between femininity and violence."

2

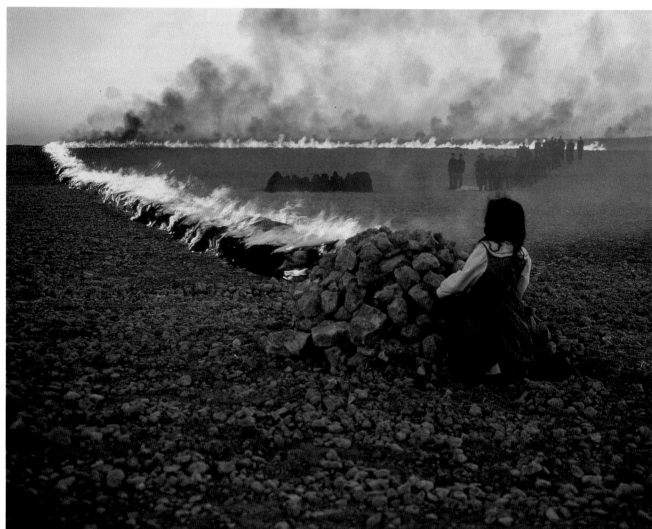

3

4

Ernesto Neto

1964 born in Rio de Janeiro, lives and works in Rio de Janeiro, Brazil

Ernesto Neto's *Naves* are tent-like structures made of lycra that envelop viewers in transparent, multi-sensory environments. The *Naves,* which means "spaceships" in Portuguese, are suspended, anchored, and balanced within the gallery space by counter-weights filled with sand and other materials. Neto also creates room-scale installations, such as *It happens on the friction of the bodies,* 1998, and *We fishing the line,* 1999, that utilise the pliable fabric to create column-like forms that are suspended from above and filled with cumin, turmeric and cloves. The spices not only add colour to the bases of the organic forms, but also suffuse the gallery with rich aromas. The fabric containers, contorted from the weight of their contents, are configured in playful arrangements that surround viewers and activate the senses. The body is at the forefront of Neto's artistic practice, and many of his pieces are womb-like. Formal, conceptual and metaphoric comparisons can be drawn between the fabric of the work, human skin and architectural membranes, all of which are barriers as much as portals. While Neto's work is sensuous and organic, it also demonstrates an attention to geometry, order and balance – an apparent opposition that has played a key role in Brazilian art since the middle of the 20th century. Working in the tradition of the Neo-Concrete movement, Neto uses modest materials to engage viewers, while connecting emotional and rational approaches to art production. Many of the classic sculptural concerns, such as mass and gravity, colour and form, are important to Neto in his exploration of the sensuality of his materials.

Die *Naves* von Ernesto Neto sind zeltartige Konstruktionen aus Lycra, die den Betrachter in eine alle Sinne ansprechende transparente Welt versetzen. Im Ausstellungsraum sind die *Naves* (portugiesisch: Raumschiffe) durch ein System von – mit Sand und anderen Materialien gefüllten – Gegengewichten aufgehängt, verankert und stabilisiert. In seinen raumfüllenden Installationen – etwa *It happens on the friction of the bodies,* 1998, und *We fishing the line,* 1999, gestaltet Neto aus dem formbaren Kunststoff säulenartige, von oben herabhängende Formen. Gefüllt mit Kreuzkümmel, Kurkuma und Nelken, leuchten die unteren Bereiche der organischen Formen farbig und durchdringen mit ihrem Duft den ganzen Galerieraum. Die unter dem Gewicht ihrer Ladung verformten Lycra-„Beutel" sind in verspielten Arrangements angeordnet, die von allen Seiten auf den Betrachter einwirken und seine Sinne aktivieren. Der Körper steht im Zentrum von Netos künstlerischem Schaffen; viele seiner Arbeiten lassen an einen Uterus denken. Konzeptuelle und metaphorische Vergleiche zwischen dem Arbeitsmaterial, der menschlichen Haut und den verschiedensten architektonischen Membranen drängen sich auf, da all diese ebenso trennen wie verbinden. Aber Netos Werk besticht nicht nur durch seine Sinnlichkeit und seinen organischen Charakter, es richtet die Aufmerksamkeit zugleich auch auf Fragen der Geometrie, der Ordnung und der Balance – ein scheinbarer Widerspruch, der bereits seit Mitte des 20. Jahrhunderts im Zentrum der brasilia- nischen Kunst steht. In der Tradition der neo-konkreten Kunst verwendet Neto eher unscheinbare Materialien, um den Betrachter in den Bann zu ziehen, während in seinem Kunstschaffen zugleich emotionale und rationale Kriterien eine Verbindung eingehen. In der Erkundung der sinnlichen Eigenschaften seiner Materialien setzt Neto sich auch mit den Grundfragen der klassischen Bildhauerei auseinander, etwa dem Verhältnis von Masse und Schwerkraft, Farbe und Form.

Les *Naves* d'Ernesto Neto sont des sortes de tentes en lycra qui enveloppent les spectateurs dans des environnements transparents et multisensoriels. Ces *Naves,* qui signifient « vaisseaux spatiaux » en portugais, sont suspendues, ancrées, équilibrées dans l'espace de la galerie par des contrepoids remplis de sable et d'autres matériaux. Neto crée aussi des installations à l'échelle de la pièce, tels que *It happens on the friction of the bodies,* 1998, et *We fishing the line,* 1999, qui utilisent des matières malléables pour créer des colonnes suspendues au plafond et remplies de cumin, de curcuma et clous de girofle. Outre le fait d'ajouter de la couleur à la base des colonnes, les épices diffusent de riches arômes dans la galerie. Ces contenants, déformés par le poids de leurs contenus, sont disposés d'une manière ludique de sorte à entourer les spectateurs et à activer leurs sens. Le corps est au premier plan de la pratique artistique de Neto : bon nombre de ses pièces sont comme des ventres. On peut établir des comparaisons formelles, conceptuelles et métaphoriques entre la matière de l'œuvre, la peau humaine et les membranes architecturales, toutes étant des barrières ainsi que des portes. Si le travail de Neto est sensuel et organique, il est également attentif à la géométrie, à l'ordre et à l'équilibre, une opposition apparente qui joue un rôle clef dans l'art brésilien depuis le milieu du 20ème siècle. En travaillant dans la tradition du mouvement Néoconcret, Neto utilise des matériaux humbles pour séduire le spectateur tout en associant ses démarches émotionnelles et rationnelles à la réalisation de l'œuvre d'art. Dans son exploration de la sensualité des matériaux, il attache égale- ment une grande importance aux préoccupations de la sculpture classique, telles que la masse et la gravité, la couleur et la forme. Ro. S.

SELECTED EXHIBITIONS →
1998 *XXIV Bienal Internacional de São Paulo,* Brazil **1999** Contempor- ary Arts Museum, Houston (TX), USA; *Carnegie International,* Carnegie Museum of Art, Pittsburgh (PA), USA **2000** Institute of Contemporary Arts, London, UK; SITE Santa Fe (NM), USA; Wexner Center for the Arts, Columbus (OH), USA; *Wonderland,* Saint Louis Art Museum, St. Louis (MS), USA **2001** *Matrix 190,* University Art Museum, Berkeley (CA), USA; Brazilian Pavilion, *49. Biennale di Venezia,* Venice, Italy

SELECTED BIBLIOGRAPHY →
1998 Carlos Basualdo, *Ernesto Neto,* São Paulo **1999** *Ernesto Neto: naves, ceus, sonhos,* Galeria Camargo Vilaça, São Paulo; *Carnegie International,* Carnegie Museum of Art, Pittsburgh (PA) **2000** *Wonder- land,* Saint Louis Art Museum, St. Louis (MS) **2001** *MATRIX 190: Ernesto Neto,* University Art Museum, Berkeley (CA)

1 **Nhó Nhó Nave,** 1999, stocking, sand, installation view, Contemporary Arts Museum, Houston (TX)
2 **The Ovaloids' Meeting,** 1998, stocking, styrofoam, installation view, Tanya Bonakdar Gallery, New York (NY)

3 **O Bicho,** 2001, textile, spices, c. 5 x 12 x 12 m, installation view, Arsenale, *49. Biennale di Venezia,* Venice
4 **Walking in Venus blue cave,** 2001, stocking, styrofoam, buttons, incandescent lights, 396 x 777 x 833 cm, installation views, *Only the amoebas are happy,* Tanya Bonakdar Gallery, New York (NY)

„Ich stelle mir den Körper gerne zugleich als architektonisches Bauwerk und als Landschaft vor."

« J'aime à imaginer le corps comme étant à la fois une construction architecturale et un paysage. »

"I like to think of the body as both an architectural construction and a landscape."

2

3

4

Rivane Neuenschwander

1967 born in Belo Horizonte, lives and works in Belo Horizonte, Brazil

The architecture of exhibition spaces, the rigour of minimalist geometry and the accidental nature of organic life meet in Rivane Neuenschwander's art. She is a poetess of disintegration and recomposition. In nature, once begun these processes never end, because the circulation of matter is never-ending. Neuenschwander stops the natural process: life freezes into an artwork. A piece of white rice paper being devoured by slugs slowly surrenders to something that can be described as a map of slug peregrinations (*Starving letters*, 2000). Neuenschwander uses materials which refer to the sense of smell, touch and taste: black pepper between stretches of two-sided adhesive tape; a plate inlaid with dried slices of tomato; white marble dust filling fissures in the floor. Her works cannot be reduced to images and concepts. They engage the viewer's physical presence in transactions with their own material composition: the viewer inadvertently adds his or her own dust to the tape installation on the wall. In her recent installation *Scrabble*, 2001, at ArtPace, a room was arranged into a sort of scrabble board. In a labyrinth of cardboard boxes and newspapers laid out on the floor, viewers could compose words with letters cut out of dried grapefruit peel. Finally, in a black-and-white film made in collaboration with Brazilian filmmaker Cao Guimarães, ants carry the words WORLD and WORD cut out of a dictionary, and fight over them (*World/Word*, 2001). Neuenschwander attempts to study the crucial connection between words and beings and objects.

In der Kunst von Rivane Neuenschwander trifft die Architektur des Ausstellungsraumes mit der minimalistischen Geometrie und dem Zufallsprinzip des organischen Lebens zusammen. Die Künstlerin ist eine Poetin der Desintegration und der Rekomposition. In der Natur bilden diese Prozesse, sobald sie einmal begonnen haben, eine endlose Kette, weil die Zirkulation der Materie kein Ende kennt. Neuenschwander bringt dieses natürliche Geschehen zum Stillstand: Das Leben gerinnt zu einem Kunstwerk. So verwandelt sich beispielsweise ein Stück weißes Reispapier, das von Schnecken verschlungen wird, in eine Kartografie der Fortbewegung der kleinen Tiere (*Starving letters*, 2000). Die Materialien, mit denen Neuenschwander arbeitet, verweisen auf unseren Geruchs-, Tast- und Geschmackssinn: schwarzer Pfeffer zwischen beidseitig haftenden Klebebandstreifen; ein mit getrockneten Tomatenscheiben belegter Teller; weißer Marmorstaub, der Risse im Boden ausfüllt. Ihre Arbeiten lassen sich nicht auf Bilder und Konzepte reduzieren. Sie verwickeln den Betrachter vielmehr fast „körperlich" in Austauschprozesse, da die Installation an der Wand durch Kleinstpartikel verändert wird, die der Besucher unwissentlich hinterlässt. In einer neueren Installation (*Scrabble*, 2001), die sie für ArtPace gemacht hat, arrangierte sie einen Raum nach Art eines Scrabblebretts. Sie schuf auf dem Boden aus Pappkartons und Zeitungen eine Art Labyrinth und überließ es dem Publikum, aus Buchstaben, die aus getrockneten Pampelmusenschalen ausgeschnitten waren, Wörter zu bilden. Außerdem drehte Neuenschwander zusammen mit dem brasilianischen Filmemacher Cao Guimarães einen Schwarzweißfilm, in dem Ameisen zu sehen sind, die die aus einem Wörterbuch ausgeschnittenen Wörter WORLD und WORD umherschleppen und um die Schnipsel kämpfen (*World/Word*, 2001). In diesem Projekt erkundet Neuenschwander die Schnittstelle zwischen Wörtern, Lebewesen und Objekten.

L'architecture de l'espace d'exposition, la rigueur de la géométrie minimaliste et la nature accidentelle de la vie organique se rejoignent dans le travail de Rivane Neuenschwander. C'est une poétesse de la désintégration et de la recomposition. Dans la nature, une fois que ces processus sont enclenchés, ils ne s'interrompent jamais, car la circulation de la matière est perpétuelle. Neuenschwander arrête le processus naturel : la vie se fige en une œuvre d'art. Un morceau de papier de riz blanc dévoré par des limaces se métamorphose lentement en une sorte de carte des pérégrinations des gastéropodes (*Starving letters*, 2000). Neuenschwander utilise des matériaux qui renvoient aux sens du toucher, de l'odorat et du goût : du poivre noir entre deux bandes de ruban adhésif double face ; une assiette incrustée de tranches de tomates séchées ; de la poudre de marbre blanc comblant des fissures dans le sol. Ses œuvres ne peuvent être réduites à des images ou des concepts. Elles entraînent la présence physique du spectateur dans des transactions avec leurs propres compositions matérielles : sans s'en rendre compte, le spectateur ajoute sa propre poussière à l'installation adhésive sur le mur. Dans son installation récente à ArtPace (*Scrabble*, 2001), une pièce était aménagée comme une sorte de plateau de scrabble. Dans un labyrinthe de caisses en carton et de journaux étalés sur le sol, les spectateurs pouvaient composer des mots avec des lettres découpées dans des pelures séchées de pamplemousse. Enfin, dans un film en noir et blanc réalisé en collaboration avec le réalisateur brésilien Cao Guimarães, des fourmis transportaient et se disputaient les mots WORLD et WORD découpés dans un dictionnaire (*World/Word*, 2001). Neuenschwander tente d'étudier la connexion vitale entre les mots, les êtres et les objets.

A. S.

SELECTED EXHIBITIONS →
1997 Stephen Friedman Gallery, London, UK; *2nd Johannesburg Biennale*, Johannesburg, South Africa **1998** New Museum, New York (NY), USA **1999** *SITE Santa Fe 3rd International Biennial*, Santa Fe (NM), USA **2000** *Syndrome*, IASPIS, Stockholm, Sweden; Douglas Hyde Gallery, Dublin, Ireland; Galerie Camargo Vilaça, São Paulo, Brazil; *Homage to the Space*, The National Museum of Art, Osaka, Japan **2001** The Americas Society, New York (NY), USA; ArtPace, San Antonio (TX), USA

SELECTED BIBLIOGRAPHY →
1998 *Cream*, London **1999** *Powder*, Aspen Art Museum, Aspen (CO) **2000** *Rivane Neuenschwander*, Galeria Camargo Vilaça, São Paulo/Stephen Friedman Gallery, London/The Douglas Hyde Gallery, Dublin

Olaf Nicolai

1962 born in Halle/Saale, lives and works in Berlin, Germany

A graduate in philology and semantics, Olaf Nicolai grew up in the German Democratic Republic. In his art, Nicolai also confronts seemingly impenetrable systems. For example, he explores the role of nature in a thoroughly artificial environment. Or he fathoms the possibilities of "free" artistic output in a world governed by aesthetic considerations, in which each new formulation seems to be a quotation from something else. At first sight, *Labyrinth,* 1998, looks like a rectangular maze composed of green shrubs set in an idyllic park. A closer look reveals that what appears natural is in fact made of plastic brooms, the kind used for sweeping the streets. The labyrinth is itself a reference to the French baroque. This is an example of how the artist draws on different sources to create a vertiginous mix of the historical and contemporary, of the natural and the artificial. At another exhibition of his work, Nicolai presented an enormous, inflated Nike trainer, *Big Sneaker,* 2001, bearing the cult label "Air Max". This style-conscious, ostentatious, overpowering object assumes the same role as that of the "real-life" original version – an expensive status symbol that guarantees the wearer will be seen as modishly hip and trendily stylish. Nicolai ironically exposes this attitude, and questions the mechanisms that made the Nike sneaker one of the unique style icons of the 1990s. The artist's heightened aesthetic take on this cult object is a response to the mystique with which the company's marketing strategists surrounded this lifestyle statement. Perhaps only this kind of critique proves that art and everyday design are becoming interchangeable.

Der studierte Sprachwissenschaftler Olaf Nicolai ist in der DDR aufgewachsen. Scheinbar geschlossenen Systemen widmet er auch in der Kunst seine Aufmerksamkeit: zum Beispiel untersucht er die Qualität von Natur in einer durch und durch künstlichen Umwelt. Oder er lotet die Möglichkeiten von „freier" künstlerischer Produktion in einer komplett ästhetisierten Welt aus, in der jede neue Formulierung bereits ein Zitat zu sein scheint. Das *Labyrinth,* 1998, sieht auf den ersten Blick aus wie ein quadratischer Irrgarten, gepflanzt aus grünen Sträuchern inmitten einer idyllischen Parklandschaft. Auf den zweiten Blick entlarvt sich die vermeintliche Natur als aus grünen Plastikimitaten hergestellt, genauer: aus Besen für die Straßenreinigung. Die konkrete Form des Labyrinth ist ein Zitat aus dem französischen Barock. So sampelt der Künstler aus verschiedenen Quellen einen verwirrenden Mix aus Geschichte und Gegenwart sowie aus Künstlichkeit und Natürlichkeit. In einer anderen Ausstellung von Nicolai lag ein riesiger, aufgeblasener Nike-Schuh, *Big Sneaker,* 2001, des Kultmodells „Air Max". Stilbewusst und protzend zeugt dieses vereinnahmende Objekt von der Rolle, die sein kleineres „Original" im „wirklichen Leben" spielt: Als teures Statussymbol garantiert es modische Hipness und trendsicheres Auftreten. Nicolai deckt diese Haltung auf, ironisiert sie und fragt zudem nach den Mechanismen, die den Nike-Schuh zu einem einzigartigen Kultobjekt der neunziger Jahre gemacht haben. Die überhöhte Ästhetisierung durch den Künstler antwortet auf genau die Mystifizierung, mit der die Nike-Marketingstrategen ihren Lifestyle-Schuh versehen haben. Kunst und Alltagsdesign werden austauschbar, wobei die Kunst sich vielleicht noch durch ihren kritischen Impetus auszeichnet.

L'ancien étudiant en linguistique Olaf Nicolai a grandi en RDA. Dans son art aussi, Nicolai se penche sur les systèmes apparemment clos. Ainsi, il analyse par exemple la « qualité » de la nature dans un environnement artificiel. Ou bien il sonde les possibilités d'une production artistique dite « libre » au sein d'un monde intégralement esthétisé, et dans lequel toute formulation nouvelle apparaît d'emblée comme une citation. Le *Labyrinthe,* 1998, ressemble à première vue effectivement à un labyrinthe carré, planté de buissons verts et situé au beau milieu d'un idyllique parc paysager. Au second regard, la prétendue nature s'avère néanmoins être composée d'une fausse végétation de plastique vert, plus exactement : de balais employés au nettoyage urbain. Un autre aspect important est donné par le fait que la forme du labyrinthe est en fait une citation du jardin baroque à la française. Ainsi, l'artiste sample différentes sources en un troublant mixage d'histoire et de contemporanéité, d'artifice et de nature. Dans une autre exposition de Nicolai, on pouvait voir gonflée une immense chaussure Nike, *Big Sneaker,* 2001, du modèle culte « Air Max ». Par sa haute conscience stylistique et sa dilatation, cet objet séduisant illustre le rôle que le petit « original » joue dans la « vie réelle » : symbole statutaire dispendieux, il garantit une apparence « mode » et donne l'assurance d'être dans le vent. Nicolai met cette attitude en évidence par les moyens de l'ironie et questionne en même temps les mécanismes qui ont fait de la chaussure Nike un objet de culte unique des années 90. L'esthétisation sublimée par l'artiste répond en effet très exactement à la mystification qui permit aux stratèges du marketing de la firme d'associer tout un style de vie à leur chaussure. L'art et le design quotidien deviennent interchangeables, le premier ne se distinguant plus, peut-être, que par sa tendance critique. R. S.

SELECTED EXHIBITIONS →
1996 *Pflanze-Konstrukt,* Kunst in der Neuen Messe Leipzig, Germany; *nach Weimar,* Landesmuseum and Schloßmuseum Weimar, Germany **1997** *documenta X,* Kassel, Germany **2000** *Pantone Wall,* Bonner Kunstverein, Bonn, Germany; *... fading in, fading out, fading away,* Westfälischer Kunstverein, Münster, Germany; *What if,* Moderna Museet, Stockholm, Sweden; *Children of Berlin,* P.S.1, Long Island City (NY), USA **2001** Migros Museum für Gegenwartskunst, Zurich, Switzerland; *49. Biennale di Venezia,* Venice; *7th Istanbul Biennial,*
Istanbul, Turkey **2002** *Biennale of Sydney,* Australia

SELECTED BIBLIOGRAPHY →
1999 *Olaf Nicolai, show case,* Nuremberg **2000** *30 Farben,* Bonner Kunstverein **2001** *... fading in, fading out, fading away,* Westfälischer Kunstverein, Münster

1 **Labyrinth,** 1998, plastic brooms, 60 x 1000 x 1000 cm, installation view, Parc de La Courneuve, Seine-Saint-Denis
2 **Enjoy/Survivre I + II,** 2001, lightboxes, ø 210 x 25 cm
3 **Portrait of the Artist as a Weeping Narcissus,** 2000, polyester, 90 x 156 x 268 cm, installation view, Galerie Eigen + Art, Berlin

4 **Big Sneaker,** 2001, synthetic, inflatable, 9 x 4 x 3 m, installation view, Migros Museum für Gegenwartskunst, Zurich
5 **Interieur/Landschaft. Ein Kabinett,** 1997, carpets, stones, plant, lightboxes, platform, dimensions variable, installation view, *documenta X*, Kassel

„Hock dich an dein Mischpult. Sample. Und: Lass den Dingen ihren Lauf!" « S'accrocher à sa table de mixage. Sampler. Et être, tout simplement. »

"Hitch yourself to your mixing desk. Sample. And: Just be!"

2

3

4

5

Manuel Ocampo

1965 born in Quezon, Philippines, lives and works in Berkeley (CA), USA

At first sight, Manuel Ocampo's pictures recall "alternative" political comic strips. Firstly, the similarities with the genre lie in their combination of figurative representation, typical of political and pop-cultural humour, with their pornographic and scatological references, and their religious symbolism, which all come together to create apocalyptic scenarios. Secondly, Ocampo's smoothly executed canvases share with comic strips a kind of even-handedness in the interpretation of such diverse sources of inspiration. His work is deliberately intended to provoke. He places devotional images from his native Philippines side by side with swastikas or Ku Klux Klan hoods. By contrast, his paintings are executed in distinctively brilliant colours. With their combination of imagery and lettering, they resemble the sleeves of heavy metal LPs. Rather than displaying any sense of stylistic or idiomatic continuity, Ocampo's art relies on a collage-like assembly of opposites: tradition and pop culture, innocence and horror, decoration and social critique. His allegorical juxtaposition of conflicting images produces a colonialist view of the cultures of the so-called developing countries. Through ironically introducing the historical and religious symbols of the Western world, Ocampo satirises, sometimes cynically and sometimes with black humour, their iconic status and claims to authority. For example, *God*, 1991, shows huge cockroaches in a mandorla, while bloodstained knives replace the insignia of Christ. In *Untitled (Burnt-Out Europe)*, 1992, Jesus wears both the crown of thorns and eagle's wings emblazoned with swastikas. Ocampo's painting points the finger at pain and torture as negative instruments of power in the history of colonial lands.

Die Bilder von Manuel Ocampo erinnern auf den ersten Blick an politische Comics aus dem subkulturellen Bereich. Die Ähnlichkeiten zu diesem Genre liegen zum einen in der Kombination von Figürlichem aus politischen und popkulturellen Kontexten mit pornografischen Darstellungen, Fäkalischem und sakraler Symbolik zu apokalyptischen Szenen, und zum anderen in der medialen Glättung dieser heterogenen Bildquellen, die bei Ocampo auf der gleichmäßig behandelten Leinwand stattfindet. Seine Bildthemen provozieren, so stellt er zum Beispiel Votivbilder seiner philippinischen Heimat neben Hakenkreuze oder Ku-Klux-Klan-Kapuzen. Im Kontrast dazu steht die ausgeprägte strahlende Farbigkeit seiner Bilder. In der Kombination mit Schriftzügen erinnern die Arbeiten an Plattencover, etwa aus der Heavy-Metal-Szene. Vielmehr als in einer stilistischen oder idiomatischen Kontinuität liegt das Prinzip der Kunst Ocampos in der collageartigen Zusammenführung von Gegensätzen: Tradition und Popkultur, Unschuld und Horror, Dekoration und soziale Kritik. Allegorisch verwendet, widersetzen sich Ocampos Zeichenkombinationen einem kolonialistischen Blick auf die Kulturen so genannter Entwicklungsländer. Durch Einsatz der Symbole westlicher Geschichte und Religion konterkariert Ocampo in seinen Bildern ironisch, teils zynisch oder von schwarzem Humor geleitet deren hegemonialen Anspruch. Beispielsweise sind riesige Küchenschaben in einer Mandorla dargestellt und tragen anstelle der Insignien Christi blutige Messer (*God*, 1991), oder Jesus wird mit Dornenkrone und dem Körper eines Adlers versehen, auf dessen Flügeln Hakenkreuze angebracht sind (*Untitled [Burnt-Out Europe]*, 1992). Ocampos Malerei benennt Schmerz und Qual als negative Kräfte in der Geschichte der kolonialisierten Länder.

Au premier regard, les tableaux de Manuel Ocampo rappellent les bandes dessinées politiques issues du domaine subculturel. Les rapprochements avec ce genre résident d'une part dans la combinaison de scènes figurées tirées du contexte politique et de la culture pop, d'images pornographiques, d'aspects fécaux et de symboliques sacrées en scènes apocalyptiques, et d'autre part dans le lissage médiatique de ces sources iconiques hétérogènes dans une peinture homogène. Les thèmes picturaux d'Ocampo sont provocateurs. C'est ainsi qu'il juxtapose des images votives de sa patrie philippine et des croix gammées ou des capuches du Ku-Klux-Klan. Contrastant avec ces symboles, on trouve une polychromie franchement radieuse. Avec l'intégration d'éléments textuels, ses œuvres rappellent les créations des pochettes de disques, notamment du domaine du « heavy-metal ». Plus que dans la continuité stylistique ou idiomatique, le principe de l'art d'Ocampo réside dans un assemblage d'oppositions qui tient du collage : tradition et culture pop, innocence et horreur, décoration et critique sociale. Utilisées allégoriquement, les combinaisons de signes d'Ocampo se dressent contre le regard colonialiste porté sur les cultures des pays dits en voie de développement. En faisant appel aux symboles de l'histoire et de la religion occidentales, Ocampo contrecarre leurs visées hégémoniques d'une manière ironique, parfois empreinte de cynisme et d'humour noir. D'immenses blattes sont représentées dans une mandorle avec des couteaux sanglants au lieu des insignes du martyre du Christ (*God*, 1991), ou bien Jésus est affublé d'une couronne d'épines et d'un aigle dont les ailes portent des croix gammées (*Untitled [Burnt-Out Europe]*, 1992). La peinture d'Ocampo dénonce la souffrance et la torture comme des forces négatives dans l'histoire des pays colonisés.

N. M.

SELECTED EXHIBITIONS →
1992 *documenta IX*, Kassel, Germany; *Helter Skelter*, The Museum of Contemporary Art, Los Angeles (CA), USA **1997** *Kwangju Biennial*, Kwangju, South Korea **1999** *Faith: The Impact of Judeo-Christian Religion on Art at the Millennium*, The Aldrich Museum of Contemporary Art, Ridgefield (CT), USA **2001** *49. Biennale di Venezia*, Venice, Italy; *2 berlin biennale*, Berlin, Germany; *Vom Eindruck zum Ausdruck – Grässlin Collection*, Deichtorhallen Hamburg, Germany; Galería OMR, Mexico City, Mexico

SELECTED BIBLIOGRAPHY →
1995 *Manuel Ocampo, Virgin Destroyer*, Honolulu (HI)
1997 *Manuel Ocampo, Heridas de la Lengua*, Santa Monica (CA)
1998 *Yo Tambien Soy Pintura*, Museo Extremeño e Iberoamericano de Arte Contemporaneo, Badajoz

1 A Moral Exorcism Meaningless Outside a Ritualistic Sense of Artistic
Heroism, 2000, acrylic on canvas, 213 x 167 cm

2 The Failure to Express is its Expression/the Stream of Object Making
Consciously Working Towards the Goal, 2000, 15 panels, acrylic on wood,

various sizes, 2 hammocks, 2 hubble-bubbles, porn magazine, wig,
c. 7 x 8 m, installation view, Galerie Michael Neff, Frankfurt am Main

3 The World is Full of Objects More or Less interesting, 1998, acrylic and
collage on canvas, 154 x 122 cm

„Ich möchte mit den Mitteln der Malerei buchstäblich eine Landschaft ent-
stehen lassen, nicht nur ein Fenster, durch das man in einen imaginierten
Raum blickt, sondern eine wirkliche Umgebung."

« Je cherche à créer une géographie directe à l'aide de la peinture :
pas seulement une fenêtre ouverte sur un espace imaginaire, mais un
environnement. »

"I want to create a literal landscape with painting,
not just a window into an imagined space, but an environment."

2

Albert Oehlen

1954 born in Krefeld, lives and works in Cologne, Germany

Albert Oehlen called his first exhibition, staged in 1982 at the Max Hetzler gallery in Stuttgart, *Bevor ihr malt, mach ich das lieber* (Before you paint, I prefer to do it myself). And that's the way he has continued. He still feels a sense of responsibility, and sets an example with every picture. It is part of Oehlen's charm that he avoids any clear meaning, but he can always offer a point of view. He presents contemporary painting and, at the same time, the clichés of contemporary painting. Oehlen is constantly exploring new ideas, whether they involve brandishing a brush or switching on the computer or laying six million tiny stones to create a floor mosaic, as he did at EXPO 2000. Along with Werner Büttner, Georg Herold and Martin Kippenberger, he was one of the enfants terribles of the 1980s art scene. Together with Albert's brother Markus Oehlen these artists carried out extremely successful experiments with Germany's image and understanding of itself as a nation. Titles of the mid-Eighties, such as *Morgenlicht fällt ins Führerhauptquartier* (Morning Light in the Führer's Headquarters) charged painting with unusual content, self-assuredly establishing new planes of visual imagery. In the 1990s, Oehlen adopted a new strategy. Motifs went by the board; now the whole concept of art was in question. Abstract painting demanded a virtuosity that he realised he would have to achieve for himself – the finest and greatest challenge for an artist like Oehlen. As a counterpoint to his oil paintings, he produced bold and simple computer-generated collages. His agenda still includes attacking art and discovering its weak points. As he said in an interview with Rainald Goetz, "one has to go joyfully berserk".

Seine erste Einzelausstellung, 1982 bei Max Hetzler in Stuttgart, nannte Albert Oehlen *Bevor ihr malt, mach ich das lieber*. Dabei ist es geblieben. Bis heute fühlt er sich verantwortlich und gibt ein Vorbild, Bild um Bild. Es gehört zu seinem Charme, dass Oehlen jede Eindeutigkeit meidet, aber immer eine Haltung anbieten kann. Er präsentiert zeitgenössische Malerei und gleichzeitig das Klischee der zeitgenössischen Malerei – ob er dafür den Pinsel schwingt oder den Computer anwirft oder sechs Millionen Steinchen zu Bodenmosaiken verlegen lässt, wie auf der EXPO 2000. In den achtziger Jahren gehörte er zusammen mit Werner Büttner, Georg Herold und Martin Kippenberger zu den Enfants terribles der Kunstszene. Zusammen mit Alberts Bruder Markus Oehlen haben diese Künstler mit dem bundesdeutschen Selbstbildnis und Selbstverständnis die gelungensten Experimente angestellt – Titel aus der Mitte der achtziger Jahre wie *Morgenlicht fällt ins Führerhauptquartier* luden die Malerei mit ungewohnten Botschaften auf, die selbstbewusst neue Bildebenen etablierten. In den neunziger Jahren wechselte Oehlen die Strategie. Das Motiv war ausgezählt, nun ging es der Malerei direkt an den Kragen. Die abstrakte Malerei fordert eine Virtuosität, die nach seinem Verständnis sich selbst besiegen müsste – die schönste und größte Herausforderung für einen Künstler wie Oehlen. Wie ein Kontrapunkt zu den Ölbildern erscheinen die plakative Bildsprache und klaren Formen der computergenerierten Collagen, die folgten. Die Kunst attackieren und den wunden Punkt suchen, ist immer noch sein Programm. „Man muss ein fröhlicher Berserker sein", meinte Oehlen im Gespräch mit Rainald Goetz.

A sa première exposition, présentée en 1982 à la Galerie Max Hetzler à Stuttgart, Albert Oehlen avait donné pour titre : *Bevor ihr malt, mach ich das lieber* (Avant que vous peigniez, je préfère le faire moi-même). Rien n'a changé depuis. Jusqu'à ce jour, l'artiste se sent responsable et, tableau après tableau, propose toujours un modèle. Une partie de son charme repose sur le fait qu'Oehlen évite toute évidence, tout en étant à tout moment capable d'affirmer une position. Il présente tout à la fois de la peinture contemporaine et un cliché de la peinture contemporaine. Oehlen se reconçoit donc sans cesse, qu'il manie le pinceau, qu'il se mette à l'ordinateur ou qu'il fasse arranger les six millions d'éléments d'une mosaïque de sol comme il le fit pour l'exposition universelle de Hanovre EXPO 2000. Avec Werner Büttner, Georg Herold et Martin Kippenberger, il fut l'un des enfants terribles de la scène artistique des années 80. Avec le frère d'Albert Markus Oehlen, ces artistes ont réalisé les expériences les plus pertinentes sur l'autoportrait de la RFA et la conception que celle-ci a d'elle même – certains titres du milieu des années 80 comme *Morgenlicht fällt ins Führerhauptquartier* (La Lumière matinale tombant dans le quartier général du Führer) ont investi la peinture de messages inconnus qui instauraient fièrement des niveaux inédits de l'image. Dans les années 90, Oehlen change de stratégie. Le motif ayant été épuisé, le peintre s'en prend directement à la peinture. La peinture abstraite exige une virtuosité qui, selon lui, devait se vaincre elle-même – le plus beau et le plus grand défi pour un artiste comme Oehlen. Le langage affichiste et les formes claires des collages générés par ordinateur qui suivront se présentent alors comme un contrepoint aux peintures à l'huile. Attaquer l'art et chercher le point vulnérable est resté le programme de l'artiste. « Il faut être un joyeux pourfendeur », a déclaré Oehlen dans un entretien avec Rainald Goetz. F. F.

SELECTED EXHIBITIONS →
1995 The Renaissance Society, Chicago (IL), USA; *Oehlen Williams 95* (with Christopher Williams), Wexner Center for the Arts, Columbus (OH), USA **1996** IVAM, Centre del Carme, Valencia, Spain **1997** *Albert vs. History*, Kunsthalle Basel, Basle, Switzerland **1998** INIT Kunsthalle, Berlin, Germany **2000** *Der Ritt der sieben Nutten – das war mein Jahrhundert* (with Markus Oehlen), Städtisches Museum Abteiberg, Mönchengladbach, Germany; In Between, EXPO 2000, Hanover, Germany **2001** *Terminale Erfrischung*, Kestner Gesellschaft, Hanover, Germany; *Vom Eindruck zum Ausdruck – Grässlin Collection*, Deichtorhallen, Hamburg, Germany

SELECTED BIBLIOGRAPHY →
1997 *Albert vs. History*, Kunsthalle Basel, Basle **2000** *Inhaltsangabe*, Berlin; *Malerei*, Kunsthalle Vierseithof, Luckenwalde; *Der Ritt der sieben Nutten – das war mein Jahrhundert*, Städtisches Museum Abteiberg, Mönchengladbach **2001** *Terminale Erfrischung. Bilder und Computercollagen*, Kestner Gesellschaft, Hanover

354

1 **Bionic Boogie (Ich, Wasser, Technik),** 2000, mosaic, fountain, c. 2500 m²,
 In Between, EXPO 2000, Hanover
2 **Taschen shop in Paris,** 2001, computer generated murals, width 18 m

3 **Name: Kevin,** 2000, oil on canvas, 240 x 240 cm
4 **Bedrohter Schwan,** 2000, ink jet plot, 209 x 309 cm

„Ich habe meine Bilder einmal postungegenständliche Malerei und später prokrustische Malerei genannt. Mit dem ersten Begriff wollte ich ausdrücken, dass ich diese Probleme gerne hinter mir hätte. Mit dem zweiten Begriff lehne ich die ganzen Malereiethiken ab. ‚Prokrustisch' steht für Biegen und Brechen und Dehnen und Stutzen. Also nicht für materialschonend."

« Il m'est arrivé de qualifier mes tableaux de post-non-figuratifs et, plus tard, de peinture ‹ procroûtique ›. Ce que je voulais dire avec le premier concept, c'est que j'aimerais que ces problèmes ne soient plus d'actualité pour moi. Avec le deuxième, je rejette toutes les éthiques picturales. ‹ Procroûtique › renvoie au fait de tordre et de briser et d'étendre et de réduire. Autrement dit, cela ne renvoie pas au respect du matériau. »

"I once called my pictures post-non-representational painting and later I called them Procrustean painting. By the first, I meant that I was glad I had got those problems out of the way. With the second, I rejected the whole ethos of painting. Procrustean means bending and breaking and stretching and cutting to size. I mean being unmerciful with materials."

2

3

4

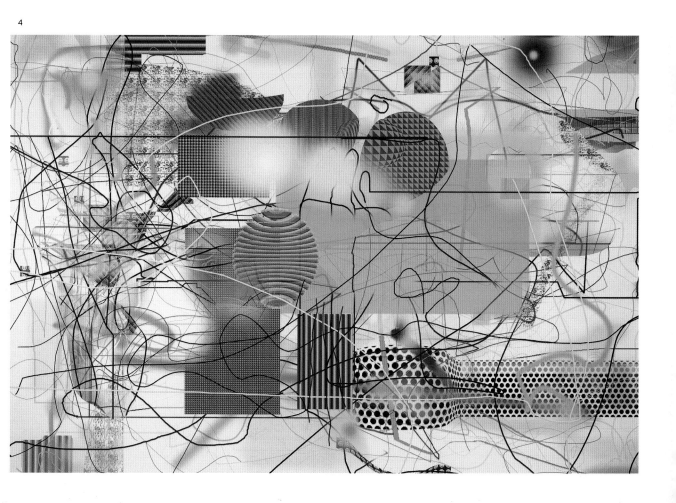

Chris Ofili

1968 born in Manchester, lives and works in London, UK

Chris Ofili's monumental paintings are as influenced by the complexities of late 1990s pop culture as the thought processes of postwar artists such as Picabia, Polke and Basquiat. In *Afrodizzia*, 1996, a maze of arabesques swirl around the collaged heads of afro-wearing black celebrities, in a psychedelic celebration of black sexual potency. Portraits such as *Prince Amongst Thieves*, 1999, in which the profile of a darkly handsome man emerges from a densely patterned background, are as decorative as the all-over floral design of abstract works such as *Through the Grapevine*, 1998. The paintings' shimmering surfaces result from multiple layers of pigment, acrylic and phosphorescent paint, swathes of glitter and strings of multicoloured beads of paint. A thick layer of translucent resin coats the paintings, giving them an oscillating depth and distancing the image until it becomes more imagined than real. The balls of elephant dung intertwined in the paintings' design have become something of a signature for Ofili, and add a sculptural element to the works while offering a range of associations from optimistic ideas about nature to obscenities and defecation. Captain Shit, Ofili's self-created black superhero, is the protagonist in a series of allegorical scenes, including the biblical context of *The Adoration of Captain Shit and the Legend of the Blackstars*, 1998, and an homage to Warhol in *Double Captain Shit*, 1999. Ofili's paintings exalt in the power of colour, decoration and sexuality, but also have a touch of wry humour as seen in *Monkey Magic – Sex, Money and Drugs*, 1999, in which a white monkey spirit conjures the three elements of worldly success: sex, money and drugs.

Die großen Gemälde von Chris Ofili verdanken der Pop-Kultur der späten neunziger Jahre genauso wesentliche Anregungen wie den Theorien von Künstlern wie Picabia, Polke und Basquiat. In *Afrodizzia*, 1996, wirbelt eine Fülle von Formen um die collagierten Köpfe schwarzer Berühmtheiten, die ihre Haare im Afro-Look tragen – eine psychedelische Hymne auf die sexuelle Potenz des schwarzen Menschen. Porträts wie *Prince Amongst Thieves*, 1999, das einen attraktiven dunkelhäutigen Mann im Profil zeigt, der aus einem dicht ornamentierten Hintergrund hervortritt, sind ebenso dekorativ wie abstrakte Arbeiten, etwa das vollständig aus Blumenmustern komponierte *Through the Grapevine*, 1998. Die schimmernden Bildoberflächen verdanken sich den vielfachen Schichten von Pigment, Acryl und Leuchtfarben sowie Glitzerpartikeln und vielfarbigen Perlenketten. Überzogen sind die Bilder mit einer dicken lichtdurchlässigen Harzschicht, der sie ihre oszillierende Tiefenwirkung und ihre an Traumgebilde erinnernde „Fern"-Wirkung verdanken. Die Elefantendungkugeln, die Ofili auf die Bildfläche aufbringt, gelten als eine Art Markenzeichen und verstärken die plastische Wirkung seiner Bilder. Zugleich eröffnen sie ein weites assoziatives Feld: von optimistischen Vorstellungen von der Natur bis zu Obszönitäten und Defäkation. In einem Zyklus allegorischer Szenen lässt Ofili den selbst erfundenen schwarzen Supermann Captain Shit auftreten. Eine dieser Arbeiten operiert mit biblischen Anklängen, *The Adoration of Captain Shit and the Legend of the Blackstars*, 1998, während *Double Captain Shit*, 1999, eine Hommage an Warhol ist. Ofilis Malerei feiert die Kraft der Farben, der dekorativen Prachtentfaltung und der Sexualität; sie besticht zugleich durch ihren sarkastischen Humor. Ein Beispiel dafür ist *Monkey Magic – Sex, Money and Drugs*, 1999, in dem ein weißer Affen-Geist die drei Elemente des irdischen Erfolges beschwört: Sex, Geld und Drogen.

Les toiles monumentales de Chris Ofili sont autant influencées par les complexités de la culture populaire de la fin des années 90 que par la façon de penser des artistes d'après-guerre comme Picabia, Polke et Basquiat. Dans *Afrodizzia*, 1996, un dédale d'arabesques tournoie autour d'un collage de têtes de célébrités noires coiffées à l'afro, découpées dans des magazines, forme de célébration psychédélique de la puissance sexuelle noire. Ses portraits tels que *Prince Among Thieves*, 1999, où le profil d'un séduisant ténébreux émerge d'un fond densément rempli de motifs, sont aussi décoratifs que ses œuvres abstraites entièrement couvertes de fleurs comme *Through the Grapevine*, 1998. La surface scintillante de ses toiles est due à de multiples couches de pigments, de collages, de peinture acrylique et phosphorescente, de bandes pailletées et de filets multicolores de perles de peinture. Une épaisse couche de résine translucide recouvre le tout, donnant au tableau une profondeur changeante et distançant l'image jusqu'à ce qu'elle paraisse plus imaginée que réelle. Les boules d'excréments d'éléphant insérées dans la composition sont devenues une sorte de signature de l'artiste. Elles ajoutent un élément sculptural aux œuvres tout en offrant une gamme d'associations, allant des idées optimistes sur la nature à des obscénités et à la défécation. Le Capitaine Shit, superhéros créé par Ofili, est au centre d'une série de scènes allégoriques, dont celle aux connotations bibliques, *The Adoration of Captain Shit and the Legend of the Blackstars*, 1998, et un hommage à Warhol, *Double Captain Shit*, 1999. Les peintures d'Ofili exaltent la puissance de la couleur, de la décoration et de la sexualité, mais elles dégagent également un humour noir comme dans *Monkey Magic – Sex, Money and Drugs*, 1999, où un esprit singe blanc invoque les trois éléments de la réussite sur terre : le sexe, l'argent et la drogue. K. B.

SELECTED EXHIBITIONS →
1995 *Brilliant!*, Walker Art Center, Minneapolis (MN), USA **1997** *Sensation*, Royal Academy of Arts, London, UK **1998** Southampton City Art Gallery, Southampton, UK; *The Turner Prize Exhibition*, Tate Gallery, London, UK **1999** *Afrobiotics*, Gavin Brown's enterprise, New York (NY), USA; *Carnegie International*, Carnegie Museum of Art, Pittsburgh (PA), USA **2000** *Drawings*, Victoria Miro Gallery, London, UK **2001** *Public Offerings*, Museum of Contemporary Art, Los Angeles (CA), USA

SELECTED BIBLIOGRAPHY →
1995 *Brilliant! New Art from London*, Walker Art Center, Minneapolis (MN) **1998** *Chris Ofili*, Southampton City Art Gallery, Southampton/ Serpentine Gallery, London **1999** *Young British Art. The Saatchi Decade*, London; *Carnegie International*, Carnegie Museum of Art, Pittsburgh (PA) **2001** *Public Offerings*, Museum of Contemporary Art, Los Angeles (CA)

1 **Monkey Magic – Sex, Money and Drugs,** 1999, acrylic, collage, glitter,
 resin, pencil, map pins, elephant dung on canvas, 244 x 183 cm

2 **The Holy Virgin Mary,** 1996, mixed media on canvas, 244 x 183 cm
3 **Afrodizzia (2nd version),** 1996, mixed media on canvas, 244 x 183 cm

„Ich glaube, Kreativität hat mit Improvisation zu tun –
mit dem, was um uns herum vor sich geht."

« Je pense que la créativité est liée à l'improvisation,
à ce qui se passe autour de nous. »

"I think creativity's to do with improvisation – what's happening around you."

2

Gabriel Orozco

1962 born in Jalapa, lives and works in Mexico City, Mexico, and New York (NY), USA

Gabriel Orozco's work combines conceptual soundness and politicised practice, which in many ways is compatible with the art movements of Dada, Surrealism and Arte Povera, and with the poetic and subjective moment. In an interview Orozco stated that his cultural interventions in the public domain began in 1986, when he rearranged a joiner's offcuts that had been left on a rain-sodden street in Madrid and then photographed the result. In other works Orozco largely refrains from intervening in found situations, and uses his camera mainly to capture the tension between his own intentions and reality. A series of videos shot while strolling through urban areas, for example *From Dog Shit to Irma Vep*, 1997, condense the permanent flow of his everyday perception of objects and events. Other works take a participatory line on the production of art. For his 1993 New York Museum of Modern Art project *Home Run*, he asked the residents of surrounding buildings to place oranges on their windowsills, thus bestowing on the windows the function of exhibition spaces beyond the Museum's perimeter. The relationships between public and private spheres, everyday objects and works of art was altered and thrown into question. Similarly Orozco repeatedly stages the complex interrelationships between cultural and economic periphery and centre. His photograph *Isla dentro de la isla/ Island within an Island*, 1993, portrays – before a background of New York's skyline – a shabby replica made of garbage of the same silhouette in an empty car park.

Im Werk von Gabriel Orozco verbindet sich eine konzeptuell fundierte und politisierte Praxis – die in vielfältiger Weise mit künstlerischen Bewegungen wie Dada, Surrealismus und Arte Povera korrespondiert – mit einem Moment des Poetischen und Subjektiven. Den Beginn seiner skulpturalen Interventionen im öffentlichen Raum datierte Orozco in einem Interview auf das Jahr 1986, als er auf einer regennassen Madrider Straße die Holzabfälle einer Schreinerei arrangierte und das Resultat fotografierte. In anderen Arbeiten verzichtet Orozco weitgehend auf Eingriffe in vorgefundene Situationen und benutzt die Kamera vorwiegend, um das Spannungsverhältnis zwischen den eigenen Intentionen und der Realität festzuhalten; eine Reihe von Videofilmen wie *From Dog Shit to Irma Vep*, 1997, die während langer Spaziergänge in urbanen Umgebungen entstanden, kondensieren den permanenten Fluss seiner alltäglichen Wahrnehmungen von Objekten und Ereignissen. Andere Arbeiten Orozcos basieren auf einem partizipatorischen Prozess der Kunstproduktion. So ließ er in seinem Projekt *Home Run*, 1993, für das New Yorker Museum of Modern Art die Bewohner der umliegenden Häuser fragen, ob sie bereit seien, Orangen auf ihre Fensterbänke zu legen. Die Fenster nahmen dadurch die Funktion von Ausstellungsorten jenseits des Museums an; das Verhältnis zwischen öffentlicher und privater Sphäre, Alltagsgegenständen und Kunstobjekten wurde verschoben und in Frage gestellt. In ähnlicher Weise inszeniert Orozco immer wieder die komplexen Wechselbeziehungen zwischen kultureller und ökonomischer Peripherie und Zentrum: So zeigt seine Fotografie *Isla dentro de la Isla/Island within an Island*, 1993 – vor dem Hintergrund der New Yorker Skyline – eine ärmliche Nachbildung dieser Silhouette aus Abfällen auf einem leeren Parkplatz.

Dans l'œuvre de Gabriel Orozco se mélangent une pratique politique définie sur des bases rigoureusement conceptuelles – qui correspond par bien des aspects à des mouvements artistiques comme le dadaïsme, le surréalisme et l'Arte Povera – et un facteur poétique et subjectif. Dans une interview, Orozco a daté ses premières interventions sculpturales dans l'espace public de 1986, lorsqu'il arrangea les déchets d'une menuiserie dans une rue de Madrid mouillée de pluie avant de photographier le résultat de ce travail. Dans d'autres œuvres, Orozco renonce en grande partie à sa propre intervention et se sert de l'appareil photo avant tout pour fixer le jeu de tensions entre son propos artistique et la réalité. Toute une série de vidéos nées de longues promenades dans l'environnement urbain, par exemple *From Dog Shit to Irma Vep*, 1997, condensent le flux permanent de sa perception quotidienne des objets et des événements. D'autres œuvres d'Orozco reposent sur une démarche participative de la production artistique. Dans le projet *Home Run*, 1993, réalisé pour le Museum of Modern Art de New York, Orozco faisait demander aux habitants des immeubles environnants s'ils étaient d'accord pour disposer des oranges à leurs fenêtres. Les fenêtres prenaient ainsi la fonction de lieux d'exposition au-delà du musée ; le rapport entre sphère privée et publique, entre objet quotidien et objet d'art était décalé et remis en question. D'une façon similaire, Orozco revient constamment à la mise en scène des interrelations complexes entre les aspects périphérique et central de la culture et de l'économie : avec pour toile de fond la silhouette new-yorkaise, la photographie *Isla dentro de la Isla/Island within an Island*, 1993, montre par exemple une reconstitution maladroite de la même silhouette réalisée à partir de détritus dans un parking vide.

B. H.

SELECTED EXHIBITIONS →
1997 *documenta X*, Kassel, Germany **1998** *XXIV Biennial Internacional*, São Paulo, Brazil; Musée d'Art Moderne de la Ville de Paris, France **1999** Centre pour l'Image Contemporaine, Geneva, Switzerland; *Looking for a place*, SITE, Santa Fe (NM), USA **2000** The Museum of Contemporary Art, Los Angeles (CA), USA; *In Between*, EXPO 2000, Hanover, Germany **2001** Museo de Arte Contemporaneo de Monterrey, Mexico; Museo Internacional Rufino Tamayo, Mexico City, Mexico; *7th Istanbul Biennial*, Istanbul, Turkey

SELECTED BIBLIOGRAPHY →
1998 *Clinton is Innocent*, Musée d'Art Moderne de la Ville de Paris **1999** *Photogravity*, Philadelphia Museum of Art, Philadelphia (PA); *Chacahua*, Frankfurt am Main **2000** *Gabriel Orozco*, The Museum of Contemporary Art, Los Angeles (LA)

1 **Mixiotes,** 2001, cactus leaves, rubber balls, plastic bags, installation view, Marian Goodman Gallery, New York (NY)
2 **Hoja Suspendida,** 2001, Cibachrome, 41 x 51 cm

3 **My Hands Are My Heart,** 1991, Cibachrome, 2 parts, each 41 x 51 cm
4 **Clipped Paper,** 2001, Cibachrome, 41 x 51 cm

„Ich sehe meine Arbeit gerne als das Ergebnis oder Abfallprodukt oder Überbleibsel spezifischer Situationen."

« Il est important pour moi que mon œuvre soit un ‹ sous-produit ›, un amoncellement de situations spécifiques. »

"I like to see my work as the result or a by-product or a leftover of specific situations."

2

3

4

Laura Owens

1970 born in Euclid (OH), lives and works in Los Angeles (CA), USA

Laura Owens' paintings have an ephemeral quality. Her large-scale canvases are sparsely marked, the simplest lines suggesting figurative images. Three succinct blue lines indicate the sky, two black strokes provide a pattern like flying birds, and a couple of crooked lines form a high-rise apartment block or the mullion and transom of a window. The artist shows a fondness for conventional subjects such as flower arrangements and landscapes, which she often paints in a style that evokes traditional Japanese art. Some of her paintings feature cartoon elements – like little bees flying over a meadow of naïvely painted plants – which provide an impression of wallpaper patterns or folk art. At first sight some of her paintings look like abstract structures. Her upright format *Untitled*, 1999, in acrylic on canvas shows a grid of irregular lines. Crude blue blobs push their way into the picture from right to left, an immediate reminder of the Abstract Expressionists' experiments with form. But then Owens' forms and colour values meld together to suggest a landscape. Owens' paintings are untitled, suggesting that a single picture should not be seen as important, or accorded the value of uniqueness. And yet the exceptional lightness of her work is the result of long and careful preparation, and each image presents a particular painterly pose. The artist is always searching for principles of order to create inner tension in the composition. Hence, the "neurotic joviality" of her motifs encounters a formal composition of emptiness, calm, simplicity and chance. The interplay of tensions in Owens' paintings is modern and elegant, while at the same time seeming to contain humorous allusions to Zen Buddhism.

Die Malerei von Laura Owens ist von ephemerer Natur. Ihre großformatigen Leinwände sind nur spärlich mit Farben markiert, mit einfachsten Gesten wird Figuratives angedeutet. Drei lapidare blaue Linien zeigen einen Horizont an, zwei schwarze Striche stehen für Vögel am Himmel, ein paar krumme Linien bilden ein Fensterkreuz oder einen Block von Hochhäusern. Die Künstlerin hat eine Vorliebe für konventionelle Motive wie Blumenarrangements und Landschaften, die sie oft in einem auf traditionelle japanische Malerei anspielenden Stil malt. In manchen Gemälden tauchen Cartoon-Elemente auf wie die kleinen Bienen, die über eine Wiese fliegen, deren Pflanzen in einer naiv typisierten Weise gemalt sind, was den Eindruck von Tapetendekors oder Volkskunst hervorruft. Andere Bilder wirken zunächst wie abstrakte Strukturen. Auf einem hochformatigen Acrylbild von 1999 *(Untitled)* ist ein Gitter von unregelmäßigen Linien gezogen. Von rechts und links schieben sich plumpe blaue Kleckse ins Bild. Zunächst erinnern sie an die formalen Experimente des Abstrakten Expressionismus. Dann aber verbinden sich die Formen und Farbwerte und suggerieren eine Landschaft. Owens gibt ihren Werken keine Titel, so als sollte ein einzelnes Bild keine gewichtige Bedeutung oder den Wert der Einmaligkeit erhalten. Die ungemeine Leichtigkeit in ihren Bildern ist lang und präzise vorbereitet, jedes führt eine bestimmte malerische Pose vor. Zugleich ist die Künstlerin auf der Suche nach Ordnungsprinzipien, die eine innere Spannung im Bild erzeugen. So trifft diese Art „neurotischer Lustigkeit" ihrer Motive auf eine formale Komposition von Leere, Ruhe, Einfachheit und Zufall. Es ist ein modernes, elegantes Spannungsverhältnis in Owens' Malerei, das in humorvoller Weise auf zen-buddhistisches Denken anzuspielen scheint.

La peinture de Laura Owens est de nature éphémère. Ses toiles grand format ne présentent le plus souvent que des couleurs parcimonieuses avec lesquelles les gestes les plus simples esquissent des formes figuratives. Trois lignes bleues lapidaires figurent un horizon, deux traits noirs schématisent des oiseaux dans le ciel, quelques courbes dessinent une croisée de fenêtre ou un bloc d'immeubles. On y relève la prédilection de l'artiste pour les motifs conventionnels : arrangements floraux et paysages qu'elle peint souvent dans un style qui rappelle la peinture traditionnelle japonaise. Dans certaines peintures, on voit apparaître des éléments de dessins animés : petites abeilles survolant un pré dont les plantes sont traitées avec une caractérisation naïve évoquant le décor d'un papier peint ou une décoration folklorique. D'autres tableaux font en revanche d'abord l'effet de structures abstraites. Dans une acrylique verticale de 1999 *(Untitled)*, on peut voir une trame de lignes irrégulières. Des taches grossières entrent dans le tableau par la droite et par la gauche. Dans un premier temps, on songe aux recherches formelles de l'expressionnisme abstrait, mais les formes et les valeurs chromatiques s'associent ensuite pour suggérer un paysage. Owens ne donne pas de titres à ses œuvres, comme si le tableau ne devait pas recevoir de signification singulière ni prendre la valeur particulière de l'unicité. Pourtant, la légèreté inhabituelle de ces œuvres résulte d'une longue et minutieuse préparation, dans la mesure où chacune occupe une position picturale particulière. En même temps, l'artiste est à la recherche de principes d'ordre qui génèrent une tension dans le tableau, où la « volupté névrotique » des motifs est associée à une composition faite de vide, de paix, de hasard et de simplicité. Il y a dans la peinture d'Owens un rapport de tension moderne, élégant, qui semble également se référer de manière humoristique à la pensée zen-bouddhiste. A. K.

SELECTED EXHIBITIONS →
1998 *Young Americans 2*, The Saatchi Gallery, London, UK **1999** *Malerei*, INIT Kunsthalle, Berlin, Germany; Los Angeles (CA), USA; *Nach-Bild*, Kunsthalle Basel, Basle, Switzerland **2000** *Examining Pictures: Exhibiting Paintings*, Museum of Contemporary Art, Chicago (IL), USA; UCLA Hammer Museum, Los Angeles (CA), USA **2001** Isabella Steward Gardner Museum, Boston (MA), USA; *Public Offerings*, Museum of Contemporary Art, Los Angeles (CA), USA; *Painting at the Edge of the World*, Walker Art Center, Minneapolis (MN), USA

SELECTED BIBLIOGRAPHY →
1998 *Nothing left Undone. Young Americans 2*, Saatchi Gallery, London **1999** *Standing Still and Walking in Los Angeles*, Gagosian Gallery, Los Angeles (CA); *Nach-Bild*, Kunsthalle Basel; *Examinig Pictures*, Whitechapel Gallery, London/Museum of Contemporary Art, Chicago (IL) **2001** Uta Grosenick (ed.), *Women Artists*, Cologne

2

3

4

Jorge Pardo

1963 born in Havana, Cuba, lives and works in Los Angeles (CA) and New York (NY), USA

Art is beauty and the promise of happiness: that is what Jorge Pardo means when he subverts existing connections while at the same time creating new ones. His objects, installations and paintings seem familiar to us; they make connections with already existing associations. His art always includes what the viewer expects. Pardo's interest in the piece of art is actually his interest in its potential to mean something to the viewer, while drawing him or her into new relationships. It is not the picture on the wall that matters, it is the way in which it affects the view of the world. The book, *Ten people, ten books*, published in 1994, contains building plans and the licence for copying a bungalow, and was described by Pardo as a sculpture. At the same time Pardo emphasises the generic frontier between design and art, turning it into a valuable tension in his works. In 1998 he transformed the ground floor of the New York Dia Center for the Arts into a colourful and exhilarating creation for the next two years: the façade was replaced by a transparent glass frontage; light, bright ceramic floor tiles conveyed a relaxed atmosphere; the new furniture drew inspiration from pragmatic, serviceable modernism. What drives Pardo is the question of how something is held in high regard for its aesthetic values. He removes the seriousness from painting by using over-dimensional formats and by silk screen printing from computer designs. A kaleidoscope of colours and shapes come together in any number of new combinations; sensitive colour matches seem to dwell in continually cheerful vibrations; the lone picture now represents only a relative size.

Kunst ist Schönheit und das Versprechen von Glück. Dies ist die Maxime von Jorge Pardo, wenn er bestehende Zusammenhänge aufnimmt und dabei neue schafft. Seine Objekte, Installationen und Gemälde erscheinen uns bekannt; sie suchen den Anschluss an schon bestehende Assoziationen. Seine Kunst bezieht die Erwartungshaltung des Betrachters immer ein. Pardos Interesse am Kunstobjekt gilt seinem Potenzial, dem Betrachter etwas zu bedeuten und ihn so in neue Beziehungen zu verwickeln. Nicht das Bild an der Wand ist entscheidend, vielmehr die Weise, wie es die Betrachtung der Welt beeinflusst. Das Buch *Ten people, ten books,* veröffentlicht 1994, beinhaltet Baupläne und die Lizenz für den Nachbau eines Bungalows und wurde von Pardo als Skulptur bezeichnet. Dabei hob Pardo die Gattungsgrenze zwischen Design und Kunst hervor und machte sie als Spannung für seine Arbeiten wertvoll. 1998 gestaltete er das Erdgeschoss des New Yorker Dia Center for the Arts für die nächsten zwei Jahre in eine farbenfrohe und heitere Angelegenheit um: Die Fassade wurde durch eine transparente Glasfront ersetzt, helle farbige Bodenfliesen verbreiteten eine lockere Atmosphäre, das neue Mobiliar orientierte sich am pragmatischen dienstfertigen Modernismus. Was Pardo antreibt ist die Frage, wie ästhetische Wertschätzungen entstehen. Er nimmt der Malerei ihre Ernsthaftigkeit mittels überdimensionaler Formate und dank der Tatsache, dass es sich um Computerentwürfe im Siebdruckverfahren handelt. Kaleidoskopisch fügen sich Farben und Formen zu immer neuen Kombinationen zusammen, sensibel abgestimmtes Kolorit scheint in beständiger heiterer Schwingung zu verweilen: Das einzelne Bild stellt nur mehr eine relative Größe dar.

L'art est beauté et promesse de bonheur. C'est aussi le but vers lequel tend Jorge Pardo lorsqu'il assimile des contextes existants et qu'il s'en sert pour en créer de nouveaux. Ses objets, installations et peintures ont un air familier, ils cherchent à se rattacher à des associations existantes. L'intérêt de Pardo pour l'objet artistique est lié à l'importance potentielle que celui-ci peut prendre pour le spectateur et, partant, à la possibilité d'investir le spectateur de nouvelles relations. Ce n'est pas le tableau accroché au mur qui est important en soi, mais la manière dont il influence le regard que nous portons sur le monde. Le livre *Ten people, ten books* publié en 1994, et qui contient les plans et la licence pour la construction d'un bungalow, a été défini par Pardo comme une sculpture. En même temps, Pardo faisait ressortir la frontière entre les genres « design » et « art », et la rendait significative pour ses œuvres en ce qu'elle est révélatrice d'un champ de tension. En 1998 et pendant deux ans, il a transformé le rez-de-chaussée du Dia Center for the Arts de New York en un événement multicolore et gai : la façade était remplacée par du verre transparent, tandis que des carrelages clairs répandaient une atmosphère décontractée, où le nouveau mobilier s'appuyait sur un modernisme utilitaire et pratique. Ce qui stimule Pardo, c'est la question de savoir comment naissent les jugements et les échelles de valeur esthétiques. Pardo libère la peinture de son sérieux par l'utilisation de formats surdimensionnés et de procédés informatiques et sérigraphiques. Les couleurs et les formes s'agencent de manière kaléidoscopique en combinaisons sans cesse nouvelles, le chromatisme aux nuances sensibles semble demeurer dans une vibration toujours joyeuse : le tableau isolé devient alors une unité très relative. F. F.

SELECTED EXHIBITIONS →
1990 Thomas Solomon's Garage, Los Angeles (CA), USA **1993** *Backstage*, Kunstverein in Hamburg, Germany **1994** neugerriemschneider, Berlin, Germany **1996** *traffic*, capcMusée d'Art Contemporain, Bordeaux, France **1997** *Lighthouse*, Museum Boijmans Van Beuningen, Rotterdam, The Netherlands; *Skulptur. Projekte*, Münster, Germany **1999** *What if*, Moderna Museet, Stockholm, Sweden **2000** Dia Art Foundation, New York (NY), USA; Kunsthalle Basel, Basle, Switzerland **2001** *public offerings*, Museum of Contemporary Art, Los Angeles (CA), USA

SELECTED BIBLIOGRAPHY →
2000 *Elysian Fields*, Centre Georges Pompidou, Paris; Kunsthalle Basel, Basle **2001** Jörn Schafaff/Barbara Steiner (ed.), *Jorge Pardo*, Ostfildern-Ruit

374

„Allerdings hat mich nie die manuelle Tätigkeit des Malens interessiert, sondern die Zusammenhänge, in denen ein Bild entstehen kann. Ich setze mich nicht mit genuin malerischen Fragen auseinander. Vielmehr integriere ich den Alltag, das reale Leben in die Kunst. Meine Bilder entstehen aus einer großen Distanz zum Malen selbst, deshalb sind sie sehr kühl, überhaupt nicht emotional."

« Il est vrai que je n'ai jamais été intéressé par l'activité manuelle de peindre, mais par les correspondances contextuelles dans lesquelles le tableau peut être créé. Je ne travaille pas sur des problèmes fondamentalement picturaux. J'intègre plutôt le quotidien, la vie réelle dans l'art. Mes tableaux résultent d'une grande distance à l'égard de l'acte pictural en tant que tel, c'est pourquoi il sont plutôt froids et pas du tout émotionnels. »

"Mind you, the manual activity of painting has never interested me; it is has always been the connections or correlations within which a picture can be created. I don't think about the actual painting side of things. I'm more likely to integrate the day-to-day, real life into art. My pictures are created at a great distance from the actual painting aspect itself, and so they are very cool, not in the least emotional."

2

3

Philippe Parreno

1964 born in Oran, Algeria, lives and works in Paris, France

Philippe Parreno's exhibitions present a new model for collaborative work with other artists. For the extensive work-in-progress which he realised in association with Dominique Gonzalez-Foerster, Pierre Huyghe and the Parisian graphic design office M/M, the artist acquired the rights to the computer-generated Manga character Ann Lee. The artists adapted and subverted economic strategies by buying the cheapest, and therefore simplest, version available, and developing it themselves. Their video character introduces us to her "identity" and the history of her origin. Parreno's works relate to the media's everyday realities, which he transfers to the field of art. He projects experiences gained in cinematic, cartoon and advertising films onto the medium of exhibitions. *Speechbubbles*, 1997, is an installation of helium balloons shaped like comic book speech bubbles that produce a soundless, confused babble of voices, thereby moderating the information issued by the entertainment media. Parreno frequently looks to the cinema for his themes (for example, *Listen to the Picture*, 1998), and produces his own films, such as *Le pont du Trieur/Tadjikistan*, 1998 (with Charles de Meaux), in which reality and fiction merge with equal authenticity. This film is about a (fictional) radio transmission relating (real) events and conditions in the Pamir region of the Republic of Tajikistan. As well as associating with artists and other manufacturers of culture, Parreno likes the public to be involved in his works. *Factory of Clouds*, 1995, exemplifies his approach to audience participation whereby the arrangement of Parreno's work, which is many-faceted on all levels of production and reception, can be linked to contemporary, post-structuralist models of thought.

Die Ausstellungen von Philippe Parreno stellen neue Modelle der Zusammenarbeit mit wechselnden Künstlern vor. Für ein mit Dominique Gonzalez-Foerster, Pierre Huyghe und dem Pariser Grafikbüro M/M gemeinsam realisiertes umfangreiches Work-in-progress erwarben die Künstler von einem japanischen Anbieter die Rechte an der computergenerierten Manga-Figur Ann Lee. Die Künstler adaptierten ökonomische Strategien, durchbrachen sie aber auch, indem sie die günstigste und damit simpelste Version der Figur kauften und sie eigenständig weiterentwickelten. In den Videos stellt die Figur ihre „Identität" und Entstehungsgeschichte vor. Parrenos Arbeiten beziehen sich auf alltägliche Medienrealitäten, die er ins Kunstfeld transferiert. Er projiziert Kino-, Comic- und Werbefilmerfahrungen auf das Medium der Ausstellung. Die *Speechbubbles*, 1997, mit Helium gefüllte Ballons in Form von leeren Comic-Sprechblasen, produzieren ein lautloses Stimmengewirr und relativieren den Informationsgehalt von Unterhaltungsmedien. Häufiger nimmt Parreno das Thema Kino auf (etwa *Listen to the Picture*, 1998) und dreht auch selbst Filme wie *Le pont du Trieur/Tadjikistan*, 1998 (in Zusammenarbeit mit Charles de Meaux), in dem sich Realität und Fiktion in Echtzeit vermischen. Der Film handelt von einer (fiktiven) Radiosendung über (reale) Ereignisse und Gegebenheiten in Pamir, einer Region in der Republik Tadschikistan. Neben Künstlern und anderen Kulturproduzenten involviert Parreno auch das Publikum in seine Arbeiten. Die *Factory of Clouds*, 1995, ist ein Beispiel für diesen partizipatorischen Ansatz. Dabei lässt sich die auf allen Ebenen der Produktion und Rezeption beziehungsreiche Anordnung der Arbeiten Parrenos mit zeitgenössischen Denkmodellen des Poststrukturalismus koppeln.

Les expositions de Philippe Parreno proposent de nouveaux modèles de collaboration avec différents artistes. Pour un work-in-progress réalisé en collaboration avec Dominique Gonzalez-Foerster, Pierre Huyghe et le bureau de graphisme parisien M/M, les artistes ont acquis auprès d'un prestataire japonais les droits d'un personnage de manga généré par ordinateur – Ann Lee. Les artistes adoptent des stratégies commerciales, mais les invalident aussi en achetant la version de base la moins chère et la plus simple, et en la développant eux-mêmes. Dans leurs vidéos, le personnage décline son « identité » et présente l'histoire de sa genèse. Les œuvres de Parreno se réfèrent aux réalités quotidiennes des médias, qui sont transposées dans le domaine de l'art. Il projette vers le médium « exposition » ses expériences dans le domaine du cinéma, de la bande dessinée et du film publicitaire. Les *Speechbubbles*, 1997, ballons gonflés à l'hélium arborant la forme de bulles de bandes dessinées vides, produisent une muette confusion de voix et relativisent le contenu informatif des médias. Plus souvent encore, Parreno s'attache au thème du cinéma, comme dans *Listen to the Picture*, 1998, et réalise lui-même des films, comme *Le pont du Trieur/Tadjikistan*, 1998 (avec Charles de Meaux), dans lequel réalité et fiction se mélangent en temps réel. Ce film traite d'une émission de radio (fictive) sur des faits et des événements (réels) se déroulant à Pamir, une région de la République de Tadjikistan. A côté de la collaboration avec des artistes et d'autres producteurs du domaine culturel, Parreno associe aussi le public à son travail. *Factory of Clouds*, 1995, est un bon exemple de cette démarche participative. Par ailleurs, la conception de ses œuvres riches de références à tous les niveaux de la production et de la réception, peut être mise en relation avec les modèles de pensée contemporains du poststructuralisme. N. M.

SELECTED EXHIBITIONS →
1995 *Snow dancing*, Le Consortium, Dijon, France; *While ...*, Kunstverein in Hamburg, Germany **1996** *Traffic*, capcMusée d'Art Contemporain, Bordeaux, France **1998** *Dominique Gonzalez-Foerster, Pierre Huyghe, Philippe Parreno*, Musée d'Art Moderne de la Ville de Paris, France **1999** *dAPERTuttO, 48. Biennale di Venezia*, Venice, Italy **2000** *What If*, Moderna Museet, Stockholm, Sweden; *One Thousand Pictures Falling from One Thousand Walls*, MAMCO – Musée d'art moderne et contemporain, Geneva, Switzerland **2001** *Neue Welt*, Frankfurter Kunstverein, Frankfurt am Main, Germany; Institute of Contemporary Arts (with Pierre Huyghe), London, UK **2002** *Ann Lee*, Kunsthalle Zürich, Zurich, Switzerland

SELECTED BIBLIOGRAPHY →
1995 *Snow dancing*, London **1996** *Traffic*, capcMusée d'Art Contemporain, Bordeaux **1998** *Dominique Gonzalez-Foerster, Pierre Huyghe, Philippe Parreno*, ARC Musée d'Art Moderne de la Ville de Paris **2000** *EDIT*, Badischer Kunstverein, Karlsruhe

1 Credits: Michel Amathieu, Djamel Benameur, Jacques Chaban Delmas, James Chinlund, Maurice Cotticelli, Hubert Dubedout, François Dumoulin, Ebenezer Howard, M/M Paris, Pierre Mendès-France, Miko Neyrpic, Alain Peyrefitte, Inez van Lamsweerde & Vinoodh Matadin, Anna-Léna Vaney, Angus Young, 2000, film stills

2 Installation view, *One thousand Pictures Falling from One Thousand Walls*, MAMCO – Musée d'art moderne et contemporain, Geneva, 2000 Foreground: **M/M-Paris – No Ghost Just a Shell**, un film imaginaire de Pierre Huyghe, Philippe Parreno, 2000; background: **M/M-Paris – Poster Twice (Ann Lee colours)**, 2000
3 **Anywhere Out of the World**, 2000, video, 4 min

„Man muss mit einem Bild beginnen, um ein Bild hervorzurufen."

« Il faut commencer avec une image pour susciter une image. »

"You have to start with an image to bring forth an image."

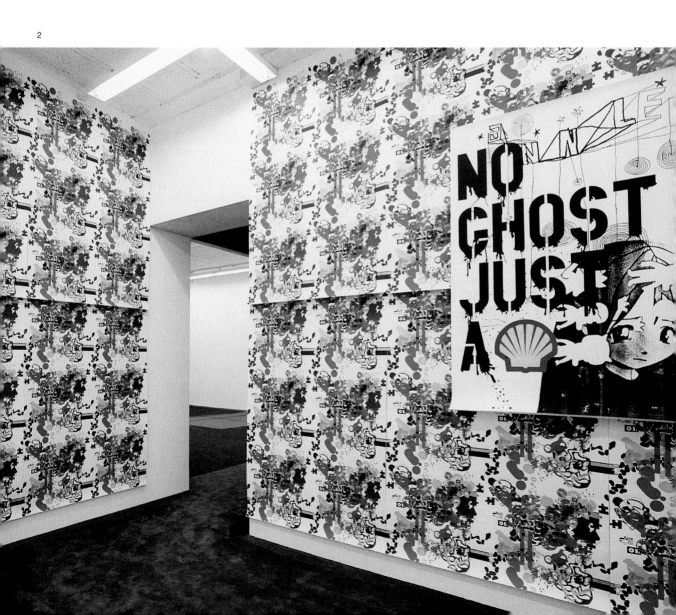

2

3

Manfred Pernice

1963 born in Hildesheim, lives and works in Berlin, Germany

Manfred Pernice's work is architectural in its references. His pieces might resemble building plans or maquettes for realizable structures, but key elements such as windows and doors are often missing or not to scale, rendering them futile. Pernice is fascinated by ships, containers and other vessels, and often includes transport and harbour references in his work. Frequently, collaged newspaper and magazine images or shipping documents are applied to his structures and integrated into his drawings. His plywood containers, such as *Bell II*, 1998, and *Sieg*, 2001, appear to be models of vessels used to transport goods, except they are non-functional in their materials and construction. Inspired by a ship in Bremerhaven, he also made reference to a boat in *Bad, Bath*, 1998, in which he erected panels with angled portions painted battleship grey at the bottom and round "portholes" at the top. Pernice's work is often linked to actual places, though his representations are conceptual rather than direct. His large-scale *Sardinien*, 1996, shares formal characteristic with the whitewashed homes and buildings perched on cliffs of Mediterranean towns. However, the shape of the sculpture itself, with rounded edges and protruding parts, is also reminiscent of recreational vehicles. The artist's inclusion of a photograph of the coast strengthens the reference to Sardinia, but its placement on the surface of the structure seems to turn the piece inside out. The photo as well as a shelf and other detailing associated with the interior of a domestic structure appear on the exterior of Pernice's sculpture and deepen the work's architectural ambiguity.

Manfred Pernice nimmt in seiner Arbeit Bezug auf architektonische Formen. Seine Werke erinnern nicht selten an Pläne oder Entwürfe, die zur baulichen Realisierung bestimmt sind, denen aber so wichtige Elemente wie Fenster und Türen fehlen oder die sämtliche Proportionen sprengen, also völlig sinnlos sind. Da Schiffe, Container und andere Transportmittel auf Pernice eine besondere Faszination ausüben, finden sich in seinen Werken vielfach Verweise auf Häfen und Transportfunktionen. Immer wieder sind collagierte Zeitungs- und Illustriertenbilder oder Frachtpapiere in seine Strukturen oder Zeichnungen integriert. Pernices Sperrholzcontainer, etwa *Bell II*, 1998, und *Sieg*, 2001, erscheinen wie Modelle für Transportbehältnisse, nur dass weder Material noch Bauweise mit einer solchen Funktion vereinbar sind. Auch seine Arbeit *Bad, bath*, 1998, zu der ihn ein Schiff in Bremerhaven inspiriert hat, erweckt solche Assoziationen. Das Werk besteht aus senkrecht aufgestellten – in dem für Schlachtschiffe typischen Grau gehaltenen – Paneelen mit abgeknickten Partien und „Bullaugen" im oberen Bereich. Pernices Werke nehmen häufig auf reale Orte Bezug, obwohl seine Darstellungen mehr konzeptuell als abbildhaft zu verstehen sind. Seine großformatige Arbeit *Sardinien*, 1996, weist zwar formale Übereinstimmungen mit den weiß getünchten, auf Fels gebauten Häusern mediterraner Dörfer auf, mit ihren abgerundeten Ecken und vorstehenden Teilen könnte es sich bei der Skulptur aber ebenso gut um einen Wohnwagen handeln. Die Fotografie einer Küstenlandschaft, die an dieser Konstruktion aufgehängt ist, unterstreicht zwar die Sardinien-Assoziation, da sie jedoch an einer Außenwand angebracht ist, scheint das Innere der Struktur nach außen gekehrt zu sein. Dies wird durch den schrankartigen Vorbau und weitere Details, die man üblicherweise mit einer zum Wohnen bestimmten Räumlichkeit in Verbindung bringt, nahegelegt. Sie verstärken damit den Eindruck der architektonischen Mehrdeutigkeit.

Le travail de Manfred Pernice est architectural par ses références. Ses pièces ressemblent tantôt à des plans de bâtiments tantôt à des modèles réduits de structures réalisables, mais les éléments clés tels que les fenêtres et les portes manquent ou ne sont pas à l'échelle, les rendant futiles. Fascinés par les bateaux, les containers et autres vaisseaux, Pernice inclut souvent des références aux ports et aux transports dans ses travaux. Des collages de papier journal, d'images de magazine ou de documents d'expédition sont appliqués sur ses structures et intégrés à ses dessins. Ses containers en contre-plaqué, tels que *Bell II*, 1998, et *Sieg*, 2001, semblent être des modèles de vaisseaux pour transporter des marchandises, sauf qu'ils ne sont pas fonctionnels par leur matériau et leur construction. Inspiré par un navire de Bremerhaven, Pernice fait également référence à un bateau dans *Bad, bath*, 1998, où il érige des panneaux avec des portions en angle. Le bas est peint en gris « navire de guerre » et le haut avec de faux hublots ronds. Le travail de Pernice est souvent lié à des lieux réels, bien que ses représentations soient conceptuelles plutôt que directes. Son grand *Sardinien*, 1996, partage des caractéristiques formelles avec les maisons et les bâtiments blanchis à la chaux perchés au bord de falaises de villes méditerranéennes. Toutefois, la forme de la sculpture, avec ses angles ronds et ses parties saillantes, rappelle également un camping-car. L'inclusion d'une photographie d'une côte renforce la référence à la Sardaigne, mais son positionnement sur la surface de la structure semble retourner la pièce comme un gant. La photo, tout comme l'étagère et d'autres détails associés à l'intérieur d'une maison apparaissent à l'extérieur de la sculpture et renforcent son ambiguïté architecturale. Ro. S.

SELECTED EXHIBITIONS →
1997 *4ème Biennale de Lyon*, France **1998** *Migrateurs*, Musée d'Art Moderne de la Ville de Paris, France; *1. berlin biennale*, Berlin, Germany **2000** Kunsthalle Zürich, Zurich, Switzerland; *Work-Raum*, National-galerie im Hamburger Bahnhof, Museum für Gegenwart, Berlin, Germany; Institute of Visual Arts, University of Wisconsin, Milwaukee (WC), USA; *Manifesta 3*, Ljubljana, Slovenia **2001** Sprengel Museum, Hanover, Germany; *49. Biennale di Venezia*, Venice, Italy; *Public Offerings*, Museum of Contemporary Art, Los Angeles (CA), USA

SELECTED BIBLIOGRAPHY →
1997 Harald Szeemann, *4ème Biennale de Lyon* **1998** *Mai 98*, Josef-Haubrich-Kunsthalle, Cologne **1999** Burkhard Riemschneider/ Uta Grosenick (eds.), *Art at the Turn of the Millennium*, Cologne **2000** *Manfred Pernice*, Kunsthalle Zürich, Zurich; *Made in Berlin*, Städtische Galerie L. Kanakakis, Rethymnon

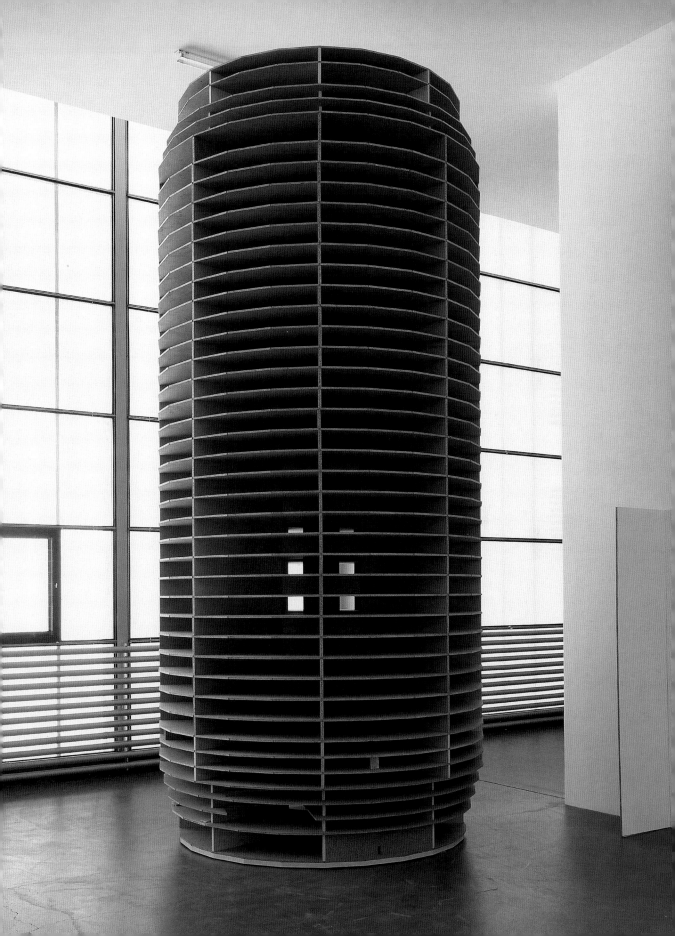

382

1 **Haupt/Centraldose,** 1998–2000, mixed media, 6 x Ø 2 m, installation view, Kunsthalle Zürich, Zurich
2 **Flat** (detail), 2000, mixed media, installation view, Kunsthalle Zürich, Zurich

3 **Dosenfeld '00,** 2000, mixed media, installation view, Kunsthalle Zürich, Zurich
4 **Kümo,** 1999, mixed media, installation view, Nationalgalerie im Hamburger Bahnhof, Museum für Gegenwart, Berlin, 2000

„Im Widerspiel des Unmöglichen mit dem Möglichen erweitern wir unsere Möglichkeiten." (Ingeborg Bachmann)

« Dans l'opposition du possible avec l'impossible nous élargissons nos possibilités. » (Ingeborg Bachmann)

"In the interplay of the impossible and the possible, we extend the range of our possibilities." (Ingeborg Bachmann)

2

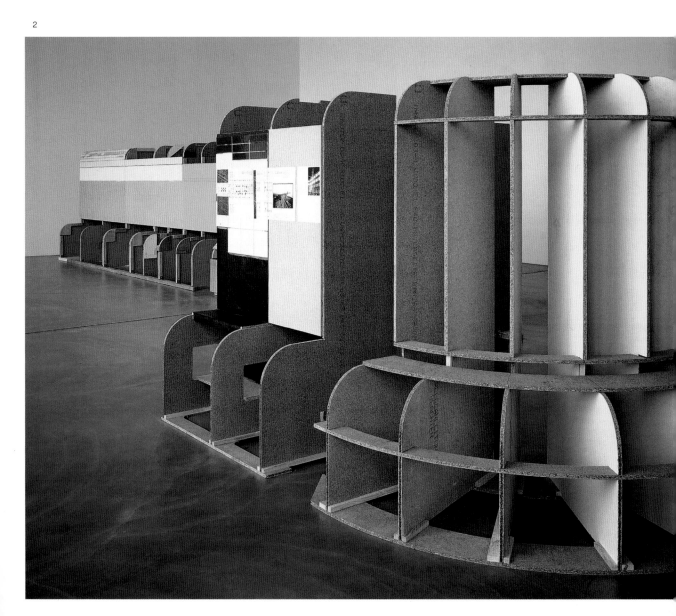

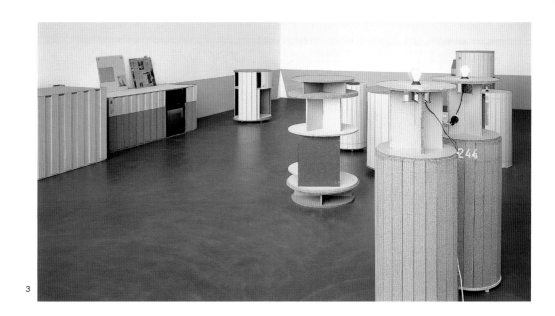

3

4

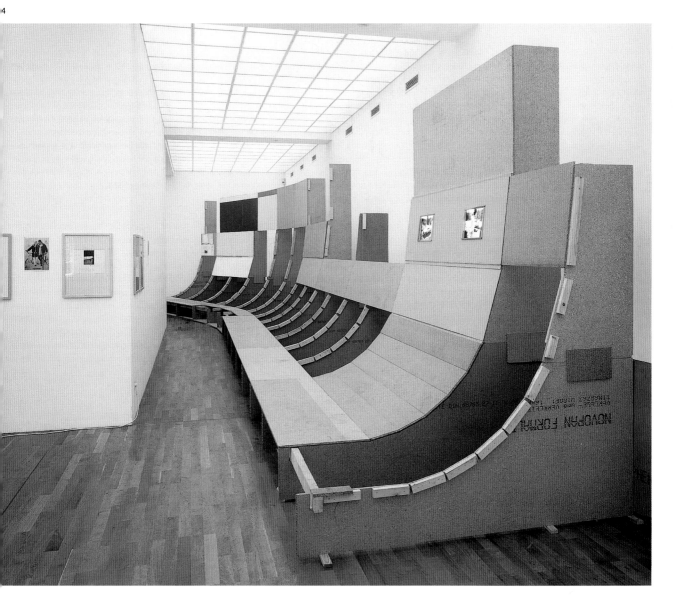

Dan Peterman

1960 born in Minneapolis (MN), lives and works in Chicago (IL), USA

Dan Peterman is both artist and "social worker", and the two working spheres constantly overlap. On the one hand, Peterman creates sculptures from recycled plastics; on the other, he runs an alternative cultural and business centre on Chicago's 61st Street, which includes a recycling centre, a bicycle workshop, the editorial offices of the political magazine "Baffler" and an ecological urban farm. Peterman's furniture-like sculptures provide a good example of how his non-artistic interests infiltrate his work as an artist. In museums and galleries his artefacts assume the role of minimalist objects while the recycled materials from which they are made are themselves allusions to consumerism, waste and ecological issues. The objects on public display, such as a perfectly ordinary bench, manufactured using very environmentally friendly methods, also perform a useful function. Peterman's *61st Street Bottlecap Pasta*, 2001, demonstrates the increasing complexity of his art. In a mobile kitchen, mounted on a stand made at the Chicago centre from recycled plastic, the artist uses bottle caps to cut out pasta shapes which are then sold to visitors. Thus Peterman cleverly combines his different interests. The work is simultaneously a micropolitical model for commercial activity, alternative projects, artistic strategy and critical thought.

Dan Peterman arbeitet gleichzeitig als Künstler und als „Sozialarbeiter", beide Arbeitsbereiche durchdringen sich dabei wechsel-seitig. Einerseits nämlich stellt Peterman Skulpturen aus recycelten Kunststoffen her, andererseits betreibt er in der 61. Straße von Chicago ein alternatives Kultur- und Produktionszentrum, zu dem u. a. ein Recyclinghof, eine Fahrradwerkstatt, die Redaktionsräume für das politische Magazin „Baffler" und ein ökologischer Bauernhof gehören. Die möbelartigen Skulpturen von Peterman sind ein gutes Beispiel dafür, wie er seine Arbeiten in künstlerische, aber auch in nicht-künstlerische Lebenswelten einschleusen kann: Im Museum oder in einer Galerie funktionieren diese Artefakte als minimalistische Objekte, die mit ihren recycelten Materialien an Konsum, Abfall und Ökologie erinnern. Im öffentlichen Raum aufgestellt, bekommen die Objekte eine Funktion, zum Beispiel als ganz gewöhnliche Sitzbank, die allerdings besonders umweltfreundlich hergestellt wurde. Petermans Arbeit *61st Street Bottlecap Pasta*, 2001, zeigt, wie seine Kunst zunehmend komplexer wird: Auf einem aus recyceltem Kunststoff produzierten Gestell ist eine mobile Küche platziert, in der Tortellini mithilfe von Kronkorken hergestellt werden, die zuvor in Petermans Kulturzentrum in Chicago produziert wurden. Anschließend werden die Nudeln zum Verkauf angeboten. So verknüpft der Künstler geschickt verschiedene Ebenen miteinander, ist diese Arbeit doch ein mikropolitisches Modell sowohl für kommerzielle Betriebe wie auch für alternative Projekte, für künstlerische Strategien und kritische Gedanken.

Dan Peterman travaille à la fois comme artiste et comme « travaileur social », ces deux domaines d'activité s'influençant l'un l'autre. D'un côté en effet, Peterman réalise des sculptures à partir de matériaux recyclés, de l'autre, il dirige dans la 61ème rue à Chicago, un centre de production et de culture alternative dans lequel on trouve notamment un atelier de recyclage, un garage de réparation de vélos, les salles de rédaction du magazine politique « Baffler » et une ferme écologique. Apparentées à des meubles, les sculptures de Peterman sont un bon exemple de la manière dont l'artiste sait faire entrer ses œuvres dans des domaines artistiques aussi bien que non-artistiques : au musée ou dans une galerie, ces artefacts fonctionnent comme des objets minimalistes dont les matériaux recyclés évoquent la consommation, les déchets et l'écologie. Exposés dans l'espace public, les mêmes objets deviennent fonctionnels et figurent par exemple comme banc public tout à fait ordinaire, fabriqué il est vrai de manière particulièrement écologique. *61st Street Bottlecap Pasta*, 2001, illustre la complexité croissante de la démarche de Peterman : une structure en plastique recyclé supporte une cuisine mobile dans laquelle des tortellinis sont fabriqués à partir de capsules de bouteilles précédemment produites dans le centre culturel de Peterman à Chicago. L'artiste relie ainsi très habilement entre eux différents niveaux, ce travail s'affirmant comme un modèle micropolitique tout à la fois pour les entreprises commerciales et les projets alternatifs, les stratégies artistiques et la critique intellectuelle.

R. S.

SELECTED EXHIBITIONS →
1995 *Nutopi*, Rooseum, Center for Contemporary Art, Malmö, Sweden **1997** Galerie Klosterfelde, Berlin, Germany; *Home Sweet Home*, Deichtorhallen Hamburg, Germany **1998** *Currents 73: Dan Peterman*, The Saint Louis Art Museum, St. Louis (MO), USA; Kunsthalle Basel, Basle, Switzerland **1999** *Recent Economies*, Andrea Rosen Gallery, New York (NY), USA **2001** Kunstverein Hannover, Hanover, Germany; *2. berlin biennale*, Berlin, Germany; *Arbeit Essen Angst*, Kokerei Zollverein, Essen, Germany

SELECTED BIBLIOGRAPHY →
1998 *Dan Peterman*, Kunsthalle Basel, Basle **1999** *Dream City*, Munich; Burkhard Riemschneider/Uta Grosenick (eds.), *Art at the Turn of the Millennium*, Cologne **2001** *2. berlin biennale*, Berlin; *Plug-In. Einheit und Mobilität*, Westfälisches Landesmuseum, Münster

1 **61st Street Bottlecap Pasta/Accessories to an Event,** 2001, pasta, reprocessed, post-consumer plastic, table, refrigerator, installation view, *2. berlin biennale*, Berlin

2 **Carbon Bank (Spring 1999),** 1999, municipal garden-center, installation view, *Dream City*, Kunstraum München, Kunstverein München, Museum Villa Stuck, Siemens-Kulturprogramm, Munich

3 **Excerpts From The Universal Lab,** 2000, mixed media installation, installation views, *Ecologies: Mark Dion, Peter Fend, Dan Peterman,* The David and Alfred Smart Museum of Art, The University of Chicago, Chicago (IL)

„Ich baue und präsentiere Möbel und Accessoires gewissermaßen mit einem Doppelleben, um auf diese Weise reale Materialien aufzubewahren."

« Je crée et présente des meubles et des accessoires comme s'ils avaient deux vies, comme une manière de préserver des matériaux physiques. »

"I create and present furniture and accessories as having a double life, as a way of preserving physical materials."

2

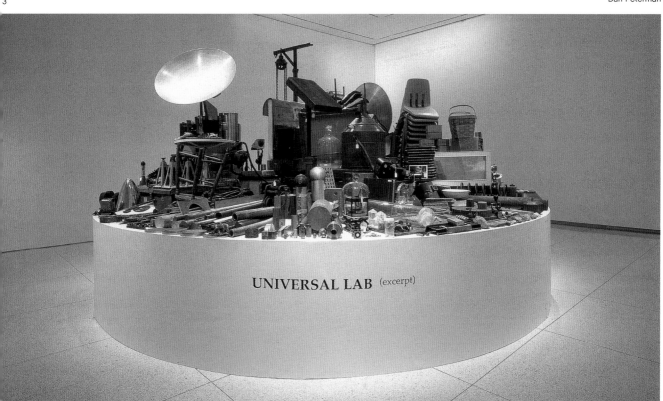

UNIVERSAL LAB (excerpt)

Elizabeth Peyton

1965 born in Danbury (CT), lives and works in New York (NY), USA

Elizabeth Peyton creates small, gem-like portraits of popular and historical figures, well-known musicians, fellow artists, and friends. Her visual biographies are suspended between the humanity and timelessness of traditional portraiture and the personal obsessions of an artist of her generation. She creates images that reflect her own ideas about beauty as well as beauty as it is constructed in contemporary culture. Each of the personalities she portrays – including the historic Ludwig II and Oscar Wilde, the popular Kurt Cobain from "Nirvana" and Noel Gallagher from "Oasis", and her artist-friends Craig Wadlin and Piotr Uklański – exhibits an elusive yet captivating vibrancy. Most of her subjects are men who share an androgynous quality, and she typically presents them with similar features including creamy skin and ruby lips. Working from photographs she takes or those she finds on albums and in books and magazines, Peyton surrounds herself with the people she most admires, constructing an ideal world that is filled with personal heroes and modern-day legends. But unlike the mass media which presents surface qualities, Peyton portrays the essence of her subjects with sincerity and tender admiration. She does not make distinctions in her work between people she knows personally and those she is acquainted with through their music, photos, or biographies. Rather, she chooses subjects whose spirit inspires her and influences others. Often she depicts individuals early in their lives and before they became famous, such as *Liam and Noel in the 70s*, 1997.

Elizabeth Peyton porträtiert in ihren kleinformatigen Arbeiten populäre und historische Figuren, etwa bekannte Sänger, Künstler, aber auch Freunde. Ihre visuellen Biografien sind im Spannungsfeld zwischen der Humanität und Zeitlosigkeit traditioneller Porträtkunst und den persönlichen Obsessionen einer Künstlerin ihrer Generation angesiedelt. Sie schafft Bilder, in denen sich ihr eigenes Schönheitsideal ebenso widerspiegelt wie das von der heutigen Popkultur geschaffene. Jede der von ihr porträtierten Persönlichkeiten – historische Figuren wie König Ludwig II. und Oscar Wilde, Popstars wie Kurt Cobain von „Nirvana" und Noel Gallagher von „Oasis" oder Künstlerfreunde wie Craig Wadlin und Piotr Uklański – zeichnet sich durch eine ebenso schwer fassbare wie ergreifende Lebendigkeit aus. Die meisten der von ihr Porträtierten sind androgyne Männer. Peyton gibt sie mit ähnlichen Zügen wieder, dazu gehören samtweiche Haut und rubinrote Lippen. Peyton arbeitet nach Fotografien, die sie entweder selbst aufnimmt oder auf CD-Hüllen oder in Büchern oder Zeitschriften findet, und umgibt sich auf diese Weise mit den Leuten, die sie am meisten bewundert. So entwirft sie eine Idealwelt, die von ihren persönlichen Heroen und den Legenden der Moderne bevölkert wird. Aber anders als die Massenmedien, denen es lediglich um die Oberfläche zu tun ist, stellt Peyton die von ihr porträtierten Persönlichkeiten voll Aufrichtigkeit und zärtlicher Bewunderung dar. Sie macht in ihrer Arbeit keinen Unterschied zwischen Leuten, die sie persönlich kennt, und solchen, mit denen sie lediglich durch ihre Musik, von Fotos oder aus Büchern vertraut ist. Ja, sie wählt für ihre Bildnisse Menschen aus, durch die sie sich inspiriert fühlt und die auch andere beeinflussen. Außerdem hat sie immer wieder Prominente in deren Jugend dargestellt, noch bevor sie berühmt geworden sind, etwa in der Arbeit *Liam and Noel in the 70s*, 1997.

Elizabeth Peyton réalise de petits portraits bijoux de personnages populaires et historiques, de musiciens connus, d'artistes et d'amis. Ses biographies visuelles sont suspendues entre, d'une part, l'humanité et l'intemporalité du portrait traditionnel et, de l'autre, les obsessions personnelles d'une artiste de sa génération. Elle crée des images qui reflètent ses propres critères de beauté ainsi que la beauté telle qu'elle est construite dans la culture contemporaine. Chacune des personnalités qu'elle dépeint – qu'il s'agisse de Louis II de Bavière ou d'Oscar Wilde, du chanteur de « Nirvana », Kurt Cobain, à celui d'« Oasis », Noel Gallagher, ou de ses amis artistes Craig Wadlin et Piotr Uklański – dégage des vibrations floues mais néanmoins captivantes. La plupart de ses sujets sont des hommes qui partagent une qualité androgyne. Elle les représente tous avec des traits similaires qui incluent un teint crémeux et des lèvres rouge rubis. Travaillant à partir de photographies qu'elle prend elle-même ou qu'elle trouve dans des albums, des livres ou des magazines, Peyton s'entoure des gens qu'elle admire le plus, construisant un monde idéal rempli de héros personnels et de légendes d'aujourd'hui. Mais contrairement aux médias qui présentent leurs qualités de surface, elle dépeint l'essence de ses sujets avec sincérité et une admiration teintée de tendresse. Dans son travail, elle ne fait pas de distinction entre ceux qu'elle connaît personnellement et ceux qu'elle connaît au travers de leur musique, de leurs photos ou de leur biographie. Elle choisit plutôt les sujets dont l'esprit l'inspire et influence les autres. Elle présente souvent ses personnages tôt dans leur vie, avant qu'ils ne soient devenus célèbres, comme dans le cas de *Liam and Noel in the 70s*, 1997.

Ro. S.

SELECTED EXHIBITIONS →
1998 Museum für Gegenwartskunst, Basle, Switzerland; Kunstmuseum Wolfsburg, Germany **1999** Castello di Rivoli, Turin, Italy **2000** *Tony*, Westfälischer Kunstverein, Münster, Germany; Aspen Art Museum, Aspen (CO), USA; *What if*, Moderna Museet, Stockholm, Sweden **2001** Deichtorhallen, Hamburg, Germany

SELECTED BIBLIOGRAPHY →
1998 Museum für Gegenwartskunst, Basle; Kunstmuseum Wolfsburg **2000** *Tony*, Westfälischer Kunstverein, Münster; Aspen Art Museum, Aspen (CO) **2001** Uta Grosenick (ed.), *Women Artists*, Cologne; Deichtorhallen, Hamburg

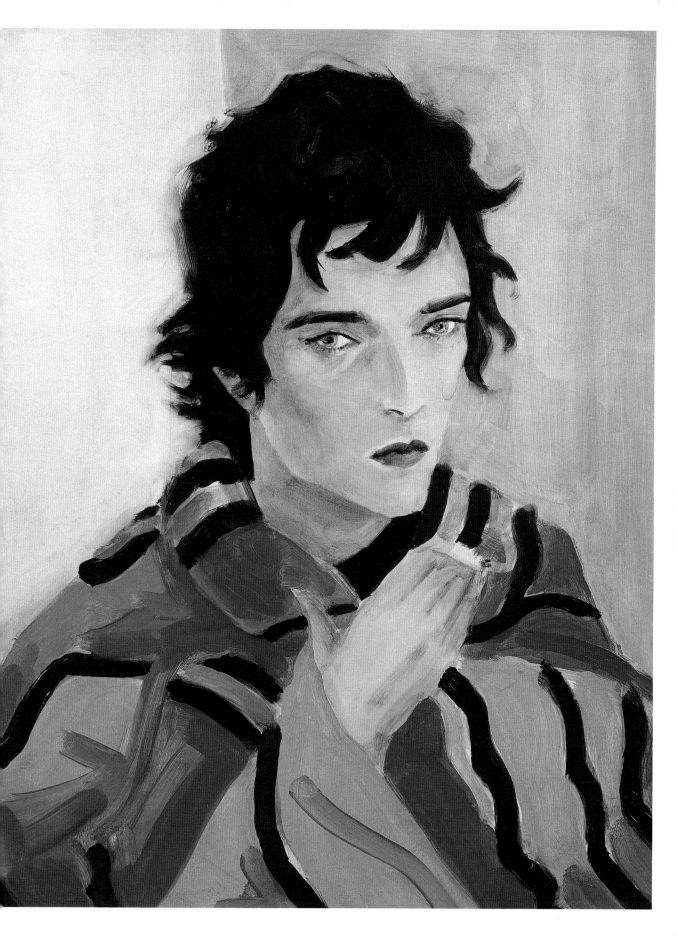

1 **Luing (Tony),** 2001, oil on MDF, 36 x 28 cm

2 **Spencer drawing,** 1999, oil on MDF, 23 x 30 cm
3 **Kirsty at Jorge's wedding,** 2001, oil on board, 36 x 28 cm

„Am meisten interessiert mich, glaube ich, die Fähigkeit der von mir
dargestellten Personen, sie selbst zu bleiben, obwohl sie in der Vorstellung
der Öffentlichkeit eine so unglaublich wichtige Rolle spielen.
Man kann ihren Willen unmittelbar erkennen, und das ist unglaublich schön."

« Je suppose que ce qui m'intéresse, c'est la faculté de mes sujets
à être eux-mêmes tout en occupant ce rôle extrême dans l'imagination
publique. On peut voir leur volonté, ce qui est incroyablement beau. »

**"I guess what I'm interested in is the quality
of my subjects' being able to be themselves while occupying
this extreme role in the public imagination.
You can see their will, and that's incredibly beautiful."**

2

Paul Pfeiffer

1966 born in Honolulu (HI), lives and works in New York (NY), USA

At the heart of Paul Pfeiffer's installations, sculptures and videos lies a fascination with the mechanics of the spectacle. He singles out large-scale sporting events, sports celebrities, movies and movie stars, but his centre of focus is not their action, appearances or narrative meaning. Instead, his work highlights the backgrounds, props or intuitive gestures that betray the elaborate structures beneath each polished surface. *Self-Portrait as a Fountain*, 2000, reconstructs the shower from the famously terrifying scene in Alfred Hitchcock's "Psycho". Pfeiffer skirts around its disquieting associations, however, to emphasise its manifest reality, slightly exaggerating its scale and surrounding it with glaring stage lights and tiny cameras, each of which represents one of the many shots Hitchcock used to compose his scene. For the video piece *John 3:16*, 2000, Pfeiffer reanimated thousands of stills taken from a year of basketball playoffs, but cropped everything except for the ball itself out of frame: the players, the hoop, the stadium, the audience; all were removed. The ball alone is given the starring role, jerking from frame to frame but always remaining central and close-up. Through Pfeiffer's sophisticated digital editing techniques the technological devices that manipulate an audience's responses are stripped away to reveal instead the materiality of mass culture. Indeed the video triptych *The Long Count (I Shook Up the World)*, 2000, confronts the audience directly with its own image. Each screen shows a legendary Muhammad Ali fight, but both boxers have been digitally erased, leaving only ghostly traces of their movement and an audience transfixed by a now empty ring.

Die Installationen, plastischen Arbeiten und Videos von Paul Pfeiffer drehen sich vor allem um die Mechanik des Spektakels. Er verwendet Bildmaterial großer Sportereignisse, berühmter Sportler, von Kinofilmen und Starschauspielern. Aber sein Hauptinteresse gilt weder dem Geschehen noch den Auftritten oder der Erzählstruktur. Vielmehr beleuchtet er die hinter den polierten Oberflächen verborgenen Motivationen, Requisiten und intuitiven Gesten. In *Self-Portrait as a Fountain*, 2000, hat er die Dusche aus der berühmten Schreckensszene in Alfred Hitchcocks „Psycho" rekonstruiert. Pfeiffer evoziert die mit der Szene verbundenen Assoziationen nur schemenhaft und hebt die manifeste Realität des Schauplatzes stärker hervor, indem er die Dusche überlebensgroß darstellt und sie mit grell leuchtenden Scheinwerfern und winzigen Kameras umstellt, von denen jede für eine der zahlreichen Einstellungen steht, aus denen Hitchcock die Szene komponiert hat. Für die Video-Arbeit *John 3:16*, 2000, hat Pfeiffer Tausende von Videostills von Basketball-Play-off-Spielen eines Jahres verwendet, dabei jedoch bis auf den Ball sämtliche Einzelheiten aus den Bildern herausgenommen: die Spieler, den Korbring, das Stadion, die Zuschauer – einfach alles. Die Hauptrolle spielt einzig der von Bild zu Bild ruckelnde Ball, der in Großaufnahme zu sehen ist. Dank Pfeiffers raffinierter digitaler Bearbeitungsverfahren sind die zur Manipulation des Publikums bestimmten technischen Hilfsmittel aus den Bildern eliminiert, um die Materialität der Massenkultur aufzudecken. Das Videotriptychon *The Long Count (I Shook Up the World)*, 2000, konfrontiert das Publikum unmittelbar mit seinem eigenen Bild. Jeder Monitor zeigt einen legendären Muhammad-Ali-Kampf, aber beide Boxer sind digital ausradiert, so dass lediglich gespenstische Spuren ihrer Bewegungen zu sehen sind und die Zuschauer gebannt auf den leeren Ring starren.

Au cœur des installations, des sculptures et des vidéos de Paul Pfeiffer se trouve une fascination pour la mécanique du spectacle. Il isole des événements sportifs d'envergure, des dieux du stade, des films ou des stars de cinéma, mais sans pour autant se concentrer sur leurs actions, leur aspect ou leur signification narrative. Son travail met plutôt en valeur les coulisses, les accessoires ou les gestes intuitifs qui trahissent les structures complexes derrière chaque surface polie. *Self-Portrait as a Fountain*, 2000, reconstitue la célèbre scène de la douche du film d'Alfred Hitchcock « Psychose ». Toutefois, Pfeiffer minimise ses connotations angoissantes pour mettre l'accent sur sa réalité manifeste, exagérant légèrement son échelle, l'entourant de projecteurs aveuglants et de caméras minuscules, dont chacune représente l'un des nombreux plans utilisés par Hitchcock pour composer sa scène. Pour sa vidéo *John 3:16*, 2000, Pfeiffer a utilisé des milliers d'arrêts sur image pris pendant une année de matchs de basket-ball mais, dans chaque plan, il a coupé tout ce qui n'était pas le ballon : les joueurs, le panier, la salle, le public. Le ballon occupe le premier rôle, sautant de plan en plan mais restant toujours au centre de l'image et en gros plan. Bien que la technologie soit immédiatement apparente dans les montages sophistiqués de Pfeiffer mettant à nu les dispositifs qui manipulent les réactions du public pour révéler la matérialité de la culture de masse. De fait, le triptyque vidéo *The Long Count (I Shook Up the World)*, 2000, confronte directement le public avec sa propre image. Chaque écran montre un combat du légendaire Muhammad Ali, mais les deux boxeurs ont été effacés numériquement. On ne voit plus que des traces spectrales de leurs mouvements et un public tétanisé par un ring vide.

K. B.

SELECTED EXHIBITIONS →
1995 *In a Different Light*, University Art Museum, Berkeley (CA), USA
1998 The Project, New York (NY), USA **2000** Kunst-Werke, Berlin, Germany; *Hypermental*, Kunsthaus Zürich, Zurich, Switzerland; *Whitney Biennial*, The Whitney Museum of American Art, New York (NY), USA **2001** UCLA Hammer Museum, Los Angeles (CA), USA; Barbican Art Center, London, UK; Kunsthaus Glarus, Switzerland; *The Americans*, Barbican Arts Center, London, UK; *49. Biennale di Venezia*, Venice, Italy; *Sport als Motiv in der zeitgenössischen Kunst*, Kunsthalle Nürnberg, Nuremberg, Germany

SELECTED BIBLIOGRAPHY →
1995 *In a Different Light*, University Art Museum, Berkeley (CA)
1998 *At Home and Abroad: 20 Contemporary Filipino Artists*, San Francisco Asian Art Museum, San Francisco (CA) **2000** *Greater New York: New York Art in New York Now*, P.S.1, Long Island City (NY); *Whitney Biennial*, The Whitney Museum of American Art, New York (NY) **2001** *The Americans*, Barbican Arts Center, London

394

1 **Self-Portrait as a Fountain,** 2000, oversized fibreglass bathtub/shower with gel coat finish, chrome plated metal and plastic bathroom fixtures, copper plumbing, galvanised iron water reservoir with Plexiglas cover, wood and aluminium supports, studio lights, water circulation system, multi-channel video surveillance system, c. 5.50 x 1.80 x 3 m

2 **Race Riot,** 2001, digital camcorder, DVD player, digital video loop, vitrine, vitrine 51 x 51 x 56 cm, image size 4 x 5 cm

3 Installation view, *Sex Machine,* The Project, Los Angeles, 2001

4 **Three Studies For Figures at the Base Of a Crucifixion,** 2001, CPJ projectors, DVDs, DVD players, metal armatures, 122 x 208 x 107 cm

„Du bist bereits zutiefst von der Technik infiziert." « La technologie est déjà profondément en vous. »

"Technology is already deep inside you."

2

3

4

Daniel Pflumm

1968 born in Geneva, Switzerland, lives and works in Berlin, Germany

Music and art are the contexts for Daniel Pflumm's creative works. The strategies he applies vary depending on the field in which he is working. In 1995, he and musicians Klaus Kotai and Mo co-founded the "EMD" (Elektro Music Department) label for which Pflumm designs record sleeves, flyers and merchandising. In 1992, he was involved in launching the "Elektro" club in Berlin, where he screened his first videos, which were specifically devised as visuals for the club: continuously changing images of products and labels, mostly from the sphere of electronic media, which included AT&T, VH-1, Motorola, United Technologies and MasterCard. For his exhibitions Pflumm has returned his attention to logos, which he uses in his light boxes and videos. He transfers the visual strategies of business to the world of art by his use of these logos. At first he kept the company names featured on the logos, but as a political gesture he deleted them for his exhibition on the occasion of the Bund Deutscher Industrie's (German association of industry) art award ceremony in 1997. For his videos, Pflumm loops clips from advertising films (*Stuttgart-tape*, 1997), or the blinking eyes of CNN newscasters (*CNN*, 1997), while the soundtrack features EMD's minimalist electronic sound. The works are presented on screens set into walls to make the moving images appear flatter. Pflumm's websites contain scattered ideas, for example a database of images for graphic designers (see www.seltsam.com). In his latest works he again quotes and subverts logos, but he also transfers the mechanisms and aesthetics of corporate identity onto a "branding policy" of the art world.

Daniel Pflumm realisiert seine Arbeiten sowohl im Kunst- als auch im Musikkontext. In beiden Bereichen arbeitet er mit unterschiedlichen Strategien. 1995 gründete er mit den Musikern Klaus Kotai und Mo das Label „EMD" (Elektro Music Department), für dessen visuelle Gestaltung von Plattencovern, Flyern und Merchandising er verantwortlich ist. In dem 1992 von ihm mitinitiierten Berliner Club „Elektro" zeigte er seine frühen Videos, die als Visuals für den Clubkontext konzipiert waren: sich immer wieder aufbauende Bilder von Produktansichten oder Labels, hauptsächlich aus dem Bereich elektronischer Medien, wie AT&T, VH-1, Motorola, United Technologies oder MasterCard. Im Ausstellungskontext nimmt Pflumm das Logo-Thema in Leuchtkästen und Videos auf. Mit dem Gebrauch von Logos überträgt er visuelle Strategien aus der Ökonomie in den Kunstbereich. Anfänglich waren die Logos noch mit dem Namenszug der jeweiligen Firma versehen; als politische Geste eliminiert er diese jedoch seit seiner Ausstellung anlässlich der Kunstpreisverleihung des Bundes Deutscher Industrie 1997. In seinen Videos montiert Pflumm Ausschnitte aus Werbefilmen (*Stuttgart-tape*, 1997) oder die zwinkernden Augenbewegungen von CNN-Nachrichtensprechern (*CNN*, 1997) zu Loops, zu denen der minimalistische Elektro-Sound von EMD von der Tonspur zu hören ist. Die Arbeiten werden auf Monitoren gezeigt, die in eine Wand eingelassen sind, sodass das bewegte Bild plan wahrgenommen wird. Auf Pflumms Websites finden sich verstreute Ideen, zum Beispiel eine Art Datenbank für Grafikdesigner mit Abbildungen (siehe www.seltsam.com). In neueren Arbeiten zitiert und verfremdet er nicht nur Logos, sondern überträgt die Mechanismen und die Ästhetik einer Corporate identity auf eine „Markenpolitik" innerhalb des Kunstfelds.

Daniel Pflumm réalise ses œuvres dans le double contexte des scènes artistique et musicale. Dans ces deux domaines, il travaille avec différentes stratégies. En 1995, il fonde avec Klaus Kotai et Mo le label « EMD » (Elektro Music Department), pour lequel il assume la réalisation visuelle des pochettes de disques, des prospectus et du merchandising. C'est dans le club « Elektro », dont il fut cofondateur en 1992, qu'il montre ses premières vidéos conçues comme des visuels pour l'animation du club : images en perpétuelle reconstruction de produits ou de labels issus pour l'essentiel des médias électroniques – AT&T, VH-1, Motorola, United Technologies ou MasterCard. Dans ses expositions, Pflumm reprend le thème du logo dans des boîtes lumineuses et des vidéos. Avec l'utilisation de logos, il transpose les stratégies de l'image commerciale dans le contexte de l'art. Au départ, les logos étaient assortis du nom de l'entreprise. Par un acte politique, l'artiste les éliminera néanmoins après l'exposition organisée en 1997 pour la remise du Prix du Bund Deutscher Industrie (l'Industrie allemande). Dans ses vidéos accompagnées d'une bande son électro-minimaliste d'EMD, Pflumm met en boucle des séquences de films publicitaires (*Stuttgart-tape*, 1997) ou les mouvements et les clignements d'yeux des journalistes télévisés de CNN (*CNN*, 1997). Les œuvres sont montrées sur des moniteurs logés dans le mur, de sorte que les mouvements de l'image sont perçus de manière totalement plane. Le site web de Pflumm fourmille d'idées disséminées. On y trouve par exemple une sorte de base de données pour designers (référence www.seltsam.com [www.étrange.com]). Dans ses œuvres récentes, Pflumm ne se contente pas de citer et de détourner des logos, il transpose les mécanismes et l'esthétique d'une corporate identity dans les termes d'une « politique d'entreprise » au sein du contexte artistique. N. M.

SELECTED EXHIBITIONS →
1997 Künstlerhaus Stuttgart, Germany **1998** A+J, London, UK; *1. berlin biennale*, Berlin **1999** Galerie Neu, Berlin, Germany; Haus der Kunst, Munich, Germany; The New Museum, New York (NY), USA; *German Open*, Kunstmuseum Wolfsburg, Germany **2000** Kunstverein Frankfurt, Frankfurt am Main, Germany; *Taipei Biennale*, Taipei, Taiwan **2001** Palais de Tokyo, Paris, France; Oslo Kunsthall, Oslo, Norway; Kunsthalle Zürich, Zurich, Switzerland; Museum of Contemporary Art Sydney, Australia

SELECTED BIBLIOGRAPHY →
1997 Kulturkreis der deutschen Wirtschaft (ed.), *ars viva, 97/98*, Cologne **1998** *Ortsbegehungen 4. body of the message*, Neuer Berliner Kunstverein, Berlin **2000** *German Open*, Kunstmuseum Wolfsburg **2001** Kunsthalle Zürich, Zurich

SELTSAM.COM

nupicom
MAXIMUMREQUEST.COM

1 **Ohne Titel,** 2001, lightbox, 12 x 65 x 10 cm
2 **Ohne Titel,** 2001, lightbox, 20 x 55 x 13 cm
3 **Questions and Answers,** 1997, video, 24 min

4 **Ohne Titel,** 2001, lightbox, 53 x 153 x 15 cm
5 **Ohne Titel,** 1998, lightbox, 89 x 110 x 15 cm

„Für Sicherheit gibt es mit Sicherheit keine Sicherheit." « Il n'y a pas d'assurance pour la certitude, c'est certain. »

"For certainty there is certainly no certainty."

3

4
5

Richard Phillips

1962 born in Marblehead (MA), lives and works in New York (NY), USA

Richard Phillips is known for his heroic-scale portraits copied from 1960s and 1970s fashion magazines. He adopts oil painting techniques that date back to the 19th century, though the harsh lighting and steely photo-realist surfaces of his works contradict this academic approach. His billboard-size paintings of fashion models from 1996 exhibit a cool blankness, and seem devoid of interior thought. In *Untitled (Cold Cream Woman)*, 1995, a generic beauty tilts her head in a typical pose despite the mask of thick white cream that obscures her features and provides a clear reference to the artifice involved in image-making. In a series of highly eroticised paintings from 1997, Phillips focuses his attention on the pre-Aids optimism of the 1970s soft-porn industry. *Tongue*, 1997, is a classic porn-mag shot: its low viewpoint places the model's parted lips and glistening tongue provocatively at the center of the image. Its larger-than-life proportions make it an intimidating vision of exaggerated sexuality. Phillips examines the precarious state of fame in two paintings from 1998. *Jacko (after Jeff Koons)*, is a portrait of Michael Jackson modelled on a sculpture by Jeff Koons, and *Portrait of God (after Richard Bernstein)* is a portrait of Rob Lowe at the height of his stardom, based on an "Interview" magazine cover. Both celebrities' reputations were tarnished by highly publicised sex scandals and Phillips' heroic paintings seem to reclaim the fallen heroes. Yet the titles' explicit reference to their intermediate source spells out Phillips' ironic distance and subordinates the star's identity to the power of his constructed image.

Richard Phillips ist für seine großformatigen Bildnisse bekannt, die von Modezeitschriften der sechziger und siebziger Jahre kopiert sind. Er verwendet Techniken der Ölmalerei des 19. Jahrhunderts, wenngleich die harte Ausleuchtung und die in fotorealistischer Nüchternheit gestalteten Oberflächen seiner Bilder dieser akademischen Vorgehensweise widersprechen. Seine plakatgroßen Gemälde von Supermodels (1996) stellen ihre kühle Glattheit und einen vollständigen Mangel an Emotionalität aus. *Untitled (Cold Cream Woman)*, 1995, zeigt eine typische Schönheit, die ihren Kopf in Pose wirft, trotz der dicken Feuchtigkeitsmaske, die ihre Züge fast unkenntlich macht und auf die Künstlichkeit jeder Bildkreation verweist. In einer Serie hocherotischer Gemälde von 1997 beschäftigt sich Phillips mit dem Optimismus der Softporno-Industrie der siebziger Jahre vor dem Auftreten von AIDS. *Tongue*, 1997, bietet die klassische Einstellung aus einem Pornomagazin: In der Untersicht rücken die geöffneten Lippen und die feucht glänzende Zunge des Models provokativ in den Mittelpunkt des Bildes. Das überlebensgroße Format macht es zur Angst erregenden Vision einer aus den Fugen geratenen Sexualität. In zwei Arbeiten von 1998 hat Phillips sich mit den Wechselfällen der Popularität auseinandergesetzt. *Jacko (after Jeff Koons)* ist ein – nach einer Skulptur von Jeff Koons modelliertes – Michael-Jackson-Porträt, während *Portrait of God (after Richard Bernstein)* Rob Lowe auf der Höhe seines Erfolgs zeigt; dieses Bildnis ist nach einem Titelfoto des „Interview"-Magazins entstanden. Auf die Popularität beider Stars ist ein dunkler Schatten gefallen, seit sie wegen angeblicher sexueller Verfehlungen in die Schusslinie der Medien geraten sind. Mit seiner heroischen Darstellung scheint Phillips die beiden gestürzten Helden wieder auf ihre Sockel stellen zu wollen. Durch den expliziten Verweis der Titel auf die Vorlagen der beiden Bilder demonstriert Phillips zugleich seine ironische Distanz und zeigt, dass die Identität eines Stars der Macht seines von den Medien geschaffenen Images unterworfen ist.

Richard Phillips est connu pour ses portraits grand format inspirés des magasines de mode des années 60 et 70. Il utilise des techniques de peinture à l'huile qui remontent au 19ème siècle, même si la lumière crue et les surfaces brillantes photo-réalistes de ses œuvres contredisent cette démarche académique. Ses tableaux de la taille de panneaux publicitaires géants représentent des mannequins et datant 1996 font preuve d'une neutralité froide et paraissent dépourvus d'intériorité. Dans *Untitled (Cold Cream Woman)*, 1995, une beauté générique renverse la tête en arrière dans une pose typique malgré l'épais masque de crème blanche qui dissimule ses traits et renvoie clairement aux artifices impliqués dans la fabrication des images. Dans une série de tableaux très érotiques de 1997, Phillips concentre son attention sur l'optimisme de l'industrie du porno soft des années 1970 avant l'apparition du sida. *Tongue*, 1997, est un cliché classique de revue X. Sa perspective provocante vers le haut place les lèvres entrouvertes et la langue luisante du modèle au centre de l'image. Toutefois, les proportions plus grandes que nature en font une vision intimidante de sexualité exagérée. Phillips se penche sur l'état précaire de la célébrité dans deux peintures de 1998 : *Jacko (after Jeff Koons)* est un portrait de Michael Jackson réalisé d'après une sculpture de Jeff Koons, et *Portrait of God (after Richard Bernstein)* celui de Rob Lowe au sommet de sa gloire, basé sur une couverture du magazine « Interview ». Ces deux célébrités ayant vu leur réputation salie par des scandales sexuels fortement médiatisés, ces toiles grand format semblent réhabiliter les héros déchus. Pourtant, les références explicites dans les titres à des sources intermédiaires trahissent la distance ironique de Phillips et subordonnent l'identité de la star à la puissance de son image construite. K. B.

SELECTED BIBLIOGRAPHY →
1999 Marcia Fortes, *ArtLovers*, Liverpool Biennial, Liverpool
2000 Mendes Burgi/Ronald Jones, *Richard Phillips*, Munich; *Greater New York*, P.S.1, Long Island City (NY); *The Figure: Another Side of Modernism. Paintings from 1950 to the Present*, Newhouse Center for Contemporary Art, Snug Harbour Cultural Center, Staten Island (NY)

1 **Scout,** 1999, oil on linen, 259 x 178 cm
2 **The President of the United States of America,** 2001, oil on linen, 263 x 396 cm

3 Installation view, Kunsthalle Zürich, Zurich, 2000
4 **Blessed Mother,** 2000, oil on linen, 213 x 183 cm

„In meinen Bildern geht es um verschwendete Schönheit –
das ist von jeher das Grundthema meiner Arbeit gewesen."

« Mes images évoquent une sorte de beauté gaspillée,
le fil conducteur de tout mon travail. »

"My pictures involve a kind of wasted beauty – that's always been a thread in my work."

3

4

Paola Pivi

1971 born in Milan, lives and works in Alicudi, Italy

Paola Pivi is concerned with the problematic relationships between reality, its presentation, and conventional ways of seeing. The performance artist, photographer and installation artist duplicates whatever material appears available and arranges it in pithy but magically bizarre situations. Pivi's early work *Camion*, 1997, typifies her artistic strategy. She placed a new lorry, turned over on its side, right in front of an exhibition venue in Pescara, where it stood at the side of the road like a helpless, oversized beetle. Using a technically complex but actually very simple device, the artist transformed the truck into something poetic, summoning up associations between its vulnerability, mysterious power and sheer strength and its state of absurd disarray. Two years later, she turned an Italian air force fighter on its back in the Arsenale at the Venice *Biennale*. In *Untitled (aeroplane)*, aggression and absurdity went hand in hand. In the same year, Pivi dazzled viewers with her performance *Untitled (100 Chinese)*. One hundred black-haired Chinese of both sexes were crammed into a gallery space. All of them were dressed alike in grey shirts and blue trousers and shoes. These "models" with their "non-identical identity", who were later photographed, almost incidentally posed questions about complete conformity and individual differences. For her current *Alicudi Project*, 2001, Pivi is having a photograph of the Italian island where she lives enlarged on a scale of 1 : 1, on gigantic PVC strips, with the intention of laying them out in due course in the Libyan desert. Here, it is the place rather than the visitor that has made the journey, creating a shift in reality whose enchantment lies in its very impossibility.

Schon ihre frühe Arbeit *Camion*, 1997, ist typisch für die künstlerische Strategie von Paola Pivi: Sie hat einen Truck direkt vor einem Ausstellungsgebäude in Pescara auf die Seite gekippt – wie ein überdimensionierter hilfloser Käfer lag der Lastwagen am Wegesrand. Mit nur einem, technisch höchst aufwendigen, aber eigentlich recht einfachen Eingriff hat die Künstlerin das Automobil in ein poetisches Geflecht übersetzt, das Assoziationen an eigene Verletzbarkeit und anonyme Macht, an schiere Kraft und irrationale Unordnung weckte. Zwei Jahre später war es ein Kampfflugzeug der italienischen Luftwaffe, das auf der *Biennale* von Venedig in den Hallen des Arsenals auf dem Rücken lag – Aggressivität und Absurdität reichten sich in der Arbeit *Untitled (aeroplane)*, die Hand. Im selben Jahr verblüffte Pivi mit ihrer Performance *Untitled (100 Chinese)*. Hundert schwarzhaarige Chinesen beiderlei Geschlechts standen in einem nun prall gefüllten Galerieraum. Alle waren mit grauem Hemd, blauer Hose und dunklen Schuhen gleich gekleidet. Und dennoch: Die später fotografierten „Modelle" stellten mit ihrer „un-identischen Identität" fast nebenbei die Frage nach serieller Norm und individueller Abweichung. Für ihr aktuelles *Alicudi Project*, 2001, lässt sie eine Fotografie der Insel, auf der sie lebt, 1 : 1 auf riesigen PVC-Bahnen vergrößern, und plant, es in der libyschen Wüste auszulegen. Nicht der Mensch soll hier auf die Reise gehen, sondern eine Örtlichkeit – so wird eine Realitätsverschiebung inszeniert, die uns gerade dank ihrer Unmöglichkeit zu bezaubern vermag.

Paola Pivi travaille sur le rapport problématique entre la réalité, sa présentation et la perception courante que nous en avons. C'est pourquoi la performeuse, photographe et artiste de l'objet duplique des objets apparemment trouvés et les arrange en situations lapidaires, mais d'un effet quasi magique. Une de ses premières œuvres, *Camion*, 1997, est caractéristique de sa stratégie : directement devant un bâtiment d'exposition de Pescara, l'artiste avait renversé sur le flanc un camion qui gisait ainsi au bord de la route comme un gigantesque hanneton sur le dos. Par une intervention hautement élaborée du point de vue technique, mais en définitive très simple, l'artiste transplantait le véhicule dans un champ d'associations poétiques renvoyant à la vulnérabilité personnelle et à l'anonymat du pouvoir, à la force brute et au désordre irrationnel. Pour *Untitled (aeroplane)*, exposé deux ans plus tard à l'Arsenal de la *Biennale* de Venise, Pivi retourne sur le dos un avion de combat de l'armée de l'air italienne, renvoyant dos à dos l'agressivité et l'absurde. La même année, Pivi surprend tout le monde avec sa performance *Untitled (100 Chinese)*. Cent Chinois des deux sexes, cheveux noirs, se tenaient debout dans une galerie pleine à craquer. Tous portaient la même chemise grise, le même pantalon bleu et les mêmes chaussures foncées. Avec leur « identité non identique », les « modèles » photographiés plus tard posaient pourtant presque accessoirement le problème de la norme collective et de l'écart individuel. Pour son projet actuel *Alicudi Project*, 2001, Pivi fait agrandir 1 : 1 un tirage photographique de l'île d'Alicudi, où elle habite, sur d'immenses bandes en PVC qu'elle prévoit de déposer dans le désert de Libye. Ici, ce n'est plus l'homme qui part en voyage, mais le lieu lui-même – mise en scène d'un décalage du réel capable précisément de séduire par son infaisabilité.

R. S.

SELECTED EXHIBITIONS →
1996 Via Farini, Milan, Italy **1997** *Opera Prima*, Galerie Arte Nova, Pescara, Italy **1998** Galleria Massimo De Carlo, Milan, Italy **1999** *dAPERTuttO, 48. Biennale di Venezia*, Venice, Italy **2000** Castello di Rivoli, Turin, Italy; *Clockwork 2000*, P.S.1, Long Island City (NY), USA **2001** Galleria Massimo De Carlo, Milan, Italy; Galerie Emmanuel Perrotin, Paris, France; *Alicudi Project*, Galerie Michael Neff, Frankfurt am Main, Germany

SELECTED BIBLIOGRAPHY →
1999 *dAPERTuttO, 48. Biennale di Venezia*, Venice

1 **Alicudi Project,** 2001, inkjet print on PVC, 1819 x 500 m, work in progress
2 **Alicudi Project,** 2001, inkjet prints on PVC, installation view, Galerie Michael Neff, Frankfurt am Main
3 **Untitled (aeroplane),** 1999, Fiat G-91 aeroplane, 3 x 11.80 x 8.60 m,

installation view, Arsenale, *48. Biennale di Venezia*, Venice
4 **Lions,** 1998, 64.000 W lamps, cables, generating truck, shelves, 266 x 304 x 51 cm
5 **Camion,** 1997, lorry, 2.50 x 16 x 4 m

„Das Hirn existiert, weil es das Überleben und die Vervielfältigung der Gene befördert, die seine Versammlung ordnen." (Edward O. Wilson)

« Le cerveau existe car il encourage la survie et la multiplication des gènes qui organisent sa composition. » (Edward O. Wilson)

"The brain exists because it promotes the survival and multiplication of the genes that direct its assembly." (Edward O. Wilson)

3

4

5

408

Peter Pommerer

1968 born in Stuttgart, lives and works in Berlin, Germany

Drawing is lighter and faster than other media. It is traditionally contrasted with painting, including mural painting. In theory, drawings are impermanent, private, mobile and free by reason of not being attached to a stable background. Peter Pommerer's drawings shed new light on the issue, forcing a reconsideration of the alleged freedom of drawing. Most of his drawings are executed on walls while the backdrop for their restless presence is the rigid architecture of the galleries and other interiors. In crayon and pencil Pommerer wickedly embellishes the immaculate and pompous white spaces, walls, windows, doorways and pillars. The tradition Pommerer invokes with its themes from fairytale narratives with elephants parading single-file past innumerable castles atop lofty summits, and psychedelic steamboat rides through tropical scenery full of palm trees and magic mushrooms, has more in common with the simple repetitive rhythms of cave painting and the anarchy of children's scribbles than the complex harmonies of European *disegno* – that crowning achievement of true European spirituality. Pommerer is ironic when it comes to official art history: one of his works is called *Did Henri Matisse Do Abstract Paintings In Secret?*, 2000. In its place he offers a history of his own, full of gaps and ambiguity. By almost exclusively focusing on ephemeral mural compositions, he gives up manufacturing for the uniqueness of making, the joyous knowledge of being in every single second, with crayon in hand.

Das Medium Zeichnung ist leichter und schneller als andere. Für gewöhnlich stellt man die Handzeichnung der Malerei – einschließlich der Wandmalerei – gegenüber. In der Theorie ist die Zeichnung durch Kurzlebigkeit, Privatheit, Mobilität und Unabhängigkeit charakterisiert, weil sie nicht auf einen dauerhaften Bildträger aufgebracht wird. Die Zeichnungen von Peter Pommerer lassen diese Vorstellungen in einem neuen Licht erscheinen; sie zwingen dazu, die vorgebliche Freiheit des Zeichenaktes neu zu überdenken. Pommerer führt die meisten seiner Zeichnungen an Wänden aus, dabei fungieren die rigide Architektur der Ausstellungsräume und das typische Galerie-Interieur als Hintergrund für die ruhelose Präsenz dieser Arbeiten. Und so macht sich Pommerer – wie es scheint – fast ein wenig schadenfroh daran, mit dem Blei- oder Buntstift ebenso makellose wie pompöse weiße Flächen – Wände, Fenster, Türen und Pfeiler – zu verzieren. Tatsächlich erinnern Pommerers Arbeiten mit ihrer Themenwahl aus märchenhaften Bildfolgen mit Elefanten, die in einer Reihe an Burgen auf erhabenen Gipfeln vorbeiparadieren, psychedelischen Dampferfahrten durch tropische Gefilde samt Palmen und magischen Pilzen an die einfachen, repetitiven Rhythmen der Höhlenmalerei oder die Anarchie kindlicher Kritzeleien. Die komplexen Harmonien des europäischen *disegno* – also die höchsten Errungenschaften der europäischen Spiritualität – hingegen scheinen ihn kaum zu interessieren. Pommerer betrachtet die offizielle Kunstgeschichte sogar mit einer gewissen Ironie: So trägt eines seiner Werke den Titel *Did Henri Matisse Do Abstract Paintings In Secret?*, 2000. Er offeriert vielmehr eine ganz eigene – ebenso lückenhafte wie mehrdeutige – Historie. Durch die fast ausschließliche Beschränkung auf kurzlebige Wandarbeiten gibt er den Bereich der Herstellung zugunsten der Einzigartigkeit auf. Er scheint damit zufrieden, mit dem Buntstift in der Hand jeden einzelnen Augenblick des Daseins zu genießen.

Le dessin est plus léger et plus rapide que n'importe quel autre médium. On l'oppose traditionnellement à la peinture, y compris à la peinture murale. En théorie, dans la mesure où ils ne sont pas attachés à un support stable, les dessins sont éphémères, privés, mobiles et libres. Les dessins de Peter Pommerer modifient cette donne, nous obligeant à repenser la liberté du dessin. La plupart des siens sont réalisés sur des murs, la toile de fond de leur présence agitée étant l'architecture rigide des galeries et d'autres intérieurs. Au crayon et à la plume, Pommerer embellit sournoisement les espaces blancs immaculés et pompeux : murs, fenêtres, portes et colonnes. Le choix de ses thèmes, des récits de contes de fées avec des éléphants défilant à la queue leu leu devant d'innombrables châteaux perchés sur des sommets, et des bateaux à vapeur psychédéliques naviguant à travers des décors tropicaux remplis de palmiers et de champignons magiques, tient davantage des rythmes simples et répétitifs de la peinture rupestre ainsi que de l'anarchie de dessins d'enfants que des harmonies complexes du *disegno* européen, l'accomplissement venant couronner la vraie spiritualité européenne. Pommerer est ironique quant à l'histoire officielle de l'art : une de ses œuvres s'intitule *Did Henri Matisse Do Abstract Paintings in Secret ?* (Henri Matisse faisait-il de l'art abstrait en cachette ?, 2000). Il la remplace par une histoire de son cru, remplie de lacunes et d'ambiguïtés. En se concentrant presque exclusivement sur des compositions murales éphémères, il abandonne la fabrication de masse pour l'unicité de la réalisation, la connaissance joyeuse d'être chaque seconde, le crayon à la main.

A. S.

SELECTED EXHIBITIONS →
1996 *NowHere*, Louisiana Museum of Modern Art, Humlebæk, Denmark **1997** *time out*, Kunsthalle Nürnberg, Nuremberg, Germany **1998** Raum für Aktuelle Kunst, Vienna, Austria; *Glut*, Kunsthalle Düsseldorf, Germany **1999** Meyer Riegger Galerie, Karlsruhe, Germany; *German Open*, Kunstmuseum Wolfsburg, Germany **2000** Galerie Gebauer, Berlin, Germany; *Creeping Revolution*, Galeria Foksal, Warsaw, Poland **2001** *Where snakes in the grass go absolutely free...*, Institute of Contemporary Arts, London, UK

SELECTED BIBLIOGRAPHY →
1996 *NowHere*, Louisiana Museum of Modern Art, Humlebæk **1997** *time out*, Kunsthalle Nürnberg, Nuremberg **1999** *German Open*, Kunstmuseum Wolfsburg **2002** *Peter Pommerer*, Kunstverein Hannover, Hanover/Württembergischer Kunstverein, Stuttgart

410

1 **Catwoman,** 2001, lightbox, X-ray, mummified cat, painted plinth, 90 x 110 x 95 cm, installation view, *Katze. Aluminiumherz. Jetztzeit,* Meyer Riegger, Karlsruhe
2 **Erschrickst Du Dich wenn Du mich siehst,** 1999, installation view, *German Open,* Kunstmuseum Wolfsburg

3 **Fischrevier,** 1998, crayon and watercolour on paper, 40 x 49 cm
4 **Japanese Dreams,** 1999, crayon, Indian ink, watercolour and acrylic on paper, 71 x 90 cm
5 Installation view, *Die Pest der Phantasmen,* Galerie Gebauer, Berlin, 2000

„Eine Straße beginnt genau dort, wo sie aufhört."

« Une rue commence exactement là où elle finit. »

"A street begins exactly where it ends."

2

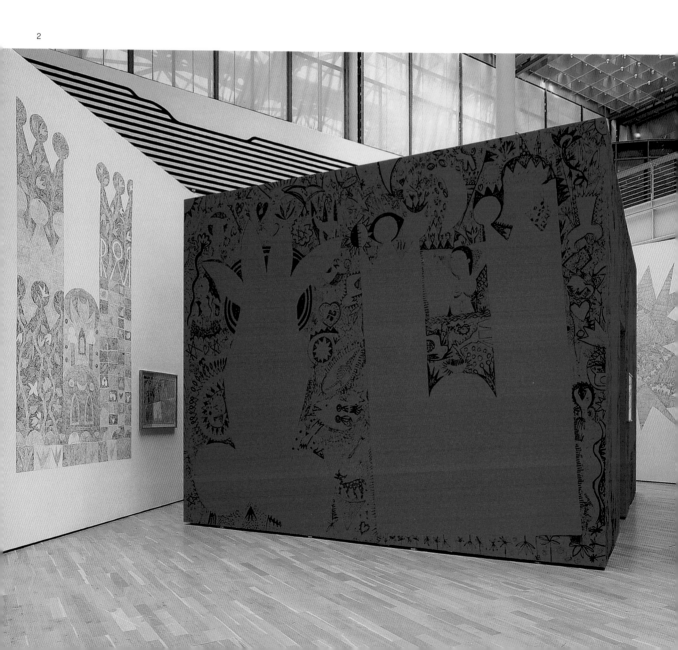

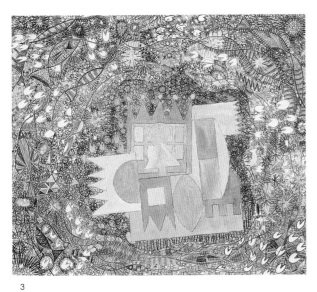

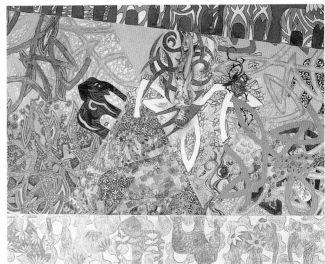

3

4

5

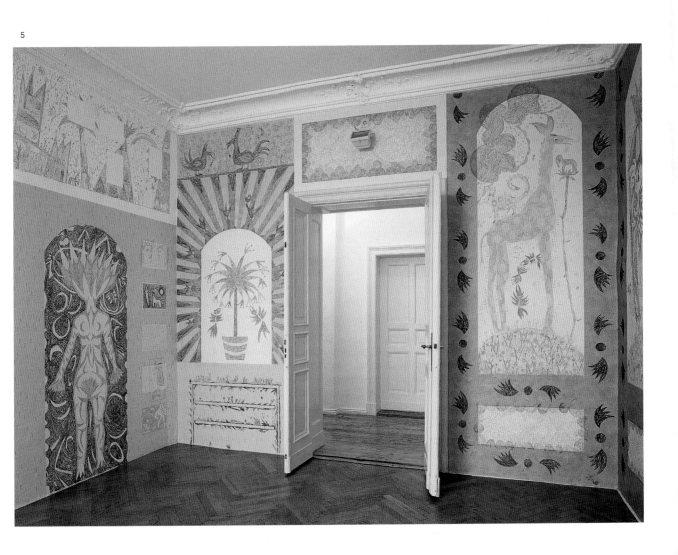

Neo Rauch

1960 born in Leipzig, lives and works in Leipzig, Germany

The colours, figures and forms in Neo Rauch's paintings are those of a bygone era. His personal background lies in the figurative East German paintings of the GDR's Leipzig School, with artists such as Wolfgang Mattheuer and Werner Tübke, but he is also influenced by the model of socialist perfection and the conventional graphic art of the period between 1940 and 1960. Comparable to montages, Rauch's paintings combine quotations and historical fragments to create designs full of narrative that exhibit his own clear viewpoint. He provides the trappings for a world of creation and change, a symbolic realism that dramaturgically traces life as it is arranged and mechanised. He fuses cartoons and print media with photography and film to serve his painting, and, ultimately, to produce an imagery of power. Rauch's ideas are based on the dissecting tension of the single frame, picked out like a film still, which he inserts in a structure somewhere between the aesthetic ideology of power and the political forces of socialism and capitalism. The titles of his works – *Werkschutz* (Factory Security), 1997, *Nachtarbeit* (Nightshift), 1997, *Arbeiter* (Worker), 1998, or *Form,* 1999 – refer to an associative construction of productive forces. Rauch is a producer and a creator – the inventor of idealistic characters whose hopes have failed or become meaningless. He is an alchemist who uses his tools and materials as if they were the pieces in a bewitched jigsaw puzzle. The moment of painting is always primary, and the power of painting within the structural canon of the 1960s remains present as a contemporary story, which he brings to our attention not as a linear narrative but as an irritation created by breaking open the surface, inserting new objects, interfacings, transferences and terms.

In den Gemälden von Neo Rauch sind Farben, Figuren und Formen einer vergangenen Epoche zugegen. Sein persönlicher Hintergrund ist die figurative ostdeutsche Malerei der Leipziger Schule in der DDR, Wolfgang Mattheuer und Werner Tübke, aber auch das Musterbild sozialistischer Vollkommenheit oder der Gebrauchsgrafik der vierziger bis sechziger Jahre. Rauch kombiniert wie in einer Montage Zitate und historische Fragmente zu einem Entwurf eines eigenen klaren Horizonts voller Erzählungen. Er richtet eine Welt des Schaffens und Werdens ein, einen symbolischen Realismus, der dramaturgisch dem arrangierten, mechanisierten Leben folgt. Die der Malerei dienende Verschränkung von Comic oder Printmedien und Fotografie oder Film ist letztlich eine Metaphorik der Kräfte. Rauchs Idee fußt auf der sezierenden Spannung eines Einzelbildes, herausgelöst wie ein Filmstill. Er legt es unter ein Raster zwischen der ästhetischen Ideologie der Macht und politischen Kräften wie Sozialismus und Kapitalismus. Titel seiner Arbeiten lauten *Werkschutz*, 1997, *Nachtarbeit*, 1997, *Arbeiter*, 1998, oder *Form,* 1999, und verweisen auf ein assoziatives Gefüge von Produktivkräften. Rauch ist produzierender Gestalter – Erfinder von Figuren voller Ideale, aber auch sinnentleerter, gescheiterter Hoffnungen. Er ist ein puzzelnder Alchimist, der die Apparaturen als prozessuale Materialien nutzt. Das malerische Moment bleibt immer vorrangig, und die Macht der Malerei im Formenkanon der sechziger Jahre ist als gegenwärtige Erzählung anwesend. Diese wird durch Aufbrechen der Fläche, Einschübe, Geflechte, Versätze oder Begriffe nicht narrativ und linear, sondern irritierend simultan vor Augen geführt.

Dans les peintures de Neo Rauch, on assiste à la résurgence de couleurs, de personnages et de formes issus d'époques passées. L'arrière-plan biographique de l'artiste est celui de la peinture figurative de l'école de Leipzig en RDA, avec Wolfgang Mattheuer ou Werner Tübke, mais aussi le modèle de la perfection socialiste ou le graphisme utilitaire des années 40 à 60. A partir de citations et de fragments historiques, Rauch concrétise le projet d'un horizon personnel limpide et plein d'anecdotes, un peu comme dans un montage, arrangeant un monde de création et de devenir, un réalisme symbolique dont la dramaturgie se calque sur la vie arrangée et mécanisée. En définitive, la combinaison entre bande dessinée et médias imprimés, ou entre photographie et cinéma mise au service de la peinture, est une grande métaphore filée des forces en présence. L'idée de Rauch repose sur l'énergie disséquante de l'image unique isolée comme une photographie de plateau, soumise à une trame mêlant idéologie esthétique du pouvoir et forces politiques telles que le socialisme et le capitalisme. Les titres de ses œuvres – *Werkschutz* (Sécurité de l'entreprise), 1997, *Nachtarbeit* (Travail de nuit), 1997, *Arbeiter* (Travailleur), 1998, ou *Form* (Forme), 1999 – renvoient à la synergie des forces de production. Rauch est créateur et producteur – inventeur de figures chargées d'idéaux, mais aussi d'espoirs échoués et vidés de sens. Il est un alchimiste composant un puzzle, et qui se sert de son appareillage comme d'un matériau processuel. L'élément pictural demeure toujours prédominant, et le pouvoir de la peinture réalisée dans le canon formel des années 60 est présent sous la forme d'un récit contemporain que les rupture de plans, les inserts, les trames, les décalages ou les concepts ne présentent jamais de façon narrative ou linéaire, mais dans une irritante simultanéité.

G. J.

SELECTED EXHIBITIONS →
1995 Dresdner Bank, Leipzig, Germany **1999** *After the Wall*, Moderna Museet, Stockholm, Sweden; *Malerei*, INIT Kunsthalle, Berlin, Germany **2000** Galerie Eigen+Art, Leipzig, Germany; David Zwirner Gallery, New York (NY), USA; *German Open*, Kunstmuseum Wolfsburg, Germany **2001** Galerie für Zeitgenössische Kunst Leipzig, Germany; *Contemporary German Art/The Last Thirty Years/Thirty Artists from Germany*, Goethe-Institut, Bombay, India; *49. Biennale di Venezia*, Venice, Italy

SELECTED BIBLIOGRAPHY →
2000 *Randgebiet*, Galerie für Zeitgenössische Kunst Leipzig; *Neo Rauch – Sammlung Deutsche Bank*, Leipzig

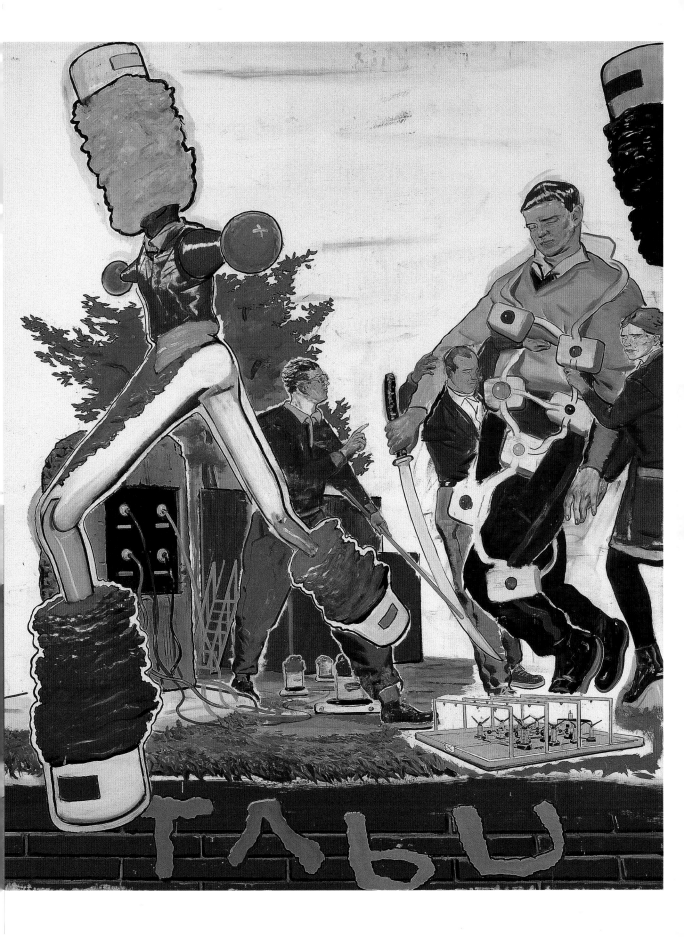

Navin Rawanchaikul

1971 born in Chiang Mai, lives and works in Chiang Mai, Thailand, and Fukuoka, Japan

Taxi driving is art, says Navin Rawanchaikul. He deploys a range of arguments to support his claim. Not only is the taxi a mode of transport, an essential feature of urban life, and a means of publicity and communication, taxi cabs can also serve as exhibition spaces. Rawanchaikul fulfils many roles – communicator, organiser, entertainer and even taxi driver – and all of them involve providing a service. His projects, created in collaboration with many different groups of people and sharing the common theme of art as communication, are all exhibited in public spaces, such as billboards and fences around building sites, on public transport and in restaurants. The visual narratives usually take the form of comic strips and viewers become actors in the stories. Audience participation enables art to become part of everyday life and vice versa. The culture of the artist's homeland plays a significant role in his work. He uses the exotic imagery created for his own "Navin Production Co Ltd.", as well as the brightly coloured, typically Thai chequered fabric known as "Pha Khao Mar", which has become a kind of corporate design. Rawanchaikul works with other artists, like Kosit Juntaratip, Rirkrit Tiravanija and Philippe Parreno, and with schoolchildren, students, local residents and taxi drivers, with a special fondness for intercultural projects. Big billboards and little comic strips create a fictionalised reality that combines art and storytelling. Here, for the most part, Rawanchaikul plays with the dreams inspired by cinema, love stories and the hopes and desires common to us all, in an effort to discover the whys and wherefores of our lives.

Taxifahren ist Kunst, sagt Navin Rawanchaikul, und er liefert vielfältige Belege: Mobilität, Transport, Verkehr, Urbanität, Dynamik, Öffentlichkeit, Kommunikation und nicht zuletzt Ausstellungen im Taxi. Dienstleistung ist wesentlich für die vielen Rollen, die er im Kunstkontext einnimmt, als Vermittler, Organisator, Unterhalter oder eben Taxiunternehmer. Seine Projekte finden in öffentlichen Räumen statt und thematisieren das Kunstsystem als Kommunikationssystem. Die Plakatwände und Bauzäune der Städte, die Fortbewegungsmittel der Metropolen oder die Restaurants bestimmen seine Handlungsorte, in denen die Kommunikation, aber auch die Zusammenarbeit mit unterschiedlichsten Personengruppen eine untrennbare Einheit bildet. Zumeist eingebunden in visuelle Erzählungen wie Comic-Geschichten finden sich die Ausstellungsbesucher als Akteure ein, die zum Mitmachen aufgefordert werden und durch deren Partizipation auch der Alltag in die Kunst und vice versa einfließt. Rawanchaikuls Heimat wirkt dabei prägend, nicht nur für die optische Exotik des Unternehmens „Navin Production Co Ltd.", bei der das universal verwendete bunte Webtuch „Pha Khao Mar" zum Corporate design mutiert. Mit anderen Künstlern wie Kosit Juntaratip, Rirkrit Tiravanija, Philippe Parreno oder mit Schülern, Studenten, Bürgern und Taxifahrern ist er gemeinsam tätig und lädt zu Unternehmungen zwischen den Kulturen ein. Hierbei stützen die großen Plakatwände wie die kleinen Comics den Anspruch und die als Fiktion gestaltete Realität zwischen Kunst und Erzählung. In ihnen spielt Rawanchaikul zumeist auf Kinoträume, Liebesgeschichten oder überlieferte Wünsche und Hoffnungen an – auf der Suche nach dem Woher, Wohin und Wofür im Leben.

Faire le taxi est de l'art, affirme Navin Rawanchaikul. Et d'en donner de nombreuses preuves : mobilité, transport, trafic, urbanité, dynamique, vie publique, communication et pour finir, expositions dans un taxi. La prestation de service est un aspect essentiel des nombreux rôles adoptés dans le contexte de l'art par l'artiste médiateur, organisateur, amuseur ou, précisément, comme directeur d'une compagnie de taxis. Ses projets s'insèrent dans des espaces publics et présentent le système de l'art comme un système de communication. Les affiches et les palissades des chantiers urbains, les moyens de transport des métropoles ou les restaurants, définissent des lieux d'action dans lesquels la communication, mais aussi la collaboration avec les groupes les plus divers forment une indissociable unité. Intégrés le plus souvent dans des récits visuels tels que les bandes dessinées, les visiteurs de ses expositions figurent en qualité d'acteurs incités à une participation qui fait entrer l'art dans le quotidien et vice versa. Sa propre patrie joue ici un rôle déterminant : pas seulement pour l'exotisme visuel de la « Navin Production Co Ltd. », pour laquelle il a transformé en corporate design le « Pha Khao Mar », tissu brodé universellement utilisé. Collaborant avec d'autres artistes comme Kosit Juntaratip, Rirkrit Tiravanija, Philippe Parreno ou avec des élèves, des étudiants, des citoyens et des chauffeurs de taxi, il invite à des actions qui jettent des ponts entre les cultures. Dans ce travail, les immenses affiches urbaines aussi bien que les petites bandes dessinées, prônent la formulation artistique de cette revendication et de la réalité sous la forme d'une fiction à mi-chemin entre art et narration. Dans ses actions, Rawanchaikul se réfère le plus souvent à des rêves cinématographiques, à des histoires d'amour ou à des désirs et des espoirs traditionnels – à la recherche du sens de la vie.

G. J.

SELECTED EXHIBITIONS →
1997 *Navin and his Gang (Visit)* Vancouver, Contemporary Art Gallery, Vancouver, Canada; *Cities on the move*, Wiener Secession, Vienna, Austria **1999** Satani Gallery, Tokyo, Japan; *Game over*, Watari-Um Museum, Tokyo, Japan **2000** Le Consortium, Dijon, France; *The Gift of Hope*, Museum of Contemporary Art, Tokyo, Japan; *5ème Biennale de Lyon*, France **2001** *I ♥ Taxi*, P.S.1, Long Island City (NY), USA; *Target Art in the Park*, Madison Square Garden, New York (NY), USA; *2.berlin biennale*, Berlin, Germany

SELECTED BIBLIOGRAPHY →
1995 *Substanceaboutnosubstance*, Goethe-Institut, Bangkok
1997 *Out of India*, Queens Museum of Art, New York (NY) **1999** *Navin Rawanchaikul, Comm..., Individual and Collaborative Projects 1993-1999*, Tokyo **2001** *2.berlin biennale*, Berlin

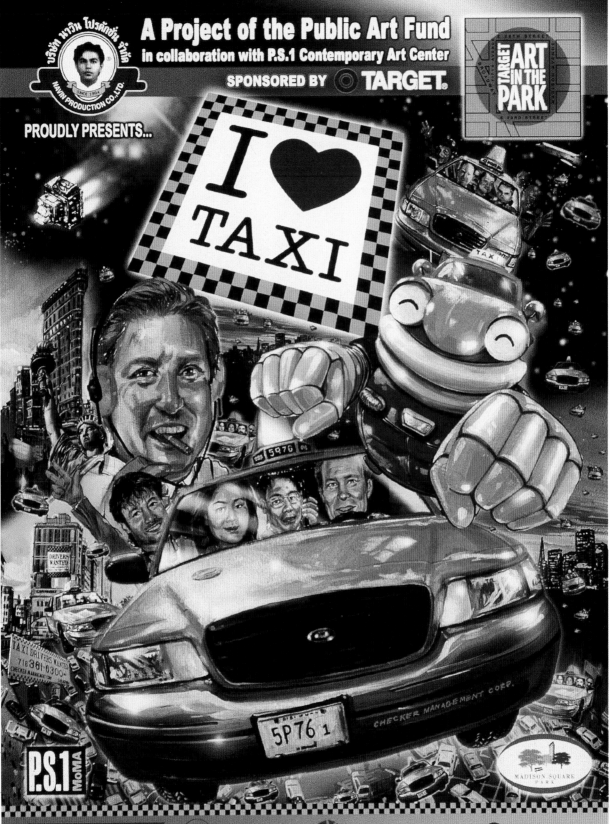

1 **Target Art in the Park, I ♥ Taxi,** 2001, comic book cover, a project of the Public Art Fund in collaboration with P.S.1, Long Island City (NY)
2 **I ♥ Taxi cafe,** 2001, installation view, P.S.1, Long Island City (NY)

3 **Same Same but over the Edges,** 2000, *Over the Edges,* S.M.A.K., Stedelijk Museum voor Actuele Kunst, Ghent
4 **Pha Khao Mar on Tour,** 2000, installation view and performance, *5ème Biennale de Lyon*

„In meinem Werk geht es nicht um Kunsterziehung oder gesellschaftliche Reformen. Ich bin ein Mensch, der zufällig Kunst macht, und ich muss zusammen mit anderen in dieser Gesellschaft leben.
Ich möchte nichts weiter, als meine Erfahrungen, meine Ideen und meine Arbeit zu den ganz alltäglichen Ereignissen in Beziehung setzen."

« Mon travail n'a pas pour propos la pédagogie de l'art ni la réforme sociale. Je suis quelqu'un qui fait de l'art et je dois vivre avec les autres dans cette société. Tout ce que je veux, c'est associer mes expériences, mes idées et mon travail aux événements de la vie quotidienne qui m'entoure. »

"My work is not about art education or social reform. I am a person who happens to make art and I must live together with others in this society. All I want is to combine my experiences, my ideas and my work with the events and the surroundings of everyday life."

2

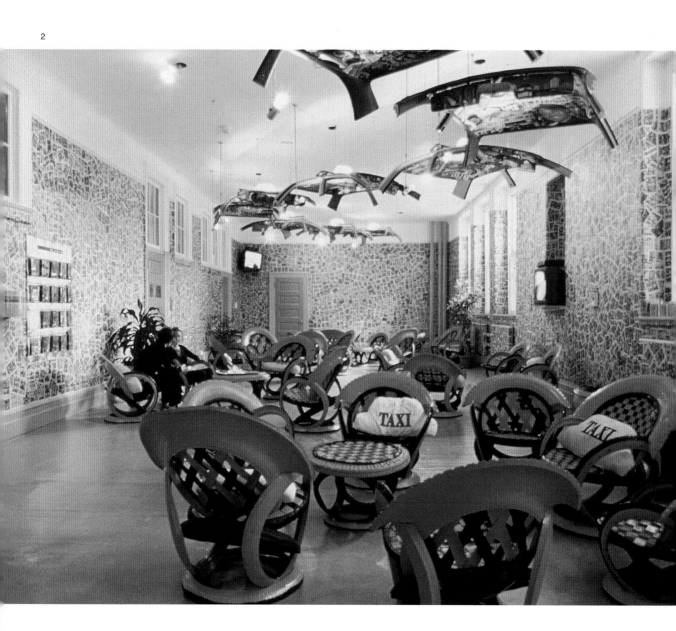

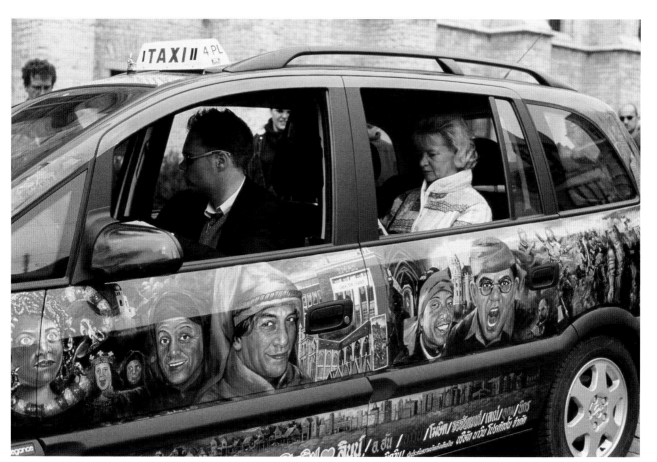

3

4

Tobias Rehberger

1966 born in Esslingen, lives and works in Frankfurt am Main, Germany

Tobias Rehberger's inclusive approach to his art involves museum staff, curators, gallery owners and friends in the process of artistic creation. Some of his works are designed simply to fulfill the physical requirements of a gallery's staff members, such as *vorschlag für die decke eines gemeinschaftsraums [frau sievert und frau eckhardt-salaemae]* (suggestion for the ceiling of a common room), 1997. Others result from proposals for comfortable furnishings. As a result of a survey held in the changing exhibition space at Frankfurt's Portikus, he ordered new door handles to be fitted, placed newspapers in toilets, gave instructions for the exhibition space to be fitted with a colourful, sprung timber floor, and designed a 1970s-style seating arrangement. His comfort displays (*Lying around lazy. Not even moving for TV, sweets, Coke and vaseline*, 1996) have links with the clubbing scene, where the design of lounges and chill-out zones is often inspired by 1970s interiors. Rehberger's inclusive working method often involves delegating the actual production of his works, and so he commissioned the construction of two cars of the type men dream of – a Porsche 911 and a MacLaren. The vehicles were built cheaply in Thailand using sketches he had drawn from memory. Rehberger appropriates the mechanisms of the service industry by treating galleries as "customers", and by confirming and including the "productive force of consumers" (Michel de Certeau). His *Bindan GmbH & Co.*, 2000, shown at the Kunsthalle in Hamburg, creates a direct link between the work of museums and that of business. The installation consists of hand-blown lamps, which switch on automatically as soon as people enter the meeting room of a temp agency in the office building across the street.

Der partizipatorische Ansatz von Tobias Rehberger beteiligt Museumsmitarbeiter, Kuratoren, Galeristen und Freunde am Entstehungsprozess seiner Werke. Einige Arbeiten sind lediglich nach den Körpermaßen von Institutionsmitarbeitern ausgerichtet (*vorschlag für die decke eines gemeinschaftsraums [frau sievert und frau eckhardt-salaemae]*, 1997), andere folgen den Vorschlägen für eine besonders angenehme Inneneinrichtung. So ließ er nach einer Befragung im Frankfurter Portikus neue Türklinken anbringen, deponierte Zeitungen in den Toiletten, ließ den Ausstellungsraum mit einem farbigen, federnden Holzboden auslegen und entwarf eine Sitzgruppe im Siebziger-Jahre-Design. Die Gestaltung seiner Wohlfühldisplays (*Lying around lazy. Not even moving for TV, sweets, Coke and vaseline,* 1996) stellt Beziehungen zum Clubkontext her, wo Siebziger-Jahre-Design den Einrichtungsstandard von Lounges und Chill-Out-Zonen bestimmt. Zu Rehbergers integrativem Arbeitsprozess gehört auch, dass er die Produktion der Arbeiten delegiert. So ließ er zwei Autos, von denen Jungen häufig träumen, einen Porsche 911 und einen MacLaren, im Billigproduktionsland Thailand nach Skizzen anfertigen, die er aus der Erinnerung gezeichnet hatte. Rehberger übernimmt Mechanismen der Dienstleistungsökonomie, indem er die Ausstellungsinstitution als eine Art „Kunden" betrachtet, und die „Produktivkraft der Konsumenten" (Michel de Certeau) konstatiert und miteinbezieht. In seiner Arbeit *Bindan GmbH & Co.,* 2000, in der Hamburger Kunsthalle, verknüpft Rehberger die Arbeit im Museum unmittelbar mit derjenigen eines Wirtschaftsbetriebs. Die Installation aus mundgeblasenen Lampen schaltet sich ein, wenn in einer Zeitarbeitsfirma im gegenüber liegenden Bürohaus der Konferenzraum genutzt wird.

La démarche de Tobias Rehberger est ouverture à l'intervention du personnel des musées, des conservateurs, des galeristes et des amis dans la genèse des œuvres. Certaines s'appuient simplement sur les mensurations des employés de certaines institutions (*vorschlag für die decke eines gemeinschaftsraums [frau sievert und frau eckhardt-salaemae]*/proposition pour le plafond d'une salle commune, 1997), d'autres répondent à des propositions pour tel ou tel aménagement intérieur particulièrement agréable. Ainsi, après avoir procédé à un sondage, l'artiste faisait installer au Portikus de Francfort de nouvelles poignées de porte, disposait des journaux dans les toilettes, faisait installer au sol de la salle d'exposition un plancher de bois souple et coloré, et concevait un ensemble de sièges dans le style des années 70. La création de ces éléments de bien-être (*Lying around lazy. Not even moving for TV, sweets, Coke and vaseline,* 1996) se réfère au contexte des clubs, dans lesquels le design des années 1970 a posé le standard des aménagements des salons et des zones de transit. Un facteur du processus de travail intégratif de Rehberger consiste à déléguer la production des œuvres. Ainsi, dans un pays de production rentable comme la Thaïlande, l'artiste a fait fabriquer sur la base d'esquisses réalisées de mémoire, deux voitures dont les jeunes rêvent souvent : une Porsche 911 et une MacLaren. Rehberger adopte les mécanismes du secteur tertiaire en considérant l'institution exposante comme une sorte de « client », enregistrant et intégrant la « force de production du consommateur » (Michel de Certeau). Dans *Bindan GmbH & Co.,* 2000, une œuvre exposée à la Kunsthalle de Hambourg, Rehberger lie le travail du musée à celui de l'entreprise : l'installation de lampes soufflées à la main s'allume lorsqu'une salle de conférence est utilisée dans l'agence d'intérim de l'immeuble de bureaux qui fait face au musée.　　　　　N. M.

SELECTED EXHIBITIONS →
1996 *Heetz, Nowak, Rehberger,* Städtisches Museum Abteiberg, Mönchengladbach, Germany **1997** *Home Sweet Home,* Deichtorhallen Hamburg, Germany **1998** Kunsthalle Basel, Basle, Switzerland; *Manifesta 2,* Luxembourg **1999** *The Secret Bulb in Barry L.,* Galerie für Zeitgenössische Kunst, Leipzig, Germany **2000** *The Sun from Above,* Museum of Contemporary Art, Chicago (IL), USA; *In Between,* EXPO 2000, Hanover, Germany; *What if,* Moderna Museet, Stockholm, Sweden **2001** *Plug In,* Westfälisches Landesmuseum, Münster, Germany

SELECTED BIBLIOGRAPHY →
1998 *Tobias Rehberger,* Moderna Museet, Stockholm; *Tobias Rehberger,* Kunsthalle Basel, Basle **1999** Burkhard Riemschneider/ Uta Grosenick (eds.), *Art at the Turn of the Millennium,* Cologne **2001** *(whenever you need me),* Westfälischer Kunstverein, Münster

1 Installation views, *Nana*, neugerriemschneider, Berlin;
 left: **Yam Koon Chien,** 2000, mixed media, 112 x 430 x 180 cm;
 right: **Kao Ka Moo,** 2000, mixed media, 142 x 430 x 180 cm

2 **Tsutsumu,** 2000, installation view, *In Between,* EXPO 2000, Hanover
3 **Die Ex II,** 2000, nylon cord, dimensions variable
4 **Jack Lemmon's legs and libraries,** 2000, installation view, Friedrich Petzel
 Gallery, New York (NY)

„Das, was mir angenehm ist, ist das ‚Außer-Kontrolle-Geraten'.
Mich interessiert die Differenz zwischen dem, was ich gewollt habe und
dem, was einer draus gemacht hat."

« Ce qui me plaît, c'est la perte de contrôle. Ce qui m'intéresse,
c'est la différence entre ce que j'ai voulu et ce que d'autres en ont fait. »

"I enjoy the aspect of 'losing control'.
I'm interested in the difference between my intention
and what someone else has done with it."

2

3

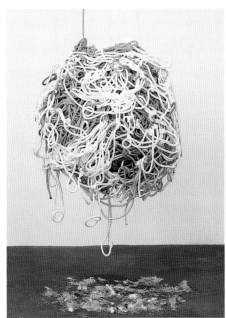

4

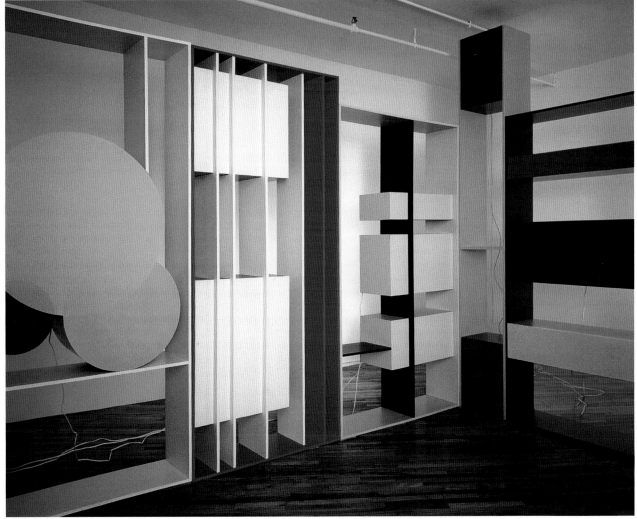

Jason Rhoades

1965 born in Newcastle (CA), lives and works in Los Angeles (CA), USA

Male obsessions determine Jason Rhoades' urge for accumulation: large, fast sports cars, car races, weapons, phallic constructions and ejaculations, machinery, tools, engines. Masses of materials are acquired, organised, purchased, owned, collected, constructed. Everything is connected with everything else and it is all part of the scupltural process. The formation of an idea in space is a precise combination of ordinary materials, which are subjected by Rhoades to a new interrelation of meaning and a new order. The personal cosmos and private context is frequently a background for his subjective interpretations. This can be seen in the world's largest sculpture, *Perfect World*, 1999, displayed in the Deichtorhallen in Hamburg. Reinterpreted as a secular Garden of Eden, the parent garden in California was lifted from the soil and placed onto a second level. With this colossal construction of polished aluminium pipes and wooden boards, Rhoades constructed an airy, biblical Paradise. Whether they are experiences in space or moments of physical danger on crossing from the public to the private space via a hydraulic ramp, all this is part of the work, a personal system within an artificial system. All of Rhoades' artistic thought is focused on the imagined, not the real space. It is apparent that the physical principle, indeed a principle of physics, is of far more importance than the masculine. After spending a year as a guest lecturer in Frankfurt, he installed the *Costner Complex (Perfect Process)* in the Portikus in Frankfurt, where he created a totally uninhibited mixture of Hollywood kitsch, gastronomic culture and sculptural concept. The moment of conviction lies in the overwhelming power of his creativity and perception.

Männliche Obsessionen bestimmen den Akkumulationsdrang von Jason Rhoades: schnelle, große Autos, Autorennen, Waffen, phallische Konstruktionen und Ejakulationen, Maschinen, Werkzeug, Motoren. Massen von Material werden beschafft, organisiert, gekauft, besessen, gesammelt, zusammengestellt. Alles hängt mit allem zusammen und ist skulpturaler Prozess. Die Formbildung ist eine präzise Kombination handelsüblicher Materialien, die von Rhoades einem neuen Sinnzusammenhang und einer neuen Ordnung unterworfen werden. Der persönliche Kosmos ist häufig Hintergrund der Interpretationen wie auch bei der größten Skulptur der Welt in den Hamburger Deichtorhallen, *Perfect World*, 1999. Zum weltlichen Paradiesgarten Eden umgedeutet, war der väterliche Garten in Kalifornien dem Boden enthoben und erhielt auf einer zweiten Ebene Raum. Mit einer gewaltigen Konstruktion aus polierten Alu-Rohren, Holzplatten und Computerprints der fotografierten Pflanzen errichtete Rhoades die luftige, biblische Paradieszone. In ihr fanden Raumerfahrungen, physische Gefahrenmomente wie das Durch-fahren vom öffentlichen in den privaten Raum mit einer Hebebühne statt – all das ist Teil der Arbeit, ein eigenes System im Kunstsystem. Dem imaginären, nicht dem realen Raum gilt die künstlerische Hoffnung Rhoades'. Deutlich wird hierbei, dass das physikalische, mithin physische Prinzip weitaus wesentlicher als das männliche ist. Für den Frankfurter Portikus brachte er nach einer einjährigen Gastprofessur ebendort den *Costner Complex (Perfect Process)* in den Kunstbetrieb und mixte ungeniert Hollywood-Glamour, Esskultur und Skulpturbegriff zusammen. In der Überforderung der Schaffenskraft und der Wahrnehmung liegt das überzeugende Moment.

Les obsessions masculines sont à l'origine du besoin d'accumulation de Jason Rhoades : voitures de sport rapides et imposantes, courses automobiles, armes, constructions phalliques et éjaculations, machines, outils, moteurs. Des masses de matériau sont commandées, organisées, achetées, habitées, collectionnées, agencées. Tout est lié à tout et devient processus sculptural. La mise en forme de l'idée d'espace est une combinaison précise de matériaux courants que Rhoades soumet à un ordre et à une cohérence sémantique nouveaux. L'univers personnel et le contexte privé servent souvent de toile de fond à ces interprétations subjectives, comme l'a montré la plus grande sculpture du monde exposée dans les Deichtorhallen de Hambourg, *Perfect World*, 1999. Réinterprété en Eden terrestre, le jardin californien du père de l'artiste fut surélevé et installé sur un deuxième niveau. Avec sa gigantesque structure de tubes d'aluminium poli et de planches de bois, Rhoades édifiait la zone aérienne, biblique, du paradis. Les perceptions spatiales et les menaces physiques au moment du passage de la sphère privée à la sphère publique – à l'aide d'un plateau hydraulique – tout ceci fait partie de l'œuvre et constitue un système particulier au sein du système « art ». En fait, l'espoir artistique de Rhoades porte sur l'espace neutre, pas sur l'espace réel. Ici manifestement, le principe physique, par conséquent physiologique, est de loin plus essentiel que le principe masculin. Après avoir été professeur invité pendant un an à Francfort, l'artiste installait au Portikus de Francfort son *Costner Complex (Perfect Process)*, qui mêlait insolement Kitsch hollywoodien, culture gastronomique et concept sculptural. Ce travail emporte l'adhésion par l'exacerbation de la force créatrice et de la perception. G. J.

SELECTED EXHIBITIONS →
1996 Kunsthalle Basel, Basle, Switzerland **1997** *Whitney Biennial*, The Whitney Museum of American Art, New York (NY), USA **1998** *The Purple Penis and the Venus*, Kunsthalle Nürnberg, Nuremberg, Germany **1999** Danish Pavilion (with Peter Bonde), *48. Biennale di Venezia*, Venice, Italy; *dAPERTuttO, 49. Biennale di Venezia*, Venice, Italy; *A Perfect World*, Deichtorhallen, Hamburg, Germany **2001** *Costner Complex (Perfect Process)*, Portikus, Frankfurt am Main, Germany; *Public Offerings*, Museum of Contemporary Art, Los Angeles (CA), USA

SELECTED BIBLIOGRAPHY →
1998 *The Purple Penis and the Venus*, Kunsthalle Nürnberg, Nuremberg; *The Purple Penis and the Venus in Eindhoven – A Spiral with Flaps and Two useless Appendages. After the Seven Stomachs of Nurnberg as Part of the Creation Myth*, Van Abbemuseum, Eindhoven **1999** Burkhard Riemschneider/Uta Grosenick (eds.), *Art at the Turn of the Millennium*, Cologne; *A Perfect World*, Deichtorhallen, Hamburg

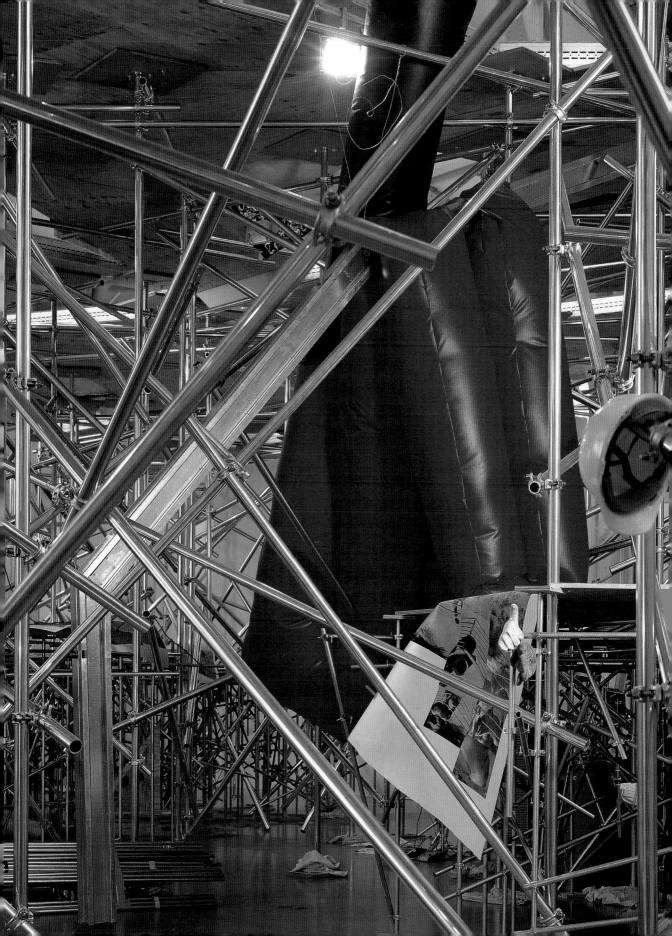

1, 2, 3 **Perfect World,** 1999, installation views, Deichtorhallen Hamburg
4 **Costner Complex (Perfect Process),** 2001, installation view, Portikus, Frankfurt am Main

5 **A Few Free Years,** 1998, 18 gaming machines, installation view, Kunsthalle Bremen, 1999

„Es gibt nichts Beliebiges in meiner Arbeit, weil es immer eine Reaktion auf die Beliebigkeit gibt, die sie dann wieder präzise macht."

« Il n'y a rien d'arbitraire dans mon travail, car il existe toujours une réaction qui rend l'arbitraire précis. »

"There's nothing arbitrary about anything in my work because there's always a reaction to the arbitrariness which make it precise."

2

3

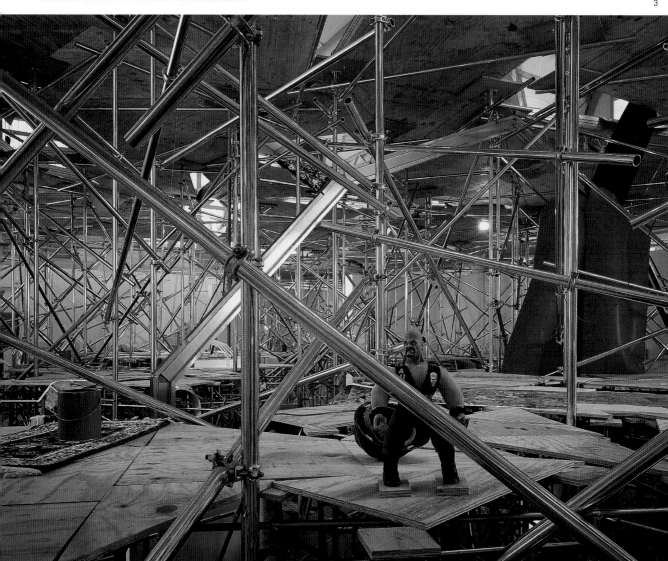

4

5

Daniel Richter

1962 born in Eutin, lives and works in Berlin, Germany

At the beginning of his artistic career the graphic artist and painter Daniel Richter worked as an illustrator for popular music magazines. This affinity with music is reflected in his early paintings: like a DJ with his mixing desks, he feverishly sampled a variety of painting styles and traditions. The canvases contain references to other artists, including Asger Jorn, Gerhard Richter and Philip Guston. His extraordinary imagery is also infiltrated by ornamentation and abstract figures from popular culture. These paintings, such as *Babylon Disco vs. Disco Babylon,* 1999, are full to bursting point, and test the limits of painting as a storage medium and the receptiveness of the almost overloaded viewer. Richter has expanded the stylistic repertoire of his more recent pictures by integrating representational elements. Virtually naturalistic representations enter into an intense dialogue with a psychedelic expressiveness of colour. Again Richter refers to the painterly positions of others, including James Ensor and Peter Doig, while at the same time dealing with overtly political subjects like violence and emigration. The painting *Tarifa,* 2001, for instance, depicts refugees in a stormy sea, helplessly crowded together in a small inflatable dinghy. The sea is painted an expressive black, while the figures seem irradiated by garish colour. This work can be viewed as an aesthetic testing ground for the autonomy of painting, its historicity and its scope for political application.

Der Maler und Zeichner Daniel Richter war zu Beginn seiner künstlerischen Karriere auch als Illustrator für populäre Musikmagazine tätig. Die Verwandtschaft zur Musik findet sich in seinen frühen Gemälden wieder: Diverse malerische Stile und Traditionen werden wie auf dem Mixpult eines DJs furios gesampelt. Referenzen an Maler wie Asger Jorn, Gerhard Richter oder Philip Guston etwa sind auf der Leinwand auszumachen. Aber auch Ornamente und abstrakte Figuren aus der Populärkultur werden eingeschleust in diese fantastische Bilderwelt. Zum Bersten voll sind diese Gemälde, zum Beispiel sein *Babylon Disco vs. Disco Babylon,* 1999, und testen so die Grenzen der Aufnahmefähigkeit – der Aufnahmefähigkeit des Speichermediums Gemälde, aber auch die des fast schon überforderten Rezipienten. In neueren Bildern hat Richter sein stilistisches Repertoire erweitert, indem er auch gegenständliche Formen in seine Malerei integriert. Beinahe naturalistische Abbildungen und eine psychedelisch-expressive Farbigkeit treten in einen spannungsvollen Dialog. Wieder bezieht sich Richter dabei auf andere malerische Positionen, zum Beispiel auf James Ensor oder Peter Doig. Gleichzeitig behandelt der Künstler in diesen Arbeiten dezidiert politische Themen wie Gewalt oder Emigration. In dem Bild *Tarifa,* 2001, etwa sind Flüchtlinge auf schwerer See zu sehen, hilflos in einem kleinen Schlauchboot eingepfercht. Das Meer ist in expressivem Schwarz gemalt, die Figuren dagegen scheinen in greller Farbigkeit gleichsam durchleuchtet worden zu sein. Hier stehen die Autonomie des Genres Malerei, seine Geschichtlichkeit und die Möglichkeiten auch für politische Anwendungen auf dem ästhetischen Prüfstand.

Au début de sa carrière artistique, le peintre et dessinateur Daniel Richter a notamment travaillé comme illustrateur pour des revues de musique pop. Le parallèle avec la musique se retrouve dans ses premières peintures : différents styles et traditions picturaux sont furieusement samplés comme sur la table de mixage d'un DJ. Dans ces toiles, on relève toutes sortes de références picturales, notamment à Asger Jorn, Gerhard Richter ou Philip Guston. Mais cet univers visuel fantastique intègre aussi des ornements et des figures abstraites issues de la culture populaire. Ces peintures sont pleines à craquer, comme par exemple *Babylon Disco vs. Disco Babylon,* 1999, et sondent ainsi les limites de l'assimilation, à savoir la capacité d'accueil du support de données qu'est le « tableau », mais aussi la réceptivité d'un spectateur presque dépassé par cette profusion. Dans ses œuvres récentes, Richter a étendu son répertoire stylistique en intégrant aussi dans sa peinture des formes figuratives. Des représentations quasi naturalistes et un chromatisme psychédélique-expressif y entretiennent un passionnant dialogue. Dans ces œuvres, Richter fait également référence à d'autres positions artistiques comme James Ensor ou Peter Doig. En même temps, il y aborde des thèmes résolument politiques, tels que la violence et l'immigration. Dans *Tarifa,* 2001, il nous montre des réfugiés en haute mer entassés sans défense dans un zodiaque. La mer est peinte dans un noir expressif, tandis qu'avec leurs couleurs stridentes, les figures semblent en quelque sorte irradiées. Ici, l'autonomie du genre « peinture », son historicité et ses possibilités sont aussi mises à l'épreuve de leur utilisation politique.

R. S.

SELECTED EXHIBITIONS →
1997 *punch in out,* Kunsthaus Hamburg, Germany **1998** *Organisierte Kriminalität,* Contemporary Fine Arts, Berlin, Germany; *Otto-Dix-Preis,* Kunstsammlung Gera, Germany **1999** *Fool on a Hill,* Galerie Johnen + Schöttle, Cologne, Germany; *Malerei,* INIT Kunsthalle, Berlin, Germany; *German Open,* Kunstmuseum Wolfsburg, Germany **2001** *Billard um halbzehn,* Kunsthalle zu Kiel, Germany; *Painting,* Victoria Miró Gallery, London, UK; *La cause du peuple,* Patrick Painter Inc., Santa Monica (CA), USA

SELECTED BIBLIOGRAPHY →
1997 *Daniel Richter, 17 Jahre Nasenbluten,* Berlin **2000** *German Open,* Kunstmuseum Wolfsburg **2001** *Daniel Richter, Billard um halbzehn,* Kunsthalle zu Kiel

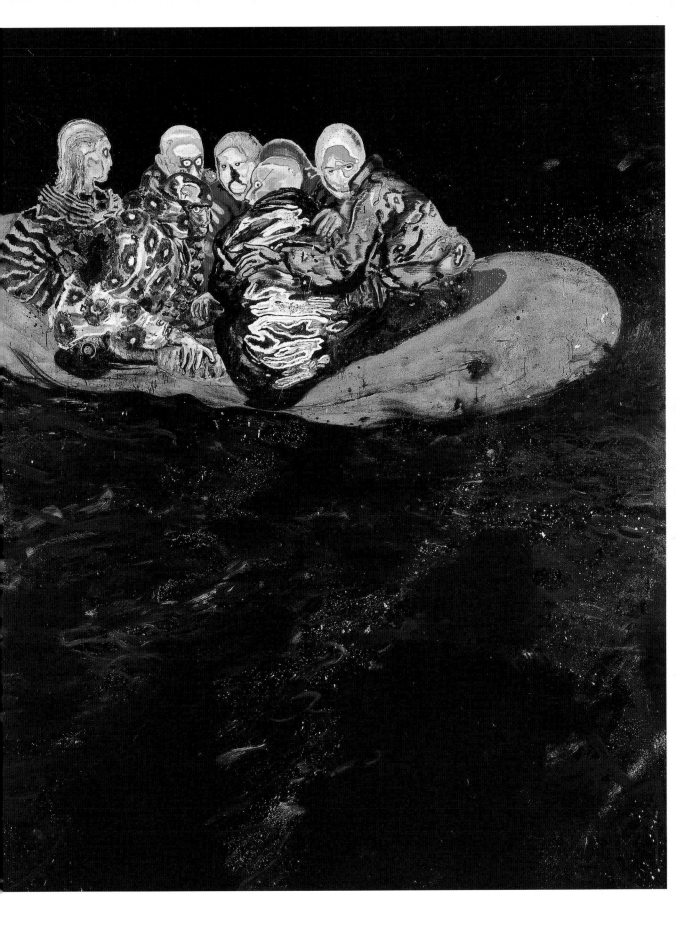

1 **Tarifa,** 2001, oil on canvas, 350 x 280 cm

2 **Fool on a Hill,** 1999, oil, gloss paint on canvas, 255 x 405 cm
3 **King Kong,** 1999, oil, gloss paint on canvas, 225 x 180 cm

„Malerei ist das trägste, langsamste und traditionsbewussteste Medium, das am schwersten zu erweitern ist."

« La peinture est le médium le plus figé, le plus lent et le plus conscient de la tradition, et donc le plus difficile à élargir. »

"Painting is the most sluggish, unhurried and tradition-conscious medium, and the most difficult to broaden."

2

de Rijke/de Rooij

Jeroen de Rijke, 1970 born in Browershaven, and
Willem de Rooij, 1969 born in Beverwijk; live and work in Amsterdam, The Netherlands

The beauty and minimalism of de Rijke/de Rooij's films aim for a visual gratification that is reflective of the viewer's presence in space. Film's unique characteristic, its duration, is emphasised in the screening situation: Demanding temporary attention for images in this way partly defines the content of de Rijke/de Rooij's work. Each film is shown with fixed intervals, or at request, in a more or less darkened space. It is projected on the wall, while the autonomous character of the projection is maintained by means of the empty space around the image that forms a frame. In their 35 mm film *Bantar Gebang*, 2000, the sun rises in a single 10 minute shot over a Djakarta ghetto like a faint 3rd world echo of Andy Warhol's films. *Bantar Gebang* urges us to travel through the ambivalence inherent to the quick way we usually consume images. The work's paradox is the fact that a moving image of non-place seemingly erases hours and hours of overlaid pictures on our retinas. In what is orchestrated deceptively as an escapist moment we meet the flip side of Western wealth and power and hence an "empty" image. In de Rijke and de Rooij, art has been catapulted through the galactic drama of spectacle culture only to end up in a quiet place that looks deceptively like art always used to: meditative and silent. But it is somehow fundamentally different, as if after time travel a spaceship has delivered us on a rubbish dump in the old world after a mind-numbing blast through time and space that has re-evaluated visual desire.

Die Filme von de Rijke/de Rooij verschaffen durch ihre Schönheit und ihren Minimalismus einen Genuss, in dem sich die räumliche Präsenz des Betrachters gewissermaßen spiegelt. Das herausragende Merkmal des Mediums Film ist die Dauer, die durch die Vorführsituation noch unterstrichen wird. Die – zeitlich gedehnte – Aufmerksamkeit für ihre Bilder, die de Rijke/de Rooij dem Zuschauer abverlangen, bestimmt daher auch, zumindest teilweise, den Gehalt ihrer Werke. Ihre Filme werden in einem abgedunkelten Raum an die Wand projiziert, wobei der autonome Charakter der Projektion durch die leere Fläche gewährleistet wird, die die Bilder wie ein Rahmen einfasst. In ihrem 35-mm-Film *Bantar Gebang*, 2000, ist in einer zehnminütigen Einstellung der Aufgang der Sonne über einem Ghetto in Djakarta zu sehen – so dass man sich gewissermaßen in eine „Dritte-Welt"-Version eines Andy-Warhol-Films versetzt fühlt. *Bantar Gebang* zwingt uns zur Auseinandersetzung mit der Ambivalenz, durch die unser – üblicherweise – hastiger Bilderkonsum charakterisiert ist. Die paradoxe Wirkung der Arbeit ist dem Umstand zu verdanken, dass die bewegten Bildern des völlig unspektakulären Schauplatzes all die anderen Bilder auszulöschen vermögen, die sich in stundenlangem Bildkonsum auf unserer Retina abgelagert haben. In einer trügerisch als eskapistische Erfahrung orchestrierten Darbietung lernen wir aber auch die Kehrseite des Reichtums und der Macht der westlichen Welt kennen, haben es also gewissermaßen mit einem „leeren" Bild zu tun. De Rijke/de Rooij katapultieren die Kunst durch das galaktische Drama der Spektakel-Kultur und lassen sie an einem ruhigen Ort landen, der sich durch jene meditativen Qualitäten und jene Stille auszeichnet, wie sie der Kunst von jeher eigen gewesen sind. Und doch gibt es eine fundamentale Differenz: Denn als Betrachter hat man das Gefühl, nach einer überwältigenden Reise durch Raum und Zeit – die sämtliche visuellen Begierden in ihrer üblichen Rangfolge auf den Kopf stellt – von einem Raumschiff wieder in der altbekannten Welt ausgesetzt zu werden.

La beauté et le minimalisme des films de de Rijke/de Rooij tendent vers une gratification visuelle qui reflète la présence du spectateur dans l'espace. Le caractère unique du film, sa durée, est accentué par la manière dont il est visionné : l'attention temporaire qu'il exige pour regarder les images définit en partie la teneur du travail de de Rijke/de Rooij. Chaque film est montré à intervalles réguliers, ou à la demande, dans un espace plus ou moins sombre. Il est projeté sur un mur, le caractère autonome de la projection étant entretenu par l'espace vide qui forme un cadre autour de l'image. Dans le film en 35mm *Bantar Gebang*, 2000, le soleil se lève dans un plan unique de 10 minutes au-dessus du ghetto de Djakarta tel un vague écho tiers-mondiste des films d'Andy Warhol. *Bantar Gebang* nous enjoint à voyager au travers de l'ambivalence inhérente à la rapidité avec laquelle nous consommons habituellement des images. Le paradoxe de l'œuvre est que l'image animée d'un « non-lieu » efface apparemment des heures et des heures d'images superposées sur nos rétines. Dans ce qui est orchestré de manière trompeuse comme un moment d'évasion, nous sommes confrontés au revers de la richesse et de la puissance du monde occidental et donc à une image « vide ». Dans les œuvres de de Rijke et de Rooij, l'art a été catapulté à travers le drame galactique de la culture spectacle pour atterrir dans un lieu tranquille qui ressemble trompeusement à ce qu'il était autrefois : méditatif et silencieux. Pourtant, il est fondamentalement différent, comme si, ayant voyagé dans le temps, notre vaisseau spatial nous avait déposés dans un dépotoir de l'ancien monde après une projection fulgurante à travers le temps et l'espace, provoquant une réévaluation du désir visuel.

L. B. L.

SELECTED EXHIBITIONS →
1998 *Manifesta 2*, Luxembourg **1999** *Fri-Art*, Fribourg, Switzerland; Galerie Daniel Buchholz, Cologne, Germany; *h:min:sec*, Kunstraum Innsbruck, Austria **2000** Museum of Art, Yokohama, Japan; *forreal*, Stedelijk Museum Bureau, Amsterdam, The Netherlands; *Man muss ganz schön viel lernen, um hier zu funktionieren*, Frankfurter Kunstverein, Frankfurt am Main, Germany **2001** The Museum of Contemporary Art, Oslo, Norway; *Casino 2001*, S.M.A.K., Stedelijk Museum voor Actuele Kunst, Ghent, Belgium

SELECTED BIBLIOGRAPHY →
2000 *After The Hunt*, Lukas & Sternberg, New York (NY); *Manifesta 2*, Luxembourg **2001** *De Rijke/de Rooij*, The Museum of Contemporary Art, Oslo

434

1 **Home of Ashok Advani,** Bombay, May 1995, c-print, 44 x 56 cm
2 **Untitled,** 2001, 10 min, 35 mm film, silent

3 **Fatih Mosque,** Amsterdam, November 1998
4 **Bantar Gebang,** Bekasi, East Java, May 2000

„Wir versuchen eine atmosphärische Mischung aus Kino und Ausstellungs-
raum zu erzeugen."

« On essaie de créer un mélange d'ambiance entre le cinéma et
l'espace d'exposition. »

"We try to create an atmospheric mix between cinema and exhibition space."

3

Pipilotti Rist

1962 born in Rheintal, lives and works in Zurich, Switzerland

Pipilotti Rist is best known for her double video projection *Ever Is Over All*, 1997, which is set to mesmerizing music composed by Anders Guggisberg. One image features a young woman wearing a light blue dress and red shoes; she carries a flower called a red-hot poker that has been cast in metal and uses it to smash the windows of cars parked along her path. That image is juxtaposed with a video featuring a garden of red-hot pokers, a swirling abstraction of enlarged stalks and colourful blossoms. Rist's combinations of strong soundtracks and vibrant moving images has led to her work being compared with music videos. Many of her video pieces, including *Sip My Ocean*, 1996, and *I'm Not The Girl Who Misses Much*, 1986, make direct references to popular music and the genre of music videos, recasting songs by Chris Isaak and John Lennon respectively. In addition to making videos, Rist constructs spaces in which to view them. *Das Zimmer* (The Room), 1994, includes an oversized red leather sofa and a television featuring a selection of her videos. A large-scale remote control labelled "Pipi TV" allows viewers to choose the videos they watch. *Himalaya Goldsteins Stube* (H. G.'s Room), 1997–99, approximates the playful ambience of a young woman's apartment. Monitors and projectors are inset into walls and furniture so that moving images appear on the sofas, chairs, lampshades and tables. Like the pervasive tune in *Ever Is Over All*, the piece's haunting melody adds to the overall ambience and engaging experience of the installation. Viewers are invited to make themselves at home, sit on the furniture, wander around the rooms and watch her videos.

Am bekanntesten ist Pipilotti Rist für ihre doppelte Videoprojektion *Ever Is Over All*, 1997, die von Anders Guggisbergs faszinierender Musik untermalt wird. Auf einer der Bildfolgen ist eine junge Frau in einem hellblauen Kleid und mit roten Schuhen zu sehen. Sie hält eine in Metall gegossene Fackellilie in der Hand und zertrümmert damit die Scheiben der Autos am Straßenrand. Parallel dazu läuft ein Video, das einen Garten mit Fackellilien zeigt, der wie eine wirbelnde Abstraktion aus vergrößerten Stengeln und farbenprächtigen Blüten erscheint. Wegen der Kombination eindrucksvoller Musik mit pulsierend bewegten Bildern werden Rists Arbeiten immer wieder mit Musikvideos verglichen. Viele ihrer Videostücke, etwa *Sip My Ocean*, 1996, und *I'm Not The Girl Who Misses Much*, 1986, enthalten direkte Verweise auf die Popmusik sowie das Genre des Musikvideos und präsentieren Lieder von Chris Isaak und John Lennon in ganz neuen Kontexten. Rist produziert nicht nur Videos, sondern entwirft auch die Räume, in denen sie gezeigt werden. In der Installation *Das Zimmer*, 1994, hat sie ein überdimensioniertes Sofa und einen Fernseher aufgestellt, auf dem eine Auswahl ihrer Videos gezeigt wird. Eine großformatige Fernbedienung mit der Aufschrift „Pipi TV" gestattet es dem Betrachter, selbst zu entscheiden, welches Video er sehen möchte. *Himalaya Goldsteins Stube*, 1997–99, erinnert mit seinem verspielten Interieur an die Wohnung einer jungen Frau. In die Wände und Möbel sind Monitore und Projektoren eingebaut, so dass in den Oberflächen der Sofas, Stühle, Lampenschirme und Tische bewegte Bilder erscheinen. Genau wie in *Ever Is Over All* verstärkt auch hier die ungemein eindrucksvolle musikalische „Untermalung" die atmosphärische Gesamtwirkung der Installation. Der Betrachter ist eingeladen, es sich bequem zu machen, die Möbel zu benutzen, durch die Räume zu schlendern und sich Rists Videos anzuschauen.

Pipilotti Rist est surtout connue pour sa double projection vidéo, *Ever Is Over All*, 1997, qui s'accompagne d'une musique envoûtante composée par Anders Guggisberg. Sur un écran, une jeune femme, vêtue d'une légère robe bleue et de souliers rouges, porte une fleur en métal appelée un « fer rouge » avec laquelle elle fracasse les vitres des voitures garées le long de son chemin. Cette image est juxtaposée à une seconde projection présentant un jardin de « fers rouges », une abstraction tourbillonnante d'agrandissements de tiges et de fleurs colorées. Les associations de bandes son marquantes et d'images vibrantes ont souvent fait comparer son travail à des clips vidéos. De fait, un grand nombre de ses œuvres vidéos, dont *Sip My Ocean*, 1996, et *I'm Not The Girl Who Misses Much*, 1986, font directement référence à la musique populaire et au monde du clip, recourant à des chansons de, respectivement, Chris Isaak et John Lennon. Outre ses vidéos, Rist construit des espaces dans lesquels les visionner. *Das Zimmer* (La Chambre), 1994, inclut un canapé géant en cuir rouge et un poste de télévision dans lequel passe une sélection de ses vidéos. Une grande télécommande, baptisée « Pipi TV » permet aux spectateurs de choisir leur programme. *Himalaya Goldsteins Stube* (chambre de H. G.) 1997–99, recrée l'atmosphère ludique de l'appartement d'une jeune femme. Des écrans et des projecteurs sont encastrés dans les murs et les meubles de sorte que des images animées apparaissent sur les canapés, les fauteuils, les abat-jour et les tables. Comme l'air entêtant de *Ever Is Over All*, une mélodie envoûtante en fond sonore ajoute à l'atmosphère d'ensemble et à l'expérience conviviale de l'installation. Les spectateurs sont invités à prendre leurs aises, à s'asseoir sur les meubles, à se promener dans les pièces et à regarder ses vidéos.

Ro. S.

SELECTED EXHIBITIONS →
1996 *Sip My Ocean*, Museum of Contemporary Art, Chicago (IL), USA **1997** *Future Past Present, 47. Biennale di Venezia*, Venice, Italy **1998** *Remake of the Weekend*, Musée d'Art Moderne de la Ville de Paris, France; *I. berlin biennale*, Germany **1999** *Regarding Beauty*, Hirshhorn Museum and Sculpture Garden, Washington D.C., USA; *6th Istanbul Biennial*, Istanbul, Turkey **2000** *Wonderland*, Saint Louis Art Museum, St. Louis (MS), USA **2001** Museo Nacional de Arte Reina-Sofia, Madrid, Spain

SELECTED BIBLIOGRAPHY →
1995 Pipilotti Rist, *I'm Not The Girl Who Misses Much*, Stuttgart **1996** *Sip My Ocean*, Museum of Contemporary Art, Chicago (IL) **1998** Pipilotti Rist, *Himalaya: Pipilotti Rist: 50 kg*, Cologne; Pipilotti Rist, *Remake of the Weekend*, Cologne **2000** *Wonderland*, Saint Louis Art Museum, St. Louis (MS)

Panasonic

438

1 **Open My Glade,** 2000, 16 different 1 min videos for the NBC Astrovision
 by Panasonic Video Screen at Times Square, New York City commissioned
 by Public Art Fund, running every quarter past the hour from April 6
 through May 20

2 **Extremitäten (weich, weich),** 1999, video installation, installation view,
 Kunsthalle Zürich, Zurich
3 **Extremitäten (weich, weich),** 1999, video stills
4 **Himalaya Goldsteins Stube (Remake of the Weekend),** 1998/99,
 video installation, installation view, Kunsthalle Zürich, Zurich, 1999

„Wir versuchen Visionen zu schaffen, die die Leute mit dem ganzen Körper
erfahren können. Denn virtuelle Welten vermögen das Bedürfnis nach Sinnes-
wahrnehmungen nicht zu ersetzen."

« Nous essayons de construire des visions que les gens peuvent vivre
avec l'ensemble de leur corps, car les mondes virtuels ne peuvent remplacer
le besoin de perceptions sensuelles. »

"We are trying to build visions that people can experience with their whole bodies, because virtual worlds cannot replace the need for sensual perceptions."

2

4

3

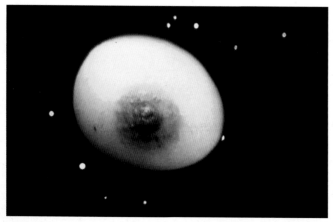

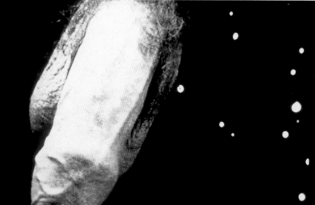

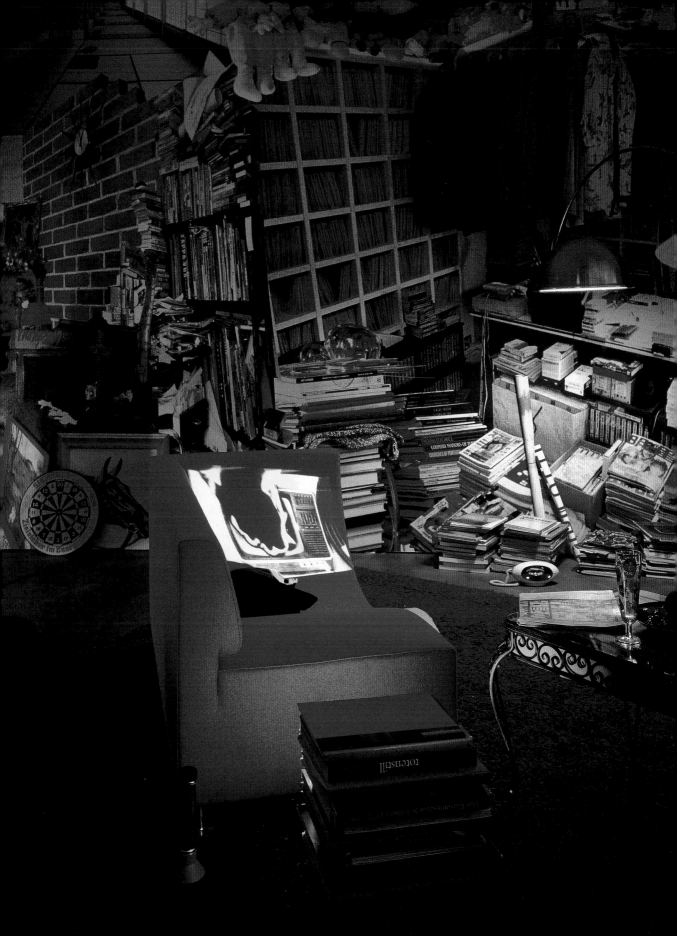

Ugo Rondinone

1964 born in Brunnen, lives and works in Zurich, Switzerland, and New York (NY), USA

This enigmatic statement ("I never sleep …", p. 442) is the title of a 1999 installation by Ugo Rondinone. A small orchard of eight trees, their branches bandaged with black electrical tape, is planted in a field of black rubber on the floor of the gallery. The gallery windows are covered with acid green gel, infusing the room with green light while giving the landscape outside an unnatural, nauseating fluorescence. The boundaries between nature and artifice blur until both states seem elusive and unreliable. Tiny speakers dangling from the trees inside whisper a melancholy monologue (from which the title is taken), further complicating the perceptual process by lulling the viewer into a dreamlike state. Sleep itself is literally manifest in *Where Do We Go From Here*, 1996, a filmed performance in which four costumed clowns lie sleeping fitfully on the gallery floor, ignoring their task of entertainment in an illustration of affected ennui. Rondinone's work is riddled with unsettling effects, not least due to the proliferation of media he chooses to work with. He produces small "diaries" filled with ink drawings and wistful texts; large circular paintings in day-glo colours whose concentric rings merge into each other like intoxicated targets; photographs borrowed from high-fashion magazines with his facial features digitally grafted onto the supermodel's own. Rondinone disassembles the forms of contemporary mass media and uses their flimsy structures to rebuild a separate hazy world where reality is hesitant, activity is circular, identity is transitory and melancholy is the overriding emotional force.

Das rätselhafte Statement („I never sleep …", S. 442) ist der Titel einer Installation von Ugo Rondinone aus dem Jahr 1999: Er pflanzte einen kleinen Hain aus acht Bäumen, deren Äste mit schwarzem Isolierband umwickelt waren, In einem mit schwarzem Gummi ausgelegtem Ausstellungsraum. Die Galeriefenster waren mit einem giftgrünen Gel verkleistert, so dass der Raum von grünem Licht durchflutet wurde, während die Landschaft draußen auf eine unnatürliche, Übelkeit erregende Weise zu leuchten schien. Die Grenzen zwischen Natur und Kunst verschwammen so weit, dass beide Ebenen sich als flüchtig und ungreifbar erwiesen. Kleine Lautsprecher, die von den Bäumen baumelten, flüsterten einen melancholischen Monolog (dem auch der Titel entnommen ist), der den Betrachter in seinen Wahrnehmungen noch mehr verwirrte und in eine Art Traumzustand versetzte. Ausdrücklich behandelt wird das Thema Schlaf in *Where Do We Go From Here*, 1996, einer gefilmten Performance, in der vier kostümierte Clowns unruhig auf dem Boden der Galerie schlafend sich demonstrativ ihrer eigentlichen Aufgabe zu unterhalten verweigern. Rondinones Werk gibt durch seine verstörenden Effekte immer neue Rätsel auf, nicht zuletzt wegen der Vielfalt der Medien, in denen er arbeitet. So kreiert er mit Tuschezeichnungen und sehnsuchtsvollen Texten angefüllte kleine „Tagebücher"; mit fluoreszierenden Day-Glo-Farben ausgeführte großformatige kreisrunde Gemälde, deren konzentrische Ringe wie auf einer benebelten Zielscheibe ineinander fließen. Oder aber er nimmt Fotografien aus Modemagazinen und kopiert sein Gesicht digital über die Züge eines Supermodels. Rondinone zerlegt die zeitgenössischen Massenmedien in ihre Bestandteile und baut ihre zerbrechlichen Elemente zu einer ganz eigenen schemenhaften Welt neu zusammen – einer Welt, deren Wirklichkeit sich nur zögernd offenbart, in der alles Tun im Kreis verläuft und in der sich Identität als ein höchst flüchtiges Gebilde und Melancholie als die Grundbefindlichkeit erweisen.

Cette déclaration énigmatique (« I never sleep … », p. 442) est le titre d'une installation d'Ugo Rondinone de 1999. Un petit verger de huit arbres, leurs branches bandées de ruban isolant noir, est planté dans un champ de caoutchouc noir sur le plancher de la galerie. Les fenêtres sont enduites d'un gel vert acidulé, diffusant dans la pièce une lumière verte tout en conférant au paysage extérieur une fluorescence irréelle et écœurante. Les frontières entre la nature et l'artifice se fondent jusqu'à ce que les deux états paraissent également fuyants et trompeurs. De minuscules haut-parleurs suspendus aux arbres chuchotent un monologue mélancolique (d'où est extrait le titre), compliquant encore le processus perceptif en berçant le spectateur dans un état proche du rêve. Le sommeil est littéralement présent dans *Where Do We Go From Here*, 1996, une performance filmée où quatre clowns en costume dorment d'un sommeil agité sur le sol de la galerie, négligeant leur mission d'amuseurs dans une illustration d'ennui affecté. Le travail de Rondinone fourmille d'effets déstabilisateurs, dus notamment à la prolifération des techniques avec lesquelles il choisit de s'exprimer. Il réalise de petits « journaux intimes » remplis de dessins à l'encre et de textes nostalgiques ; de grandes peintures circulaires aux couleurs fluorescentes dont les anneaux concentriques se télescopent et fusionnent comme des cibles ivres ; des photographies empruntées à des revues de haute couture avec de nouveaux visages greffés numériquement sur ceux des top models. Rondinone démonte les formes des médias contemporains et utilise leurs structures fragiles pour reconstruire un autre univers brumeux où la réalité est hésitante, l'activité circulaire, l'identité transitoire et la mélancolie la force émotionnelle directrice. K. B.

SELECTED EXHIBITIONS →
1994 *Oh boy, it's a girl*, Kunstverein München, Munich, Germany
1996 *XXIII Bienal Internacional de São Paulo*, Brazil; *Dog days are over*, Museum für Gegenwartskunst, Zurich, Switzerland **1998** *From the corner of the eye*, Stedelijk Museum, Amsterdam, The Netherlands **1999** Kunsthaus Glarus, Switzerland; *6th Istanbul Biennial*, Istanbul, Turkey **2000** P.S.1, Long Island City (NY), USA; *Let's Entertain*, Walker Art Center, Minneapolis (MN), USA

SELECTED BIBLIOGRAPHY →
1993 *Die Sprache der Kunst*, Kunsthalle Wien, Vienna/Frankfurter Kunstverein, Frankfurt am Main **1996** *Where do we go from here?*, XXIII Bienal Internacional de São Paulo; *heyday*, Museum für Gegenwartskunst, Zurich **2000** *Guided by Voices*, Kunsthaus Glarus

1 **If There Were Anywhere But Desert (1),** 2000, 1 Clown (cotton, polyester), glitter, dimensions of the artist, installation view, Galerie Almine Rech, Paris, 2001

2 **Love Invents Us,** 1999, acrylic glass, neon, 3.10 x 7.20 m, installation view, *Moonlighting*, Galerie Hauser & Wirth & Presenhuber, Zurich

3 **Grand Central Station,** 1999, wood, plaster, 2 trees, 2 x 20 loudspeakers, CD-player, amplifier, sound, installation view, *Moonlighting*, Galerie Hauser & Wirth & Presenhuber, Zurich

4 **Where Do We Go From Here?,** 1996, wall painting in Indian ink, wood, yellow neon light, 4 video projectors, sound, dimensions variable, installation view, Le Consortium – Centre d'Art Contemporain, Dijon

„Ich schlafe nie. Ich habe noch nie geschlafen. Ich habe noch nie einen Traum gehabt. Das alles könnte wahr sein."

« Je ne dors jamais. Je n'ai jamais dormi. Je n'ai jamais rêvé. Tout ceci pourrait être vrai. »

"I never sleep. I've never slept at all. I've never had a dream. All of that could be true."

2

3

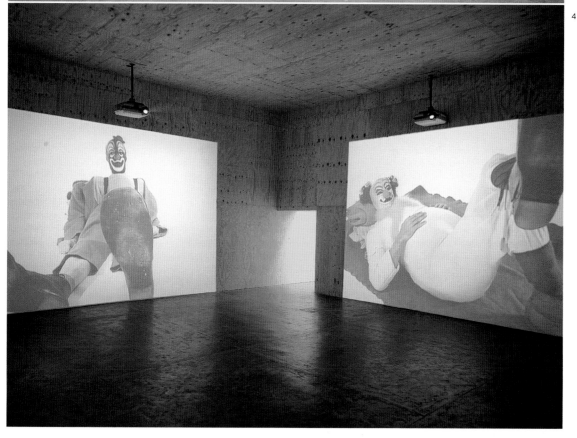

Thomas Ruff

1958 born in Zell am Harmersbach, lives and works in Düsseldorf, Germany

Thomas Ruff's approach to the production of images could be described as a sceptical examination of the conventions of various genres such as portraiture, political posters and the photography of architecture. Although Ruff is grouped with Düsseldorf's "Becher School", and his output therefore associated with the medium of photography, his work reaches beyond the boundaries of conventional photography. Ruff commonly refers to ready-made visual material and makes use of the computer's ability to retrieve and manipulate images. For his *nudes* series (begun in 1999), he downloaded pornographic images from the Internet and then modified them by altering colours, blurring the pictures and adding a "painterly" touch by softening the focus. The visible structures of pixels on the hugely enlarged *nudes* guide the viewer to the pictures' surfaces; they remove the pornographic gaze from the depicted reality and offer themselves up for perception in a more aestheticised form. Hence photographic considerations – with regard to reproduction, mass reception and relation to reality – are developed further using visual techniques. Ruff uses all of his extensive series to test the resistance and transformational capacity of omnipresent (imaginary) images. The points of reference for his *l. m. v. d. r.* series (1999–2001) are famous works by the architect Ludwig Mies van der Rohe: icons of modernism whose perception has to a high degree been shaped by photographs. Again, Ruff asks whether it is possible to remove or add a dimension to material that is all too familiar – be it through the spatial effects of stereo photography or by virtually "accelerating" the viewer's gaze with horizontally blurred motifs.

Die Herangehensweise von Thomas Ruff an die Produktion von Bildern lässt sich beschreiben als skeptische Beschäftigung mit den Konventionen verschiedener Genres, wie etwa Porträt, politisches Plakat oder Architekturfotografie. Auch wenn man Ruff der Düsseldorfer „Becher-Schule" zurechnet und sein Werk daher mit dem Medium Fotografie assoziiert, geht seine Arbeit über das konventionell Fotografische hinaus. Häufig greift Ruff auf bereits vorhandenes visuelles Material zurück und bedient sich der Möglichkeiten der Bildrecherche und -bearbeitung am Computer. Für die Serie der *nudes* (1999 begonnen) verwendete er pornografische Darstellungen aus dem Internet, die er durch Farbveränderungen, Bewegungsunschärfen und „malerische" Weichzeichner modifizierte. Die erkennbare Pixelstruktur der stark vergrößerten *nudes* verweist den Betrachter auf die Oberfläche der Bilder; sie entziehen die dargestellten Tatsachen dem pornografischen Blick und bieten sich für eine stärker ästhetisierende Wahrnehmung an. So werden fotografische Überlegungen – zu Reproduzierbarkeit, massenhafter Rezeption und zum Wirklichkeitsbezug – mittels neuer Techniken des Visuellen weitergeführt. In umfangreichen Serien testet Ruff allgegenwärtige (Vorstellungs-)Bilder auf ihre Resistenz oder Wandlungsfähigkeit. Bezugspunkt seiner Serie *l. m. v. d. r.* (1999–2001) sind berühmte Werke des Architekten Ludwig Mies van der Rohe, Ikonen der Moderne, deren Wahrnehmung in hohem Maß durch Fotografien geprägt wurde. Auch hier geht Ruff der Frage nach, ob es möglich ist, einem allzu bekannt erscheinenden Ausgangsmaterial eine Dimension zu nehmen oder hinzuzufügen – sei es durch räumlich wirkende Stereofotografien oder eine virtuelle „Beschleunigung" des Blicks durch horizontale Verwischungen der Motive.

La manière dont Thomas Ruff aborde la production d'images pourrait se décrire comme un travail sceptique sur les conventions de genres comme le portrait, l'affiche politique ou la photographie d'architecture. Même s'il peut être classé dans « l'école de Becher » et que son œuvre est associée de ce fait au médium photographique, le travail de Ruff va au-delà de la photographie au sens conventionnel. Ruff fait appel à un matériau visuel préexistant et se sert des outils de recherche et de traitement informatiques de l'image. Pour sa série *nudes* (commencée en 1999), l'artiste s'est servi de représentations pornographiques tirées de l'Internet, modifiées par altération des couleurs, par des flous dynamiques et par l'utilisation de l'outil « artistique ». La structure pixellisée des *nudes* fortement agrandis renvoie le spectateur à la surface des images, qui soustraient la représentation au regard pornographique et proposent une perception plus fortement esthétique. Ainsi, l'emploi de nouvelles techniques visuelles permet de développer la réflexion photographique sur la reproductibilité, la réception massive et le rapport au réel. Dans ses vastes séries, Ruff teste des images (fantasmatiques) omniprésentes quant à leur résistance ou à leur évolutivité potentielle. La série *l. m. v. d. r.* (1999–2001) a pour référence les célèbres réalisations de l'architecte Ludwig Mies van der Rohe, icônes de la modernité dont la perception a été fortement marquée par la photographie. Ici encore, Ruff se penche sur la question de savoir s'il est possible de tirer ou d'ajouter une dimension à un matériau initial à première vue trop connu – que ce soit par les effets tridimensionnels de la stéréographie ou par une « accélération » virtuelle du regard produite par des traînées horizontales appliquées aux motifs. B. H.

SELECTED EXHIBITIONS →
2000 *l. m. v. d. r.*, Haus Lange/Haus Esters, Krefeld, Germany; *How you look at it*, Sprengel Museum, Hanover, Germany **2001** Chabot Museum, Rotterdam, The Netherlands; *ex(o)DUS*, Haifa Museum of Art, Haifa, Israel; *Mies in Berlin*, The Museum of Modern Art, New York (NY), USA **2002** Folkwang Museum, Essen, Germany; Lenbachhaus, Munich, Germany

SELECTED BIBLIOGRAPHY →
1997 *Œuvres 1979–97*, Centre National de la Photographie, Paris **1999** Burkhard Riemschneider/Uta Grosenick (eds.), *Art at the Turn of the Millennium*, Cologne **2000** *l. m. v. d. r./l. m. v. d. r.*, Haus Lange/Haus Esters, Krefeld

1 **nudes mn23,** 1999, c-print, 160 x 110 cm
2 **d. p. b. 02,** 1999, c-print, 185 x 285 cm

3 **h. l. k. 01,** 2000, c-print, 185 x 285 cm
4 **h. l. k. 02,** 2000, c-print, 185 x 270 cm

„Aktfotos müssen schön sein."

« Les photos de nus doivent être belles. »

"Photographs of the nude have to be beautiful."

2

3

4

Gregor Schneider

1969 born in Rheydt, lives and works in Rheydt, Germany

Art circles obsessively around the home, wishing either to flee or to return. In times of homelessness, when the familiar suddenly becomes alien and the distant and strange make up for the lack of privacy, Gregor Schneider chooses to stay at home. His house in Rheydt has become the scene of one of the most radical projects at the turn of the century. While its unassuming bourgeois façade would seem to indicate stability, the *House ur* (as the artist calls it) is being continually remodelled. In most of the rooms Schneider has erected additional walls, installed extra windows and soundproof panels, and enveloped living space within a cocoon of lead. He builds inwards, closing certain rooms off for good; the phantasm of perfect isolation is a leitmotif of his work. A web of conjecture hangs around the house. Schneider makes no concessions to the inquisitive, merely mentions having "relatives in the cellar" and provides proof of his fascination with the dark, the hidden and the perverse. Having worked inside the house since the late 1980s, the artist faced the issue of letting his work be seen. Using the same material that the room in the *House ur* was made of, he recreates his innocent white spaces and the mysterious stains on the carpet. Rooms disappear from the house as Schneider puts them on display. After the exhibition the rooms fall back into place. The *House ur* absorbs them like a mother in reverse.

Die Kunst kreist wie besessen um das traute Heim, möchte entweder davor fliehen oder dorthin zurückkehren. In Zeiten der Heimatlosigkeit, da das Vertraute plötzlich fremd erscheint und das Ferne und Fremde den Verlust an Geborgenheit kompensieren soll, entscheidet sich Gregor Schneider dafür, zu Hause zu bleiben. Sein Haus im niederrheinischen Rheydt ist zum Schauplatz eines der radikalsten Projekte der Jahrhundertwende geworden. Mag auch die unprätentiöse Fassade des *Haus ur* (wie der Künstler seine Heimstatt nennt) auf den ersten Blick Stabilität verheißen, das Innere des Gebäudes ist gleichwohl einem Prozess der permanenten Umgestaltung unterworfen. Schneider hat in den meisten Räumen zusätzliche Wände gesetzt, Extrafenster und schalldämpfende Platten eingebaut und den Wohnraum mit einer Bleischicht umkleidet. Der Umbau schreitet immer weiter nach innen fort; einige Räume sind versiegelt. Das Phantasma der perfekten Isolation ist ein Leitmotiv seiner Arbeit. Sein Haus ist in ein ganzes Gewebe von Mutmaßungen eingesponnen. Doch Schneider quittiert die Neugier mit Schweigen und erwähnt lediglich, dass er „Verwandte im Keller" hat. Dies alles belegt die Faszination, die das Dunkle, das Verborgene und Perverse auf ihn ausüben. Bereits Ende der achtziger Jahre hat der Künstler mit der Umgestaltung seines Hauses begonnen und stand schließlich vor dem Problem, sein Werk zu zeigen. Unter Verwendung der Materialien aus *Haus ur* entstehen seither andernorts unschuldig weiße Nachbauten der betreffenden Zimmer – mitsamt den mysteriösen Flecken auf dem Teppichboden. So verschwinden nach und nach ganze Räume aus seinem Haus, die Schneider anderswo wieder aufbaut. Nach dem Ende einer Ausstellung lässt Schneider die betreffenden Räume an ihrem Ursprungsort neu erstehen. Das *Haus ur* nimmt sie wie eine Mutter wieder in sich auf.

L'art gravite de manière obsessionnelle autour du foyer, qu'il tente de le fuir ou d'y pénétrer. En ces temps d'errance, alors que le familier devient étranger et que le distant et l'étrange compensent l'absence d'intimité, Gregor Schneider a choisi de rester chez lui. Sa maison à Rheydt est devenue la scène de l'un des projets les plus radicaux du tournant du siècle. En dépit de sa façade bourgeoise sans prétention qui semble suggérer une certaine stabilité, la *Haus ur* (Maison ur, comme l'appelle l'artiste) est continuellement en train d'être remodelée. Dans la plupart des pièces, Schneider a érigé des murs supplémentaires, rajoutant des fenêtres et des panneaux insonorisants, avant d'envelopper l'espace habitable d'un cocon en plomb. Il construit vers l'intérieur, condamnant définitivement certaines pièces. Le fantasme d'un isolement parfait est un leitmotiv dans son travail. Un réseau de conjectures plane sur la maison. Schneider ne fait aucune concession à la curiosité des autres, mentionnant vaguement qu'il a des « parents dans la cave ». En outre, il apporte les preuves de sa fascination pour les ténèbres, le caché et le pervers. Ayant travaillé dans sa maison depuis la fin des années 80, l'artiste a été confronté à la question de laisser voir son travail. Utilisant les mêmes matériaux que dans la *Haus ur*, il recrée ses espaces blancs innocents et les taches mystérieuses sur le tapis. Les pièces disparaissent de la maison à mesure que Schneider les expose. Après l'exposition, les pièces retrouvent leur place. La *Haus ur* les absorbe comme une mère à l'envers.

A. S.

SELECTED EXHIBITIONS →
1996 Kunsthalle Bern, Berne, Switzerland **1997** Portikus, Frankfurt am Main, Germany; *Niemandsland*, Museum Haus Lange/Haus Esters, Krefeld, Germany **1998** *Performing Buildings*, Tate Gallery, London, UK **1999** Kabinett für aktuelle Kunst, Bremerhaven, Germany; *Anarchitecture*, Stichting De Appel, Amsterdam, The Netherlands; *Carnegie International*, Carnegie Museum of Art, Pittsburgh (PA), USA **2001** Wiener Secession, Vienna, Austria; German Pavilion, *49. Biennale di Venezia*, Venice, Italy

SELECTED BIBLIOGRAPHY →
1996 *Gregor Schneider*, Kunsthalle Bern, Berne **1997** *Totes Haus ur/ Dead House ur/Martwy Dom ur 1985–1997*, Frankfurt am Main/ Warsaw/Mönchengladbach/Paris **1999** *Gregor Schneider. Keller*, Wiener Secession, Vienna; Burkhard Riemschneider/Uta Grosenick (eds.), *Art at the Turn of the Millennium*, Cologne **2001** *Gregor Schneider, Totes Haus ur, 49. Biennale di Venezia*, Venice

ÜR AKTUELLE KUNST

1 Installation view, *N. Schmidt*, Kabinett für Aktuelle Kunst, Bremerhaven, 2001

2 Installation view, *Hannelore Reuen, alte Hausschlampe*, Galeria Foksal, Warsaw, 1999

3 Installation view, *ur36, Hardcore*, Haus Esters, Krefeld, 2000

„Wenn ein Werk ausgestellt wird, verliert es seine Schärfe."

« Quand une œuvre est exposée, elle perd de son tranchant. »

"When a work is exhibited it loses its edge."

2

Cindy Sherman

1954 born in Glen Ridge (NJ), lives and works in New York (NY), USA

In 1978, at the age of 23, Cindy Sherman began her landmark photographic series *Untitled Film Stills*. In each small-format black and white image, Sherman plays a different role – prim office worker, suburban housewife, glamorous femme fatale – in a minutely staged psychologically intense drama. Although she is the only character in shot, her transformation in each image is so complete that her personal identity disappears and instead of a series of self-portraits, we have a comprehensive repertoire of 20th-century female stereotypes. For most of the 1980s, Sherman continued to use her body as her central prop, working with colour photography to explore aspects of horror, violence and the grotesque. The *Fairy Tales*, 1984–86, *Disaster Series*, 1987–89, and *Sex Pictures*, 1992, employed an array of prosthetic teeth, snouts and breasts, mysterious liquids, rotting food and anatomically rearranged mannequin limbs to portray nightmarish visions of deformity and scenes of sexual violence, half seen, half imagined. A palpable tension exists between the pictures' seductive, vividly coloured surfaces and their disgusting, anxiety-inducing subject matter. This sense of anxiety is apparent throughout Sherman's work. Her most recent series *Untitled* features twelve new fictional characters – all over-tanned, over-dressed, heavily made-up women "of a certain age". Occupying the narrow terrain between pathos and parody, these large-format colour portraits examine women's attempts to defy, deny or at least slow down old age, while suggesting the small disappointments and minor tragedies embedded in each character's personal history.

Im Alter von 23 Jahren hat Cindy Sherman 1978 ihre bahnbrechende Fotoserie *Untitled Film Stills* begonnen. Auf jedem der kleinformatigen Schwarzweißbilder spielt Sherman eine andere Rolle – pedantische Büroangestellte, Vorstadt-Hausfrau, glamouröse Femme fatale – in einem detailliert inszenierten Drama von hoher Intensität. Obwohl Sherman selbst abgebildet ist, erscheint ihre Verwandlung von Bild zu Bild so komplett, dass ihre Identität dahinter verschwindet. Statt einer Serie von Selbstporträts sehen wir ein umfassendes Repertoire weiblicher Stereotype des 20. Jahrhunderts. In den achtziger Jahren hat Sherman ihren Körper weiter als Requisit eingesetzt, als sie in Farbfotografien verschiedene Aspekte des Horrors, der Gewalt und des Grotesken erkundete. Für die Serien *Fairy Tales*, 1984–86, *Disasters*, 1987–89, und *Sex Pictures*, 1992, griff sie auf ein Arsenal von künstlichen Zähnen, Nasen und Brüsten zurück, auf mysteriöse Flüssigkeiten, verrottende Lebensmittel und anatomisch neu arrangierte Glieder von Schaufensterpuppen, um albtraumhafte Visionen der Deformation und der sexuellen Gewalt zu inszenieren, die nur ansatzweise zu erkennen sind und in der Fantasie des Betrachters ergänzt werden. Zwischen der verführerischen Oberfläche und den lebhaften Farben der Bilder und ihren abstoßenden, Angst erregenden Motiven besteht ein spürbares Spannungsverhältnis. Dieses Gefühl der Angst ist für Shermans gesamtes Werk bestimmend. In ihrer neuesten Serie *Untitled* zeigt sie zwölf tief gebräunte, aufgetakelte, stark geschminkte Frauen „in den besten Jahren". Auf dem schmalen Grat zwischen Pathos und Parodie setzen sich diese großformatigen Farbporträts mit dem Wunsch der Frauen auseinander, dem Verfall zu trotzen, ihn zu verleugnen oder wenigstens zu verlangsamen. Zugleich werden auf den Bildern die kleinen Enttäuschungen und Tragödien sichtbar, von denen die Geschichte jeder Figur gezeichnet ist.

Cindy Sherman a commencé sa célèbre série photographique *Untitled Film Stills* en 1978, à l'âge de 23 ans. Sur chacune de ses images petit format en noir et blanc, elle joue un nouveau rôle – employée de bureau guindée, ménagère de banlieue, femme fatale glamour – dans une mise en scène minutieuse et psychologiquement intense. Bien qu'elle soit le seul personnage dans le plan, sa transformation est à chaque fois si complète que sa propre personnalité s'efface. Au lieu d'une série d'autoportraits, cela donne un répertoire complet des stéréotypes féminins du 20ème siècle. Pendant presque toutes les années 80, Sherman a continué à utiliser son corps comme accessoire principal, travaillant avec la photo couleur pour explorer divers aspects de l'horreur, de la violence et du grotesque. Dans ses séries *Fairy Tales*, 1984–86, *Disasters*, 1987–89, et *Sex Pictures*, 1992, elle recourt à tout un assortiment de prothèses dentaires, de groins en plastique, de faux seins, de liquides mystérieux, d'aliments pourris et de membres de mannequins anatomiquement modifiés pour dépeindre des visions cauchemardesques de difformité et des scènes d'une violence sexuelle, mi montrée mi suggérée. Il existe une tension palpable entre les surfaces séduisantes vivement colorées de ses photos et leur sujet répugnant et angoissant. Cette angoisse se retrouve dans toute l'œuvre de Sherman. Sa toute dernière série *Untitled* présente douze nouveaux personnages de fiction – des femmes « d'un certain âge » au bronzage intégral, trop habillées, exagérément maquillées. Se situant dans l'espace étroit entre le pathos et la parodie, ces portraits en couleurs grand format examinent les tentatives des femmes pour défier, nier ou du moins ralentir le vieillissement, tout en suggérant les petites désillusions et les tragédies mineures enchâssées dans l'histoire personnelle de chacune d'elles.

K. B.

SELECTED EXHIBITIONS →
1995 *Photographien 1975–1995*, Deichtorhallen Hamburg, Germany; *46. Biennale di Venezia*, Venice, Italy **1997** Museum Ludwig, Cologne, Germany; *The Complete Untitled Film Stills*, Museum of Modern Art, New York (NY), USA; *Retrospective*, Museum of Contemporary Art, Los Angeles (CA), USA **1998** *Mirror Images: Women, Surrealism and Self-Representation*, MIT-List Visual Arts Center, Cambridge (MA), USA **2000** *Die verletzte Diva*, Kunstverein München/Städtische Galerie im Lenbachhaus, Munich, Germany

SELECTED BIBLIOGRAPHY →
1995 *Cindy Sherman: Photoarbeiten 1975–1995*, Deichtorhallen, Hamburg/Malmö Konsthall, Malmö/Kunstmuseum Luzern, Lucerne **1996** *Cindy Sherman*, Museum of Modern Art, Shiga **1997** *Cindy Sherman: Retrospective*, Museum of Contemporary Art, Los Angeles (CA); *Cindy Sherman*, Museum Ludwig, Cologne **2000** *Cindy Sherman*, Hasselblad Center, Göteborg **2001** Uta Grosenick (ed.), *Women Artists*, Cologne

1 **Untitled,** 1999, black and white photograph, 119 x 86 cm
2 **Untitled,** 2000, colour print, 91 x 61 cm
3 **Untitled,** 2000, colour print, 69 x 46 cm
4 **Untitled,** 1976/2000, black and white photograph, 18 x 13 cm

5 **Untitled (The Press),** 1976/2000, black and white photograph, 18 x 13 cm
6 **Untitled,** 2000, colour print, 76 x 51 cm
7 **Untitled,** 2000, colour print, 76 x 51 cm

„Es geht unter anderem darum, das Publikum so weit zu bringen, dass es anfängt, seine vorgefassten Meinungen über Frauen, Sex und solche Sachen zu hinterfragen."

« Il s'agit en partie de faire en sorte que le public remette en question ses idées préconçues sur les femmes, le sexe, ce genre de choses. »

"Part of the idea is to get the audience to question their preconceived ideas about women, sex – things like that."

2

3

4

5

6

7

David Shrigley

1968 born in Macclesfield, lives and works in Glasgow, UK

Surplus and harmony never appear in David Shrigley's work. His drawings, photos and sculptures could be said to be a mapping of the gap between the vital things that should have held your attention at important moments of your life and the negligible or ominous things you actually perceived. His cartoon-like drawings take the form of confessions, the mapping of universal predicaments, or slightly paranoid fairy tales culled from modern anxiety themes such as alien abduction, plane crashes and job insecurity. They are often structured as schemas, bestiaries or different sorts of maps or inventories. Everything is rendered in a deadpan and rudimentary, sketchy style, as if the world were being recreated from scratch with the scarcest of means. Here, everyday life is a periodic table of certain givens between birth, school, work and death, where human contact often remains unreciprocated and where hope lies in the reduction of things to their absurdity. The single Shrigley drawing conveys an event, with the logical "before" and "after" eerily missing; there is no God or centre to hold things together. The mapping of the world is scattered across single sheets. Each drawing defies logical development, as in a modernist novel where the plot's most important conversation is drowned out by external noise or takes place the second the main character falls asleep. Always accompanying the darkness and fatalism, there is a comic relief in Shrigley's work that delivers an immediate empathy with the concerns and small routines that make up people's lives.

Mehrertrag und Harmonie kommen in der Arbeit von David Shrigley nicht vor. Man könnte seine Zeichnungen, Fotografien und Skulpturen sogar als Kartografien jenes Abgrunds bezeichnen, der sich zwischen den – von uns in den entscheidenden Momenten unseres Daseins vernachlässigten – elementaren Dingen und jenen Nebensächlichkeiten auftut, die wir tatsächlich registriert haben. Seine cartoonartigen Zeichnungen kommen als Bekenntnisse daher, als Beschreibungen universell verbreiteter Notlagen oder als leicht paranoide Märchen aus dem Bereich der heute angstbesetzten Themen, als da wären: Entführungen durch Außerirdische, Flugzeugabstürze, drohende Arbeitslosigkeit. Sie sind häufig schematisch strukturiert – wie Bestiarien oder geografische Karten oder Inventare. Alles erscheint in einem ebenso apathisch-rudimentären wie skizzenhaften Stil dargestellt, als ob es darum ginge, die Welt mit den sparsamsten Mitteln aus dünnen Strichen neu zu schaffen. Dabei erscheint das Alltagsleben als eine periodische Abfolge bestimmter Gegebenheiten zwischen Geburt, Schule, Arbeit und Tod – als eine Situation, in der der Wunsch nach menschlicher Nähe häufig unerwidert bleibt und die einzige Hoffnung darin besteht, die Dinge auf den Kern ihrer Absurdität zu reduzieren. Die einzelne Shrigley-Zeichnung beschreibt ein Ereignis, das auf fast gespenstische Weise dem „Vorher"-„Nachher"-Schema enthoben zu sein scheint; es gibt keinen Gott oder kein Zentrum, das die Dinge zusammenhält. Die Kartografie der Welt ist auf einzelnen zerstreuten Blättern festgehalten. Jede der Zeichnungen setzt sich gegen logische Folgerichtigkeit zur Wehr – wie in einem modernen Roman, in dem das wichtigste Gespräch der ganzen Geschichte durch höllischen Lärm überdröhnt wird oder just in dem Augenblick beginnt, da die Hauptfigur einschläft. Obwohl stets auf Tuchfühlung mit den dunklen Seiten des Daseins und dem Fatalismus, besticht Shrigleys Werk gleichwohl durch eine Komik, die unmittelbar ein Gefühl für die unser aller Leben bestimmenden Sorgen und kleinen Routinen weckt.

Le surplus et l'harmonie n'émergent jamais du travail de David Shrigley. Ses dessins, ses photos et ses sculptures pourraient être qualifiés de cartographie de l'écart entre les choses vitales qui auraient dû retenir notre attention à des moments importants de notre vie et les choses négligeables ou menaçantes que nous percevons réellement. Ses dessins semblables à des bandes dessinées prennent la forme de confessions, de cartes des aléas universels ou de contes de fées légèrement paranoïaques puisés parmi les thèmes de l'anxiété moderne tels que l'enlèvement par des extra-terrestres, les crashs d'avions ou la précarité de l'emploi. Ils sont souvent structurés comme des schémas, des bestiaires ou différentes sortes de cartes ou d'inventaires. Tout est rendu sous forme d'esquisses pince-sans-rire et rudimentaires, comme si le monde était entièrement recréé à partir de bric et de broc. Ici, tous les jours, la vie est un tableau de classification de certaines données entre la naissance, l'école, le travail et la mort, où le contact humain reste souvent sans réponse et où l'espoir réside dans la réduction des choses à leur absurdité. Le dessin de Shrigley transmet un événement dont « l'avant » et « l'après » manquent étrangement ; il n'y a ni Dieu ni centre pour assurer une cohésion. La cartographie du monde est éparpillée sur des feuilles isolées. Chaque dessin défie le raisonnement logique, tout comme dans un roman moderne où la conversation la plus importante de la trame est étouffée par des bruits extérieurs ou se déroule dès l'instant où le personnage principal s'endort. Accompagnant toujours les ténèbres et le fatalisme, le travail de Shrigley comporte un élément comique qui offre une empathie immédiate avec les préoccupations et les petites routines qui composent la vie des gens.

L. B. L.

SELECTED EXHIBITIONS →
1995 *Map Of The Sewer*, Transmission Gallery, Glasgow, UK
1997 Centre for Contemporary Arts, Glasgow, UK; *Art Calls*, Telephone project, Copenhagen, Denmark; *About Life In the Periphery, Young Scene*, Wiener Secession, Vienna, Austria **1999** *A Slip of the Mind*, Centre Régional d'Art Contemporain, Languedoc-Roussillon, France **2000** *Beck's Futures*, Institute of Contemporary Arts, London, UK; *The British Art Show 5*, Hayward Gallery, London, UK **2001** Center for Curatorial Studies, Bard College, New York (NY), USA

SELECTED BIBLIOGRAPHY →
1992 *Merry Eczema*, Montreal **1998** *Blank Page and Other Pages*, Modern Institute, Glasgow **1999** *The Beast is Near*, London; *To Make Meringue You Must Beat The Egg Whites Until They Look Like This*, Nicolai Wallner, Copenhagen **2000** *Grip*, Edinburgh

458

1 Your portrait here ..., 1997, 2 colour photographs, each 15 x 20 cm
2 Untitled (We took your stuff), 2000, acrylic, poster colour on paper,
 40 x 46 cm
3 Untitled (Salt & pepper pots), 2001, acrylic on paper, 78 x 78 cm
4 Untitled (Stay out of our bed), 2001, ink and acrylic on paper, 40 x 35 cm
5 River for sale, 1999, colour photograph, 31 x 41 cm
6 Untitled (There is nothing in the desert), 2001, ink on paper, 36 x 40 cm
7 Land Mine, 1995, colour photograph, 30 x 30 cm

8 Hell, 1992, colour photograph, 27 x 31 cm
9 Untitled (Brain sucked out), 2000, mixed media on paper, 36 x 41 cm
10 Untitled (Helmet), 1998, ink on paper, 21 x 14 cm
11 Potato Scull, 1999, colour photograph, 34 x 51 cm
12 Untitled (How we are soiled), 2001, ink and photograph on paper, 36 x 40 cm
13 Untitled (Rare bird's egg), 2001, ink on paper, 44 x 36 cm
14 Untitled (Silhouette on red background), 2001, acrylic on paper,
 34 x 32 cm

„Meine Liebe zu dir bleibt unvermindert."

« Mon amour pour vous demeure intact. »

"My love for you remains undiminished."

8

9

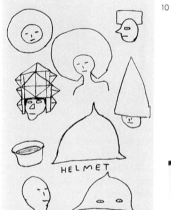

10

12

11

13

14

1 SANTIAGO SIERRA. OBSTRUCCION DE UNA VIA CON DIVERSOS OBJETOS. OBSTRUCTION OF A ROAD WITH DIFFERENT OBJECTS. BLOCKIEREN EINER STRASSE MIT DIVERSEN OBJEKTEN., Calle Glenworth. Limerick. March 2000, black and white photograph, 150 x 224 cm
2 SANTIAGO SIERRA. 133 PERSONAS REMUNERADAS PARA SER TEÑIDAS. 133 PERSONS PAID TO HAVE THEIR HAIR DYED. 133 PERSONEN, DIE DAFÜR BEZAHLT WURDEN, SICH DAS HAAR BLOND FÄRBEN ZU LASSEN., Biennale di Venezia, Junio de 2001/June 2001, black and white photograph, 150 x 192 cm
3 LINEA DE 160 CM TATUADA SOBRE CUATRO PERSONAS. 160 CM LINE TATTOOED ON FOUR PEOPLE. 160 CM LANGE LINIE AUF VIER PERSONEN

TÄTOWIERT., El Gallo Arte Contemporáneo. Salamanca. España. Spain. December 2000, black and white photograph, 155 x 231 cm
4 DIEZ PERSONAS REMUNERADAS PARA MASTURBARSE. TEN PEOPLE PAID TO MASTURBATE. ZEHN PERSONEN, DIE DAFÜR BEZAHLT WURDEN, ZU MASTURBIEREN., Habana Vieja, La Habana/Old Havana, Havana. November 2000, black and white photograph, 150 x 190 cm
5 PERSONA REMUNERADA DURANTE UNA JORNADA DE 360 HORAS CONTINUAS. A PERSON PAID FOR 360 CONTINUOUS WORKING HOURS. EIN FÜR 360 STUNDEN KONTINUIERLICHE ARBEIT BEZAHLTER MENSCH, P.S.1 Contemporary Art Center, New York, September 2000, black and white photograph on cibachrome paper, 150 x 217 cm

„Die Prostitution ist nicht nur das Paradigma für jede Form der Lohnarbeit schlechthin, sondern gleichermaßen für die vielgepriesene Globalisierung."

« Si la prostitution est un paradigme du travail, c'est également un paradigme de la mondialisation tant vantée. »

"If prostitution is a paradigm for work, it is also a paradigm for the much-praised globalisation."

2

3

4

5

Dirk Skreber

1961 born in Lübeck, lives and works in Düsseldorf, Germany

Even if he does not want to describe, tell a story, or provide an interpretation, a painter still needs a subject – although it may be destined to play a very minor part in his work. Therefore, Dirk Skreber paints what is familiar to us all: train engines, furniture, football grounds and residential buildings. And yet, some of the engines and houses appear as if they had just been waiting to be painted by Skreber so that he could bring them to life – like the higgledy-piggledy piece of architecture laconically entitled *o. T. (Ultra Violence)*, 2000. Skreber likes his paintings to be lifelike in the sense that a one-family dwelling seems familiar to us all. We take part in the elemental destructions that this archetypal Skreber subject is exposed to. Catastrophe is ever-present in his paintings, and is represented by a number of forceful interventions in his imagery, such as brutal drips of paint. Paint is no longer subject to gravity, at the same time as the subject seems to be trying to escape the confines of the painting. Although the façade still stands, it is in danger of toppling over. The "other" is already on the threshold, lying in wait – nuclear fallout, hurricanes and floods. Not even the walls of the large wooden sheds used by Skreber to install his works in 2000 were spared this sense of instability, and were distinctly shaky. The situations he depicts are clearly unsustainable. With supreme confidence he goes for broke, using the instant just before anything has happened as if he alone can determine the outcome. With no past and no future, his images deny history. The pictorial motifs push themselves forward in their concreteness, as if predicting their own fate. Skreber's paintings provide fertile soil for more extensive illusion, and that is where his strength lies.

Der Maler, der nicht abbilden, nicht erzählen, erst recht nicht interpretieren will, braucht trotzdem Motive – selbst wenn sie kaum eine Rolle spielen sollen. So malt er Dinge, die jeder kennt. Lokomotiven, Möbel, Fußballplätze, Wohnhäuser. Trotzdem sehen einige Lokomotiven und Einfamilienhäuser so aus, als hätten sie nur darauf gewartet, gemalt zu werden: von Dirk Skreber. Um von ihm mit einem passenden Kommentar ins Leben entlassen zu werden: wie das lakonisch *o. T. (Ultra Violence)*, 2000, genannte, verschachtelte Stückchen Architektur. Skreber favorisiert eine Malerei, die nahe am Leben ist in dem Sinne, wie ein Einfamilienhaus uns allen bekannt vorkommt. Wir nehmen Anteil an den elementaren Destruktionen, die diesem archetypischen Skreberschen Motiv widerfahren können. Die Katastrophe ist stets präsent in der Malerei von Skreber. Brutale Farbdrippings stellen dabei nicht die einzigen schlagenden Eingriffe in die Bildwelt dar. Nicht nur die Farbe verliert ihre Schwerkraft, auch der Bildgegenstand scheint dem Bildraum entfliehen zu wollen. Steht noch die Fassade, droht sie zu kippen: auf der Schwelle lauert bereits das Andere – atomarer Fallout, Hurrikane und Fluten. Selbst in den groben Holzverschlägen, in denen Skreber im Jahre 2000 seine großformatigen Gemälde installierte, wackelten die Wände. Es sind offensichtlich unhaltbare Situationen, die er in seinen Bildern aufgreift. Er reizt diesen Moment selbstbewusst aus, als sei er der allein Entscheidende: der Augenblick, in dem noch nichts passiert. Ohne ein Vorher, ohne ein Nachher, verweigern seine Bilder eine Geschichte. Die Bildmotive drängen in ihrer Gegenständlichkeit nach vorne, als ob sie wüssten, was ihnen bevorstehen könnte. Skreber liefert mit seinen Gemälden den Boden für eine weiterreichende Täuschung, das macht ihre Stärke aus.

Le peintre qui refuse la représentation et l'anecdote, et a fortiori l'interprétation, a néanmoins besoin de motifs – même si ceux-ci revêtent une importance très secondaire. Il peint alors des choses que chacun connaît : locomotives, meubles, terrains de football, immeubles. Certaines locomotives et certains immeubles se présentent pourtant comme s'ils n'avaient rien attendu d'autre que d'être peints … par Dirk Skreber – avant d'être rendus à la vie courante assortis d'un commentaire aussi ciblé que le laconique *o. T. (Ultra Violence)*, 2000, un petit morceau d'architecture imbriquée. Skreber préconise une peinture proche de la vie, au sens où un pavillon de banlieue nous semble tout à fait familier. Nous prenons part aux destructions élémentaires que peuvent subir les motifs archétypaux de Skreber. Dans sa peinture, la catastrophe est sans cesse présente. Des drippings de peinture brutaux ne sont pas les seules interventions pertinentes dans ce monde iconique. Si la couleur y perd toute pesanteur, le sujet pictural semble lui aussi vouloir échapper à l'espace pictural. La façade est encore debout, mais menace de s'effondrer : sur le seuil guettent déjà des éléments étrangers – retombées atomiques, cyclones et pluies diluviennes. Même dans les baraques de bois grossières dans lesquelles Skreber installait ses grands formats en 2000, les murs sont branlants. Manifestement, les situations que lui fait entrer dans ses tableaux sont intenables. Cet aspect est délibérément exacerbé, comme s'il était le seul décisif : l'instant où rien encore n'a lieu. Sans un avant, sans un après, les tableaux interdisent toute histoire. Les motifs iconiques se présent vers l'avant en leur caractère d'objet, comme s'ils savaient ce qui peut les attendre. Avec ses peintures, Skreber alimente une illusion lourde de conséquences, et c'est ce qui fait toute leur force.

F. F.

SELECTED EXHIBITIONS →
1995 *Das Abenteuer der Malerei*, Kunstverein für die Rheinlande und Westfalen, Düsseldorf, Germany **1996** *ars viva 96/97*, Förderpreis des Kulturkreises des BDI, Galerie am Fischmarkt, Erfurt, Germany **1997** Galerie Luis Campaña, Cologne, Germany **1999** Kunstmuseum Arnheim (with Björn Dahlem and Isa Genzken), The Netherlands **2000** Luis Campaña, Cologne, Germany; *Preis der Nationalgalerie für junge Kunst*, Nationalgalerie im Hamburger Bahnhof, Museum für Gegenwart, Berlin, Germany **2001** Kerstin Engholm Galerie, Vienna, Austria; Blum & Poe, Los Angeles (CA), USA; *Hypermental*, Kunsthaus Zürich, Zurich, Switzerland **2002** Kunstverein Freiburg, Germany

SELECTED BIBLIOGRAPHY →
2000 *Hypermental. Wahnhafte Wirklichkeit 1950–2000*, Ostfildern-Ruit **2001** *Wirklichkeit in der zeitgenössischen Malerei*, Städtische Galerie Delmenhorst; *Musterkarte*, Goethe-Institut, Madrid

1 **o. T.,** 2001, mixed media, 280 x 160 cm
2 **o. T.,** 1999, mixed media, 180 x 240 cm

3 **o. T. (Ultra Violence),** 2000, mixed media, 235 x 335 cm
4 **o. T. (Beyond Taxes),** 1999, mixed media, 140 x 400 cm

„Es ist furchtbar, Maler zu sein."

« Etre un peintre, c'est terrible. »

"It is terrible to be a painter."

2

Andreas Slominski

1959 born in Meppen, lives and works in Hamburg, Germany

Andreas Slominski is a sculptor. He is also a maker of traps, with a sly sense of humour, whose art requires closer examination to discover its hidden meaning. The materials Slominski puts together to create his cunning works of art are mostly drawn from everyday life. Only the slightest shift of perspective is enough to reveal the darkness, cynicism and absurd complexities behind familiar façades. His *Schrank für Liebhaber im Rollstuhl* (Wardrobe for lovers in wheelchairs), 2000, is based on the cliché of the adulterer caught in flagrante hiding in the wardrobe. In Slominski's version, the lover is a less nimble wheelchair user. So the artist supplies a perfectly ordinary wardrobe with a wheelchair-friendly ramp arrangement to ensure escape from the irate husband. In recent years, Slominski's work has become more complex with stronger narrative content. Where once they used simple means to question the illusory nature of art, his sometimes large installations play masterfully with the different levels of fictionality. In his *Vogelfangstation* (Bird Trap), executed 1998/99, various fully functioning traps are arranged around a fenced-in hut. Who does the viewer identify with while contemplating this representation of violence? The hidden trappers or the supposed victims? Is it about sadism or compassion, the thrill of the hunt or animal protection? It is the multiplicity of allusions that creates the tension of the work.

Andreas Slominski ist Bildhauer. Und er ist ein hintersinniger Fallensteller, dessen Kunst erst auf den zweiten Blick ihren doppelten Boden offenbart. Das Material, aus dem sich Slominskis tückische Kunst zusammensetzt, ist meist unserer alltäglichen Lebenswelt entnommen – nur eine kleine Verschiebung genügt und schon tun sich hinter der Fassade des Gewöhnlichen zynische Abgründe und absurde Verwicklungen auf. Der *Schrank für Liebhaber im Rollstuhl*, 2000, etwa basiert auf dem Klischee, dass sich in flagranti ertappte Ehebrecher flugs im Schlafzimmerschrank verstecken. Bei Slominski allerdings ist dieser Liebhaber ein normalerweise nicht so flinker Rollstuhlfahrer. Also versieht der Künstler einen handelsüblichen Schrank mit einer Schienenkonstruktion, die ein Rollstuhl leicht hinauffahren kann – die Rettung vor dem erbosten Ehegatten scheint nun gesichert. Slominskis Arbeiten sind in den letzten Jahren aufwendiger und erzählerischer geworden. Befragten sie früher eher mit sparsamen Mitteln den Schein-Charakter von Kunst, so spielen jetzt die zum Teil raumfüllenden Installationen virtuos mit verschiedenen Ebenen von Fiktionalität: So etwa die *Vogelfangstation,* 1998/99, in der diverse funktionstüchtige Fallen um eine verrammelte Hütte arrangiert sind, die den Mittelpunkt der imaginären Jagd darstellt. Mit wem identifiziert sich der Kunstfreund angesichts dieser beeindruckenden Inszenierung von Gewalt: mit den im Verborgenen bleibenden Tätern oder mit den vermeintlichen Opfern dieser Vogelfangstation? Sadismus oder Mitleid, Jagdfieber oder Tierschutz heißen die Schlagwörter, die diese Arbeit anspielungsreich unter Spannung setzen.

Andreas Slominski est sculpteur. Il est aussi un profond poseur de pièges dont l'art ne dévoile son double fond qu'au second regard. Le matériau dont se compose l'art malicieux de Slominski est emprunté le plus souvent à notre univers quotidien ; souvent, un décalage minime suffit pour que des abîmes cyniques et des trames d'interrelations absurdes s'ouvrent derrière la façade de l'habitude. Le *Schrank für Liebhaber im Rollstuhl* (Armoire pour amant en fauteuil roulant), 2000, par exemple, repose sur le schéma classique dans lequel les amants adultères pris sur le fait se cachent dans l'armoire de la chambre à coucher. Chez Slominski, l'amant est assis dans un fauteuil roulant qui n'est pas aussi leste. L'artiste a donc prévu une armoire courante du commerce munie de glissières permettant de hisser aisément un fauteuil roulant – la fuite devant le mari en colère semble dès lors assurée. Au cours des dernières années, les œuvres de Slominski sont devenues plus complexes et plus narratives. Si des moyens parcimonieux remettaient naguère en cause le caractère fictif de l'art, les installations parfois intégrales jouent aujourd'hui avec une indéniable virtuosité sur différents niveaux de fiction. La *Vogelfangstation* (Station ornithologique) 1998/99, dans laquelle différents pièges armés sont disposés autour d'une cabane soigneusement barricadée représentent le centre d'une chasse imaginaire, en est un bon exemple. Avec qui s'identifie l'amateur d'art au regard de cette impressionnante mise en scène de la violence : avec les acteurs cachés ou avec les soi-disant victimes de cette station ? Sadisme ou pitié, fièvre de la chasse ou protection des animaux, tels sont les slogans qui placent cette œuvre dans un champ de tension hautement allusif.

R. S.

SELECTED EXHIBITIONS →
1998 Kunsthalle Zürich, Zurich, Switzerland **1999** Deutsche Guggenheim, Berlin, Germany; *collection 99,* Galerie für Zeitgenössische Kunst, Leipzig, Germany **2000** Jablonka Galerie, Cologne, Germany; *Orbis Terrarum,* Museum Plantin-Moretus, Antwerp, Belgium; *Tout le temps, La Biennale de Montréal,* Centre international d'art contemporain de Montréal, Canada; *Let's Entertain,* Walker Art Center, Minneapolis (MN), USA **2001** Wako Works of Art, Tokyo, Japan; *The Big Show 2,* New International Cultural Center, Antwerp, Belgium

SELECTED BIBLIOGRAPHY →
1999 *Andreas Slominski,* Berlin; Burkhard Riemschneider/ Uta Grosenick (eds.), *Art at the Turn of the Millennium,* Cologne **2000** *Let's Entertain,* Walker Art Center, Minneapolis (MN)

1 Gerät zum Knicken von Antennen, 2001, metal, 65 x 6 x 21 cm

2 Die Hose des Einbeinigen trocknen (Drying the trousers of the one-legged man), 2000, kunstwegen, Städtische Galerie Nordhorn

„Wo sind die Skier?"

"Where are the skiers?"

« Où sont les skis ? »

2

Yutaka Sone

1965 born in Shizuoka, lives and works in Tokyo, Japan, and Los Angeles (CA), USA

Yutaka Sone's priorities are process, thought, action and creation; results are of minimal importance to him. He likes to subvert familiar patterns of behaviour, and tries to broaden our horizons with works like *Birthday Party*, 1997. Every day for several weeks he held a birthday party in a different location, thereby realising a child's dream in a way that, for adults viewing it realistically, seems absurd, even frightening. Not so for Sone. Life in his art projects is a many-layered, crazy and utopian game. This applies as much to *Tour de France* – for which he has been putting together a team and seeking sponsors since 1993 – as it does to the extreme ski tours planned with other artists, or his roller-coaster sculptures, or even a trip to the moon to lay Astroturf. We might come to believe that the Japanese artist's intention is to utilise utopia as a humorous variety of everyday tragedy if it were not for his architectural background, and his ceaseless investigation of the spatial experience of time. In trying to locate the processes of perception, he is to some extent driven by a social dimension, which frequently gives rise to interdisciplinary projects with musicians, film makers and other artists that result in sculptures, performances, videos, drawings and paintings. The alteration of familiar dimensions, as in his marble images of Hong Kong and Manhattan, describes the chasm that lies between different observational levels. What is real life and what is artistic conception? And what are happiness, tragedy, failed hope, or the absence of faith? Sone explains nothing while challenging us to supply feelings and moods that can convey more about the nature of thought than any intellectual commentary.

Yutaka Sone stellt den Prozess, das Denken, Handeln und Schaffen, über das Ergebnis. Er unterläuft gewohnte Handlungsmuster und erweitert unseren Horizont, etwa mit der Arbeit *Birthday Party*, 1997: jeden Tag Geburtstag – ein Kindheitstraum, dessen reale Ebene dem Erwachsenen absurd scheinen, ja beinahe Angst machen mag – nicht so bei Sone. In seinen Kunstprojekten ist das Leben in vielschichtigen, irrwitzigen und utopischen Spielformen zugegen. Sei es auf der *Tour de France*, für die er seit 1993 ein Team zusammenstellt und als Unternehmen noch Sponsoren sucht, sei es auf den extremen Skitouren, die er mit Kollegen plant, oder den Achterbahnen, die an verschiedenen Orten Spaß und Schwung in die Kunst bringen, und gar der Reise zum Mond, um dort Kunstrasen auszulegen. Utopie als humoristische Sonderform der alltäglichen Tragik? Wäre da nicht der architektonische Hintergrund des japanischen Künstlers, seine permanente Verhandlung räumlicher Zeiterfahrung. Beim Verorten von Wahrnehmungsprozessen ist sein Antrieb auch die soziale Dimension, weshalb mit Musikern, Filmemachern oder anderen Künstlern häufig interdisziplinäre Projekte entstehen, die ihren Niederschlag in Skulpturen, Performances, Videos, Zeichnungen oder Bildern finden. Die Veränderung von gewohnten Dimensionen, wie in den Marmorabbildern von Hongkong und Manhattan, beschreibt die Kluft zwischen Betrachtungsebenen. Was ist das wahre Leben, was ist künstlerisches Konzept? Und was ist Glück, was Tragik, gescheiterte Hoffnung oder einfach nur fehlender Glaube? Sone erklärt uns nichts, aber er fordert Gefühle, Stimmungen, die mehr über die Art des Denkens vermitteln als es intellektuelle Bezugnahmen könnten.

Yutaka Sone met le processus, la pensée, l'action et la création au-dessus du résultat. Il sape les schémas ordinaires de l'action et élargit notre horizon, par exemple avec un travail comme *Birthday Party*, 1997 : fêter chaque jour son anniversaire, voilà un rêve d'enfant dont la concrétisation semble absurde aux adultes, qui en auraient même presque peur, contrairement à Sone. Dans ses projets artistiques, la vie est présente dans des déclinaisons ludiques multiples, délirantes et utopiques, qu'il s'agisse de *Tour de France*, œuvre pour laquelle il regroupe une équipe depuis 1993 et pour laquelle il est encore à la recherche de sponsors, qu'il s'agisse de randonnées de ski extrême qu'il projette de réaliser avec des collègues, ou encore de montagnes russes qui doivent mettre de l'ambiance et de la gaieté dans l'art sur toutes sortes de sites, ou encore du voyage sur la lune en vue d'y installer un gazon artificiel. L'utopie comme forme particulière, humoristique du tragique quotidien ? Ne serait-ce pas là la toile de fond architectonique de l'artiste japonais, sa négociation continuelle de l'expérience spatiale du temps ? En concrétisant les processus de la perception, son moteur est aussi la dimension sociale de l'action, ce qui explique pourquoi il travaille souvent à des projets interdisciplinaires avec des musiciens, des réalisateurs de cinéma ou d'autres artistes, projets qui se répercutent ensuite dans ses sculptures, performances, vidéos, dessins ou tableaux. La modification des dimensions habituelles, comme dans les reproductions en marbre de Hongkong et de Manhattan, décrit le fossé entre les niveaux de regard. Qu'est-ce que la vraie vie, qu'est-ce qu'un concept artistique ? Et qu'est-ce que le bonheur, le tragique, l'espoir anéanti ou simplement le manque de foi ? Sone n'explique rien, mais il encourage les sentiments et les atmosphères qui en disent plus long sur son mode de pensée que ne pourraient le faire des systèmes de référence intellectuelles.

G. J.

SELECTED EXHIBITIONS →
1993 *Her 19th Foot*, Mito Art Tower, Japan **1997** *At the End of All The Journeys*, Hiroshima Contemporary Art Museum, Shiseido Art House, Kakegawa, Japan; *Skulptur. Projekte*, Münster, Germany **1999** *Alpine Attack*, Sogetsu Art Museum, Tokyo, Japan **2000** *Double Six*, Artpace, San Antonio (TX), USA; *In Between*, EXPO 2000, Hanover, Germany; *Le Jardin*, Académie de France à Rome – Villa Medici, Rome, Italy; *The Greenhouse Effect*, Serpentine Gallery, London, UK **2001** David Zwirner, New York (NY), USA; *Public Offerings*, The Museum of Contemporary Art, Los Angeles (CA), USA; *Phillip Morris Art Award*, Tokyo and Osaka, Japan; *International Triennale of Contemporary Art*, Yokohama, Japan; *7th Istanbul Biennial*, Istanbul, Turkey **2002** *Biennale of Sydney*, Australia

SELECTED BIBLIOGRAPHY →
1996 *Building Romance*, Mitika City Arts Foundation, Tokyo **2000** *In Between*, EXPO 2000, Hanover; *La Ville, Le Jardin, La Mémoire*, Villa Medici, Rome

474

„Für mich ist ein Prozess ein Objekt.
Ich möchte mich mit Skulpturen und Prozessen befassen."

« Pour moi, le processus est un objet.
Je veux travailler sur la sculpture et le processus. »

"For me process is an object.
I want to deal with sculpture and process."

2

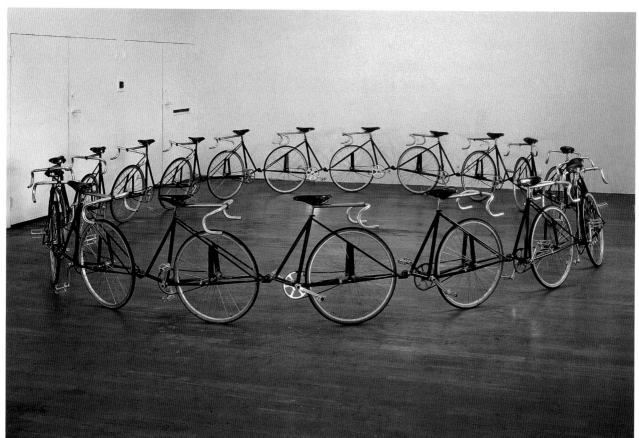

3

4

Eliezer Sonnenschein

1967 born in Haifa, lives and works in Tel Aviv, Israel

Eliezer Sonnenschein's first exhibitions of his work in 1994 were unauthorised "penetrations", performative actions infiltrating the Tel Aviv Museum of Art. Titled *Channel A Molotov Cocktails* or *Channel A Shit*, in reference to his virtual television channel "Channel A(narchy)", they were designed to enforce the participation of curators and public using guerrilla tactics, reflecting the state of daily violence while critiquing the enclosed nature of the museum. Installations such as *ACP (Anti Cellular Pollution)*, 1999, created visually aggressive spaces with aesthetics derived from the universal language of computer games, television and advertising to underline the proliferation of their empty, violent images. *Can't Won't Don't Stop*, 1998, presented wall-mounted models of guns covered with the corporate logos of the Western world – CNN, Marlboro, Adidas – against a sloganeering backdrop. The installations are often accompanied by texts in the hard-boiled style of American thriller writers; ironic narratives of corruption, violence, corporate domination and urban paranoia. *PORT*, installed in the 2001 Venice *Biennale*, is a panorama of twelve large-scale computer generated c-prints which chart various stages of the art world – The Underground, Art School, Art & History – as if they are skill levels in an art-world version of Super Mario. Sonnenschein's work illustrates the hypocrisies and power struggles intrinsic to the art world against a wider political context of violence and capitalist oppression.

Die ersten Präsentationen der Arbeiten von Eliezer Sonnenschein waren 1994 unbefugte „Interventionen", das heißt performative Akte, die er im Kunstmuseum von Tel Aviv durchführte. Diese unter Verweis auf seinen virtuellen Fernsehkanal „Channel A(narchy)" mit Titeln wie *Channel A Molotov Cocktails* oder *Channel A Shit* bezeichneten Aktionen verfolgten das Ziel, mithilfe von Guerillataktiken die Mitwirkung der Kuratoren und des Publikums zu erzwingen. Zugleich sollten sie aber auch den Zustand alltäglicher Gewalt reflektieren und die hermetische Abgeschlossenheit des Museums kritisch beleuchten. In seinen Installationen, etwa *ACP (Anti Cellular Pollution)*, 1999, hat der Künstler zudem visuell aggressive Räume kreiert, deren Ästhetik entscheidend durch die globale Sprache der Computerspiele, des Fernsehens und der Werbung inspiriert ist und einen Eindruck von der inflationären Verbreitung (sinn)leerer, gewaltgeladener Bilder vermitteln soll. In der Arbeit *Can't Won't Don't Stop*, 1998, zeigte er eine Auswahl von an der Wand hängenden Schusswaffen, die die Logos großer weltweit operierender Konzerne – etwa CNN, Marlboro, Adidas – trugen. Den Hintergrund bildeten dabei Werbeslogans. Begleitet werden Sonnenscheins Installationen häufig von Texten, die im Stil hartgesottener amerikanischer Thriller-Autoren geschrieben sind: ironischen Schilderungen der Korruption, der Gewalt, der Dominanz ökonomischer Interessen und der großstädtischen Paranoia. Bei der 2001 auf der *Biennale* in Venedig gezeigten Installation *PORT* handelt es sich um ein Panorama von zwölf großformatigen computergenerierten Farbausdrucken, die verschiedene Ebenen des Kunstgeschehens – The Underground, Art School, Art & History – so beschreiben, als ob es dabei um unterschiedliche Grade der Beherrschung des Computerspiels Super Mario ginge. Vor dem Hintergrund einer durch Gewalt und kapitalistische Unterdrückung gekennzeichneten allgemeinen politischen Situation illustriert Sonnenschein in seinem Werk die für die Kunst-Welt typischen Heucheleien und Machtkämpfe.

Les premières expositions d'Eliezer Sonnenschein en 1994 étaient des « pénétrations » non autorisées, des opérations performatives d'infiltration du musée d'art de Tel Aviv. Intitulées *Channel A Molotov Cocktails* ou *Channel A Shit*, en référence à sa chaîne de télévision virtuelle « Channel A(narchy) », elles étaient conçues pour forcer la participation des conservateurs et du public en utilisant des tactiques de guérilla, reflétant l'état de violence quotidienne en Israël tout en critiquant la nature fermée du musée. Des installations telles que *ACP (Anti Cellular Pollution)*, 1999, créaient des espaces visuellement agressifs avec une esthétique empruntée au langage universel des jeux vidéos, de la télévision et de la publicité pour dénoncer la prolifération de leurs images violentes et vides. *Can't Won't Don't Stop*, 1998, présentait, accrochées à un mur, des modèles d'armes à feu estampillés des logos de grandes compagnies du monde occidental – CNN, Marlboro, Adidas – sur un fond plein de slogans. Ces installations s'accompagnent souvent de textes dans le style dur à cuir des polars américains : des récits ironiques de corruption, de violence, de domination de grandes firmes et de paranoïa urbaine. *PORT*, installé à la *Biennale* de Venise de 2001, est un panorama de douze tirages grand format générés par ordinateur présentant diverses facettes du monde de l'art : The Underground, Art School, Art & History, comme s'il s'agissait de différents paliers d'un jeu de Super Mario adapté au monde de l'art. Son travail illustre les hypocrisies et les luttes de pouvoir intrinsèques au monde de l'art dans un contexte politique plus large reposant sur la violence et l'oppression capitaliste.

K. B.

1 Installation details, Arsenale, *49. Biennale di Venezia*, Venice, 2001;
 above: **PORT – Art School,** 2001, Lambda print;
 below: **PORT – The Underground,** 2001, Lambda print

2 **ACP, 1999,** mixed media, installation view, Sommer Contemporary Art,
 Tel Aviv
3 **Baby Demo Test Space,** 1999, mixed media, installation view,
 Herzliya Museum of Art, Herzliya

„Ich wünschte, ich könnte fliegen."
„Ich wünschte, ich wäre unschuldig."
„Ich wünsche dies auch dir."

« J'aimerais bien savoir voler. »
« J'aimerais bien être innocent. »
« Je te le souhaite aussi. »

"I wish I could fly."
"I wish I were innocent."
"I wish it for you too."

Simon Starling

1967 born in Epsom, lives and works in Glasgow, UK

When did modernism end? It hasn't yet, as demonstrated by the strength with which modernistic ideas are still projected. They are exemplified in design, architecture and art works, which provoke artists to invest new meanings in the worn but destruction-resistant project of our culture. Simon Starling's works are strolls in time and space. He starts with an object. It can be an empty crate for a piece of art from Edinburgh that the artist reworks into a fishing boat in Marseille. Or a can of Eichenbaum Pils beer found somewhere in the Bauhaus complex in Dessau. Each object triggers a process of translocation, circular returns and violent leaps in time and space, in which our perception of the meaning of objects is ruthlessly revised. Starling weaves a web of incredible links between distant facts and places. His works result from the processes of reflection that reveal the psychology of objects and the psychology of our understanding of culture. In Starling's installation *burn-time*, 2000/01, the Bauhaus designed egg-coddlers were confronted with a model of the Neo-classical prison building, made into a functioning hen-house. However improbable such combination might appear, in the end the mesh of interlocking links between seemingly disparate objects and facts proved far more convincing than the chance coincidences praised by surrealists. History is everywhere and its center is nowhere. Starling undermines our knowledge in order to reintroduce us to the adventure of knowing.

Wann ist die Moderne zu Ende gegangen? Noch gar nicht – wie der Einfluss bezeugt, den die Ideen der Moderne bis heute aus-üben. Sie prägen noch immer das Design, die Architektur und jene Werke, in denen Künstler sich bemühen, das ebenso verbrauchte wie zerstörungsresistente Projekt unserer Kultur mit neuen Bedeutungen zu füllen. Bei den Werken von Simon Starling handelt es sich um Wanderungen durch Zeit und Raum. Er beginnt mit einem Objekt. Das kann eine leere Kiste sein, in der zuvor ein Kunstwerk aus Edinburgh untergebracht war, die er in Marseille zu einem Fischerboot umgestaltet. Sein Ausgangsmaterial kann aber genauso gut eine Eichenbaum-Pils-Bierdose sein, die er irgendwo auf dem Bauhaus-Gelände in Dessau gefunden hat. Jedes dieser Objekte ist Anlass für eine ganze Abfolge von Translokationen, Kreisbewegungen und gewaltsamen Sprüngen in Raum und Zeit – ein Prozess, der uns die Objekte in einem völlig neuen Licht erscheinen lässt. Starling spinnt ein Netzwerk völlig unwahrscheinlicher Verbindungen zwischen weit auseinander liegenden Fakten und Orten. Seine Arbeit ist das Ergebnis eines Reflexionsprozesses, in dem die Mechanismen unserer Erfahrung der Objektwelt und die Gesetze zutage treten, denen unser Kulturverständnis unterliegt. In Starlings Installation *burn-time*, 2000/01, konfrontiertr er Bauhaus-Eierpochierer mit dem neo-klassizistischen Modell eines Gefängnisses, das zu einem Hühnerhaus umfunktioniert wurde. So unwahrscheinlich diese Kombination auch scheinen mag, am Ende erweist sie sich im Verknüpfen scheinbar verschiedener Objekte und Fakten als weitaus überzeugender als der von den Surrealisten gepriesene Zufall. Die – historische – Geschichte ist überall zugleich und hat nirgends ein Zentrum. Starling entzieht unserem Wissen den Boden, um uns aufs Neue mit dem Abenteuer des Wissens zu konfrontieren.

Quand le modernisme s'est-il éteint ? Pas encore, comme le démontre la puissance avec laquelle des idées modernistes sont encore projetées. Elles sont illustrées dans le design, l'architecture et l'art, incitant les artistes à investir de nouveaux sens dans le projet usé mais indestructible de notre culture. Les travaux de Simon Starling sont des promenades dans le temps et l'espace. Il part d'un objet. Il peut s'agir d'une caisse vide ayant contenu une œuvre d'art à Edimbourg qu'il retravaille en barque de pêcheur à Marseille. Ou d'une canette de bière Eichenbaum Pils trouvée quelque part dans le complexe Bauhaus de Dessau. Chaque objet déclenche un processus de translocation, des retours circulaires et des bonds violents dans le temps et l'espace, où notre perception du sens de l'objet est impitoyablement remise en question. Starling tisse une toile de liens incroyables entre des faits et des lieux éloignés. Ses travaux sont le résultat de réflexions qui révèlent la psychologie des objets et celle de notre compréhension de la culture. Dans l'installation de Starling *burn-time*, 2000/01, les pocheuses des-sinées par le Bauhaus étaient confrontées à une maquette de bâtiment pénitentiaire néoclassique, transformé en poulailler fonctionnel. Aussi improbable que puisse paraître une telle combinaison, à la fin le réseau de liens entre des objets et des faits qui semblent disparates était plus convaincant que les coïncidences fortuites louées par les surréalistes. L'histoire est partout et son centre n'est nulle part. Starling sape nos connaissances pour mieux nous réapprendre l'aventure du savoir.

A. S.

SELECTED EXHIBITIONS →
1996 *An Eichenbaum Pils beer can...*, The Showroom, London, UK
1997 *Blue Boat Black*, Transmission Gallery, Glasgow, UK; *Glasgow*, Kunsthalle Bern, Berne, Switzerland **1999** *Blinky Palermo Preis*, Galerie für Zeitgenössische Kunst, Leipzig, Germany; The Living Art Museum, Reykjavik, Iceland **2000** Camden Arts Centre, London, UK; *Manifesta 3*, Ljubljana, Slovenia; *The British Art Show 5*, Hayward Gallery, London, UK; *What if*, Moderna Museet, Stockholm **2001** *Squatters*, Museu Serralves, Oporto, Portugal

SELECTED BIBLIOGRAPHY →
1995 *An Eichenbaum Pils beer can...*, The Showroom, London **1997** *Blue Boat Black*, Transmission Gallery, Glasgow **1998** *Simon Starling*, Moderna Museet Project Room, Stockholm **2001** *back to front*, Camden Art Centre, London/John Hansard Gallery, Southampton

1 Work, made ready, Kunsthalle Bern, 1997, a Marin "Sausalito" bicycle remade using the metal from one Charles Eames "Aluminium Group Chair", a Charles Eames "Aluminium Group Chair" remade using the metal from one Marin "Sausalito" bicycle, 1997, bicycle, chair, 2 plinths, glass, vinyl text, dimensions variable, installation view, Kunsthalle Bern, Berne
2 **Burn-time,** 2001, C-type print, 78 x 101 cm
3 **Burn-time,** 2000/01, installation views, neugerriemschneider, Berlin

„Ich möchte Dinge zusammenzwingen, die sonst unverbunden nebeneinander stünden."

« Etablir de force des relations entre des choses qui autrement n'auraient probablement aucun lien entre elles. »

"Forcing things to relate that would probably otherwise be unrelated."

2

Thomas Struth

1954 born in Geldern, lives and works in Düsseldorf, Germany

Paradise – the idea of a joyful place from which our search for knowledge made us outcasts – has been a source of fascination since time immemorial. Many have travelled to supposedly "promised lands" in search of their own paradise. In this respect, visual representations have been the easiest to understand and the most enduring. Thomas Struth has made use of this sense of yearning for his latest photographs: several series of landscape images depicting the great forests of the world and the western deserts of the USA. Whereas his earlier works dealt principally with buildings, museums and portraits, the photographs taken since 1999 and entitled *Paradise* provide us with observations of unspoiled nature. As the opposite of the differentiated urban space that shapes our perception, nature and wilderness can only be experienced as distance and, in this respect, as both intellectual and physical. His interest in anthropology always shines through in his precise "portraits of conditions" (Struth). What is astonishing about his pictures is their sublime aesthetic, and the magnificence with which their ambivalent effect is achieved. In contrast to the terse *Unbewußte Orte* (unconscious places) that characterised his early photographs, there is now a metaphoric, emotional aspect, which brings to mind the description "remarkable places". Experiences are organised, although neither the paradises nor the American sequence provide many clues; their details flicker between sensitive composition and fleeting moment. Reminiscences and collective memories bestow the raised position of the camera with a far-sightedness in which glimmers the retrospective vision of a dialectic relationship between loss and gain, nature and culture. Ultimately, photographs are always reminders of actions left undone.

Das Paradies – seit Menschengedenken fasziniert die Vorstellung über den glücklichen Ort, aus dem wir vertrieben wurden, weil wir Erkenntnis suchten. Oft schon zogen Menschen in ein vermeintlich „gelobtes Land", auf der verheißungsvollen Suche nach einem Paradies. Hierbei scheint die visuelle Vorstellung die sinnfälligste, nachhaltigste. Mit dieser Sehnsucht arbeiten auch die neuen Fotografien von Thomas Struth: Landschaftsserien aus den großen Wäldern der Welt und den Wüsten Westamerikas. Waren es vorrangig Gebäude, Museumsräume und Porträts, die seine Arbeiten bisher bestimmten, sind es seit 1999 die *Paradiese (Paradise)* betitelten Fotografien, in denen Einblicke in unberührte Natur gewährt werden. Natur, Wildnis als Gegensatz zum differenzierten Stadtraum, der die Wahrnehmung prägend bestimmt, ist immer als Distanz und insoweit mental wie physisch zu erfahren. Sein soziologisches Interesse an Kulturen ist immer präsent, er zeigt präzise „Porträts von Bedingungen" (Struth). Erstaunlich ist bei der Betrachtung der Bilder, wie ästhetisch erhaben, wie grandios ihre ambivalente Wirkung erzeugt wird. Im Gegensatz zu den lapidaren *Unbewußten Orten* des Beginns seiner fotografischen Tätigkeit kommt eine metaphorische, emotionale Sphäre hinzu, die als „bemerkenswerte Orte" indiziert werden könnte. Erfahrungen werden sortiert, obwohl die *Paradiese* oder die amerikanische Folge kaum Anhaltspunkt bieten – ihre Ausschnitte changieren zwischen sensibler Komposition und flüchtigem Moment. Und es sind Reminiszenzen, kollektive Erinnerungen, denen die erhöhte Stellung des Aufnahmeapparates ihre Weitsicht verleiht. Hierin glimmt eine rückblickende Vision auf, das dialektische Verhältnis von Verlust und Gewinn von Natur und Kultur auf. Eine Fotografie erinnert letztlich immer auch an unerledigte Taten.

Le paradis – de tout temps, l'homme a été fasciné par l'idée d'un lieu heureux dont il fut chassé pour avoir cherché la connaissance. Souvent des hommes sont partis pour une terre « promise » dans l'espoir d'y trouver un paradis. Dans ce domaine, c'est la représentation visuelle qui s'avère la plus marquante et la plus durable. Les nouvelles photographies de Thomas Struth, séries de paysages des grandes forêts de la planète et des déserts de l'Ouest américain, travaillent aujourd'hui sur ce même désir. Si l'œuvre de Struth a été dominée jusqu'ici par des vues d'immeubles, de salles de musées et des portraits, la série *Paradise,* sur laquelle l'artiste travaille depuis 1999, propose les aperçus d'une nature encore vierge. La nature – l'état sauvage comme pôle opposé de l'espace urbain différencié qui conditionne notre regard – est toujours vécue sous le signe de la distance et donc de manière mentale tout autant que physique. L'intérêt sociologique pour les cultures du monde y est toujours opérant et produit des « portraits de conditions » (Struth) précis. Ce qui surprend dans ces images, c'est l'élévation esthétique et la grandeur avec laquelle est générée leur ambivalence. A l'inverse des lapidaires *Unbewußte Orte* (lieux inconscients) qui ont marqué les débuts de Struth, on assiste à l'intervention d'une dimension métaphorique et émotionnelle qu'on pourrait désigner sous l'appellation « lieux remarquables ». Les expériences sont triées, bien que les Paradis ou le cycle américain ne proposent guère de points de repères – leurs cadrages évoluent entre composition sensible et fugacité de l'instant. Ce sont des réminiscences, des souvenirs collectifs auxquels la position surélevée de l'appareil photo confère toute leur vastitude. Une vision rétrospective entonne ici son rapport dialectique entre perte et gain de la nature et de la culture : en définitive, toute photographie draine avec elle l'évocation de certains actes manqués. G. J.

1 **Paradise 22 – São Francisco de Xavier,** 2001, print, 177 x 135 cm 3 **Paradise 5 – Daintree/Australien,** 1998, print, 134 x 174 cm
2 **Drammen 1 – Drammen/Oslo,** 2001, print, 130 x 170 cm

„Ein Bild der leeren Landschaft kommt insofern dem fotografischen « L'image du paysage vide se prête au médium photographique
Medium entgegen, als es trotz seiner geschichtlichen Referenzialität stets dans la mesure où elle intègre aussi l'instant présent malgré le référentiel
auch das Jetzt einbezieht." historique. »

"The image of an empty landscape accommodates the medium of photography in so far as it always involves the present, despite being historically referential."

2

Superflex

Bjørnsternje Christiansen, born 1969, Rasmus Nielsen, born 1969, Jakob Fenger, born 1968, live and work in Copenhagen, Denmark

The artistic projects initiated by the three-man collective Superflex have clear political intentions. They always take the form of working models which, when scaled up, can be put to good use. Once in place, they serve both a practical and a social purpose. The *Biogas* project, on which the members of Superflex have been working since 1997, involves the development, production and operation of an eco-friendly biogas plant to meet local energy needs in areas with no power supply. Development aid as artistic venture: a highly pragmatic way of encouraging a rethink of current politico-economic structures. In 1999, the group came up with its Internet project *Karlskrona 2*, a digital representation of the Swedish city, where different ways of organising all aspects of urban life are under constant scrutiny. All the inhabitants of the real city can take part, while other Internet users can follow the virtual debate as "visitors". Latest developments in the project are periodically shown in exhibition spaces. In their latest undertaking *Superchannel*, the three Danes are exploring the potential of basic, non-hierarchical democracies. *Superchannel* is an on-line community channel providing "experimental space", and a variety of tools, from a public chatroom to live video pictures, through which users can voice their concerns, both local and global, for transmission worldwide.

Das dreiköpfige Künstlerkollektiv Superflex initiiert künstlerische Projekte, die klar abgesteckten politischen Inhalten dienen. Stets handelt es sich bei ihren Arbeiten um funktionstüchtige Modellsituationen, die sich für eine Realisation im größeren Maßstab anbieten. Bereits am Ort ihrer Anwendung aber besitzen sie eine so praktische wie gesellschaftskritische Qualität. Das Projekt *Biogas*, an dem Superflex seit 1997 arbeitet, besteht aus der Entwicklung, der Produktion und dem Vertrieb eines ökologischen Ofens, der in Gebieten ohne Stromanschluss die lokale Energieversorgung übernehmen kann: Entwicklungshilfe also als ästhetisches Unternehmen, das ganz pragmatisch zum Überdenken bestehender Formen der politisch-ökonomischen Weltordnung auffordert. Zwei Jahre später konzipierte die Gruppe die Internetarbeit *Karlskrona 2*, in der auf virtueller Ebene verschiedene Möglichkeiten von Stadtnutzung durchgespielt werden. Alle Einwohner der realen Stadt Karlskrona können hier teilnehmen, während andere Internet-Nutzer als „Besucher" der virtuellen Diskussion folgen können. Im Ausstellungsraum werden die Entwicklung und der jeweils aktuelle Stand des Prozesses vorgestellt. Auch in ihrem neuesten Unternehmen *Superchannel* testen die drei Dänen neue Möglichkeiten einer potenziell hierarchiefreien Basisdemokratie aus. Die kommunikative Plattform *Superchannel* bietet dafür im Internet einen „Raum für Experimente", der vom offenen Chatroom bis zum Live-Videobild unterschiedliche Werkzeuge zur Verfügung stellt, mit denen bestehende Kommunikationssysteme mikropolitisch vor Ort und zugleich weltweit unterlaufen werden können.

Les trois artistes du collectif Superflex sont à l'origine de projets artistiques servant des messages politiques au contenu clairement défini. Dans leurs œuvres, il s'agit toujours de la modélisation parfaitement fonctionnelle de certaines situations en vue d'une réalisation à plus grande échelle. Sur les lieux de leur concrétisation, elles ont néanmoins une qualité aussi pratique que sociocritique. Le projet *Biogas*, sur lequel Superflex travaille depuis 1997, intègre la mise au point, la production et la diffusion d'une unité écologique susceptible d'assurer la distribution d'énergie dans des zones non couvertes par l'électricité. Il s'agit donc d'une aide aux pays en voie de développement sous forme d'entreprise esthétique, qui appelle de manière très concrète à la réflexion sur les formes existantes de l'ordre politico-économique mondial. Deux ans plus tard, le groupe réalise *Karlskrona 2*, une œuvre conçue pour l'Internet et dans laquelle différentes possibilités d'utilisation de l'espace urbain sont déclinées au niveau virtuel. Tous les habitants de la ville concrète de Karlskrona peuvent apporter leur participation au projet, d'autres utilisateurs du web peuvent suivre le débat virtuel comme « visiteurs ». L'espace d'exposition présente les développements et différents stades d'évolution du processus. Dans leurs derniers projets, notamment dans *Superchannel*, les trois Danois explorent de nouvelles possibilités d'une démocratie fondamentale potentiellement dégagée de toute hiérarchie. A cette fin, la plate-forme de communication *Superchannel* propose sur l'Internet un « espace d'expériences » qui, du forum de discussion ouvert à tous, à l'image vidéo live, met à la disposition de l'utilisateur toutes sortes d'outils au moyen desquels les systèmes de communication peuvent être court-circuités au niveau micropolitique aussi bien qu'au niveau mondial.

R. S.

SELECTED EXHIBITIONS →
1998 *Superflex Biogas in Africa*, Accès Local, Paris, France; *Bicycle thieves*, The Monk Parakeet, Chicago (IL), USA **1999** *Tools*, Kunst-verein Wolfsburg, Germany; *Superchannel*, Artspace 1%, Copenhagen, Denmark; *Karlskrona 2/Utrecht 2*, CASCO Projects, Utrecht, The Netherlands **2000** *Superflex in company/economic potentials*, Center for Curatorial Studies, Bard College, Annandale-on-Hudson (NY), USA; *Norden*, Kunsthalle Wien, Vienna, Austria; *What if*, Moderna Museet, Stockholm, Sweden **2001** *Le Repubbliche*

Dell'Arte Germania, Palazzo delle Papesse, Siena, Italy; *2. berlin biennale*, Berlin, Germany

SELECTED BIBLIOGRAPHY →
1998 *Cream*, London **2000** *Das unheimliche Heim*, Kunstverein Wolfsburg **2001** *Le Repubbliche Dell'Arte Germania*, Siena

„Wir möchten, dass unsere Kunst eine soziale Relevanz hat, und übernehmen die volle Verantwortung für die Konsequenzen."

« Nous voulons que notre art ait une pertinence sociale, et nous assumons l'entière responsabilité des conséquences. »

"We want our art to have social relevance and we take full responsibility for the consequences."

2

3

Fiona Tan

1966 born in Pekan Baru, Indonesia, lives and works in Berlin, Germany, and Amsterdam, The Netherlands

Fiona Tan works with video and film, with moments in time and outcomes. While the technical reproduction of images is linked to media and space, she regards content as equally bound to questions of cultural character and identity. Working in the context of globalisation and migration, she devoted three years to investigating her identity for the documentary *May You Live in Interesting Times*, 1997. Tan travelled the world to find and visit members of her Indonesian family, who were scattered as a result of the turmoil of the 1960s. The daughter of a Chinese-Indonesian father and an Australian mother, she grew up in Australia and moved to Europe to study. The result of her social and cultural background is a migrant trans-identity. Tan's own history is bound to the understanding that our knowledge of the world is informed by the mass media, which is not always free of the suspicion of manipulation. Documentaries from distant countries are particularly important in shaping our opinions and understanding of the big wide world – and this includes exoticism. By formally combining, contrasting and sounding the depth of spaces, and by carefully selecting her found material, Tan alerts the viewer to the exploratory authenticity of the viewed work's function, which is to search for a position. She consciously manipulates the narrative by inserting her own film and video sequences, thereby ensuring that the film is perceived as a structural presence. Tan has set up a two-screen car-wreck cinema (*Car Wreck Cinema*, 2000), in which visitors can watch her films through the windscreen or in the rear-view mirror. The use of filmed fiction and world citizenship as identity can be light and humorous, yet always remains part of the complex system of social reality contained in implements and appliances, whether they are art, culture or cinema.

Fiona Tan arbeitet mit Video und Film, mit Augenblick und Wirkung. Die technische Reproduzierbarkeit von Bildern beschäftigt sie ebenso wie die Frage nach kultureller Prägung und Identität. Im Kontext von Globalisierung und Migration widmete sie sich drei Jahre lang in dem Dokumentarfilm *May You Live in Interesting Times* von 1997 ihrer Herkunft. Sie (be)suchte ihre nach dem Aufruhr der sechziger Jahre über die ganze Welt verstreute indonesische Familie. Als Tochter eines chinesisch-indonesischen Vaters und einer australischen Mutter – aufgewachsen in Australien und zum Studium nach Europa aufgebrochen – ist Tans sozio-kultureller Hintergrund der einer migrantischen Transidentität. Ihre Geschichte ist verbunden mit der Erfahrung, dass unser Wissen über die Welt aus den Massenmedien stammt, die nicht immer frei von einem Manipulationsverdacht sind. Insbesondere Dokumentarfilme aus fernen Ländern bestimmen maßgeblich unsere Auffassung und Erkenntnis von der weiten Welt – und mithin unsere Exotismen. Im Kombinieren, Gegenüberstellen, räumlichen Ausloten auf formaler Ebene und in der Auswahl des gefundenen Materials macht Tan dem Betrachter die forschende Authentizität des Gesehenen als Standortsuche bewusst. Durch den Einbau eigener Film- und Videosequenzen wird die Erzählung gezielt manipuliert, so dass Film als strukturelle Präsenz wahrgenommen wird. Tan hat ein Schrottwagen-Autokino mit zwei Leinwänden installiert (*Car Wreck Cinema*, 2000), bei dem die Besucher die Filme durch die Windschutzscheibe und im Rückspiegel betrachten konnten. Die Thematisierung von filmischer Fiktion und Weltbürgeridentität kann sehr leicht und humorvoll sein, aber immer ist sie Teil des komplexen Systems von gesellschaftlicher Realität in Geräten und Apparaturen, seien sie Kunst, Kultur oder Kino.

Fiona Tan travaille avec la vidéo et le cinéma, avec l'instant et l'effet. La reproductibilité technique des images est liée aux médias, à l'espace et, en termes de contenu, tout aussi étroitement à l'empreinte et à l'identité culturelle. Dans le contexte de la globalisation et des flux migratoires, Tan s'est consacrée pendant trois ans au problème de sa propre identité dans le documentaire *May You Live in Interesting Times*, 1997, partant sur les traces de sa famille disséminée dans le monde entier après les événements des années 60. La toile de fond culturelle de Tan est celle d'une trans-identité migrante : fille d'un père sino-indochinois et d'une mère australienne, elle a grandi en Australie et a fait ses études en Europe. Son expérience personnelle est liée au fait que notre idée et notre connaissance du monde sont modelées par les mass media, qui ne sont pas toujours au-dessus de tout soupçon du point de vue de la manipulation. En particulier, les documentaires qui nous informent sur des pays lointains conditionnent de manière déterminante notre manière de connaître et d'appréhender le vaste monde – et aussi nos propres exotismes. En combinant, en comparant, en sondant l'espace au niveau formel, mais aussi dans le choix des sujets, Tan fait vivre l'authenticité de ce qu'elle a filmé sous la forme d'une recherche de points de repères. En y intégrant des séquences personnelles, elle manipule délibérément le récit de manière à faire percevoir le film dans sa qualité structurelle. Tan a aussi installé un cinéma de plein air dans une casse automobile (*Car Wreck Cinema*, 2000), avec deux écrans où passaient des films que les spectateurs pouvaient regarder à travers le pare-brise et dans le rétroviseur. L'illustration de la fiction filmique et de l'identité de citoyen du monde peut être tout à fait légère et humoristique, mais elle participe toujours du système complexe de la réalité sociale à travers les différents outils et appareils, que ceux-ci soient art, culture ou cinéma.

G. J.

SELECTED EXHIBITIONS →
1997 *2nd Johannesburg Biennale*, Johannesburg, South Africa
1998 *Traces of Science in Art*, Het Trippenhuis KNAW, Amsterdam, The Netherlands **1999** *Roll I & II*, Museum De Pont, Tilburg, The Netherlands; *Cradle*, Galerie Paul Andriesse, Amsterdam, The Netherlands; *Life Cycles*, Galerie für Zeitgenössische Kunst, Leipzig, Germany; *Go Away*, Royal College of Art, London, UK **2000** *Scenario*, Kunstverein Hamburg, Germany; ‹hers› *Video as a Female Terrain*, Steirischer Herbst, Graz, Austria; *5ème Biennale de Lyon*, Institut d'art contemporain Villeurbanne, France **2001** *Matrix 145*, Wadsworth Atheneum, Hartford (CT), USA; *Yokohama Triennale*, Japan; *49. Biennale di Venezia*, Venice, Italy; *2. berlin biennale*, Berlin, Germany

SELECTED BIBLIOGRAPHY →
2000 *Fiona Tan, Scenario*, Rotterdam

494

1 **Facing Forward,** 1998/99, video projection, installation view, *<hers> – Video as a Female Terrain,* Steirischer Herbst, Graz 2000
2 **Car Wreck Cinema,** 2000, installation view, *Außendienst, Kunstprojekte in öffentlichen Räumen,* Hamburg
3 **Thin Cities,** 1999/2000, video installation, installation view, *Scenario,* Kunstverein in Hamburg, 2000

„Das Konzept von Vergangenheit, von Geschichte ist Menschenwerk. Ein vergängliches Konzept. Wie das Museum ist es eine Institution des 19. Jahrhunderts. Konzepte, die mich schwindlig machen, die ich noch nicht ausloten kann."

« Même l'idée de passé, d'histoire, est un concept créé par l'homme. Un concept éphémère. C'est comme un musée, une institution du 19ème siècle. Des concepts qui donnent le vertige, que je ne puis encore sonder. »

"Even the idea of the past, of history, is a man-made concept. A temporary one. Like the museum, it is a 19th-century institution. Concepts which make me dizzy, I cannot yet fathom."

2

Vibeke Tandberg

1967 born in Oslo, lives and works in Oslo, Norway

The fantasy of a second-self, of another I and hyper-I, was recalled in the work of many artists of the late 20th century. The boundary of imagination, defined by the requirement of a psychological and physical integrity, has been annihilated. In parallel with others' breathtaking experiments on cloning living organisms, artists have begun to explore the restricted zone of split personality. In her film and photographic works, Vibeke Tandberg has created an uncanny gallery of doubled characters for whom she herself is the mother and father: her body, her facial gestures, her bodily movements. Doubly exposed or computer-aided photographs show Tandberg and different variations of her alter ego in such a way that it is as if the physical existence of a "stranger to ourselves" was a common thing. How can you live with your own mirror image? Tandberg has shown how, in a series of staged photographs (*Living Together*, 1996) where we see her (or rather THEM) in private, almost intimate situations. Two young women who strangely resemble each other are in an apartment, among scattered pieces of clothing, having a drink and playing cards, resting, or lost in reflection. She analyses a whole range of tense relationships that can occur between two people. For that purpose, she superimposes on her image a virtual partner – often antagonistic – or appropriates other, fictitious identities. Tandberg performs a multiple reversal of roles, although it is always She, and Her I.

Die Fantasie eines zweiten Selbst, eines anderen Ich oder Über-Ich hat am Ende des 20. Jahrhunderts die Arbeit vieler Künstler inspiriert. Dabei haben sich jene Grenzen der Vorstellungskraft aufgelöst, die in der Idee einer psychischen und physischen Integrität vorgegeben sind. Während die Wissenschaft in atemberaubenden Experimenten lebende Organismen klont, haben die Künstler damit begonnen, die begrenzte Zone der gespaltenen Persönlichkeit zu erkunden. So hat zum Beispiel Vibeke Tandberg in ihren filmischen und fotografischen Arbeiten eine unheimliche Galerie verdoppelter Persönlichkeiten geschaffen, für die sie zugleich Mutter und Vater ist – ihnen gewissermaßen ihren Körper, ihren Gesichtsausdruck, ihre Bewegungen leiht. Auf doppelt belichteten oder per Computer bearbeiteten Fotografien präsentiert Tandberg sich selbst und die verschiedenen Varianten ihres Alter Ego so, dass die physische Existenz verschiedener Möglichkeiten des „Doppelgängers" eigentlich völlig normal erscheint. Wie kann man mit dem eigenen Spiegelbild leben? Tandberg hat gezeigt, wie das geht, und zwar in einer Serie inszenierter Fotografien (*Living Together*, 1996), auf denen wir sie (beziehungsweise ihre verschiedenen Identitäten) in privaten, fast intimen Situationen sehen: Zwei junge Frauen, die sich merkwürdig ähnlich sehen und in einer Wohnung zwischen zerstreut herumliegenden Kleidern etwas trinken, Karten spielen, sich ausruhen, nachdenken. Sie analysiert ein breites Spektrum spannungsgeladener Beziehungen, in denen zwei Menschen zueinander stehen können. Zu diesem Zweck überblendet sie ihr eigenes Bild mit den Zügen eines – vielfach antagonistischen – virtuellen Partners, oder aber sie macht sich fremde, fiktive Identitäten zu Eigen. Tandberg führt eine Vielzahl von Rollenverkehrungen vor, obwohl es sich immer um sie selbst, ihr Ich handelt.

La fantasme d'un second moi, d'un autre « Je » et d'un « hyper-Je », a été souvent évoqué par les artistes de la fin du 20ème siècle. Les limites de l'imagination, définies par la nécessité d'une intégrité psychologique et physique, ont été annihilées. Parallèlement aux expériences hallucinantes d'autres sur le clonage d'organismes vivants, les artistes se sont mis à explorer la zone interdite de la double personnalité. Dans ses films et ses photographies, Vibeke Tandberg a créé une galerie irréelle de personnages dédoublés dont elle est à la fois la mère et le père : ils ont son corps, ses mimiques, sa gestuelle. Des photographies à double exposition ou assistées par ordinateur la montrent avec différentes variations de son alter ego d'une telle manière que l'existence physique d'un « étranger à nous-mêmes » nous paraît commune. Comment peut-on vivre avec le reflet de soi-même ? Tandberg nous l'explique dans une série de photos mises en scène (*Living Together*, 1996) où on la voit, (ou plutôt, on « les » voit) dans des situations privées, presque intimes. Deux jeunes femmes qui se ressemblent étrangement sont dans un appartement, parmi des vêtements épars, buvant un verre, jouant aux cartes, se reposant ou perdues dans leurs pensées. Elle analyse toute une gamme de relations tendues qui peuvent se produire entre deux personnes. A cette fin, elle superpose sur son image un partenaire virtuel – souvent antagoniste – ou s'approprie d'autres identités fictives. Tandberg effectue un inversement multiple des rôles, même si elle reste toujours Elle, son Moi.

A. S.

SELECTED EXHIBITIONS →
1997 *Des Histoires en Formes*, Magasin, Grenoble, France
1998 *c/o – Atle Gerhardsen*, Oslo, Norway; *1. berlin biennale*, Berlin, Germany **1999** Andrea Rosen Gallery, New York (NY), USA; Galleri Nicolai Wallner, Copenhagen, Denmark; *Social Engagement, Politics and the Everyday in Art*, Museet for Samtidskunst, Oslo, Norway **2000** Kunstmuseum Thun, Switzerland; *Organizing Freedom*, Moderna Museet, Stockholm, Sweden **2001** *endtroducing*, Villa Arson, Nice, France; *Sport als Motiv in der zeitgenössischen Kunst*, Kunsthalle Nürnberg, Nuremberg, Germany **2002** Gagosian Gallery, London, UK; *Biennale of Sydney*, Australia

SELECTED BIBLIOGRAPHY →
1998 *1. berlin biennale*, Berlin **1999** *Welcome to the Art World*, Badischer Kunstverein, Karlsruhe **2000** *Vibeke Tandberg*, Kunstmuseum Thun; *Organising Freedom*, Moderna Museet, Stockholm; *Ich ist etwas Anderes. Kunst am Ende des 20. Jahrhunderts*, Kunstsammlung Nordrhein-Westfalen, Düsseldorf

1 **Boxing,** 1998, production stills from double-exposed 16 mm film
2 **Dad,** 2000, c-prints, each 139 x 105 cm

3 **Taxi Driver Too,** 2000, film stills from 16 mm colour film, each 46 x 56 cm

„Mein nächstes Projekt ist ein Remake von ‚The Hustler' mit Paul Newman. Ich werde darin die Rolle des Billardspielers übernehmen, der am Ende mit seinem eigenen Gewissen in Konflikt gerät."

« Mon prochain projet est un remake de ‹ L'Arnaqueur › avec Paul Newman, où je jouerai le rôle du joueur de billard qui finit en conflit avec sa propre conscience. »

"My next project is a remake of 'The Hustler' with Paul Newman, in which I will play the role of the billiard player who ends up in conflict with his own conscience."

2

3

502

1 **Blushes #2,** 2000, c-print, unique piece, 61 x 51 cm
2 Installation view, *The Turner Prize Exhibition,* Tate Britain, London, 2000

3 **Blushes #66,** 2000, ink jet print, 304 x 242 cm

„Meine Arbeit zielt darauf ab, eine Welt zu schaffen, in der ich leben möchte. Also geht es um die Erzeugung eines Ideals mit der Hilfe realistischer Technik. Meine Motivation ist der Wunsch nach Einheit, Verschmelzen und Gemeinschaftssinn."

« Mon travail est destiné à créer un monde dans lequel je souhaite vivre. Par conséquent, il s'agit de créer des idéaux à l'aide de techniques réalistes. Ma motivation essentielle est un désir d'unité, de fusion et de sens de la communauté. »

"My work is aimed at creating a world in which I wish to live. Consequently, it is about creating ideals with the aid of realistic techniques. My most fundamental motivation is a desire for unity, fusion and sense of community."

2

Rirkrit Tiravanija

1961 born in Buenos Aires, Argentina, lives and works in New York (NY), USA, and Berlin, Germany

During the 1990s, Rirkrit Tiravanija helped shape an aesthetic that broke radically with classic methods like painting and sculpture. In his live acts he cooked for exhibition visitors, and faithfully recreated his apartment in an institution then opened it to the public for 24 hours. The bringing together of art and life, as practised by the Fluxus group and applied in conceptual art, has found a contemporary successor in Tiravanija. The artist, who was brought up in Argentina, Thailand and Canada, links the positive, communicative energy of such actions with contemporary issues like cultural transfer and the translation of specific acts from one geographic and economic sphere into another. Tiravanija's cookery projects in particular confronted his enthusiastic public with the "exotic cuisine" cliché, which is often the only form of inter-cultural encounter many people experience in their everyday lives, and the only expression of other cultures they are able to "digest". In his latest projects, Tiravanija has pursued the themes of cultural nomadism and global art by exhibiting his actions live on the Internet. He has also been working for some time on the idea of an art magazine in which all kinds of contributions can be published across the world without editorial input. This newspaper would become an almost impossible network of spontaneous, democratic communication, subject to new inter-media conditions. Tiravanija has homes in many parts of the globe, and pays great attention to integrating the conditions pertaining to his surroundings, wherever they may be, into his artistic thought. Hence his approach to the work is always processual, and his installations are stationary with fluid transitions to future projects.

Rirkrit Tiravanija prägte in den neunziger Jahren eine Ästhetik, die mit den klassischen Medien wie Malerei und Skulptur radikal gebrochen hat. In seinen Live-Acts kochte er für die Besucher seiner Ausstellungen oder baute sein Apartment originalgetreu in einer Institution auf und stellte es 24 Stunden lang der Öffentlichkeit zur Verfügung. Die Verknüpfung von Kunst und Leben, wie sie besonders im Fluxus und in der Konzeptkunst ausgelebt wurde, findet so in Tiravanija einen zeitgenössischen Nachfolger. Dabei verbindet der in Argentinien, Thailand und Kanada aufgewachsene Künstler die positive, kommunikative Energie solcher Aktionen mit neuen Themen wie dem kulturellen Transfer, der Übersetzung spezifischer Handlungen von einer geografischen und ökonomischen Sphäre in eine andere. Gerade Tiravanijas Koch-Projekte konfrontierten das begeisterte Publikum mit dem Klischee von „exotischer Küche" als die oft einzige Form interkultureller Begegnung, die viele im Alltag erleben und als Ausdruck einer anderen Kultur „verdauen" können. Das Thema des kulturellen Nomadentums und einer globalen Kunst verfolgt Tiravanija in seinen jüngsten Projekten, indem er seine Aktionen live ins Internet stellt. Daneben realisiert er seit einiger Zeit die Idee eines Kunstmagazins, in dem Beiträge aller Art weltweit unlektoriert veröffentlicht werden können. Die Zeitung wird somit zu einem Netzwerk spontaner, demokratischer Kommunikation unter neuen intermedialen Bedingungen. Tiravanija lebt an mehreren Orten auf der Welt und integriert mit höchster Aufmerksamkeit die Bedingungen der jeweiligen Umgebung in sein künstlerisches Denken. Sein Arbeitsansatz bleibt so immer prozessual, seine Installationen sind stationär und haben fließende Übergänge zu künftigen Projekten.

Dans les années 90, Rirkrit Tiravanija a marqué de son empreinte une esthétique qui rompait radicalement avec les médiums classiques de la peinture et de la sculpture. Dans ses live-acts, il faisait la cuisine pour les visiteurs de ses expositions ou reconstituait fidèlement son appartement pour le mettre à la disposition du public pendant 24 heures. Ainsi, la mise en relation de l'art et de la vie, telle qu'elle a été pratiquée en particulier au sein du mouvement Fluxus et de l'art conceptuel, trouve aujourd'hui son successeur en la personne de Tiravanija. Cet artiste qui a grandi en Argentine, en Thaïlande et au Canada, combine l'énergie positive et communicative de ce type d'actions avec des thèmes actuels comme le transfert culturel, la transposition d'actions spécifiques d'une zone géographique et économique vers une autre. Ce sont précisément les projets culinaires de Tiravanija qui confrontent le public enthousiaste avec le cliché de la « cuisine exotique » comme la seule forme de rencontre interculturelle que beaucoup vivent dans le quotidien et sont capables de « digérer » comme expression d'une autre culture. Dans ses derniers projets, Tiravanija poursuit le thème du nomadisme culturel et d'un art global en mettant ses actions en live sur Internet. Parallèlement, Tiravanija réalise depuis quelque temps l'idée d'un magazine d'art dans lequel toutes sortes de contributions peuvent être publiées à l'échelle planétaire sans relecture éditoriale. Ce magazine devient ainsi un réseau foisonnant de communication spontanée et démocratique dans les nouvelles conditions intermédiatiques. Tiravanija vit à plusieurs endroits de par le monde et met une attention extrême à intégrer dans sa pensée artistique les conditions de chaque environnement. Sa démarche artistique demeure donc toujours processuelle, ses installations sont stationnaires et contiennent des transitions fluides vers ses projets futurs.

A. K.

SELECTED EXHIBITIONS →
1996 *Untitled 1996 (Tomorrow is another day)*, Kölnischer Kunstverein, Cologne, Germany **1997** *Untitled, 1997 (playtime)*, Projects 58, Museum of Modern Art, New York (NY), USA **1998** *Untitled, 1998 (das soziale Kapital)*, Migros Museum für Gegenwartskunst, Zurich, Switzerland **1999** *Community Cinema for a Quit Intersection (Against Oldenburg)*, The Modern Institute, Glasgow, UK; *Untitled, 1999 (Mobile Home)*, Fundacio „la caixa", Barcelona, Spain **2001** *DemoStation*, Portikus, Frankfurt am Main, Germany; Kunstverein Wolfsburg, Germany

SELECTED BIBLIOGRAPHY →
1996 *Untitled 1996 (Tomorrow is another day)*, Kölnischer Kunstverein, Cologne; *Real Time*, Institute of Contemporary Arts, London **1997** Biennale of Sydney; *Cities on the Move*, Wiener Secession/ capcMusée d'Art Contemporain, Vienna/Bordeaux **1998** *Untitled, 1998 (das soziale Kapital)*, Migros Museum für Gegenwartskunst, Zurich; Franz Ackermann/Rirkrit Tiravanija, *RE public*, Grazer Kunstverein **1999** *dAPERTutto, 48. Biennale di Venezia*, Venice; *Untitled, 1999 (Mobile Home)*, Fundació „la caixa", Barcelona

1 **Untitled 1999 (Thai Pavilion),** installation view, dAPERTuttO,
48. Biennale di Venezia, Venice, 1999
2 **Untitled 1999 (Community for a quiet intersection) (After Oldenburg),**

installation view, The Modern Institute, Glasgow, 1999
3 **Untitled 2001 (DemoStation),** 2001, installation view, Portikus,
Frankfurt am Main

„Ich mag positive Ironie.
Ironie kann neue Metaphern schaffen, und das finde ich interessant."

« J'aime l'ironie positive.
L'ironie peut générer de nouvelles métaphores, et c'est ce qui m'intéresse. »

"I like positive irony.
Irony can create new metaphors, and I find that interesting."

2

3

3

Grazia Toderi

1963 born in Padua, lives and works in Milan, Italy

Grazia Toderi's fascination with water led her to video, a medium she exploits to create the most authentic representation of the process of flux. In her early work, she explored the physical quality of water as it reacted to the laws of nature. *Nontiscordardime*, 1993, shows a forget-me-not being constantly sprayed by water from a bathroom shower. Toderi finds her motifs in the world of household things. In *Soap*, 1993, Barbie's boyfriend Ken is spun in a tumble dryer to the music of "Casta Diva". Her video *Terra*, 1997, is also the result of her fascination with the power of the elements. An aircraft is seen repeatedly taking off, only to lose height as though it cannot escape the earth's magnetic force. This observation of an elementary process through constantly repeated sequences recalls the Process Art of the 1970s. In Toderi's more recent work, light and the sky play a significant role. They show people in relation to the cosmos, from an astronomical standpoint with stargazers in a planetarium (*Planeta*, 2001), but more often on a metaphorical level. In her 1998 video installation *Il fiore delle 1001 notte*, inspired by Pasolini, different realities, earthly and cosmic, virtual and dreamlike, unfold. During the same period in the late 1990s, Toderi produced several series of transparencies, using white light to "paint" figures in starry skies. In *Il decollo*, 1998, and *San Siro*, 2000, she combines images of packed flood-light stadiums and the roar of jubilant spectators with distant aerial perspectives. *Olympia*, 2000, shows the perpetual rotation of a fixed image turned upside down between heaven and earth, as if the viewer were looking at the world from a roller coaster.

Ihre Faszination für das Element Wasser führte Grazia Toderi zum Video, in dem sie mediale Parallelen für eine möglichst „authentische" Darstellung des Fließenden fand. In frühen Arbeiten untersuchte sie die physikalische Qualität des Wassers unter dem Einfluss von Natur-gesetzen (*Nontiscordardime*, 1993, zeigt einen Duschstrahl, der kontinuierlich auf eine Vergissmeinnichtpflanze prasselt) und suchte ihre Motive im häuslichen Bereich (in *Soap*, 1993, wird Barbies Freund Ken zur Musik von „Casta Diva" in der Waschtrommel geschleudert). Toderis Interesse an den Kräften der Elemente liegt auch dem Video *Terra*, 1997, zugrunde, in dem ein Flugzeug immer wieder abhebt, um dann an Höhe zu verlieren, als könne es die Erdanziehungskraft nicht überwinden. Dabei erinnern die Beobachtung eines elementaren Prozesses und die sich ständig wiederholenden Sequenzen an Strategien der Process-Art der siebziger Jahre. In den neueren Arbeiten spielen das Licht und der Himmel eine besondere Rolle. Sie zeigen den Menschen im Verhältnis zum Kosmos, einmal aus einem astronomischen Blickwinkel mit Sternguckern im Planetarium (*Planeta*, 2001), und häufiger auf einer metaphorischen Ebene. Dort entfalten sich Zwischenwelten von irdischer und kosmischer, medialer und traumhafter Realität, zum Beispiel in dem an Pasolini angelehnten Videofilm *Il fiore delle 1001 notte*, 1998. Um 1998 produzierte Toderi mehrere Arbeiten mit Dias, in denen sie weißes Licht benutzte, um Figuren in den Sternenhimmel zu „malen". In ihren verschiedenen Ansichten von nächtlichen, vollbesetzten Stadien kombiniert sie die unmittelbaren Geräusche jubelnder Menschenmassen mit einer entrückten Luft-perspektive (*Il decollo*, 1998, und *San Siro*, 2000). Die perpetuierende Rotation eines feststehenden Bildes aus der Aufsicht wird in *Olympia*, 2000, in eine Kopfüber-Perspektive zwischen Himmel und Erde gekippt, als ob man die Welt aus einer Achterbahn heraus betrachten würde.

C'est sa fascination pour l'élément eau qui a conduit Grazia Toderi à la vidéo, médium dans lequel elle perçoit des analogies avec une représentation aussi « authentique » que possible de la fluidité. Dans ses premières œuvres, Toderi analysait la qualité physique de l'eau sous l'influence des lois naturelles (*Nontiscordardime*, 1993) montrait un jet de douche tombant sans discontinuer sur un myosotis), et recher-chait ses motifs dans le domaine domestique (dans *Soap*, 1993, Ken, petit ami de la poupée Barbie, est essoré dans un tambour de lave-linge sur la musique de « Casta Diva »). L'intérêt de Toderi pour les forces élémentaires fonde aussi sa vidéo *Terra*, 1997, dans laquelle un avion ne cesse de décoller pour perdre ensuite de l'altitude, comme s'il ne pouvait surmonter l'attraction terrestre. Dans cette œuvre, l'observation d'un processus élémentaire et les séquences répétitives font appel aux stratégies du Process Art des années 70. Dans son travail récent, la lumière et le ciel jouent un rôle particulier. L'homme y est montré dans son rapport au cosmos : d'un point de vue astronomique avec les télescopes d'un planétarium (*Planeta*, 2001), et plus souvent encore à un niveau métaphorique. Des mondes intermédiaires s'y déploient qui possèdent une réalité terrestre et cosmique, médiale et onirique (notamment dans la vidéo *Il fiore delle 1001 notte*, 1998, qui fait référence à Pasolini). Vers 1998, Toderi produit plusieurs œuvres basées sur des diapositives, et pour lesquelles elle se sert de lumière blanche pour « peindre » des figures dans le ciel étoilé. Dans ses différentes prises de vue de stades nocturnes pleins à craquer, elle associe le brouhaha concret des masses humaines jubilantes à une perspective aérienne distancée (*Il decollo*, 1998, et *San Siro*, 2000). Dans *Olympia*, 2000, la rotation continue d'un plan fixe pris en contre-plongée se transforme en une perspective mouvante du plongeon entre ciel et terre, comme si l'on regardait le monde depuis des montagnes russes.

N. M.

SELECTED EXHIBITIONS →
1993 *45. Biennale di Venezia*, Venice, Italy **1998** *Biennale of Sydney*, Australia; Castello di Rivoli, Turin, Italy; Casino Luxembourg, Luxem-bourg **2000** *Quotidiana*, Castello di Rivoli, Turin, Italy; *Die andauern-den Städte. Urbane Situationen*, Galerie im Taxispalais, Innsbruck, Austria **1999** Projektraum, Museum Ludwig, Cologne, Germany **2001** Micromuseum for Contemporary Art, Palermo, Italy; The Project, New York (NY), USA; *Futureland*, Städtisches Museum Abteiberg, Mönchengladbach, Germany

SELECTED BIBLIOGRAPHY →
1999 *Get Together. Art as Teamwork*, Kunsthalle Wien, Vienna; *Monica Bonvicini, Liliana Moro, Grazia Toderi*, Stichting De Appel, Amsterdam

1	**Il fiore delle 1001 notte,** 1998, video projection	5	**Soap,** 1993, video, 30 min
2	**Terra,** 1997, video projection	6	**I decollo,** 1998, video projection
3	**Nata del 63,** 1996, video projection	7	**San Siro,** 2000, video projection
4	**C'era in lei qualcosa della fata,** 1994, video, 30 min		

„Man kann in die Dinge zugleich total involviert sein und sie sich vom Leibe halten. Auf diese Weise lassen sich Grenzen überschreiten und Erfahrungen machen, die den unmittelbaren Alltag transzendieren."

« Vous pouvez être totalement engagé tout en gardant vos distances. Ainsi vous pouvez dépasser des limites et tenter d'atteindre une dimensio qui transforme les choses immédiates, permanentes, quotidiennes. »

"You can be totally involved in things while at the same time keeping your distance. That way you can overstep boundaries and strive for a dimension that transforms immediate, permanent, everyday things."

Luc Tuymans

1958 born in Mortsel, lives and works in Antwerp, Belgium

Indifference, anxiety and an atmosphere of suppressed violence seep from Luc Tuymans' small haunting paintings. He derives his imagery from other pictures or films, considering the only possible form of originality to be the "authentic forgery", and uses an anemic palette of dirty greys and yellows that recall bleached out photographs or faded newspaper clippings. The paintings seem old from the start, creating a temporal distance between the work and its producer while stimulating the memory of the viewer. Memory, or its failure, is a central concern, whether childhood recollections of fear and sickness or the collective trauma of the most horrendous episodes of recent history. The paintings in his 1992 exhibition *Disenchantment* refer to Nazi concentration camps, although the specific horror of images such as a flatly painted cellar interior is made explicit only in the painting's title, *Gas Chamber*. His subjects are often blank or evasive: a portrait painted with closed eyes (*Secrets*, 1990); a detail of a body so enlarged as to be unrecognisable (*Nose*, 1993); or a series of paintings of shadows. This apparent incompleteness signifies the failure of the painted image to adequately represent the horror or guilt of history, or the complexity of personal identity. A recent group of works, *Mwana Kitoko*, 2000, looks at the murky end of Belgian colonialism in the Congo. These seemingly unconnected images: a portrait of an assassinated revolutionary, a tower block hanging the Belgian and Congolese flags, an anonymous bunker-like whitewashed church, piece together a fragmentary narrative that reflects the complexity of their subject while suggesting the selective nature of his nation's memory.

Die kleinformatigen Bilder von Luc Tuymans vermitteln einen diffusen Eindruck der Indifferenz, der Angst und der unterdrückten Gewalt. Seine Motive entnimmt er anderen Bildvorlagen oder Filmen, da er die „authentische Fälschung" ohnehin für die einzig mögliche Form von Originalität hält. Dabei verwendet er eine anämische Palette schmutziger Grau- und Gelbtöne, die an vergilbte Fotografien oder Zeitungsausschnitte erinnern. Die von Anfang an alt erscheinenden Gemälde evozieren den Eindruck einer zeitlichen Distanz zwischen dem Werk und seinem Produzenten und rufen beim Betrachter Erinnerungen hervor. Das Gelingen oder Scheitern von Erinnerung ist ein zentrales Thema, ob es sich nun um Kindheitserinnerungen an Angstzustände oder Krankheiten oder um das kollektive Trauma der grauenhaftesten Geschehnisse der jüngeren Vergangenheit handelt. Die Bilder seiner Ausstellung *Disenchantment* (1992) nehmen auf die Konzentrationslager der Nationalsozialisten Bezug, auch wenn der spezifische Horror bestimmter Bilder, etwa eines schlicht gemalten Kellers, nur im Werktitel *Gas Chamber* ausgedrück wird. Seine Sujets sind häufig kaum identifizierbar oder erscheinen ungreifbar: etwa ein Porträt, gemalt mit geschlossenen Augen (*Secrets*, 1990), ein bis zur Unkenntlichkeit vergrößertes Detail eines Körpers (*Nose*, 1993) oder eine Serie von Schattenbildern. Diese offenkundige Unvollständigkeit verweist auf das Unvermögen des gemalten Bildes, das Grauen und die Schuld der Geschichte oder die Komplexität personaler Identität angemessen darzustellen. In der neueren Werkgruppe *Mwana Kitoko*, 2000, beschäftigt sich Tuymans mit dem finsteren Ende des belgischen Kolonialismus im Kongo. Diese Bilder scheinen kaum etwas gemein zu haben: das Porträt eines ermordeten Revolutionärs, ein Gebäude, an dem die belgische und die kongolesische Flagge wehen, eine anonyme bunkerartige weiße Kirche. Aus ihnen setzt sich eine fragmentarische Erzählung zusammen, die die Komplexität der Thematik spiegelt und von der selektiven Erinnerung der vormaligen Kolonialmacht kündet.

L'indifférence, l'angoisse et une atmosphère de violence retenue se dégagent des petits tableaux troublants de Luc Tuymans. Il puise son iconographie dans d'autres peintures ou films, considérant que la seule forme d'originalité possible est « l'authentique contrefaçon ». Il utilise une palette anémique de gris et de jaunes sales qui rappellent des photos décolorées ou des coupures de presse jaunies. Ses tableaux semblent vieux d'emblée, créant une distance temporelle entre l'œuvre et son créateur tout en stimulant la mémoire du spectateur. La mémoire, ou son échec, est une préoccupation centrale de l'artiste, qu'il s'agisse de souvenirs d'enfance marqués par la peur et la maladie aux traumatismes collectifs des épisodes les plus monstrueux de notre histoire récente. Les peintures de son exposition de 1992, *Disenchantment*, renvoient aux camps de concentration nazis, bien que l'horreur spécifique d'images telles que les murs ternes d'une cave ne soit explicite que par le titre du tableau, *Gas Chamber*. Ses sujets sont souvent neutres ou fuyants : un visage aux yeux fermés (*Secrets*, 1990), le détail d'un corps agrandi au point de devenir méconnaissable (*Nose*, 1993) ; ou une série de peintures d'ombres. Cette absence apparente d'achèvement signifie l'échec de l'image peinte à représenter de manière adéquate l'horreur ou la culpabilité de l'histoire, ou encore la complexité de l'identité d'un être. Un groupe d'œuvres récentes, *Mwana Kitoko*, 2000, traite des derniers jours glauques du colonialisme belge au Congo. Ces images apparemment sans liens – le portrait d'un révolutionnaire assassiné, une tour d'appartements où sont accrochés les drapeaux belges et congolais, une église blanche anonyme qui ressemble à un bunker – tissent un récit fragmentaire qui reflète la complexité de leur sujet tout en suggérant la nature sélective de la mémoire collective belge.

K. B.

SELECTED EXHIBITIONS →
1997 *John Currin, Elizabeth Peyton, Luc Tuymans*, Museum of Modern Art, New York (NY), USA **1999** *The Passion*, Douglas Hyde Gallery, Dublin, Ireland; *The Purge, Paintings 1991–1998*, Kunstmuseum Wolfsburg, Germany; *Carnegie International*, Carnegie Museum of Art, Pittsburgh (PA), USA **2000** *Luc Tuymans Sincerely*, Tokyo Opera City Art Gallery, Tokyo, Japan; *Biennale of Sydney*, Australia; *Apocalypse*, Royal Academy of Arts, London, UK **2001** Nationalgalerie im Hamburger Bahnhof, Museum für Gegenwart, Berlin, Germany;

Belgian Pavilion, *49. Biennale di Venezia*, Venice, Italy; *The Beauty of Intimacy*, Gemeentemuseum Den Haag, The Netherlands

SELECTED BIBLIOGRAPHY →
1996 *Luc Tuymans*, London **1999** *The Purge*, Kunstmuseum Wolfsburg; Bonnefantenmuseum, Maastricht **2001** *Signal*, Nationalgalerie im Hamburger Bahnhof, Museum für Gegenwart, Berlin **2002** *Luc Tuymans: Mwana Kitoko (Beautiful White Man)*, S.M.A.K., Stedelijk Museum voor Actuele Kunst, Ghent

1 **Der Architekt,** 1997, oil on canvas, 113 x 145 cm
2 **Himmler,** 1998, oil on canvas, 52 x 36 cm

3 **Soldier,** 1999, oil on canvas, 60 x 50 cm
4 Installation view, Belgian Pavilion, *49. Biennale di Venezia*, Venice, 2001

„Meine Gemälde zeichnen sich durch eine Art Indifferenz aus, die sie fast gewalttätig erscheinen lässt, da in ihnen die Objekte gewissermaßen ausradiert, annulliert erscheinen."

« Il y a dans mes peintures une sorte d'indifférence qui les rend plus violentes, car tous les objets représentés sont comme effacés, annulés. »

"There is a sort of indifference in my paintings which makes them more violent, because any objects in them are as if erased, cancelled."

2

3

4

Piotr Uklański

1968 born in Warsaw, Poland, lives and works in New York (NY), USA

Now that the entire world has turned into its own image, you could quote the German philosopher Martin Heidegger and begin a moralizing monologue. But Piotr Uklański draws very different conclusions from the statements repeated ad nauseam today. The transparency of things, and the foggy clichés of the image culture are the basis of a gambling contest for him. The beauty of this game conceals a political explosive. The artist locates his projects in the vicinity of the banal, kitsch and sentimental. His works are studies of light effects in which psycho-analysis mingles with spectral analysis. A stuntman is set on fire for 30 seconds at an exhibition opening (*The Full Burn*, 1998), or a disco floor is designed in the pulp esthetic. Seemingly distant associations meet on a level of seduction. Uklański suspends our moral judgement in a space of uncertainty when the faces of 165 actors playing Nazi roles look at the viewer and ask for love (*The Nazis*, 1998). *Summerlove*, 2000, is a work-in-progress, the first true western movie set amidst the realities of Poland. Uklański pushes the stereotype to the extreme: a spaghetti western, a western in Spanish, Yugoslav or Polish scenery, they move away from a non-existent archetype, making us realise the dubiousness of our favourite images' cultural roots. The artist tests the distribution mechanisms, as in *Special Sneak Preview*, 2001, where pirated movies were shown on video in a museum before their official première. And he notoriously violated the rules of decorum when he placed a pony painted in Native American patterns in the midst of a Belgian country landscape.

Jetzt, da die ganze Welt sich in ihr eigenes Bild verwandelt hat, könnte man den deutschen Philosophen Martin Heidegger zitieren und sich aufs Moralisieren verlegen. Doch Piotr Uklański zieht aus solchen heutzutage bis zum Überdruss wiederholten Feststellungen völlig andere Schlussfolgerungen. Für ihn bilden die Transparenz der Dinge und die nebulösen Klischees von einer Bild-Kultur lediglich die Basis eines Glücksspiels. Hinter der Schönheit dieses Spiels verbirgt sich politischer Sprengstoff. Der Künstler begibt sich mit seinen Projekten in den Dunstkreis des Banalen, des Kitsches und der Sentimentalität. Er experimentiert in seinen Arbeiten mit Lichteffekten, mit einer Mischung aus Psycho- und Spektralanalyse. So lässt er etwa bei einer Ausstellungseröffnung einen Stuntman für dreißig Sekunden in Flammen aufgehen (*The Full Burn*, 1998). Oder er gestaltet einen Disko-Tanzboden nach den Kriterien der „Pulp"-Ästhetik. Scheinbar weit auseinander liegende Assoziationsketten begegnen sich auf der Ebene der Verführung. Wenn Uklański 165 Schauspieler in Nazirollen präsentiert (*The Nazis*, 1998), die den Betrachter anschauen und um Liebe bitten, stellt er unsere moralische Urteilskraft auf eine harte Probe. Bei der Arbeit *Summerlove*, 2000, handelt es sich um ein Work-in-progress, den ersten authentischen Western, der inmitten der heutigen polnischen Realität angesiedelt ist. Uklański treibt das Stereotyp in sein Extrem: Ein Italo-Western oder ein Western, der in einem spanischen, jugoslawischen oder gar polni-schen Umfeld gedreht wird, geht auf Abstand zu einem nicht existierenden Archetyp, so dass wir den zweifelhaften Charakter der Wurzeln erkennen, aus denen unsere Lieblingsbilder sich herleiten. Er stellte auch das Verleihsystem in Frage, etwa als er in *Special Sneak Preview*, 2001, in einem Museum auf Videomonitoren „Piraten"-Kopien von Filmen zeigte, die noch gar nicht offiziell uraufgeführt waren. Gegen die Etikette verstieß er auch, als er ein Pony wie ein amerikanisches Indianerpferd bemalte und dann mitten in eine belgische Landschaft stellte.

A présent que le monde entier s'est transformé en sa propre image, on pourrait citer le philosophe allemand Martin Heidegger et entamer un monologue moralisateur. Mais Piotr Uklański tire des conclusions très différentes des déclarations répétées aujourd'hui ad nauseam. La transparence des choses et les clichés brumeux de la culture de l'image sont pour lui la base d'un concours de paris. La beauté du jeu cache un détonateur politique. L'artiste situe ses projets dans un environnement banal, kitsch et sentimental. Ses travaux sont des études des effets de lumière où la psychanalyse se mêle à l'analyse spectrale. Un cascadeur se transforme en torche vivante pendant 30 secondes lors d'un vernissage (*The Full Burn*, 1998), ou la piste de danse discothèque est décorée dans une esthétique « pulp ». Des associations apparemment lointaines se rejoignent sur le plan de la séduction. Uklański suspend notre jugement moral dans un espace d'incertitude quand les visages de 165 acteurs incarnant des nazis regardent le spectateur en lui demandant de l'amour (*The Nazis*, 1998). *Summerlove*, 2000, est une œuvre en cours, le premier vrai western dont l'action se situe dans les réalités de la Pologne. Uklański pousse le stéréotype à l'extrême : son western spaghetti, dans un décor espagnol, yougoslave ou polonais, s'éloigne d'un archétype non existant, nous faisant prendre conscience du caractère douteux des racines culturelles de nos images favorites. L'artiste met à l'épreuve les mécanismes de la distribution, comme dans *Special Sneak Preview*, 2001, où des films piratés ont été montrés en vidéo dans un musée avant leur première officielle. Il a violé les codes du décorum en plaçant un poney peint de motifs des indiens d'Amérique du nord au beau milieu de la campagne belge.

A. S.

SELECTED EXHIBITIONS →
1998 *More Joy of Photography*, Gavin Brown's enterprise, New York (NY), USA; *I love New York*, Museum Ludwig, Cologne, Germany **2000** *The Nazis*, Kunst-Werke, Berlin, Germany **2001** *Let's Entertain*, Kunstmuseum Wolfsburg, Germany; Galerie Enja Wonneberger, Kiel, Germany; *Special Sneak Preview*, Migros Museum für Gegenwarts-kunst, Zürich, Switzerland **2002** *Mirroring Evil: Nazi Imagery/Recent Art*, The Jewish Museum, New York (NY), USA

SELECTED BIBLIOGRAPHY →
1998 *I love New York*, Museum Ludwig, Cologne; *Minimal – Maximal*, Neues Museum Weserburg, Bremen

1 From above left to below right: **The Nazis,** 1998
Robert Duvall in "The Eagle Has Landed" directed by John Sturges, 1976.
ITC Entertainment, publicity material; Erich von Stroheim in "Five Graves
to Cairo" directed by Billy Wilder, 1943. Paramount Pictures, publicity
material; Robert Culp in "Inside Out" directed by Peter Duffell, 1975.
Warner Brothers, publicity material; Klaus Kinski in "Churchill's Killers"

directed by Maurizio Pradeaux, 1970. SAP Cinematographica, French
poster. Artwork by R. Cocaro
2 **Untitled (Wet Water),** 2001, water, installation view, Gavin Brown's
enterprise, New York (NY)
3 **The Full Burn,** 1998, stuntman's performance at *Manifesta 2,* Luxembourg

„Ich arbeite mit Nackten, Blumen, Sonnenschein und brutalster Gewalt." « Je travaille les nus, les fleurs, les rayons de soleil et l'extrême violence. »

"I work with nudes, flowers, sunshine and ultra-violence."

2

Kara Walker

1969 born in Stockton (CA), lives and works in Maine, USA

In Kara Walker's drawings and black paper cut-out silhouettes, racial issues are depicted with an ambiguous, satirical humour. Her works are like a joke: simultaneously a release of repressed tension and a symptom of what is kept hidden inside a person or concealed by a culture. The joke can be derisive laughter at somebody, or a chortle in solidarity with them. Formally, her works draw on the 19th- and early 20th-century stereotypes with which African Americans were represented in Western arts and popular culture. In a caricature of these mass cultural icons, Walker's work frowns back at condescending ideological fantasies. There is a cruel excess of symbolism in Walker's rehashing of old-fashioned styles. The black body becomes a symbol that is weighed down by racist bias and unstable, because it has been historically manipulated into representing much beyond itself. The cruelties of antebellum America are shown to resonate through the nation's racial history. In the grotesque narratives of Walker's silhouettes, there is an insistence on the equivocal savagery of political and psychological primal scenes. Stock racial imagery is reshuffled into a delirium of nightmarish abandon and the enactment of sexual and physical abuse. Icons from the hallowed Western canon are also thrown into this maelstrom. The viewer is reminded of the fact that chauvinist ideologies are a negative historical force through which people continue to perceive and interact with each other. In this sense Walker's work is about prejudice as a predicament shared by oppressed and oppressor, as well as their respective progeny.

In ihren Zeichnungen und den aus schwarzem Papier ausgeschnittenen Silhouetten beschreibt Kara Walker mit vieldeutigem und satirischem Humor Fragen der Rassenbeziehungen. Ihre Arbeiten sind wie ein guter Witz: Sie bauen unterdrückte Spannungen ab und sind zugleich symptomatisch für persönlich Verdrängtes oder kulturell Verheimlichtes. Mal löst ein solcher Witz hämisches Gelächter aus, mal ein mitfühlendes Lachen. Formal nehmen Walkers Werke auf die stereotypen Darstellungen der Afro-Amerikaner in der westlichen Kunst und Kultur des 19. und frühen 20. Jahrhunderts Bezug. In der Karikatur dieser massenkulturellen Bildtypen hält Walker uns die Grimasse herablassender ideologischer Fantasien entgegen. Walkers Neuauflage vergangener Stile ist von schmerzlich übersteigerter Symbolik. Der schwarze Körper wird zu einem Zeichen, das durch rassistische Vorurteile belastet und unbeständig ist, da es, historisch manipuliert, weit über sich selbst hinausweist. Es zeigt sich, dass die Grausamkeiten der Zeit vor dem Bürgerkrieg in der Geschichte des Verhältnisses der Rassen nachhallen. Durch die grotesken Geschichten, die sie in ihren Silhouetten anklingen lässt, veranschaulicht sie die unerbittlichen Nachwirkungen der Barbarei jener politischen und psychologischen Ur-Szene. Die klischeebeladene Bildsprache des Rassismus gerät dabei zu einem albtraumhaften Delirium der Verlassenheit und der sexuellen und körperlichen Erniedrigung. Aber auch die Ikonen des sakrosankten westlichen Kunstkanons werden in diesen Strudel hineingerissen. Der Betrachter dieser Werke fühlt sich daran erinnert, dass es sich bei den chauvinistischen Ideologien, die solchen Ausbeutungsverhältnissen zu Grunde liegen, um eine negative historische Energie handelt, die bis heute die Wahrnehmung der Menschen voneinander und ihren Umgang miteinander bestimmt. So gesehen geht es in Walkers Arbeit um das Vorurteil als Dilemma, das Unterdrückte wie Unterdrücker mitsamt ihrer Nachkommenschaft teilen.

Dans les dessins et les silhouettes en noir et blanc découpées de Kara Walker, les questions raciales sont dépeintes avec un humour satirique ambigu. Ses œuvres sont comme une plaisanterie, à la fois la décharge d'une tension réprimée et le symptôme de ce qu'on cache à l'intérieur de soi-même, ou de ce que cache la culture. Ici, la plaisanterie peut déclencher un rire moqueur contre quelqu'un ou un rire solidaire avec un groupe. Formellement, ses œuvres s'inspirent des stéréotypes du 19ème et du début du 20ème siècles avec lesquels étaient représentés les Afro-américains dans l'art et la culture populaire d'Occident. Il y a un excès de sens cruel dans la manière dont Walker ressasse ces styles désuets. Le corps noir devient une fois de plus un signe chargé de préjugés racistes et instables dans la mesure où il a été historiquement manipulé pour représenter beaucoup plus que ce qu'il n'est. Les cruautés de l'Amérique d'avant la guerre de Sécession sont présentées résonnant à travers l'histoire raciale de la nation. Les récits grotesques de ses silhouettes soulignent la sauvagerie équivoque des scènes politiques et psychologiques primitives. L'imagerie raciale de base est remaniée dans un délire d'abandon cauchemardesque et une reconstitution de délits sexuels et corporels. Des icônes du canon occidental sanctifié sont également précipitées dans ce maelström. Le spectateur se sent rappelé que les idéologies chauvines sont une force constitutive historique négative dans la manière dont on continue de percevoir les autres et d'interagir avec eux. En ce sens, le travail de Walker traite du préjugé comme d'un sort partagé par l'opprimé et l'oppresseur, ainsi que par leurs progénitures respectives.

L. B. L.

SELECTED EXHIBITIONS →
1995 *Look Away! Look Away! Look Away!*, Center for Curatorial Studies, Bard College, Annandale-on-Hudson (NY), USA **1997** *Presenting Negro Scenes ...*, The Renaissance Society, Chicago (IL), USA **1999** *6th Istanbul Biennial*, Istanbul, Turkey; *No mere words can Adequately reflect the Remorse ...*, UCLA Hammer Museum, Los Angeles (CA), USA **2000** *Why I Like White Boys, an Illustrated Novel by Kara E. Walker Negress*, Centre d'Art Contemporain, Geneva, Switzerland **2002** *XXV Bienal de São Paulo*, Brazil

SELECTED BIBLIOGRAPHY →
1997 *No Place (Like Home)*, Walker Art Center, Minneapolis (MN)
1998 *Strange Days*, The Art Gallery of New South Wales, Sydney
1999 *Das Gedächtnis der Kunst: History and Memory in Contemporary Art*, Historisches Museum, Frankfurt am Main
2001 Uta Grosenick (ed.), *Women Artists*, Cologne; *the americans. new art*, Barbican Gallery, London; *Ornament and Abstraction*, Fondation Beyeler, Basle

522

„Viele der Sachen, die ich mache, überraschen mich selbst. Wenn dieses Zeug schon in meinem Kopf herumschwirrt, warum sollte das dann bei anderen Leuten anders sein?"

« Bon nombre des choses que je fais me surprennent, moi aussi. Mais si ces choses sont dans ma tête, elles sont sûrement dans celles des autres. »

"A lot of the stuff I do surprises even me. I mean, if this stuff is even in my head, it must be in other people's."

2

3

4

5

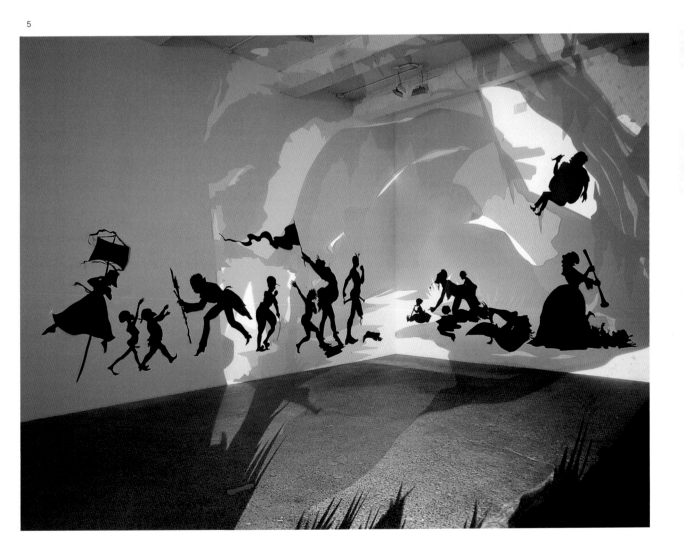

Jeff Wall

1946 born in Vancouver, lives and works in Vancouver, Canada

Although Jeff Wall's medium is photography, his large-scale transparencies in fluorescent lightboxes speak more about traditions of historical narrative painting than those of classical photography. Although some works such as *A Sudden Gust of Wind (After Hokusai)*, 1993, refer directly to existing paintings, Wall is mainly interested in the formal qualities associated with painting: the sense of scale in relation to the human body, the procedure of composing an image piece by piece, and the use of colour. He counteracts the spontaneity fundamental to the nature of photography by planning each image precisely, constructing elaborate stage sets in his studio and taking multiple shots while his cast enact the same isolated moment again and again. For works such as *The Flooded Grave*, 1998–2000, he shoots each element independently and uses a computer to montage them seamlessly together. A freshly dug grave occupies the foreground of this ordinary-looking cemetery landscape, but instead of just an empty hole, the grave is host to an ocean rock pool, filled with vividly coloured starfish, sea urchins and anemones. To make the image as plausible as possible, Wall spent two years researching every detail, from the cemetery's topography, soil and light to the exact rock formations and sea creatures local to the area. The documentary straight-forwardness of the finished image collides with the immense artifice involved in its production. Throughout his work, Wall seeks to remove the evidence of cause and effect while packing each picture with clues to possible allegorical or socio-political meanings.

Mag auch die Fotografie das Medium von Jeff Wall sein: Seine großformatigen, in Leuchtkästen präsentierten Diapositive sind den Traditionen der narrativen Malerei stärker verpflichtet als denen der klassischen Fotografie. Obwohl manche seiner Werke, etwa *A Sudden Gust of Wind (After Hokusai)*, 1993, direkt auf ein bestimmtes Gemälde verweisen, interessiert sich Wall vor allem für die formalen Möglichkeiten der Malerei: die Größenverhältnisse in Bezug zum menschlichen Körper, die Technik, ein Bild Stück für Stück zu komponieren, und die Verwendung der Farbe. Die dem fotografischen Verfahren zutiefst eigene Spontaneität konterkariert er, indem er jedes einzelne Bild sorgfältig plant, in seinem Atelier kunstvolle Bühnenaufbauten vornimmt und zahllose Aufnahmen macht, während die Mitwirkenden dieselbe ganz für sich stehende Szene ein ums andere Mal aufführen. Für Werke wie *The Flooded Grave*, 1998–2000, montiert er viele jeweils für sich fotografierte Elemente am Computer nahtlos zusammen. Im Vordergrund dieser völlig unspektakulär erscheinenden Friedhofslandschaft ist ein frisch ausgehobenes Grab zu sehen. Es handelt sich nicht lediglich um ein leeres Loch, das Grab beherbergt vielmehr einen Teil des Ozeans, in dem allerlei farbenprächtige Seesterne, Seeigel und Seeanemonen dahintreiben. Um das Bild so plausibel wie möglich erscheinen zu lassen, hat Wall zwei Jahre lang sämtliche Details recherchiert – von der Topografie und dem Boden des Friedhofs bis hin zu den Lichtverhältnissen, der Beschaffenheit der Felsformationen und den Meerestieren der Region. Die dokumentarische Direktheit des fertigen Bildes kollidiert mit den zahllosen Kunstgriffen, denen es seine Entstehung verdankt. In seinem Œuvre ist Wall darum bemüht, sämtliche Belege, aus denen sich auf Ursachen und Wirkungen schließen ließe, verschwinden zu lassen. Zugleich enthält jedes seiner Bilder zahllose Hinweise auf mögliche allegorische und sozio-politische Bedeutungen.

Bien que le médium de Jeff Wall soit la photographie, ses diapositives grand format dans des boîtes de lumière fluorescentes rappellent davantage les traditions de la peinture narrative historique que celles de la photographie classique. Néanmoins, si certaines œuvres telles que *A Sudden Gust of Wind (After Hokusai)*, 1993, renvoient directement à des tableaux existants, ce sont surtout les qualités formelles de la peinture qui intéressent Wall : son sens de l'échelle par rapport au corps humain, la composition d'une image élément par élément et l'utilisation de la couleur. Il contrecarre la spontanéité fondamentale de la photographie en planifiant chaque image avec minutie, construisant des décors sophistiqués et prenant des clichés multiples pendant que ses acteurs rejouent les mêmes moments isolés encore et encore. Pour des œuvres telles que *The Flooded Grave*, 1998–2000, il photographie chaque élément séparément puis utilise un ordinateur pour les assembler de manière invisible. Une tombe qui vient d'être creusée occupe le premier plan de ce cimetière d'apparence banale mais, au lieu d'un simple trou vide, la tombe accueille une mare retenue entre des rochers au bord d'un océan. Elle est remplie d'étoiles de mer, d'oursins et d'anémones de mer. Pour rendre l'image plus plausible possible, Wall a passé deux ans à en étudier les moindres détails, de la topographie, du sol et de la lumière du cimetière, aux formations rocheuses exactes et à la faune marine locale. La simplicité documentaire de l'image finale se heurte à l'immense artifice impliqué dans son élaboration. Dans l'ensemble de ses œuvres, Wall cherche à effacer les traces de causalités tout en saturant chaque image d'indices menant à d'éventuelles significations allégoriques ou socio-politiques.

K. B.

SELECTED EXHIBITIONS →
1990 The Carnegie Museum of Art, Pittsburgh (PA), USA
1995 Galerie Nationale du Jeu de Paume, Paris, France; *Whitney Biennial*, The Whitney Museum of American Art, New York (NY), USA
1996 Whitechapel Art Gallery, London, UK **1997** *documenta X*, Kassel, Germany **1999** *Œuvres 1990–1998*, Musée d'Art Contemporain, Montreal, Canada; *Carnegie International*, Carnegie Museum of Art, Pittsburgh (PA), USA **2000** *Biennale of Sydney*, Australia
2001 *Elusive Paradise*, National Gallery of Canada, Ottawa, Canada

SELECTED BIBLIOGRAPHY →
1995 *Jeff Wall*, The Museum of Contemporary Art, Chicago (IL)
1996 *Jeff Wall: Landscapes and Other Pictures*, Kunstmuseum Wolfsburg; *Jeff Wall*, London **1997** *Jeff Wall*, The Museum of Contemporary Art, Los Angeles (CA) **1999** Burkhard Riemschneider/ Uta Grosenick (eds.), *Art at the Turn of the Millennium*, Cologne; *Jeff Wall: Œuvres 1990–1998*, Musée d'Art Contemporain de Montréal

1 **The Flooded Grave,** 1998–2000, transparency in lightbox, 246 x 299 cm

2 **Morning Cleaning, Mies van der Rohe Foundation, Barcelona,** 1999, transparency in lightbox, 187 x 352 cm

3 **Tattoos and Shadows,** 2000, transparency in lightbox, 196 x 255 cm

„Ein Bild ist etwas, das sein Vorher und Nachher unsichtbar macht."

« Une image est une chose qui rend invisible son avant et son après. »

"A picture is something that makes invisible its before and after."

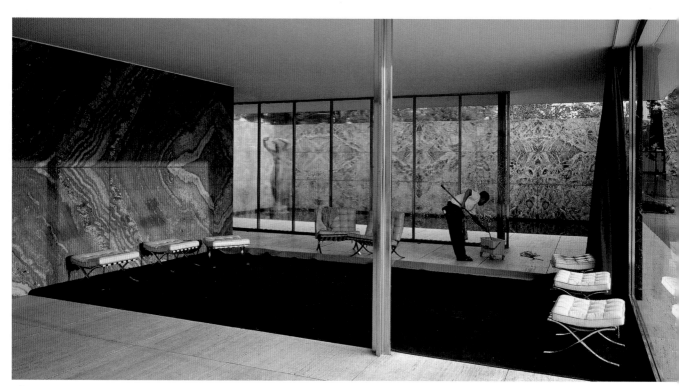

2

Franz West

1947 born in Vienna, lives and works in Vienna, Austria

Do symbolic forms of interpretation necessarily precede physical and material ones? In the work of Franz West, one can't be so sure about the primacy of intellect vis-à-vis the challenges of a visceral understanding of objects and environments. The notion of sculpture in West's version is tactile and sensual, as well as having metaphorical relations to the body of the beholder. When the beholder lounges on a piece of West furniture he or she often has to work his or her body through hitherto unknown positions, while taking possession of the furniture and in a sense co-authoring it. His *Passstücke* (Fitting Pieces), for example, are unwieldy objects the beholder is expected to take and parade in the exhibition space; a use has to be invented for them as if they were prostheses of negative space. West's works are hybrids between pure form and pure function, art-object and use-object. The way we use our bodies in the world is something that has to be worked through and reinvented, as if the body itself were the interpretation of a cryptic dream surrendered on the couch of a psychoanalyst. The rusticated surfaces and crude materiality of West's work, with all the traces of its manufacture, suggest how the labour of contemplation is extroverted into space. West is at once raw materiality and ephemeral poetry; carnality, spirituality and sociability. West's amorphous plastic formulations are a kind of idealist sculptural slapstick that uses as well as opens up the art work's self-referentiality. A West is exactly that – a Franz West – with its own indelible craftmanship and unique "thingliness". But at the same time it issues an open invitation to events in the space outside itself.

Gehen symbolische Formen der Interpretation notwendig physischen oder materiellen voraus? Im Werk von Franz West kann man über den Primat des Intellekts gegenüber einer instinktgeleiteten Aneignung seiner Objekte und Environments nicht sicher sein. Die Vorstellung von Skulptur bei West ist taktil und sinnlich, gleichzeitig hat sie metaphorische Beziehungen zum Körper des Betrachters. Wenn der Nutzer es sich auf einem West-Möbel bequem machen möchte, sieht er oder sie sich des Öfteren gezwungen, den eigenen Körper in bis dato unbekannte Positionen zu bringen und dabei das Möbel zugleich in Besitz zu nehmen und gewissermaßen mitzukreieren. Seine *Passstücke* zum Beispiel sind unhandliche Objekte, die der Besucher im Galerieraum umhertragen soll. Dabei gilt es, ihren Verwendungszweck erst noch zu entdecken, als ob man es mit Prothesen des negativen Raumes zu tun hätte. Wests Arbeiten sind Zwitterwesen aus reiner Form und reiner Funktion, Kunstobjekt und Gebrauchsgegenstand. Sie verlangen, dass wir uns über die Bewegung unseres Körpers in der Welt Klarheit verschaffen und uns dann neu erfinden, als ob der Körper selbst die Deutung eines auf der Analytikercouch preisgegebenen rätselhaften Traumes wäre. Die handfesten Oberflächen und krude bearbeiteten Materialien von Wests Arbeiten, mit sämtlichen Spuren ihrer Herstellung, vermitteln einen Eindruck davon, wie die Arbeit der Kontemplation sich in den Raum entäußert. West ist zugleich rohe Materialität und ephemere Poesie; Fleischlichkeit, Spiritualität und Geselligkeit. Bei seinen amorphen plastischen Formulierungen haben wir es mit einer Art idealistischem skulpturalem Slapstick zu tun, der die Selbstbezüglichkeit des Kunstwerks zugleich ausschlachtet und für neue Möglichkeiten öffnet. Ein West ist genau das: ein Franz West – mit seiner unauslöschlichen materiellen Handschrift und seiner einzigartigen „Dinglichkeit". Doch zugleich spricht seine Arbeit eine Einladung an all jene Ereignisse aus, die in dem Raum außerhalb seiner selbst stattfinden. [1]

Les formes symboliques de l'interprétation précèdent-elles nécessairement les formes physiques et matérielles ? Dans l'œuvre de Franz West, on ne peut jamais être tout à fait sûr de la primauté de l'intellect sur les défis d'une compréhension viscérale des objets et des environnements. Chez lui, la notion de sculpture est tactile et sensuelle. Elle est métaphoriquement liée au corps du spectateur. Lorsque ce dernier s'installe sur un meuble de West, il doit souvent adopter des positions qui lui étaient jusque-là inconnues, tout en prenant possession du meuble et, dans un sens, en devenant le coauteur. Ses *Passstücke* (Accolements), par exemple, sont des objets encombrants que le spectateur est censé prendre et transporter dans l'espace de la galerie. Il est contraint de leur inventer un usage comme s'il s'agissait des prothèses d'un espace négatif. Les travaux de West sont des hybrides entre la forme pure et la fonction pure, entre des objets-art et des objets-utilisation. La manière dont nous utilisons notre corps dans le monde doit être retravaillée et réinventée, comme si le corps lui-même était l'interprétation d'un rêve énigmatique éructé sur le canapé d'un psychanalyste. Les surfaces vieillies et la matérialité grossière des œuvres de West, toutes portant les traces de leur fabrication, suggèrent comment le travail de contemplation est extraverti en espace. West est à la fois matérialité brute et poésie éphémère ; corporalité, spiritualité et sociabilité. Ses formulations plastiques amorphes sont une sorte de burlesque sculptural idéaliste qui exploite et élargit l'auto-référentialité de l'œuvre d'art. Un West est exactement cela : un Franz West, avec sa propre dextérité indélébile et son « état d'objet » unique. Mais parallèlement, il lance une invitation à des événements se déroulant dans l'espace en dehors de lui-même. L.B.L. [2]

SELECTED EXHIBITIONS →
1997 *Skulptur. Projekte*, Münster, Germany; *documenta X*, Kassel, Germany **1998** *São Paulo Biennale*, São Paulo, Brazil **1999** Rooseum Center for Contemporary Art, Malmö, Sweden **2000** The Renaissance Society, Chicago (IL), USA; *Biennale of Sydney*, Australia; *In Between*, EXPO 2000, Hanover, Germany **2001** Wexner Centre of the Arts, Columbus (OH), USA; Museum für Angewandte Kunst, Vienna, Austria; *Yokohama Triennial*, Yokohama, Japan

SELECTED BIBLIOGRAPHY →
1998 *Franz West*, Rooseum, Malmö **1999** *Limited*, Franz West, London **2000** *Franz West – In & Out*, Museum für Neue Kunst, Zentrum für Kunst und Medientechnologie, Karlsruhe; *Franz West*, Fundaçao de Serralves, Oporto

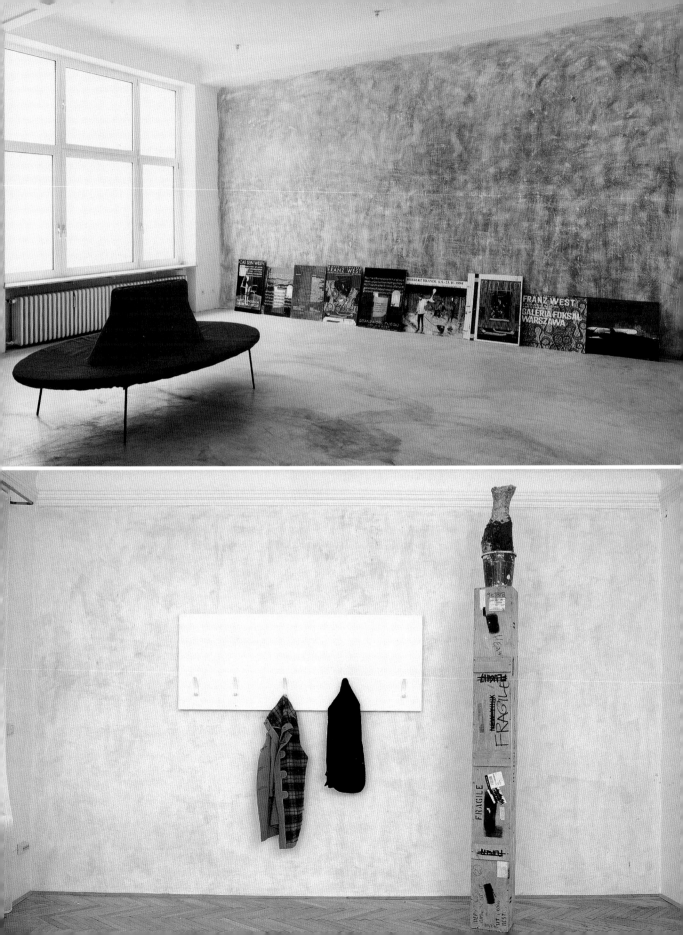

1 **Pouf,** 2000, metal, foam material, linen, cotton piqué, 220 x 150 x 80 cm, poster designs, installation view, *Plakatentwürfe*, Galerie Gisela Capitain, Cologne
2 **Oh Oklahoma,** 1999, wall piece: wood, plastic, paint, 80 x 206 x 15 cm, sculpture: papier maché, 77 x 30 x 30 cm, pedestal: wood, 241 x 34 x 28 cm
3 **3 Sitzwuste,** 2000, aluminium, painted, each c. 484 x 55 x 75 cm, installation view, Schlosspark Ambras, Innsbruck, 2000
4 In collaboration with Heimo Zobernig:
 Auto Sex, 1999, 2 chairs, metal, wood, foam material, cotton, each

45 x 54 x 84 cm, transparent reflector foil, 150 x 150 cm, rubber floor covering, 141 x 320 cm
5 **Blickle,** 1999, Passstück: epoxy resin, emulsion paint, metal, 46 x 44 x 25 cm, plinth: wood, emulsion paint, video monitor, video
6 **Vorschein und Alltag (Pre-Semblance and the Everyday)** (detail), 1999/2000, installation with 15 sculptures on plinths, 2 divans, 2 club armchairs and 11 collages, installation view, Renaissance Society, Chicago (IL), 2000

„Nimm einen Stuhl aus dem Regal, verwende ihn für seinen Zweck und stelle ihn dann zurück."

« Prenez une chaise sur l'étagère, utilisez-la pour ce pour quoi elle a été conçue, puis remettez-la à sa place. »

"Take a chair off the shelf, use it for its purpose and then put it back again."

3

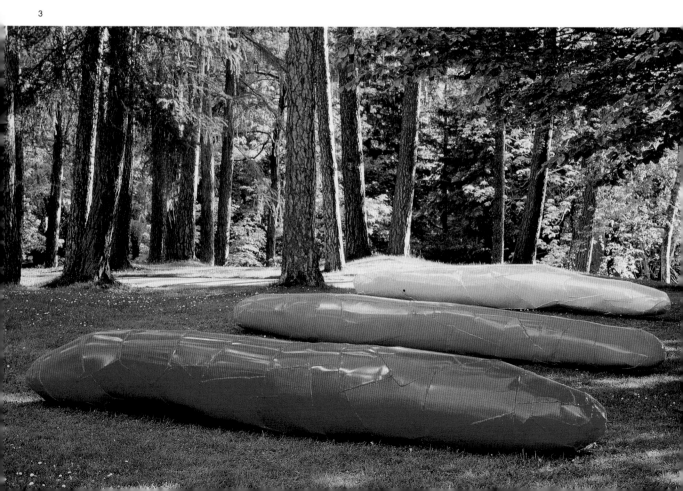

4

5

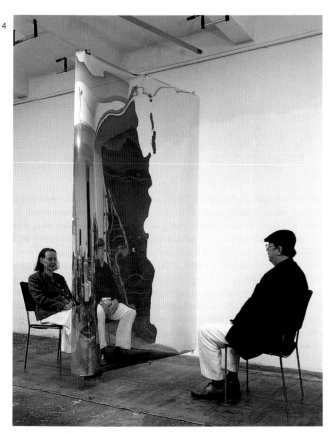

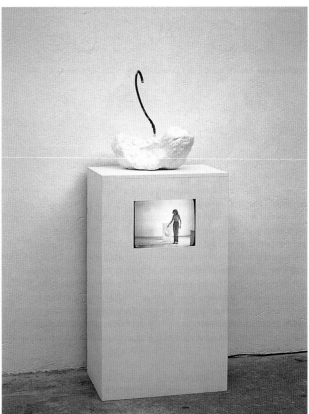

6

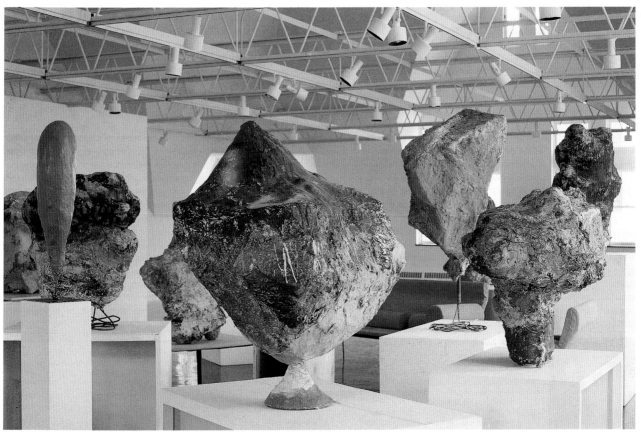

T. J. Wilcox

1965 born in Seattle (WA), lives and works in New York (NY), USA

T. J. Wilcox regards his films as installations, which is why he only screens them in an exhibition context rather than in the cinema. He shoots in 8-mm, transfers his work to video for editing, then back to nostalgic 16-mm for projection. The transference of images leaves behind traces, which are intrinsic aesthetic elements of the work and reveal the material processes involved in the film's creation. In his films, Wilcox portrays famous personalities whose lives he transforms into glamorous fiction. In his fantasy interpretations of the biographies of public figures, like Marlene Dietrich, Marie-Antoinette and the first Emperor of China, he manipulates familiar images, culminating in an imagined funeral ceremony, as in *The Funeral of Marlene Dietrich,* 1999. To complete the picture, he uses "thumb cinema", or flick-book animations, showing dramatic scenes of various types of death. Wilcox puts together silent clips from films and documentaries, which he shoots straight off the TV screen. Often, they have little to do with the main subject, but Wilcox imaginatively links them, with continuous commentary or subtitling contributing to the impression of a connected narrative. The films provide a sympathetic view of obsessive lifestyles as in *Stephen Tennant Homage,* 1998. The Greek saga of the tragic love of *Hadrian and Antinous,* 2000, refers to gay mythology. In a seven-part series of c-prints entitled *Peeping Thomas John,* 1999, Wilcox deals with the power of vision in the production of an image. A camera with a zoom lens moves progressively closer to model Kate Moss, and the sequence ends as she angrily discovers the voyeur.

T. J. Wilcox begreift die Präsentation seiner Filme als Installation, weswegen er sie ausschließlich im Ausstellungszusammenhang und nicht im Kino zeigt. Er dreht die Filme auf 8 mm, kopiert sie zur Bearbeitung auf Video, um sie dann zur Vorführung wiederum auf Filmmaterial, auf das nostalgische 16-mm-Format, zu kopieren. Der Transfer der Bilder hinterlässt Spuren, die ästhetischer und inhaltlicher Bestandteil der Arbeit sind und die materiale Konsistenz offenlegen. Wilcox porträtiert in seinen Filmen Persönlichkeiten, deren Selbstinszenierung in glamouröse Fiktion übergeht. Die fantastische Präsentation der eigenen Biografie inklusive Steuerung der öffentlichen Bilder beispielsweise bei Marlene Dietrich, Marie-Antoinette oder dem ersten Kaiser von China, kulminiert in den Vorstellungen der Zeremonien beim eigenen Tod (*The Funeral of Marlene Dietrich,* 1999). Den Film ergänzen Daumenkinos mit theatralischen Szenen möglicher Todesarten. Wilcox' montiert Sequenzen, selbst gedrehte und ohne Ton aus Filmen und Dokumentationen vom TV-Bildschirm abgefilmte. Häufig haben sie nichts mit dem Hauptthema zu tun, sondern werden von Wilcox zu einer imaginären Handlung aneinandergefügt, wobei kontinuierliche Kommentare oder Untertitelungen den Eindruck einer zusammenhängenden Erzählung unterstützen. Die Filme vermitteln eine bewundernde Sicht auf obsessive Lebensweisen, etwa in *Stephen Tennant Homage,* 1998. Schwule Mythen greift auch die griechische Sage um die tragische Liebe von *Hadrian and Antinous,* 2000, auf. In einer siebenteiligen Serie von C-prints (*Peeping Thomas John,* 1999), thematisiert Wilcox die Macht des Blicks in der Bildproduktion: Die von einem Zoom-Objektiv geleitete, schrittweise Annäherung an das Model Kate Moss endet mit der erzürnten Entdeckung des Beobachters.

T. J. Wilcox comprend la présentation de ses films comme une installation, c'est pourquoi il les montre exclusivement dans un contexte d'exposition et non dans les salles de cinéma. Ses films sont tournés en 8 mm, puis copiés en format vidéo pour traitement, avant d'être recopiés dans un média cinématographique – en l'occurrence le nostalgique format 16 mm – en vue de leur présentation. Ce transfert d'un média à l'autre laisse des traces qui confèrent à son travail une qualité esthétique et sémantique, et qui font ressortir une certaine consistance matérielle. Dans ses films, Wilcox fait le portrait de personnalités que leur mise en scène d'eux-mêmes transforme en fiction glamour. L'élaboration fantastique de biographies personnelles incluant la manipulation des images officielles – par exemple de Marlene Dietrich, de Marie-Antoinette ou du premier empereur de Chine – culmine dans la représentation des cérémonies funèbres (*The Funeral of Marlene Dietrich*/L'enterrement de Marlene Dietrich, 1999). Le film est complété par des folioscopes montrant des mises en scène de différentes manières de mourir. Wilcox intègre dans ses films des séquences tournées par ses soins ou refilmées à partir de films et de documentaires TV. Ces séquences sont souvent sans rapport avec le thème principal, mais s'agencent de manière à former une action imaginaire, tandis qu'un commentaire continu ou un sous-titrage nourrissent le sentiment d'un récit cohérent. Ces films communiquent une vision admirative de certains modes de vie obsessionnels, comme on le voit dans *Stephen Tennant Homage,* 1998. Des mythes homosexuels sont également traités, notamment à travers la légende grecque de l'amour tragique entre *Hadrian and Antinous,* 2000. Dans sa série de c-prints en sept parties *Peeping Thomas John,* 1999, Wilcox traite du pouvoir du regard dans la production d'images : l'approche graduelle du top model Kate Moss à coups de zoom s'achève sur la découverte indignée de l'observateur.

N. M.

SELECTED EXHIBITIONS →
1997 *47. Biennale di Venezia,* Venice, Italy; *Whitney Biennial,* The Whitney Museum of American Art, New York (NY), USA; *Sunshine and Noir, Art in Los Angeles, 1960–97,* Louisiana Museum of Modern Art, Humlebæk, Denmark **1999** *Moving Images,* Galerie für Zeitgenössische Kunst Leipzig, Germany **2000** *Greater New York,* P.S.1, Long Island City (NY), USA **2001** *47. Internationale Kurzfilmtage,* Oberhausen, Germany

SELECTED BIBLIOGRAPHY →
1998 *T. J. Wilcox,* Institute of Contemporary Arts, London; *Dialogues: T.J. Wilcox,* Walker Art Center, Minneapolis (MN)

在這些水銀河上永遠的遨遊,
to navigate the silver rivers eternally.

1 Photographs of the film **The Death and Burial of the First Emperor of China,** 1997
2 Photographs of the film **The Funeral of Marlene Dietrich,** 1999, R-prints, each 16 x 20 cm
3 Photograph of the film **Hadrian and Antinous** (diptych, detail), 2000
4 Photograph of the film **Hadrian and Antinous** (triptych, detail), 2000
5 Installation view, Galerie Daniel Buchholz, Cologne, 2001

„Ich versuche immer, den filmischen Aspekt der Filme zu übertreiben, so dass dies Teil der Bedeutung der ganzen Angelegenheit wird."

« En fait, je tâche toujours d'exagérer le côté filmique de mes films, et cela devient une partie intégrante du sens global de la chose. »

"I always try to kind of exaggerate the filminess of the films, so that that becomes a part of the meaning of the whole thing."

2

3

4

5

Johannes Wohnseifer

1967 born in Cologne, lives and works in Cologne, Germany

Johannes Wohnseifer combines the Rhinelander's love of storytelling with conceptual restraint. He impressively mixes different media and exploits their individual effects. *Braunmusic*, 1997, consisted of the sounds of Braun alarm clocks sampled by some of the design fan's DJ friends. *Spindy*, 1995, was a wardrobe-sized sculptural mix of skateboard ramps and a Red Army Faction "people's cell". Whatever his subject, he always tells a convincing story. In his *Museum*, 1999, at Cologne's Museum Ludwig, recent history and modern myth – the 1972 Munich Olympics and the current trainer culture – came together in a flea circus of (German) post-war art, with work by Gerhard Richter, Blinky Palermo and Carl Andre. Wohnseifer has no hesitation in acknowledging the influence of his fellow artists. For him, the road into the past is easy, for he loves to collect things. En route, Wohnseifer makes playful connections between his material and the internationalisation of German provincialism. As well as delighting in objects, such as aircraft and cars – "hardware", in other words – he casts a searching eye on their "soft" surroundings and the immaterial, intangible nature of software. He makes it transparent, by revealing the laws and strategies behind it. With their intellectual and even vaguely nonsensical excess of allusions and references, they promise to create more or less meaningful connections. Wohnseifer highlights their ambivalence, vulnerability and fragility. He has a unique knack for filling empty spaces, and in *This night*, 2000, Wohnseifer takes as his theme the first of Rainer Werner Fassbinder's films, which is now lost. A gap in Fassbinder's œuvre, a film no one knows, becomes the central motif of a Wohnseifer exhibition.

Der Kölner Johannes Wohnseifer verbindet rheinische Fabulierlust mit konzeptueller Zurückhaltung. Souverän mischt er die Medien und ihre jeweiligen Effekte. In *braunmusic*, 1997, ließ der Design-Fan die Töne von Braun-Weckern von befreundeten DJs sampeln. In *spindy*, 1995, bot er einen skulpturalen Mix von Skateboardrampe und RAF-Volksgefängnis in Kleiderschrankgröße. Was er auch aufgreift, es wird bezwingend narrativ. In seinem *Museum*, 1999, im Kölner Museum Ludwig trafen Zeitgeschichte und moderne Mythen – Olympia 1972 in München und die gegenwärtige Sportschuhkultur – auf einen Flohzirkus (deutscher) Nachkriegskunst: Gerhard Richter, Blinky Palermo oder Carl Andre. Wohnseifer kennt keine Probleme, sich zu Künstlerkollegen und ihrem Einfluss zu bekennen. Der Weg in die Vergangenheit ist leicht für ihn, er nimmt den Pfad des Liebhabers. Auf ihm findet Wohnseifer spielerisch die Nähe zu seinem Material und zur Internationalisierung der bundesrepublikanischen Provinz. Zu der Liebe zu den Gegenständen – egal ob Flugzeuge oder Automobile, Hardware eben – kommt der feine Blick auf die „weichere" Umgebung hinzu, die ungegenständliche, schwer fassbare Weise der Software. Er macht sie transparent, indem er die assoziativen Gesetze und Strategien erkennen lässt, die in ihrem intellektuellen, bis in die vage Nähe des Nonsens reichenden Überfluss an Anspielungen und Verweisen mehr oder minder sinnvolle Zusammenhänge herzustellen versprechen. Wohnseifer besteht auf ihrer Ambivalenz, Schutzlosigkeit und Brüchigkeit. Mit dem ihm eigenen Mut zur Lücke thematisiert Wohnseifer in *This night*, 2000, den ersten, verschollenen Film von Rainer Werner Fassbinder. Eine Leerstelle im Werk von Fassbinder, ein Film, den niemand kennt, wird zum zentralen Motiv einer Wohnseifer-Ausstellung.

Originaire de Cologne, Johannes Wohnseifer associe dans son œuvre la verve rhénane et la circonspection conceptuelle. Il y mélange souverainement les médias et leurs effets respectifs. Dans *braunmusic*, 1997, ce fan de design avait demandé à des amis DJ de sampler les sons de réveils Braun. Dans *spindy*, 1995, il proposait une sculpture composite à mi-chemin entre rampe de skate et « prison populaire » de la Fraction Armée Rouge, le tout de la taille d'une penderie. Quel que soit le sujet traité, tout chez lui devient éminemment narratif. Dans son *Museum*, 1999, du Musée Ludwig à Cologne, l'histoire récente et les mythes modernes – jeux olympiques de 1972 à Munich et culture contemporaine des chaussures de sport – rencontraient un marché au puces de l'art (allemand) d'après-guerre – Gerhard Richter, Blinky Palermo ou Carl Andre. Wohnseifer n'éprouve aucun mal à reconnaître l'influence de ses collègues artistes. L'accès au passé lui est facile, il emprunte le chemin de l'amateur, sur lequel il trouve ludiquement sa propre approche du matériau artistique et l'internationalisation de la province fédérale allemande. A son amour des objets quels qu'ils soient – avions ou voitures : le hardware, précisément – s'ajoute un regard subtil sur un environnement plus « mou », le mode non figuratif et intangible du software. Cet environnement, Wohnseifer le matérialise en visualisant les stratégies et les lois associatives qui promettent une cohérence plus ou moins sensée en proposant une profusion intellectuelle d'allusions et de références confinant vaguement au non-sens. Wohnseifer défend leur ambiguïté, leur vulnérabilité, leur fragilité. Dans *This Night*, 2000, avec son courage spécifique à investir les créneaux, Wohnseifer se penche sur le premier film perdu de Rainer Werner Fassbinder. Une lacune dans l'œuvre de Fassbinder, un film dont personne ne sait rien, devient le thème central d'une exposition Wohnseifer.　　　　F. F.

SELECTED EXHIBITIONS →
1995 *spindy/spindy b*, neugerriemschneider, Cologne, Germany; Künstlerhaus Bethanien, Berlin, Germany **1997** *braunmusic live*, Kölnischer Kunstverein, Cologne, Germany; *someone else with my fingerprints*, David Zwirner, New York (NY), USA **1998** *Fast Forward – Trade Marks*, Kunstverein in Hamburg, Germany **1999** *Museum*, Museum Ludwig, Cologne, Germany; *German Open*, Kunstmuseum Wolfsburg, Germany **2000** *This Night Worldwide*, Galerie Gisela Capitain, Cologne, Germany; *Deep Distance*, Kunsthalle Basel, Basle, Switzerland **2001** *Yokohama Triennale of Contemporary Art*, Yokohama, Japan; Skulpturenpark, Cologne, Germany

SELECTED BIBLIOGRAPHY →
1997 *Die Nerven enden an den Fingerspitzen*, Cologne **1998** *Museum als Vehikel*, Museum Ludwig, Cologne **1999** *El Niño*, Städtisches Museum Abteiberg, Mönchengladbach **2000** *German Open*, Kunstmuseum Wolfsburg

1 **Come Clean,** 2000, acrylic on aluminium, 140 x 100 cm

2 **whitepeoplearedevils,** 2001, custom built bicycle, installation view,
 ars viva, Museum für Angewandte Kunst, Cologne
3 Installation views, *Museum,* Museum Ludwig, Cologne, 1999

"If I die in a car crash, it was meant to be a sculpture."

2

3

Richard Wright

1960 born in London, lives and works in Glasgow, UK

Today more than ever, artists want to know what has already been written, sculpted and painted, and what has been said about it. For Richard Wright, this knowledge is a starting point for original speculations on painting that draw upon the viewer's erudition as well as to his musical sensibility. Wright's technique is archaic: the thinnest brush, a piece of wall and weeks of time. He takes his subjects from the respectable history of art, and from the aggressive everyday life of the metropolis. Tattoos, blazing illuminations on the margins of medieval manuscripts, a gothic print type, graffiti, minimal art, icons of modernistic design – all are blended into flat-painted closed-composition patterns in which the individual motif surrenders to a rhythmical processing, as in techno music or bebop. The artist makes use of constructional slips and inaccuracies that result from users' subsequent intervention in the inanimate order of the designer's vision. Vents, plugs and discreet disturbances in wall surfaces provide a pretext to develop painting variations in the direct vicinity of architectural "non-specific moments". Although he takes his time making them, Wright usually regards his works as ephemera and most of them are destroyed after the exhibition. In his opinion, the difficulty of production and the effort involved cannot be an argument for the paintings' immortality. Painting interacts with the environment without any special privileges and asks no mercy.

Heute sind Künstler mehr als je zuvor daran interessiert zu erfahren, was schon alles geschrieben, plastisch gestaltet und gemalt worden ist und welche Äußerungen es darüber gibt. Dieses Wissen bildet den Ausgangspunkt für die höchst originellen Spekulationen über Malerei von Richard Wright, in denen er auf das Wissen des Betrachters und auf seine musikalische Empfindsamkeit Bezug nimmt. Wrights Technik ist archaisch: ein dünner Pinsel, ein Stück Wand und wochenlange Arbeit. Seine Motive entnimmt er der respektablen Kunstgeschichte und dem aggressiven Alltag der Metropolen. Tätowierungen, leuchtende Illuminationen an den Rändern mittelalterlicher Manuskripte, gotische Schrift, Graffiti, Minimal-Art, Ikonen des modernen Designs – dies alles wird zu Mustern einer geschlossenen Komposition vermischt, in denen sich das einzelne Motiv wie in der Technomusik oder im Bebop einem dominierenden Rhythmus unterwirft. Der Künstler macht sich bauliche Fehler und Ungenauigkeiten zunutze, die aus nachträglichen Eingriffen des Benutzers in die leblose Ordnung der planerischen Vision resultieren. Öffnungen, Dübel und unscheinbare Unregelmäßigkeiten in der Wandoberfläche bieten ihm den Vorwand, in unmittelbarer Nachbarschaft architektonisch „unspezifischer Gegebenheiten" malerische Variationen zu entwickeln. Obwohl er sich für seine Arbeit viel Zeit nimmt, betrachtet er seine Werke für gewöhnlich als vergänglich, zerstört die meisten nach ihrer öffentlichen Präsentation. Er ist der Meinung, dass die Schwierigkeiten und Mühen, die ihm seine künstlerische Tätigkeit abverlangt, noch keinen „Ewigkeits"-Status solcher Gemälde begründen. Die Malerei interagiert vielmehr mit ihrem jeweiligen Umfeld, ohne daraus irgendwelche Privilegien oder einen Anspruch auf Gnade abzuleiten.

Aujourd'hui plus que jamais, les artistes veulent savoir ce qui a déjà été écrit, peint et sculpté et ce qui a été dit à leur sujet. Pour Richard Wright, cette connaissance est le point de départ de spéculations originales sur la peinture qui font référence à l'érudition du spectateur ainsi qu'à sa sensibilité musicale. La technique de Wright est archaïque : le pinceau le plus fin, un mur et des semaines de travail. Il trouve ses sujets dans la respectable histoire de l'art et dans la vie quotidienne agressive de la métropole. Des tatouages, des illuminations flamboyantes en marge de manuscrits médiévaux, des calligraphies gothiques, des graffitis, de l'art minimaliste, des classiques du design moderniste, tous se mêlent dans des compositions peintes closes et plates où le motif individuel cède le pas à un traitement rythmique, comme dans la musique techno ou le bebop. L'artiste utilise les glissements et les inexactitudes qui résultent de l'intervention subséquente de l'utilisateur dans l'ordre inanimé de la vision de l'architecte. Les conduits d'aération, les prises de courant et toutes les perturbations discrètes dans les surfaces des murs sont prétexte à développer des variations de peinture dans le voisinage direct des « moments non-spécifiques » architecturaux. Bien qu'il prenne son temps pour les réaliser, il considère généralement ses œuvres comme éphémères et la plupart sont détruites après l'exposition. A son avis, la difficulté de la production et l'effort impliqué ne peuvent justifier l'immortalité de la peinture. Celle-ci interagit avec l'environnement sans jouir d'aucun privilège particulier ni demander grâce.

A. S.

SELECTED EXHIBITIONS →
1997 *Pictura Britannica*, Museum of Contemporary Art, Sydney, Australia **1998** *Manifesta 2*, Luxembourg **1999** Inverleith House, Edinburgh, UK; *Creeping Revolution*, Foksal Gallery Foundation, Warsaw, Poland **2000** *Intelligence*, Tate Britain, London, UK; *Amateur/Eldsjal*, Göteborgs Konstmuseum, Göteborg, Sweden; *The British Art Show 5*, Hayward Gallery, London, UK **2001** Kunsthalle Bern, Berne, Switzerland; *Painting at the Edge of the World*, Walker Art Center, Minneapolis (MS), USA

SELECTED BIBLIOGRAPHY →
1998 *Manifesta 2*, Luxembourg; *Netverk*, Museet for Samtidskunst, Oslo **1999** *Richard Wright*, BQ, Cologne; *De coraz(I)on*, Tecla Sala, Barcelona **2000** *The south east corner of things*, Locus +/Milton Keynes Art Gallery, Newcastle

3

3

Cerith Wyn Evans

1958 born in Wales, lives and works in London, UK

Between 1979 and 1989 Cerith Wyn Evans made twelve short films which were screened internationally, before concentrating on sculpture and installations. Film continues to feature in his work. In his 16 mm film *Firework Text (Pasolini)*, 1998, a panel of text with letters made out of fireworks is set ablaze. A verse of "Oedipus Rex", quoted in Pier Paolo Pasolini's film of the same name, flares up before wreaths of smoke drift and disappear above the beach at Ostia, precisely where Pasolini was murdered. Wyn Evans' entire artistic output is based on the combined concept of melancholic, emotional processes, intended as homages to people or objects, and meticulously composed structures. Subjective desire is the starting point for his strictly conceptualised strategy. In his installation *Take Your Desires for Reality*, 1996, the self-referential message appears in neon lettering, while *In Girum Imus Nocte Et Consumimur Igni (We go round and round in the night and are consumed by fire)*, 1997, the neon-lit circle of words, borrowed from the title of a film by Guy Debord, is suspended like a chandelier. The subliminal themes of transience or the relative instability of physical form is immediately apparent in *Inverse, Reverse, Perverse*, 1996, where the distorted reflection of the viewer appears in a concave mirror. Wyn Evans' deliberate use of allusion and insinuation culminates in his complex, space-art installation *Dreamachine*, 1998. In a neatly constructed setting of tatami mats and Japanese-style seating, stands a reconstruction of Brion Gysin's revolving lamp, throwing flickering light on the wall. Viewers are invited to close their eyes and observe the hallucinatory images summoned up by the inner eye.

Zwischen 1979 und 1989 drehte Cerith Wyn Evans zwölf Kurzfilme, die in Kinos gezeigt wurden, bevor er seinen Schwerpunkt auf installative Arbeiten und Ausstellungen im Kunstkontext legte. Dabei bleiben Filme weiterhin Bestandteil seiner Arbeiten. In seinem 16-mm-Film *Firework Text (Pasolini)*, 1998, wird eine Schrifttafel, deren Buchstaben aus Feuerwerkskörpern bestehen, entzündet. Ein poetischer Vers aus Pier Paolo Pasolinis „Oedipus Rex" flackert auf, bevor die Rauchschwaden über dem Strand von Ostia verschwinden, genau dort, wo Pasolini ermordet wurde. Das Zusammenwirken melancholisch emotionaler Prozesse, das eine Hommage an eine Person oder Sache evoziert, und ein präzise strukturierter Aufbau der Arbeit bilden den Hintergrund von Wyn Evans' gesamtem Werk. Das subjektive Begehren steht am Ausgangspunkt einer streng konzeptuellen Vorgehensweise. Dahingehend tragen Wyn Evans' Neon-Schriftzüge auch einen selbstreferenziellen Zug: *Take Your Desires for Reality*, 1996, oder das wie ein Kronleuchter angebrachte Wortspiel *In Girum Imus Nocte Et Consumimur Igni (We go round and round in the night and are consumed by fire)*, 1997, ein Zitat aus einem Film von Guy Debord. Das unterschwellige Thema der Vergänglichkeit beziehungsweise der Relativität von Körperlichkeit in diesen Arbeiten wird am unmittelbarsten erfahrbar in den Konkavspiegeln von *Inverse, Reverse, Perverse*, 1996, in denen der Betrachter deformiert oder auf den Kopf gestellt erscheint. Wyn Evans' bewusster Einsatz von Anspielungen kulminiert in der komplexen Raum-Arbeit *Dreamachine*, 1998. In einem klar konstruierten Setting von Tatamimatten und japanisierenden Sitzgelegenheiten steht ein Nachbau der rotierenden Lampe von Brion Gysin, die flackernde Lichtpunkte an die Wand wirft, welche mit geschlossenen Augen „betrachtet" halluzinatorische Bilder vor dem inneren Auge hervorrufen.

Entre 1979 et 1989, Cerith Wyn Evans tournait douze courts métrages qui furent montrés au cinéma, avant que l'accent principal de son travail porte sur des installations et des expositions dans le contexte de l'art. Le cinéma restera néanmoins un élément constitutif de ses œuvres. Dans son film en 16 mm *Firework Text (Pasolini)*, 1998, on assiste à la mise à feu d'un panneau dont les lettres sont constituées de pièces de feu d'artifice. Un vers poétique d'« Oedipus Rex » de Pier Paolo Pasolini s'embrase avant que les nuages de fumée ne se dissipent au-dessus de la plage d'Ostie, à l'endroit même où le cinéaste fut assassiné. La collusion entre différents processus émotionnels, mélancoliques, évoquant l'hommage à une personne ou à une chose, et une grande précision dans la structure constructive, constituent l'arrière-plan de tout l'œuvre de Wyn Evans. Le désir subjectif est à l'origine d'une démarche de rigueur conceptuelle. En revanche, les écritures au néon de l'artiste comportent aussi un aspect autoréférentiel, comme le montre *Take Your Desires for Reality*, 1996, ou *Girum Imus Nocte Et Consumimur Igni (We go round and round in the night and are consumed by fire)*, 1997, dont le titre fait référence à un film de Guy Debord, et où ce jeu de mots est arrangé comme un lustre. Dans ces œuvres, le thème sous-jacent de la fugacité, mieux, de la relativité du corporel, se perçoit de la manière la plus directe dans les miroirs concaves de *Inverse, Reverse, Perverse*, 1996, miroirs dans lesquels le spectateur apparaît déformé ou la tête en bas. L'emploi délibéré de l'allusion culmine avec *Dreamachine*, 1998. Dans l'agencement d'un espace clairement construit à partir de tatamis et de sièges japonisants, se dresse une reconstitution de la lampe rotative de Brion Gysin, qui projette au mur des points lumineux vibrants qui, « regardés » les yeux fermés, produisent des images hallucinatoires devant l'œil intérieur. N. M.

SELECTED EXHIBITIONS →
1996 *Life/Live*, Musée d'Art Moderne de la Ville de Paris, France;
1997 *Sensation*, Royal Academy of Arts, London, UK **1998** Centre for Contemporary Art, Kitakyushu, Japan **2000** *Art Now*, Tate Britain, London, UK; *Lost*, IKON Gallery, Birmingham, UK; *The British Art Show 5*, Hayward Gallery, London, UK **2001** *Yokohama Triennale*, Yokohama, Japan; *TimeWaveZero – The Politics of Ecstasy*, Kunstverein Graz, Austria

SELECTED BIBLIOGRAPHY →
1995 *General Release: Young British Artists*, Scuola di San Pasquale, Venice **1998** *From the Corner of the Eye*, Stedelijk Museum, Amsterdam

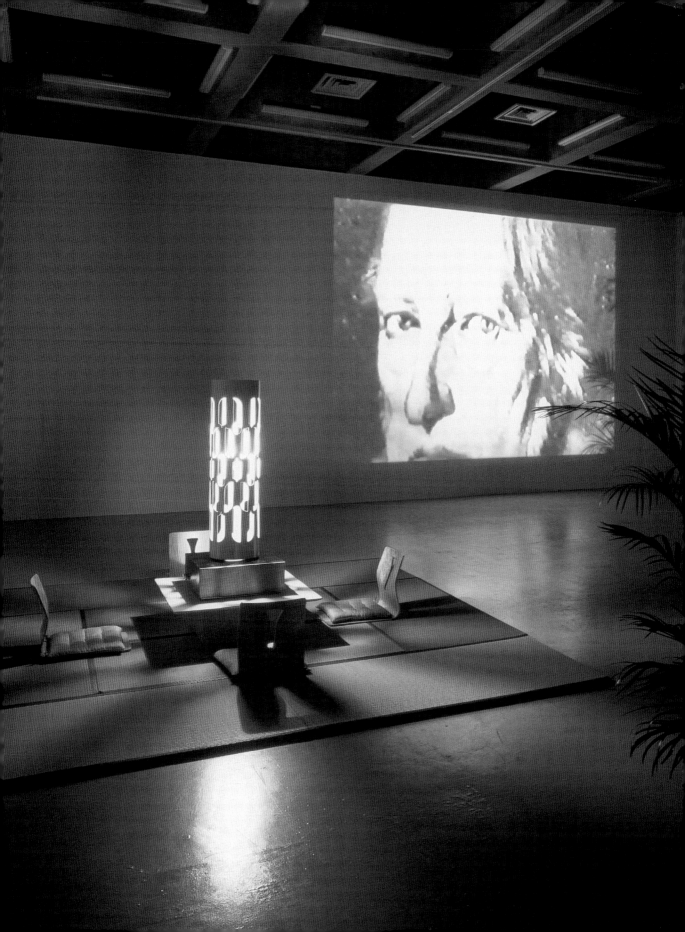

1 **Dreamachine,** 1998, mixed media, installation view, Center for
 Contemporary Art, Kitakyushu
2 Installation view, Deitch Projects, New York (NY), 1997

3 **In Girum Imus Nocte Et Consumimur Igni,** 1997, neon, ø 3.30 m,
 height 12 cm
4 **Firework Text (Pasolini),** 1998, super 16 mm film, 15 min

„Mein Thema sind die Mehrdeutigkeit und die Desorientiertheit. Deshalb
setze ich die Deplatzierung des Betrachters bewusst ein, damit er Fragen
stellen kann, weil er nämlich nicht recht weiß, was er eigentlich sieht."

« Les notions d'ambiguïte et de désorientation m'intéressent vraiment –
dans un déplacement délibéré du spectateur, afin d'ouvrir des zones de
questionnement en les faisant douter de ce qu'ils sont en train de voir. »

"I am really interested in notions of ambiguity and disorientation – in a wilful displacement of the viewer in order to open up areas of questioning by making them doubt what it is they're seeing."

2

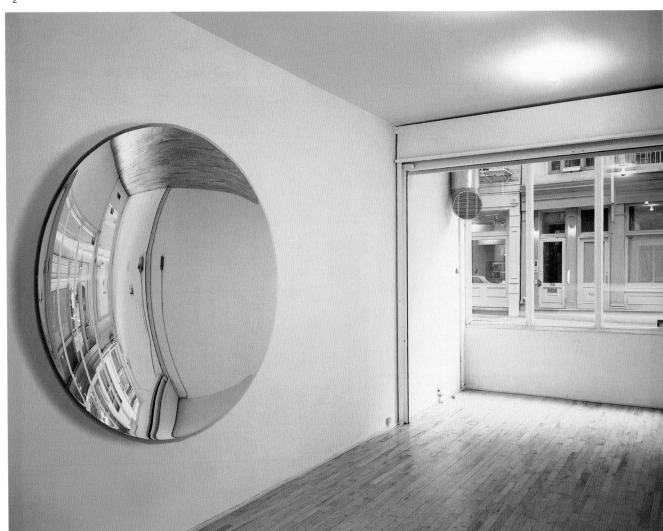

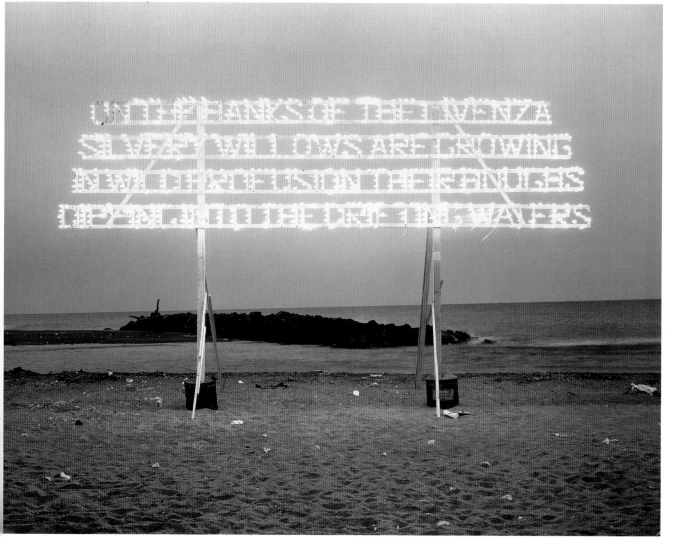

Andrea Zittel

1965 born in Escondido (CA), lives and works in New York (NY) and Altadena (CA), USA

Since 1992 Andrea Zittel has made domestic products under the company name "A–Z Administrative Services". She has designed collapsible *Living Units*, 1993/94, all-in-one structures with spaces for cooking, eating, washing and sleeping. She has also created clothes, food and other personal items to streamline users' daily routine. The *A–Z Comfort Units*, 1994, which allow individuals to perform tasks without getting out of bed, and *A–Z Ottoman Furniture*, 1994, which combines storage solutions with flexible seating and sleeping surfaces, demonstrate the dual nature of Zittel's work as idealistic yet practical. Zittel's inspiration is truly American. She is interested in American mass production and, perhaps paradoxically, the growing demand for customisation. The *A–Z Escape Vehicles*, 1996, and *A–Z Travel Trailer Units*, 1995, demonstrate this commitment to unique products: the pod-like "Escape Vehicles" and "Travel Trailers", which resemble recreational vehicles, have uniform metal exteriors, but Zittel encourages their owners to customise the interiors to reflect their personal needs and individual styles. Both of these projects highlight the nomadic quality of Zittel's work, whether it is an escape inside the hermetic environment of the "Escape Vehicles" or a journey into the landscape with the "Travel Trailer Units". Recently Zittel has branched out to create a new line of products under the label "Raugh", that strives to accommodate rather than control daily activities. These products, which include large-scale foam seating units that resemble rock formations, are meant to be comfortable and practical in their use and wear.

Seit 1992 stellen die von Andrea Zittel gegründeten „A–Z Adminstrative Services" Haushaltsgegenstände her. So hat Zittel etwa zusammenfaltbare *Living Units*, 1993/94, entworfen, bei denen es sich um kompakte Wohneinheiten handelt, in denen die Funktionen Kochen, Essen, Waschen und Schlafen auf engstem Raum zusammengefasst sind. Sie hat aber auch Kleider, Lebensmittel und sonstige persönliche Utensilien gestaltet, die den Alltag erleichtern. Beispiele für die doppelte – idealistische und zugleich praktische – Zielrichtung von Zittels Arbeit sind auch Werke wie *A–Z Comfort Units*, 1994, die es dem Benutzer gestatten, allfällige Aufgaben vom Bett aus zu erledigen, sowie *A–Z Ottoman Furniture*, 1994, eine Kombination aus Stauraum und flexiblen Sitz- und Schlafelementen. Dabei lässt sich Zittel von einem wahrhaft amerikanischen Pragmatismus leiten. So interessiert sie sich etwa für Massenproduktion und, paradoxerweise, den damit einhergehenden Wunsch nach individuellen Lösungen. Beispielhaft für derart einzigartige Produkte sind die *A–Z Escape Vehicles*, 1996, und die *A–Z Travel Trailer Units*, 1995. Die fast kugelförmigen „Escape Vehicles" und „Travel Trailers" erinnern an Wohnwagen. Sie sind zwar außen mit einer einheitlichen Metallverkleidung ausgestattet, aber Zittel ermutigt die Besitzer der Wohnmobile dazu, diese so einzurichten, wie es ihren persönlichen Bedürfnissen und ästhetischen Vorlieben entspricht. Beide Projekte betonen das nomadische Element in Zittels Arbeit, ob es sich dabei nun um eine Flucht in das hermetisch abgeschlossene Innere der „Escape Vehicles" handelt oder um eine Reise durch die offene Landschaft in einer „Travel Trailer Unit". Erst unlängst hat Zittel ihr Tätigkeitsfeld erweitert und kreiert jetzt unter dem Namen „Raugh" eine neue Produktlinie, die tägliche Aufgaben erleichtern, nicht kontrollieren soll. Diese Produkte, zu denen auch großformatige Sitzgelegenheiten aus Schaumstoff gehören, sollen sich ebenso bequem und praktisch am Körper tragen lassen wie – je nach Funktion – für andere Zwecke eignen.

Depuis 1992, Andrea Zittel fabrique des produits domestiques sous le nom de compagnie « A–Z Administrative Services ». Elle a conçu des *Living Units* (Unités habitables, 1993/94) pliables, des structures intégrées comprenant des espaces pour cuisiner, manger, laver et dormir. Elle a également créé des vêtements, de la nourriture et d'autres articles personnels pour rationaliser sa vie quotidienne. Les *A–Z Comfort Units*, 1994, qui permettent d'effectuer des tâches sans quitter son lit, et les *A–Z Ottoman Furniture*, 1994, qui associent des solutions de rangement à des sièges souples et des surfaces de couchage, démontrent la dualité du travail de Zittel, idéaliste tout en étant pratique. Son inspiration est profondément américaine. Elle s'intéresse à la fabrication de masse associée à la production américaine et, peut-être paradoxalement, au désir croissant de customisation. Les *A–Z Escape Vehicles*, 1996, et *A–Z Travel Trailer Units*, 1995, attestent de cet attachement à des produits uniques : ses « véhicules d'évasion » en forme de cosse et ses « caravanes » ont des extérieurs métalliques uniformes, mais Zittel encourage leurs propriétaires à aménager leur intérieur de sorte à refléter leurs besoins personnels et leurs styles individuels. Ces deux projets soulignent la qualité nomade du travail de Zittel, qu'il s'agisse d'une fuite à l'intérieur de l'environnement hermétique des « Escape Vehicles » ou d'un voyage dans le paysage avec les « Travel Trailers Units ». Récemment, Zittel s'est diversifiée pour créer une nouvelle ligne de produits sous la marque « Raugh » qui visent à accommoder plutôt qu'à contrôler les activités quotidiennes. Ces produits, qui incluent de grands sièges en mousse qui ressemblent à des rochers, sont censés être confortables et pratiques dans leur utilisation tout en vieillissant bien. Ro. S.

SELECTED EXHIBITIONS →
1995 San Francisco Museum of Modern Art, San Francisco (CA), USA **1996** Museum für Gegenwartskunst, Basel, Basle, Switzerland **1997** *documenta X*, Kassel, Germany; *Skulptur. Projekte*, Münster, Germany **1999** Deichtorhallen, Hamburg, Germany **2000** *Made In California*, Los Angeles County Museum of Art, Los Angeles (CA), USA; *Against Design*, Institute of Contemporary Art, Philadelphia (PA), USA **2000** *What if*, Moderna Museet, Stockholm, Sweden **2001** IKON Gallery, Birmingham, UK; *International Communities*, Rooseum, Malmö, Sweden

SELECTED BIBLIOGRAPHY →
1997 Klaus Bußmann/Kasper König/Florian Matzner (eds.), *Skulptur. Projekte*, Münster **1999** *Andrea Zittel*, Deichtorhallen, Hamburg **2001** Uta Grosenick (ed.), *Women Artists*, Cologne

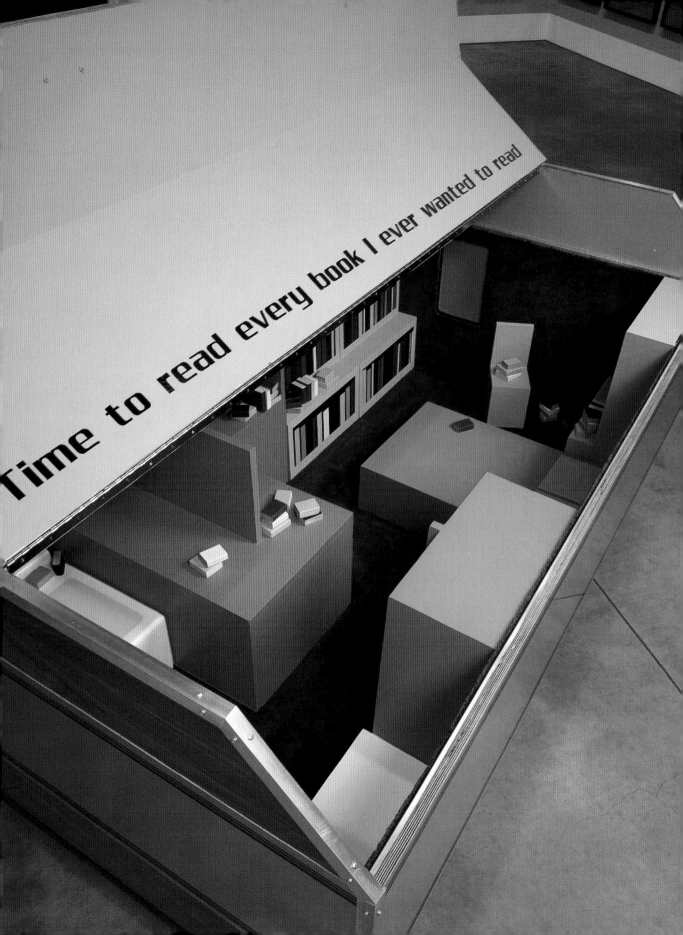

554

„Früher wollte ich mal Designerin werden, aber als Designer steht man vor der Aufgabe, Produkte zu gestalten, die der Mehrzahl der Leute gefallen müssen, und das finde ich nun auch wieder nicht sonderlich befreiend."

« J'ai envisagé de devenir designer, mais le designer a la responsabilité de concevoir des objets qui servent le plus grand nombre, et je ne pense pas que ce soit si libératoire. »

"I thought about becoming a designer but designers are responsible for making products that best serve the greatest number of people, and I don't think that's so liberating."

2

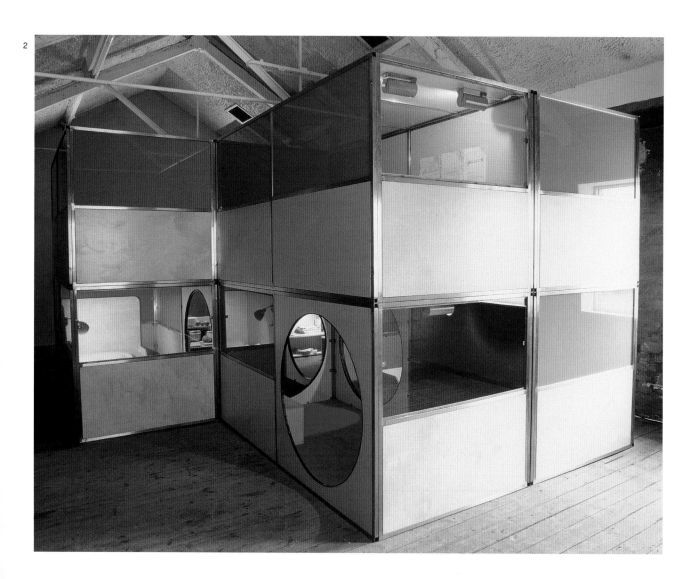

3

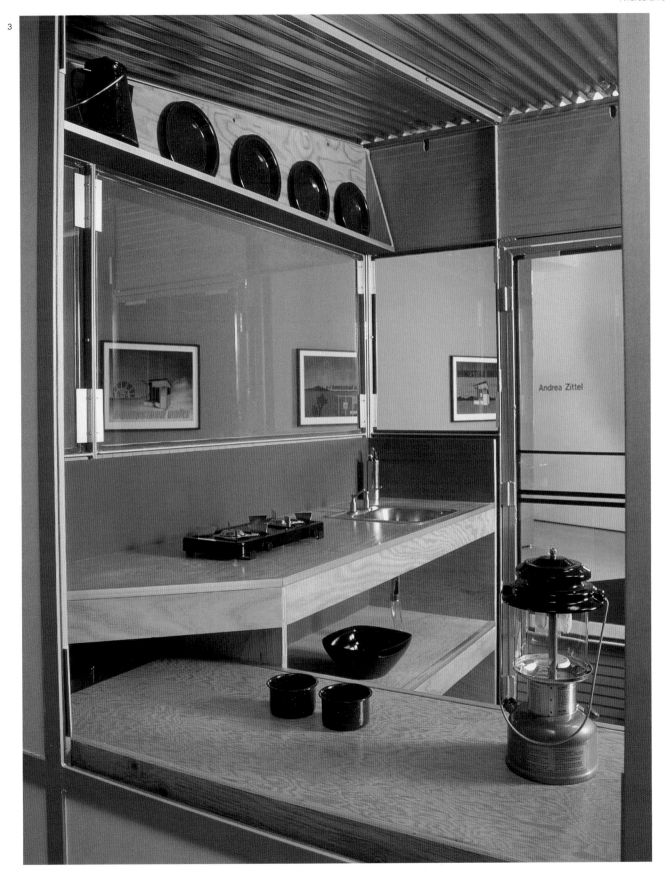

Heimo Zobernig

1958 born in Mauthen, lives and works in Vienna, Austria

Heimo Zobernig's artistic output is a painstaking interpretation of the spaces in between: between things; between the letters of the alphabet; between colours; and between specific objects and space. His art clearly shows how it works and what makes it art. It is art appearing as itself. Zobernig has little interest in materials; he merely copies forms and convincingly uses the simplest substances to the greatest effect. For example, recycled materials reduced to basic, minimalist forms. The rest is put together in the mind of the viewer. That is the way art works – it only becomes art when someone else looks at it and perceives it as art. Things are what they are because of where they are. Spaces work because they interrelate. Meaning can be understood through the interplay of the work of art and its location. It is simply about creating these minute differences and then watching people accept them, Zobernig says. For these reasons, the things that Zobernig puts on show to the art world find it hard to be quickly identified as art objects. They are insistently literal. *Der Katalog* (The Catalogue), 1999, consisted of wood veneer filing cabinets with some 3,000 drawers which once housed the card catalogue of the contents of the Austrian National Library, now rendered obsolete by electronic data bases. The redundant catalogue in all its massive, worn-out materiality now stood in space as a piece of free sculpture. Moreover, *Der Katalog* demonstrated how computerisation was both an historic turning point in the dissemination of knowledge and an intrusion into our consciousness. The principle of physically storing information and the system of intellectual discipline are now out of date. Zobernig's economical and humorous way of working is an ideal vehicle for carrying such a message.

Heimo Zobernig betreibt seine künstlerische Produktion als eine behutsame Hermeneutik der Zwischenräume: zwischen den Dingen, zwischen den Buchstaben des Alphabets, zwischen Farben, zwischen spezifischen Objekten und dem Raum. Seine Kunst zeigt vor, wie sie funktioniert und was sie zur Kunst macht – die Kunst erscheint als sie selbst. Den Künstler interessiert das Material kaum. Es genügt ihm, die Form zu kopieren und dabei erscheint das simpelste Mittel als das geeignetste: beispielsweise recycelte Materialien, auf wesentliche, minimalistische Formen reduziert. Der Rest wird im Kopf des Betrachters zusammengesetzt. So arbeitet das System Kunst – es kann nur zu einem werden, wenn ein anderer es betrachtet und zu diesem macht. Dinge werden durch ihren Ort konstituiert. Räume wirken durch ihre maßstäblichen Beziehungen. Bedeutungen erschließen sich im Zusammenspiel von Arbeit und Ort. Es sind nur diese minimalen Differenzen, die man schafft und die dann akzeptiert werden, meint Zobernig. Aus diesem Grund verweigern sich die Dinge, die Zobernig auf der Bühne des Kunstmarkts arrangiert, einer schnellen Identifikation als Kunstobjekte. Sie beharren auf ihrer Buchstäblichkeit. *Der Katalog*, 1999, versammelte dreitausend kunststofffurnierte Holzbehälter: alle Zettelkataloge der Österreichischen Nationalbibliothek, die durch elektronische Datenspeicher ersetzt wurden. Der funktionslose Katalog konnte als freie Skulptur im Raum wahrgenommen werden, massiv in seiner abgenutzten Stofflichkeit. Darüber hinaus zeigt *Der Katalog*, dass Digitalisierung ein historischer Einschnitt in der Wissensvermittlung wie ein Eingriff in unser Bewusstsein ist. Zurück bleibt das nackte Ordnungsprinzip Erinnerungsspeicher und das Instrument der geistigen Disziplinierung. Dies ist eine Perspektive, die Zobernigs ökonomischer wie humorvoller Arbeitsweise entspricht.

Heimo Zobernig pratique sa production artistique comme une herméneutique circonspecte : entre les choses, entre les lettres de l'alphabet, entre les couleurs, entre des objets particuliers et l'espace. Son art montre comment il fonctionne : ce qui en fait de l'art – l'art apparaît en tant que tel. L'artiste n'est guère intéressé par le matériau. Il lui suffit de copier la forme. Pour cela, le moyen le plus simple s'avère le plus approprié : ce seront par exemple des matériaux recyclés, réduits à des formes essentielles, minimalistes. Le reste se compose dans la tête du spectateur. Ainsi travaille le système « art » – qui ne peut être que si quelqu'un le regarde et le fait exister. Le site est un élément constitutif des choses. Les espaces agissent par leur échelle. Les significations s'acquièrent par l'interaction entre l'œuvre et le lieu. Seules ces infimes différences sont créées, puis acceptées, estime Zobernig. C'est pour cette raison que les choses arrangées sur la scène du marché de l'art par Zobernig refusent toute identification hâtive comme objets d'art. Elles insistent sur leur littéralité. *Der Katalog* (Le catalogue), 1999, regroupait trois mille boîtiers en bois plastifié : l'ensemble des fichiers de la Bibliothèque Nationale d'Autriche, que cette institution a remplacés par un archivage informatique. Dépossédé de sa fonction, le catalogue pourrait être perçu comme une sculpture dans l'espace, massive en sa matérialité marquée par l'usure. Au-delà de ce constat, *Der Katalog* montre qu'en tant que césure historique dans la transmission des connaissances, la numérisation est comme une intervention directe dans notre conscience. Tout ce qui reste, c'est le principe d'ordre mis à nu, stockage de souvenirs et instrument de discipline intellectuelle. Cette perspective correspond parfaitement à la démarche à la fois humoristique et économique de Zobernig.

F. F.

SELECTED EXHIBITIONS →
1997 Villa Merkel, Esslingen, Germany; *documenta X*, Kassel, Germany; *Skulptur. Projekte*, Münster, Germany **1998** Bonner Kunstverein, Bonn, Germany; *Mai 98*, Josef-Haubrich-Kunsthalle, Cologne, Germany **1999** *Der Katalog* (with Ernst Strouhal), Portikus, Frankfurt am Main, Germany; Museum für angewandte Kunst, Vienna, Austria; *Minimal – Maximal*, Neues Museum Weserburg, Bremen, Germany **2000** Galerie Christian Nagel, Cologne, Germany **2001** *49. Biennale di Venezia*, Venice, Italy

SELECTED BIBLIOGRAPHY →
1996 The Renaissance Society, Chicago (IL) **1997** Villa Merkel, Esslingen; *documenta X*, Ostfildern-Ruit **1998** *Minimal – Maximal*, Neues Museum Weserburg, Bremen **1999** *Der Katalog*, Wien/New York (NY) **2000** *Farbenlehre*, Galerie & Edition Artelier, Graz; *ein/räumen ARBEITEN IM MUSEUM*, Hamburger Kunsthalle, Hamburg **2001** *Projekt Fassade*, Wiener Secession, Vienna

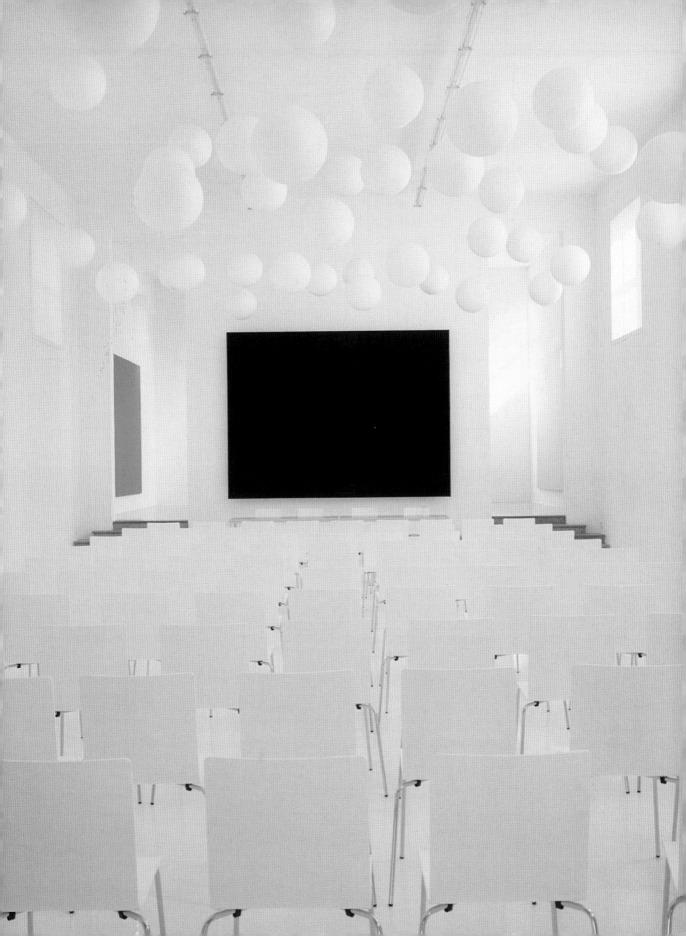

1. **Ohne Titel,** 1999, installation view, Kunstverein München, Munich
2. **Ohne Titel,** 1999, video red, untreated Trevira CS cotton, TELEVISION CS, 280 x 373 cm, installation view, Kunstverein München, Munich
3. **Ohne Titel,** 1999, reflector foil on aluminium stretcher, 24 panels, each 300 x 118 x 5 cm, installation view, Kunstverein München, Munich
4. In collaboration with Ernst Strouhal: **Der Katalog,** 1999, installation view, Museum für Angewandte Kunst, Vienna

„Alles wird offengelegt, das heißt auch der Moment des Täuschens."

« Tout est divulgué, c'est-à-dire aussi le moment de la mystification. »

"Everything is revealed, including the moment of deception."

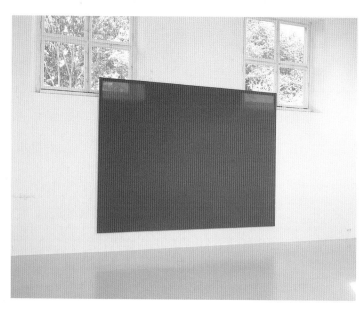

2

4

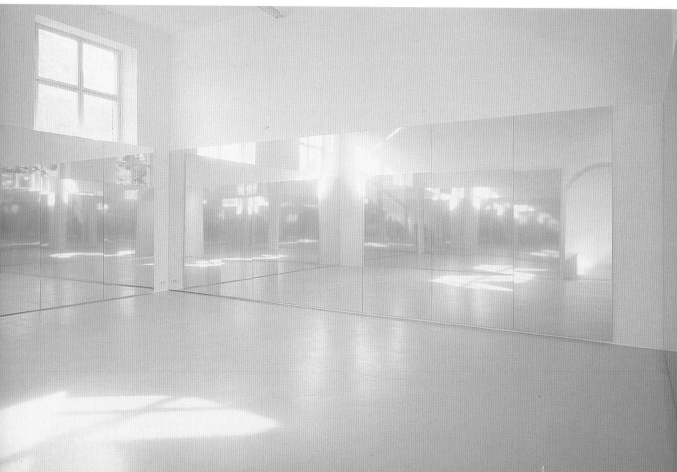

3

Imprint — Impressum — Imprint

© 2002 TASCHEN GmbH
Hohenzollernring 53, D–50672 Köln
www.taschen.com

© for the illustrations by Thomas Demand, Andreas Gursky, Carsten Höller,
Neo Rauch, Thomas Ruff, Gregor Schneider: 2002 VG Bild-Kunst, Bonn

Texts by Kirsty Bell, Ariane Beyn, Frank Frangenberg, Barbara Hess, Gregor Jansen, Anke Kempkes,
Lars Bang Larsen, Nina Möntmann, Raimar Stange, Rochelle Steiner, Adam Szymczyk

English translation by Monica Bloxam, Isabel Varea, Karen Waloschek
for Grapevine Publishing Service Ltd., London
German translation by Christian Quatmann, Munich
French translation by Gunter Fruhtrunk, Philippe Safavi, Paris

Editorial coordination and copy-editing by Uta Grosenick, Sabine Bleßmann, Cologne
Design by Sense/Net, Andy Disl & Birgit Reber, Cologne
Production by Ute Wachendorf, Cologne

Printed in Italy
ISBN 3–8228–1444–X

INTERNATIONAL EDITION

THE ART NEWSPAPER

Provides art market details for all the artists
and essential facts about the leading art cities of the world

Introduction

The artists featured in this book exist in the context of the contemporary art market. In this section of the book we provide an overview of their place in this market by providing contact details for each artist's representatives, general price ranges, public collections which feature the artist's work, and auction results where applicable.

Except in cases where representation is exclusive, most artists will be represented simultaneously by as many as four different galleries, each dealing with sales and marketing within their region.

The price range listed for each artist appears in varying degrees of detail, as dictated by each gallery. These prices are for new works by the artist, and are referred to as the "primary market." At the lower end of each range will be multiples, prints and other small projects. At the other extreme will be the artist's signature pieces, major installations or very large paintings, and occasionally individual sales will go well beyond this upper limit. Between the upper and lower limits, prices vary along a sliding scale depending usually both on the size of the work and the expense and time in making it, as well as previous sale prices for similar works. The prices presented here are a guide only, and reflect a combination of each gallery's individual pricing policies and currencies. An artist's prices can change dramatically as a result of the securing of a new commission or prize, a sale to an important collection, or a particularly good or poor result at auction. In addition, work is not always available, and for some particularly popular artists there are lists of waiting buyers, but this is the exception rather than the norm.

The collections listed here are a representative sample of all the collections which might feature an artist's work. Private collectors, who form the bulk of art buyers, are not listed. Though an artist's work might be in the collection of various important museums, their work will often not be on display, but their mere presence in the collection's storage is enough to confer benefit to their status and sale prices.

Auction results are listed for those artists who have made it to the "secondary market," in which buyers of an artist's work sell the pieces on to other collectors or investors. For the emerging artists described in this book, the hammer price, that is the final price at the end of the auction, will generally not be representative of the artist's value in the way that auction results do represent overall value for artists of older generations. The artists in this book are still fully engaged in producing works for the primary market of contemporary commercial art galleries. As time passes and the production of new works drops off, or as later sales drive up the price of early works, they will start to appear more commonly at the auction houses, but for most of the artists dealt with in this book, there are several decades to go before this happens. For the works listed in these results, the date of the original production of the work by the artists is usually not listed, auction houses focus on the name and the final price, though nearly all works listed were produced in the 1990s.

Finally, it should be noted that not all galleries wished to provide price ranges or information about collections, or sometimes one and not the other. We apologise for any shortcomings, and would urge interested parties to contact the galleries directly when any information is lacking here.

Peter Schauer

Artist Information

FRANZ ACKERMANN

REPRESENTATION →
Gavin Brown's enterprise
436 West 15th Street
USA – New York, NY 10011
tel: +1 212 627-5258
fax: +1 212 627-5261

neugerriemschneider
Linienstraße 155
D – 10115 Berlin
tel: +49 (0)30 3087-2810
fax: +49 (0)30 3087-2811

PRICE RANGE →
$1,750 – $50,000

AUCTION SALES →
Price: $42,120
Untitled, Mental Map,
Evasion I, 1996
280 x 290 cm
Date sold: 08-Dec-99
Auction house: Christie's, London

Price: $29,160
Evasion I
acrylic, 280 x 290 cm
Date sold: 08-Dec-99
Auction house: Christie's,
Kensington

Price: $25,920
Evasion XVIII, 1998
building with one window lifted,
200 x 200 cm
Date sold: 08-Dec-99
Auction house: Christie's, London

Price: $9,656
Untitled, 1994/95
colour pencil, gouache, 13 x 18 cm
Date sold: 28-Mar-01
Auction house: Christie's,
Kensington

DOUG AITKEN

REPRESENTATION →
Hauser & Wirth & Presenhuber
Limmatstrasse 270
CH – 8005 Zurich
tel: +41 (0)1 446-8060
fax: +41 (0)1 446-8065
www.ghwp.ch

Victoria Miro Gallery
16 Wharf Road
GB – London N1 7RW
tel: +44 (0)20 7336-8109
fax: +44 (0)20 7251-5596
www.victoria-miro.com

303 Gallery
525 West 22nd Street
USA – New York, NY 10011
tel: +1 212 255-1121
fax: +1 212 255-0024
www.303gallery.com

COLLECTIONS →
Astrup Fearnley Museum of
Modern Art, Oslo, Norway
Centre National des Arts
Plastiques, France
Dallas Museum of Art,
Dallas (TX), USA
Fondazione Sandretto Re
Rebaudengo per l'Arte, Turin, Italy
Contemporary Art Museum,
Kanazawa, Japan
La Colección Júmex,
Mexico City, Mexico
Louisiana Museum of Modern Art,
Humlebæk, Denmark
Musée national d'art moderne,
Centre Georges Pompidou, Paris,
France
Museum of Contemporary Art,
Chicago (IL), USA
The Museum of Contemporary
Art, Los Angeles (CA), USA
University Art Museum,
Berkeley (CA), USA
Walker Art Center,
Minneapolis (MN), USA
Whitney Museum of American Art,
New York (NY), USA

PRICE RANGE →
$10,000 – $22,000 (editioned
photographs); $45,000 – $80,000
(light boxes); $30,000 – $200,000
(film works and installations)

AUCTION SALES →
Price: $10,000
Mirror No. 2, 1998
colour coupler print mounted
on Plexiglas, 51 x 63 cm
Date sold: 18-May-01
Auction house: Christie's,
Rockefeller NY

Price: $4,200
Mirror no 7
c-print, laid down on Plexiglas,
num. 1/10, 76 x 89 cm
Date sold: 28-Jun-01
Auction house: Sotheby's, London

DARREN ALMOND

REPRESENTATION →
Galerie Max Hetzler
Zimmerstraße 90/91

D – 10117 Berlin
tel: +49 (0)30 229-2437
fax: +49 (0)30 229-2417
www.maxhetzler.com

Jay Jopling/White Cube²
48 Hoxton Square
GB – London N1 6PB
tel: +44 (0)20 7930-5373
fax: +44 (0)20 7749-7460
www.whitecube.com

Matthew Marks Gallery
523 West 24th Street
USA – New York, NY 10011
tel: +1 212 243-0200
fax: +1 212 243-0047

COLLECTIONS →
Fondazione Sandretto Re
Rebaudengo per l'Arte, Turin, Italy
Imperial War Museum, London, UK
The Art Institute of Chicago,
Chicago (IL), USA
The Metropolitan Museum of Art,
New York (NY), USA

PRICE RANGE →
$9,500 – $90,000

AUCTION SALES →
Price: $1,660
Clock, 1997
Perspex infra-red sound stores
electric motor, num. 5/10,
31 x 41 x variable cm
Date sold: 23-Jun-97
Auction house: Sotheby's, London

PAWEŁ ALTHAMER

REPRESENTATION →
Galeria Foksal
ul. Foksal 1/4
PL – 00-950 Warsaw
tel/fax: +48 22 827-6243

COLLECTIONS →
Museum Ludwig, Cologne,
Germany

PRICE RANGE →
$3,000 – $25,000

AUCTION SALES →
No auction results

KAI ALTHOFF

REPRESENTATION →
Anton Kern
532 West 20th Street

USA – New York, NY 10011
tel: +1 212 367-9663
fax: +1 212 367-8135

Galerie Christian Nagel
Richard-Wagner-Straße 28
D – 50674 Cologne
tel: +49 (0)221 257-0591
fax: +49 (0)221 257-0592
www.galerie-nagel.de

Galerie Neu
Philippstraße 13
D – 10115 Berlin
tel: +49 (0)30 285-7550
fax: +49 (0)30 281-0085

COLLECTIONS →
The Art Institute of Chicago,
Chicago (IL), USA
The Museum of Modern Art,
New York (NY), USA
The Museum of Contemporary
Art, Los Angeles (CA), USA
Walker Art Center,
Minneapolis (MN), USA

PRICE RANGE →
$2,000 (drawings) – $60,000
(installations)

AUCTION SALES →
No auction results

FRANCIS ALŸS

REPRESENTATION →
Galeria Fortes Vilaça
Rua Fradique Coutinho 1500
BRAZ – 05416-001 São Paulo
tel: +55 (0)11 3032-7066
fax: +55 (0)11 3097-0384

Galerie Peter Kilchmann
Limmatstrasse 270
CH – 8005 Zurich
tel: +41 (0)1 440-3931
fax: +41 (0)1 440-3932
www.kilchmanngalerie.com

Lisson Gallery
52–54 Bell Street
GB – London NW1 5DA
tel: +44 (0)20 7724-2739
fax: +44 (0)20 7724-7124
www.lisson.co.uk

COLLECTIONS →
Kunsthaus Zürich, Zurich,
Switzerland
La Colección Júmex,
Mexico City, Mexico
Museum für Moderne Kunst,

Artist Information

Frankfurt am Main, Germany
Stedelijk Museum, Amsterdam,
The Netherlands
Tate Gallery, London, UK
The Israel Museum, Jerusalem,
Israel

PRICE RANGE →
$1,000 – $70,000

AUCTION SALES →
Price: $50,000
Entr'acte, NYC Series, 1995
painted photographs, set of
thirty on one mount
Date sold: 02-Jun-99
Auction house: Christie's,
Rockefeller NY

Price: $10,000
Untitled, a polyptych, 1993/94
oil, enamel, canvas, metal,
four panels, 112 x 202 cm
Date sold: 24-Nov-98
Auction house: Christie's,
New York (NY)

Price: $7,000
Untitled, diptych, 1997
oil on wood, oil on metal,
82 x 103 cm
Date sold: 22-Nov-99
Auction house: Christie's,
Rockefeller NY

GHADA AMER

REPRESENTATION →
Deitch Projects
76 Grand Street
USA – New York, NY 10013
tel: +1 212 343-7300
fax: +1 212 343-2954

COLLECTIONS →
Fonds National d'Art
Contemporain, Paris, France
Fonds Régional d'Art
Contemporain, Auvergne, France
Tel Aviv Museum, Israel
The Art Institute of Chicago,
Chicago (IL), USA
The Israel Museum,
Jerusalem, Israel

PRICE RANGE →
$4,000 – $150,000

AUCTION SALES →
No auction results

MIRIAM BÄCKSTRÖM

REPRESENTATION →
Nils Stærk
Njalsgade 19 C
DK – 2300 Copenhagen
tel: +45 3254-4562
fax: +45 3254-4526
www.nilsstaerk.dk

COLLECTIONS →
Borås Konstmuseum, Sweden
Esbjerg Kunstmuseum, Denmark
Grazer Kunstverein, Graz, Austria
Louisiana Museum of Modern Art,
Humlebæk, Denmark
Magasin 3, Stockholm
Konsthall, Sweden
Moderna Museet,
Stockholm, Sweden
Museum Folkwang,
Essen, Germany
National Public Art Council,
Stockholm, Sweden
National Museum of Iceland,
Reykjavik, Iceland

PRICE RANGE →
$3,000 – $20,000

AUCTION SALES →
No auction results

MATTHEW BARNEY

REPRESENTATION →
Barbara Gladstone Gallery
515 West 24th Street
USA – New York, NY 10011
tel: +1 212 206-9300
fax: +1 212 206-9301
www.gladstonegallery.com

Regen Projects
629 North Almont Drive
USA – Los Angeles, CA 90069
tel: +1 310 276-5424
fax: +1 310 276-7430
www.regenprojects.com

COLLECTIONS →
Solomon R. Guggenheim
Museum, New York (NY), USA
The Museum of Modern Art,
New York (NY), USA

PRICE RANGE →
Not available

AUCTION SALES →
Price: $350,000
Cremaster 4, 1994/95
plastic banner, tartan, laser disk,

plastic vitrine with Plexiglas case,
num. 3/10, 120 x 120 x 90 cm
Date sold: 19-May-99
Auction house: Christie's,
Rockefeller NY

Price: $310,000
Transsexualis – decline, 1991
walk-in cooler, petroleum jelly,
bench, video monitors,
366 x 427 x 259 cm
Date sold: 06-May-97
Auction house: Sotheby's,
New York (NY)

Price: $160,000
Cremaster 4, the Isle of Man
five cibachrome prints, num. 1/3,
42 x 38 cm
Date sold: 16-May-00
Auction house: Christie's,
Rockefeller NY

Price: $100,000
*Cremaster 2: The Ballad
of Max Jensen*, 1999
cibachrome print triptych,
84 x 229 cm
Date sold: 16-Nov-00
Auction house: Christie's,
Rockefeller NY

Price: $90,000
Away gown
plastic wall mount, NFL jersey
titanium screws, num. 1/2,
dimensions variable
Date sold: 17-May-01
Auction house: Christie's,
Rockefeller NY

JOHN BOCK

REPRESENTATION →
Anton Kern
532 West 20th Street
USA – New York, NY 10011
tel: +1 212 367-9663
fax: +1 212 367-8135

Klosterfelde
Zimmerstraße 90/91
D – 10117 Berlin
tel: +49 (0)30 283-5305
fax: +49 (0)30 283-5306
www.klosterfelde.de

Giò Marconi
Via Tadino 15
I – 20124 Milan
tel: +39 (0)2 2940-4373
fax: +39 (0)2 2940-5573

COLLECTIONS →
Castello di Rivoli, Museo d'Arte
Contemporanea, Rivoli, Italy
Städtisches Museum Abteiberg,
Mönchengladbach, Germany
The Museum of Contemporary
Art, Los Angeles (CA), USA

PRICE RANGE →
$500 – $80,000

AUCTION SALES →
Price: $8,910
*Heu in der Kadernwelle,
Jerry Hall's Kunstwohlfahrt-
gebirgsgondel*
mixed media, wooden box, video,
220 x 250 x 125 cm
Date sold: 08-Dec-99
Auction house: Christie's, London

Price: $2,916
Lord Byron-Stiefel
plastic construction foam, fabric,
leather, 75 x 20 x 42 cm
Date sold: 08-Dec-99
Auction house: Christie's,
Kensington

Price: $1,782
Elastizitatendiagramm
acrylic, glass, fabric, modeling
clay, 70 x 46 x 40 cm
Date sold: 08-Dec-99
Auction house: Christie's,
Kensington

COSIMA VON BONIN

REPRESENTATION →
Galleria Emi Fontana
Viale Bligny 42
I – 20136 Milan
tel: +39 (0)2 5832-2237
fax: +39 (0)2 5830-6855

Galerie Christian Nagel
Richard-Wagner-Straße 28
D – 50674 Cologne
tel: +49 (0)221 257-0591
fax: +49 (0)221 257-0592
www.galerie-nagel.de

Friedrich Petzel Gallery
535 West 22nd Street
USA – New York, NY 10011
tel: +1 212 680-9467
fax: +1 212 680-9473
www.petzel.com

PRICE RANGE →
Not available

AUCTION SALES →
No auction results

MONICA BONVICINI

REPRESENTATION →
chouakri brahms berlin
Holzmarktstraße 15–18
S-Bahnbogen 47
D – 10179 Berlin
tel: +49 (0)30 2839-1153
fax: +49 (0)30 2839-1154
www.chouakribrahms-berlin.com

Galleria Emi Fontana
Viale Bligny 42
I – 20136 Milan
tel: +39 (0)2 5832-2237
fax: +39 (0)2 5830-6855

Anton Kern
532 West 20th Street
USA – New York, NY 10011
tel: +1 212 367-9663
fax: +1 212 367-8135

COLLECTIONS →
ARCO Foundation, Madrid, Spain
Castello di Rivoli, Museo d'Arte
Contemporanea, Rivoli, Italy
Neues Museum, Weimar, Germany

PRICE RANGE →
Drawings and collages from
$1,250; photographs from $10,000;
$13,000 – $53,000 (installations)

AUCTION SALES →
No auction results

CANDICE BREITZ

REPRESENTATION →
Art & Public
35, rue des Bains
CH – 1205 Geneva
tel: +41 (0)22 781-4666
fax: +41 (0)22 781-4715
www.artpublic.ch

Johnen + Schöttle
Maria-Hilf-Straße 17
D – 50677 Cologne
tel: +49 (0)221 310-2727
fax: +49 (0)221 310-2727
www.johnen-schoettle.de

Galleria Francesca Kaufmann
Via dell'Orso 16
I – 20121 Milan
tel: +39 (0)2 7209-4331
fax: +39 (0)2 7209-6873

COLLECTIONS →
ARCO Foundation, Madrid, Spain
Castello di Rivoli, Museo d'Arte
Contemporanea, Rivoli, Italy
Fonds Régional d'Art
Contemporain Rhône-Alpes, France
Galleria d'Arte Moderna, Turin, Italy
Hamburger Kunsthalle, Hamburg,
Germany

PRICE RANGE →
$4,000 – $8,000 (photographs);
$5,000 – $25,000 (video
installations)

AUCTION SALES →
No auction results

OLAF BREUNING

REPRESENTATION →
Arndt & Partner
Zimmerstraße 90/91
D – 10117 Berlin
tel: +49 (0)30 280-8123
fax: +49 (0)30 283-3738
www.arndt-partner.de

arsFutura Galerie
Bleicherweg 45
CH – 8002 Zurich
tel: +41 (0)1 201-8810
fax: +41 (0)1 201-8811
www.arsfutura.ch

Metro Pictures
519 West 24th Street
USA – New York, NY 10011
tel: +1 212 206-7100
fax: +1 212 337-0070

COLLECTIONS →
Fonds National d'Art
Contemporain, Paris, France
Fonds Régional d'Art
Contemporain, Bourgogne, France
Graphische Sammlung des
Museums für Gestaltung, Zurich,
Switzerland
Kunsthaus Glarus, Switzerland
Kunsthaus Zürich, Zurich,
Switzerland

PRICE RANGE →
$1,000 – $10,000 (photographs);
$2,400 (videos); $10,000 (light-
boxes); $5,000 – $24,000
(installations)

AUCTION SALES →
No auction results

GLENN BROWN

REPRESENTATION →
Galerie Max Hetzler
Zimmerstraße 90/91
D – 10117 Berlin
tel: +49 (0)30 229-2437
fax: +49 (0)30 229-2417
www.maxhetzler.com

Patrick Painter Inc.
2525 Michigan Ave #B2
USA – Santa Monica, CA 90404
tel: +1 310 264-5988
fax: +1 310 264-5998

PRICE RANGE →
$20,000 – $50,000

AUCTION SALES →
Price: $39,480
*Ornamental despair –
painting for Ian Curtis*, 1994
oil on canvas, 201 x 300 cm
Date sold: 06-Feb-02
Auction house: Christie's, London

Price: $28,800
*Exercise One, for Ian Curtis,
after Chris Foss*
oil on canvas on board, 50 x 70 cm
Date sold: 09-Feb-01
Auction house: Christie's, London

Price: $28,690
*You take my place
in this showdown*
296 x 215 cm
Date sold: 28-Jun-00
Auction house: Christie's, London

Price: $27,360
Creeping Flesh
56 x 51 cm
Date sold: 07-Feb-01
Auction house: Sotheby's, London

Price: $23,780
Telstar, 1995
oil on canvas laid on board,
71 x 58 cm
Date sold: 03-Jul-98
Auction house: Sotheby's, London

DANIELE BUETTI

REPRESENTATION →
Ace Gallery
5514 Wilshire Blvd
USA – Los Angeles, CA 90036
tel: +1 323 935-4411
fax: +1 323 935-9988

arsFutura Galerie
Bleicherweg 45
CH – 8002 Zurich
tel: +41 (0)1 201-8810
fax: +41 (0)1 201-8811
www.arsfutura.ch

COLLECTIONS →
Fonds Régional d'Art
Contemporain, Provence-
Alpes-Côte d'Azur, France
Kunsthaus Bregenz, Austria
Kunsthaus Zürich, Zurich,
Switzerland
Kunstmuseum, Berne, Switzerland
Maison Européenne de la
Photographie, Paris, France
Migros Museum für Gegenwarts-
kunst, Zurich, Switzerland
Museo Nacional Centro de Arte
Reina Sofía, Madrid, Spain

PRICE RANGE →
$1,750 – $10,000 (photographs);
$4,850 – $10,500 (lightboxes);
$30,000 – $50,000 (installations)

AUCTION SALES →
No auction results

ANGELA BULLOCH

REPRESENTATION →
Hauser & Wirth & Presenhuber
Limmatstrasse 270
CH – 8005 Zurich
tel: +41 (0)1 446-8060
fax: +41 (0)1 446-8065
www.ghwp.ch

Magnani
82 Commercial Street
GB – London E1 6LY
tel: +44 (0)20 7375-3002
fax: +44 (0)20 7375-3006

Schipper & Krome
Linienstraße 85
D – 10119 Berlin
tel: +49 (0)30 2839-0139
fax: +49 (0)30 2839-0140
www.schipper-krome.com

COLLECTIONS →
Fondazione Sandretto Re
Rebaudengo per l'Arte, Turin, Italy
Neue Galerie am Landesmuseum
Joanneum, Graz, Austria

PRICE RANGE →
$4,000 – $150,000

Artist Information

AUCTION SALES →
Price: $11,340
Yellow double switch piece
two polycarbonate spheres
lamps, electrical mechanism,
50 x variable x variable cm
Date sold: 08-Dec-99
Auction house: Christie's, London

Price: $11,200
Happy sacks, 1994
canvas polystyrene felt, set of
three, variable x 250 x variable cm
Date sold: 27-Jun-01
Auction house: Christie's, London

JANET CARDIFF

REPRESENTATION →
Luhring Augustine
531 West 24th Street
USA – New York, NY 10011
tel: +1 212 206-9100
fax: +1 212 206-9055
www.luhringaugustine.com

Galerie Barbara Weiss
Zimmerstraße 88–91
D – 10117 Berlin
tel: +49 (0)30 262-4284
fax: +49 (0)30 265-1652
www.galeriebarbaraweiss.de

COLLECTIONS →
Albright-Knox Art Gallery,
Buffalo (NY), USA
Dallas Museum of Art,
Dallas (TX), USA
National Gallery
of Canada, Canada
Tate Gallery, London, UK
The Museum of Modern Art,
New York (NY), USA
San Francisco Museum of
Modern Art, San Francisco (CA),
USA

PRICE RANGE →
Not available

AUCTION SALES →
No auction results

MERLIN CARPENTER

REPRESENTATION →
Galerie Max Hetzler
Zimmerstraße 90/91
D – 10117 Berlin
tel: +49 (0)30 229-2437
fax: +49 (0)30 229-2417
www.maxhetzler.com

Magnani
82 Commercial Street
GB – London E1 6LY
tel: +44 (0)20 7375-3002
fax: +44 (0)20 7375-3006
www.magnani.co.uk

Galerie Christian Nagel
Richard-Wagner-Straße 28
D – 50674 Cologne
tel: +49 (0)221 257-0591
fax: +49 (0)221 257-0592
www.galerie-nagel.de

PRICE RANGE →
$1,500 – $18,000

AUCTION SALES →
No auction results

MAURIZIO CATTELAN

REPRESENTATION →
Massimo De Carlo
Viale Corsica 41
I – 20133 Milan
tel: +39 (0)2 7000-3987
fax: +39 (0)2 749-2135

Marian Goodman Gallery
24 West 57th Street
USA – New York, NY 10019
tel: +1 212 977-7160
fax: +1 212 581-5187
www.mariangoodman.com

Galerie Emmanuel Perrotin
30, rue Louise Weiss
F – 75013 Paris
tel: +33 (0)1 4216-7979
fax: +33 (0)1 4216-7974
www.galerieperrotin.com

COLLECTIONS →
Castello di Rivoli, Museo d'Arte
Contemporanea, Rivoli, Italy
Fonds Régional d'Art
Contemporain, Languedoc-
Roussillon, France
Fondazione Sandretto Re
Rebaudengo per l'Arte, Turin, Italy
Fonds National d'Art
Contemporain, Paris, France
Kunsthaus Zürich, Zurich, Switzerland
Migros Museum für Gegenwarts-
kunst, Zurich, Switzerland
Museum Boijmans Van Beuningen,
Rotterdam, The Netherlands
Museum of Contemporary Art,
Chicago (IL), USA
Solomon R. Guggenheim
Museum, New York (NY), USA
The Israel Museum,

Jerusalem, Israel
The Metropolitan Museum of Art,
New York (NY), USA

PRICE RANGE →
$5,000 – $250,000

AUCTION SALES →
Price: $800,000
La Nona Ora, 1999
wax, cloth, resin, metallic powder,
rock, carpet, glass, dimensions
variable
Date sold: 17-May-01
Auction house: Christie's,
Rockefeller NY

Price: $784,000
La Ballata di Trotsky, 1996
taxidermied horse, saddlery rope,
pulley horse, 270 x 200 x 75 cm
Date sold: 27-Jun-01
Auction house: Christie's, London

Price: $550,000
*The first, they said, sweet like
love, second bitter, like life,
third soft, like death*
taxidermied donkey, dog, cat,
bird, 165 x 120 x 40 cm
Date sold: 14-Nov-01
Auction house: Sotheby's, New
York (NY)

Price: $240,000
Untitled
taxidermied ostrich, 78 x 85 x 33 cm
Date sold: 16-Nov-00
Auction house: Christie's,
Rockefeller NY

Price: $223,200
Untitled – Gerard
life-size plastic dummy, clothes,
shoes blanket
Date sold: 08-Feb-01
Auction house: Christie's, London

JAKE & DINOS CHAPMAN

REPRESENTATION →
Gagosian Gallery
555 West 24th Street
USA – New York, NY 10011
tel: +1 212 741-1111
fax: +1 212 741-9611
www.gagosian.com

Jay Jopling/White Cube²
48 Hoxton Square
GB – London N1 6PB
tel: +44 (0)20 7930-5373
fax: +44 (0)20 7749-7460

www.whitecube.com

Galerie Daniel Templon
30, rue Beaubourg
F – 75003 Paris
tel: +33 (0)1 4272-1410
fax: +33 (0)1 4277-4536
www.danieltemplon.com

COLLECTIONS →
Deste Foundation, Athens, Greece
The British Museum, London, UK
Walker Art Center,
Minneapolis (MN), USA

PRICE RANGE →
$5,000 – $180,000

AUCTION SALES →
Price: $83,520
Cyber-iconic man, 1996
mixed media, 150 x 180 x 140 cm
Date sold: 08-Feb-01
Auction house: Christie's, London

Price: $35,000
Island of Dr. Moron
mixed media, 160 x 130 x 220 cm
Date sold: 27-Jun-01
Auction house: Sotheby's, London

Price: $28,220
Iconic hallucination box
mixed media, 150 x 180 x 140 cm
Date sold: 22-Apr-98
Auction house: Christie's, London

Price: $28,000
Untitled – two faced cunt, 1996
crayon, pencil, 168 x 135 cm
Date sold: 27-Jun-01
Auction house: Christie's, London

Price: $25,200
*Untitled – excess energy
expenditure*, 1996
crayon, pencil, 168 x 135 cm
Date sold: 27-Jun-01
Auction house: Christie's, London

MARTIN CREED

REPRESENTATION →
Gavin Brown's enterprise
436 West 15th Street
USA – New York, NY 10011
tel: +1 212 627-5258
fax: +1 212 627-5261

Cabinet Gallery
20a Northburgh Street
GB – London EC1V 0EA
tel: +44 (0)20 7253-5377

fax: +44 (0)20 7608-2414

Johnen + Schöttle
Maria-Hilf-Straße 17
D – 50677 Cologne
tel: +49 (0)221 310-2727
fax: +49 (0)221 310-2727
www.johnen-schoettle.de

COLLECTIONS →
Arts Council of England, UK
Contemporary Art Society,
London, UK
Government Art Collection,
London, UK
Tate Gallery, London, UK

PRICE RANGE →
$1,500 – $45,000

AUCTION SALES →
No auction results

JOHN CURRIN

REPRESENTATION →
Regen Projects
629 North Almont Drive
USA – Los Angeles, CA 90069
tel: +1 310 276-5424
fax: +1 310 276-7430
www.regenprojects.com

Andrea Rosen Gallery
525 West 24th Street
USA – New York, NY 10011
tel: +1 212 627-6000
fax: +1 212 627-5450
www.andrearosengallery.com

Monika Sprüth –
Philomene Magers
Wormser Straße 23
D – 50677 Cologne
tel: +49 (0)221 380-415
fax: +49 (0)221 380-417
Schellingstraße 48
D – 80799 Munich
tel: +49 (0)89 3304-0600
fax: +49 (0)89 397-302
www.philomenemagers.com

COLLECTIONS →
Indianapolis Museum of Art, USA
Musée national d'art moderne,
Centre Georges Pompidou,
Paris, France
Museum of Contemporary Art,
Chicago (IL), USA
Tate Gallery, London, UK
The Art Institute of Chicago,
Chicago (IL), USA
The Museum of Modern Art,

New York (NY), USA
Walker Art Center,
Minneapolis (MN), USA
Whitney Museum of American Art,
New York (NY), USA

PRICE RANGE →
$20,000 – $120,000

AUCTION SALES →
Price: $300,000
Standing nude, 1993
oil on canvas, 122 x 91 cm
Date sold: 18-May-01
Auction house: Christie's,
Rockefeller NY

Price: $140,000
Grandmother
oil on canvas, 96 x 81 cm
Date sold: 15-Nov-01
Auction house: Christie's,
Rockefeller NY

Price: $130,000
Autumn lovers, 1994
oil on canvas, 101 x 81 cm
Date sold: 16-May-00
Auction house: Christie's,
Rockefeller NY

Price: $116,640
The magnificent bosom, 1997
oil on canvas, 92 x 71 cm
Date sold: 08-Dec-99
Auction house: Christie's, London

Price: $90,600
Sister, 1992
oil on canvas, 91 x 81 cm
Date sold: 27-Jun-00
Auction house: Christie's, London

BJÖRN DAHLEM

REPRESENTATION →
Luis Campaña
An der Schanz 1a
D – 50735 Cologne
tel: +49 (0)221 256-712
fax: +49 (0)221 256-213

Galería Heinrich Ehrhardt
San Lorenzo 11
E – 28004 Madrid
tel: +34 (91) 310-4415
fax: +34 (91) 310-2845

Maschenmode
Guido W. Baudach
Torstraße 230
D – 10115 Berlin
tel/fax: +49 (0)30 2804-7727

www.maschenmode-berlin.de

PRICE RANGE →
$500 – $20,000

AUCTION SALES →
No auction results

TACITA DEAN

REPRESENTATION →
Frith Street Gallery
59–60 Frith Street
GB – London W1V 5TA
tel: +44 (0)20 749-4155
fax: +44 (0)20 7287-3733
www.frithstreetgallery.co.uk

Marian Goodman Gallery
24 West 57th Street
USA – New York, NY 10019
tel: +1 212 977-7160
fax: +1 212 581-5187
www.mariangoodman.com

COLLECTIONS →
ARC Musee d'Art Moderne de la
Ville de Paris, France
Arts Council of England, UK
British Council, UK
De Pont Foundation for
Contemporary Art, Tilburg,
The Netherlands
Emanuel Hoffmann Foundation,
Basel, Basle, Switzerland
Fonds National d'Art Contemporain,
Paris, France
Fonds Régional d'Art
Contemporain, Bretagne, France
Fundació "la Caixa",
Barcelona, Spain
Haags Gemeentemuseum,
The Netherlands
Hyogo Prefectural Museum of
Modern Art, Japan
Kunstmuseum Winterthur,
Switzerland
Leeds City Art Gallery, Leeds, UK
Museo Nacional Centro de Arte
Reine Sofía, Madrid, Spain
Tate Gallery, London, UK
The Art Institute of Chicago,
Chicago (IL), USA

PRICE RANGE →
$850 – $1,705 (prints); $5,500
(photographs); $25,000 (films);
$42,000 (films with photographs
or drawings)

AUCTION SALES →
Price: $36,000
Disappearance at sea I–VI, 1995

chalk on blackboard, six panels,
240 x 240 cm
Date sold: 08-Feb-01
Auction house: Christie's, London

THOMAS DEMAND

REPRESENTATION →
Victoria Miro Gallery
16 Wharf Road
GB – London N1 7RW
tel: +44 (0)20 7336-8109
fax: +44 (0)20 7251-5596
www.victoria-miro.com

Schipper & Krome
Linienstraße 85
D – 10119 Berlin
tel: +49 (0)30 2839-0139
fax: +49 (0)30 2839-0140
www.schipper-krome.com

Monika Sprüth –
Philomene Magers
Wormser Straße 23
D – 50677 Cologne
tel: +49 (0)221 380-415
fax: +49 (0)221 380-417
Schellingstraße 48
D – 80799 Munich
tel: +49 (0)89 3304-0600
fax: +49 (0)89 397-302
www.philomenemagers.com

303 Gallery
525 West 22nd Street
USA – New York, NY 10011
tel: +1 212 255-1121
fax: +1 212 255-0024
www.303gallery.com

COLLECTIONS →
Carnegie Museum of Art,
Pittsburgh (PA), USA
Fondazione Sandretto Re
Rebaudengo per l'Arte, Turin, Italy
Museum of Contemporary Art,
Chicago (IL), USA
Solomon R. Guggenheim
Museum, New York (NY), USA
Staatsgalerie Moderner Kunst,
Munich, Germany
Tate Gallery, London, UK
The Museum of Modern Art,
New York (NY), USA

PRICE RANGE →
$9,000 – $44,000

AUCTION SALES →
Price: $91,650
Studio, 1998
c-print, num. 5/6, 183 x 350 cm

Artist Information

Date sold: 06-Feb-02
Auction house: Christie's, London

Price: $85,000
Büro, 1995
chromogenic print and Diasec,
num. 5/5, 184 x 240 cm
Date sold: 17-May-01
Auction house: Christie's,
Rockefeller NY

Price: $85,000
Scheune – Barn, 1997
chromogenic print on photo-
graphic paper, 183 x 254 cm
Date sold: 15-Nov-01
Auction house: Christie's,
Rockefeller NY

Price: $75,000
Archiv – archive, 1995
chromogenic print on photo-
graphic paper, 183 x 233 cm
Date sold: 15-Nov-01
Auction house: Christie's,
Rockefeller NY

Price: $55,000
Badezimmer – Beaux rivage, 1997
chromogenic print on photo-
graphic paper, 160 x 122 cm
Date sold: 18-May-01
Auction house: Christie's,
Rockefeller NY

RINEKE DIJKSTRA

REPRESENTATION →
Marian Goodman Gallery
24 West 57th Street
USA – New York, NY 10019
tel: +1 212 977-7160
fax: +1 212 581-5187
www.mariangoodman.com

Galerie Max Hetzler
Zimmerstraße 90/91
D – 10117 Berlin
tel: +49 (0)30 229-2437
fax: +49 (0)30 229-2417
www.maxhetzler.com

COLLECTIONS →
Musée national d'art moderne,
Centre Georges Pompidou,
Paris, France
The Art Institute of Chicago,
Chicago (IL), USA
The Museum of Modern Art,
New York (NY), USA
Staatsgalerie Moderner Kunst,
Munich, Germany

PRICE RANGE →
$20,000 – $50,000

AUCTION SALES →
Price: $90,000
*Julie, Den Haag. Saskia,
Harderwijk. Tecla,
Amsterdam,* 1994
colour coupler prints set
of three, 154 x 130 cm
Date sold: 15-Nov-01
Auction house: Christie's,
Rockefeller NY

Price: $64,860
*Coney Island, NY, USA, June 20,
1993,* 1996
c-print, 153 x 129 cm
Date sold: 06-Feb-02
Auction house: Christie's, London

Price: $46,000
Jalta, Ukraine, July 29, 1993, 1999
colour coupler print, 153 x 129 cm
Date sold: 13-Nov-00
Auction house: Phillips,
New York (NY)

Price: $31,680
Jalta, Ukraine, July 29. 1993
c-print, num. 1/6, 153 x 129 cm
Date sold: 09-Feb-01
Auction house: Christie's, London

Price: $30,000
*Hilton Head Island, South
Carolina,* 1992
colour coupler print, 34 x 28 cm
Date sold: 18-May-01
Auction house: Christie's,
Rockefeller NY

MARK DION

REPRESENTATION →
Tanya Bonakdar
521 West 21st Street
USA – New York, NY 10011
tel: +1 212 414-4144
fax: +1 212 414-1535
www.tanyabonakdargallery.com

Georg Kargl
Schleifmühlgasse 5
A – 1040 Vienna
tel: +43 (0)1 585-4199
fax: +43 (0)1 5854-1999

Galerie Christian Nagel
Richard-Wagner-Straße 28
D – 50674 Cologne
tel: +49 (0)221 257-0591
fax: +49 (0)221 257-0592

www.galerie-nagel.de

COLLECTIONS →
Fonds Régional d'Art
Contemporain, Languedoc-
Roussillon, France
Kunsthaus Zürich, Zurich,
Switzerland
Museum of Contemporary Art
San Diego (CA), USA
Tate Gallery, London, UK
The Israel Museum,
Jerusalem, Israel

PRICE RANGE →
$1,000 – $90,000

AUCTION SALES →
No auction results

PETER DOIG

REPRESENTATION →
Gavin Brown's enterprise
436 West 15th Street
USA – New York, NY 10011
tel: +1 212 627-5258
fax: +1 212 627-5261

Contemporary Fine Arts
Sophienstraße 21
D – 10178 Berlin
tel: +49 (0)30 288-7870
fax: +49 (0)30 2887-8726
www.cfa-berlin.com

Victoria Miro Gallery
16 Wharf Road
GB – London N1 7RW
tel: +44 (0)20 7336-8109
fax: +44 (0)20 7251-5596
www.victoria-miro.com

COLLECTIONS →
Arts Council of England, UK
Astrup Fearnley Museum of
Modern Art, Oslo, Norway
British Council, UK
Contemporary Arts Society,
London, UK
European Parliament,
Brussels, Belgium
Kunsthalle zu Kiel, Germany
Tate Gallery, London, UK
The Art Institute of Chicago,
Chicago (IL), USA
The Museum of Contemporary
Art, Los Angeles (CA), USA
The Museum of Modern Art,
New York (NY), USA
Walker Art Gallery, Liverpool, UK

PRICE RANGE →
$90,000 – $120,000
(large paintings)

AUCTION SALES →
Price: $408,900
Swamped, 1990
oil on canvas, 197 x 241 cm
Date sold: 07-Feb-02
Auction house: Sotheby's, London

Price: $153,900
Lunker
oil on canvas, 200 x 266 cm
Date sold: 08-Dec-99
Auction house: Christie's, London

Price: $140,000
Briey, concrete cabin, 1994
oil on canvas, 275 x 200 cm
Date sold: 16-Nov-00
Auction house: Christie's,
Rockefeller NY

Price: $140,000
Concrete cabin, 1994
oil on canvas, 198 x 275 cm
Date sold: 18-May-00
Auction house: Phillips,
New York (NY)

Price: $120,000
Bellevarde, 1995
oil on canvas, 200 x 275 cm
Date sold: 17-May-01
Auction house: Christie's,
Rockefeller NY

KEITH EDMIER

REPRESENTATION →
Sadie Coles HQ
35 Heddon Street
GB – London W1B 4BP
tel: +44 (0)20 7434-2227
fax: +44 (0)20 7434-2228
www.sadiecoles.com

neugerriemschneider
Linienstraße 155
D – 10115 Berlin
tel: +49 (0)30 3087-2810
fax: +49 (0)30 3087-2811

Friedrich Petzel Gallery
535 West 22nd Street
USA – New York, NY 10011
tel: +1 212 680-9467
fax: +1 212 680-9473
www.petzel.com

COLLECTIONS →
Museum of Contemporary Art,

Chicago (IL), USA
Tate Gallery, London, UK

PRICE RANGE →
$10,000 – $150,000

AUCTION SALES →
No auction results

OLAFUR ELIASSON

REPRESENTATION →
Tanya Bonakdar
521 West 21st Street
USA – New York, NY 10011
tel: +1 212 414-4144
fax: +1 212 414-1535
www.tanyabonakdargallery.com

neugerriemschneider
Linienstraße 155
D – 10115 Berlin
tel: +49 (0)30 3087-2810
fax: +49 (0)30 3087-2811

COLLECTIONS →
K21 Kunstsammlung im
Ständehaus, Düsseldorf, Germany
San Francisco Museum of Modern
Art, San Francisco (CA), USA
Solomon R. Guggenheim
Museum, New York (NY), USA
The Art Institute of Chicago,
Chicago (IL), USA

PRICE RANGE →
$1,000 – $180,000

AUCTION SALES →
Price: $3,575
Untitled, num. 49
colour coupler print, num. 1/1,
60 x 90 cm
Date sold: 23-Oct-01
Auction house: Christie's, London

MICHAEL ELMGREEN
& INGAR DRAGSET

REPRESENTATION →
Tanya Bonakdar
521 West 21st Street
USA – New York, NY 10011
tel: +1 212 414-4144
fax: +1 212 414-1535
www.tanyabonakdargallery.com

Klosterfelde
Zimmerstraße 90/91
D – 10117 Berlin
tel: +49 (0)30 283-5305
fax: +49 (0)30 283-5306

www.klosterfelde.de

Galleri Nicolai Wallner
Njalsgade 21
DK – 2300 Copenhagen
tel: +45 3257-0970
fax: +45 3257-0971
www.nicolaiwallner.com

COLLECTIONS →
Horsens Kunstmuseum, Denmark
Louisiana Museum of Modern Art,
Humlebæk, Denmark
Malmö Konstmuseum, Sweden
Moderna Museet, Stockholm,
Sweden

PRICE RANGE →
$1,000 – $50,000

AUCTION SALES →
No auction results

TRACEY EMIN

REPRESENTATION →
carlier I gebauer
Holzmarktstraße 15–18
S-Bahnbogen 51/52
D – 10179 Berlin
tel: +49 (0)30 280-8110
fax: +49 (0)30 280-8109
www.carliergebauer.com

Jay Jopling/White Cube[2]
48 Hoxton Square
GB – London N1 6PB
tel: +44 (0)20 7930-5373
fax: +44 (0)20 7749-7460
www.whitecube.com

Lehmann Maupin
39 Greene Street
USA – New York, NY 10013
tel: +1 212 965-0753
fax: +1 212 965-0754

COLLECTIONS →
Art/Pace Roberts Foundation,
San Antonio (TX), USA
Arts Council of England, UK
Hamburger Kunsthalle,
Hamburg, Germany
Mattress Factory,
Pittsburgh (PA), USA
Musée national d'art moderne,
Centre Georges Pompidou,
Paris, France
Museum of Contemporary Art,
San Diego (CA), USA
Museum van Loon, Amsterdam,
The Netherlands
National Portrait Gallery, London, UK

Neue Nationalgalerie im
Hamburger Bahnhof, Museum für
Gegenwart, Berlin, Germany
Scottish National Gallery,
Edinburgh, UK
Tate Gallery, London, UK
The British Museum, London, UK
Walker Art Center,
Minneapolis (MN), USA

PRICE RANGE →
$6,000 – $115,000

AUCTION SALES →
Price: $136,800
*Exorcism of the last painting
I ever made*, 1996
installation with many objects,
dimensions variable
Date sold: 08-Feb-01
Auction house: Christie's, London

Price: $20,020
*It's not me that's crying it's
my soul*, 1996
red neon, 14 x 220 x variable cm
Date sold: 23-Oct-01
Auction house: Sotheby's, London

Price: $18,200
My abortion, 1990
water colour, pencil, pen, ink,
glass, plastic bottle
Date sold: 29-Jun-01
Auction house: Christie's,
Kensington

Price: $15,840
*Naked photos –
life model goes mad*, 1996
set of nine colour photographs,
53 x 52 cm
Date sold: 08-Feb-01
Auction house: Christie's, London

Price: $12,690
Sobasex
neon, Plexiglas, num. 2/3,
51 x 514 x 9 cm
Date sold: 08-Feb-02
Auction house: Sotheby's, London

AYŞE ERKMEN

REPRESENTATION →
Galleria Continua
Via del Castello, II
I – 53037 San Gimignano (Siena)
tel: +39 (0)577 943-134
fax: +39 (0)577 940-484
www.galleriacontinua.com

Galerie Nächst St. Stephan
Rosemarie Schwarzwälder
Grünangergasse 1/2
A – 1010 Vienna
tel: +43 (0)1 512-1266
fax: +43 (0)1 513-4307
www.schwarzwaelder.at

Galerie Barbara Weiss
Zimmerstraße 88–91
D – 10117 Berlin
tel: +49 (0)30 262-4284
fax: +49 (0)30 265-1652
www.galeriebarbaraweiss.de

PRICE RANGE →
Not available

AUCTION SALES →
No auction results

MALACHI FARRELL

REPRESENTATION →
Xippas
108, rue Vieille-du-Temple
F – 75003 Paris
tel: +33 (0)1 4027-0555
fax: +33 (0)1 4027-0716

COLLECTIONS →
Fonds National d'Art
Contemporain, Paris, France
Musée d'Art Contemporain,
Marseille, France

PRICE RANGE →
$1,000 – $5,000 (drawings);
$5,000 – $40,000 (installations)

AUCTION SALES →
No auction results

SYLVIE FLEURY

REPRESENTATION →
chouakri brahms berlin
Holzmarktstraße 15–18
S-Bahnbogen 47
D – 10179 Berlin
tel: +49 (0)30 2839-1153
fax: +49 (0)30 2839-1154
www.chouakribrahms-berlin.com

Hauser & Wirth & Presenhuber
Limmatstrasse 270
CH – 8005 Zurich
tel: +41 (0)1 446-8060
fax: +41 (0)1 446-8065
www.ghwp.ch

Artist Information

Monika Sprüth –
Philomene Magers
Wormser Straße 23
D – 50677 Cologne
tel: +49 (0)221 380-415
fax: +49 (0)221 380-417
Schellingstraße 48
D – 80799 Munich
tel: +49 (0)89 3304-0600
fax: +49 (0)89 397-302
www.philomenemagers.com

COLLECTIONS →
Centre d'Art contemporain Fri-Art,
Fribourg, Switzerland
Centre Pasq'Art, Biel, Switzerland
Centre pour l'image contemporaine,
Saint-Gérvais, Geneva,
Switzerland
Denver Art Museum,
Denver (CO), USA
Kunsthaus Bregenz, Austria
Kunsthaus Zürich, Zurich,
Switzerland
Kunstmuseum St. Gallen,
Switzerland
Le Consortium, Dijon, France
Le Magasin, Grenoble, France
Migros Museum für Gegenwarts-
kunst, Zurich, Switzerland
Musée d'art moderne et contem-
porain, Geneva, Switzerland

PRICE RANGE →
$2,000 (video stills); $5,000
(small neon works); $120,000
(installations)

AUCTION SALES →
Price: $37,440
Skin crime 3 – Givenchy, 1997
compressed car, enamel,
90 x 150 x 390 cm
Date sold: 08-Feb-01
Auction house: Christie's, London

Price: $35,000
Louis Vuitton, 2000
solid bronze, silver, 46 x 79 x 20 cm
Date sold: 15-May-01
Auction house: Phillips,
New York (NY)

Price: $12,534
Gucci
bronze pair, num. 6/8,
11 x 22 x 8 cm
Date sold: 18-Dec-01
Auction house: Artcurial Briest,
Paris

Price: $6,804
Sex money compromise, 1993
cibachrome on aluminium,

155 x 120 cm
Date sold: 10-Dec-99
Auction house: Sotheby's, London

Price: $5,500
Glamour, 1992
photograph mounted on
aluminium, 158 x 120 cm
Date sold: 15-May-01
Auction house: Christie's East,
New York (NY)

CEAL FLOYER

REPRESENTATION →
Casey Kaplan
416 West 14th Street
USA – New York, NY 10014
tel: +1 212 645-7335
fax: +1 212 645-7835

Lisson Gallery
52–54 Bell Street
GB – London NW1 5DA
tel: +44 (0)20 7724-2739
fax: +44 (0)20 7724-7124
www.lisson.co.uk

COLLECTIONS →
La Colección Júmex,
Mexico City, Mexico
New Museum of Contemporary
Art, New York (NY), USA

PRICE RANGE →
Not available

AUCTION SALES →
No auction results

TOM FRIEDMAN

REPRESENTATION →
Feature Inc.
530 West 25th Street
USA – New York, NY 10001
tel: +1 212 675-7772
fax: +1 212 675-7773
www.featureinc.com

Stephen Friedman Gallery
25–28 Old Burlington Street
GB – London W1S 3AN
tel: +44 (0)20 7494-1434
fax: +44 (0)20 7494-1431
www.stephenfriedman.com

Tomio Koyama Gallery
Saga 1-8-13-2F, Koto-ku
JPN – Tokyo 135-0031
tel/fax: +81 (0)3 3630-2205

PRICE RANGE →
$1,800 – $100,000

AUCTION SALES →
Price: $75,000
Untitled, fly
paint, plastic, hair fuzz,
play-doh, wire, 1 x 1 x 2 cm
Date sold: 17-Nov-00
Auction house: Christie's,
Rockefeller NY

Price: $50,000
Untitled, 1990
bar of soap, artist pubic hair,
8 x 10 x 4 cm
Date sold: 15-Nov-01
Auction house: Christie's,
Rockefeller NY

Price: $46,810
Untitled
black and white photograph,
num. 7, 89 x 63 cm
Date sold: 28-Jun-00
Auction house: Christie's, London

Price: $28,000
Untitled, spider, 1998
clay, fishline hair, paint,
13 x 10 x 2 cm
Date sold: 18-May-01
Auction house: Christie's,
Rockefeller NY

Price: $26,600
Untitled, curse, 1992
cursed space plinth, 13 x 10 x 2 cm
Date sold: 27-Jun-01
Auction house: Christie's, London

ELLEN GALLAGHER

REPRESENTATION →
Gagosian Gallery
555 West 24th Street
USA – New York, NY 10011
tel: +1 212 741-1111
fax: +1 212 741-9611
www.gagosian.com

Galerie Max Hetzler
Zimmerstraße 90/91
D – 10117 Berlin
tel: +49 (0)30 229-2437
fax: +49 (0)30 229-2417
www.maxhetzler.com

COLLECTIONS →
Nationalgalerie im Hamburger
Bahnhof, Museum für Gegenwart,
Berlin, Germany
Solomon R. Guggenheim

Museum, New York (NY), USA
San Francisco Museum of Modern
Art, San Francisco (CA), USA
The Museum of Modern Art,
New York (NY), USA

PRICE RANGE →
$15,000 – $100,000

AUCTION SALES →
Price: $100,000
Soma, 1998
oil, pencil, paper, canvas,
244 x 213 cm
Date sold: 15-May-01
Auction house: Sotheby's,
New York (NY)

Price: $40,000
Untitled, 1992
graphite, collage on panel,
152 x 38 cm.
Date sold: 20-May-99
Auction house: Christie's,
Rockefeller NY

KENDELL GEERS

REPRESENTATION →
Buchmann Galerie
Aachener Straße 65
D – 50674 Cologne
tel: +49 (0)221 730-650
fax: +49 (0)221 730-420

Stephen Friedman Gallery
25–28 Old Burlington Street
GB – London W1S 3AN
tel: +44 (0)20 7494-1434
fax: +44 (0)20 7494-1431
www.stephenfriedman.com

PRICE RANGE →
$5,000 – $40,000

AUCTION SALES →
Price: $314
Untitled – sex – diptych
part one and two
mixed media board, 112 x 150 cm
Date sold: 07-May-01
Auction house: Stephan Welz,
Johannesburg

LIAM GILLICK

REPRESENTATION →
Casey Kaplan
416 West 14th Street
USA – New York, NY 10014
tel: +1 212 645-7335
fax: +1 212 645-7835

Hauser & Wirth & Presenhuber
Limmatstrasse 270
CH – 8005 Zurich
tel: +41 (0)1 446-8060
fax: +41 (0)1 446-8065
www.ghwp.ch

Schipper & Krome
Linienstraße 85
D – 10119 Berlin
tel: +49 (0)30 2839-0139
fax: +49 (0)30 2839-0140
www.schipper-krome.com

COLLECTIONS →
Arts Council of England, UK
K21 Kunstsammlung im
Ständehaus, Düsseldorf, Germany
Fonds National d'Art
Contemporain, Paris, France
Solomon R. Guggenheim
Museum, New York (NY), USA
Tate Gallery, London, UK

PRICE RANGE →
$10 (books) – $90,000

AUCTION SALES →
Price: $1,660
Single leaning corner rail, 1989
nylon covered steel,
150 x 3 cm x variable
Date sold: 23-Jun-97
Auction house: Sotheby's, London

DOMINIQUE
GONZALEZ-FOERSTER

REPRESENTATION →
Galerie Jennifer Flay
20, rue Louise Weiss
F – 75013 Paris
tel: +33 (0)1 4406-7360
fax: +33 (0)1 4406-7366

Schipper & Krome
Linienstraße 85
D – 10119 Berlin
tel: +49 (0)30 2839-0139
fax: +49 (0)30 2839-0140
www.schipper-krome.com

COLLECTIONS →
ARC Musée d'Art Moderne
de la Ville de Paris, France
Espace d'Art Moderne et
Contemporain de Toulouse
et Midi, France
Fonds National des Arts
Plastiques, France
Fondation François Pinault, France
Fonds Régional d'Art
Contemporain, Corse, France

Fonds Régional d'Art
Contemporain, Languedoc-
Roussillon, France
Fonds Régional d'Art Contemporain,
Nord Pas de Calais, France
Fonds Régional d'Art Contemporain,
Pays de Loire, France
Moderna Museet,
Stockholm, Sweden
Musée national d'art moderne,
Centre Georges Pompidou,
Paris, France

PRICE RANGE →
$8,000 – $50,000

AUCTION SALES →
No auction results

FELIX GONZALEZ-TORRES

The Estate is represented by
Andrea Rosen Gallery
525 West 24th Street
USA – New York, NY 10011
tel: +1 212 627-6000
fax: +1 212 627-5450
www.andrearosengallery.com

COLLECTIONS →
The Museum of Modern Art,
New York (NY), USA
Whitney Museum of Art,
New York (NY), USA
Solomon R Guggenheim Museum,
New York (NY), USA
Walker Art Center,
Minneapolis (MN), USA
San Francisco Museum of Modern
Art, San Francisco (CA), USA
Hirshhorn Museum and Sculpture
Garden, Washington DC
Philadelphia Museum of Art,
Philadelphia (PA), USA
The Museum of Contemporary
Art, Los Angeles (CA), USA
Art Gallery of Ontario, Toronto,
Canada
Astrup Fearnley Museum of
Modern Art, Oslo, Norway
Sprengel Museum, Hanover,
Germany

PRICE RANGE →
$10,000 – $1 million

AUCTION SALES →
Price: $1,500,000
Untitled, Blood
plastic beads, metal rod,
dimensions variable
Date sold: 16-Nov-2000
Auction house: Christie's,

Rockefeller NY

Price: $600,000
Untitled – Blue placebo
candies, individually wrapped in
blue cellophane, 325 lbs.,
dimensions variable
Date sold: 15-Nov-2001
Auction house: Christie's,
Rockefeller NY

Price: $410,000
Lover boys
blue white candies, wrapped in
cellophane, dimensions variable
Date sold: 14-Nov-2000
Auction house: Sotheby's,
New York (NY)

Price: $280,000
Untitled, double bloodworks
acrylic, graphite on canvas on two
panels, 36 x 66 cm
Date sold: 17-May-2001
Auction house: Christie's,
Rockefeller NY

Price: $157,700
Untitled, Rossmore
green sweets, wrapped in
cellophane, 4 x 488 x 36 cm
Date sold: 22-Apr-1998
Auction house: Christie's, London

DOUGLAS GORDON

REPRESENTATION →
Gagosian Gallery
555 West 24th Street
USA – New York, NY 10011
tel: +1 212 741-1111
fax: +1 212 741-9611
www.gagosian.com

Galerie Yvon Lambert
108, rue Vieille-du-Temple
F – 75003 Paris
tel: +33 (0)1 4271-0933
fax: +33 (0)1 4271-8747

Lisson Gallery
52–54 Bell Street
GB – London NW1 5DA
tel: +44 (0)20 7724-2739
fax: +44 (0)20 7724-7124
www.lisson.co.uk

COLLECTIONS →
La Colección Júmex,
Mexico City, Mexico
Musée national d'art moderne,
Centre Georges Pompidou,
Paris, France

Stedelijk Van Abbemuseum,
Eindhoven, The Netherlands
Solomon R. Guggenheim
Museum, New York (NY), USA
Tate Gallery, London, UK
The Museum of Contemporary
Art, Los Angeles (CA), USA

PRICE RANGE →
$1,000 – $150,000

AUCTION SALES →
Price: $36,660
Instruction No. 8, 1994
certificate with two black white
photographs, 57 x 64 cm
Date sold: 07-Feb-02
Auction house: Sotheby's, London

Price: $17,820
*Douglas Gordon sings
the best of Lou Reed and
the Velvet Underground*
video installation, num. 1/3,
48 x variable cm
Date sold: 08-Dec-99
Auction house: Christie's, London

ANDREAS GURSKY

REPRESENTATION →
Mai 36 Galerie
Rämistrasse 37
CH – 8001 Zurich
tel: +41 (0)1 261-6880
fax: +41 (0)1 261-6881
www.artgalleries.ch/mai 36

Matthew Marks Gallery
523 West 24th Street
USA – New York, NY 10011
tel: +1 212 243-0200
fax: +1 212 243-0047

Monika Sprüth –
Philomene Magers
Wormser Straße 23
D – 50677 Cologne
tel: +49 (0)221 380-415
fax: +49 (0)221 380-417
Schellingstraße 48
D – 80799 Munich
tel: +49 (0)89 3304-0600
fax: +49 (0)89 397-302
www.philomenemagers.com

COLLECTIONS →
Kunsthalle Zürich, Zurich,
Switzerland
K21 Kunstsammlung im
Ständehaus, Düsseldorf, Germany
Musée national d'art moderne,
Centre Georges Pompidou,

Artist Information

Paris, France
Museum Ludwig, Cologne,
Germany
Tate Modern, London, UK
The Museum of Modern Art,
New York (NY), USA

PRICE RANGE →
$9,000 – $175,000

AUCTION SALES →
Price: $549,900
Untitled V, 1997
num. 6/6, 185 x 443 cm
Date sold: 06-Feb-02
Auction house: Christie's, London

Price: $540,000
Paris, Montparnasse, 1993
colour coupler print, 147 x 357 cm
Date sold: 15-Nov-01
Auction house: Christie's,
Rockefeller NY

Price: $273,600
O. T. VI, 1997
cibachrome print, num. 3/6,
186 x 239 cm
Date sold: 07-Feb-01
Auction house: Sotheby's, London

Price: $260,000
N.Y. Mercantile Exchange, 2000
colour coupler print on Plexiglas,
num. 1/6, 207 x 258 cm
Date sold: 17-May-01
Auction house: Christie's,
Rockefeller NY

Price: $240,000
Prada II, 1997
colour coupler print, num. 3/6,
166 x 316 cm
Date sold: 16-Nov-00
Auction house: Christie's,
Rockefeller NY

FABRICE GYGI

REPRESENTATION →
Galerie Bob van Orsouw
Limmatstrasse 270
Ch – 8005 Zurich
tel: +41 (0)1 273-1100
fax: +41 (0)1 273-1102

Galerie Chantal Crousel
40, rue Quincampoix
F – 75004 Paris
tel: +33 (0)1 4277-3887
fax: +33 (0)1 4277-5900
www.crousel.com

COLLECTIONS →
Centre National des Arts
Plastiques, Paris, France
Centre National d'Art
Contemporain, Grenoble, France
Fondation Municipal d'Art
Contemporain, Geneva, Switzerland
Fonds Cantonal de décoration et
d'Art Visuel, Geneva, Switzerland
Fonds Régional d'Art
Contemporain, Bourgogne, France
Fonds Régional d'Art
Contemporain, Ile de France, France
Migros Museum für Gegenwarts-
kunst, Zurich, Switzerland
Musée d'Art Moderne et
Contemporain, Geneva, Switzerland
Stedelijk Museum, Amsterdam,
The Netherlands

PRICE RANGE →
$4,000 – $35,000

AUCTION SALES →
No auction results

THOMAS HIRSCHHORN

REPRESENTATION →
Arndt & Partner
Zimmerstraße 90/91
D – 10117 Berlin
tel: +49 (0)30 280-8123
fax: +49 (0)30 283-3738
www.arndt-partner.de

Stephen Friedman Gallery
25–28 Old Burlington Street
GB – London W1S 3AN
tel: +44 (0)20 7494-1434
fax: +44 (0)20 7494-1431
www.stephenfriedman.com

Barbara Gladstone Gallery
515 West 24th Street
USA – New York, NY 10011
tel: +1 212 206-9300
fax: +1 212 206-9301
www.gladstonegallery.com

COLLECTIONS →
Bonnefanten Museum,
Maastricht, The Netherlands
Fondació Arco, Santiago de
Compostela, Spain
Fondation Lambert, Avignon, France
Fondation Musée d'Art Moderne
Grand-Duc Jean, Luxembourg
Fonds Municipal d'Art Contem-
porain, Geneva, Switzerland
Fonds National d'Art
Contemporain, Paris, France
Fonds Régional d'Art

Contemporain, Aquitaine, France
Fonds Régional d'Art
Contemporain, Corse, France
Fonds Régional d'Art
Contemporain, Provence-Alpes-
Côtes d'Azur, France
Kunsthaus Zürich, Zurich,
Switzerland
Kunstmuseum Basel, Basle,
Switzerland
Kunstmuseum, St. Gallen,
Switzerland
Musée d'Art Moderne,
Saint-Etienne, France
Musée national d'art moderne,
Centre Georges Pompidou,
Paris, France
Fondazione Re Rebaudengo
per l'Arte, Turin, Italy
Sammlung Stiftung Kunst Heute,
Berne, Switzerland
Stedelijk Museum voor Actuele
Kunst, Ghent, Belgium
The Art Institute of Chicago,
Chicago (IL), USA
The Museum of Modern Art,
New York (NY), USA
Universität Irchel, Zurich, Switzerland
Walker Art Center,
Minneapolis (MN), USA

PRICE RANGE →
from $2,500 (drawings);
$10,000 – $200,000 (installations)

AUCTION SALES →
No auction results

DAMIEN HIRST

REPRESENTATION →
Gagosian Gallery
555 West 24th Street
USA – New York, NY 10011
tel: +1 212 741-1111
fax: +1 212 741-9611
www.gagosian.com

Jay Jopling/White Cube[2]
48 Hoxton Square
GB – London N1 6PB
tel: +44 (0)20 7930-5373
fax: +44 (0)20 7749-7460
www.whitecube.com

COLLECTIONS →
Astrup Fearnley Museum of
Contemporary Art, Oslo, Norway
Beckman Foundation,
New York (NY), USA
British Council, UK
Denver Art Museum,
Denver (CO), USA

Deste Foundation, Athens, Greece
Fondazione Sandretto Re
Rebaudengo per l'Arte, Turin, Italy
Fondazione Prada, Milan, Italy
Hirshhorn Museum and Sculpture
Garden, Washington DC, USA
The Israel Museum, Jerusalem,
Israel
Kunstmuseum Wolfsburg,
Germany
The Museum of Modern Art,
New York (NY), USA
San Diego Museum of Contem-
porary Art, San Diego (CA), USA
Scottish National Gallery,
Edinburgh, UK
Stedelijk Museum, Amsterdam,
The Netherlands
Tate Gallery, London, UK
Yale Center for British Art,
New Haven (CT), USA

PRICE RANGE →
Not available

AUCTION SALES →
Price: $680,000
In love – out of love
gloss household paint, butterflies,
diptych, 121 x 244 cm
Date sold: 13-Nov-2000
Auction house: Phillips,
New York (NY)

Price: $500,000
Out of sight, out of mind
glass, steel, two cows heads,
formaldehyde solution, two parts,
46 x 84 x 46 cm
Date sold: 18-May-2000
Auction house: Phillips,
New York (NY)

Price: $460,000
*Dead ends died out –
examined*, 1993
cigarette butts, wooden glass
vitrine, 152 x 243 x 12 cm
Date sold: 13-Nov-2000
Auction house: Phillips,
New York (NY)

Price: $320,000
My Way, 1990/91
glass, steel, board, old drug
bottles, 137 x 102 x 23 cm
Date sold: 16-Nov-1999
Auction house: Christie's,
Rockefeller NY

Price: $300,000
Amphotericin B, 1993
gloss household paint,
305 x 335 cm

Date sold: 17-May-2000
Auction house: Sotheby's,
New York (NY)

CARSTEN HÖLLER

REPRESENTATION →
Air de Paris
32, rue Louise Weiss
F – 75013 Paris
tel: +33 (0)1 4423-0277
fax: +33 (0)1 5361-2284
www.airdeparis.com

Casey Kaplan
416 West 14th Street
USA – New York, NY 10014
tel: +1 212 645-7335
fax: +1 212 645-7835

Schipper & Krome
Linienstraße 85
D – 10119 Berlin
tel: +49 (0)30 2839-0139
fax: +49 (0)30 2839-0140
www.schipper-krome.com

COLLECTIONS →
Centre National des Arts
Plastiques, France
Fondazione Prada, Milan, Italy
Fonds Régional d'Art
Contemporain, Languedoc-
Roussillon, France
Kunsthaus Zürich, Zurich, Switzerland
Moderna Museet,
Stockholm, Sweden
Museum für Moderne Kunst,
Frankfurt am Main, Germany
Stedelijk Museum voor Actuele
Kunst, Ghent, Belgium

PRICE RANGE →
$1,200 – $120,000

AUCTION SALES →
Price: $5,285
220 volts
plugs, flex, chocolates,
dimensions variable
Date sold: 28-Jun-00
Auction house: Christie's, London

JONATHAN HOROWITZ

REPRESENTATION →
China Art Objects Galleries
933 Chung King Road
USA – Los Angeles, CA 90012
tel/fax: +1 213 613-0384

Greene Naftali
526 West 26th Street
USA – New York, NY 10001
tel: +1 212 463-7770
fax: +1 212 463-0890

Galerie Yvon Lambert
108, rue Vieille-du-Temple
F – 75003 Paris
tel: +33 (0)1 4271-0933
fax: +33 (0)1 4271-8747

COLLECTIONS →
Musée national d'art moderne,
Centre Georges Pompidou,
Paris, France
New Museum of Contemporary
Art, New York (NY), USA
Stedelijk Museum voor Actuele
Kunst, Ghent, Belgium

PRICE RANGE →
$1,000 – $25,000

AUCTION SALES →
No auction results

GARY HUME

REPRESENTATION →
Jay Jopling/White Cube²
48 Hoxton Square
GB – London N1 6PB
tel: +44 (0)20 7930-5373
fax: +44 (0)20 7749-7460
www.whitecube.com

Matthew Marks Gallery
523 West 24th Street
USA – New York, NY 10011
tel: +1 212 243-0200
fax: +1 212 243-0047

COLLECTIONS →
Astrup Fearnley Museum of
Modern Art, Oslo, Norway
Bonnefanten Museum,
Maastricht, The Netherlands
Kunstmuseum Wolfsburg, Germany
Tate Gallery, London, UK

PRICE RANGE →
$17,000 – $145,000

AUCTION SALES →
Price: $244,800
Love loves unlovable, 1994
glass paint on panel, 216 x 366 cm
Date sold: 08-Feb-01
Auction house: Christie's, London

Price: $140,000
Pauline, 1996

verso gloss paint aluminium,
208 x 117 cm
Date sold: 14-Nov-00
Auction house: Sotheby's,
New York (NY)

Price: $95,880
Tony Blackburn, 1993
gloss paint MDF panel, 193 x 137 cm
Date sold: 06-Feb-02
Auction house: Christie's, London

Price: $86,400
Untitled – portrait of Zoe, 1999
enamel on aluminium, 104 x 73 cm
Date sold: 08-Feb-01
Auction house: Christie's, London

Price: $84,000
Like father like son, 1998
household paint, mixed media
on aluminium, 200 x 162 cm
Date sold: 27-Jun-01
Auction house: Christie's, London

PIERRE HUYGHE

REPRESENTATION →
Marian Goodman Gallery
24 West 57th Street
USA – New York, NY 10019
tel: +1 212 977-7160
fax: +1 212 581-5187
www.mariangoodmann.com

Roger Pailhas Gallery
20, quai de Rive Neuve
F – 13007 Marseille
tel: +33 (0)4 9154-0222
fax: +33 (0)4 9155-6688
www.rogerpailhas.com

Schipper & Krome
Linienstraße 85
D – 10119 Berlin
tel: +49 (0)30 2839-0139
fax: +49 (0)30 2839-0140
www.schipper-krome.com

COLLECTIONS →
Musée national d'art moderne,
Centre Georges Pompidou,
Paris, France
Stedelijk Van Abbemuseum,
Eindhoven, The Netherlands
San Francisco Museum of Modern
Art, San Francisco (CA), USA
Solomon R. Guggenheim
Museum, New York (NY), USA
Walker Art Center,
Minneapolis (MN), USA

PRICE RANGE →
Not available

AUCTION SALES →
No auction results

CHRISTIAN JANKOWSKI

REPRESENTATION →
Klosterfelde
Zimmerstraße 90/91
D – 10117 Berlin
tel: +49 (0)30 283-5305
fax: +49 (0)30 283-5306
www.klosterfelde.de

Maccarone Inc.
45 Canal Street
USA – New York, NY 10002
tel: +1 212 431-4977
fax: +1 212 965-5262

COLLECTIONS →
Hamburger Kunsthalle,
Hamburg, Germany
Kunstmuseum Wolfsburg,
Germany
Wadsworth Atheneum Museum
of Art, Hartford (CT), USA

PRICE RANGE →
$1,000 – $60,000

AUCTION SALES →
No auction results

MIKE KELLEY

REPRESENTATION →
Jablonka Galerie
Lindenstraße 19
D – 50674 Cologne
tel: +49 (0)221 240-3426
fax: +49 (0)221 240-8132
www.jablonkagalerie.com

Metro Pictures
519 West 24th Street
USA – New York, NY 10011
tel: +1 212 206-7100
fax: +1 212 337-0070

Patrick Painter Inc.
2525 Michigan Ave #B2
USA – Santa Monica, CA 90404
tel: +1 310 264-5988
fax: +1 310 264-5998

COLLECTIONS →
Baltimore Museum of Art,
Baltimore (MD), USA
capcMusée d'Art Contemporain,

Artist Information

Bordeaux, France
Carnegie Museum of Art,
Pittsburgh (PA), USA
K21 Kunstsammlung im
Ständehaus, Düsseldorf, Germany
Los Angeles County Museum of
Art, Los Angeles (CA), USA
Musée national d'art moderne,
Centre Georges Pompidou, Paris,
France
Museum Boijmans Van Beuningen,
Rotterdam, The Netherlands
Museum Moderner Kunst, Stiftung
Ludwig, Vienna, Austria
Museum of Contemporary Art,
Chicago (IL), USA
Museum of Fine Arts,
Boston (MA), USA
Solomon R. Guggenheim
Museum, New York (NY), USA
The Museum of Contemporary
Art, Los Angeles (CA), USA
The Museum of Modern Art,
New York (NY), USA
Museum van Hedendaagse Kunst,
Ghent, Belgium
The Art Institute of Chicago,
Chicago (IL), USA
Whitney Museum of American Art,
New York (NY), USA

PRICE RANGE →
$45,000 – $85,000

AUCTION SALES →
Price: $150,000
The Sublime,
The Sublime framed, 1983
synthetic, polymer, paper,
10 parts, 356 x 103 cm
Date sold: 16-Nov-99
Auction house: Christie's,
Rockefeller NY

Price: $130,000
Human geometry
acrylic, paper, triptych,
236 x 543 cm
Date sold: 17-May-01
Auction house: Christie's,
Rockefeller NY

Price: $110,000
Estral star 1
tied stuffed cloth animals,
80 x 30 x 16 cm
Date sold: 16-May-00
Auction house: Christie's,
Rockefeller NY

Price: $60,000
Untitled
two rag dolls sewn together,
76 x 33 x 8 cm

Date sold: 15-May-01
Auction house: Sotheby's,
New York (NY)

Price: $60,000
Pagan altar
synthetic polymer, panel, dried
corn, 249 x 254 cm
Date sold: 16-Nov-00
Auction house: Christie's,
Rockefeller NY

RACHEL KHEDOORI

REPRESENTATION →
Galerie Gisela Capitain
Aachener Straße 5
D – 50674 Cologne
tel: +49 (0)221 256-676
fax: +49 (0)221 256-593
www.galerie-capitain.de

Hauser & Wirth
Limmatstrasse 270
CH – 8005 Zurich
tel: +41 (0)1 446-8050
fax: +41 (0)1 446-8055
www.ghw.ch

David Zwirner
43 Greene Street
USA – New York, NY 10013
tel: +1 212 966-9074
fax: +1 212 966-4952
www.davidzwirner.com

PRICE RANGE →
$2,500 – $12,500 (photographs;
$15,000 (sculptures);
$15,000 (installations);
overall $2,500 – $60,000

AUCTION SALES →
No auction results

KAREN KILIMNIK

REPRESENTATION →
Hauser & Wirth & Presenhuber
Limmatstrasse 270
CH – 8005 Zurich
tel: +41 (0)1 446-8060
fax: +41 (0)1 446-8065
www.ghwp.ch

Monika Sprüth –
Philomene Magers
Wormser Straße 23
D – 50677 Cologne
tel: +49 (0)221 380-415
fax: +49 (0)221 380-417
Schellingstraße 48

D – 80799 Munich
tel: +49 (0)89 3304-0600
fax: +49 (0)89 397-302
www.philomenemagers.com

Emily Tsingou
10 Charles II Street
GB – London SW1Y 4AA
tel: +44 (0)20 7839-5320
fax: +44 (0)20 7839-5321
www.emilytsingougallery.com

303 Gallery
525 West 22nd Street
USA – New York, NY 10011
tel: +1 212 255-1121
fax: +1 212 255-0024
www.303gallery.com

COLLECTIONS →
American Academy of Arts
and Letters, New York (NY), USA
Fondazione Prada, Milan, Italy
Graphische Sammlung der ETH,
Zurich, Switzerland
Museum of Contemporary Art,
Chicago (IL), USA
Statens Museum for Kunst,
Copenhagen, Denmark
The Museum of Modern Art,
New York (NY), USA
Whitney Museum of
American Art, New York (NY)

PRICE RANGE →
$1,500 – $2,500 (c-prints);
$7,000 – $13,000 (drawings);
$8,000 – $12,000 (pastels);
$10,000 – $35,000 (paintings)

AUCTION SALES →
No auction results

BODYS ISEK KINGELEZ

REPRESENTATION →
Galerie Peter Herrmann
Uhlandstraße 184
D – 10623 Berlin
tel: +49 (0)30 8862-5846
fax: +49 (0)30 8862-5847
www.galerie-herrmann.de

PRICE RANGE →
$9,000 – $11,000

AUCTION SALES →
Price: $11,060
Kimbembele Ihunga, 1992
paper cardboard, mixed media,
51 x 108 x 86 cm.
Date sold: 24-Jun-99
Auction house: Sotheby's, London

Price: $9,480
Palais d'Ihunga, Chicodi Stars
49 x 70 x 38 cm
Date sold: 24-Jun-99
Auction house: Sotheby's, London

MARTIN KIPPENBERGER

The Estate is represented by
Galerie Gisela Capitain
Aachener Straße 5
D – 50674 Cologne
tel: +49 (0)221 256-676
fax: +49 (0)221 256-593
www.galerie-capitain.de

PRICE RANGE →
Not available

AUCTION SALES →
Price: $650,000
Untitled
200 x 240 cm
Date sold: 16-Nov-1999
Auction house: Christie's,
Rockefeller NY

Price: $230,400
*Woman is the most dangerous
weapon of the apartment,* 1984
oil, paper, collage, staples, six
canvases, 227 x 181 cm
Date sold: 7-Feb-2001
Auction house: Sotheby's, London

Price: $225,000
Kasperle VIII, 1993
180 x 150 cm
Date sold: 15-Nov-2001
Auction house: Christie's,
Rockefeller NY

Price: $220,000
*Meine Lügen sind ehrlich –
My lies are honest*
200 x 24 cm
Date sold: 14-Nov-2001
Auction house: Sotheby's,
New York (NY)

Price: $170,000
Untitled
oil, oil-stick, 150 x 180 cm
Date sold: 17-May-2001
Auction house: Christie's,
Rockefeller NY

JEFF KOONS

REPRESENTATION →
Gagosian Gallery
555 West 24th Street

USA – New York, NY 10011
tel: +1 212 741-1111
fax: +1 212 741-9611
www.gagosian.com

Galerie Max Hetzler
Zimmerstraße 90/91
D – 10117 Berlin
tel: +49 (0)30 229-2437
fax: +49 (0)30 229-2417
www.maxhetzler.com

Sonnabend Gallery
532 West, 22nd Street
USA – New York, NY 10011
tel: +1 212 627-1018
fax: +1 212 627-0489

COLLECTIONS →
Baltimore Museum of Art,
Baltimore (MD), USA
capcMusee d'Art Contemporain,
Bordeaux, France
Des Moines Art Center,
Des Moines (IA), USA
Deutsche Guggenheim Berlin,
Germany
Groninger Museum, Groningen,
The Netherlands
Guggenheim Museum, Bilbao, Spain
Hirschhorn Museum and Sculpture
Garden, Washington DC, USA
Kunstmuseum Wolfsburg, Germany
Metropolitan Museum, Tokyo, Japan
Milwaukee Art Museum,
Milwaukee (WI), USA
Museum Boijmans Van Beuningen,
Rotterdam, The Netherlands
Museum Ludwig, Cologne, Germany
Museum of Contemporary Art,
Chicago (IL), USA
Nationalgalerie im Hamburger
Bahnhof, Museum für Gegenwart,
Berlin, Germany
San Francisco Museum of Modern
Art, San Francisco (CA), USA
Staatsgalerie Stuttgart, Germany
Stedelijk Museum, Amsterdam,
The Netherlands
Tate Gallery, London, UK
The Museum of Contemporary
Art, Los Angeles (CA), USA
The Museum of Modern Art,
New York (NY), USA
The National Gallery,
Washington DC, USA
Whitney Museum of American Art,
New York (NY), USA
Wright State University Art
Museum, Dayton (OH), USA

PRICE RANGE →
$10,000 (multiples); $150,000 –
$3,000,000 (other works); several

million for monumental sculpture

AUCTION SALES →
Price: $5,100,000
Michael Jackson and
Bubbles, 1988
porcelain ceramic blend,
num. 3/3, 107 x 179 x 83 cm
Date sold: 15-May-01
Auction house: Sotheby's,
New York (NY)

Price: $2,600,000
Woman in tub, 1988
porcelain, num. 1/3,
62 x 91 x 69 cm
Date sold: 17-May-01
Auction house: Christie's,
Rockefeller NY

Price: $1,700,000
Ushering in banality
polychromed wood, num. 2/3,
96 x 157 x 76 cm
Date sold: 14-Nov-01
Auction house: Sotheby's,
New York (NY)

Price: $1,650,000
Pink Panther, 1988
porcelain, num. 3/3,
104 x 52 x 48 cm
Date sold: 16-Nov-99
Auction house: Christie's,
Rockefeller NY

Price: $1,550,000
Woman in tub, 1988
porcelain, num. 3/3,
157 x 23 x 175 cm
Date sold: 16-May-00
Auction house: Christie's,
Rockefeller NY

UDOMSAK KRISANAMIS

REPRESENTATION →
Gavin Brown's enterprise
436 West 15th Street
USA – New York, NY 10011
tel: +1 212 627-5258
fax: +1 212 627-5261

Victoria Miro Gallery
16 Wharf Road
GB – London N1 7RW
tel: +44 (0)20 7336-8109
fax: +44 (0)20 7251-5596
www.victoria-miro.com

Gallery Side 2
Shima Crest B1F 1-19-4,
Sendagaya Shibuya-ku

JPN – Tokyo 151-0051
tel: +81 (0)3 5771-5263
fax: +81 (0)3 5771-5264

COLLECTIONS →
Albright-Knox Art Gallery,
Buffalo (NY), USA
Fondation Cartier pour l'Art
Contemporain, Paris, France
Fondazione Sandretto Re
Rebaudengo per l'Arte, Turin, Italy
San Francisco Museum of Modern
Art, San Francisco (CA), USA

PRICE RANGE →
$4,000 – $25,000

AUCTION SALES →
Price: $16,000
Untitled
122 x 122 cm
Date sold: 19-May-00
Auction house: Phillips,
New York (NY)

Price: $10,000
Starry, 1993
ink, oil on paper, collage,
120 x 120 cm
Date sold: 17-Nov-00
Auction house: Christie's,
Rockefeller NY

ELKE KRYSTUFEK

REPRESENTATION →
Georg Kargl
Schleifmühlgasse 5
A – 1040 Vienna
tel: +43 (0)1 585-4199
fax: +43 (0)1 5854-1999

Gallery Side 2
Shima Crest B1F 1-19-4,
Sendagaya Shibuya-ku
JPN – Tokyo 151-0051
tel: +81 (0)3 5771-5263
fax: +81 (0)3 5771-5264

Emily Tsingou
10 Charles II Street
GB – London SW1Y 4AA
tel: +44 (0)20 7839-5320
fax: +44 (0)20 7839-5321
www.emilytsingougallery.com

COLLECTIONS →
BAWAG Foundation, Vienna, Austria
Galerie der Stadt Esslingen,
Villa Merkel, Esslingen, Germany
Galerie im Taxispalais,
Innsbruck, Austria

Generali Foundation, Vienna,
Austria
Künstlerhaus Palais Thurn und
Taxis, Bregenz, Austria
Maison Levanneur Centre
National de l'Estampe,
Chatou, France
Migros Museum für Gegenwarts-
kunst, Zurich, Switzerland
Museum Moderner Kunst, Stiftung
Ludwig, Vienna, Austria
Österreichische Galerie im
Oberen Belvedere, Vienna, Austria
Neue Galerie der Stadt Linz, Austria
Statens Museum for Kunst,
Copenhagen, Denmark

PRICE RANGE →
$1,800 (drawings) – $22,000
(paintings); $25,000 – $100,000
(installations)

AUCTION SALES →
Price: $5,188
Imperial palace – Las Vegas, 1999
acrylic, 180 x 140 cm
Date sold: 11-Apr-00
Auction house: Wiener Kunst
Auktionen, Vienna

Price: $2,916
I can see the whole room
and there's nobody in it
acrylic, cotton, 76 x 79 cm
Date sold: 08-Dec-99
Auction house: Christie's,
Kensington

Price: $2,754
Marilyn und Selbstserie
acrylic, cotton, 100 x 100 cm
Date sold: 08-Dec-99
Auction house: Christie's,
Kensington

Price: $1,815
Happy birthday, 1993
tempera, cotton, 42 x 29 cm
Date sold: 27-Nov-01
Auction house: Dorotheum, Vienna

OLEG KULIK

REPRESENTATION →
Guelman
Mal. Polianka, d. 7
RUS – 109180 Moscow
tel/fax: +7 (0)95 238-8492
www.guelman.ru

Galerie Krinzinger
Seilerstätte 16
A – 1010 Vienna

Artist Information

tel: +43 (0)1 513-3006
fax: +43 (0)1 51330-0633
www.galerie-krinzinger.at

COLLECTIONS →
ARC Musée de la Ville de Paris,
France
Fonds Régional d'Art
Contemporain des
Pays de la Loire, France
Moderna Museet, Stockholm, Sweden
Museum of Contemporary Art,
Moscow, Russia
Museum Moderner Kunst, Stiftung
Ludwig, Vienna, Austria
Stedelijk Museum voor Actuele
Kunst, Ghent, Belgium

PRICE RANGE →
$4,000 – $35,000 (installations)

AUCTION SALES →
No auction results

JIM LAMBIE

REPRESENTATION →
Sadie Coles HQ
35 Heddon Street
GB – London W1B 4BP
tel: +44 (0)20 7434-2227
fax: +44 (0)20 7434-2228
www.sadiecoles.com

Anton Kern
532 West 20th Street
USA – New York, NY 10011
tel: +1 212 367-9663
fax: +1 212 367-8135

The Modern Institute
73 Robertson Street, Suite 6 fl. 1
GB – Glasgow G2 8QD
tel: +44 (0)141 248-3711
fax: +44 (0)141 248-3280
www.themoderninstitute.org

COLLECTIONS →
Arts Council of England, UK
British Council, UK
Carnegie Museum of Art,
Pittsburgh (PA), USA
The Museum of Modern Art,
New York (NY), USA
Scottish National Gallery of
Modern Art, Edinburgh, UK

PRICE RANGE →
$2,000 – $25,000

AUCTION SALES →
No auction results

ZOE LEONARD

REPRESENTATION →
Galerie Gisela Capitain
Aachener Straße 5
D – 50674 Cologne
tel: +49 (0)221 256-676
fax: +49 (0)221 256-593
www.galerie-capitain.de

Paula Cooper Gallery
534 West 21st Street
USA – New York, NY 10011
tel: +1 212 255-1105
fax: +1 212 255-5156

COLLECTIONS →
Baltimore Museum of Art,
Baltimore (MD), USA
Denver Art Museum,
Denver (CO), USA
Fonds Régional d'Art
Contemporain, Rouen, France
Generali Foundation, Vienna, Austria
Groninger Museum, Groningen,
The Netherlands
K21 Kunstsammlung im
Ständehaus, Düsseldorf, Germany
Musée d'Art Moderne et
Contemporain, Geneva, Switzerland
Museum of Contemporary Art,
Miami, USA
Philadelphia Museum of Art,
Philadelphia (PA), USA
Provinciaal Museum voor
Fotografie, Antwerp, Belgium
San Francisco Museum of Modern
Art, San Francisco (CA), USA
Sheldon Memorial Museum,
Omaha, USA
Städtische Galerie, Kassel, Germany
Stedelijk Museum voor Actuele
Kunst, Ghent, Belgium
The Museum of Contemporary
Art, Los Angeles (CA), USA
Museum of Fine Arts,
Houston (TX), USA
The Museum of Modern Art,
New York (NY), USA
University Art Museum,
Berkeley (CA), USA
Whitney Museum of American Art,
New York (NY), USA
Wiener Secession, Vienna, Austria

PRICE RANGE →
$ 1,500 – $25,000 (photographs);
$10,000 – $ 80,000 (installations
and sculpture)

AUCTION SALES →
Price: $5,460
Seated anatomical model, 1991
black and white photograph,
num. 9/12, 50 x 35 cm
Date sold: 16-Dec-00
Auction house: Francis Briest,
Paris

Price: $3,500
Dress and suit – for Nancy,
1990/1995
gelatin silver print, num. 6/6,
70 x 49 cm
Date sold: 29-Jun-01
Auction house: Christie's,
Kensington

Price: $3,200
Trophies, museo di storia
naturale, Venice, 1989/90
gelatin silver print, 76 x 109 cm
Date sold: 17-May-00
Auction house: Christie's,
Rockefeller NY

ATELIER VAN LIESHOUT

REPRESENTATION →
Galerie Bob van Orsouw
Limmatstrasse 270
CH – 8005 Zurich
tel: +41 (0)1 273-1100
fax: +41 (0)1 273-1102

Fons Welters
Bloemstraat 140
NL – 1016 LJ Amsterdam
tel: +31 (0)20 423-3046
fax: +31 (0)20 620-8433
www.fonswelters.nl

Jack Tilton Gallery
49 Greene Street
USA – New York, NY 10013
tel: +1 212 941-1775
fax: +1 212 941-1812
www.jacktiltongallery.com

Magazzino d'Arte Moderna
Mauro Nicoletti
Via dei Prefetti, 17
I – 00186 Rome
tel/fax: +39 (0)6 687-5951

COLLECTIONS →
The Museum of Modern Art,
New York (NY), USA
Walker Art Center,
Minneapolis (MN), USA

PRICE RANGE →
$500 – $1800 (trash cans);
$900 – $2800 (soft edge tables);
$1400 (drawings);
overall $500 – $30,000;
$50,000 – 150,000 (mobile homes)

AUCTION SALES →
No auction results

WON JU LIM

REPRESENTATION →
Galerie Max Hetzler
Zimmerstraße 90/91
D – 10117 Berlin
tel: +49 (0)30 229-2437
fax: +49 (0)30 229-2417
www.maxhetzler.com

Patrick Painter Inc.
2525 Michigan Ave #B2
USA – Santa Monica, CA 90404
tel: +1 310 264-5988
fax: +1 310 264-5998

PRICE RANGE →
$10,000 – $40,000

AUCTION SALES →
No auction results

SHARON LOCKHART

REPRESENTATION →
Barbara Gladstone Gallery
515 West 24th Street
USA – New York, NY 10011
tel: +1 212 206-9300
fax: +1 212 206-9301
www.gladstonegallery.com

Blum & Poe
2042 Broadway
USA – Santa Monica, CA 90404
tel: +1 310 453-8311
fax: +1 310 453-2821

neugerriemschneider
Linienstraße 155
D – 10115 Berlin
tel: +49 (0)30 3087-2810
fax: +49 (0)30 3087-2811

COLLECTIONS →
Albright-Knox Art Gallery,
Buffalo (NY), USA
Eli Broad Family Foundation,
Los Angeles (CA), USA
Henry Art Gallery,
Seattle (WA), USA
Los Angeles County Museum
of Art, Los Angeles (CA), USA
La Colección Júmex,
Mexico City, Mexico
Museum Boijmans Van Beuningen,
Rotterdam, The Netherlands
Museum of Contemporary Art,
Chicago (IL), USA

Museum of Contemporary Art,
San Diego (CA), USA
St. Louis Art Museum,
St. Louis (MO), USA
The Israel Museum,
Jerusalem, Israel
The Museum of Contemporary
Art, Los Angeles (CA), USA
Walker Art Center,
Minneapolis (MN), USA
Whitney Museum of American Art,
New York (NY), USA
Worcester Art Museum,
Worcester (MA), USA
Yokohama Museum of Art, Japan

PRICE RANGE →
$2,500 (smaller studies or small
black and white work) – $75,000
(very large single chromogenic
prints or large works in a series,
i. e. three to four images)

AUCTION SALES →
No auction results

SARAH LUCAS

REPRESENTATION →
Sadie Coles HQ
35 Heddon Street
GB – London W1B 4BP
tel: +44 (0)20 7434-2227
fax: +44 (0)20 7434-2228
www.sadiecoles.com

Contemporary Fine Arts
Sophienstraße 21
D – 10178 Berlin
tel: +49 (0)30 288-7870
fax: +49 (0)30 2887-8726
www.cfa-berlin.com

Barbara Gladstone Gallery
515 West 24th Street
USA – New York, NY 10011
tel: +1 212 206-9300
fax: +1 212 206-9301
www.gladstonegallery.com

COLLECTIONS →
Tate Gallery, London, UK
The Museum of Modern Art,
New York (NY), USA

PRICE RANGE →
$1,400 – $170,000

AUCTION SALES →
Price: $172,800
Fighting fire with fire 6 pack, 1997
black and white photographs, ink,
acrylic, set of six, 305 x 340 cm

Date sold: 08-Feb-01
Auction house: Christie's, London

Price: $67,950
Self portrait with fried eggs
c-print, 167 x 119 cm
Date sold: 28-Jun-00
Auction house: Christie's, London
Lot: 127

Price: $48,320
Where does it all end
wax, cigarette, 6 x 9 x 6 cm
Date sold: 27-Jun-00
Auction house: Christie's, London
Lot: 26

Price: $51,840
Human toilet
c-print, num. 1/1, 244 x 188 cm
Date sold: 08-Dec-99
Auction house: Christie's, London

Price: $45,360
Great dates
photocopy, paint, photo collage,
masonite, 223 x 143 cm
Date sold: 08-Dec-98
Auction house: Christie's, London

MICHEL MAJERUS

REPRESENTATION →
asprey jacques
4 Clifford Street
GB – London W1X 1RB
tel: +44 (0)20 7287-7675
fax: +44 (0)20 7287-7674
www.aspreyjacques.com

neugerriemschneider
Linienstraße 155
D – 10115 Berlin
tel: +49 (0)30 3087-2810
fax: +49 (0)30 3087-2811

Friedrich Petzel Gallery
535 West 22nd Street
USA – New York, NY 10011
tel: +1 212 680-9467
fax: +1 212 680-9473
www.petzel.com

PRICE RANGE →
$750 – $22,000

AUCTION SALES →
Price: $3,240
Ethyl alcohol, fragrance, 1994
acrylic on canvas, 140 x 160 cm
Date sold: 08-Dec-99
Auction house: Christie's, Kensington

PAUL MCCARTHY

REPRESENTATION →
Hauser & Wirth
Limmatstrasse 270
CH – 8005 Zurich
tel: +41 (0)1 446-8050
fax: +41 (0)1 446-8055
www.ghw.ch

Luhring Augustine
531 West 24th Street
USA – New York, NY 10011
tel: +1 212 206-9055
fax: +1 212 206-9055
www.luhringaugustine.com

Patrick Painter Inc.
2525 Michigan Ave #B2
USA – Santa Monica, CA 90404
tel: +1 310 264-5988
fax: +1 310 264-5998

COLLECTIONS →
K21 Kunstsammlung im
Ständehaus, Düsseldorf, Germany
New Museum of Contemporary
Art, New York (NY), USA
Solomon R. Guggenheim
Museum, New York (NY), USA
The Museum of Modern Art,
New York (NY), USA
Walker Art Center,
Minneapolis (MN), USA

PRICE RANGE →
$5,000 - $300,000

AUCTION SALES →
Price: $19,000
Experimental dancer-rumpus room
three gelatin silver prints, 76 x 61 cm
Date sold: 18-May-01
Auction house: Christie's,
Rockefeller NY

Price: $19,000
Mascara de Arafat, 1994
colour coupler print, 185 x 122 cm
Date sold: 16-Nov-01
Auction house: Christie's,
Rockefeller NY

Price: $16,610
Man fucking a tree, garden, 1992
felt tip pen, 220 x 150 cm
Date sold: 28-Jun-00
Auction house: Christie's, London

Price: $4,800
Hot dog 1974, 1996
cibachrome print mounted on
board, num. 3/5, 103 x 78 cm
Date sold: 17-May-00

Auction house: Christie's,
Rockefeller NY

Price: $3,250
Untitled, 1998
ink, 102 x 66 cm
Date sold: 15-Nov-01
Auction house: Sotheby's,
New York (NY)

JONATHAN MEESE

REPRESENTATION →
Contemporary Fine Arts
Sophienstraße 21
D – 10178 Berlin
tel: +49 (0)30 288-7870
fax: +49 (0)30 2887-8726
www.cfa-berlin.com

Leo Koenig Inc.
339 Broadway·
USA – New York, NY 10013
tel: +1 212 334-9255
fax: +1 212 334-9304

COLLECTIONS →
Sammlung zeitgenössischer Kunst
der Bundesrepublik Deutschland,
Germany

PRICE RANGE →
from $1,200 (works on paper);
$6,000 – $20,000 (paintings)

AUCTION SALES →
No auction results

AERNOUT MIK

REPRESENTATION →
carlier I gebauer
Holzmarktstraße 15–18
S-Bahnbogen 51/52
D – 10179 Berlin
tel: +49 (0)30 280-8110
fax: +49 (0)30 280-8109
www.carliergebauer.com

Deweer Art Gallery
Tiegemstraat 6/A
B – 8553 Otegem
tel: +32 (0)56 644-893
fax: +32 (0)56 647-685

Fons Welters
Bloemstraat 140
NL – 1016 LJ Amsterdam
tel: +31 (0)20 423-3046
fax: +31 (0)20 620-8433
www.fonswelters.nl

Artist Information

COLLECTIONS →
Fonds National d'Art
Contemporain, Paris, France
Museum für Moderne Kunst,
Frankfurt am Main, Germany
Stedelijk Museum, Amsterdam,
The Netherlands
Stedelijk Van Abbemuseum,
Eindhoven, The Netherlands

PRICE RANGE →
Not available

AUCTION SALES →
No auction results

JONATHAN MONK

REPRESENTATION →
Galerie Yvon Lambert
108, rue Vieille-du-Temple
F – 75003 Paris
tel: +33 (0)1 4271-0933
fax: +33 (0)1 4271-8747

Lisson Gallery
52–54 Bell Street
GB – London NW1 5DA
tel: +44 (0)20 7724-2739
fax: +44 (0)20 7724-7124
www.lisson.co.uk

Meyer Riegger
Klauprechtstraße 22
D – 76137 Karlsruhe
tel: +49 (0)721 821-292
fax: +49 (0)721 982-2141
www.meyer-riegger.de

COLLECTIONS →
Fonds Régional d'Art
Contemporain des Pays de la
Loire, France
Fonds Régional d'Art
Contemporain, Languedoc-
Roussillon, France
Moderna Museet, Stockholm,
Sweden
Statens Museum for Kunst,
Copenhagen, Denmark

PRICE RANGE →
$500 – $20,000

AUCTION SALES →
No auction results

MARIKO MORI

REPRESENTATION →
Deitch Projects
76 Grand Street

USA – New York, NY 10013
tel: +1 212 343-7300
fax: +1 212 343-2954

Gallery Koyanagi
Koyanagi Bldg. 1F, 1-7-5 Ginza,
Chuo-ku
JPN – Tokyo 104-0061
tel: +81 (0)3 3561-1896
fax: +81 (0)3 3563-3236

COLLECTIONS →
Benesse Museum,
Naoshima, Japan
Fonds National d'Art
Contemporain, Paris, France
Fondazione Prada, Milan, Italy
Kobe Fashion Museum, Japan
Museum of Contemporary Art,
Chicago (IL), USA
The Israel Museum,
Jerusalem, Israel
The New York Public Library, New
York (NY), USA

PRICE RANGE →
$15,000 – $250,000

AUCTION SALES →
Price: $120,000
Last departure, 1996
Fuji supergloss duraflex print,
213 x 366 cm
Date sold: 14-May-01
Auction house: Phillips,
New York (NY)

Price: $101,500
Play with me, 1994
Fuji supergloss duraflex print,
num. 1/3, 305 x 306 cm
Date sold: 26-Oct-00
Auction house: Sotheby's, London

Price: $50,000
Love hotel
cibachrome on panel, num. 2/4,
121 x 152 cm
Date sold: 15-Nov-00
Auction house: Sotheby's,
New York (NY)

Price: $48,000
Warrior
Fuji supergloss duraflex print,
122 x 152 cm
Date sold: 16-Nov-00
Auction house: Christie's,
Rockefeller NY

Price: $50,000
Mirage – image D
glass with photo interlayer,
61 x 76 cm

Date sold: 18-May-00
Auction house: Sotheby's,
New York (NY)

SARAH MORRIS

REPRESENTATION →
Galerie Max Hetzler
Zimmerstraße 90/91
D – 10117 Berlin
tel: +49 (0)30 229-2437
fax: +49 (0)30 229-2417
www.maxhetzler.com

Jay Jopling/White Cube²
48 Hoxton Square
GB – London N1 6PB
tel: +44 (0)20 7930-5373
fax: +44 (0)20 7749-7460
www.whitecube.com

Friedrich Petzel Gallery
535 West 22nd Street
USA – New York, NY 10011
tel: +1 212 680-9467
fax: +1 212 680-9473
www.petzel.com

Galerie Aurel Scheibler
St.-Apern-Straße 20–26
D – 50667 Cologne
tel: +49 (0)221 311-011
fax: +49 (0)221 331-9615
www.aurelscheibler.com

COLLECTIONS →
Fondazione Prada, Milan, Italy
Kunstmuseum Wolfsburg, Germany
Nationalgalerie im Hamburger
Bahnhof, Museum für Gegenwart,
Berlin, Germany
Solomon R. Guggenheim
Museum, New York (NY), USA
Stedelijk Museum, Amsterdam,
The Netherlands
Tate Gallery, London, UK

PRICE RANGE →
$4,000 – $45,000

AUCTION SALES →
Price: $12,000
Mental
152 x 220 cm
Date sold: 17-Nov-00
Auction house: Christie's,
Rockefeller NY

Price: $9,060
Sorry
gloss house paint on canvas,
152 x 244 cm
Date sold: 28-Jun-00

Auction house: Christie's, London

Price: $8,736
Johnny, 1995
household gloss paint,
152 x 244 cm
Date sold: 08-Dec-98
Auction house: Christie's, London

Price: $5,130
Jesus knows, 1994
acrylic, 122 x 170 cm
Date sold: 08-Oct-98
Auction house: Christie's, London

VIK MUNIZ

Brent Sikkema Gallery
530 West 22nd Street
USA – New York, NY 10011
tel: +1 212 929-2262
fax: +1 212 929-2340

Galeria Fortes Vilaça
Rua Fradique Coutinho 1500
BRAZ – 05416-001 São Paulo
tel: +55 (0)11 3032-7066
fax: +55 (0)11 3097-0384

COLLECTIONS →
Centre National de la
Photography, Paris, France
International Center for
Photography, New York (NY), USA
San Francisco Museum of Modern
Art, San Francisco (CA), USA
The Art Institute of Chicago,
Chicago (IL), USA
The Metropolitan Museum
of Art, New York (NY), USA
The Museum of Contemporary
Art, Los Angeles (CA), USA
The Museum of Modern Art,
New York (NY), USA
Tate Gallery, London, UK
Whitney Museum of American Art,
New York (NY), USA

PRICE RANGE →
$1,000 – $60,000

AUCTION SALES →
Price: $64,000
*Criancas de acucar –
Sugar children*, 1996
gelatin silver print, set of six,
num. 4/10, 34 x 26 cm
Date sold: 19-Nov-2001
Auction house: Christie's,
Rockefeller NY

Price: $40,000
Bloody Marilyn, 2001

cibachrome print, 145 x 125 cm
Date sold: 16-Nov-2001
Auction house: Christie's,
Rockefeller NY

Price: $32,000
*Action photo – from pictures
of chocolate*, 1997
cibachrome print after Hans
Namuth, 155 x 123 cm
Date sold: 18-May-2001
Auction house: Christie's,
Rockefeller NY

Price: $28,000
Action photo, 1997
cibachrome print, num. 2/3,
99 x 79 cm
Date sold: 12-Oct-2000
Auction house: Christie's,
Rockefeller NY

Price: $22,000
*Yves Klein – from pictures
of chocolate*, 1999
cibachrome print, 114 x 135 cm
Date sold: 16-Nov-2001
Auction house: Christie's,
Rockefeller NY

MUNTEAN/ROSENBLUM

REPRESENTATION →
Georg Kargl
Schleifmühlgasse 5
A – 1040 Vienna
tel: +43 (0)1 585-4199
fax: +43 (0)1 5854-1999

Galleria Franco Noero
Via Mazzini 39 A
I – 10123 Turin
tel7fax: +39 (0)11 882-208

Sommer Contemporary Art
64, Rothschild Blvd
ISR – 65785 Tel Aviv
tel: +972 (0)3 560-0630
fax: +972 (0)3 566-5501
www.sommercontemporaryart.com

COLLECTIONS →
Kunsthaus Bregenz, Austria
Museum Moderner Kunst, Stiftung
Ludwig, Vienna, Austria
Fondazione Sandretto Re
Rebaudengo per l'Arte, Turin, Italy

PRICE RANGE →
from $1,000 (drawings);
$10,000 – $22,000 (paintings);
$35,000 – $100,000 (installations)

AUCTION SALES →
Price: $4,842
Untitled, 1999
acrylic, 194 x 94 cm
Date sold: 11-Apr-00
Auction house: Wiener Kunst
Auktionen, Vienna

TAKASHI MURAKAMI

REPRESENTATION →
Blum & Poe
2042 Broadway
USA – Santa Monica, CA 90404
tel: +1 310 453-8311
fax: +1 310 453-2821

Marianne Boesky Gallery
535 West 22nd Street
USA – New York, NY 10011
tel: +1 212 680-9889
fax: +1 212 680-9897
www.marianneboeskygallery.com

Tomio Koyama Gallery
Saga 1-8-13-2F, Koto-ku
JPN – Tokyo 135-0031
tel/fax: +81 (0)3 3630-2205

COLLECTIONS →
Center for Curatorial Studies
Museum, Bard College,
Annandale-on-Hudson (NY), USA
Contemporary Art Museum,
Kanazawa, Japan
Museum of Fine Arts, Boston (MA), USA
Queensland Museum, Brisbane,
Australia
San Francisco Museum of Modern
Art, San Francisco (CA), USA
The Museum of Contemporary Art
Los Angeles (CA), USA

PRICE RANGE →
up to $350,000 (major new
sculpture); paintings from
$9,000 (38 x 38 cm), $70,000
(2 x 2 m), $90,000 (3 x 3 m),
$120,000 (3 x 4,50 m)

AUCTION SALES →
Price: $10,000
Peach milk, 1998
acrylic on canvas on panel,
50 x 65 cm
Date sold: 16-Nov-01
Auction house: Christie's,
Rockefeller NY

Price: $1,900
Project ko. 2, perfect edition, 1999
painted resin doll, 53 x 21 x 15 cm
Date sold: 14-Nov-00

Auction house: Phillips,
New York (NY)

YOSHITOMO NARA

REPRESENTATION →
Stephen Friedman Gallery
25–28 Old Burlington Street
GB – London W1S 3AN
tel: +44 (0)20 7494-1434
fax: +44 (0)20 7494-1431
www.stephenfriedman.com

Johnen + Schöttle
Maria-Hilf-Straße 17
D – 50677 Cologne
tel: +49 (0)221 310-270
fax: +49 (0)221 310-2727
www.johnen-schoettle.de

Tomio Koyama Gallery
Saga 1-8-13-2F, Koto-ku
JPN – Tokyo 135-0031
tel/fax: +81 (0)3 3630-2205

PRICE RANGE →
$5,000 – $60,000

AUCTION SALES →
Price: $1,900
No pain no gain, 1997
gouache, 30 x 97 cm
Date sold: 17-May-00
Auction house: Christie's,
Rockefeller NY

MIKE NELSON

REPRESENTATION →
Matt's Gallery
42–44 Copperfield Road
GB – London E3 4RR
tel: +44 (0)20 8983-1771
fax: +44 (0)20 8983-1435
www.mattsgallery.org

COLLECTIONS →
Arts Council of England, UK
British Council, UK

PRICE RANGE →
Not available

AUCTION SALES →
No auction results

SHIRIN NESHAT

REPRESENTATION →
Barbara Gladstone Gallery
515 West 24th Street

USA – New York, NY 10011
tel: +1 212 206-9300
fax: +1 212 206-9301
www.gladstonegallery.com

Patrick Painter Inc.
2525 Michigan Ave #B2
USA – Santa Monica, CA 90404
tel: +1 310 264-5988
fax: +1 310 264-5998

Galerie Thomas Rehbein
Maria-Hilf-Straße 17
D – 50677 Cologne
tel: +49 (0)221 310-1000
fax: +49 (0)221 310-1003

COLLECTIONS →
Hamburger Kunsthalle, Hamburg,
Germany
Fondazione Sandretto Re
Rebaudengo per l'Arte, Turin, Italy

PRICE RANGE →
$10,000 (small works);
$20,000 (larger works);
$50,000 – $100,000 (videos)

AUCTION SALES →
Price: $62,000
Speechless, 1996
pen ink over gelatin silver print,
124 x 91 cm
Date sold: 14-May-01
Auction house: Phillips,
New York (NY)

Price: $58,000
Unveiling, 1993
colour ink over gelatin silver print
on foamcore, 149 x 102 cm
Date sold: 18-May-01
Auction house: Christie's,
Rockefeller NY

Price: $57,000
*Offered eyes –
unveiling series*, 1993
pen ink over gelatin silver print,
144 x 100 cm
Date sold: 15-May-01
Auction house: Phillips,
New York (NY)

Price: $44,000
Innocent memories, 1994
ink over gelatin silver print,
152 x 102 cm
Date sold: 14-Nov-00
Auction house: Phillips,
New York (NY)

Price: $42,000
Allegiance with wakefulness, 1994

Artist Information

brush pen and black ink over
silver print, num. 3/3, 130 x 103 cm
Date sold: 17-Nov-00
Auction house: Christie's,
Rockefeller NY

ERNESTO NETO

REPRESENTATION →
Tanya Bonakdar
521 West 21st Street
USA – New York, NY 10011
tel: +1 212 414-4144
fax: +1 212 414-1535
www.tanyabonakdargallery.com

Galeria Fortes Vilaça
Rua Fradique Coutinho 1500
BRAZ – 05416-001 São Paulo
tel: +55 (0)11 3032-7066
fax: +55 (0)11 3097-0384

Galerie Yvon Lambert
108, rue Vieille-du-Temple
F – 75003 Paris
tel: +33 (0)1 4271-0933
fax: +33 (0)1 4271-8747

COLLECTIONS →
Carnegie Museum of Art,
Pittsburgh (PA), USA
Museo Nacional Centro de Arte
Reina Sofía, Madrid, Spain
Museu de Arte Moderna
Rio de Janeiro, Brazil
Solomon R. Guggenheim
Museum, New York (NY), USA
Tate Gallery, London, UK
The Museum of Modern Art,
New York (NY), USA

PRICE RANGE →
$1,000 – $80,000

AUCTION SALES →
Price: $45,000
*It happens in the frictions
of the bodies*
spices in polymade fabric
10 x 5 x variable m
Date sold: 14-Nov-01
Auction house: Sotheby's,
New York (NY)

Price: $30,000
Apollo three
aluminium, polyamide, cotton,
rubber, steel, 335 x 335 x 274 cm
Date sold: 21-Nov-00
Auction house: Christie's,
Rockefeller NY

Price: $30,000
Concreta Sonho, Female, 1994
lead, steel, cotton, rubber,
marble, 230 x 166 x 25 cm
Date sold: 02-Jun-99
Auction house: Christie's,
Rockefeller NY

Price: $4,500
Maos Dadas, 1994
lead, aluminium, silk, ribbon,
dimensions variable
Date sold: 17-Nov-99
Auction house: Christie's,
Rockefeller NY

Price: $4,000
Sem titulo, 1994
lead, pellets, nylon, tin can,
dimensions variable
Date sold: 01-Jun-00
Auction house: Christie's,
Rockefeller NY

RIVANE NEUENSCHWANDER

REPRESENTATION →
Galeria Fortes Vilaça
Rua Fradique Coutinho 1500
BRAZ – 05416-001 São Paulo
tel: +55 (0)11 3032-7066
fax: +55 (0)11 3097-0384

Stephen Friedman Gallery
25–28 Old Burlington Street
GB – London W1S 3AN
tel: +44 (0)20 7494-1434
fax: +44 (0)20 7494-1431
www.stephenfriedman.com

COLLECTIONS →
Art/Pace Roberts Foundation,
San Antonio (TX), USA
University Art Museum,
Berkeley (CA), USA
Museo Nacional Centro de Arte
Reina Sofía, Madrid, Spain
Museu de Arte Moderna
de São Paulo, Brazil
Walker Art Center,
Minneapolis (MN), USA

PRICE RANGE →
$5,000 – $50,000

AUCTION SALES →
No auction results

OLAF NICOLAI

REPRESENTATION →
EIGEN + ART
Auguststraße 26
D – 10117 Berlin
tel: +49 (0)30 280-6605
fax: +49 (0)30 280-6616
www.eigen-art.com

Galerie Fabian & Claude Walter
Wallstrasse 13
CH – 4010 Basle
tel: +41 (0)61 271-3877
fax: +41 (0)61 271-3887
www.fabian-claude-walter.com

COLLECTIONS →
Nationalgalerie im Hamburger
Bahnhof, Museum für Gegenwart,
Berlin, Germany
Migros Museum für Gegenwarts-
kunst, Zurich, Switzerland
Museum der Bildenden Künste
Leipzig, Germany

PRICE RANGE →
$1,000 – $12,500;
$13,000 – $60,000 (installations)

AUCTION SALES →
Price: $4,548
Two sides of the book, 1990
mixed media, card, 66 x 94 cm
Date sold: 28-May-99
Auction house: Lempertz, Cologne

Price: $952
Untitled, 1992
paper collage, acrylic, oil,
31 x 30 cm
Date sold: 02-Jun-01
Auction house: Lempertz, Cologne

MANUEL OCAMPO

REPRESENTATION →
Galería OMR
Plaza Rio de Janeiro 54
BRAZ – 06700 D.F. Rio de Janeiro
tel: +52 (0)55 5511-1179
fax: +52 (0)55 5533-4244
www.galeriaomr.com

Monika Sprüth –
Philomene Magers
Wormser Straße 23
D – 50677 Cologne
tel: +49 (0)221 380-415
fax: +49 (0)221 380-417
Schellingstraße 48
D – 80799 Munich
tel: +49 (0)89 3304-0600

fax: +49 (0)89 397-302
www.philomenemagers.com

COLLECTIONS →
Centro Atlantico de Arte Moderno,
Canary Islands, Spain
Fonds National d'Art
Contemporain, Paris, France
Fukuoka Asian Art Museum, Japan
IVAM Centre del Carme,
Valencia, Spain
Laguna Art Museum, Laguna
Beach (CA), USA
Museo Extremeño e
Iberoamericano de Arte
Contemporáneo, Junta de
Extramadura, Spain
Museo Nacional Centro de Arte
Reina Sofía, Madrid, Spain
Oakland Museum,
Oakland (CA), USA
Sintra Museu de Arte Moderna,
Lisbon, Portugal
The Contemporary Museum,
Honolulu (HI), USA
The Museum of Contemporary
Art, Los Angeles (CA), USA

PRICE RANGE →
$2,500 – $30,000

AUCTION SALES →
Price: $12,000
Dolor de muelas
diptych, 244 x 305 cm
Date sold: 18-Nov-97
Auction house: Christie's East,
New York (NY)

Price: $11,000
*Iglesia de Enfermeria Catholica
Rex de Espana*, 1991
diptych, 244 x 305 cm
Date sold: 17-May-00
Auction house: Christie's,
Rockefeller NY

Price: $11,000
Untitled
triptych, 152 x 396 cm
Date sold: 18-May-00
Auction house: Sotheby's,
New York (NY)

Price: $8,000
Anak
oil and acrylic on paper, collage,
136 x 258 cm
Date sold: 19-May-00
Auction house: Phillips,
New York (NY)

Price: $8,000
El tirano de Europa,

el tirano de America
oil collage on canvas, two parts,
244 x 305 cm
Date sold: 18-Nov-99
Auction house: Sotheby's,
New York (NY)

ALBERT OEHLEN

REPRESENTATION →
Galerie Max Hetzler
Zimmerstraße 90/91
D – 10117 Berlin
tel: +49 (0)30 229-2437
fax: +49 (0)30 229-2417
www.maxhetzler.com

Luhring Augustine
531 West 24th Street
USA – New York, NY 10011
tel: +1 212 206-9055
fax: +1 212 206-9055
www.luhringaugustine.com

Patrick Painter Inc.
2525 Michigan Ave #B2
USA – Santa Monica, CA 90404
tel: +1 310 264-5988
fax: +1 310 264-5998

COLLECTIONS →
Hamburger Kunsthalle, Hamburg,
Germany
Museum für Moderne Kunst
Frankfurt am Main, Germany
Museum Ludwig, Cologne, Germany
The Museum of Contemporary
Art, Los Angeles (CA), USA
The Museum of Modern Art,
New York (NY), USA

PRICE RANGE →
$35,000 – $60,000

AUCTION SALES →
Price: $55,000
Untitled
oil on printed fabric, 240 x 240 cm
Date sold: 16-Nov-00
Auction house: Christie's,
Rockefeller NY

Price: $40,987
Golden man hitting slut, 1984
stretcher, acrylic, 261 x 200 cm
Date sold: 05-Dec-01
Auction house: Lempertz,
Cologne

Price: $27,929
*When God founded rock
he must have been lustful,
Rockmusik 3*, 1984

acrylic, 200 x 200 cm
Date sold: 26-Sep-95
Auction house: Wiener Kunst
Auktionen, Vienna

Price: $23,333
*Suspended street
of volunteers*, 1987
170 x 219 cm
Date sold: 28-Jun-01
Auction house:
Villa Grisebach, Berlin

Price: $22,000
Loves body, 1985
oil, plastic, 199 x 199 cm
Date sold: 24-Feb-93
Auction house: Christie's,
New York (NY)

CHRIS OFILI

REPRESENTATION →
Gavin Brown's enterprise
436 West 15th Street
USA – New York, NY 10011
tel: +1 212 627-5258
fax: +1 212 627-5261

Contemporary Fine Arts
Sophienstraße 21
D – 10178 Berlin
tel: +49 (0)30 288-7870
fax: +49 (0)30 2887-8726
www.cfa-berlin.com

Victoria Miro Gallery
16 Wharf Road
GB – London N1 7RW
tel: +44 (0)20 7336-8109
fax: +44 (0)20 7251-5596
www.victoria-miro.com

COLLECTIONS →
Arts Council of England, UK
Astrup Fearnley Museum of
Modern Art, Oslo, Norway
British Council, UK
Carnegie Museum of Art,
Pittsburgh (PA), USA
Deste Foundation, Athens, Greece
Museum of Contemporary Art,
Los Angeles (CA), USA
San Francisco Museum of Modern
Art, San Francisco (CA), USA
Southampton City Art Gallery, UK
Tate Gallery, London, UK
The Museum of Modern Art,
New York (NY), USA
Walker Art Center,
Minneapolis (MN), USA
Whitworth Art Gallery,
Manchester, UK

PRICE RANGE →
$60,000 – $90,000

AUCTION SALES →
Price: $210,000
X plus Y equals O
oil, collage, resin, glitter on linen,
elephant dung, diptych,
244 x 366 cm
Date sold: 17-May-01
Auction house: Christie's,
Rockefeller NY

Price: $190,000
Foxy Roxy, 1997
oil, polyester, resin, paper collage
on stretcher, 244 x 183 cm
Date sold: 14-May-01
Auction house: Phillips,
New York (NY)

Price: $154,000
Flowers heads
oil, acrylic, paper collage, glitter,
resin, map pin on linen, elephant
dung, 244 x 183 cm
Date sold: 27-Jun-01
Auction house: Christie's, London

Price: $140,000
Blind popcorn
oil, paper collage, glitter, resin,
map pins on linen, elephant dung,
183 x 122 cm
Date sold: 27-Jun-01
Auction house: Christie's, London

Price: $121,500
Untitled, 1998
acrylic, oil, resin, map pins on
canvas, elephant dung,
190 x 120 cm
Date sold: 08-Dec-99
Auction house: Christie's, London

HENRIK OLESEN

REPRESENTATION →
Galerie Daniel Buchholz
Neven-DuMont-Straße 17
D – 50667 Cologne
tel: +49 (0)221 257-4946
fax: +49 (0)221 253-351
www.galeriebuchholz.de

Anton Kern
532 West 20th Street
USA – New York, NY 10011
tel: +1 212 367-9663
fax: +1 212 367-8135

Klosterfelde
Zimmerstraße 90/91

D – 10117 Berlin
tel: +49 (0)30 283-5305
fax: +49 (0)30 283-5306
www.klosterfelde.de

Galleria Franco Noero
Via Mazzini 39 A
I – 10123 Turin
tel: +39 (0)11 882-208
fax: +39 (0)11 882-208

COLLECTIONS →
Sammlung zeitgenössischer Kunst
der Bundesrepublik Deutschland,
Germany
Malmö Konstmuseum, Sweden
Walker Art Center,
Minneapolis (MN), USA

PRICE RANGE →
$500 – $60,000

AUCTION SALES →
No auction results

GABRIEL OROZCO

REPRESENTATION →
Galerie Chantal Crousel
40, rue Quincampoix
F – 75004 Paris
tel: +33 (0)1 4277-3887
fax: +33 (0)1 4277-5900
www.crousel.com

Marian Goodman Gallery
24 West 57th Street
USA – New York, NY 10019
tel: +1 212 977-7160
fax: +1 212 581-5187
www.mariangoodman.com

COLLECTIONS →
Fonds National d'Art
Contemporain, Paris, France
Gestion Cultural y
Communication, Santander, Spain
Musée national d'art moderne,
Centre Georges Pompidou,
Paris, France
Philadelphia Museum of Art,
Philadelphia (PA), USA
San Francisco Museum of Modern
Art, San Francisco (CA), USA
Solomon R. Guggenheim
Museum, New York (NY), USA
The Museum of Contemporary
Art, Los Angeles (CA), USA
The Museum of Modern Art,
New York (NY), USA
Walker Art Center,
Minneapolis (MN), USA

Artist Information

PRICE RANGE →
$7,500 – $100,000

AUCTION SALES →
Price: $75,000
*Horses running endlessly,
chess set*
wood, num. 1/3, 2 x 88 x 88 cm
Date sold: 16-Nov-00
Auction house: Christie's,
Rockefeller NY

Price: $35,000
Arbol Lunar, Moon Tree
bark, paper, discs, plastic,
num. 1/9, 254 x 200 x 200 cm
Date sold: 16-Nov-00
Auction house: Christie's,
Rockefeller NY

Price: $35,000
Orange without space, 1993
plasticine oranges,
variable x 50 x variable cm
Date sold: 16-Nov-01
Auction house: Christie's,
Rockefeller NY

Price: $26,000
*Atomistas,
doble desconcierto*, 1996
iris print, six parts, diptych,
366 x 312 cm
Date sold: 15-May-01
Auction house: Phillips,
New York (NY)

Price: $17,000
Atomists – making strides
computer generated plastic-
coated print on two sheets,
199 x 195 cm
Date sold: 18-May-01
Auction house: Christie's,
Rockefeller NY

LAURA OWENS

REPRESENTATION →
ACME
6150 Wilshire Blvd
USA – Los Angeles, CA 90048
tel: +1 323 857-5942
fax: +1 323 857-5864

Gavin Brown's enterprise
436 West 15th Street
USA – New York, NY 10011
tel: +1 212 627-5258
fax: +1 212 627-5261

Galerie Gisela Capitain
Aachener Straße 5

D – 50674 Cologne
tel: +49 (0)221 256-676
fax: +49 (0)221 256-593
www.galerie-capitain.de

Sadie Coles HQ
35 Heddon Street
GB – London W1B 4BP
tel: +44 (0)20 7434-2227
fax: +44 (0)20 7434-2228
www.sadiecoles.com

COLLECTIONS →
Carnegie Museum of Art,
Pittsburgh (PA), USA
Los Angeles County Museum of
Art, Los Angeles (CA), USA
Musée national d'art moderne,
Centre Georges Pompidou,
Paris, France
Museum für Gegenwartskunst,
Basel, Basle, Switzerland
Museum of Art, Rhode Island
School of Design,
Providence (RI), USA
Museum of Contemporary Art,
Chicago (IL), USA
The Metropolitan Museum of Art,
New York (NY), USA
The Museum of Contemporary
Art, Los Angeles (CA), USA
The Museum of Modern Art,
New York (NY), USA
San Francisco Museum of Modern
Art, San Francisco (CA), USA
Solomon R. Guggenheim
Museum, New York (NY), USA
Whitney Museum of American Art,
New York (NY), USA

PRICE RANGE →
$800 – $6,000 (works on paper);
$6,000 – $50,000 (paintings)

AUCTION SALES →
Price: $7,500
Untitled, Chicago, 1997
51 x 47 cm
Date sold: 17-Nov-00
Auction house: Christie's,
Rockefeller NY

JORGE PARDO

REPRESENTATION →
1301PE
6150 Wilshire Blvd
USA – Santa Monica, CA 90048
tel: +1 323 938-5822
fax: +1 323 938-6106

Galerie Gisela Capitain
Aachener Straße 5

D – 50674 Cologne
tel: +49 (0)221 256-676
fax: +49 (0)221 256-593
www.galerie-capitain.de

neugerriemschneider
Linienstraße 155
D – 10115 Berlin
tel: +49 (0)30 3087-2810
fax: +49 (0)30 3087-2811

Friedrich Petzel Gallery
535 West 22nd Street
USA – New York, NY 10011
tel: +1 212 680-9467
fax: +1 212 680-9473
www.petzel.com

PRICE RANGE →
$1,500 – $8,000 (drawings);
$18,000 – $40,000 (paintings);
up to $150,000 (installations)

AUCTION SALES →
Price: $23,000
Untitled – 9, 1999
ink on vellum, 133 x 133 cm
Date sold: 16-May-01
Auction house: Sotheby's,
New York (NY)

Price: $10,530
One, 2, 3, 4, 5, 6, 7, 8, 10
MDF, lacquer, acrylic, glass, metal,
8 x 100 x 65 cm
Date sold: 08-Dec-99
Auction house: Christie's, London

Price: $9,720
Untitled
plastic lamp shade,
24 x 52 x 52 cm
Date sold: 08-Dec-99
Auction house: Christie's, London

Price: $7,500
Untitled, 1999
ink on vellum, 102 x 72 cm
Date sold: 15-Nov-01
Auction house: Sotheby's,
New York (NY)

PHILIPPE PARRENO

REPRESENTATION →
Air de Paris
32, rue Louise Weiss
F – 75013 Paris
tel: +33 (0)1 4423-0277
fax: +33 (0)1 5361-2284
www.airdeparis.com

Friedrich Petzel Gallery
535 West 22nd Street
USA – New York, NY 10011
tel: +1 212 680-9467
fax: +1 212 680-9473
www.petzel.com

Schipper & Krome
Linienstraße 85
D – 10119 Berlin
tel: +49 (0)30 2839-0139
fax: +49 (0)30 2839-0140
www.schipper-krome.com

COLLECTIONS →
ARC Musée d'Art Moderne
de la Ville de Paris, France
Fonds National d'Art
Contemporain, Paris, France
Fonds Régional d'Art Contem-
porain Poitou-Charentes, France
Walker Art Center,
Minneapolis (MN), USA
Contemporary Art Museum,
Kanazawa, Japan

PRICE RANGE →
$1,200 – $24,000

AUCTION SALES →
No auction results

MANFRED PERNICE

REPRESENTATION →
Anton Kern
532 West 20th Street
USA – New York, NY 10011
tel: +1 212 367-9663
fax: +1 212 367-8135

Mai 36 Galerie
Rämistrasse 37
CH – 8001 Zurich
tel: +41 (0)1 261-6880
fax: +41 (0)1 261-6881
www.artgalleries.ch/mai 36

Galerie Neu
Philippstraße 13
D – 10117 Berlin
tel: +49 (0)30 285-7550
fax: +49 (0)30 281-0085

COLLECTIONS →
Sammlung zeitgenössischer Kunst
der Bundesrepublik Deutschland,
Germany
Kunstmuseum Wolfsburg,
Germany
The Museum of Contemporary
Art, Los Angeles (CA), USA

PRICE RANGE →
$2,000 (drawings) – $60,000
(installations)

AUCTION SALES →
No auction results

DAN PETERMAN

REPRESENTATION →
Klosterfelde
Zimmerstraße 90/91
D – 10117 Berlin
tel: +49 (0)30 283-5305
fax: +49 (0)30 283-5306
www.klosterfelde.de

Andrea Rosen Gallery
525 West 24th Street
USA – New York, NY 10011
tel: +1 212 627-6000
fax: +1 212 627-5450
www.andrearosengallery.com

COLLECTIONS →
Städtisches Museum Abteiberg,
Mönchengladbach, Germany
Museum der Bildenden Künste,
Leipzig, Germany
The Art Institute of Chicago,
Chicago (IL), USA

PRICE RANGE →
$500 – $40,000

AUCTION SALES →
No auction results

ELIZABETH PEYTON

REPRESENTATION →
Gavin Brown's enterprise
436 West 15th Street
USA – New York, NY 10011
tel: +1 212 627-5258
fax: +1 212 627-5261

Sadie Coles HQ
35 Heddon Street
GB – London W1B 4BP
tel: +44 (0)20 7434-2227
fax: +44 (0)20 7434-2228
www.sadiecoles.com

neugerriemschneider
Linienstraße 155
D – 10115 Berlin
tel: +49 (0)30 3087-2810
fax: +49 (0)30 3087-2811

COLLECTIONS →
Museum für Gegenwartskunst,

Basel, Basle, Switzerland
Kunstmuseum Wolfsburg, Germany
Musée national d'art moderne,
Centre Georges Pompidou,
Paris, France
San Francisco Museum of Modern
Art, San Francisco (CA), USA
The Museum of Modern Art,
New York (NY), USA
Walker Art Center,
Minneapolis (MN), USA

PRICE RANGE →
$4,000 – $45,000

AUCTION SALES →
Price: $80,000
David, Victoria and Brooklyn, 1999
152 x 102 cm
Date sold: 17-May-01
Auction house: Christie's,
Rockefeller NY

Price: $68,000
Colin de Land, 1994
152 x 102 cm
Date sold: 14-May-01
Auction house: Phillips,
New York (NY)

Price: $60,000
*The origin of the order
of the Garter*, 1995
oil on panel, 50 x 41 cm
Date sold: 17-May-00
Auction house: Christie's,
Rockefeller NY

Price: $55,000
Kurt smoking, 1995
oil on masonite, 30 x 22 cm
Date sold: 15-Nov-01
Auction house: Christie's,
Rockefeller NY

Price: $38,070
Princess Elizabeth, 1995
oil, plaster on masonite, 21 x 23 cm
Date sold: 06-Feb-02
Auction house: Christie's, London

PAUL PFEIFFER

REPRESENTATION →
Giò Marconi
Via Tadino 15
I – 20124 Milan
tel: +39 (0)2 2940-4373
fax: +39 (0)2 2940-5573

The Project
427 West 126th Street
USA – New York, NY 10027

tel: +1 212 662-8610
fax: +1 212 662-2800
www.elproyecto.com

COLLECTIONS →
K21 Kunstsammlung im
Ständehaus, Düsseldorf, Germany
Museum of Contemporary Art,
Chicago (IL), USA
Whitney Museum of American Art,
New York (NY), USA

PRICE RANGE →
$10,000 (photos);
$20,000 – $30,000 (videos)

AUCTION SALES →
No auction results

DANIEL PFLUMM

REPRESENTATION →
Greene Naftali
526 West 26th Street
USA – New York, NY 10001
tel: +1 212 463-7770
fax: +1 212 463-0890

Galerie Neu
Philippstraße 13
D – 10117 Berlin
tel: +49 (0)30 285-7550
fax: +49 (0)30 281-0085

COLLECTIONS →
Kunstmuseum Wolfsburg,
Germany

PRICE RANGE →
$3,000 – $10,000 (lightboxes,
videos)

AUCTION SALES →
No auction results

RICHARD PHILLIPS

REPRESENTATION →
Stephen Friedman Gallery
25–28 Old Burlington Street
GB – London W1S 3AN
tel: +44 (0)20 7494-1434
fax: +44 (0)20 7494-1431
www.stephenfriedman.com

Galerie Max Hetzler
Zimmerstraße 90/91
D – 10117 Berlin
tel: +49 (0)30 229-2437
fax: +49 (0)30 229-2417
www.maxhetzler.com

Friedrich Petzel Gallery
535 West 22nd Street
USA – New York, NY 10011
tel: +1 212 680-9467
fax: +1 212 680-9473
www.petzel.com

COLLECTIONS →
Albright-Knox Art Gallery,
Buffalo (NY), USA
Memphis Museum, USA
Modern Art Museum of
Fort Worth (TX), USA
San Francisco Museum of Modern
Art, San Francisco (CA), USA
Weatherspoon Art Gallery,
Greensboro (NC), USA
Whitney Museum of American Art,
New York (NY), USA

PRICE RANGE →
$3,000 – $6,000 (works on paper);
$10,000 – $65,000 (paintings)

AUCTION SALES →
No auction results

PAOLA PIVI

REPRESENTATION →
Massimo De Carlo
Viale Corsica 41
I – 20133 Milan
tel: +39 (0)2 7000-3987
fax: +39 (0)2 749-2135

Galerie Emmanuel Perrotin
30, rue Louise Weiss
F – 75013 Paris
tel: +33 (0)1 4216-7979
fax: +33 (0)1 4216-7974
www.galerieperrotin.com

Galerie Michael Neff
Hanauer Landstraße 52
D – 60314 Frankfurt am Main
tel: +49 (0)69 9043-1467
fax: +49 (0)69 4908-4345

PRICE RANGE →
$4,000 – $9,000 (small works);
$13,000 – $26,000 (medium
installations); $40,000 – $130,000
(large installations)

AUCTION SALES →
No auction results

PETER POMMERER

REPRESENTATION →
carlier l gebauer

Artist Information

Holzmarktstraße 15–18
S-Bahnbogen 51/52
D – 10179 Berlin
tel: +49 (0)30 280-8110
fax: +49 (0)30 280-8109
www.carliergebauer.com

Meyer Riegger
Klauprechtstraße 22
D – 76137 Karlsruhe
tel: +49 (0)721 821-292
fax: +49 (0)721 982-2141
www.meyer-riegger.de

Raum aktueller Kunst
Martin Janda
Eschenbachgasse 11
A – 1010 Vienna
tel: +43 (0)1 585-7371
fax: +43 (0)1 585-7372
www.raumaktuellerkunst.at

Taro Nasu Gallery
1-8-13-2F Saga, Kotu-ku
JPN – Tokyo 135-0031
tel/fax: +81 (0)3 3630-7759

PRICE RANGE →
$500 – $10,000

AUCTION SALES →
No auction results

NEO RAUCH

REPRESENTATION →
David Zwirner
43 Greene Street
USA – New York, NY 10013
tel: +1 212 966-9074
fax: +1 212 966-4952
www.davidzwirner.com

EIGEN + ART
Auguststraße 26
D – 10117 Berlin
tel: +49 (0)30 280-6605
fax: +49 (0)30 280-6616
www.eigen-art.com

COLLECTIONS →
Galerie für Zeitgenössische
Kunst, Leipzig, Germany
Kunstmuseum Wolfsburg, Germany
Museum der Bildenden Künste
Leipzig, Germany
Museum Ludwig, Cologne,
Germany
Solomon R. Guggenheim
Museum, New York (NY), USA
Sammlung zeitgenössischer Kunst
der Bundesrepublik Deutschland,
Germany

The Museum of Modern Art,
New York (NY), USA

PRICE RANGE →
$2,500 – $50,000 (works on
paper); $13,000 – $100,000 (works
on canvas)

AUCTION SALES →
Price: $6,000
Untitled, 1995
ink, gouache, 49 x 63 cm
Date sold: 15-Nov-01
Auction house: Sotheby's,
New York (NY)

Price: $5,185
Composition, 1990
board, 125 x 190 cm
Date sold: 28-Jun-01
Auction house: Villa Grisebach,
Berlin

NAVIN RAWANCHAIKUL

REPRESENTATION →
Air de Paris
32, rue Louise Weiss
F – 75013 Paris
tel: +33 (0)1 4423-0277
fax: +33 (0)1 5361-2284
www.airdeparis.com

Shugoarts
Shokuryo Bldg
1-8-13-3F Saga, Koto-ku
JPN – Tokyo 135-0031
tel: +81 (0)3 5646-0481
fax: +81 (0)3 5646-0483

COLLECTIONS →
Stedelijk Museum voor Actuele
Kunst, Ghent, Belgium

PRICE RANGE →
$200 – $80,000

AUCTION SALES →
No auction results

TOBIAS REHBERGER

REPRESENTATION →
Giò Marconi
Via Tadino 15
I – 20124 Milan
tel: +39 (0)2 2940-4373
fax: +39 (0)2 2940-5573

neugerriemschneider
Linienstraße 155
D – 10115 Berlin

tel: +49 (0)30 3087-2810
fax: +49 (0)30 3087-2811

Friedrich Petzel Gallery
535 West 22nd Street
USA – New York, NY 10111
tel: +1 212 680-9467
fax: +1 212 680-9473
www.petzel.com

PRICE RANGE →
$750 – $75,000

AUCTION SALES →
No auction results

JASON RHOADES

REPRESENTATION →
Hauser & Wirth
Limmatstrasse 27
CH – 8005 Zurich
tel: +41 (0)1 446-8050
fax: +41 (0)1 446-8055
www.ghw.ch

David Zwirner
43 Greene Street
USA – New York, NY 10013
tel: +1 212 966-9074
fax: +1 212 966-4952
www.davidzwirner.com

COLLECTIONS →
Fondazione Sandretto Re
Rebaudengo per l'Arte, Turin, Italy
Los Angeles County Museum of
Art, Los Angeles (CA), USA
Museum voor Hedendaagse
Kunst, Ghent, Belgium
Solomon R. Guggenheim
Museum, New York (NY), USA
The Museum of Contemporary
Art, Los Angeles (CA), USA
The Museum of Modern Art,
New York (NY), USA

PRICE RANGE →
$3,000– $100,000

AUCTION SALES →
No auction results

DANIEL RICHTER

REPRESENTATION →
Contemporary Fine Arts
Sophienstraße 2
D – 10178 Berlin
tel: +49 (0)30 288-7870
fax: +49 (0)30 2887-8726
www.cfa-berlin.com

Galerie Ghislaine Hussenot
5 bis, rue des Haudriettes
F – 75003 Paris
tel: +33 (0)1 4887-6081
fax: +33 (0)1 4887-0501

Patrick Painter Inc.
2525 Michigan Ave #B2
USA – Santa Monica, CA 90404
tel: +1 310 264-5988
fax: +1 310 264-5998

COLLECTIONS →
Kunsthalle zu Kiel, Germany

PRICE RANGE →
$18,000 – $40,000

AUCTION SALES →
Price: $8,100
Ohne Lösung
oil, acrylic, 150 x 165 cm
Date sold: 08-Dec-99
Auction house: Christie's, London

Price: $4,536
Krillmasser, 1995
120 x 100 cm
Date sold: 08-Dec-99
Auction house: Christie's,
Kensington

DE RIJKE/DE ROOIJ

REPRESENTATION →
Galerie Daniel Buchholz
Neven-DuMont-Straße 17
D – 50667 Köln
tel: +49 (0)221 257-4946
fax: +49 (0)221 253-351
www.galeriebuchholz.de

COLLECTIONS →
Hamburger Kunsthalle,
Hamburg, Germany

PRICE RANGE →
$13,000 – $22,000

AUCTION SALES →
No auction results

PIPILOTTI RIST

REPRESENTATION →
Hauser & Wirth
Limmatstrasse 270
CH – 8005 Zurich
tel: +41 (0)1 446-8050
fax: +41 (0)1 446-8055
www.ghw.ch

Luhring Augustine
531 West 24th Street
USA – New York, NY 10011
tel: +1 212 206-9055
fax: +1 212 206-9055
www.luhringaugustine.com

COLLECTIONS →
Bayerische Staatsgemälde-
sammlung, Munich, Germany
Centraal Museum, Ütrecht,
Netherlands
Fondação de Serralves,
Oporto, Portugal
Solomon R. Guggenheim
Museum, New York (NY), USA
Kunsthalle Nürnberg, Nuremberg,
Germany
Musée des Beaux-Arts,
Montreal, Canada
Museum Ludwig, Cologne, Germany
Museum of Contemporary Art,
Los Angeles (CA), USA
Museum of Modern Art,
New York (NY), USA
Ydessa Hendeles Art Foundation,
Canada

PRICE RANGE →
$5,000 – $100,000

AUCTION SALES →
Price: $105,700
Bar
MDF, various objects, dimensions
variable
Date sold: 27-Jun-00
Auction house: Christie's, London

Price: $60,000
Wunderlampe, miracle lamp
monitor, video player, prismatic
plastic, video tape, steel,
150 x 55 x 44 cm
Date sold: 16-Nov-00
Auction house: Christie's,
Rockefeller NY

Price: $25,280
Hallo, Guten Tag, 1995
mirror, video, num. 9/10,
40 x 30 x variable cm
Date sold: 24-Jun-99
Auction house: Sotheby's, London

Price: $25,200
Hallo, Guten Tag, 1995
mirror, video, num. 8/10,
40 x 30 x variable cm
Date sold: 10-Dec-98
Auction house: Sotheby's, London

Price: $18,000
In the middle of life, we are, 1999
video still, cibachrome, num. 1/5,
125 x 160 cm
Date sold: 15-Nov-01
Auction house: Sotheby's,
New York (NY)

UGO RONDINONE

REPRESENTATION →
Hauser & Wirth & Presenhuber
Limmatstrasse 270
CH – 8005 Zurich
tel: +41 (0)1 446-8060
fax: +41 (0)1 446-8065
www.ghwp.ch

Matthew Marks Gallery
523 West 24th Street
USA – New York, NY 10111
tel: +1 212 243-0200
fax: +1 212 243-0047

Schipper & Krome
Linienstraße 85
D – 10119 Berlin
tel: +49 (0)30 2839-0139
fax: +49 (0)30 2839-0140
www.schipper-krome.com

COLLECTIONS →
Albertina, Vienna, Austria
ARC Musée d'Art Moderne
de la Ville de Paris, France
capcMusée d'Art Contemporain,
Bordeaux, France
Centre d'Art Contemporain,
Geneva, Switzerland
Fondazione Prada, Milan, Italy
Fonds Régional d'Art Contem-
porain, Nord-Pas de Calais, France
Fonds Régional d'Art Contem-
porain, Poitou-Charentes, France
Fonds Régional d'Art
Contemporain, Provence-
Alpes-Côte d'Azur, France
Galerie der Stadt Esslingen,
Villa Merkel, Esslingen, Germany
Galerie für Zeitgenössische Kunst,
Leipzig, Germany
Herzliya Museum of Art,
Herzliya, Israel
Institute of Contemporary Art,
Philadelphia (PA), USA
Kunsthaus Glarus, Switzerland
Kunsthaus Zürich, Zurich,
Switzerland
Kunstmuseum, Berne, Switzerland
Kunstmuseum Luzern, Switzerland
Kunstmuseum St. Gallen,
Switzerland
Kunstmuseum Wolfsburg, Germany

Kunstsammlung Nordrhein-
Westfalen, Düsseldorf, Germany
Le Consortium, Dijon, France
Louisiana Museum of Modern Art,
Humlebæk, Denmark
Migros Museum für Gegenwarts-
kunst, Zurich, Switzerland
Musée d'Art Moderne et
Contemporain, Strasbourg, France
Musée national d'art moderne,
Centre Georges Pompidou,
Paris, France
Museum Dhondt Dhaenens,
Deurle, Belgium
Museum für Gegenwartskunst,
Basel, Basle, Switzerland
Museum in Progress, Vienna, Austria
Museum of Contemporary Art
Kiasma, Helsinki, Finland
Museum of Contemporary Art,
Chicago (IL), USA
Palazzo delle Papesse, Siena, Italy
Staatliche Kunsthalle
Baden-Baden, Germany
Stedelijk Museum voor Actuele
Kunst, Ghent, Belgium
The Israel Museum,
Jerusalem, Israel
The Museum of Modern Art,
New York (NY), USA
Villa Arson, Nice, France

PRICE RANGE →
$5,600 – $120,000

AUCTION SALES →
Price: $1,143
Untitled, 1984
mixed media, 70 x 100 cm
Date sold: 13-Nov-01
Auction house: Germann, Zurich

Price: $819
Sans titre, 1995
white crayon, 68 x 50 cm
Date sold: 16-Dec-00
Auction house: Francis Briest,
Paris

THOMAS RUFF

REPRESENTATION →
Johnen + Schöttle
Maria-Hilf-Straße 17
D – 50677 Cologne
tel: +49 (0)221 310-270
fax: +49 (0)221 310-2727
www.johnen-schoettle.de

Mai 36 Galerie
Rämistrasse 37
CH – 8001 Zurich
tel: +41 (0)1 261-6880

fax: +41 (0)1 261-6881
www.artgalleries.ch/mai 36

David Zwirner
43 Greene Street
USA – New York, NY 10013
tel: +1 212 966-9074
fax: +1 212 966-4952
www.davidzwirner.com

COLLECTIONS →
Hamburger Kunsthalle,
Hamburg, Germany
K21 Kunstsammlung im
Ständehaus, Düsseldorf, Germany
Kunstmuseum Basel, Basle,
Switzerland
Musée national d'art moderne,
Centre Georges Pompidou,
Paris, France
Museum für Moderne Kunst,
Frankfurt am Main, Germany
Museum Ludwig, Cologne, Germany
Solomon R. Guggenheim
Museum, New York (NY), USA
Tate Gallery, London, UK
The Art Institute of Chicago,
Chicago (IL), USA
The Metropolitan Museum of Art,
New York (NY), USA
The Museum of Modern Art,
New York (NY), USA
Vancouver Art Gallery, Canada

PRICE RANGE →
$1,200 – $75,000

AUCTION SALES →
Price: $100,100
Sterne 02h 56m – 65
colour coupler print, num. 1/2,
252 x 180 cm
Date sold: 23-Oct-01
Auction house: Christie's, London

Price: $86,400
Photo 09h 58m – 40, 1990/1992
c-print, 201 x 134 cm
Date sold: 09-Feb-01
Auction house: Christie's, London

Price: $85,000
21h 32m – 60, 1992
260 x 190 cm
Date sold: 15-Nov-01
Auction house: Christie's,
Rockefeller NY

Price: $77,000
7h 48m – 70, 1990
c-print, num. 1/2, 260 x 185 cm
Date sold: 27-Jun-01
Auction house: Christie's, London

Artist Information

Price: $75,000
19h 38m – 60, 1992
colour coupler print, num. 1/2,
258 x 186 cm
Date sold: 18-May-01
Auction house: Christie's,
Rockefeller NY

GREGOR SCHNEIDER

REPRESENTATION →
Luis Campaña
An der Schanz 1a
D – 50735 Cologne
tel: +49 (0)221 256-712
fax: +49 (0)221 256-213

Konrad Fischer Galerie
Platanenstraße 7
D – 40233 Düsseldorf
tel: +49 (0)211 685-908
fax: +49 (0)211 689-780
www.konradfischergalerie.de

Barbara Gladstone Gallery
515 West 24th Street
USA – New York, NY 10011
tel: +1 212 206-9300
fax: +1 212 206-9301
www.gladstonegallery.com

COLLECTIONS →
K21 Kunstsammlung im
Ständehaus, Düsseldorf, Germany
Städtisches Museum Abteiberg,
Mönchengladbach, Germany

PRICE RANGE →
$1,500 (photos); $25,000 (medium
size sculptures); up to $110,000
(large rooms)

AUCTION SALES →
Price: $56,400
Kellerfenster, 1985–1999
wood, plaster, cement, metal grill,
brackets, 237 x 135 x 47 cm
Date sold: 06-Feb-02
Auction house: Christie's, London

CINDY SHERMAN

REPRESENTATION →
Metro Pictures
519 West 24th Street
USA – New York, NY 10011
tel: +1 212 206-7100
fax: +1 212 337-0070

Monika Sprüth –
Philomene Magers
Wormser Straße 23

D – 50677 Cologne
tel: +49 (0)221 380-415
fax: +49 (0)221 380-417
Schellingstraße 48
D – 80799 Munich
tel: +49 (0)89 3304-0600
fax: +49 (0)89 397-302
www.philomenemagers.com

COLLECTIONS →
Albright-Knox Art Gallery,
Buffalo (NY), USA
Art Gallery of New South Wales,
Sydney, Australia
Art Gallery of Ontario,
Toronto, Canada
Astrup Fearnley Museum of
Modern Art, Oslo, Norway
Carnegie Museum of Art,
Pittsburgh (PA), USA
Dallas Museum of Arts,
Dallas (TX), USA
Fondation Musée d'Art Moderne
Grand-Duc Jean, Luxembourg
Hamburger Kunsthalle,
Hamburg, Germany
Kunsthaus Zürich, Zurich,
Switzerland
Kunstmuseum Wolfsburg, Germany
Los Angeles County Museum of
Art, Los Angeles (CA), USA
Louisiana Museum of Modern Art,
Humlebæk, Denmark
Metropolitan Museum of
Photography, Tokyo, Japan
Moderna Museet,
Stockholm, Sweden
Musée d'Art Contemporain,
Montreal, Canada
Musée national d'art moderne,
Centre Georges Pompidou,
Paris, France
Museet for Samtidskunst,
Oslo, Norway
Museo Nacional Centro de Arte
Reina Sofía, Madrid, Spain
Museum Boijmans Van Beuningen,
Rotterdam, The Netherlands
Museum Folkwang, Essen, Germany
Museum Ludwig, Cologne, Germany
Museum of Contemporary Art,
Chicago (IL), USA
Museum of Contemporary Art,
Helsinki, Finland
Museum of Fine Arts,
Boston (MA), USA
Museum of Fine Arts,
Houston (TX), USA
Museum of Modern Art,
New York (NY), USA
Nationalgalerie im Hamburger
Bahnhof, Museum für Gegenwart,
Berlin, Germany
Philadelphia Museum of Art,

Philadelphia (PA), USA
Rijksmuseum Kroller-Müller,
Otterlo, The Netherlands
San Francisco Museum of Modern
Art, San Francisco (CA), USA
Solomon R. Guggenheim
Museum, New York (NY), USA
Sprengel Museum,
Hanover, Germany
St. Louis Art Museum,
St. Louis (MO), USA
Staatsgalerie Stuttgart, Germany
Stedelijk Museum, Amsterdam,
The Netherlands
Tate Gallery, London, UK
The Art Institute of Chicago,
Chicago (IL), USA
The Israel Museum,
Jerusalem, Israel
The Metropolitan Museum of Art,
New York (NY), USA
The Museum of Contemporary
Art, Los Angeles (CA), USA
Victoria and Albert Museum,
London, UK
Wadsworth Atheneum Museum
of Art, Hartford (CT), USA
Walker Art Center,
Minneapolis (MN), USA
Whitney Museum of American Art,
New York (NY), USA

PRICE RANGE →
$10,000 – $75,000

AUCTION SALES →
Price: $300,000
Untitled film still No. 48
gelatin silver, num. 1/10, 20 x 25 cm
Date sold: 17-May-01
Auction house: Christie's,
Rockefeller NY

Price: $240,000
Untitled, 1989
colour photograph, 145 x 104 cm
Date sold: 17-May-00
Auction house: Sotheby's,
New York (NY)

Price: $230,000
Untitled No. 92, 1982
colour coupler print, num. 10/10,
61 x 122 cm
Date sold: 16-Nov-00
Auction house: Christie's,
Rockefeller NY

Price: $150,000
Untitled film No. 13, 1978
gelatin silver print, num. 2/3,
102 x 76 cm
Date sold: 18-May-00
Auction house: Phillips,

New York (NY)

Price: $150,000
Untitled no. 86, 1981
Cibachrome, 61 x 122 cm
Date sold: 14-May-01
Auction house: Phillips,
New York (NY)

DAVID SHRIGLEY

REPRESENTATION →
Stephen Friedman Gallery
25–28 Old Burlington Street
GB – London WIS 3AN
tel: +44 (0)20 7494-1434
fax: +44 (0)20 7494-1431
www.stephenfriedman.com

Galerie Yvon Lambert
108, rue Vieille-du-Temple
F – 75003 Paris
tel: +33 (0)1 4271-0933
fax: +33 (0)1 4271-8747

Galleri Nicolai Wallner
Njalsgade 21
DK – 2300 Copenhagen
tel: +45 3257-0970
fax: +45 3257-0971
www.nicolaiwallner.com

COLLECTIONS →
Arts Council of England, UK
Statens Museum for Kunst,
Copenhagen, Denmark

PRICE RANGE →
$1,000 – $60,000

AUCTION SALES →
No auction results

SANTIAGO SIERRA

REPRESENTATION →
carlier I gebauer
Holzmarktstraße 15–18
S-Bahnbogen 51/52
D – 10179 Berlin
tel: +49 (0)30 280-8110
fax: +49 (0)30 280-8109
www.carliergebauer.com

Galeria Enrique Guerrero
Horacio 1549/A, Col Polanco
MEX – Mexico City 11540
tel: +52 5 280-2941
fax: +52 5 280-3283

Galerie Peter Kilchmann
Limmatstrasse 270

CH – 8005 Zurich
tel: +41 (0)1 440-3931
fax: +41 (0)1 440-3932
www.kilchmanngalerie.com

COLLECTIONS →
La Colección Júmex, Mexico City,
Mexico
Montenmedio Arte
Contemporáneo, Cádiz, Spain
Museo Nacional Centro de Arte
Reina Sofía, Madrid, Spain

PRICE RANGE →
$2,000 – $20,000

AUCTION SALES →
No auction results

DIRK SKREBER

REPRESENTATION →
Blum & Poe
2042 Broadway
USA – Santa Monica, CA 90404
tel: +1 310 453-8311
fax: +1 310 453-2821

Luis Campaña
An der Schanz 1a
D – 50735 Cologne
tel: +49 (0)221 256-712
fax: +49 (0)221 256-213

Kerstin Engholm Galerie
Schleifmühlgasse 3
A – 1040 Vienna
tel: +43 (0)1 585-7337
fax: +43 (0)1 585-7338
www.kerstinengholm.com

Jiri Svestka Gallery
Jungmannova 30
CZ – 110 00 Prague 1
tel: +420 (0)2 9624-5024
fax: +420 (0)2 9624-5014
www.jirisvestka.com

COLLECTIONS →
Fondazione Sandretto Re
Rebaudengo per l'Arte, Turin, Italy
Museum Kurhaus, Kleve, Germany
Museum voor Moderne Kunst,
Arnhem, The Netherlands
Sammlung zeitgenössischer Kunst
der Bundesrepublik Deutschland,
Germany
The Museum of Contemporary
Art, Los Angeles (CA), USA

PRICE RANGE →
$15,000 – $30,000 (paintings);
$4,000 – $8,000 (small sculptures);

$35,000 – $44,000 (large
sculptures and installations)

AUCTION SALES →
Price: $10,813
Untitled
240 x 150 cm
Date sold: 26-Nov-00
Auction house: Sotheby's, Munich

ANDREAS SLOMINSKI

REPRESENTATION →
Jablonka Galerie
Lindenstraße 19
D – 50674 Cologne
tel: +49 (0)221 240-3426
fax: +49 (0)221 240-8132
www.jablonkagalerie.com

Metro Pictures
519 West 24th Street
USA – New York, NY 10011
tel: +1 212 206-7100
fax: +1 212 337-0070

Galerie Neu
Philippstraße 13
D – 10117 Berlin
tel: +49 (0)30 285-7550
fax: +49 (0)30 281-0085

Produzentengalerie Hamburg
Admiralitätstraße 71
D – 20459 Hamburg
tel: +49 (0)40 378-232
fax: +49 (0)40 363-304
www.produzentengalerie.com

COLLECTIONS →
Fundación "la Caxia",
Barcelona, Spain
Hamburger Kunsthalle,
Hamburg, Germany
K21 Kunstsammlung im
Ständehaus, Düsseldorf, Germany
Museum für Moderne Kunst,
Frankfurt am Main, Germany
Solomon R. Guggenheim
Museum, New York (NY), USA

PRICE RANGE →
$2,000 – $70,000

AUCTION SALES →
Price: $7,000
Polecat trap
wood metal, 19 x 101 x 18 cm
Date sold: 29-Jun-01
Auction house: Christie's,
Kensington

YUTAKA SONE

REPRESENTATION →
David Zwirner
43 Greene Street
USA – New York, NY 10013
tel: +1 212 966-9074
fax: +1 212 966-4952
www.davidzwirner.com

COLLECTIONS →
Contemporary Art Center,
Mito, Japan
Contemporary Art Museum,
Kanazawa, Japan
Fondazione Sandretto Re
Rebaudengo per l'Arte, Turin, Italy
The Museum of Contemporary
Art, Los Angeles (CA), USA
Toyota Municipal Museum of Art,
Toyota Aichi, Japan

PRICE RANGE →
$2,000 – $75,000

AUCTION SALES →
No auction results

ELIEZER SONNENSCHEIN

REPRESENTATION →
Sommer Contemporary Art
64 Rothschild Blvd
ISR – 65785 Tel Aviv
tel: +972 (0)3 560-0630
fax: +972 (0)3 566-5501
www.sommercontemporaryart.com

COLLECTIONS →
Tel Aviv Museum of Art, Israel

PRICE RANGE →
$3,000 – $8,000 (paintings);
$10,000 – $15,000 (sculptures);
$50,000 (installations)

AUCTION SALES →
No auction results

SIMON STARLING

REPRESENTATION →
Casey Kaplan
416 West 14th Street
USA – New York, NY 10014
tel: +1 212 645-7335
fax: +1 212 645-7835

The Modern Institute
73 Robertson Street, Suite 6 fl. 1
GB – Glasgow G2 8QD
tel: +44 (0)141 248-3711

fax: +44 (0)141 248-3280
www.themoderninstitute.org

neugerriemschneider
Linienstraße 155
D – 10115 Berlin
tel: +49 (0)30 3087-2810
fax: +49 (0)30 3087-2811

COLLECTIONS →
Arts Council of England, UK
Fonds Régional d'Art
Contemporain, Languedoc-
Roussillon, France
Scottish Arts Council, UK

PRICE RANGE →
$1,400 – $45,000

AUCTION SALES →
No auction results

THOMAS STRUTH

REPRESENTATION →
Marian Goodman Gallery
24 West 57th Street
USA – New York, NY 10019
tel: +1 212 977-7160
fax: +1 212 581-5187
www.mariangoodman.com

Galerie Max Hetzler
Zimmerstraße 90/91
D – 10117 Berlin
tel: +49 (0)30 229-2437
fax: +49 (0)30 229-2417
www.maxhetzler.com

Johnen + Schöttle
Maria-Hilf-Straße 17
D – 50677 Cologne
tel: +49 (0)221 310-270
fax: +49 (0)221 310-2727
www.johnen-schoettle.de

COLLECTIONS →
Hamburger Kunsthalle,
Hamburg, Germany
Musée national d'art moderne,
Centre Georges Pompidou,
Paris, France
Staatsgalerie Stuttgart, Germany
Tate Gallery, London, UK
The Metropolitan Museum of Art,
New York (NY), USA
The Museum of Modern Art,
New York (NY), USA

PRICE RANGE →
from $35,000

Artist Information

AUCTION SALES →
Price: $260,850
*Galleria dell'Accademia,
Venice,* 1992
Cibachrome, num. 1/10,
189 x 234 cm
Date sold: 07-Feb-02
Auction house: Sotheby's, London

Price: $240,000
Pantheon, Rome, 1990
Cibachrome, num. 1/10,
188 x 241 cm
Date sold: 16-May-00
Auction house: Christie's,
Rockefeller NY

Price: $210,000
Pantheon, Rome
Cibachrome, num. 7/10,
183 x 238 cm
Date sold: 14-Nov-00
Auction house: Sotheby's,
New York (NY)

Price: $180,000
Galleria dell'Accademia I, 1992
chromogenic colour print,
184 x 228
Date sold: 18-May-00
Auction house: Phillips,
New York (NY)

Price: $155,000
Musee du Louvre 2, 1989
Cibachrome, num. 9/10,
219 x 180 cm
Date sold: 17-May-00
Auction house: Sotheby's,
New York (NY)

SUPERFLEX

REPRESENTATION →
Jesper Nymark
no address
DK – Copenhagen
tel: +45 2093-3833
nymark@cphpoStreetdk

COLLECTIONS →
Arken Museum of Modern Art,
Ishøj, Denmark
Galerie für Zeitgenössische Kunst,
Leipzig, Germany

PRICE RANGE →
$1,750 (stocks); $4,250 (photo-
series); $30,000 (installations)

AUCTION SALES →
No auction results

FIONA TAN

REPRESENTATION →
Galerie Paul Andriesse
Prinsengracht 116
NL – 1015 EA Amsterdam
tel: +31 (0)20 623-6237
fax: +31 (0)20 639-0038

Frith Street Gallery
59–60 Frith Street
GB – London W1V 5TA
tel: +44 (0)20 7494-155
fax: +44 (0)20 7287-3733
www.frithstreetgallery.co.uk

COLLECTIONS →
ARC Musee d'Art moderne
de la Ville de Paris, France
De Pont Foundation for
Contemporary Art, Tilburg,
The Netherlands
Fonds National d'Art
Contemporain, Paris, France
Fonds Régional d'Art
Contemporain, Rhône-Alpes, France
Museum Boijmans Van Beuningen,
Rotterdam, The Netherlands
National Museum of Modern Art,
Kyoto, Japan
Stedelijk Museum, Amsterdam,
The Netherlands

PRICE RANGE →
$70 (editions) –
$35,000 (installations)

AUCTION SALES →
No auction results

VIBEKE TANDBERG

REPRESENTATION →
c/o Atle Gerhardsen
Holzmarktstraße 15–18
S-Bahnbogen 46
10179 Berlin
tel: +49 (0)30 6951-8341
fax: +49 (0)30 6951-8342
www.atlegerhardsen.com

Klosterfelde
Zimmerstraße 90/91
D – 10117 Berlin
tel: +49 (0)30 283-5305
fax: +49 (0)30 283-5306
www.klosterfelde.com

Tomio Koyama Gallery
Saga 1-8-13-2F, Koto-ku
JPN – Tokyo 135-0031
tel/fax: +81 (0)3 3630-2205

Galerie Yvon Lambert
108, rue Vieille-du-Temple
F – 75003 Paris
tel: +33 (0)1 4271-0933
fax: +33 (0)1 4271-8747

COLLECTIONS →
ARC Musée d'Art Moderne
de la Ville de Paris, France
Astrup Fearnley Museum of
Modern Art, Oslo, Norway
Fonds Regional d'Art Contem-
porain du Limousin, France
Moderna Museet,
Stockholm, Sweden
Museet for Samtidskunst,
Oslo, Norway
Museum Folkwang, Essen, Germany
New Museum of Contemporary
Art, New York (NY), USA
Nork Kulturråd, Oslo, Norway
Oslo Kommunes Kunstamlinger,
Oslo, Norway
The National Museum of
Photography, Copenhagen,
Denmark

PRICE RANGE →
$450 (production still) – $16,000
(complete series); $10,000 (film)

AUCTION SALES →
No auction results

WOLFGANG TILLMANS

REPRESENTATION →
Galerie Daniel Buchholz
Neven-DuMont-Straße 17
D – 50667 Cologne
tel: +49 (0)221 257-4946
fax: +49 (0)221 253-351
www.galeriebuchholz.de

Interim Art/Maureen Paley
21 Herald Road
GB – London E2 6JT
tel: +44 (0)20 7729-4112
fax: +44 (0)20 7729-4113

Andrea Rosen Gallery
525 West 24th Street
USA – New York, NY 10011
tel: +1 212 627-6000
fax: +1 212 627-5450
www.andrearosengallery.com

COLLECTIONS →
Arken Museum of Modern Art,
Ishøj, Denmark
Museum Ludwig, Cologne, Germany
Musée des Beaux-Arts, Nantes,
France

Tate Gallery, London, UK
The Metropolitan Museum of Art,
New York (NY), USA

PRICE RANGE →
$2,000 – $30,000

AUCTION SALES →
Price: $21,060
*Suzanne and Lutz, white dress,
army skirt,* 1993
c-print, 61 x 51 cm
Date sold: 08-Dec-99
Auction house: Christie's, London

Price: $20,160
Alex and Lutz in the trees, 1992
c-print, 30 x 40 cm
Date sold: 09-Feb-01
Auction house: Christie's, London

Price: $19,440
Kate sitting
ink jet print sold with original
photo, 172 x 120 cm
Date sold: 08-Dec-99
Auction house: Christie's, London

Price: $15,840
Suzanne and Lutz, Bournemouth
c-print, num. 1/10, 40 x 30 cm
Date sold: 09-Feb-01
Auction house: Christie's, London

Price: $14,400
Stiefelknecht, Cologne, 1993
ink jet print, 116 x 173 cm
Date sold: 08-Feb-01
Auction house: Christie's, London

RIRKRIT TIRAVANIJA

REPRESENTATION →
Gavin Brown's enterprise
436 West 15th Street
USA – New York, NY 10011
tel: +1 212 627-5258
fax: +1 212 627-5261

neugerriemschneider
Linienstraße 155
D – 10115 Berlin
tel: +49 (0)30 3087-2810
fax: +49 (0)30 3087-2811

Gallery Side 2
Shima Crest B1F 1-19-4,
Sendagaya Shibuya-ku
JPN – Tokyo 151-0051
tel: +81 (0)3 5771-5263
fax: +81 (0)3 5771-5264

PRICE RANGE →
$1,000 – $95,000

AUCTION SALES →
Price: $37,440
Untitled – cure, 1993
installation, cloth, tent, table, stool
and shelf, 350 x 350 x 350 cm
Date sold: 08-Feb-01
Auction house: Christie's, London

Price: $8,000
Untitled
graphite, 49 x 40 cm
Date sold: 18-May-00
Auction house: Sotheby's,
New York (NY)

GRAZIA TODERI

REPRESENTATION →
Giò Marconi
Via Tadino 15
I – 20124 Milan
tel: +39 (0)2 2940-4373
fax: +39 (0)2 2940-5573

Meert Rihoux
13, rue du Canal
B – 1000 Brussels
tel: +32 (0)2 219-1422
fax: +32 (0)2 219-3721

The Project
427 West 126th Street
USA – New York, NY 10027
tel: +1 212 662-8610
fax: +1 212 662-2800
www.elproyecto.com

COLLECTIONS →
Casino Luxembourg, Forum d'Art
Contemporain, Luxembourg
Castello di Rivoli, Museo
Contemporanea, Rivoli, Italy
Ludwig Forum für Internationale
Kunst, Aachen, Germany
Fonds Régional d'Art
Contemporain, Bourgogne, France
The Museum of Contemporary
Art, Los Angeles (CA), USA

PRICE RANGE →
$6,000 – $14,000

AUCTION SALES →
Price: $13,585
San Siro, 2000
video projection, DVD
Date sold: 22-Oct-01
Auction house: Sotheby's, London

LUC TUYMANS

REPRESENTATION →
carlier I gebauer
Holzmarktstraße 15–18
S-Bahnbogen 51/52
D – 10179 Berlin
tel: +49 (0)30 280-8110
fax: +49 (0)30 280-8109
www.carliergebauer.com

David Zwirner
43 Greene Street
USA – New York, NY 10013
tel: +1 212 966-9074
fax: +1 212 966-4952
www.davidzwirner.com

Zeno X Gallery
Leopold de Waelplaats 16
B – 2000 Antwerp
tel: +32 (0)3 216-1626
fax: +32 (0)3 216-0992

COLLECTIONS →
Carnegie Museum of Art,
Pittsburgh (PA), USA
De Pont Foundation for
Contemporary Art, Tilburg,
The Netherlands
Fonds Régional d'Art
Contemporain, Auvergne, France
Fondação de Serralves,
Oporto, Portugal
Hirshhorn Museum and Sculpture
Garden, Washington D.C., USA
K21 Kunstsammlung im
Ständehaus, Düsseldorf, Germany
Kaiser-Wilhelm-Museum,
Krefeld, Germany
Kunstmuseum, Berne, Switzerland
Louisiana Museum of Modern Art,
Humlebæk, Denmark
Museum of Contemporary Art,
Antwerp, Belgium
Musée des Beaux-Arts, Nantes,
France
Museum für Moderne Kunst,
Frankfurt am Main, Germany
New Museum of Contemporary
Art, New York (NY), USA
Philadelphia Museum of Art,
Philadelphia (PA), USA
Provinciaal Museum van Moderne
Kunst, Ostende, Belgium
Stedelijk Museum voor Actuele
Kunst, Ghent, Belgium
Stedelijk Museum, Amsterdam,
The Netherlands
Tate Gallery, London, UK
The Museum of Modern Art,
New York (NY), USA
University Art Museum,
Berkeley (CA), USA

PRICE RANGE →
$80,000 (+/- 70 x 60 cm) –
$160,000 (+/- 140 x 130 cm);
$6,000 – $300,000 (overall)

AUCTION SALES →
Price: $95,000
Drops, 1995
oil on canvas, 81 x 52 cm
Date sold: 16-May-00
Auction house: Christie's,
Rockefeller NY

Price: $55,000
Hotel lobby, 1991
oil on canvas 43 x 32 cm
Date sold: 18-May-00
Auction house: Phillips,
New York (NY)

Price: $54,340
Achterhof, 1993
oil on canvas 65 x 42 cm
Date sold: 23-Oct-01
Auction house: Christie's, London

Price: $50,000
Maria, 1987
oil on canvas, 60 x 70 cm
Date sold: 16-Nov-99
Auction house: Christie's,
Rockefeller NY

Price: $42,000
Ceiling, 1993
oil on canvas, 30 x 50 cm
Date sold: 27-Jun-01
Auction house: Christie's, London

PIOTR UKLAŃSKI

REPRESENTATION →
Gavin Brown's enterprise
436 West 15th Street
USA – New York, NY 10011
tel: +1 212 627-5258
fax: +1 212 627-5261

Massimo De Carlo
Viale Corsica 41
I – 20133 Milan
tel: +39 (0)2 7000-3987
fax: +39 (0)2 749-2135

Galeria Foksal
ul. Foksal 1/4
PL – 00-950 Warsaw
tel/fax: +48 22 827-6243

COLLECTIONS →
Fondazione Sandretto Re
Rebaudengo per l'Arte, Turin, Italy
Museum Ludwig, Cologne, Germany

Migros Museum für Gegenwarts-
kunst, Zurich, Switzerland
Walker Art Center,
Minneapolis (MN), USA

PRICE RANGE →
Not available

AUCTION SALES →
No auction results

KARA WALKER

REPRESENTATION →
Galerie Max Hetzler
Zimmerstraße 90/91
D – 10117 Berlin
tel: +49 (0)30 229-2437
fax: +49 (0)30 229-2417
www.maxhetzler.com

Brent Sikkema Gallery
530 West 22nd Street
USA – New York, NY 10011
tel: +1 212 929-2262
fax: +1 212 929-2340

COLLECTIONS →
San Francisco Museum of Modern
Art, San Francisco (CA), USA
Solomon R. Guggenheim
Museum, New York (NY), USA
The Museum of Modern Art,
New York (NY), USA
Whitney Museum of American Art,
New York (NY), USA

PRICE RANGE →
$7,500 – $150,000

AUCTION SALES →
Price: $25,000
Untitled, 1996/97
cut paper between linen,
mounted wooden box, 152 x 72 cm
Date sold: 17-Nov-99
Auction house: Christie's,
Rockefeller NY

Price: $22,000
Gatorbait, 1996
oil, paper, collage, 152 x 132 cm
Date sold: 13-Nov-98
Auction house: Christie's,
New York (NY)

Price: $17,000
Equality
cut paper, 121 x 107 cm
Date sold: 18-May-00
Auction house: Sotheby's,
New York (NY)

Artist Information

Price: $16,000
Revolt, 1996
oil, paper, collage, 152 x 132 cm
Date sold: 13-Nov-98
Auction house: Christie's,
New York (NY)

Price: $15,000
Untitled
paper collage, 137 x 152 cm
Date sold: 19-May-00
Auction house: Phillips,
New York (NY)

JEFF WALL

REPRESENTATION →
Marian Goodman Gallery
24 West 57th Street
USA – New York, NY 10019
tel: +1 212 977-7160
fax: +1 212 581-5187
www.mariangoodman.com

Johnen + Schöttle
Maria-Hilf-Straße 17
D – 50677 Cologne
tel: +49 (0)221 310-2727
fax: +49 (0)221 310-2727
www.johnen-schoettle.de

Roger Pailhas Gallery
20, quai de Rive Neuve
F – 13007 Marseille
tel: +33 (0)4 9154-0222
fax: +33 (0)4 9155-6688
www.rogerpailhas.com

COLLECTIONS →
Hirshhorn Museum and Sculpture
Garden, Washington DC, USA
K21 Kunstsammlung im
Ständehaus, Düsseldorf, Germany
Musée national d'art moderne,
Centre Georges Pompidou,
Paris, France
Museum für Moderne Kunst,
Frankfurt am Main, Germany
Museum Ludwig, Cologne, Germany
San Francisco Museum of Modern
Art, San Francisco (CA), USA
The Art Institute of Chicago,
Chicago (IL), USA
The Museum of Contemporary
Art, Los Angeles (CA), USA
The Museum of Modern Art,
New York (NY), USA
Walker Art Center,
Minneapolis (MN), USA
Ydessa Hendeles Foundation,
Toronto, Canada

PRICE RANGE →
$55,000 – $600,000

AUCTION SALES →
Price: $250,000
The well
cibachrome transparency,
fluorescent lightbox display case,
229 x 179 cm
Date sold: 13-Nov-00
Auction house: Phillips,
New York (NY)

Price: $130,000
The crooked path
cibachrome transparency in
lightbox, 135 x 165 cm
Date sold: 17-May-01
Auction house: Christie's,
Rockefeller NY

Price: $90,000
Little children X
transparency in lightbox, num. 1/3,
135 x variable x variable cm
Date sold: 15-May-01
Auction house: Sotheby's,
New York (NY)

Price: $68,000
Green rectangle
cibachrome transparency,
fluorescent lightbox display case,
145 x 178 cm
Date sold: 14-May-01
Auction house: Phillips,
New York (NY)

Price: $65,000
Coastal motifs, 1989
cibachrome transparency in light-
box, num. 1/3, 135 x 163 x 22 cm
Date sold: 17-Nov-98
Auction house: Sotheby's,
New York (NY)

FRANZ WEST

REPRESENTATION →
Gagosian Gallery
555 West 24th Street
USA – New York, NY 10011
tel: +1 212 741-1111
fax: +1 212 741-9611
www.gagosian.com

Galerie Bärbel Grässlin
Bleichstraße 48
D – 60313 Frankfurt
tel: +49 (0)69 280-961
fax: +49 (0)69 294-277
www.galerie-graesslin.de

Hauser & Wirth & Presenhuber
Limmatstrasse 270
CH – 8005 Zurich
tel: +41 (0)1 446-8060
fax: +41 (0)1 446-8065
www.ghwp.ch

COLLECTIONS →
Bonnefantenmuseum, Maastricht,
The Netherlands
K21 Kunstsammlung im
Ständehaus, Düsseldorf, Germany
Kröller-Müller Museum, Otterlo,
The Netherlands
Musée national d'art moderne,
Centre Georges Pompidou,
Paris, France
Museum Ludwig, Cologne, Germany
Museum Moderner Kunst, Stiftung
Ludwig, Vienna, Austria
Neue Galerie am Landesmuseum
Joanneum, Graz, Austria
Philadelphia Museum of Art,
Philadelphia (PA), USA
Rupertinum, Museum für Moderne
Kunst, Salzburg, Austria
Stedelijk Museum voor Actuele
Kunst, Ghent, Belgium
The Museum of Contemporary
Art, Los Angeles (CA), USA
The Museum of Modern Art,
New York (NY), USA
Walker Art Center,
Minneapolis (MN), USA

PRICE RANGE →
$1,000 – $600,000

AUCTION SALES →
Price: $35,280
Curacao, 1996
papier mâché, installation, glass,
plastic, gauze, board,
145 x 266 x 122 cm
Date sold: 08-Dec-98
Auction house: Christie's, London

Price: $21,152
Untitled
collage, corrugated cardboard,
40 x 147 cm
Date sold: 02-Dec-98
Auction house: Dorotheum, Vienna

Price: $21,068
Untitled
painted papier mâché, wire
netting material, 220 x 68 x 53 cm
Date sold: 12-Jun-98
Auction house: Hauswedell &
Nolte, Hamburg

Price: $20,459
Schirches Bild

mixed media, collage, 83 x 104 cm
Date sold: 13-Nov-01
Auction house: Dorotheum, Vienna

Price: $19,959
Vesuv
painted papier mâché,
212 x 140 x 64 cm
Date sold: 12-Jun-98
Auction house: Hauswedell
& Nolte, Hamburg

PAE WHITE

REPRESENTATION →
Galerie Daniel Buchholz
Neven-DuMont-Straße 17
D – 50667 Cologne
tel: +49 (0)221 257-4946
fax: +49 (0)221 253-351
www.galeriebuchholz.de

Greengrassi
39c Fitzroy Street
London W1P 5HR
tel: +44 (0)20 7387-8747
fax +44 (0)20 7388-3555

Metro Pictures
519 West 24th Street
USA – New York, NY 10011
tel: +1 212 206-7100
fax: +1 212 337-0070

neugerriemschneider
Linienstraße 155
D – 10115 Berlin
tel: +49 (0)30 3087-2810
fax: +49 (0)30 3087-2811

1301PE
6150 Wilshire Blvd
USA – Santa Monica, CA 90048
tel: +1 323 938-5822
fax: +1 323 938-6106

COLLECTIONS →
Los Angeles County Museum of
Art, Los Angeles (CA), USA
The Museum of Contemporary
Art, Los Angeles (CA), USA
The Museum of Modern Art,
New York (NY), USA
Weatherspoon Art Gallery,
Greensboro (NC), USA

PRICE RANGE →
$1,000 – $35,000

AUCTION SALES →
No auction results

T. J. WILCOX

REPRESENTATION →
Galerie Daniel Buchholz
Neven-DuMont-Straße 17
D – 50667 Cologne
tel: +49 (0)221 257-4946
fax: +49 (0)221 253-351
www.galeriebuchholz.de

Sadie Coles HQ
35 Heddon Street
GB – London W1B 4BP
tel: +44 (0)20 7434-2227
fax: +44 (0)20 7434-2228
www.sadiecoles.com

Metro Pictures
519 West 24th Street
USA – New York, NY 10011
tel: +1 212 206-7100
fax: +1 212 337-0070

PRICE RANGE →
$1,500 – $20,000

AUCTION SALES →
No auction results

JOHANNES WOHNSEIFER

REPRESENTATION →
Galerie Gisela Capitain
Aachener Straße 5
D – 50674 Cologne
tel: +49 (0)221 256-676
fax: +49 (0)221 256-593
www.galerie-capitain.de

COLLECTIONS →
Museum am Ostwall, Dortmund,
Germany

PRICE RANGE →
$5,500 (paintings); $600 (drawings);
$2,500 – $16,000 (sculptures);
$35,000 (installations)

AUCTION SALES →
No auction results

RICHARD WRIGHT

REPRESENTATION →
BQ/Jörn Bötnagel and
Yvonne Quirmbach
Jülicher Straße 14
D-50674 Cologne
tel: +49 (0)221 285-8862
fax: +49 (0)221 285-8864

Gagosian Gallery
555 West 24th Street
USA – New York, NY 10011
tel: +1 212 741-1111
fax: +1 212 741-9611
www.gagosian.com

The Modern Institute
73 Robertson Street, Suite 6 fl. 1
GB – Glasgow G2 8QD
tel: +44 (0)141 248-3711
fax: +44 (0)141 248-3280
www.themoderninstitute.org

PRICE RANGE →
$2,000 – $50,000

AUCTION SALES →
No auction results

CERITH WYN EVANS

REPRESENTATION →
Jay Jopling/White Cube²
48 Hoxton Square
GB – London N1 6PB
tel: +44 (0)20 7930-5373
fax: +44 (0)20 7749-7460
www.whitecube.com

Georg Kargl
Schleifmühlgasse 5
A – 1040 Vienna
tel: +43 (0)1 585-4199
fax: +43 (0)1 5854-1999

Galerie Neu
Philippstraße 13
D – 10117 Berlin
tel: +49 (0)30 285-7550
fax: +49 (0)30 281-0085

COLLECTIONS →
British Museum, London, UK
Fondazione Sandretto Re
Rebaudengo per l'Arte, Turin, Italy
Museo de Arte Acarigua-Araure,
Caracas, Venezuela
Tate Gallery, London, UK

PRICE RANGE →
$3,000 – $75,000 (photos to
installations)

AUCTION SALES →
No auction results

ANDREA ZITTEL

REPRESENTATION →
Sadie Coles HQ
35 Heddon Street

GB – London W1B 4BP
tel: +44 (0)20 7434-2227
fax: +44 (0)20 7434-2228
www.sadiecoles.com

Andrea Rosen Gallery
525 West 24th Street
USA – New York, NY 10011
tel: +1 212 627-6000
fax: +1 212 627-5450
www.andrearosengallery.com

COLLECTIONS →
Tate Gallery, London, UK
The Museum of Modern Art,
New York (NY), USA

PRICE RANGE →
$7,000 – $150,000

AUCTION SALES →
Price: $50,000
*A–Z living unit customized for
Leonora and Jimmy Belilty*, 1994
steel, wood, mattress, glass,
mirror, lighting unit, oven,
145 x 213 x 208 cm
Date sold: 16-Nov-99
Auction house: Christie's,
Rockefeller NY

Price: $4,500
Study for carpet/furniture, 1993
gouache, graphite, 38 x 51 cm
Date sold: 14-Nov-00
Auction house: Phillips,
New York (NY)

Price: $2,158
Study for carpet/furniture, 1992
gouache, pencil, 28 x 35 cm
Date sold: 23-Jun-97
Auction house: Sotheby's, London

Price: $1,400
Study for carpet/furniture
pencil, gouache, 28 x 36 cm
Date sold: 21-Dec-99
Auction house: Artnet,
New York (NY)

HEIMO ZOBERNIG

REPRESENTATION →
Galerie Meyer Kainer
Eschenbachgasse 9
A – 1010 Vienna
tel: +43 (0)1 585-7277
fax: +43 (0)1 585-7539
www.meyerkainer.at

Galerie Christian Nagel
Richard-Wagner-Straße 28

D – 50674 Cologne
tel: +49 (0)221 257-0591
fax: +49 (0)221 257-0592
www.galerie-nagel.de

Andrea Rosen Gallery
525 West 24th Street
USA – New York, NY 10011
tel: +1 212 627-6000
fax: +1 212 627-5450
www.andrearosengallery.com

COLLECTIONS →
Museum Moderner Kunst, Stiftung
Ludwig, Vienna, Austria
Österreichische Galerie im
Oberen Belvedere, Vienna, Austria
Neue Galerie am Landesmuseum
Joanneum, Graz, Austria

PRICE RANGE →
$1,750 – $90,000

AUCTION SALES →
Price: $13,861
Untitled
eight diafilm monitors, plastic film,
45 x 44 x 47 cm
Date sold: 12-Jun-98
Auction house: Hauswedell
& Nolte, Hamburg

Price: $6,930
Untitled, 1986
cardboard, synthetic resin,
185 x 90 x 36 cm
Date sold: 12-Jun-98
Auction house: Hauswedell
& Nolte, Hamburg

Price: $5,128
Untitled, 1985
cardboard, resin, 177 x 38 x 37 cm
Date sold: 03-Dec-99
Auction house: Hauswedell
& Nolte, Hamburg

Price: $4,351
Untitled
119 x 95 cm
Date sold: 13-Oct-99
Auction house: Wiener Kunst
Auktionen, Vienna

Price: $3,604
Untitled, 1987
119 x 94 cm
Date sold: 12-Jun-98
Auction house: Hauswedell
& Nolte, Hamburg

Introduction to city guides

Editor: Kirsty Bell

These 16 cities have been selected as important centres of contemporary art: Antwerp, Barcelona, Berlin, Cologne, London, Los Angeles, Madrid, México D. F., Milan, New York, Paris, São Paulo, Sydney, Tokyo, Vienna, and Zurich.

Each city guide contains an introduction, provided by a local writer, to the city's place in the international contemporary art scene and a list of the main contemporary art events that take place there throughout year. There are contact details for the leading contemporary commercial galleries and for the public galleries which hold significant collections or exhibitions of contemporary art. We have also made a selection of hotels, bars or restaurants which may be of interest to the contemporary art collector — or art-world celebrity spotter. Airports are listed with addresses, contact numbers, website and orientation in relation to each city centre.

Information has been arranged alphabetically. Telephone numbers have been listed as they are to be dialled from outside the country and fax numbers, email and website addresses have been provided where available.

The contributors to these city guides are Hosanna Abela, René Ammann, Javier Barreiro Cavestany, Emma Beatty, Silke Becker, Roberta Bosco, Adrian Dannatt, David D'Arcy, Fabienne Fulchéri, Simon Grant, Daniela Gutfreund, Giovanni Intra, Maren Lübbke, Elizabeth Moody-Stuart, Ada Masoero, Neumann+Luz, Els Roelandt, Sebastian Smee, Marina Sorbello, Ali Subotnik, David G. Torres, Isobel Whitelegg and Fiona Wilson.

A great debt of thanks for additional information is owed to:
James Angus, Yuko Aoki, Charles Asprey, Edgar Bryan, Sadie Coles, Florence Derieux, Marcia Fortes, Alexandre Gabriel, Max Hetzler, Francesca Kaufmann, Alice Kögel, Sam Keller, Mónica Manzutto, Giò Marconi, Isabela Mora, Rafa Mastella, Pablo Moreno, Gregor Muir, Franco Noero, José Oliver, Laura Owens, Samia Saouma, Robert Self, Asuka Shibata, Junko Shimada, Salomé Sommer, Micheline Szwajcer, Johannes Wohnseifer.

Elizabeth Moody-Stuart

Antwerpen

GMT + 1 (GMT + 2 between April and October)

As a harbour city Antwerp has a rich cultural past. It has been a place where artists from all over the world have come together. Nowadays, Antwerpen fosters tradition (it has a good range of art and historical museums), but also creates breathing space for artistic renewal. In recent decades this artistic renewal has expressed itself most noticeably in the fashion world. Ten years ago, the Koninklijke Mode Academie van Antwerpenen (Antwerp Royal Fashion Academy) produced a number of much talked-about students, such as Martin Margiela, Walter van Beirendonck, Ann Demeulemeester and Dries van Noten, who suddenly made the city world-famous in the fashion arena. The energy released by the fashion scene was eventually channelled, leading in particular to the opening in September 2002 of Modenatie (Fashion Land), a genuine fashion museum in the rag-trade neighbourhood of the city. The centre for contemporary art is a little further from the city centre in the southern district known as 'Zuid'. Some of Belgian's world-renowned artists, including Luc Tuymans, Panamarenko and Jan Fabre, are based there, as are galleries with an international profile such as Micheline Szwajcer and Zeno X. Here too is the somewhat newer space run by Stella Lohaus, daughter of the artist Bernd Lohaus who, together with his wife, ran the celebrated Wide White Space gallery (where Marcel Broodthaers, Panamarenko and others lived as children) for more than 20 years. Artists' initiatives have also developed in this

area. One is the NICC (New International Cultural Centre), which grew in no time from an experimental venue that focused on defending the rights of artists, into an exhibition venue with both the style and policy of a museum. Hal is another artists' initiative that has flourished in Antwerp for some years; its originality lies in providing residences for young artists from all over the world, and in working with visiting Belgian and international curators. Zuid is also the home of Muhka (Museum voor Hedendaagse Kunst Antwerpen), the foremost museum of contemporary art in Belgium (together with SMAK, the Stedelijk Museum Actuele Kunst in Ghent). Muhka, an institution supported by the Flemish government, was recently taken over by a new director, Bart de Baere (a former assistant of Jan Hoet, the director of SMAK), a promising curator whose international reputation is firmly established. From September of 2002, Bart de Baere will direct the museum's exhibition policy and also take responsibility for the permanent collection and new purchases. He plans to expand Muhka, in close collaboration with existing local institutions such as the NICC and the nearby Museum of Photography, into an international centre of excellence that will appeal to both the local audience and the international scene. De Baere has a reputation for quality, as his earlier exhibitions have proved, but whether this quality will also be to the taste of Antwerp's general public remains to be seen.

EVENTS →
"Nocturnes"
Six times a year all contemporary galleries and alternative spaces have openings on the same evening

COMMERCIAL GALLERIES →
Galerie Annie Gentils
Peter Benoitstraat 40
2000 Antwerpen
tel/fax: +32 (0)3 216 3028
annie.gentils@pandora.be

Galerie Annette De Keyser
Gen. Belliardstraat 19
2000 Antwerpen
tel./fax: +32 (0)3 231 9056
adk.taraclub@worldonline.be

Stella Lohaus Gallery
Vlaamsekaai 47
2000 Antwerpen
tel: +32 (0)3 248 0871
fax: +32 (0)3 257 1350
stella-lohaus@antwerpen.be

Galerie Micheline Szwajcer
Verlatstraat 14
2000 Antwerpen
tel: +32 (0)3 237 1127
fax: +32 (0)3 238 9819info@gms.be
www.gms.be

Van Laere Contemporary Art
Verlatstraat 23/25
2000 Antwerpen
tel: +32 (0)3 257 1417
fax: +32 (0)3 257 1425
vanlaere.art@yucom.be

Zeno X Gallery
Leopold De Waelplaats 16
2000 Antwerpen
tel: +32 (0)3 216 1626
fax: +32 (0)3 216 0992
zeno-x@village.uunet.be

PUBLIC GALLERIES →
De Singel
Desguinlei 25
2018 Antwerpen
tel: +32 (0) 3 248 2828
fax: +32 (0)3 248 2828
www.desingel.be
Platform for arts including theatre, dance, music, architecture and the visual arts

Hal
Bleekhofstraat 22
2018 Antwerpen
tel: +32 (0) 3 232 7395
Artist-run space for exhibitions of contemporary art and artist residencies

Koninklijk Museum voor Schone Kunsten

Leopold de Waelplaats
2000 Antwerpen
tel: +32 (0)3 238 7809
fax: +32 (0)3 248 0810
postmaster@kmska.be
www.dma.be/cultur/kmska/index.htm
19th century neo-classical building housing a historical collection of art from the 14th century to the present day, and a programme of changing exhibitions of historical, and occasionally contemporary, art

Museum voor Fotografie
Waalse Kaai 47
2000 Antwerpen
tel: +32 (0) 3 242 9305
fax: +32 (0) 3 242 9310
www.provant.be/fotomuseum
Museum dedicated to the history, collection and exhibition of photography

Modenatie
Momu-Fashionmuseum
Nationalestraat 28B
2000 Antwerpen
(Opens in September 2002)
www.ffi.be
Museum dedicated to the history and promotion of contemporary fashion, run in collaboration with the Flanders Fashion Institute

Muhka (Museum voor hedendaagse Kunst)
Leuvenstraat
2000 Antwerpen
tel: +32 (0)3 238 5960
fax: +32 (0)3 216 2486
www.muhka.be
Contemporary Art Museum housed in a converted grain silo and adjacent warehouse with collection of art from 1970 to the present, and an active programme of contemporary exhibitions; including bookshop

NICC
Pourbusstraat 5
2000 Antwerpen
tel: +32 (0)3 216 0771
www.nicc.be
International cultural centre supporting visual arts with exhibitions, special commissions and artists' studios

HIP PLACES →
Bar Room
Leopold de Waelplaats 30
2000 Antwerpen
tel: +32 (0)3 248 5252
Three level restaurant and lounge bar specialising in fish and meat, with resident DJs and well-mixed cocktails

Café d'Anvers
Verversrui 15
2000 Antwerpen
tel: +32 (0)3 226 3870
fax: +32 (0)3 226 7231
Nightclub in the red light district
considered to be Antwerp's best
venue for 'house' music

De Witte Lelie
Keizerstraat 16–18
2000 Antwerpen
tel: +32 (0)3 226 1966
fax: +32 (0)3 234 0019

hotel@dewittelelie.be
Small but chic hotel in three
newly renovated 17th century
canal houses

Dock's Cafe
Jordaanskaai 7
2000 Antwerpen
tel: +32 (0)3 226 6330
French-style bistro near the city
centre

l'Entrepot du Congo
Vlaamse Kaai 42

2000 Antwerpen
tel: +32 (0)3 238 9232
fax: +32 (0)3 257 1648
Fashionable bar in the South
district of the city

AIRPORTS →
Antwerp international airport
Luchthavenlei, Duerne, Antwerpen
The airport is located 2km from
the business centre of Antwerpen
and 4km from the historic centre
tel: +32 (0)3 285 6500·
fax: +32 (0)3 285 6501

www.antwerpairport.be

Brussels Airport (BRU)
Brussels International Airport
Company, Brussels Airport,
1930 Zaventem, Belgium
The airport is located 40 km
southeast of Antwerp
tel: +32 (0)2 753 4200
fax: +32 (0)2 753 4250
info@biac.be
www.brusselsairport.be

Barcelona

GMT + 1 (GMT + 2 between April and October)

In most cases, to attempt to determine how a city generates an artistic scene is like asking which came first, the chicken or the egg, but in the case of Barcelona it is easier to pinpoint. Fifteen years ago Barcelona had very few galleries and only a couple of institutions would show contemporary art, and then rarely. Because of the Olympic Games, however, 1992 was the key year for all kinds of investments and renovations in the city. Many institutions dedicated exclusively to contemporary art were created, enabling Barcelona to achieve a similar status as other major European cities, now boasting its own museum, two or three local government funded centers, new project rooms and production centers. But these new establishments were not entirely responsible for Barcelona's artistic scene, which was also in part generated by the broad panorama of artists, mainly, but also curators and art-critics who were already active in the early 1970s. During this time, conceptual artists such as Antoni Muntadas and Francesc Torres began what now forms the legacy of the Barcelona artist scene with their political opposition to Franco's regime as well as their artistic opposition to Informalism, the dominant art movement of which Antoni Tàpies was the principal exponent. Against this background, a new generation of 90s artists such as Eulalia Valldosera, Toni Abad and Jordi Colomer began to show their work in some of the newly established exhibition spaces. The project rooms Sala Montcada (part of "La Caixa" Foundation) and Espai 13 (belonging to the Miró Foundation) hire a different curator every year and are well known for being the first to show many local and international artists in Barcelona. The activities of such spaces have increased and enriched the artistic scene, encouraging a new gener-

ation of artists such as Tere Recarens, Martí Anson and Antonio Ortega. Despite this wide and varied range of artistic activity, however, there are few collectors and only a handful of commercial galleries dealing exclusively in contemporary art, thus leaving most of the initiatives in the hands of the state, private institutions and occasional private interests. La Virreina and Santa Mónica art centers are supported by the local and regional governments, as is Barcelona's new museum of contemporary art, MacBa, which has recently increased its collection which focuses on conceptual and political art. Their activity is complemented by other more-or-less private institutions such as the Miró, Tàpies and "La Caixa" foundations. The engagement of private interests in contemporary art is evident only in spaces like Metrònom, a project room belonging to a private collector, and commercial galleries such as Galeria Toni Tàpies and Galeria Estrany-de la Mota. Perhaps the clearest example of the chicken/egg situation is provided by Hangar, created by and run in collaboration with the Artists Association that represents all artists working in Catalonia. It is more a multi-media laboratory than an exhibition space, with workshops, performance spaces, video, photo and new media productions and international internships with other institutions such as P.S. 1 in New York, although it does have the odd exhibition of work by artists in residence. While Madrid may hold most of the cards in terms of the Spanish art market, with a more successful contemporary art fair as well as the country's main national and international auction houses, Barcelona, with its vibrant community of artists, both established and emerging, could be said to be the country's creative capital.

EVENTS →
Art Futura (exhibition of art and technology)
Every year in October
www.artfutura.org

Barcelona Triennale (exhibition of contemporary art)
Every three years, next in 2004
tel: +34 93 301 77 75

NewArt (contemporary art fair)
Every winter
www.artbarcelona.es

Sonar (advanced music and multimedia festival)
Every year in June
www.sonar.es

COMMERCIAL GALLERIES →
Alter Ego
Doctor Dou, 11
08001 Barcelona
tel/fax: +34 93 302 36 98
doctordou@hotmail.com

Jordi Barnadas
Consell de Cent, 347

08007 Barcelona
tel: +34 93 215 63 65
fax: +34 93 487 25 88
baranadas@retemail.es
www.barnadas.com

Antonio de Barnola
Palau, 4
08002 Barcelona
tel: +34 93 412 22 14
fax: +34 93 412 19 31
gbarnola@es.europost.org

Berini
Pl. Comercial, 3
08003 Barcelona
tel: +34 93 310 54 43
fax: +34 93 319 56 40
galeria@berini.com
www.berini.com

Cotthem Gallery
Doctor Dou, 15
08001 Barcelona
tel: +34 93 270 16 69
fax: +34 93 270 12 25
www.cotthemgallery.com

Dels Angels
Carrer dels Angels, 16
08001 Barcelona
tel: +34 93 412 54 54
fax: +34 93 412 54 00
1001@mail.cinet.es

Estrany – de la Mota
Passatge Mercader, 18
08008 Barcelona
tel: +34 93 215 70 51
fax: +34 93 487 35 52
estranydelamota@teleline.es

Ferrán Cano
Plaza dels Angels, 4
08001 Barcelona
tel/fax: +34 93 301 15 48

Galeria María José Castellví
Consell de Cent, 278
08007 Barcelona
tel: +34 93 216 04 82
fax: +34 93 487 43 05
camariajose@worldonline.es
www.galeriamariajosecastellvi.com

H2O
Verdi, 152
08012 Barcelona
tel: +34 93 415 18 01
fax: +34 93 415 41 43
galeria@h2o.es
www.h2o.es

Galeria Llucià Homs
Consell de Cent, 315
08007 Barcelona
tel: +34 93 317 48 77
fax: +34 93 467 71 62
llhoms@infomail.lacaixa.es

Kowasa Gallery
Mallorca, 235
08008 Barcelona
tel: +34 93 487 35 88
fax: +34 93 215 80 54
info@kowasa.com
www.kowasa.com

Galeria Miguel Marcos
Jonqueres, 10
08003 Barcelona
tel: +34 93 319 26 27
fax: +34 93 319 07 57
zetabe@izones.com

Galeria René Metras
Consell de Cent, 331
08007 Barcelona
tel: +34 93 487 58 74
fax: +34 93 487 95 08
Email: rt0023hu@eresmas.net

Galeria Metropolitana de
Barcelona
Rambla Cataluña, 50
08007 Barcelona
tel: +34 93 487 40 42
fax: +34 93 487 50 92
mail@galeria-metropolitana.com
www.galeria-metropolitana.com

Galeria Joan Prats
Rambla Catalunya, 54
08007 Barcelona
tel: +34 93 216 02 90
fax: +34 93 487 16 14
www.galeriajoanprats.com

Alejandro Sales
Julián Romea, 16
08006 Barcelona
tel: +34 93 415 20 54
fax: +34 93 415 65 33
galeria@alejandrosales.com
www.alejandrosales.com

Carles Taché
Consell de Cent, 290
08007 Barcelona
tel: +34 93 487 88 36
fax: +34 93 487 42 38
galeria@carlestache.com
www.carlestache.com

Galeria Toni Tàpies
Consell de Cent, 282
08007 Barcelona
tel: +34 93 487 64 02
fax: +34 93 488 24 95
info@tonitapies.com
www.tonitapies.com

Trama
Petritxol, 8
08002 Barcelona
tel: +34 93 317 48 77
fax: +34 93 317 30 10
galeriatrama@salapares.com
www.galeriatrama.com

Alicia Ventura
Enric Granados, 9
08008 Barcelona
tel: +34 93 451 06 23
g_ambit.teleline.es@irinfo.es

PUBLIC GALLERIES →
La Capella de l'Antic Hospital de
la Santa Creus
Hospital, 56
08001 Barcelona
tel: +34 93 442 71 71
Cutting edge space focusing on
young artists from Barcelona

CaixaForum
Avda. Marqués de Comillas, 6–8
08038 Barcelona
tel: +34 93 476 86 00
fax: +34 93 476 86 35
info.fundacio@lacaixa.es
www.fundacio.lacaixa.es
Permanent collection of contem-
porary art with a programme of
historical and contemporary art
as well as conferences, theatre,
literature and music events

Centro de Arte Santa Mònica
Rambla Santa Mònica, 7
08002 Barcelona
tel: +34 93 316 28 10
Art centre with three different
spaces for group and solo con-
temporary art exhibitions, with an
emphasis on Catalan art.

Centro de Cultura
Contemporánea de Barcelona
Montalegre, 5
08001 Barcelona
tel: +34 93 306 41 00
www.cccb.org
Cultural centre hosting a variety
of events including art and
cultural exhibitions, symposiums
and concerts.

Centro Cultural Tecla Sala
Avda. Josep Tarradelles, 44
L'Hospitalet
08901 Barcelona
tel: +34 93 338 57 71
Contemporary art centre with an
active programme of international
group exhibitions

Fundación Antoni Tàpies
Aragó, 255
O8007 Barcelona
tel: +34 93 487 03 15
www.fundaciotapies.com
Permanent collection of work
by Antoni Tàpies, plus a
programme of about five solo or
group exhibitions of international
contemporary art per year

Fundación Foto Colectania
Jualian Romea, 6
08006 Barcelona
tel: +34 93 217 16 26
www.colectania.es
Exhibitions and activities dedica-
ted exclusively to Spanish and
international contemporary photo-
graphy

Fundación Joan Miró
Parc de Montjuïc
08038 Barcelona
tel: +34 93 443 94 70
www.bcn.fjmiro.es
Permanent collection of work by
Joan Miró, a programme of
temporary exhibitions of late 20th
century to present day, and a
separate project room, Espai 13.

Metrònom
C. Fusina, 9
08003 Barcelona
tel: +34 93 268 42 98
Art centre with three galleries
showing work by young contem-
porary artists, with an emphasis
photography, video and new
media.

Museo de Arte Contemporaneo
de Barcelona (MACBA)
Plaza dels Angels, 1
08001 Barcelona
tel: +34 93 412 08 10
www.macba.es
Permanent collection of contem-
porary art, in particular political
and conceptual art, plus tempor-
ary exhibitions of Spanish and
international contemporary work

Palau de La Virreina
La Rambla, 99
08002 Barcelona
tel: +34 93 301 77 75
www.bcn.es/virreinaexposicions
Art centre with a changing pro-
gramme of mainly group exhib-
itions of Spanish and international
contemporary art

La Pedrera—
Centro Cultural Caixa Cataluña
Paseo de Gracia, 92
08008 Barcelona
tel: +34 93 484 59 00
www.caixacatalunya.es
Venue with a changing programme
of historical exhibitions

ART BOOKSHOP →
LAIE
Pau Claris 85
Barcelona
tel: +34 93 318 17 39

HIP PLACES →
Almirall
Joaquín Costa, 33
Barcelona
Old fashioned bar in modernist
style near MacBa

Café de las Delicias
Rambla de Raval, 47
Barcelona
Recently opened old style café
with a small library of books to
browse through while drinking a
coffee

Gimlet
Rec, 24
Barcelona

tel: +34 9331027
Cocktail bar in the trendy "el
Born" area with several terraces,
cafes and restaurants

The Loft
Calle Pamplona, 88
Barcelona
tel: +34 93 272 09 10
Club in an industrial building
playing the kind of electronic

music celebrated every year by
the 'Sonar' festival

Mond Bar
Plaza del Sol, 21
Barcelona
tel: +34 93 272 09 10
Bar with well-known DJs popular
with artists in the city

AIRPORT →
Barcelona Airport (BCN)
Edificio Bloque Tecnico
08820 El Prat de Llobregat
The airport is located 12 km
southwest of Barcelona city centre
tel: +34 93 298 3838
fax: +34 93 298 3737
www.aena.es/ae/bcn/homepage.htm

Berlin

GMT + 1 (GMT + 2 between April and October)

There are no official figures for the numbers of artists who have chosen to live and work in Berlin in the last ten years. But according to calculations by the Senate Department of Science, Research and Culture, of a population of almost four million, at least 25,000 people are now working in the arts (including related occupations such as architects, designers, musicians and actors). Today, more than ten years after re-unification, Berlin is an atypical capital. Isolated in the middle of the no-man's-land of Brandenburg, impoverished and snubbed by the economy, it is an anomaly as regards the rest of Germany. Despite this, or perhaps because of it, Berlin holds a great attraction for artists of all kinds, and since the fall of the Wall its galleries have grown in number exponentially. Berlin at the beginning of the 90s presented an extremely unusual urban scenario, characterised by grand spaces that were cheap to rent, or even free, often in the old east of the city. In the course of the 90s the 'Mitte' area in particular became the centre of the new artistic scene, concentrated on the Auguststraße and Linienstraße. The art scene in Berlin today is still very much alive but has matured as galleries have taken the place of out of the way sites where projects were organised by artists themselves. On Zimmerstraße next to Checkpoint Charlie, the former frontier between East and West Berlin, the biggest explosion of galleries has recently taken place. Here, on the edge of Mitte and Kreuzberg, the further you get from the rebuilt Friedrichstraße, the more it looks like no-man's land. But as tourists have invaded the gallery district in Mitte and the rents there have shot up, the current trend is to move to quieter areas with bigger spaces ideal for showing contemporary art. Thus, semi-derelict Berlin courtyards, cramped basements and apartment galleries are now out of vogue; in favour are airy post-industrial spaces of hundreds of square metres in the style of New York's Chelsea. The gallerist Max Hetzler pioneered Zimmerstraße in the early 90s and was followed later by a clutch of younger galleries including Martin Klosterfelde and Stockholm gallerist Claes Nordenhake. Another area of interest is the Holzmarktstraße, to the southeast of Alexanderplatz, where a series of spaces in archways beneath the S-Bahn tracks were used for the 2001 Berlin Biennale. Since then, the Norwegian gallerist Atle Gerhardsen, carlier I Gebauer, Büro Friedrich, chouakri brahms berlin and a second branch of Max Hetzler have all opened in these 'S-Bahnbögen'. While several more established galleries such as Contemporary Fine Arts, neugerriemschneider, EIGEN + ART and Schipper & Krome remain in Mitte, their presence is complemented by spaces like Maschenmode or Koch & Kesslau, which have developed from independent or artist-run spaces into increasingly professional galleries. Since the 90s boom in the art scene, young galleries have been trying to make a name for themselves in the hope that the economic scandal that hit Berlin, through the debts accumulated by a semi-public regional bank, will not harm the cultural scene and art market. It is no secret that Berlin lacks investors and collectors, but it seems to attract visitors from afar, proof of this being the international interest in the contemporary art fair art forum berlin. Despite its shaky infrastructure and perilous economy, Berlin functions as an international platform, with several galleries from cities ranging from Cologne to Tokyo and New York relocating or opening new branches here.

EVENTS →
art forum berlin (contemporary art
fair) every year in September
Messe Berlin GmbH
Messedamm 22
14055 Berlin
tel: +49 (0)30 30382077/1833
info@art-forum-berlin.com
www.art-forum-berlin.com

berlin biennale (exhibition of contemporary art) every two years,
next edition 2003
Kunst-Werke
Auguststraße 69
10117 Berlin
tel: +49 (0)30 28445033

office@berlinbiennale.de
www.berlinbiennale.de

Preis der Nationalgalerie
für junge Kunst
every two years,
next award 2002
Hamburger Bahnhof
tel: +49 (0)30 20905555
www.smb.spk-berlin.de/hbf

COMMERCIAL GALLERIES →
Akira Ikeda Gallery
Schönhauser Allee 176
10119 Berlin (Prenzlauer Berg)
tel: +49 (0)30 44328510
fax: +49 (0)30 44328511

berlin@akiraikedagallery.net
www.akiraikedagallery.com/
berlin.htm

Arndt & Partner
Zimmerstraße 90/91
10117 Berlin (Mitte)
tel: +49 (0)30 2808123
fax: +49 (0)30 2833738
arndt@arndt-partner,de
www.arndt-partner.de

Büro Friedrich
Holzmarktstraße 15–18
10179 Berlin (Mitte)
tel: +49 (0)30 20165115
fax: +49 (0)30 20165114

office@buerofriedrich.org
www.buerofriedrich.org

carlier I gebauer
Holzmarktstraße 15–18
S-Bahnbogen 51/52
10179 Berlin (Mitte)
tel: +49 (0)30 2808110
fax: +49 (0)30 2808109
office@carliergebauer.com
www.carliergebauer.com

chouakri brahms berlin
Holzmarktstraße 15–18
10179 Berlin (Mitte)
tel: +49 (0)30 20391153
fax: +49 (0)30 28391154

office@chouakri-brahms-
berlin.com
www.chouakri-brahms-berlin.com

Contemporary Fine Arts
Sophienstraße 21
10178 Berlin (Mitte)
tel: +49 (0)30 2887870
fax: +49 (0)30 28878726
office@cfa-berlin.com
www.cfa-berlin.com

Galerie Ascan Crone
Kochstraße 60
10969 Berlin
tel: +49 (0)30 25899370
fax: +49 (0)30 41344410
cronegalerie@aol.com

Galerie EIGEN + ART
Auguststraße 26
10117 Berlin (Mitte)
tel: +49 (0)30 2806605
fax: +49 (0)30 2806616
berlin@eigen-art.com
www.eigen-art.com

c/o Atle Gerhardsen
Holzmarktstraße 15–18
S-Bahnbogen 46
10179 Berlin (Mitte)
tel: +49 (0)30 69518341
fax: +49 (0)30 69518342
office@atlegerhardsen.com
www.atlegerhardsen.com

Max Hetzler
Zimmerstraße 90/91
10117 Berlin (Mitte)
tel: +49 (0)30 2292437
fax: +49 (0)30 2292417
office@maxhetzler.com
www.maxhetzler.com

Max Hetzler
Holzmarktstraße 15–18
S-Bahnbogen 48
10179 Berlin (Mitte)
tel: +49 (0)30 2292437
fax: +49 (0)30 2292417
office@maxhetzler.com
www.maxhetzler.com

Kapinos Galerie für
zeitgenössische Kunst
Gipsstraße 3
10117 Berlin (Mitte)
tel: +49 (0)30 28384755
fax: +49 (0)30 28384755
kapinos@berlin.snafu.de

Klosterfelde
Zimmerstraße 90/91
10117 Berlin (Mitte)

tel: +49 (0)30 2835305
fax: +49 (0)30 2835306
office@klosterfelde.de
www.klosterfelde.de

Koch und Kesslau
Weinbergsweg 3
10119 Berlin
tel: +49 (0)30 4482659
fax: +49 (0)30 44050204
kuk@snafu.de
www.kochundkesslau.de

Maschenmode
Guido W. Baudach
Torstraße 230
10115 Berlin (Mitte)
tel/fax: +49 (0)30 280 47727
maschenmode@gmx.de
www.maschenmode-berlin.de

Galerie Christian Nagel
Weydingerstraße 2/4
10178 Berlin (Mitte)
tel: +49 (0)30 40042641
fax: +49 (0)30 40042642
cn.berlin@galerie-nagel.de
www.galerie-nagel.de

Galerie Neu
Philippstraße 13
10115 Berlin (Mitte)
tel: +49 (0)30 2857550
fax: +49 (0)30 2810085
galerieneu@snafu.de

neugerriemschneider
Linienstraße 155
10115 Berlin (Mitte)
tel: +49 (0)30 30872810
fax: +49 (0)30 30872811
mail@neugerriemschneider.com

Galerie Nordenhake
Zimmerstraße 88–91
10117 Berlin (Mitte)
tel: +49 (0)30 2061483
fax: +49 (0)30 20614848
berlin@nordenhake.com
www.nordenhake.com

Galerie Giti Nourbakhsch
Rosenthaler Strasse 72
10117 Berlin (Mitte)
tel: +49 (0)30 44046781
fax: +49 (0)30 44046782
Nourbakhsch@t-online.de

Schipper & Krome
Linienstraße 85
10119 Berlin (Mitte)
tel: +49 (0)30 28390139
fax: +49 (0)30 28390140
office@schipper-krome.com

www.schipper-krome.com

Galerie Thomas Schulte
Mommsenstraße 56
10629 Berlin (Charlottenburg)
tel: +49 (0)30 3240044
fax: +49 (0)30 3451596
mail@galeriethomasschulte.de
www.galeriethomasschulte.de

Galerie Barbara Thumm
Dircksenstraße 41
10178 Berlin
tel: +49 (0)30 28390347
fax: +49 (0)30 28390457
b.thumm@berlin.snafu.de
www.bthumm.de

Galerie Barbara Weiss
Zimmerstraße 88–91
10117 Berlin (Mitte)
tel: +49 (0)30 2624284
fax: +49 (0)30 2651652
info@galeriebarbaraweiss.de
www.galeriebarbaraweiss.de

Barbara Wien –
Buchhandlung Verlag Galerie
Linienstraße 158
10115 Berlin (Mitte)
tel: +49 (0)30 28385352
fax: +49 (0)30 28385350
b.wien@snafu.de
www.barbarawien.de

PUBLIC GALLERIES →
Sammlung Berggruen
Westkicher Stühlerbau
Schlossstraße 1
14059 Berlin (Charlottenburg)
tel: +49 (0)30 3269580
www.smb.spk-berlin.de
Private collection of classical
modern art including Picasso,
Braque and Giacometti

DAAD Galerie
Kurfürstenstraße 58
10785 Berlin
tel: +49 (0)30 2613640
www.berliner-
kunstlerprogramm.de
Exhibitions by artists resident in
Berlin as part of the DAAD
(German Academic Exchange
Service) programme established
in the 1960s

DaimlerChrysler Contemporary
Haus Huth
Alte Potsdamer Straße 5
10785 Berlin
tel: +49 (0)30 25941420
kunst.sammlung@daimler

chrysler.com
www.sammlung.daimlerchrysler.com
Corporate collection of German
and international contemporary
art established in 1977

Deutsche Guggenheim Berlin
Unter den Linden 13–15
10117 Berlin (Mitte)
tel: +49 (0)30 20209311
berlin.guggenheim@db.com
www.deutsche-guggenheim-
berlin.de
Cooperation of the Deutsche
Bank and Solomon R.
Guggenheim Foundation hosting
three to four exhibitions of
contemporary art per year

Nationalgalerie im Hamburger
Bahnhof, Museum für Gegenwart
Invalidenstraße 51
10557 Berlin (Mitte)
tel: +49 (0)30 20905555
www.smb.spk-berlin.de/hbf
Permanent collection of contem-
porary art including works by
Joseph Beuys, Andy Warhol,
Anselm Kiefer and Damien Hirst,
and temporary exhibitions of
international contemporary art

Haus der Kulturen der Welt
John-Foster-Dulles-Allee 10
10557 Berlin
tel: +49 (0)30 397870
www.hkw.de
Centre for contemporary art of
non-European origin in the fields
of fine arts, dance, theatre, film,
performance and music and host
to international cultural conferences

Sammlung Hoffmann
Sophienstraße 21
10178 Berlin (Mitte)
By appointment only
tel: +49 (0)30 28499121
Private collection of contemporary
art from Arte Povera to the pre-
sent day

Jüdisches Museum
Lindenstraße 9–14
10969 Berlin (Kreuzberg)
tel: +49 (0)30 25993300
www.jmberlin.de
Historical exhibition in building
designed by Polish-born architect
Daniel Libeskind in the 1990s to
commemorate the history of the
Jewish people in Germany

614

Künstlerhaus Bethanien
Mariannenplatz 2
10997 Berlin
tel: +49 (0)30 6169030
www.bethanien.de
Artists studios and exhibition spa-
ces in a former hospital building,
established in 1973 to provide
artists from other countries with
residencies in Berlin

Kunst-Werke Berlin
Auguststraße 69
10117 Berlin (Mitte)
tel: +49 (0)30 2434590
info@kw-berlin.de
www.kw-berlin.de
Converted factory established in
1990 as a venue for exhibitions of
young contemporary art with
artists' studios and a café desi-
gned by Dan Graham

Neuer Berliner Kunstverein
Chausseestraße 128/129
10115 Berlin
tel: +49 (0)30 2807020
nbk@nbk.org
Art association for temporary
exhibitions of contemporary art

Neue Nationalgalerie
Potsdamer Straße 50
10785 Berlin
tel: +49 (0)30 20905555
www.smb.spk-berlin.de/nng
20th century European painting
and sculpture from classical
modern to the 1960s in a 1968
glass building designed by
Ludwig Mies van der Rohe, plus
major touring exhibitions

Vitra Design Museum
Kopenhagener Straße 58
10437 Berlin (Prenzlauer Berg)
tel: +49 (0)30 4737770
www.design-museum.de
Established by the Vitra design
company as a satellite space
for temporary exhibitions about
the history and development of
industrial design

ART BOOKSHOP →
Bücherbogen
Stadtbahnbogen 585
Savignyplatz
10623 Berlin (Charlottenburg)
tel: +49 (0)30 3132515
www.buecherbogen.com

HIP PLACES →
103
Kastanienallee 49
10119 Berlin (Mitte)
tel: +49 (0)30 48492651
Sidewalk café by day, DJ bar by
night, a new establishment on the
border of Mitte and Prenzlauer
Berg popular with young art and
media types

Café Einstein
Kurfürstenstraße 58
10785 Berlin
tel: +49 (0)30 2615096
Elegant Viennese style coffee
house in a rambling historic villa,
with the DAAD Gallery on the
second floor of the same building

Green Door
Winterfeldtstraße 50
10779 Berlin (Schöneberg)
tel: +49 (0)30 2152515
Intimate, darkly lit bar serving
classic cocktails

Monsieur Wong
Alte Schönhauser Straße 46
10119 Berlin (Mitte)
tel: +49 (0)30 30872643

Fast, good and inexpensive Asian
cuisine in new premises in the
heart of Mitte

Paris Bar
Kantstraße 153
10623 Berlin (Charlottenburg)
tel: +49 (0)30 3125739
French style brasserie that is
home to an art collection formed
by the late legendary
Martin Kippenberger of his own
and other artists' work

BERLIN AIRPORTS →
Tegel Airport (TXL)
13405 Berlin
The airport is located 8 km
northwest of the city centre

Tempelhof Airport (THF)
The airport is located 11 km
southeast of the city centre

Schönefeld International Airport
(SXF)
The airport is located 18 km
southeast of the city centre
tel: +49 (0)180 500 0186
www.berlin-airport.de

Köln

GMT + 1 (GMT + 2 between April and October)

They all lived here once, or live here now: Martin Kippenberger and Albert Oehlen, Gerhard Richter, Sigmar Polke and Rosemarie Trockel. Cologne was and still is a city of artists, whose particular cocktail of Kölsch (the local brew), art, business and culture has a long tradition. This is no surprise, given Cologne's indisputable historic credentials. The ring-shaped city with its two prominent cathedral steeples is home to a large number of medieval treasures. These days the evidence of almost 2000 years of history competes with modern buildings, designed by architects such as Jean Nouvel and Norman Foster, and with a contemporary art scene that is continually drawing on new talent. Art Cologne has been one of the world's leading art fairs for 30 years and is also the inspiration for a new art fair, Kunst Köln, that has taken place since 2000. But Cologne would be unimaginable without the involvement of the many galleries and the creativity of the numerous artists and thinkers who live there. Newcomers like Borgmann Nathusius and Frehrking Wiesehöfer are tracing the same route as established galleries such as Daniel Buchholz, Gisela Capitain, Monika Sprüth and Christian Nagel. As a booming media city, this metropolis on the Rhine with its special cultural climate is and will remain a real competitor to its eastern challenger, Berlin. It has the added advantage of being located in one of the most affluent areas of Germany and its tradition of local collectors supporting galleries and artists looks likely to continue.

Throughout Cologne, whether in the Belgian quarter or Eigelstein, Ehrenfeld or Südstadt, each with its own distinct character, a vibrant community of young people exists. "In" places come and go; what is constant is fresh conversation and new opportunities for building networks. Alongside these more intangible attractions, the physical changes taking place are highly significant. In the last few years, after lengthy discussion and planning, Cologne's museums have been re-organised. In 2000, the Wallraf-Richartz-Museum's renowned collection of medieval to 19th century art was rehoused in its own cuboid building designed by O. M. Ungers. This left the Ludwig Museum with considerably more room in which to exhibit its collection of 20th century works, reinstalled by new director Kasper König, while also providing an opportunity for Rem Koolhaas to conduct his experiments in architecture in the museum's entrance area. In 2001, the changes at the museum prompted the collector Irene Ludwig to donate 774 works by Pablo Picasso. Meanwhile, the Cologne Kunstverein is also about to move having given up its home on the Neumarkt in the heart of the city, and is currently looking for a temporary residence in the city centre. Also under construction is the new Diocesan Museum, close to the Columba chapel, conceived by Peter Zumthor as a "museum of contemplation". This is a nice metaphor bringing culture back into popular discourse while offering a promise of permanence.

EVENTS →
Art Cologne (contemporary art fair)
every year in October/November
KölnMesse GmbH
Messeplatz 1
50679 Köln
tel: +49 (0)221 8210
fax: +49 (0)221 8212574
artcologne@koelnmesse.de
www.artcologne.de

Kunst Köln (contemporary art fair)
every year in April
KölnMesse GmbH
Messeplatz 1
50679 Köln
tel: +49 (0)221 8210
fax: +49 (0)221 8212574
www.kunstkoeln.de

COMMERCIAL GALLERIES →
Galerie Borgmann Nathusius
Moltkestraße 32
50674 Köln
tel: +49 (0) 221 2718600
fax: +49 (0) 221 2718601
bornat2000@t-online
www.borgmann-nathusius.de

BQ/Jörn Bötnagel and
Yvonne Quirmbach
Jülicher Straße 14
50674 Köln
tel: +49 (0)221 2858862
fax: +49 (0)221 2858864
yvonne.quirmbach@t-online.de

Galerie Daniel Buchholz
Neven-DuMont-Straße 17
50667 Köln
tel: +49 (0)221 2574946
fax: +49 (0)221 253351
post@galeriebuchholz.de
www.galeriebuchholz.de

Buchmann Galerie
Aachener Str. 65
50674 Köln
tel: +49 (0)221 730650
fax: +49 (0)221 730420

Luis Campaña
An der Schanz 1a
50735 Köln
tel. +49 (0)221 256712
fax: +49 (0)221 256213
luis.campana@t-online.de

Galerie Gisela Capitain
Aachener Straße 5
50674 Köln
tel: +49 (0)221 256676
fax: +49 (0)221 256593
info@galerie-capitain.de

www.galerie-capitain.de

Galerie Ulrich Fiedler
Lindenstraße 19
50674 Köln
tel: +49 (0)221 9230800
fax: +49 (0)221 249601
info@ulrichfiedler.com
www.ulrichfiedler.com

Frehrking Wiesehöfer
Habsburgerring 28
50674 Köln
tel: +49 (0)221 2706885
fax: +49 (0)221 2706887
mail@afw-galerie.de
www.afw-galerie.de

Galerie Karsten Greve
Drususgasse 1–5
50667 Köln
tel: +49 (0)221 2571012
fax: +49 (0)221 2571013
galerie.greve@t-online.de

Jablonka Galerie
Lindenstraße 19
50674 Köln
tel: +49 (0)221 2403426
fax: +49 (0)221 2408132
info@jablonkagalerie.com
www.jablonkagalerie.com

Jablonka Galerie, Linn Lühn
Brüsseler Straße 4
50674 Köln
tel: +49 (0)221 3976900
fax: +49 (0)221 3976907
ll@jablonkagalerie.com
www.jablonkagalerie.com

Michael Janssen
Norbertstraße 14–16
50670 Köln
tel: +49 (0)221 1300830
fax: +49 (0)221 1300831
office@galeriemichaeljanssen.de
www.galeriemichaeljanssen.de

Johnen + Schöttle
Maria-Hilf-Straße 17
50677 Köln
tel: +49 (0)221 310270
fax: +49 (0)221 3102727
mail@johnen-schoettle.de
www. johnen-schoettle.de

Mirko Mayer Galerie
Metzerstraße 24
50677 Köln
tel: +49 (0)221 2401289
fax: +49 (0)221 2406151
Info@mirkomayer.com
www.mirkomayer.com

Galerie Christian Nagel
Richard-Wagner-Straße 28
50674 Köln
tel: +49 (0)221 2570591
fax: +49 (0)221 2570592
galerie-nagel@netcologne.de
www.galerie-nagel.de

Galerie Reckermann
Albertusstraße 16
50667 Köln
tel: +49 (0)221 2574868
fax: +49 (0)221 2574867
GalReck@aol.com

Galerie Thomas Rehbein
Maria-Hilf-Straße 17
50677 Köln
tel: +49 (0)221 3101000
fax: +49 (0)221 3101003
rehbein.galerie@netcologne.de

Galerie Rolf Ricke
Volksgartenstraße 10
50677 Köln
tel: +49 (0)221 315717
fax: +49 (0)221 327043
galerie.rolf.ricke@t-online.de

Gabriele Rivet
Jülicher Str. 27
50674 Köln
tel: +49 (0)221 319254
fax: +49 (0)221 319628
gabriele.rivet@netcologne.de

Galerie Aurel Scheibler
St.-Apern-Straße 20–26
50667 Köln
tel: +49 (0)221 311011
fax: +49 (0)221 3319615
galerie.scheibler@netcologne.de
www.aurelscheibler.com

Sabine Schmidt
An der Schanz 1a
50735 Köln
KölnTel. +49 (0)221 2578441
fax: +49 (0)221 2580979
sabine.schmidt@pironet.de

Otto Schweins
Ehrenstraße 10–12
50672 Köln
tel: +49 (0)221 9253178
fax: +49 (0)221 9253179
os@ottoschweins.de
www.ottoschweins.de

Monika Sprüth
Wormser Straße 23
50677 Köln
tel: +49 (0)221 380415
fax: +49 (0)221 380417

art@monikasprueth.com

Galerie Michael Werner
Gertrudenstraße 24–28
50667 Köln
tel: +49 (0)221 9254620
fax: +49 (0)221 9254622
mwerner@netcologne.de

PUBLIC GALLERIES →
Museum für Angewandte Kunst
An der Rechtschule
50667 Köln
tel: +49 (0)221 22126714
museumfuerangerwantekunst@
stadt-koeln.de
www.museenkoeln.de
European applied arts from
medieval to the present day

Kölnischer Kunstverein
(currently looking for a new site)
Cäcilienstraße 33
50667 Köln
tel: +49 (0)221 217021
fax: +49 (0)221 210651
koelnkv@netcologne.de
www.isp.de/koelnischerkunstverein
Temporary exhibitions of contem-
porary art

Museum Ludwig/
Agfa Photo-Historama
Bischofsgartenstraße 1
50667 Köln
tel: +49 (0)221 22126165
ml@ml-museenkoeln.de
www.museenkoeln.de
20th century German and inter-
national art, including renowned
collection of pop art

Kunst-Station Sankt Peter Köln
Jabachstraße 1, 50676 Köln
tel: +49 (0)221 9213030
tel: +49 (0)221 92130342
info@kunst-station.de
www.kunst-station.de
16th century Gothic church with
a programme of contemporary
art, music events and site specific
commissions

Wallraf-Richartz-Museum
Fondation Corboud
Martinstraße 39
50667 Köln
tel: +49 (0)221 22121119
fax: +49 (0)221 22122629
wrm@www.museenkoeln.de
www.museenkoeln.de
Collection of medieval to 19th
century art

Diözesanmuseum
Roncalliplatz 2
50667 Köln
tel: +49 (0)221 2577672
fax: +49 (0)221 254828
kolumba@t-online.de
www.kolumba.de
New exhibition space built on the
ruins of St. Columba's church
combining a historical religious
collection with contemporary art

Die Photographische
Sammlung/SK Stiftung Kultur
Im Mediapark 7
50670 Köln
tel: +49 (0)221 2265900
fax: +49 (0)221 2265901
pr@sk-kultur.de
www.sk-kultur.de
Cultural foundation for photo-
graphy and dance with a large
photography collection, including
the August Sander archive

Skulpturenpark Köln
Entrance Riehler Straße,
near Zoobrücke
tel: +49 (0)221 92122831
fax: +49 (0)221 9212286
Park with changing exhibitions
of large-scale outdoor sculptures
by contemporary artists such as
Jorge Pardo, Anish Kapoor and
Franz West

ART BOOKSHOP →
TASCHEN shop Cologne
Hohenzollernring 28
50672 Köln
tel: +49 (0)221 2573304
fax: +49 (0)221 254968
store@taschen.com
www.taschen.com

Buchhandlung Walther König
Ehrenstraße 4
50672 Köln
tel: +49 (0)221 205960
fax: +49 (0)221 2059640

info@buchhandlung-walther-
koenig.de
www.buchhandlung-walther-
koenig.de

HIP PLACES →
Barracuda Bar
Bismarckstraße 44
50672 Köln
tel: +49 (0)221 5104838
Chic bar with live DJs

Brauhaus Päffgen
Friesenstraße 64–66
50672 Köln
tel: +49 (0)221 135461
Cologne's oldest brewery serving
the local 'Kölsch' beer brewed on
the premises

Hotel Chelsea
Jülicher Straße 1
50674 Köln
tel: +49 (0)221 207150
fax: +49 (0)221 239137
chelseahotel.koeln@euro-hotel.de

Hotel popular for the art scene,
many of its rooms decorated with
works by artists from the 1980s,
such as Kippenberger who dona-
ted his work in exchange for
board there

Sixpack
Aachener Straße 33
50678 Köln
tel: +49 (0)221 254587
Dark, basically furnished bar that
is a long-standing hangout for
artists and musicians

AIRPORT →
Köln-Bonn Airport Konrad
Adenauer (CGN)
Postbox 98 01 20
51129 Köln
The airport is located 15 km
southeast of Cologne
tel: +49 (0)2203 400
fax: +49 (0)2203 4044
info@airport-cgn.de
www.airport-cgn.de

London

GMT (GMT +1 April to October)

There is no doubt that the cultural tsunami that was the decade of Young British Art is now over, but this has not diminished the sense of excitement about art in London. Thanks to the timely opening in 1999 of Tate Modern, Britain's first national museum of modern art, London has become a pivotal centre for visual arts. Even though the curators are still getting used to its non-chronological display of the collection, which can lead to some confusing (though provoking) viewing, their programme of big-name shows proves that London can hit hard. With its welcome arrival, London's other major public galleries, particularly the Serpentine Gallery and the Whitechapel Art Gallery, have had to sharpen their wits to ensure that their showcases of international artists continue to bring in the crowds. Seducing audiences to art galleries has become even more crucial, since the government's announcement in 2001 of free admission to state-run museums across the country. The trickle down effect of these developments is hard to quantify but it has inevit-ably helped the commercial galleries. The East End of London con-tinues to hold sway over the more interesting developments in new art. While well established galleries such as The Approach, White Cube, Matt's Gallery and Victoria Miro continue to show interesting, museum-destined artworks, there are several smaller, less commercial spaces that are gaining curatorial identity, including One in the Other and Magnani. Some excellent young galleries still remain in the more traditional West End, where the cream of the auction action from Sotheby's and Christie's still operates. Galleries such as Asprey Jacques, Gagosian, Sadie Coles and Stephen Friedman are proof that you can still find chal-lenging international art in this high-class neighbourhood. Despite the healthy commercial scene, some galleries have disappeared, most notably Anthony d'Offay, one of London's leading dealers in contempo-rary art until he closed his gallery in late 2001. Charles Saatchi, perhaps the most insatiable of collectors in Britain, also closed his spacious, light-filled north London space, and moved to a smaller temporary location while awaiting his move to new larger premises prominently positioned across the river from Tate Britain. It is in Tate Britain that the annual and notoriously controversial 'Turner Prize' for young British artists is awarded. Art prizes are a good way to gauge the mood of an art environment and the Turner Prize has become a touchstone for outrage at the more slippery aspects of contemporary art. Other more sedate awards, such as the John Moores, and the Jerwood Prize, both of which are devoted to painting, are left to prove that not all British artists are working against tradition or willing to get caught up in the media circus that surrounds the Turner Prize. Although the media are largely responsible for bringing contemporary art to the forefront of national consciousness, to the point where Damien Hirst and Tracey Emin have become household names, it is also to blame for a narrow view of what is happening. A reactionary tendency can still be felt amongst media hacks, who either fall for the glamour of the art world or blast its more pretentious or shocking side, often ignoring the many artists who are producing quieter work. London remains a city with several layers of artistic activity, not all palatable to the press' salacious appetite, but most of which can find a home within the vast array of older and newer commercial galleries, larger and smaller public museums, institutions, arts centres and out-of-the-way artist-run spaces.

EVENTS →
Art200X (contemporary art fair)
Every year, in January
Business Design Centre
Upper Street
London N1
tel: +44 (0)20 7288 6055
www.londonartfair.co.uk

Artangel
Programme of events during the
year, throughout London
tel: +44 (0)20 7713 1400
fax: +44 (0)20 7713 1401
www.artangel.org.uk

Becks Futures Award (for contem-
porary artists), every year in April
Institute of Contemporary Arts
The Mall
London SW1Y 5AH
tel: +44 (0)20 7930 0493
fax: +44 (0)20 7873 0051
www.ica.org.uk

Contemporary art auctions
Every year in February and June
At Christie's and Sotheby's

Turner prize
Every year, in November
Tate Britain
Millbank
London SW1P 4RG
tel: +44 (0)20 7887 8000
fax: +44 (0)20 7887 8729
www.tate.org.uk

COMMERCIAL GALLERIES →
The Approach
1st Floor, 47 Approach Road
London E2 9LY
tel: +44 (0)20 8983 3878
fax: +44 (0)20 983 3919
theapproach.gallery@virgin.net
www.theapproachgallery.co.uk

asprey jacques
4 Clifford Street
London W1X 1RB
tel: +44 (0)20 7287 7675
fax: +44 (0)20 7287 7674
info@aspreyjacques.com
www.aspreyjacques.com

Cabinet Gallery
20a Northburgh Street
London EC1V 0EX
tel: +44 (0)20 7253 5377
fax: +44 (0)20 7608 2414
art@cabinetltd.demon.co.uk

Sadie Coles HQ
35 Heddon Street

London W1B 4BP
tel: +44 (0)20 7434 2227
fax: +44 (0)20 7434 2228
press@sadiecoles.com
www.sadiecoles.com

Corvi Mora
22 Warren Street
London W1T 5LU
tel: +44 (0)20 7383 2419
fax: +44 (0)20 7383 2429
tcm@corvi-mora.com
www.corvimora.com

Stephen Friedman
25–28 Old Burlington Street
London W1S 3AN
tel: +44 (0)20 7494 1434
fax: +44 (0)20 7494 1431
info@stephenfriedman.com
www.stephenfriedman.com

Frith Street Gallery
59–60 Frith Street
London W1D 3JJ
tel: +44 (0)20 7494 1550
fax: +44 (0)20 7287 3733
frith-st@dircon.co.uk
www.frithstreetgallery.com

Gagosian
8 Heddon Street
London W1B 4BU
tel: +44 (0)20 7292 8222
fax: +44 (0)20 7292 8220
info@gagosian.com
www.gagosian.com

Vilma Gold
66 Rivington Street
London EC2A 3AY
tel: +44 (0)20 7613 1609
mail@vilmagold.com
www.vilmagold.com

Greengrassi
39c Fitzroy Street
London W1P 5HR
tel: +44 (0)20 7387 8747
fax: +44 (0)20 7388 3555

Hales Gallery
70 Deptford High Street
London SE8 4RT
tel: +44 (0)20 8694 1194
fax: +44 (0)20 8692 0471
info@halesgallery.com
www.halesgallery.com

Lisson Gallery
52–54 Bell Street &
67 Lisson Street
London NW1 5DA
tel: +44 (0)20 7724 2739

fax: +44 (0)20 7724 7124
contact@lisson.co.uk
www.lisson.co.uk

Magnani
82 Commercial Street
London E1 6LY
tel: +44 (0)20 7375 3002
fax: +44 (0)20 7375 3006
anybody@magnani.co.uk

Matt's Gallery
42–44 Copperfield Road
London E3 4RR
tel: +44 (0)20 8983 1771
fax: +44 (0)20 8983 1435
info@mattsgallery.org
www.mattsgallery.org

Victoria Miro Gallery
16 Wharf Road
London N1 7RW
tel: +44 (0)20 7336 8109
fax: +44 (0)20 7251 5596
www.victoria-miro.com

Modern Art
73 Redchurch St.
London E2 7DJ
tel: +44 (0)20 7739 2081
modernart@easynet.co.uk
www.modernartinc.com

One in the Other
4 Dingley Place
London EC1V 8BP
tel: +44 (0)20 7253 7882
oneintheother.art@virgin.net

Maureen Paley/Interim Art
21 Herald Street
London E2 6JT
tel: +44 (0)20 7729 4112
fax: +44 (0)20 7729 4113
interim.art@virgin.net

Anthony Reynolds
60 Great Marlborough Street
London W1V 2BA
tel: +44 (0)20 7439 2201
fax: +44 (0)20 7439 1869
info@anthonyreynolds.com

Emily Tsingou
10 Charles II Street
London SW1Y 4AA
tel: +44 (0)20 7839 5320
fax: +44 (0)20 7839 5321
emily@emilytsingougallery.com
www.emilytsingougallery.com

Jay Jopling/White Cube
44 Duke Street
London SW1Y 6DD

tel: +44 (0)20 7930 5373
fax: +44 (0)20 7930 9973
www.whitecube.com
info@whitecube.com

Jay Jopling/White Cube[2]
48 Hoxton Square
London N1 6PB
tel: +44 (0)20 7930 5373
fax: +44 (0)20 7749 7460
www.whitecube.com
info@whitecube.com

Anthony Wilkinson Gallery
242 Cambridge Heath Road
London E2 9DA
tel: +44 (0)20 8980 2662
info@anthonywilkinsongallery.com
www.anthonywilkinsongallery.com

PUBLIC GALLERIES →
Barbican
Silk Street
London EC1
tel: +44 (0)20 7638 4141
fax: +44 (0)20 7382 7107
www.barbican.org.uk
Multi-arts venue in London's
financial district with a changing
programme of exhibitions of
modern and contemporary art
and design

Camden Arts Centre
Arkwright Road
London NW3 6DG
tel: +44 (0)20 7435 2643
fax: +44 (0)20 7794 3371
www.camdenartscentre.org
info@camdenartscentre.org
Contemporary art exhibitions and
artist residencies in North London

Cubitt
8 Angel Mews
London N1 9HH
tel: +44 (0)20 7278 8226
fax: +44 (0)20 7278 2544
gallery@cubittartists.org.uk
www.cubittartists.org.uk
Non-profit space with programme
of exhibitions of new contemporary
art, talks, readings and film
screenings

Delfina
50 Bermondsey Street
London SE1 3UD
tel: +44 (0)20 7357 6600
fax: +44 (0)20 7357 0250
www.delfina.org.uk
Artist studios, residency program-
me and gallery for contemporary
exhibitions in a renovated factory

near Bankside

Institute of Contemporary Arts
The Mall
London SW1Y 5AH
tel: +44 (0)20 7930 0493
fax: +44 (0)20 7873 0051
www.ica.org.uk
Institution established in the
1920s as a venue for new film,
theatre and art

National Portrait Gallery
St Martin's Place
London WC2H OHE
tel: +44 (0)7 7306 0055
fax: +44 (0)7 7306 0056
www.npg.org.uk
National collection of portraits of
famous British men and women
founded in 1856 with a programme
of changing exhibitions of por-
traiture in all media

The Photographers' Gallery
5 & 8 Great Newport Street
London WC2H 7HY
tel: +44 (0)20 7831 1772
info@photonet.org.uk
www.photonet.org.uk
Venue for exhibitions and publica-
tions of contemporary photography

Royal Academy of Arts
Burlington House
Piccadilly
London WIJ OBD
tel: +44 (0)20 7300 8000
fax: +44 (0)20 7300 8001
www.royalacademy.org.uk
Temporary exhibitions including
blockbuster historical or contem-
porary shows such as 1997's
Brit Art exhibition 'Sensation'

Saatchi Gallery
30 Underwood Street
London N1 7JQ
tel: +44 (0)20 7336 7362
fax: +44 (0)20 7336 7364
Charles Saatchi's collection of
international contemporary art
including major works by British
artists such as Damien Hirst,
Tracey Emin and Chris Ofili

Serpentine Gallery
Kensington Gardens
London W2 3XA
tel: +44 (0)20 7402 6075
fax: +44 (0)20 7402 4103
www.serpentinegallery.org
1934 tea pavilion in the heart of
Kensington Gardens recently

renovated for exhibitions of
modern and contemporary art

South London Gallery
65 Peckham Road
London SE5 8UH
tel: +44 (0)20 7703 6120
fax: +44 (0)20 7858 4730
mail@southlondonart.com
www.southlondonart.com
Victorian exhibition hall in South
London with changing programme
of contemporary exhibitions

Tate Modern
Bankside
London SE1 9TG
tel: +44 (0)20 7887 8000
fax: +44 (0)20 7887 8729
www.tate.org.uk
Former power station renovated
by Swiss architects Herzog and
de Meuron that opened in 1999
and houses the national collection
of 20th and 21st century art, plus
a changing programme of inter-
national exhibitions

Tate Britain
Millbank
London SW1P 4RG
tel: +44 (0)20 7887 8000
fax: +44 (0)20 7887 8729
www.tate.org.uk
National gallery of British art
from 1500 to the present day, and
host to the annual 'Turner Prize'
for young contemporary artists

Victoria & Albert Museum
Cromwell Road
London SW7 2RL
tel: +44 (0)870 442 0808
www.vam.ac.uk
Museum of applied and decorati-
ve arts with historical collection
and changing exhibitions including
shows of modern and contempo-
rary fashion, design and photo-
graphy

Whitechapel Art Gallery
80–82 Whitechapel High Street
London E1 7QX
tel: +44 (0)20 7522 7888
fax: +44 (0)20 7377 1685
info@whitechapel.org
www.whitechapel.org
Gallery with changing programme
of contemporary exhibitions, talks
and film screenings, founded in
1901 to bring art to the East end
of London

ART BOOKSHOP →
Zwemmer's Art Bookshop
24 Litchfield Street
London WC2H 9NJ
tel: +44 (0)20 7240 4158

HIP PLACES →
The Golden Heart Pub
110 Commercial Street
London E1 6LZ
tel: +44 (0)20 7247 2158
Old-style British pub in the East
End of London whose landlady is
legendary amongst the artworld

The River Café
Thames Wharf
Rainville Road
London W6 9HA
tel: +44 (0)20 7386 4200
Waterfront restaurant designed by
British architect Sir Richard
Rogers with much-praised Italian
cuisine by his wife Ruthie Rogers
and her partner Rose Gray

The Ritzy Cinema
Brixton Oval
London SW2 1JG
tel: +44 (0)7818 000 655
Art house cinema with five
auditoriums and a restaurant
and bar

St. John Restaurant
St. John Street
London EC1M 4AY
tel: +44 (0)20 72510848
Large airy bar and restaurant in
London's old meat packing
district very popular with the art
world

Les Trois Garçons
1 Club Row
London E1 6JX
tel: +44 (0)20 7613 1924
Atmospheric French-run
restaurant in a converted pub
with a wood-panelled and
mirror-clad interior

AIRPORTS →
London City Airport (LCY)
London City Airport, Royal Docks,
London E16 2PX
Location: The airport is located
5 km from Docklands and the City
of London
tel: +44 (0)20 7646 0088
fax: +44 (0)20 7511 1040
mail@londoncityairport.com
www.londoncityairport.com

London Gatwick Airport (LGW)
London Gatwick Airport, West
Sussex RH6 0NP
The airport is located 45 km
south of central London
tel: +44 (0)870 000 2468
fax: +44 (0)1293 503 794
gatwick_feedback@baa.co.uk
www.baa.co.uk

London Heathrow Airport (LHR)
London Heathrow Airport,
Heathrow Point West
234 Bath Road, Harlington,
Middlesex UB3 5AP
The airport is located 24 km
west of central London
tel: +44 (0)870 000 0123
fax: +44 (0)20 8745 4290
lhr1feedback@baa.co.uk
www.baa.co.uk

London Luton Airport (LTN)
London Luton Airport, Percival
House, Percival Way
Luton LU2 9LY, Bedfordshire
The airport is located near Luton,
16 km from the M25 (London's
ring road) and 54 km northeast
of London
tel: +44 (0)1582 405 100
fax: +44 (0)1582 395 450
info@london-luton.co.uk
www.london-luton.com

London Stansted Airport (STN)
London Stansted Airport,
Enterprise House
Bassingbourne Road,
Essex CM24 1QW
The airport is located 54 km
northeast of central London
tel: +44 (0)870 000 0303
fax: +44 (0)1279 662 066
stansted_feedback@baa.co.uk
www.baa.com

International Rail Connections:
Waterloo Rail Station (QQW)
Highspeed passenger trains to
Paris and Brussels
www.eurostar.com

Los Angeles

GMT −8 (GMT −7 between April and October)

Los Angeles is massive but most of its urban space is ruled by a certain logic, that of the grid. The geographical separations of the city, not to mention its segregated ethnic diversity, create wide vistas of difference. As an art city, Los Angeles is exceptionally rich. Not for old culture (the city was founded in the 18th century) but for contemporary manifestations of American and international culture. Some of the most brilliant contemporary artists live here which, in turn, provides a motivation for younger artists to gravitate to Los Angeles to begin their own careers, often by way of the most important American graduate art institutions that are based here. The architectural legacy, for which Frank Lloyd Wright and his protégés such as Richard Neutra are most fashionably responsible, continues, with young architects exploiting the opportunity which still exists in the city: to build afresh. Likewise, artistic communities in the past thirty years (of which the California Institute of the Arts' Conceptual movement was exemplary) have been built upon by subsequent generations. But it is 'Hollywood' that remains the city's most famous draw. The neighbourhood itself, located in the centre of the city is, in a word, sleazy. As an attitude or a way of life, however, Hollywood is everywhere and its myths and fables seep into the work of many artists from Jim Shaw and Mike Kelley to Raymond Pettibon. The Hollywood super-collectors of contemporary art, captains of 'the industry', as it is referred to here, have defined LA art philanthropism in their generosity to cultural institutions and galleries. That you see stars everywhere you go is something of a myth, but it is certainly true that links between the art and the film worlds are strengthening, especially at such institutions as LA's downtown Museum of Contemporary Art which boasts two venues, one substantially funded by super-agent David Geffen. MoCA has been central in defining LA's identity on the international scene with excellent exhibitions by artists ranging from Willem de Kooning to Chris Burden and its now infamous 1993 exhibition 'Helter Skelter' which arguably defined a new LA aesthetic. However, the most exciting new development on the museum scene is UCLA's flagship museum, The Hammer, which has been reinvigorated with a strong contemporary programme under the directorship of Anne Philbin. LA's many smaller institutions and commercial galleries are dotted across the city. The West Side neighbourhoods (Santa Monica, Beverly Hills and West Hollywood) have traditionally been the most sympathetic for dealer galleries. The best among them include Blum & Poe, Margo Leavin, and Regen Projects, all of whom exhibit major local artists including Sharon Lockhart and Charles Ray. In the Mid-Wilshire district a cluster of spaces, including ACME and Karyn Lovegrove, present a vital younger group, while Chinatown, near downtown LA, has in the past four years become a gallery neighbourhood to watch with younger spaces such as China Art Objects and Goldman Tevis.

EVENTS →
Photo LA (photography art fair)
Every year in January
www.photola.com

COMMERCIAL GALLERIES →
1301PE
6150 Wilshire Blvd
Santa Monica, CA 90048
tel: +1 323 938 5822
fax: +1 323 938 6106

Ace Gallery
5514 Wilshire Blvd
Los Angeles, CA 90036
tel: +1 323 935 4411
fax: +1 323 935 9988
acegalleryla@excite.com

ACME
6150 Wilshire Blvd
Los Angeles, CA 90048
tel: +1 323 857 5942
fax: +1 323 857 5864
seeart@pacbell.net

Angles Gallery
2230/2222 Main Street
Santa Monica, CA 90405
tel: +1 310 396 5019
fax: +1 310 396 3797
anglesglry@aol.com

Blum & Poe
2042 Broadway

Santa Monica, CA 90404
tel: +1 310 453 8311
fax: +1 310 453 2821
blumpoe@earthlink.net

China Art Objects Galleries
933 Chung King Road
Los Angeles, CA 90012
tel/fax: +1 213 613-0384

Rosamund Felsen Gallery
Bergamot Station
2525 Michigan Avenue B4
Santa Monica, CA 90404
tel: +1 310 828 8488
fax: +1 310 828 1075
rosamund@gte.net
www.eloupe.com

Marc Foxx
6150 Wilshire Blvd
Los Angeles, CA 90048
tel: +1 323 857 5571
fax: +1 323 857 5573
gallery@marcfoxx.com

Gagosian Gallery
465 North Camden Drive
Beverly Hills, CA 90210
tel: +1 310 271 9400
fax: +1 310 271 9420
info@gagosian.com
www.gagoisan.com

Goldman Tevis
932 Chung King Road
Los Angeles, CA 90012
tel/fax: +1 213 617 8217

Grant Selwyn Fine Art
341 North Canon Drive
Beverly Hills, CA 90210
tel: +1 310 777 2400
fax: +1 310 247 8993
lexi@grantselwynla.com

Griffin Contemporary
55 North Venice Blvd
Venice, CA 90291
tel: +1 310 578 2280
fax: +1 310 578 2290
www.griffincontemporary.com

Christopher Grimes Gallery
916 Colorado Avenue
Santa Monica, CA 90401
tel: +1 310 587 3373
fax: +1 310 587 3383
cg@cgrimes.com
www.cgrimes.com

Michael Kohn Gallery
8071 Beverly Blvd
Los Angeles, CA 90048
tel: +1 323 658 8088
fax: +1 323 658 8068
kohngallery@aol.com

LA Louver Galleries
45 North Venice Blvd
Los Angeles, CA 90291
tel: +1 310 822 4955
fax: +1 310 821 7529
info@lalouver.com

Margo Leavin Gallery
812 North Robertson Blvd
Los Angeles, CA 90069
tel: +1 310 273 0603
fax: +1 310 273 9131
mlg@labridge.com

Karyn Lovegrove Gallery
6150 Wilshire Blvd #8
Los Angeles, CA 90048
tel: +1 323 525 1755
fax: +1 323 525 1245
info@karynlovegrovegallery.com
www.karynlovegrovegallery.com

LOW
9052 Santa Monica Blvd
Los Angeles, CA 90069
tel: +1 310 281 2691
fax: +1 310 281 2692
low@lowlosangeles.com
www.lowlosangeles.com

Patrick Painter Inc.
Bergamot Station
2525 Michigan Ave B2
Santa Monica, CA 90404
tel: +1 310 264 5988

fax: +1 310 264 5998
painterinc@shaw.ca

The Project
962 B East 4th Street
Los Angeles, CA 90013
tel: +1 213 620 0692
fax: +1 213 620 0743
theprojla@aol.com
www.elproyecto.com

Regen Projects
629 North Almont Drive
Los Angeles, CA 90069
tel: +1 310 276 5424
fax: +1 310 276 7430
regenprojects@regenprojects.com
www.regenprojects.com

Shoshana Wayne Gallery
Bergamot Station, 2525 Michigan
Avenue, B1
Santa Monica, CA 90404
tel: +1 310 453 7535
fax: +1 310 453 1595
shoshanawayne@hotmail.com

Daniel Weinberg Gallery
6150 Wilshire Blvd #8
Los Angeles, CA 90048
tel: +1 323 954 8425

PUBLIC GALLERIES →
J. Paul Getty Museum
1200 Getty Center Drive
Los Angeles, CA 90049
tel: +1 310 440 7300
fax: +1 310 440 7748
www.getty.edu
Extensive collection ranging from
antiquities to 20th photography
housed in a building designed by
Richard Meier overlooking the city

Japan America National Museum
369 East First Street
Los Angeles, CA 90012
tel: +1 213 625 0414
fax: +1 213 625 1770
www.janm.org
Historial exhibits and contem-
porary projects relating to
Japanese-American life

Los Angeles Contemporary
Exhibitions
6522 Hollywood Blvd
Los Angeles 90028
tel: +1 323 957 1777
fax: +1 323 957 9025
info@artleak.org
www.artleak.org
Non-profit venue established in
the early 1980's mounting chan-
ging exhibitions of contemporary
art with an LA focus.

Los Angeles County Museum of Art
5905 Wilshire Blvd
Los Angeles 90036
tel: +1 323 857 6000
fax: +1 323 931 7347
info@lacma.org
www.lacma.org
A major historical and contempo-
rary collection which is rotated
with retrospectives exhibitions
and projects by individual artists

The Museum of Contemporary Art
(MOCA) Gallery
at Pacific Design Center
8687 Melrose Avenue
West Hollywood 90069
and
250 S Grand Avenue
Los Angeles 90012
and
at Geffen Contemporary
152 North Central Avenue
Los Angeles, CA 90013
tel: +1 213 626 6222
fax: +1 213 620 8674
www.MOCA-LA.org
Three venues housing a perma-
nent collection of American and
European art since 1940 and
major solo and group exhibitions
of international contemporary art

Pasadena Museum of California Art
490 East Union Street
Pasadena, CA 91101
tel: +1 626 568 3665
fax: +1 626 568 3674.
Collection and exhibitions explor-
ing California's artistic history

from the 1850s to the present day

Santa Monica Museum of Art
Bergamot Station 2525 Michigan
Avenue, G1
Santa Monica 90404
tel: +1 310 586 6488
fax: +1 310 586 6487
info@smmoa.org
www.smmoa.org
Small but ambitious, the non-
collecting MMMOA presents
group and solo exhibitions of
contemporary art

UCLA Hammer Museum
10899 Wilshire Blvd
Los Angeles, CA 90024
tel: +1 310 443 7000 (automated
info), +1 310 443 7094 (TTY),
+1 310 443 7020 (receptionist,
Monday–Friday)
www.hammer.ucla.edu/
Excellent contemporary exhibitions
in the context of a University art
musem with an important historical
collection

ART BOOKSHOP →
TASCHEN shop Los Angeles
354 North Beverly Drive
Beverly Hills, CA 90212
(opening winter 2002/03)
www.taschen.com

Museum of Contemporary Art LA
California Plaza
250 South Grand Avenue
Los Angeles 90012
tel: +1 213 626 6222
fax: +1 213 620 8674
www.MOCA-LA.org

HIP PLACES →
Château Marmont
8221 Sunset Blvd
Hollywood, CA 90046
tel: +1 323 656 1010
fax: +1 323 655 5311
chateau@aol.com
Legendary castle-like hotel on
Sunset Strip built in 1929 with a
rich Hollywood history

The Echo
1822 Sunset Blvd
Los Angeles, CA 90005
tel: +1 213 413 8200
Shabby but cool nightclub
drawing a local crowd from the
Echo Park area with a light-up
dancefloor and all kinds of music
from hip-hop to karaoke

Nishimura
8684 Melrose Avenue
Los Angeles, CA 90069
tel: +1 310 659 4770
Cool, minimalist sushi restaurant
on the designer shopping street,
Melrose Avenue

The Standard
8300 Sunset Blvd
West Hollywood, CA 90069
tel: +1 323 650 9090
www.standardhotel.com
Hip hotel opened in 1999 with
a 50s style diner, lounge bar,
pool and very fashionable scene

AIRPORTS →
Los Angeles, CA International
Airport (LAX)
1 World Way
Los Angeles, CA 90045
The airport is located 24 km
southwest of Los Angeles (CA)
tel: +1 310 646 5252
(24-hour recorded information)
fax: +1 310 646 1893
infoline@airports.ci.la.ca.us
www.lawa.org

John Wayne Airport (SNA)
3160 Airway Avenue
Costa Mesa 92626
John Wayne Airport is located
in Santa Ana, California, 56 km
south of Los Angeles (CA)
tel: +1 949 252 5200
fax: +1 949 252 7178
amccarley@ocair.com
www.ocair.com

Madrid

GMT + 1 (GMT + 2 between April and October)

In the last 50 years Madrid has seen a radical transformation in its art scene, a change that has been particularly marked since the contem-porary art fair ARCO was established in 1981. ARCO has had such success that it could be said to mark the before and after of contemporary art

collecting in Spain. During ARCO, held every year in February, Madrid becomes not just a meeting place for Spanish artists, gallery owners, curators and critics, but a world capital of contemporary art and the main entry point for dozens of Latin American galleries for whom it is the main opportunity to exhibit in Europe. Madrid has numerous contemporary art galleries, almost all of which are grouped in the contiguous districts of Salamanca, Retiro and Centro, very close to each other and near Madrid's central museum district. These range from galleries focusing on mid 20th century art, such as Soledad Lorenzo, to the many galleries scattered along Barquillo Street which work usually with living Spanish artists. The area around the Reina Sofía Museum has the most cutting edge spaces, from Espacio Mínimo to Helga de Alvear and Salvador Díaz gallery. Despite such a broad range, there are few committed local collectors of contemporary art and most galleries depend on collectors outside of the city. Madrid's public galleries offer a comprehensive panorama of contemporary art, beginning with the Museo Nacional Centro de Arte Reina Sofía which offers, on the one hand, an overview of 20th century with its permanent collection including Picasso, Dalí, Miró, and their contemporaries (the highlight being Picasso's 'Guernica') to more recent acquisitions of Spanish and international contemporary art. On the other hand, it has an active programme of temporary exhibitions. Its "Espacio Uno" is reserved for projects by younger artists, while the palaces Velázquez and Cristal in The Retiro Park host larger exhibitions of international contemporary artists. The Thyssen-Bornemisza museum with its international collection, including major figures of European and American avant-garde art movements, completes the overview of the 20th century. In addition, cultural trusts play an important role in the city's art scene, due to their fast response to the latest trends and offer exhibitions of great impact and current relevance. Fundación Telefónica concentrates on the relation between arts and technology while "La Caixa" has a contemporary focus and the Fundación Juan March supports large-scale exhibitions. Another reference point is the Círculo de Bellas Artes that dedicates its various halls to revisiting Spanish 20th century art. The Centro Conde Duque works with that same ethos and is a good example of the energised activity of institutional exhibition spaces in Madrid.

EVENTS →
ARCO (contemporary art fair)
Every year in February
www.arco-online.ua.es

Estampa (art fair for editions and prints
Every year in November
www.salonestampa.com

PhotoEspaña (international festival of photography)
Every year in June/July
www.photoes.com

COMMERCIAL GALLERIES →
Juana de Aizpuru
Barquillo, 44
28004 Madrid
tel: +34 (0)91 310 5561
fax: +34 (0)91 5286
aizpuru@navegalia.es

Helga de Alvear
Doctor Fouquet, 12
28012 Madrid ·
tel: +34 (0)91 468 0506
fax: +34 (0)91 467 5134
galeria@helgadealvear.net
www.helgadealvear.net

Elba Benítez
San Lorenzo, 11
28004 Madrid
tel: +34 (0)91 308 0468
fax: +34 (0)91 308 0468
elbab@retemail.html
www.artnet.com/ebenitez.html

Galerie Buades
Gran Vía, 16 – 3°
28013 Madrid
tel: +34 (0)91 522 3112
fax: +34 (0)91 522 2562
buadesgal@eresmas.es

La Caja Negra
Fernando VI, 17 – 2°
28004 Madrid
tel: +34 (0)91 310 4360

Marta Cervera
Plaza de las Salesas, 2
28004 Madrid
tel: +34 (0)91 308 1332
fax: +34 (0)91 308 3963
martacervera@jazzfree.com

Galería Heinrich Ehrhardt
San Lorenzo 11
28004 Madrid
tel: +34 (0)91 310 4415
fax: +34 (0)91 310 2845
gehrhardt@retemail.es

Espacio Mínimo
Doctor Fouquet, 17
28004 Madrid
tel: +34 (0)91 559 6572
fax: +34 (0)91 467 8331

Fúcares
Conde de Xiquena, 12 – 1° izqda.
28004 Madrid
tel: +34 (0)91 308 0191
fax: +34 (0)91 308 0191
galefucares@wanadoo.es
www.centrodearte.com/galerias/fucaresmadrid

Javier López
Manuel González Longoria, 7
28010 Madrid
tel: +34 (0)91 593 2184
fax: +34 (0)91 591 2648

Soledad Lorenzo
Orfila, 5
28010 Madrid
tel: +34 (0)91 308 2887
fax: +34 (0)91 308 6830

galleria@soledadlorenzo.com
www.soledadlorenzo.com

Maes
Doctor Vallejo, 5
28007 Madrid
tel: +34 (0)91 368 0796
galleria.maes@wanadoo.es

María Martín
Pelayo, 52
28004 Madrid
tel: +34 (0)91 319 6873
fax: +34 (0)91 310 4439
marianna@santandersupernet.com

Metta
Marqués de la Ensenada, 2
28004 Madrid
tel: +34 (0)91 319 0230
fax: +34 (0)91 319 5964
metta@afinsa.com
www.afinsa.com/metta99

Galería Pilar Mulet
Claudio Coello, 23
28001 Madrid
tel: +34 (0)91 431 0382

My Name's Lolita
Salitre, 7
28012 Madrid
tel/fax: +34 (0)91 530 7237
lolitart@teleline.es
www.terra.es/personal/lolitart/home

Masha Prieto
Belén, 2
28004 Madrid
tel: +34 (0)91 319 5371
fax: +34 (0)91 310 2636
mprieto@nexo.es
www.arteycartelera.com/mashaprieto

Angel Romero
San Pedro, 5
28014 Madrid
tel: +34 (0)91 429 3208
fax: +34 (0)91 429 3208
angel.romero@artemadrid.net

PUBLIC GALLERIES →
Casa de América
Paseo de Recoletos, 2
28001 Madrid
tel: +34 (0)91 595 4800
www.casamerica.es
Museum established in 1992 in a former 19th century aristocratic mansion for exhibitions of Latin American art

Centro Cultural Conde Duque
Conde Duque, 11
28015 Madrid
tel: +34 (0)91 588 5824
fax: +34 (0)91 588 5903
18th century edifice today used as a space for exhibitions of visual art and culture, performances and conferences

Centro Cultural de la Villa
Plaza de Colón s/n
28001 Madrid
tel: +34 (0)91 575 6080
fax: +34 (0)91 576 1438
Cultural centre for theatre, dance, opera, classical music and visual art

Círculo de Bellas Artes
Marqués de la Casa Riera 2
28014 Madrid
tel: +34 (0)91 531 8503
www.circulobellasartes.com
Multi-functional cultural space with a theatre, concert hall, café and several exhibition spaces

Comunidad de Madrid
Plaza de España, 8
Madrid 28013
tel: +34 (0)91 570 4000
and
Sala del Canal de Isabel II
Santa Engracia, 125
Madrid 28010
tel: +34 (0)91 580 4000
www.comadrid.es
Changing exhibitions of largely
Spanish artists

Fundació "La Caixa"
Serrano, 60
28001 Madrid 1
tel: +34 (0)91 462 0202
fax: +34 (0)91 576 2253
www.fundacio.lacaixa.es
Exhibition centre with a changing
programme of contemporary art
exhibitions

Fundación Juan March
Castelló, 77
28001 Madrid 6
tel: +34 (0)91 435 4240
fax: +34 (0)91 763420
www.march.es
Founded by the wealthy philan-
thropist Juan March as a private
art foundation for large scale
exhibitions of 20th century and
contemporary art

Museo Telefónica Coleccion
Permanente de Arte
Fuencarral, 1
Madrid 28013
tel: +34 (0)91 522 6645
fax: +34 (0)91 531 7106

www.fundacio.telefonica.com
Collection of Spanish art owned
by Spain's largest telephone com-
pany, with an additional program-
me of performance and photogra-
phy and multi-media exhibitions

Museo Nacional Centro de Arte
Reina Sofía
Santa Isabel, 52
Madrid 28012
tel: +34 (0)91 467 5062
fax: +34 (0)91 467 3163
www.museoreinasofia.mcu.es
Renovated hospital inaugurated
in 1986 for major exhibitions of
Spanish and international con-
temporary art and a permanent
collection which includes
Picasso's 'Guernica'

Museo Thyssen-Bornemisza
Paseo del Prado 8
28014 Madrid
tel: +34 (0)91 369 0151
fax: +34 (0)91 420 2780
www.museothyssen.org
Historical and late 20th century
collection housed in a 19th
century palace

Palacio de Cristal
Parque del Retiro
28001 Madrid 9
tel: +34 (0)91 574 6614
www.palacio-cristal.com
Glass and iron building in The
Retiro Park run under the auspi-
ces of the Museo Reina Sofía for
temporary exhibitions of contem-
porary art, especially sculpture

Palacio de Velázquez
Parque del Retiro
28001 Madrid 9
tel: +34 (0)91 573 6245
www.museoreinasofia.mcu.es
Palace in The Retiro Park, under
the auspices of the Museo Reina
Sofía, hosting touring exhibitions
of contemporary art

Sala de las Alhajas
Plaza de San Martín, 1
Madrid 28013
tel: +34 (0)91 3792461
www.cajamadrid.es
Exhibition space belonging to the
Fundacio Caja Madrid hosting
four exhibitions per season of
historical and contemporary art

ART BOOKSHOP →
Bookshop at the Museo Nacional
Centro de Arte Reina Sofía
Santa Isabel, 52
Madrid 28012
tel: +34 (0)91 467 5062
fax: +34 (0)91 467 3163
www.museoreinasofia.mcu.es

HIP PLACES →
Bar Cock
Calle de la Reina 6
28004 Madrid
tel: +34 (0)91 532 2826
Lively bar open every day until
4am, home to Madrid's entire cul-
tural scene

Chicote
Calle Gran Via, 12
28013 Madrid

tel: +34 (0)91 532 6737
Former cocktail bar from the
1950s with original décor but
now playing techno or lounge
music for a mixed crowd

Candela
Calle Olmo, 3
28001 Madrid
tel: +34 (0)91 527 0830
The temple for the flamenco
scene, very popular with artists

El Viajero
Plaza Cebada, 11
28005 Madrid
tel: +34 (0)91 366 9064
Open all day for lunch, dinner,
drinks and pool with a roof
terrace and great view over one
of the city's oldest churches

El Pepinillo de Barquillo
Calle Barquillo, 42
28004 Madrid
tel: +34 (0)91 310 2546
Friendly and popular tapas
restaurant open for lunch and
dinner with live music

AIRPORT →
Madrid Barajas Airport (MAD)
28042 Madrid, Spain
The airport is located 13 km
from Madrid city centre
tel: +34 (0)90 235 3570
fax: +34 (0)(0)91 393 6204
mad.clientesmad@aena.es
www.aena.es/ae/mad/homepage.
htm

México D. F.

GMT −6 (GMT −5 between April and October)

With its prehispanic and colonial past, its multi-culturalism and nationalism, its populism and marginalism, México D. F., is an ambiguous mixture of influences that combine ancient rite and radical modernity, a dramatic blend which lies at the heart of its wide international appeal. In such a ritualised society, mythology continues to exert a deep fascin-ation in the collective imagination. Nowhere is this more so than for the artist, who continues to be surrounded by the aura of "creator", for good and for ill. The state is the main promoter of the arts in Mexico. Its virtual monopoly includes museums, theatres, libraries and festivals, as well as scholarships and prizes that prop up a large proportion of Mexico's intellectuals and artists. This is not, however, the way it works for Francisco Toledo, Gabriel Orozco or Julio Galán, who are authentic celebrities of the international art market. These artists have subverted the image of the Mexican artist as great muralist, or cult figure, such as Frida Kahlo,

or colourist, such as Rufino Tamayo. Mexico's experimental tendencies are best seen in museums such as the Carrillo Gil or del Chopo. The most interesting work is to be found here rather than on the limited circuit of commercial galleries which vary from the avant-garde spaces of the colonia Roma to the predictably bourgeois galleries of Polanco. Since the close of the Centre de Arte Contemporáneo, funded by Mexico's media giant Televisa, the great art of the 20th century is mostly in the Museo Tamayo, the Museo de Arte Moderno and the Palacio de Bellas Artes. The inauguration of the Colección Jumex was the biggest event of 2001. Housed in two spectacular industrial spaces in the north of the city, the collection presents a panorama of international art, from Minimal and Conceptual art of the 60s and 70s to the most recent con-temporary creations. One field in which Mexico has historically led the way is photography, with Cartier-Bresson, who first began photography in

Mexico, Edward Weston, and Paul Strand. Of comparable talent are the contemporary Mexican photographers Emilio Amero, Agustín Jiménez and Manuel Alvarez Bravo. Of comparable talent, Bravo has just reached his hundredth birthday, and part of the homage dedicated to this Grand Old Man of photography is the reconstruction of his 1935 group show 'Alvarez Bravo, Cartier-Bresson, Walker Evans' at the Palacio de Bellas Artes in November 2002. The Centro de la Imágen regularly exhibits international photographers and is the heart of the city's photo scene. In addition, Mexican architecture has produced a version of modernity that has not ceased reinventing itself from the 30s onwards and 2002 also marks the centenary of the birth of Mexican architect par excellence, Luis Barragán.

EVENTS →
Congreso Internacional de Arquitectura "Arquine" (congress for architecture)
Every year in March
www.arquine.com

Festival del Centro Histórico (dance and music festival)
Every year between March and April
www.fchmexico.com

Festival Internacional de Arte Sonoro (music festival)
Every year in June
xteresa@avantel.net

Simposio Internacional de Arte Contemporáneo (symposion for contemporary art)
Every year in January
sitac@pac.org.mx
www.pac.org.mx

COMMERCIAL GALLERIES →
Galería de Arte Mexicano
Gobernador Rafael Rebollar 43
San Miguel Chapultepec
México D. F., 11850
tel: +52 55 5273 1261

Galería Arvil
Cerrada de Hamburgo 7 & 9
Zona Rosa
México D. F.
tel: +52 55 5207 2820

Galeria Enrique Guerrero
Horacio 1549/A, Col Polanco
MEX – Mexico City 11540
tel: +52 5 280-2941
fax: +52 5 280-3283

kurimanzutto
Mazatlán 5, depto p-6
Condesa
México D. F., 06140
tel/fax: +52 55 5256 2408
info@kurimanzutto.com
www.kurinmanzutto.com

Galería Juan Martín
Charles Dickens 33-B
Polanco
México D. F., 11560
tel: +52 55 5280 0277

Galería Nina Menocal
Zacatecas 93
Roma
México D. F., 06700
tel: +52 55 5564 7443

Galería Mexicana de Diseño
Anatole France 13
Polanco
México D. F., 11560
tel: +52 55 5280 0080

Galería OMR
Plaza Río de Janeiro 54
Roma
México D. F., 06700
tel: +52 55 5207 1080

Galería López Quiroga
Horacio 714
Polanco
México D. F., 11560
tel: +52 55 5280 3710

Galería Pecanins
Durango 186
Roma
México D. F., 06700
tel: +52 55 5207 5661

PUBLIC GALLERIES →
Antiguo Colegio de San Ildefonso
Justo Sierra 16
Centro Histórico
México D. F., 06060
tel: +52 55 5789 2505 /
+52 55 5702 2834
Magnificent building with a permanent collection of 20th century Mexican art as well as major touring exhibitions

Casa Museo Frida Kahlo
Londres 247
Coyoacán
México D. F., 04000
tel: +52 55 5554 5999
Preserved house where painter Frida Kahlo lived with Diego Rivera from 1929 until her death in 1954, housing examples of work by both artists

Casa Museo Luis Barragán
(by appointment)
Francisco Ramírez 14
Tacubaya

México D. F.
tel: +52 55 5515 4908
Private house designed in 1947 by architect Luis Barragan now converted into a museum honouring his work

Centro de la Imagen
Plaza de la Ciudadela 2
Centro Histórico
México D. F., 06060
tel: +52 55 5709 6058 /
+52 55 5709 6095
Foundation for photography hosting exhibitions of Mexican and international photographic work

Colección Jumex
Puerta de C.M.D. Jumex 2000
Km. 19.5 Antigua Carretera
México-Pachuca
Santa María Tulpetlac
Ecatepec de Morelos
México D. F.
tel: +52 55 5699 1961
Private collection of well-known international contemporary artists from the 60s to the present day in a newly opened industrial exhibition space

Museo de Arte Carrillo Gil
Avenida Revolución 1608
San Ángel
México D. F., 01000
tel: +52 55 5550 6289 /
+52 55 5550 6260
Permanent collection of 20th century Mexican artists

Museo de Arte Contemporáneo
Rufino Tamayo
Paseo de la Reforma y Gandhi
Bosque de Chapultepec
México D. F., 11560
tel: +52 55 5286 6599 /
+52 55 5286 5889
Collection of 20th century international art and renowned Mexican muralists in a multi-level building designed in the 1980s, with several rooms dedicated to contemporary art and international exhibitions

Museo de Arte Moderno
Paseo de la Reforma y Gandhi
Bosque de Chapultepec
México D. F., 11560
tel: +52 55 5553 6233 /
+52 55 5211 8331
www.arts-history.mx/museos/
mam/home.html
Collection of Mexican art of the 20th century, temporary exhibitions of international art and a collection of sculpture in the museum's gardens

Museo Dolores Olmedo
Avenida México 5843
La Noria, Xochimilco
México D. F., 16380
tel: +52 55 5555 1016 /
+52 55 5555 0891
Private collection of work by muralist Diego Rivera in a 16th century hacienda

Museo Estudio Diego Rivera
Diego Rivera 2
San Ángel
México D. F., 01000
tel: +52 55 5550 1189 /
+52 55 5616 0996
Museum dedicated to muralist Diego Rivera in the house where he lived from 1940 until his death in 1957

Museo José Luis Cuevas
Academia 13
Centro Histórico
México D. F., 06060
tel: +52 55 5542 8959 /
+52 55 5542 6198
Museum in a refurbished convent with a collection of contemporary art

Museo del Palacio de Bellas Artes
Avenida Juárez y Avenida Hidalgo
Centro Histórico
México D. F., 06060
tel: +52 55 5709 3111
Art Nouveau and Art Deco architectural masterpiece in Mexico's principal opera house presenting important exhibitions of historical and contemporary art

Museo Universitario del Chopo
Enrique González Martínez 10
Santa María de la Ribera
México D. F.
tel: +52 55 5546 5484
University museum in a turn of
the century industrial building
housing exhibitions of contempo-
rary visual art and experimental
projects

La Panndería
Av. Amsterdam 159
Condesa
México D. F., 06140
México D. F., tel: +52 55 5286 7707
Non-profit independent exhibition
space

Sala de Arte Público Siqueiros
Tres Picos 29
Polanco
México D. F., 11560

www.salasiqueiros.artte.com
tel: +52 55 5203 5888 /
+52 55 5531 3234
Former home of Mexican muralist
David Alfaro Siqueiros preserved
with his personal belongings and
art works

ART BOOKSHOP →
Librarias Ghandi
Miguel Angel de Quevedo 134
Chimalistac
México D. F.
tel: +55 52 5661 0911
gandhi@mail.internet.com.mx
www.gandhi.com.mx

HIP PLACES →
Café la Habana
Campos Elisios 345
Chapultepec Polanco
tel: +52 55 5282 3443
Café famous for being the place

where the Cuban Revolution was
planned in the 1950s

El Gran Leon
Querétaro 225
Roma
tel: +52 55 5564 7110 /
+52 55 5584 5956
The best venue for live tropical
music, especially on Tuesday's
when there are dancing classes

La Guadalupana
Higuera 14
Coyoacán
tel: +52 55 5554 6253
Attractive cantina with delicious
food in the centre of Coyoacan,
one of the small towns swallowed
by the city's expansion

Hotel Majestic
Av. Francisco I. Madero 73

Centro
tel: +52 55 5521 8604
Hotel with a beautiful terrace
overlooking the Zocalo, the main
plaza of Mexico City

La Maraca
Av. Eugenia esq. con Mitla
Narvarte
tel: +52 55 5682 0636
Huge, very popular club with live
music which varies every night

AIRPORT →
Mexico City (MEX)
Av. Capitán Carlos León s/n
Col. Peñón de los Baños Del.
Venustiano Carranza, México D. F.
CP 15620, México
The airport is located 10 km
east of the centre of Mexico City
tel: +52 55 5571 3600
fax: +52 55 5726 0107

Milano

GMT + 1 (GMT + 2 between April and October)

Milan was the capital of Italy's contemporary art scene in the 50s and 60s and recently seems to have recovered some of its former spark. Many young galleries have opened in the last few years and colo- nised new parts of the city beyond the ultra-expensive historic Brera area. Some have moved to the area around the Bocconi University, some around the Corso Buenos Aires, and some to the now very fashionable Corso Como. Exhibitions have proliferated too, especially in private spaces, and Italian collecting habits confirm that Milan is the true centre of Italian contemporary art. Collectors from all over Italy come to Milan to buy contemporary art, as do many from outside Italy, attracted by the performance of young Italian artists on the international market. Above all, it is the fusion of the fashion and art worlds that gives Milan its character; Milan is still the undisputed world capital of fashion. Not only are there many collectors among Milan's fashion superstars (especially Miuccia Prada, who is opening her own Foundation and also supports exhibitions such as the recent Mariko Mori show in Tokyo), but there are collectors, and fans, of contemporary art from all walks of the ragtrade: fashion assistants, collaborators and stylists. This band of often very young art lovers, with their super-refined aesthetics, has taken over from the traditional art buyers, the rich businessmen. Milan still has plenty of wealthy businessmen too, but even here it has an especially youthful catchment, being the capital of Italy's new economy. These young whizz kids have both a good cultural grounding and lots of

money, bringing more fresh energy to contemporary collecting. Such energy is starting to attract more established collectors, who previously bought traditional Modern art such as de Chirico, to buy contemporary, perhaps stimulated by the recent clamorous interest in young Italian artists such as Maurizio Cattelan. Milan's contemporary art market is certainly enjoying good times at the moment, but there is much room for improvement in its public museums and galleries, and big plans to put this right: the Cimac (Civico Museo d'Arte Contemporanea), currently housed in an unfortunate spot, will be relocated in 2005 to a much more impressive site; the Museo del Novecento, with its collection of master- pieces from 1900–1970, will find a new space in the monumental Arengario near to Milan's soaring cathedral in the Piazza del Duomo; while the Museo del Presente is moving to a former gasworks in Bovisa, the industrial district on the northern edge of Milan. While we wait for this museum make-over, construction work is also taking place in private spaces: the Fondazione Prada, the Fondazione Nicola Trussardi, and Armani's new exhibition space in his palazzo on Via Manzoni, where he will show a mix of Italian and non-Italian art. Final confirmation of Milan's expanding international status comes from the Palazzo Reale, the most prestigious exhibition space of the Milan municipality. Following its recent collaboration with the Whitney Museum, it is to put on a pro- gramme of co-productions with MoMA and the Guggenheim New York set to begin in 2004.

EVENTS →
Artissima (contemporary art fair)
Every year in November
in Turin (two hours from Milan)
info@artissima.it
www.artissima.it

MIART – Fiera d'Arte Moderna
e Contemporanea (contemporary
art fair), every year in May
Rassegne s.p.a.
Foro Buonaparte 65
20121 Milano
tel: +39 (0)2 303 0211
fax: +39 (0)2 8901 1578

www.fieramilano.com

Milan Design Week
Every year in April

Milan Fashion Week
Every year in February/March and
September/October

Milan Triennale
Every three years, next edition
2005
Palazzo dell'Arte
Viale Alemagna 6
20121 Milano
tel: +39 (0)2 724 341
www.triennale.it

COMMERCIAL GALLERIES →

1000 Eventi
Via del Lauro 3
20121 Milano
tel: +39 (0)2 805 3920
fax: +39 (0)2 805 3923
milleventi@libero.it

Arte Studio Invernizzi
Via Scarlatti 12
20124 Milano
tel/fax: +39 (0)2 2940 2855
arteinvernizzi@tin.it

Cardi & Co
Corso di Porta Nuova 38
20121 Milano
tel: +39 (0)2 6269 0945
fax: +39 (0)2 6269 4016
info@galleriacardi.com
www.galleriacardi.com

Cardi & Co
Piazza San Erasmo 3
20121 Milano
tel: +39 (0)2 2900 3235
fax: +39 (0)2 2900 3382
info@galleriacardi.com
www.galleriacardi.com

Raffaella Cortese
Via Rodolfo Farneti 10
20129 Milano
tel/fax: +39 (0)2 2043 5555
rcortgal@tin.it
www.gospark.com/raffaellacortese

Paolo Curti & Co.
Via Pontaccio 19
10121 Milano
tel: +39 (0)2 8699 8170
fax: +39 (0)2 7209 4052
info@paolocurti.com
www.paolocurti.com

Monica De Cardenas
Via F. Viganò 4
20124 Milano
tel: +39 (0)2 2901 0068
fax: +39 (0)2 2900 5784
monica@decardenas.com
www.artnet.com/decardenas.html

Massimo De Carlo
Viale Corsica 41
20133 Milano
tel: +39 (0)2 7000 3987
fax: +39 (0)2 749 2135
and Via Volta 17
20121 Milano
tel: +39 (0)2 2906 0214
fax: +39 (0)2 749 2135
decarlo@iol.it

Galleria Emi Fontana
Viale Bligny 42
20136 Milano
tel: +39 (0)2 5832 2237
fax: +39 (0)2 5830 6855
emif@micronet.it

Karsten Greve
Via Santo Spirito 13
20121 Milano
tel: +39 (0)2 783 840
fax: +39 (0)2 783 866
karsten_greve.milano@tin.it
www.galerie-karsten-greve.com

Luciano Inga-Pin
Via Pontaccio 12/A
20121 Milano
tel/fax: +39 (0)2 874 237
lucianoinga-pin@hotmail.com

Francesca Kaufmann
Via dell'Orso 16
20121 Milano
tel: +39 (0)2 7209 4331
fax: +39 (0)2 7209 6873
franceska@micronet.it

Giò Marconi
Via Tadino 15
20124 Milano
tel: +39 (0)2 2940 4373
fax: +39 (0)2 2940 5573
giomarconi@mclink.it

Laura Pecci
Via Bocconi 9
20136 Milano
tel: +39 (0)2 5843 0047
fax: +39 (0)2 5843 4287
galpecci@electraline.com
www.gallerialaurapecci.com

Photology (fotografia)
Via della Moscova 25
20121 Milano
tel: +39 (0)2 659 5285
fax: +39 (0)2 654 284
photology@photology.com
www.photology.com

Lawrence Rubin
Via Marco de Marchi 1
20121 Milano
tel: +39 (0)2 2901 3189
fax+39 (0)2 2901 1294
0229013189@iol.it

Lia Rumma
Via Solferino 44
20121 Milano
tel: +39 (0)2 2900 0101
fax: +39 (0)2 2900 3805

liarumma@tin.it
www.gallerialiarumma.com

Carla Sozzani (fotografia)
Corso Como 10
20154 Milano
tel: +39 (0)2 653 531
fax: +39 (0)2 659 2015
info@carlasozzani.it
www.galleriacarlasozzani.it

Christian Stein
Corso Monforte 23
20122 Milano
tel: +39 (0)2 7639 3301
fax: +39 (0)2 7600 7114
christianstein@iol.it

Studio Guenzani
Via Eustachi 10
20129 Milano
tel: +39 (0)2 2940 9251
fax: +39 (0)2 2940 8080
guenzani@micronet.it

PUBLIC GALLERIES →

Castello di Rivoli Museo d'Arte
Contemporanea
Piazza Malfada di Savoia
10098 Rivoli, Torino
tel: +39 011 956 5222
fax: +39 011 956 5230
info@castellodirivoli.org
www.castellodirivoli.torino.it
17th century palace converted
into a museum in 1984 with an
active programme of international
contemporary exhibitions and
permanent collection, located
about one hour from Milan

CIMAC – Civico Museo d'Arte
Contemporanea
Palazzo Reale
Piazza Duomo 12
20100 Milano
tel: +39 (0)2 6208 3219
Collection of early 20th century
and post war art with an
important collection of Futurism
and other Italian modern move-
ments. Closed for restoration until
2005

Fondazione Nicola Trussardi
Piazza della Scala 5
20121 Milano
tel: +39 (0)2 806 8821
fax: +39 (0)2 806 8281
info@fondazionenicolatrussardi.com
www.fondazionenicolatrussardi.com
Foundation organising and
supporting exhibitions, seminars,

performances and publications
by Italian and international artists

Fondazione Mazzotta
Foro Buonaparte 50
20121 Milano
tel: +39 (0)2 878 197
fax: +39 (0)2 869 3046
www.mazzotta.it
Private foundation established
in 1988 for Antonio Mazzotta's col-
lection of 20th century art and
temporary exhibitions

Fondazione Mudima
Via Tadino 26
20124 Milano
tel: +39 (0)2 2940 9633
fax: +39 (0)2 2940 1455
www.mudima.com
Foundation for contemporary
visual arts and music founded in
1989, with an emphasis on work
from the 1960s and 1970s

Fondazione Prada
Via Spartaco 8
20135 Milano
tel: +39 (0)2 5467 0216
fax: +39 (0)2 5467 0258
info@fondazioneprada.org
www.fondazioneprada.org
Foundation established by the
owner of the fashion label
Miuccia Prada in 1993 for tempor-
ary exhibitions and commissions
of artwork by young contemporary
artists

Openspace Progetto Giovani
Palazzo dell'Arengario
Via Marconi 1
20121 Milano
tel: +39 (0)2 8846 4130
fax: +39 (0)2 8846 4417
milano.promcult@flashnet.it
Non-profit multi-media laboratory
for young artists

PAC – Padiglione d'Arte
Contemporanea
Via Palestro 14
20121 Milano
tel: +39 (0)2 7600 9085
fax: +39 (0)2 783 330
www.pac-milano.org
Renovated 18th century villa and
1940s building by Italian architect
Ignazio Gardella housing exhibitions
of modern and contemporary art

Studio Casoli
Corso Monforte 23

20122 Milano
tel: +39 (0)2 795 251
Former studio of Italian artist
Lucio Fontana, converted into
venue for active programme of
modern and contemporary inter-
national exhibitions

Triennale di Milano
Palazzo dell'Arte
Viale Alemagna 6
20121 Milano
tel: +39 (0)2 724 341
fax: +39 (0)2 8901 0693
info@triennale.it
www.triennale.it
Established in 1923 for permanent
collection and temporary exhibi-
tions of architecture, design and
the decorative arts

Viafarini
Via Farini 35
20159 Milano
tel: +39 (0)2 6680 4473
fax: +39 (0)2 6680 4473
www.Viafarini.org
Non-profit association inaugurated

in 1991 for research into emerging
contemporary art with an exhib-
ition space and archive of new
Italian art

ART BOOKSHOP →
a +m bookstore
Via Tadino 30
20124 Milano
tel: +39 (0)2 2952 7729

HIP PLACES →
Atomic Bar
Via Casati 24
Milano
Tel +39 (0)2 6698 3152
Informal cocktail bar for a young
crowd of artists and designers
with different DJs every night

Corso Como Cafe
Corso Como 10
Milano
tel: +39 (0)2 2901 3581
Chic cafe and bar set back in a
courtyard, very popular with the
fashion crowd and next to one of
the best fashion shops in Milan

Milch
Via Petrella 19
20124 Milano
tel: +39 (0)2 2940 5870
closed on mondays
Intimate Italian restaurant for
simple food or aperitifs with a
young, friendly atmosphere

Plastic
Viale Umbria 120
20135 Milano
tel: +39 (0)2 733 996
Nightclub established in the 1980s
that remains the focal point for
Milan's dance culture

Trattoria Giapponese
Via Cuccagna 4
20135 Milano
tel: +39 (0)2 551 6154
www.trattoriagiapponese.com
Quiet and cosy Japanese
restaurant and cocktail bar
somewhat off the beaten track

AIRPORTS →
Milan Linate
International Airport (LIN)
20090 Milano Linate
The airport is located 7 km
east of Milan
tel: +39 (0)2 7485 2200
fax: +39 (0)2 7485 2010
communication@sea-aeroporti
milano.it
www.sea-aeroportimilano.it/eng/

Milan Malpensa
Intercontinental Airport (MXP)
21010 Varese
The airport is located 45 km
northeast of Milan
tel: +39 (0)2 7485 1
fax: +39 (0)2 7485 4010
communication@sea-aeroporti
milano.it
www.sea-aeroportimilano.it/eng/

New York

GMT −5 (GMT −4 between April and October)

New York is one of the world's leading destinations for those interested in buying, selling, making or looking at art. The heart of the contemporary art market now resides in Chelsea where over 170 galleries show a variety of international contemporary artists unparalleled in any other city. A couple of large buildings house numerous mid-sized galleries, while other more-established dealers such as Gagosian own immense spaces that look more like museums, and a few less-imposing spaces like Gavin Brown's enterprise offer less-traditional programming with shows that don't always cater to the market. Despite the sheer concentration of galleries in Chelsea, the old neighbourhood of SoHo which defined the art scene in the 1980s still has a strong contemporary art presence. Two of the city's most-respected non-profit spaces, The Drawing Center and Artists Space, remain here as well as a handful of commercial galleries including David Zwirner and Deitch Projects. Meanwhile a number of New York's most respected high-end galleries such as Marian Goodman can be found near the auction houses uptown. Some of the city's most interesting galleries are even further off the beaten track, however. Young entrepreneurs in search of affordable rents have recently opened spaces in Spanish Harlem (where the nearby Studio Museum which focuses on African-American art has been increasing its contemporary art programming) and in the Lower East Side at the other end of Manhattan. Across the East River in Queens, Long Island City continues to flourish as an art centre, stimulated by the P.S.1 Contemporary Art Center, which mounts ambitious exhibitions featuring artists from around the globe. The area's profile looks set to increase now that the Museum of Modern Art is relocating there for the next few years while renovating its Manhattan galleries. New York's art scene would be nothing, however, without the large community of artists that continue to live and work here. In the 60s and 70s the community was based in SoHo which was, at that time, a haven of large, cheap lofts perfect for studios and living spaces. The galleries that followed thrived and grew, in part due to the willingness of New York collectors to support younger, less-traditional artists, a legacy already established in the 50s by local collectors of works by avant-garde artists such as Jackson Pollock and Willem de Kooning. The legacy of the engaged collector has continued through the generations in New York and many of the collectors supporting young artists today are just as young themselves. This substantial group of collectors and philanthropists sustains New York's art scene, allowing the galleries to keep growing, the museums to keep expanding and encouraging artists from all over the world to continue to settle here. Now that SoHo has been thoroughly gentrified, however, a bustling art scene has emerged in Williamsburg, Brooklyn, where many young artists have found affordable live and work spaces as an alternative to Manhattan's high rents. Here many local artists have also set up galleries to show their own and their friends' work. So, while on the surface the centre of New York's art scene may appear to be in Chelsea, a closer look reveals centers of production throughout Manhattan and its surrounding areas, proving there is more to this city than first meets the eye.

EVENTS →
The Armory Show (contemporary
art fair)
Every year in February
www.thearmoryshow.com

Hugo Boss prize (for international
contemporary artist)
Every two years, latest award 2002
www.guggenheim.org

Contemporary art auctions
Every year, in May and November
Christie's, Sotheby's and Phillips

Whitney Biennial
Every two years, latest edition 2002
www.whitney.org/exhibition/biennial

COMMERCIAL GALLERIES →
303 Gallery
525 West 22nd Street
New York, NY 10011
tel: +1 212 255 1121
fax: +1 212 255 0024
mail@303gallery.com
www.303gallery.com

American Fine Arts
22 Wooster Street
New York, NY 10013
tel: +1 212 941 0401
fax: +1 212 274 8706
america666@aol.com

Tanya Bonakdar
521 West 21st Street, 2nd floor
New York, NY 10011
tel: +1 212 414 4144
fax: +1 212 414 1535
mail@tanyabonakdargallery.com
www.tanyabonakdargallery.com

Gavin Brown's enterprise
436 West 15th Street
New York, NY 10011
tel: +1 212 627 5258
fax: +1 212 627 5261
gallery@gavinbrown.biz

Cheim & Read
547 West 25th Street
New York, NY 10011
tel: +1 212 242 7727
fax: +1 212 242 7737
gallery@cheimread.com

Paula Cooper Gallery
534 West 21st Street
New York, NY 10011
tel: +1 212 255 1105
fax: +1 212 255 5156
simone@paulcoopergallery.com

Deitch Projects
76 Grand Street/18 Wooster Street
New York, NY 10013
tel: +1 212 343 7300
fax: +1 212 343 2954
email@deitch.com

Feature Inc.
530 West 25th Street
New York, NY 10001
tel: +1 212 675 7772
fax: +1 212 675 7773
www.featureinc.com

Gagosian Gallery
555 West 24th Street
New York, NY 10011
tel: +1 212 741 1111
fax: +1 212 741 9611
and
980 Madison Avenue
New York, NY 10021
tel: +1 212 744 2313
fax: +1 212 772 7962
info@gagosian.com
www.gagosian.com

Barbara Gladstone Gallery
515 West 24th Street
New York, NY 10011
tel: +1 212 206 9300
fax: +1 212 206 9301
info@gladstonegallery.com
www.gladstonegallery.com

Marian Goodman Gallery
24 West 57th Street, 4th floor
New York, NY 10019
tel: +1 212 977 7160
fax: +1 212 581 5187
goodman@mariangoodman.com
www.mariangoodman.com

Greene Naftali
526 West 26th Street, 8th floor
New York, NY 10001
tel: +1 212 463 7770
fax: +1 212 463 0890
mail@greenenaftali.com
www.greenenaftali.com

Casey Kaplan
416 West 14th Street
New York, NY 10014
tel: +1 212 645 7335
fax: +1 646 645 7835
caseykaplan@aol.com

Anton Kern
532 West 20th Street
New York, NY 10001
tel: +1 212 367 9663
fax: +1 212 367 8135
akern@jps.net

Luhring Augustine
531 West 24th Street
New York, NY 10011
tel: +1 212 206 9100
fax: +1 212 206 9055
info@luhringaugustine.com
www.luhringaugustine.com

Maccarone Inc.
45 Canal Street
New York, NY 10002
tel: +1 212 431 4977
fax: +1 212 965 5262
kitchen@maccarone.net

Matthew Marks Gallery
523 West 24th Street and
522 West 22nd Street
New York, NY 10011
tel: +1 212 243 0200
fax: +1 212 243 0047
info@matthewmarks.com

Metro Pictures
523 West 24th Street
New York, NY 10011
tel: +1 212 206 7100
fax: +1 212 337 0070

Friedrich Petzel Gallery
535 West 22nd Street
New York, NY 10011
tel: +1 212 680 9467
fax: +1 212 680 9473
info@petzel.com
www.petzel.com

The Project
427 West 126th Street
New York, NY 10027
tel: +1 212 662 8610
fax: +1 212 662 2800
mail@elproyecto.com
www.elproyecto.com

Andrea Rosen Gallery
525 West 24th Street
New York, NY 10011
tel: +1 212 627 6000
fax: +1 212 627 5450
andrea@rosengallery.com
www.andrearosengallery.com

David Zwirner
43 Greene Street
New York, NY 10013
tel: +1 212 966 9074
fax: +1 212 966 4952
dzwirner@davidzwirner.com
www.davidzwirner.com

Zwirner & Wirth
32 East 69th Street
New York, NY 10021

tel: +1 212 517 8677
fax: +1 212 517 8959
tracy@zwirnerandwirth.com
www.zwirnerandwirth.com

PUBLIC GALLERIES →
Artists Space
38 Greene Street, 3rd floor
New York, NY 10013
tel: +1 212 226 3970
fax: +1 212 966 1434
artspace@artistsspace.org
www.artistsspace.org
Non-profit institution established
in the 1970s with a changing
programme of exhibitions of
emerging and experimental art

Dia Center for the Arts
548 West 22nd Street
New York, NY 10011
tel: +1 212 989 5566
fax: +1 212 989 4055
www.diacenter.org
Four floor exhibition space with
changing programme of large
scale one person exhibitions of
contemporary art and a permanent
installation by Dan Graham

DIA Center for the Arts
393 West Broadway
New York, NY 10012
tel: +1 212 925 9397
Permanent installation of Walter
de Maria's 1979 work 'The Broken
Kilometer'

Dia Center for the Arts
141 Wooster
New York, NY 10012
tel: +1 212 473 8072
Permanent installation of Walter
de Maria's 1977 work 'The New
York Earth Room'

The Drawing Center
35 Wooster Street
New York, NY 10013
tel: +1 212 219 2166
fax: +1 212 966 2976
drawcent@drawingcenter.org
www.drawingcenter.org
Gallery and project space
dedicated to exhibitions of
drawing and works on paper

Exit Art/The First World
548 Broadway, 2nd floor
New York, NY 10012
tel: +1 212 966 7745
fax: +1 212 925 2928
info@exitart.org
www.exitart.org

Non-profit cultural space with a changing programme of exhibitions, artists' talks, screenings and performances

Solomon R. Guggenheim Museum
1071 Fifth Avenue at 89th Street
New York, NY 10128
tel: +1 212 423 3500
fax: +1 212 941 8410
visitorinfo@guggenheim.org
www.guggenheim.org
Frank Lloyd Wright's famous spiral building, with a permanent collection of modern and contemporary art and changing exhibitions of art and popular culture

The Museum of Modern Art
11 West 53rd Street
New York, NY 10019
tel: +1 212 708 9400
fax: + 1 212 708 9889
www.moma.org
During renovation
(29 June 2002 to 2004):
MoMA QNS
45–20 33rd Street
At Queens Blvd
Long Island City
World renowned collection of American and international modern and contemporary art with a parallel programme of temporary exhibitions

Metropolitan Museum of Art
1000 Fifth Avenue
New York, NY 10028
tel: + 1 212 535 7710
www.metmuseum.org
Vast museum with collections from all over the world and all periods of time, including 20th century art and an impressive photography collection

New Museum
of Contemporary Art
583 Broadway
New York, NY 10012
tel: +1 212 219 1222
fax: + 1 212 431 5328
newmu@newmuseum.org
www.newmuseum.org
Museum in downtown New York founded in 1977 with a programme of exhibitions of new work by American and international artists

The Isamu Noguchi
Garden Museum
36–01 43rd Avenue
Long Island City, NY 11101
tel: + 718 204 7088
fax: +718 278 2348
www.noguchi.org
Permanent collection of sculpture by Isamu Noguchi exhibited in this temporary space while the original museum and sculpture garden are undergoing renovation

P.S.1 Contemporary Art Center
22–25 Jackson Avenue
Long Island City, NY 11101
tel: +1 718 784 2084
fax: +1 718 482 9454
mail@ps1.org
www.ps1.org
An old school building in Long Island City converted into an exhibition centre in the 1970s, housing large-scale mainly group exhibitions and hosting outdoor DJ events during the summer

The Studio Museum Harlem
144 West 125 Street
New York, NY 10027
tel: +1 212 864 4500
fax: +1 212 864 4800
www.studiomuseuminharlem.org

Museum dedicated to the collection and exhibition of African-American art with an ambitious contemporary programme

Whitney Museum of American Art
945 Madison Avenue at 75th Street
New York, NY 10021
tel: +1 212 570 3600
feedback@whitney.org
www.whitney.org
Permanent collection of American Art from the early 20th century to the present day and home to the much debated Whitney Biennial of contemporary art

ART BOOKSHOP →
Printed Matter, Inc.
535 West 22nd Street
New York, NY 10011
tel: +1 212 925 0325
fax: +1 212 925 0464
www.printedmatter.org

HIP PLACES →
The Brasserie
100 East 53rd Street
New York, NY 10022
tel: +1 212 751 4841
Chic restaurant designed by architects Diller and Scofidio in the basement of Mies van der Rohe's Seagrams Building

Diner
85 Broadway
Brooklyn, NY 11211
tel: +1 718 486 3077
Good simple food in an original 1950s diner very popular with young artists in the Williamsburg neighbourhood of Brooklyn

Mercer Hotel
147 Mercer Street
New York, NY 10012

tel: +1 212 966 6060
fax: +1 212 965 3838
Fashionable hotel with a cocktail bar and restaurant in the heart of SoHo

Passerby
436 West 15th Street
New York, NY 10011
tel: +1 212 206 7321
Intimate bar with great cocktails and a multi-coloured dancefloor by artist Piotr Ukla ski, owned by dealer Gavin Brown

Pastis
9 Ninth Avenue
New York, NY 10014
tel: +1 212 929 4844
Faux French brasserie in the meat-packing district, always full of a fashionable crowd

AIRPORTS →
John F. Kennedy International Airport (JFK), Building 14
Jamaica, NY 11430
The airport is located 24 km southeast of central Manhattan
tel: +1 718 244 4444
www.kennedyairport.com

La Guardia Airport (LGA)
Hangar Center, Third Floor
Flushing, NY 11371
The airport is located 13 km east of New York City
tel: +1 718 533 3400
www.laguardiaairport.com

Newark International Airport (EWR)
Tower Road, Building Ten
Newark, NJ 07114
The airport is located 3 km south of Newark, 26 km southwest of New York
tel: +1 973 961 6000
www.newarkairport.com

Paris

GMT + 1 (GMT + 2 between April and October)

After a long sluggish period, the French art scene, and more specifically the Parisian, seems to have found new vitality, taking confidence in finding itself becoming a major player in the international art market. The system of regional institutions for contemporary arts (FRAC and CRAC) established in 1982 did much to raise the profile of contemporary art throughout the country by creating international collections, supporting artists and mounting exhibitions. Paris itself, despite a difficult economic climate, made a good start to the millennium with the simultaneous opening in 2002 of two new contemporary art spaces, the Plateau and the Palais de Tokyo. The Plateau is an artist-run public gallery in the tough and multi-cultural Buttes-Chaumont area in the northeast of the city. Meanwhile, in the smart 16th arrondissement, the opposite wing from the Musée d'Art Moderne de la Ville de Paris has been stripped back to its industrial bones to provide the Palais de Tokyo with a cavernous space which is open from noon to midnight. Despite being very different in their ethos, programming and architecture, these two new spaces send out a

strong signal to the French and international public: France is looking to the future and not just living off the artistic heritage of its past. Financed mainly from the public coffers, these institutions reinforce a private sector that is full of dynamism. The blurring of boundaries between the visual arts, music, literature and design that was so much part of Modernism at the beginning of the last century is once again integral to the Parisian art scene, with architects, designers and musicians collaborating in clubs, cafés and museums. Some new galleries, such as Almine Rech, have moved into traditional grand addresses. Others are opening off the beaten track in the Marais or even further afield near Père Lachaise cemetery in the hopes this district will become the hot new area for Parisian arts, although it is very much on the edge of the traditional gallery circuit in the 13th arrondissement, with its now famously fashionable rue Louise Weiss. This French version of New York's Chelsea area has

attracted many followers (this year it celebrates five years of popularity) with new galleries drawn by the synergy between the galleries already there and the sense of change and dynamism. All together, these factors help make Paris more attractive in the eyes of art professionals and artists. As in the past, the French artistic scene is enriched by its encounters with foreign artists, with galleries often representing more international than homegrown artists. This opening out towards the international art world, reinforced by dealers, artists and institutions, makes up for what still remains France's biggest handicap: the weak showing made by French artists abroad. The recent opening of the Parisian market to foreign auction houses and the growing development of private initiatives, such as the much-heralded future creation of the Fondation Pinault, a private foundation for contemporary art, may, however, reinforce an art market that lost its supremacy in the 1950s.

EVENTS →
Fiac (contemporary art fair)
Every year in October
http://fiac.reed-oip.fr/

Paris Photo (photography fair)
Every year in November
www.parisphoto-online.com

XXe siècle
First edition 2002
tel: +33 (0)1 42 77 58 94
fax: +33 (0)1 42 77 74 27
info@corporart.com

COMMERCIAL GALLERIES →
Air de Paris
32, rue Louise Weiss
75013 Paris
tel: +33 (0)1 44 23 02 77
fax: +33 (0)1 53 61 22 84
anything@airdeparis.com
www.airdeparis.com

Galerie Art: Concept
16, rue Duchefdelaville
75013 Paris
tel: +33 (0)1 53 60 90 30
fax: +33 (0)1 53 60 90 31
antoliv@galerieartconcept.com
www.galerieartconcept.com

Galerie cent8
108, rue Vieille-du-Temple
75003 Paris
tel: +33 (0)1 42 74 53 57
fax: +33 (0)1 42 74 53 37
cent8@mail.com

Galerie Chantal Crousel
40, rue Quincampoix
75004 Paris
tel: +33 (0)1 42 77 38 87
fax: +33 (0)1 42 77 59 00
galerie@crousel.com
www.crousel.com

Christophe Daviet-Thery
10, rue Duchefdelaville

75013 Paris
tel: +33 (0)1 53 79 05 95
fax: +33 (0)1 53 79 06 19
daviet-thery@wanadoo.fr

Galerie Jennifer Flay
20, rue Louise Weiss
75013 Paris
tel: +33 (0)1 44 06 73 60
fax: +33 (0)1 44 06 73 66
gjf@sittes.net

Galerie Frank
14, rue des Pyramides
75001 Paris
tel: +33 (0)1 42 60 65 13
fax: +33 (0)1 42 60 03 72

gb agency
10, rue Duchefdelaville
75013 Paris
tel: +33 (0)1 53 79 07 13
fax: +33 (0)1 53 79 06 19
gbagency@club-internet.fr

Galerie Marian Goodman
79, rue du Temple
75003 Paris
tel: +33 (0)1 48 04 70 52
fax: +33 (0)1 40 27 81 37
marian.goodman@wanadoo.fr

Galerie Ghislaine Hussenot
5 bis, rue des Haudriettes
75003 Paris
tel: +33 (0)1 48 87 60 81
fax: +33 (0)1 48 87 05 01
ghislaine.hussenot@wanadoo.fr

in SITU / Fabienne Leclerc
10, rue Duchefdelaville
Paris 75013
tel: +33 (0)1 53 79 06 12
fax: +33 (0)1 53 79 06 19
Fabienne.leclerc@wanadoo.fe

Galerie du Jour agnès b
44, rue Quincampoix
75004 Paris

tel: +33 (0)1 44 54 55 90
fax: +33 (0)1 44 54 55 99
jour@agnesb.fr
www.agnesb.fr

Jousse Entreprise
24/34, rue Louise Weiss
75013 Paris
tel: +33 (0)1 53 82 13 60
fax: +33 (0)1 53 82 13 63
infos@jousse-entreprise.com
www.jousse-entreprise.com

Galerie Yvon Lambert
108, rue Vieille-du-Temple
75003 Paris
tel: +33 (0)1 42 71 09 33
fax: +33 (0)1 42 71 87 47
galerie.yvon.lambert@wanadoo.fr

Galerie Le Sous-Sol
9, rue de Charonne
75011 Paris
tel: +33 (0)1 47 00 02 75
fax: +33 (0)1 47 00 24 75
Sous-sol@club-internet.fr
www.perso.club-
internet.fr/sous__sol

Galerie Gabrielle Maubrie
24, rue Sainte Croix de la Bretonnerie
75004 Paris
tel: +33 (0)1 42 78 03 97
fax: +33 (0)1 42 74 54 00
www.od-arts.com/maubrie

Galerie Nelson
40, rue Quincampoix
75004 Paris
tel: +33 (0)1 42 71 74 56
fax: +33 (0)1 42 71 74 58
info@galerie-nelson.com
www.galerie-nelson.com

Galerie Emmanuel Perrotin
30, rue Louise Weiss
75013 Paris
tel: +33 (0)1 42 16 79 79

fax: +33 (0)1 42 16 79 74
info@galerieperrotin.com
www.galerieperrotin.com

Galerie Praz-Delavallade
28, rue Louise Weiss
75013 Paris
tel: +33 (0)1 45 86 20 00
fax: +33 (0)1 45 86 20 10
prazdela@club-internet.fr

Galerie Almine Rech
127, rue du Chevaleret
75013 Paris
tel: +33 1 45 83 71 90
fax: +33 1 45 70 91 30
a.rech@galeriealminerech.com
www.galeriealminerech.com

Galerie Michel Rein
42, rue de Turenne
75003 Paris
tel: +33 (0)1 42 72 68 13
fax: +33 (0)1 42 72 81 94
galerie@michelrein.com
www.michelrein.com

Galerie Chez Valentin
9, rue Saint-Gilles
75003 Paris
tel: +33 (0)1 48 87 42 55
fax: +33 (0)1 48 87 44 35
galeriechezvalentin@noos.fr

Galerie Thaddaeus Ropac
7, rue Debelleyme
75003 Paris
tel: +33 (0)1 42 72 99 00
fax: +33 (0)1 42 72 61 66

Galerie G.-P. & N. Vallois
36, rue de Seine
75006 Paris
tel: +33 (0)1 46 34 61 07
fax: +33 (0)1 43 25 18 80
ggpnv@libertysurf.fr

Galerie Anne de Villepoix
43, rue de Montmorency

75003 Paris
tel: +33 1 42 78 32 24
fax: +33 1 42 78 32 16
villepoix@easynet.fr
www.annedevillepoix.com

Galerie Anton Weller
57, rue de Bretagne
75003 Paris
tel: +33 1 42 72 05 62
fax: +33 1 42 72 05 63
antonweller@starnet.fr

PUBLIC GALLERIES →
Centre national d'art et de culture
Centre Georges Pompidou
place Georges Pompidou
75004 Paris
tel: +33 (0)1 44 78 12 33
www.cnac-gp.fr
Newly renovated museum hou-
sing a permanent collection of
20th century masterpieces plus a
programme of temporary exhibi-
tions of art, design, architecture

Centre national de la photographie
Hôtel Salomon de Rothschild
11, rue Berryer
75008 Paris
tel: +33 (0)1 53 76 12 31
www.cnp-photographie.com
Created in 1982 to promote con-
temporary photography and
support young artists working
with photographic and video arts

Fondation Cartier pour l'art
contemporain
261, boulevard Raspail
75014 Paris
tel: +33 (0)1 42 18 56 50
www.fondation.cartier.fr
Building designed by Jean Nouvel
with a permanent collection of
contemporary art from the 1980s

to the present, plus a programme
including art exhibitions, perfor-
mance, dance and theatre

Glass Box
113 bis, rue Oberkampf
75011 Paris
tel/fax: +33 (0)1 43 38 02 82
www.icono.org/glassbox
Non-profit space, originally artist-
run, with programme of young
French and international artists

La Maison Européenne de la
Photographie
82, rue François Miron
75004 Paris
tel: + 33 (0)1 44 78 75 00
fax: + 33 (0)1 44 78 75 15
www.mep-fr.org/us
Photographic collection from 1950
to the present day, including all
forms of photography from repor-
tage to fashion, and a changing
programme of exhibitions

Musée du Jeu de Paume
1 place de la Concorde
75008 Paris
tel: +33 (0)1 47 03 12 50
National gallery for contemporary
art in the Jardin des Tuileries
housing large-scale touring
exhibitions

Musée d'Art Moderne de la
Ville de Paris
11, avenue du Président Wilson
75116 Paris
tel: +33 (0)1 53 67 40 00
Municipal collections of 20th cen-
tury art with a regular programme
of contemporary exhibitions

Palais de Tokyo
2, rue de la Manutention

75116 Paris
tel: +33 (0)1 47 23 38 86
www.palaisdetokyo.com
New exhibition space inaugurated
in 2002 with an eclectic, inter-
national and interactive contem-
porary programme

Le Plateau
rue des Alouettes and
rue Carducci
75019 Paris
tel: +33 (0)1 53 19 88 10
New artist-run exhibition space in
the northeast of Paris

Public
4, Impasse Beaubourg
75003 Paris
tel: +33 (0)1 42 71 49 51
Public exhibition space with
changing programme of young
contemporary artists

ART BOOKSHOP →
TASCHEN shop Paris
2, rue de Buci
75006 Paris
tel: + 33 (0)1 40 51 79 22
fax: +33 (0)1 43 26 73 80
store@taschen-france.com
www.taschen.com

HIP PLACES →
Le Batofar
Opposite 11, quai François-
Mauriac
75013 Paris
tel: +33 1 56 29 10 00
Nightclub open from Tuesday to
Sunday (weekend until 2/4am)

Café Beaubourg
46, rue Saint-Merri
Paris 75004
tel: +33 (0)1 48 87 63 96

Bar and restaurant overlooking
the Centre Georges Pompidou

Café Charbon
109, rue Oberkampf
Paris 75011
tel: +33 (0)1 43 57 55 13
Bar and restaurant in the 11th
arrondissement

Colette
213, rue Saint Honoré
Paris 75001
tel: +33 (0)1 55 35 22 90
Concept fashion store with a
bookshop, bar and restaurant
(open only for lunch)

Georges
6ème étage du Centre Pompidou
75004 Paris
tel: +33 (0)1 44 78 47 99
Newly opened restaurant with a
fantastic view over the city

AIRPORTS →
Paris Charles de Gaulle Airport
(CDG) BP 20101
95711 Roissy Charles de Gaulle
The airport is located 23 km
northeast of Paris
tel: +33 (0)1 48 62 22 80
fax: +33 (0)1 48 62 07 52
www.roissy.aeroport.fr

Paris Orly Airport (ORY)
94396 Orly Aerogare
tel: +33 (0)1 49 75 15 15
fax: +33 (0)1 49 75 58 78
www.orly.aeroport.fr

Gare du Nord
Paris Rail Station (XPG)
High-speed passenger trains
to London
www.eurostar.com

São Paulo

GMT –2 (GMT –3 between April and October)

With solo shows of young artists from Brazil turning up in museums worldwide and the blockbuster exhibition "Brazil: Body and Soul" on a tour of the Guggenheim's international museums at the time of writing, Brazilian contemporary art is grabbing international attention. Ernesto Neto, whose giant spice-filled stockings were on view at the 2001 Venice Biennale, is now in the collections of the major museums in Europe and the United States, as are other artists of international repute such as Cildo Meireles and Vik Muniz. Part of this higher profile stems from the presence of gallery owners such as the late Marcantonio Vilaça

at major international art fairs, but the art market in São Paulo has been growing ever since the first Biennial took place here in 1951. São Paulo has a population of around 18 million – the biggest city in Latin America, and the second largest in the world – and although the Niemeyer-designed Brasília is the political capital of Brazil and there are many practicing artists in Rio de Janeiro, it is São Paulo where business is conducted. In the 60s, commercial galleries were concentrated in the southern tree-lined Jardins district, but now they are spreading towards the old centre and other areas. Galeria Fortes-Vilaça and Gabinete de

Arte, both in Pinheiros in the west of the city, Casa Triângulo, in Largo do Arouche in the old centre, Brito Cimino, in Vila Olímpia and Luisa Strina, in Cerqueira César are just a few of the major players. It is the Biennial, however, that is the most important date on the art calendar, bringing collectors, critics and artists from all over the world into Niemeyer's pavilion in Ibirapuera Park. The founder of the Biennial, Ciccillo Matarazzo, subsequently bequeathed much of his collection to two public galleries, the Museu de Arte Contemporânea da Universidade de São Paulo (MAC) and the Museu de Arte Moderna de São Paulo (MAM). The success of the Biennial has motivated other individuals and corporate interests to become involved in contemporary art. Encouraged by federal tax breaks, Brazilian banks have become art patrons and both Itaú Bank and Centro Cultural Banco do Brasil/São Paulo now have their own exhibition spaces in the city. Since 1998 Itaú Cultural has fostered Brazilian culture nationwide through a programme of travelling exhibitions, scholarships and studio-residencies in São Paulo. Milu Vilella, president of MAM and one of Itaú bank's major stockholders, has fostered a vigorous campaign in favour of the museum's cultural contribution to the country, thereby bringing in more money while director Ivo Mesquita has strengthened the museum's curatorial programming. In addition, Isabella Prata, a breakthrough collector whose husband owns the Vogue publishing house in Brazil, has encouraged MAM to acquire audacious examples of contemporary art from her position on the museum's board. But contemporary Brazilian art is not only confined to major museums and gallery spaces. During Arte/Cidade, an event supported by corporate sponsors, it filters out into the favelas (shanty towns) and commercial areas of the city during, making its presence known in the inconspicious of areas with commissioned works by artists such as Vito Acconci and Regina Silveira.

EVENTS →
Arte/Cidade (exhibition abaout art and urbanism)
Established in 1994, 4th and most recently was in 2002
www.uol.com.br/artecidade
artecidade@artecidade.org.br

Bienal Internacional de São Paulo
Every two years, March to June, most recently 2002
www.uol.com.br/bienal

Mostra Internacional de Cinema (International Film Festival)
Every year in October

São Paulo Fashion Week
Every year in April

Salão Paulista de Art Contemporanea (festival of art from SP)
Every year from April to May

COMMERCIAL GALLERIES →
Gabinete de Arte Raquel Arnaud
Rua Artur de Azevedo, 401
Pinheiros
05404-010 São Paulo
tel: +55 (0)11 3083 6322
fax: +55 (0)11 3083 6114
gabarte@amcham.com.br
www.raquelarnaud.com

Casa Triângulo
Rua Bento Freitas, 33
Centro
01220-000 São Paulo
tel/fax: +55 (0)11 220 5910
casatria@uol.com.br

Brito Cimino Arte Contemporânea
Rua Gomes de Carvalho, 842
Vila Olímpia
04547-003 São Paulo
tel/fax: +55 (0)11 3842 0634
britocimino@uol.com.br

Galeria Thomas Cohn
Avenida Europa, 641
Jardins
01449-001 São Paulo
tel: +55 (0)11 3083 3355
fax: +55 (0)11 3085 0707
galthomascohn@uol.com.br

Galeria Fortes Vilaça
Rua Fradique Coutinho, 1.500
Vila Madalena
05416-001 São Paulo
tel: +55 (0)11 3032 7066
fax: +55 (0)11 3097 0384
galeria@fortesvillaca.com.br

Galeria Andre Millan
Rua Estados Unidos, 1.581
Jardins
01427-002 São Paulo
tel/fax: +55 (0)11 3062 5722
galeriamillan@uol.com.br

Galeria Luisa Strina
Rua Padre João Manoel, 974A
Jardins
01411-000 São Paulo
tel: +55 (0)11 3088 2471
fax: +55 (0)11 3064 6391
gstrina@totalnet.com.br

PUBLIC GALLERIES →
Centro Cultural Banco do Brasil/São Paulo
Rua Álvares Penteado, 112
esquina com Rua da Quitanda
São Paulo
tel: +55 (0)11 3113 3600
ccbbsp@bb.com.br
Multi-arts centre established in 1989 with a screening room, theater and exhibition space and varied exhibitions of contemporary art and culture

Centro Cultural São Paulo
Rua Vergueiro, 1000
Paraíso
São Paulo

tel: +55 (0)11 3277 3611
ccsp@prefeitura.sp.gov.br
Cultural centre with a programme of diverse presentations and experimental projects

Centro Universitário Maria Antonia
Rua Maria Antonia, 294
Centro
012222-010 São Paulo
tel: +55 11 3255 5538
mantonia@edu.usp.br
University gallery with exhibitions largely dedicated to artists from São Paulo

Instituto Tomie Ohtake
Avenida Faria Lima, 201
São Paulo
tel: +55 (0)11 6844 1900
Institute inaugurated in 2002 dedicated to the work of Japanese/Brazilian artist Tomie Othake with additional temporary exhibitions

Museu Brasileiro de Escultura (MUBE)
Avenida Europa, 218
Jd. Europa
São Paulo
tel: +55 (0)11 3081 8611
Museum of Brasilian sculpture of more interest for its building than its programme

Museu de Arte Brasileira da Fundação Armando Álvares Penteado (MAB-FAAP)
Rua Alagoas, 9030
Prédio 01-Pacaembu
01242-001 São Paulo
tel: +55 (0)11 3663 1662
www.faap.br
Private university museum with art historical and thematic exhibitions

Museu de Arte Contemporânea da Universidade de São Paulo

Rua da Reitoria, 160 —
Cidade Universitária
05508-900 São Paulo
tel: +55 (0)11 3818 3039
fax: +55 (0)11 3812 0218
www.mac.usp.br/
Contemporary art centre created in 1963 with a collection of contemporary Brazilian and international art

Museu de Arte Moderna de São Paulo
Parque do Ibirapuera
tel: +55 (0)11 5549 9688
fax: +55 (0)11 5549 2342
www.mam.terr.br
São Paulo's most important museum for contemporary art with a permanent collection of 20th century international art and an active programme of exhibitions

Paço da Artes
Avenida da Universidade, 01
05508-900 São Paulo
tel/fax: +55 (0)11 3031 0682
Venue for exhibitions of young contemporary art

Pinacoteca do Estado
Praça da Luz, 2
01120-010 São Paulo
fax: +55 (0)11 229 9844
pinasp@uol.com.br
www.uol.com.br/pinasp
Dynamic space with temporary (usually solo) exhibitions of modern and contemporary art and photography

ART BOOKSHOP →
Bookshop in the Museu de Arte Moderna de São Paulo
Parque do Ibirapuera
tel: +55 (0)11 5549 9688
fax: +55 (0)11 5549 2342
www.mam.terr.br

HIP PLACES →
Carlota
Sergipe, 753
Consolacao
02143-001 São Paulo
tel: +55 (0)11 3664 7020
High profile restaurant for lovers
of creative cuisine

Love
Rua Pequetita, 189
Vila Olimpia
04552-060 São Paulo

tel: +55 (0)11 3044 1613
Popular club scene for a hip rich
crowd

Pandoro
Avenida Cidade Jardim, 60
Jd. Europa
01454-000 São Paulo
tel: +55 (0)1 3083 0399
fax: +55 (0)1 3083 0975
Traditional establishment for beer,
sandwiches and finger food
Terraço Itália

Avenida Ipiranga 344
41 Andar Edificio Itali
Centro
01046-010 São Paulo
tel: +55 (0)11 257 6566
Restaurant on the top floor of the
highest building in the downtown
area with a fantastic view of the
city from the roof terrace

AIRPORT →
São Paulo – Guarulhos
International Airport (GRU)

Infraero
PO Box 3061
Guarulhos
07141-970 São Paulo
The airport is located 25 km
northeast of São Paulo and linked
by the Ayrton Senna and
Presidente Dutra highways
tel: +55 (0)11 6445 2945
fax: +55 (0)11 6445 3173 or 6412 3335
www.infraero.gov.br

Sydney

GMT + 11 (GMT + 10 between April and October)

Sydney's standing as the centre of the Australian art scene is under more or less constant threat from Melbourne, the nation's second largest city. The situation is not unlike that between, say, Madrid and Barcelona: Melbourne, like Barcelona, may have more of an edge and often more of interest going on about town, but Sydney scoops the larger portion of prestige and sales for the simple, age-old reason that it has more money splashing around. Australia as a whole has a vibrant commercial gallery scene, with more than 300 established galleries nationwide selling over A$130 million worth of art annually, to complement its healthy quota of public museums. The art market, however, is notoriously parochial: with the exception of a scant number of international collectors and philanthropists, Australian buyers, both major and minor, prefer homegrown talent. Sydney has the largest number of commercial galleries in Australia, and it also hosts the Sydney Biennale, one of the world's most prestigious and longest-standing contemporary art biennials. Melbourne, meanwhile, plays host to the country's premier commercial art fair, an international biannual event considered the most important of its kind in the Asia Pacific region. While a large number of dealers in both major cities continue to prosper from the post-war generation of Australian Expressionists, the Australian market is increasingly defined by the formidable level of interest in Aboriginal art and a flourishing engagement with Asia. This grew throughout the 1990s with initiatives like Asialink, an entity organising cross-cultural exhibitions and residencies, and Brisbane's very successful Asia-Pacific Triennial. Sydney is awash with galleries showing the best of contemporary Asian art, as well as Asian-Australian art while galleries such as Darren Knight and Ray Hughes are among the best places to go for work that is at once original, up-to-the-minute and uniquely Australian. Galleries like Annandale Galleries bring in excellent international shows on a regular basis, while Roslyn Oxley9 remains the only gallery with the resources and wherewithal to push its contemporary artists into the elusive international market. Sydney's leafier and trendier eastern suburbs, primarily Paddington, but also Surry Hills and Darlinghurst, constitute the city's gallery precinct, and a lot can be learned from a day doing the rounds. Both in the commercial galleries and at auction, Aboriginal art continues to carve out a very significant share of the market. Many of the first generation of contemporary Aboriginal artists (the painting-on-canvas movement only started in the early 1970s) have died; others suffer from ill health and exploitation. But the Aboriginal art market is increasingly orientated towards ethical regulation. It remains for the new generation to convince the public that it can produce work of quality comparable to its elders.

EVENTS →
Biennale of Sydney
Every two years, next edition 2004
www.biennaleofsydney.com.au

Sydney Festival (of dance,
theatre, visual arts and music)
Every year in January
www.sydneyfestival.org.au

Sydney Film Festival
Every year in June/July
www.sydfilm-fest.com.au

COMMERCIAL GALLERIES →
Annandale Galleries
110 Trafalgar Street
Annandale, NSW 2038
tel: +61 (0)2 9552 1699
fax: +61 (0)2 9552.1689

Australian Galleries –
Painting & Sculpture
15 Roylston Street
Paddington, NSW 2021
tel: +61 (0)2 9360 5177
fax: +61 (0)2 9360 2361

Australian Galleries –
Works on paper
24 Glenmore Road
Paddington, NSW 2021
tel: +61 (0)2 9380 8744
fax: +61 (0)2 9380 8755

Martin Browne Fine Art
22 Macleay Street
Potts Point, NSW 2011
tel: +61 (0)2 9331 0100
fax: +61 (0)2 8356 9511
martinbrownefineart.com

Michael Carr Art Dealer
124a Queen Street
Woollahra, NSW 2025
tel: +61 (0)2 9327 3011
fax: +61 (0)2 9327 3155
michaelcarr@ozemail.com.au

Sarah Cottier Gallery
585 Elizabeth Street
Redfern, NSW 2012
tel: +61 (0)2 9699 3633
fax: +61 (0)2 9699 3622
sarah@cottier.com.au
www.cottier.com.au

Ray Hughes Gallery
270 Devonshire Street
Surry Hills, NSW 2010
tel: +61 (0)2 9698 3200
fax: +61 (0)2 9699 2716

Rex Irwin Art Dealer
38 Queen Street, first floor
Woollahra, NSW 2025
tel: +61 (0)2 9363 3212
fax: +61 (0)2 9363 0556
rexirwin@rexirwin.com
www.rexirwin.com

Darren Knight Gallery
840 Elizabeth Street
Waterloo, NSW 2017
tel: +61 2 9699 5353
fax: +61 2 9699 5254
dmknight@ozemail.com.au
www.darrenknightgallery.com

Mori Gallery
168 Day Street
Sydney, NSW 2000
tel: +61 2 9283 2903

fax: +61 2 9283 2909

Tim Olsen Gallery
76 Paddington Street
Paddington
NSW 2021
tel: +61 (0)2 9360 9854
fax: +61 (0)2 9360 9672
olsenga@ozemail.com

Roslyn Oxley9
Soudan Lane, off 27 Hampden
Street
Paddington, NSW 2021
tel: +61 (0)2 9331 1919
fax: +61 (0)2 9331 5609
www.roslynoxley9.com.au

Sherman Galleries Goodhope
16–18 Goodhope Street
Paddington, NSW 2021
tel: +61 (0)2 9331 1112
fax: +61 (0)2 9331 1051
info@shermangalleries.com.au

Sherman Galleries Hargrave
1 Hargrave Street
Paddington
NSW 2021
tel: +61 (0)2 9360 5566
fax: +61 (0)2 9360 5935
info@shermangalleries.com.au

Gitte Weise Gallery
56 Sutherland Street
Paddington, NSW 2021
tel: +61 (0)2 9360 2659
fax: +61 (0)2 9360 2659
weisegal@chilli.net.au

PUBLIC GALLERIES →
Art Gallery of New South Wales
Art Gallery Road, The Domain
Sydney, NSW 2000
tel: +61 (0)2 9225 1700
fax: +61 (0)2 9221 6226
www.artgallery.nsw.gov.au
Established in 1874 to house a

permanent collection of Australian,
Aboriginal and International art
plus a programme of temporary
exhibitions

Artspace
43–51 Cowper Wharf Road
Woolloomooloo, NSW 2011
tel: +61 (0)2 9368 1899
fax: +61 (0)2 9368 1705
Exhibitions, studios and conferen-
ces related to contemporary art
and culture

Australian Centre for Photography
257 Oxford Street
Paddington, NSW 2021
tel: +61 (0)2 9332 1455
fax: +61 (0)2 9331 6887
www.acp.au.com
Established in 1973 to promote
photography-based art through
exhibitions, education and
publications

Casula Powerhouse
1 Casula Road
Casula, NSW 2170
tel: +61 (0(2 9824 1121
fax: +61 (0)2 9821 4273
admin@casulapowerhouse.com
Venue with a changing programme
of exhibitions

Ivan Dougherty Gallery
UNSW College of Fine Arts
corner Albion Avenue and Selwyn
Street
Paddington, NSW 2021
tel: +61 (0)2 9385 0726
fax: +61 (0)2 9385 0603
idg@unsw.edu.au
University gallery exhibiting mainly
Australian art

Museum of Contemporary Art
140 George Street, The Rocks
Royal Exchange, NSW 1223

tel: +61 (0)2 9252 4033
fax: +61 (0)2 9252 4361
www.mca.com.au
Museum with collections of
Australian, Aboriginal and inter-
national art and a programme of
temporary international contem-
porary exhibitions

S. H. Ervin Gallery
National Trust
Watson Road
Observatory Hill, NSW 2000
tel: +61 (0)2 9258 0140
fax: +61 (0)2 9251 4355
www.nsw.nationaltrust.au/ervin.html
Early 19th century building owned
by the National Trust housing
changing exhibitions of 20th
Australian art

Sir Hermann Black Gallery
Wentworth Building, Level 5
City Road
University of Sydney, NSW 2006
tel: +61 (0)2 9563 6053
fax: +61 (0)2 9563 6029
www.usyd.edu.au/su/usu/gallery-
current.html
Gallery run by the University of
Sydney Union with a permanent
collection and temporary
exhibitions

ART BOOKSHOP →
Ariel Booksellers
42 Oxford Street
Paddington, NSW 2021
tel: +61 (0)2 9332 4581
fax: +61 (0)2 9360 9398

HIP PLACES →
BBQ King
18 Goulburn Street
Sydney, NSW 2000
tel: +61 (0)2 9267 2586
Famous barbecue restaurant in
Chinatown

Billy Kwong
355 Crown Street
Surry Hills, NSW 2010
tel: +61 (0)2 9332 3300
Good, fast, home-style Asian
cooking in a restaurant with
closely packed tables and a
bring-your-own alcohol policy

Civic Hotel
388 Pitt Street
Sydney, NSW 2000
tel: +61 (0)2 8267 3186
Recently restored Art Deco hotel
with a popular bar and modern
restaurant

Hollywood Hotel
2 Foster Street
Surry Hills, NSW 2010
tel: +61 (0)2 9281 2765
Well-preserved Art Deco pub
owned by a former Hollywood
movie star from the 1950s and
popular with artists

Hugo's Lounge
33 Bayswater Road
Potts Point, NSW 2001
tel: +61 (0)2 9357 4411
Chic and expensive restaurant
with award-winning cuisine

AIRPORT →
Kingsford Smith Airport (SYD)
Sydney Airports Corporation
Limited
Sydney Airport, PO Box 63
Mascot, NSW 1460
The airport is located 9 km
south of Sydney
tel+61 (0)2 9667 9111
fax+61 (0)2 9667 1592
webmaster@syd.com.au
www.sydneyairport.com.au

Tokyo

GMT + 9

Getting to grips with Tokyo's contemporary art scene can be a daunting experience for the casual browser. Long gone are the days when the state of Japanese art could be surveyed in an afternoon's stroll through the famous Ginza district. Today there are hundreds of galleries and art spaces scattered all over the city, housed in everything from former factory buildings to shoebox-sized rooms in faceless office blocks. Long-established contemporary galleries such as Nishimura remain in Ginza where they continue to exhibit well-known international names. But newer ventures are springing up away from the city's traditional art district, such as the new, but increasingly renowned, Wako Works of Art operating from the ground floor of an apartment building in high-rise Nishi-Shinjuku. Rather than being conveniently clustered together as in New York or London, Tokyo's contemporary art galleries are to be found in every corner of the city's vast sprawl. This is not a city

dominated by a few all-powerful galleries and commercial galleries do not have a monopoly on displaying contemporary art. No venue – whether it is a café, department store or bookshop – is deemed unsuitable for an art show. Another Tokyo peculiarity is the proliferation of rented gallery space that allows any artist, who can stump up the cash and be prepared to shoulder the almost inevitable financial loss, to mount a "gallery" show. The truth is, that even before its current economic downturn, the Japanese art market has never shown much interest in the Avant-garde. Few public museums have been prepared to take the financial risk of mounting cutting-edge shows by little known artists, and collectors have voted with their yen, largely ignoring contemporary art in favour of the more established names of the late 19th and early 20th century. Instead the torch has been carried by private galleries and institutions such as the excellent Hara Museum, which is located in a leafy 30s residence in the outlying Shinagawa district and whose eclectic programme of contemporary shows has earned it a loyal following.

Tokyo's own beleaguered, and inconveniently located, Museum of Contemporary Art has raised its profile recently with a couple of hit shows. For a long time, young Japanese artists have tended to leave Japan and head for more receptive audiences in New York or London, but the success of last year's shows by Takashi Murakami and Mariko Mori suggested that there is, after all, an eager audience for home-grown contemporary art. There are other positive signs. The Yokohama Triennale 2001, which featured over 100 international and Japanese artists attracted 350,000 visitors in less than a month; NiCAF, Japan's only significant commercial contemporary art fair, relocated to central Tokyo in 2001 and drew in the crowds; and 2003 will finally see the opening of the Mori Art Museum, an ambitious new gallery space for contemporary art on the top floors of a freshly built Roppongi skyscraper, which is intended to make Tokyo an essential stop on the international art circuit.

EVENTS →

Echigo-Tsumari Art Triennial
(exhibition of contemporary art)
Every three years in Niigata,
next in 2003
www.echigo-tsumari.jp

Nippon Contemporary Art Fair
Every two years, next in
April 2003
www.nicaf.com

Vision of Contemporary Art
(exhibition of contemporary art)
Every year at the Ueno Royal
Annual exhibition at Ueno Royal
Museum
www.ueno-mori.org

Yokohama Triennale (international
exhibition of contemporary art)
Every three years, next in 2004
www.jpf.go.jp/yt2001

COMMERCIAL GALLERIES →

Art Front Gallery & Hillside Gallery
29-18 Sarugaku-cho
Shibuya-ku
Tokyo 150-0033
tel: +81 (0)3 3476 4868
fax: +81 (0)3 3476 4874

Gallery 360 degree
5-1-27 2F Minami Aoyama
Minato-ku
Tokyo107-0062
tel: +81 (0)3 3406 5823
fax: +81 (0)3 3406 5835
gallery@360.co.jp
www.360.co.jp/

galerie deux
2-10-17 Kakinokizaka
Meguro-ku
Tokyo 152-0022
tel: +81 (0)3 3717 0020
fax: +81 (0)3 3717 0063

Gallery Humanité
Daiichikaikan Bldg 1F
3-2-18 Kyobashi
Chuo-ku
Tokyo 104-0031
tel: +81 (0)3 5255 3210
fax: +81 (0)3 5255 0221
www.kas.gaden.com/humanite.html

Taka Ishii Gallery
3-27-6 Kitaotsuka
Toshima-ku
Tokyo 170-0004
tel: +81 (0)3 3915 7784
fax: +81 (0)3 3915 7828
tig@mui.biglobe.ne.jp
www.2u.biglobe.ne.jp/~tig/tig.html

Tomio Koyama Gallery
Saga 1-8-13-2F
Koto-ku
Tokyo 135-0031
tel/fax: +81 (0)3 3630 2205
tkoyama@tke.att.ne.jp
(moving to new premises in
autumn 2002)

Gallery Koyanagi
Koyanagi Bldg. 1F, 1-7-5 Ginza
Chuo-ku
Tokyo 104-0061
tel: +81 (0)3 3561 1896
fax: +81 (0)3 3563 3236
kimata@tkk.att.ne.jp

Kyozon
5-47-6 Jingumae
Shibuya-ku
Tokyo 150-0001
tel: +81 (0)3 3407 6864
fax: +81 (0)3 3400 5060
vision@vision.co.jp
www.vision.co.jp/

Mizuma Art Gallery
Fujiya Bldg 2F
Kamimeguro 1-3-9

Meguro-ku
Tokyo 153-0063
tel: +81 (0)3 3793 7931
fax: +81 (0)3 3793 7887
mizuma-art.co.jp/news__e.html

Nagamine Projects
7-2-17-4F Ginza
Chuo-ku
Tokyo 104-0061
tel/fax: +81 (0)3 3575 5775
nagamineprojects@aol.com

Taro Nasu Gallery
1-8-13-2F Saga
Kotu-ku
Tokyo 135-0031
tel/fax: +81 (0)3 3630 7759
taronasu@tkh.att.ne.jp
(moving to new premises in
autumn 2002)

Ota Fine Arts
2-8-11 Ebisunishi
Shibuya-ku
Tokyo 150-0021
tel: +81 (0)3 3780 0911
fax: +81 (0)3 3780 0450

Gallery Q
Mac Bldg, 1-15-7 Ginza
Chuo-ku
Tokyo 104-0061
tel: +81 (0)3 3535 2524
fax: +81 (0)3 3535 2523
yuzoueda@sannet.ne.jp
www.2tky.3web.ne.jp/~galleryq/

SCAI the Bathhouse
6-1-23 Kashiwayu-Ato
Yanaka Taito-ku
Tokyo 110-0001
tel: +81 (0)3 3821 1144
fax: +81 (0)3 3821 3553
scai@ra2.so-net.ne.jp

Gallery Shimada
4-7-2 Jingumae
Shibuya
Tokyo 150-0001
tel: +81 (0)3 5411 1796
fax: +81 (0)3 5411 2496
gsmd@lime.ocn.ne.jp

Gallery Side 2
Shima Crest B1F 1-19-4,
Sendagaya
Shibuya-ku
Tokyo 151-0051
tel: +81 (0)3 5771-5263
fax: +81 (0)3 5771-5264
shima__j@qa2.so-net.ne.jp

Taguchi Fine Art
Daini Inoue Bldg. 4F
Nihonbashi Kayaba-cho
Chuo-ku
Tokyo 104-0061
tel: +81 (0)3 5652 3660
fax: +81 (0)3 5652 3661
tatsuya@taguchifineart.com
www.taguchifineart.com/top.html

Kenji Taki Gallery
3-18-2-102 Nishi-shinjuku
Shinjuku-ku
Tokyo 160-0023
tel/fax: +81 (0)3 3378 6051
www2.odn.ne.jp/kenjitaki/

Wako works of art
3-18-2-101 Nishi-shinjuku
Shinjuku-ku
Tokyo 160-0023
tel: +81 (0)3 3373 2860
fax: +81 (0)3 3373 2860
wako@tkd.att.ne.jp

PUBLIC GALLERIES →

Art Tower Mito
Gokencho 1-6-8
Mito
Ibaraki

Tokyo 310-0063
tel: +81 (0)2 9227 8111
fax: +81 (0)2 9227 8110
www.arttowermito.or.jp/art/
gallery-e.html
Arts complex comprising a theatre,
concert hall and exhibition space
for contemporary visual art

Hara Museum of Contemporary Art
4-7-25 Kita-Shinagawa
Shinagawa-ku
Tokyo 140-0001
tel: +81 (0)3 3445 0651
fax: +81 (0)3 3473 0104
www.haramuseum.or.jp
Founded in 1979 to house a col-
lection and mount exhibitions of
contemporary art

ICC
Tokyo Opera City Tower 4F
3-20-2 Nishi-Shinjuku
Shinjuku-ku
Tokyo 163-1403
tel: +0120 144199 (free dial:
domestic only)
query@ntticc.or.jp
www.ntticc.or.jp/
Cultural facility in the Tokyo
Opera City Tower focusing on
technology and the arts

Gallery Ma
TOTO Nogizaka Bldg 3F
1-24-3 Minami-Aoyama
Minato-ku
Tokyo 107-0062
tel: +81 (0)3 3402 1010
fax: +81 (0)3 3423 4085
www.toto.co.jp/GALLERMA/
Exhibition space focusing on
architecture and design

Museum of Contemporary Art,
Tokyo (MOT)
Metropolitan Kiba Park
4-1-1 Miyoshi
Koto-ku
Tokyo 135-0022
tel: +81 (0)3 5245 4111
fax: +81 (0)3 5245 1140
www.tef.or.jp/mot/index-e.html
Museum established in 1995
with a permanent collection and
temporary exhibitions of
Japanese and international art
since 1945

National Museum of Modern Art
3 Kitanomaru Koen
Chiyoda-ku
Tokyo 102-0091
tel: +81 (0)3 3214 2561

fax: +81 (0)3 3213 1340
www.momat.go.jp/english_page/
index_e.html
Japan's first national art museum
opened in 1952 and subsequently
augmented with a separate Crafts
Gallery and National Film Centre

Parco Gallery
Parco Pt 1
15-1 Udagawa-cho
Shibuya-ku
Tokyo 150-0042
tel: +81 (0)3 3477 5873
www.parco-art.com
Venue with a programme of
exhibitions of young contem-
porary art and culture

Setagaya Museum of Art
1-2 Kinuta Koen
Setagaya-ku
Tokyo 157-0075
tel: +81 (0)3 3415 6011
fax: +81 (0)3 3415 6413
www.setagayaartmuseum.com
Museum opened in 1986 to
house large-scale historical and
contemporary exhibitions

Shiseido Gallery
Tokyo Ginza Shiseido Bldg
B1F, 8-8-3 Ginza
Chuo-ku
Tokyo 104-0061
tel: +81 (0)3 3572 3901
fax: +81 (0)3 3572 3951
www.shiseido.co.jp/e/gallery/html
Exhibition space in the basement
of the Shiseido building renovated
and reopened in 2001 with an
emphasis on new Japanese and
international contemporary art

Tokyo Metropolitan Museum of
Photography
1-13-3 Mita
Meguro-ku
Tokyo 153-0062
tel: +81 (0)3 3280 0031
fax: +81 (0)3 3280 0033
www.tokyo-photo-museum.or.jp
Museum inaugurated in 1995 and
housing a collection and temporary
exhibitions of photography

Tokyo Opera City Art Gallery
Tokyo Opera City Tower
3-20-2 Nishi-Shinjuku
Shinjuku-ku
Tokyo 163-1403
tel: +81 (0)3 5353 0756
fax: +81 (0)3 5353 0776
www.operacity.jp/en/exhi.html

Exhibition space opened in 1999
in the Tokyo City Opera with
temporary and permanent
exhibitions of 21st century
visual art and music

Watari-um
(The Watari Museum of
Contemporary Art)
3-7-6 Jingumae
Shibuya-ku
Tokyo 150-0001
tel: +81 (0)3 3402 3001
fax: +81 (0)3 3405 7714
www.watarium.co.jp
Collection and changing
programme of exhibitions of
international contemporary art
from the late 20th century to
the present day

ART BOOKSHOP →
NADiff
Casolare Harajuku B1F
4-9-8 Jingumae
Shibuya-ku
Tokyo
tel: + 81 (0)3 3403 8852
fax: +81 (0)3 3403 8819

HIP PLACES →
Aoyuzu
1-8-14-B1
Ebisu
Shibuya-ku
Tokyo
tel: +81 (0)3 3449 5075
http://www.susinippan.co.jp/aoyu-
zu_ebisu.html#menu
Restaurant serving Japanese
nouvelle cuisine with a live DJ
at weekends playing everything
from garage to Brazilian
groove

Bullet's
B1F 1-7-11 Nishi Azabu
Minato-ku
Tokyo
tel: +81 (0)3 3401 4844
http://www.azzlo.com/bullets/
Lounge style bar and club with
music ranging from independent
to hardcore dance

Las Chicas
5-47-6 Jingumae
Shibuya-ku
Tokyo
tel: +81 (0)3 3407 6865
Casual and inexpensive bar/café
owned by an art dealer and loca-
ted nearby several galleries

Muginbou
Showa Bldg. 3-30-2
Ikejiri
Setagaya-ku
Tokyo
tel: +81 (0)3 3487 4811
http://www.muginbou.co.jp/
Japanese noodle restaurant
popular with young people
and open until 4am

Park Hyatt
3-7-1-2 Nishi-Shinjuku
Shinjuku-ku
Tokyo
tel: +81 (0)3 5322 1234
fax: +81 (0)3 5322 1288
Classic hotel bar

AIRPORTS →
Kansai International Airport (KIX)
Kansai International Airport
1-banchi
Senshu-kuko Kita
Izumisano-shi
Osaka 549-8501
The airport is located 50km
(31 miles) southwest of Osaka
tel: +81 (0)7 2455 2500
fax: +81 (0)7 2455 2058
tn0010@kiac.co.jp
www.kansai-airport.or.jp

New Tokyo International Airport
(NRT)
New Tokyo International Airport
Narita-shi
Chiba 282-8601
The airport is located 65km
(40 miles) east of Tokyo
tel: +81 (0)4 7632 2802
fax: +81 (0)4 7630 1571
naa1@naa.go.jp
www.narita-airport.or.jp/airport_e

Wien

GMT + 1 (GMT + 2 between April and October)

In the last few years, international attention has been fixed on the contemporary art scene in Vienna, not least as a result of the launching of the new 'Museumsquartier'. This arts and culture complex in the heart of city opened in autumn 2001 and, with its almost 650,000 square feet of space, it is one of the largest arts centres in the world. In a series of newly constructed buildings behind the baroque façade of the erstwhile court stables, a broad array of cultural institutions of every size and description awaits the visitor, including not only the Museum moderner Kunst Stiftung Ludwig Wien (Museum of Modern Art Foundation Ludwig Vienna), Kunsthalle Wien, and the Leopold Museum, but also the Architekturzentrum (Architecture Centre), dance spaces, artist-in-residence studios, bookshops and cafés. During more than ten years of planning and construction, the district became a home for many smaller cultural initiatives such as the service platform 'basis wien' and the Institute for New Culture Technologies 'public netbase'. But as the state's cultural policies focus on maximizing the prestige to be gained from the area, only time will tell whether these smaller ventures will be able to continue working here on a permanent basis. The birth of two new gallery districts has forged a ring, as it were, for contemporary art around the Museumsquartier. The local scene has seen a number of remarkable changes over the last three years as a result of all the galleries that have opened, re-opened, or moved premises. The frequently heard buzzword here is 'professionalisation'. Representative of these tendencies are, for instance, the spacious and decidedly chic galleries in Eschenbachpalais (Galerie Meyer Kainer, Raum aktueller Kunst – Martin Janda and Galerie Krobath & Wimmer), and in Schleifmühlgasse in Vienna's fourth district (Georg Kargl and Kerstin Engholm and Gabriele Senn Galerie). Naturally there can be no doubt about the importance to Vienna's international art discourse of two additional institutions: the Secession and the Generali Foundation, which are musts for any visit to the Austrian capital. The Secession is an artists' association and its programme is determined on a democratic basis by the member artists, and solely according to artistic merit. Its core agenda is to present the cutting edge of Austrian and international art, and in this it acts as an important corrective to the way numerous other institutions in Austria present contemporary art. Much the same applies to the Generali Foundation, even if this institution takes a completely different approach in the conception of its outstanding exhibitions, concentrating on scientific appraisal and documentation, free of any commercial considerations. The main focus of the collection is sculpture – understood in very broad terms and independent of the media. Since autumn 2001, the newly renovated building of the Gustinus Ambrosi-Museum in Vienna's Augarten has become a second home to the Belvedere, which above all is known for its collection that embraces masterpieces by Gustav Klimt and Egon Schiele. With his highly committed programme of theme exhibitions, curator Thomas Trummer has moulded Atelier Augarten into a small but choice centre for contemporary art.

EVENTS →

kunst wien
messe für zeitgenössische kunst
(contemporary art fair)
MAK – Österreichisches Museum
für Angewandte Kunst
Weiskirchnerstraße 3
1010 Wien

VIENNALE — Vienna International
Film Festival
Siebensterngasse 2
1070 Wien
tel: +43 (0)1 5265947
fax: +43 (0)1 523 41 72
office@viennale.at
www.viennale.at

COMMERCIAL GALLERIES →

Galerie Charim & Klocker
Dorotheergasse 12
1010 Wien
tel: +43 (0)1 5120915
fax: +43 (0)1 5120915-50
charimklocker@magnet.at
www.charimklocker.at

Galerie Heike Curtze
Seilerstätte 15/16
1010 Wien
tel: +43 (0)1 5129375
fax: +43 (0)1 5134943

Kerstin Engholm Galerie
Schleifmühlgasse 3
1040 Wien
tel: +43 (0)1 5857337
fax: +43 (0)1 5857338
office@kerstinengholm.com
www.kerstinengholm.com

Galerie Ernst Hilger
Dorotheergasse 5
1010 Wien
tel: +43 (0)1 5125315
fax: +43 (0)1 5139126
hilger@hilger.at
www.hilger.at

Galerie Grita Insam
Köllnerhofgasse 6
1010 Wien
tel: +43 (0)1 5125330
fax: +43 (0)1 5126194
GGInsam@aol.com

Georg Kargl
Schleifmühlgasse 5
1040 Wien
tel: +43 (0)1 5854199
fax: +43 (0)1 58541999
georg.kargl@netway.at

Galerie Hans Knoll
Esterhazygasse 29
1060 Wien

tel: +43 (0)1 5875052
fax: +43 (0)1 5875966
knollgalerie@aon.at
www.kunstnet.at/knoll

Galerie Christine König
Schleifmühlgasse 1a
1040 Wien
tel: +43 (0)1 5857474
fax: +43 (0)1 5857474-24
christine.koenig@chello.at
www.kunstnet.at/koenig

Galerie Krinzinger
Seilerstätte 16
1010 Wien
tel: +43 (0)1 5133006
fax: +43 (0)1 513300633
krinzinger@galerie-krinzinger.at
www.galerie-krinzinger.at

Galerie Krobath & Wimmer
Eschenbachgasse 9
1010 Wien
tel: +43 (0)1 5857470
fax: +43 (0)1 5857472
krobath.wimmer@utanet.at

Kunstbüro 1060
Schadekgasse 6
1060 Wien
tel: +43 (0)1 5852613
fax: +43(0)1 5852613

kunstbuero@utanet.at

Galerie Nächst St. Stephan
Rosemarie Schwarzwälder
Grünangergasse 1/2
1010 Wien
tel: +43 (0)1 5121266
fax: +43 (0)1 5134307
galerie@schwarzwaelder.at
www.schwarzwaelder.at

Galerie Meyer Kainer
Eschenbachgasse 9
1010 Wien
tel: +43 (0)1 5857277
fax: +43 (0)1 5857539
contact@meyerkainer.at
www.meyerkainer.at

Galerie mezzanin
Karin Handlbauer
Mariahilferstr. 74a
1070 Wien
tel: +43 (0)1 5264356
fax: +43 (0)1 5264356
mezzanin@chello.at

Raum aktueller Kunst
Martin Janda
Eschenbachgasse 11
1010 Wien
tel: +43 (0)1 5857371
fax: +43 (0)1 5857372

office@raumaktuellerkunst.at
www.raumaktuellerkunst.at

Gabriele Senn Galerie
Schleifmühlgasse 1a
1040 Wien
tel: +43 (0)1 5874163
fax: +43 (0)1 5874163
galerie.senn@aon.at

Galerie Steineck
Himmelpfortgasse 22
1010 Wien
tel: +43 (0)1 5128759
fax: +43 (0)1 5128759
galeriesteineck@eunet.at

Galerie Hubert Winter
Breite Gasse 17
1070 Wien
tel: +43 (0)1 5240976
fax: +43 (0)1 52409769
hwinter@galeriewinter.at
www.galeriewinter.at

PUBLIC GALLERIES →
Atelier Augarten
Zentrum für zeitgenössische
Kunst
Gustinus Ambrosi-Museum
Scherzergasse 1a
1020 Wien
tel: +43 (0)1 79557-0
fax: +43 (0)1 7984337
belvedere@belvedere.at
Gallery belonging to the Austrian
Galerie Belvedere (which includes
the Egon Schiele Collection) with
an ambitious programme of mostly
thematic exhibitions

basis wien
Kunst, Information und Archiv
Fünfhausgasse 5
1150 Wien
tel: +43 (0)1 5226795-0
fax: +43 (0)1 5225395-12
office@basis-wien.at
www.basis-wien.at
Service platform with up-to-the-
minute information on current art
and an online data bank

Depot
Kunst und Diskussion
Breite Gasse 3
1070 Wien
tel: +43 (0)1 5227613
fax: +43 (0)1 5226642
depot@depot.or.at
www.depot.or.at
Institute aimed at contemporary
discourse and new projects with
discussion and lecture program-

mes, symposia, workshops and
seminars to promote a critical
appraisal of contemporary art

Generali Foundation
Wiedner Hauptstraße 15
1040 Wien
tel: +43 (0)1 5049880
fax: +43 (0)1 5049883
found.office@generali.at
www.gfound.or.at
Important private institution
dedicated to building a collection
of current art that reflects
Austrian interests while placing
them in an international context,
with an active programme of
collecting, publishing and
exhibiting contemporary art

kunsthalle wien
im Museumsquartier
Museumsplatz 1
1070 Wien
tel: +43 (0)1 512891201
fax: +43 (0)1 512891260
office@kunsthallewien.at
www.kunsthallewien.at
Presentations of international
modern and contemporary art
exhibitions with an emphasis on
photography, video, film and
'experimental' architecture and
a special programme dedicated
to the work of Austrian artists.

k/haus Künstlerhaus Wien
Karlsplatz 5
1030 Wien
tel: +43 (0)1 5879663
fax: +43 (0)1 5878736
office@k-haus.at
www.k-haus.at
Founded in 1861 by the Society for
Austrian Artists with an exhibition
space, cinema and theatre, which
since 1998 has extended its focus
to include architecture, inter-
disciplinary theme exhibitions and
an experimental arena for young
artists

MAK
Museum für Angewandte Kunst
Stubenring 5
1010 Wien
tel: +43 (0)1 711360
fax: +43 (0)1 7131026
office@mak.at
www.mak.at
Extensive historical collection of
applied arts and regular presenta-
tions of international contemporary
art in special exhibitions.

MUMOK
Museum moderner Kunst Stiftung
Ludwig Wien im Museumsquartier
Museumsplatz 1
1070 Wien
tel: +43 (0)1 52500-1317
fax: +43 (0)1 52500-1300
bildung@mumok.at
www.mumok.at
The largest museum in Austria
for modern and contemporary art
with a collection focusing on art
from the second half of the 20th
century and changing exhibitions
of contemporary art.

museum in progress
Fischerstiege 1
1010 Wien
Tel.+43 (0)1 5335840
fax: +43 (0)1 5353631
office@mip.at
www.mip.at
Arts association founded in 1990
organising exhibitions in its
Medienraum as well as working
with more transitory media such
as daily newspapers, billboards,
TV and the Internet

PUBLIC NETBASE t0
Media~Space!
Institute for New Culture
Technologies im Museumsquartier
Museumsplatz 1
1070 Wien
tel: +43 (0)1 5221834
fax: +43 (0)1 5225058
office@t0.or.at
www.t0.or.at
Public Netbase t0 is a non-profit
internet server and runs a
comprehensive events and
information programme in the
Viennese Museumsquartier

Secession
Friedrichstraße 12
1010 Wien
tel: +43 (0)1 5875307
fax: +43 (0)1 5875307-34
exhibition@secession.at
www.secession.at
Independent artists' association
housed in turn-of-the-century
exhibition premises dedicated to
contemporary art with exhibitions
focussing on current developments
in the Austrian and international
art scenes

ART BOOKSHOP →
Judith Ortner
Sonnenfelsgasse 8

1010 Wien
tel: +43 (0)1 5127469
fax: +43 (0)1 5124900

HIP PLACES →
American Bar
Kärntner Durchgang 10
1010 Wien
tel: +43 (0)1 5123283
Very small but elegant bar designed
in the early 20th century by Adolf
Loos that has remained unchanged
ever since

Barfly's Club
Esterházygasse 33
1060 Wien
tel: +43 (0)1 5860825
Hotel bar for that last drink of the
night

Palmenhaus
Burggarten 2
1010 Wien
tel: +43 (0)1 5331033
Beautiful fin de siècle building in
the palace gardens with an open
terrace, café, bar and restaurant

Schikaneder
Kino und Club
Margaretenstraße 24
1040 Wien
tel: +43 (0)1 5852867
(Cinema/Club)
tel: +43 (0)1 5855888 (Office)
www.schikaneder.at
'The' meeting place for the in-crowd
from the galleries in Schleifmühl-
gasse in the Freihaus district

Tanzcafé Jenseits
Nelkengasse 3
1060 Wien
tel: +43 (0)1 5871233a
Once a somewhat dubious esta-
blishment, as still evident by the
bouncers and the peephole in the
door, now boasting a plush interior
and small dance floor

AIRPORT →
Vienna International Airport (VIE)
Wien Flughafen
Postfach 1
1300 Wien
tel: +43 (0)1 70070
fax: +43 (0)1 700723805
www.viennaairport.com

Zürich

GMT + 1 (GMT + 2 between April and October)

The unexpected rise of Zurich as one of the most concentrated and powerful scenes in contemporary art began with a political quarrel. Two institutions, the Kunsthalle Zürich and the Schauspielhaus Zürich, were fighting over the same building complex, a run down brewery in a formerly industrial district full of prostitutes and drug addicts. Kunsthalle Zürich won and moved into the building on Limmatstrasse, together with a handful of carefully selected galleries. That was in May 1996. Since then, three important institutions, six of the most exciting galleries in the country, a notable auction house, an alternative space for theatres and parties and a bookstore have joined it under the same roof. Dozens of restaurants, bars, clubs and fashion stores followed and blew new life into the former wasteland of Zürich-West. All of a sudden, the spread-out art scene had found its centre and today it continues to flourish as many more of Zurich's galleries move west along with new designers, media companies, venues, clubs, bars and restaurants. In addition, the area surrounding the Kunsthaus Zürich (which is currently being renovated) is home to several first league galleries. Not too long ago, Paul Nizon the Swiss writer living in exile in Paris, commented on the situation in the country he had earlier left, describing the desire for Swiss artists to leave their home country in search of international art movements and bring the intellectual fruits of their travels back home. Now, Swiss artists such as Fischli und Weiss, Pipilotti Rist or Roman Signer no longer leave their country for New York City or elsewhere to make their career. Instead, the newly invigorated art scene allows them to stay and live well in Zurich, a town that was, paradoxically, once known for the iconoclasm of the early 1500s, when hundreds of paintings and sculptures were destroyed by religious fundamentalists. Museums and the financial elite have always liked to shop for art in Zurich, where gallerists like Lelong sniffed out excellent artists such as Louise Bourgeois, Alexander Calder and Eduardo Chillida when they still were barely known. The city also has a long-standing intellectual reputation, due in part to the curator Harald Szeemann who was responsible for the mise-en-scene of a series of blockbuster exhibitions at the Kunsthaus Zürich in the 1980s, and to Bice Curiger, who initiated the publication of "Parkett", a bi-lingual art magazine that achieved worldwide acclaim and became one of the most respected voices in contemporary art. The backdrop to all of this art world activity is Zurich's famous lake in the centre of the city, where hundreds of locals swim during lunch breaks or after work in the summer, as well as the over three hundred open-air bistros or restaurants which provide welcome refreshment after a day in the galleries.

EVENTS →
Art Basel (international contemporary art fair)
Every year in June in Basel, two hours from Zurich
info@ArtBasel.com
www.ArtBasel.com

KunstZürich (contemporary art fair)
Every year in March
info@kunstzuerich.ch
www.kunstzuerich.ch

COMMERCIAL GALLERIES →
Thomas Ammann Fine Art AG
Restelbergstrasse 97
8044 Zürich
tel: +41 (0)1 3605160
fax: +41 (0)1 3605161
da@ammannfineart.com
www.ammannfineart.com

arsFutura Galerie
Bleicherweg 45
8002 Zürich
tel: +41 (0)1 2018810
fax: +41 (0)1 2018811
www.arsfutura.ch

Galerie Bruno Bischofberger
Utoquai 29
8008 Zürich
tel: +41 (0)1 2624020
fax: +41 (0)1 2622897
info@brunobischofberger.com
www.brunobischofberger.com

Galerie Bob Gysin
Ausstellungstrasse 24
8005 Zürich
tel: +41 (0)1 278 4060
fax: +41 (0)1 2784050
info@bg-galerie.ch
www.bg-galerie.ch

Hauser & Wirth
Limmatstrasse 270
8005 Zürich
tel: +41 (0)1 4468050
fax: +41 (0)1 4468055
info@ghw.ch
www.ghw.ch

Hauser & Wirth & Presenhuber
Limmatstrasse 270
8005 Zürich
tel: 41 (0)1 4468060
fax: +41 (0)1 4468065
info@ghwp.ch
www.ghwp.ch

Galerie Peter Kilchmann
Limmatstrasse 270
8005 Zürich
tel: 41 (0)1 440 3931
fax: +41 (0)1 440 3932
info@kilchmanngalerie.com
www.kilchmanngalerie.com

Galerie Lelong Zürich
Utoquai 31
8008 Zürich
tel: 41 (0)1 2511120
fax: +41 (0)1 2625285
galerie.lelong@dplanet.ch

Mai 36 Galerie
Rämistrasse 37
8001 Zürich
tel: 41 (0)1 2616880
fax: 41 (0)1 261 6881
mai36@artgalleries.ch
www.artgalleries.ch/mai36

Galerie Mark Müller
8001 Zürich
tel: 41 (0)1 2118155
tel: 41 (0)1 2118220
mark.mueller@dplanet.ch
www.markmueller.ch

Galerie Bob van Orsouw
Limmatstrasse 270
8005 Zürich
tel: 41 (0)1 2731100
fax: 41 (0)1 2731102
mail@bobvanorsouw.ch

de Pury & Luxembourg
Limmatstrasse 264
8005 Zürich
tel: 41 (0)1 2768020
fax: 41 (0)1 2768021
info@dplzh.com

Galerie Scalo
Weinbergstrasse 22a
8001 Zürich
tel: 41 (0)1 2610910
fax: +41 (0)1 2619262
gallery@scalo.com
www.scalo.com

Galerie Schedler
Josefstrasse 53
8005 Zürich
tel: 41 (0)1 4406120
fax: 41 (0)1 4406121
mail@schedler.ch
www.schedler.ch

Annemarie Verna Galerie
Neptunstrasse 42
8032 Zürich
tel: 41 (0)1 2623820
fax: 41 (0)1 262 3826
office@annemarie-verna.ch
www.annemarie-verna.ch

Jamileh Weber
Waldmannstrasse 6
8001 Zürich
tel: 41 (0)1 2521066
fax: 41 (0)1 2521132
jamileh@access.ch
www.jamilehweber.com

Serge Ziegler Galerie
Limmatstrasse 275
8005 Zürich
tel: 41 (0)1 4404295
fax: 41 (0)1 4404297
info@zieglergalerie.com
www.zieglergalerie.com